At Home with the Sapa Inca

AT HOME WITH THE SAPA INCA

Architecture, Space, and Legacy at Chinchero | STELLA NAIR

UNIVERSITY OF TEXAS PRESS | AUSTIN

This book is a part of the Recovering Languages and Literacies of the Americas publication initiative, funded by a grant from the Andrew W. Mellon Foundation.

Requests for permission to reproduce material
from this work should be sent to:
Permissions | University of Texas Press
P.O. Box 7819 | Austin, TX 78713-7819
http://utpress.utexas.edu/index.php/rp-form

♾ The paper used in this book meets the minimum
requirements of ANSI/NISO Z39.48-1992 (R1997)
(Permanence of Paper).

Library of Congress Cataloging-in-Publication Data
 Nair, Stella, author.
 At home with the Sapa Inca : architecture, space, and legacy
at Chinchero / by Stella Nair. — First edition.
 pages cm
 Includes bibliographical references and index.
 ISBN 978-1-4773-0249-1 (cloth : alk. paper)
 ISBN 978-1-4773-0250-7 (pbk. : alk. paper)
 ISBN 978-1-4773-0549-2 (lib. e-book)
 ISBN 978-1-4773-0550-8 (non-lib. e-book)
 1. Inca architecture. 2. Excavations (Archaeology)—
Interpretive programs—Peru—Chinchero (District)
3. Architecture and anthropology—Peru—Chinchero (District)
4. Social archaeology—Peru—Chinchero (District) 5. Incas—
History. 6. Chinchero (Peru : District)—Antiquities. 7. Peru—
History—Conquest, 1522–1548. I. Title.
 F3429.3.A65N37 2015
 985′.02—dc23 2014037027

doi:10.7560/302491

This book is dedicated to my parents,
Sterling E. Nair and Fölke D. Hinrichs-Nair,
and my friends in Cupir, Ayllupongo, and
Yanacona *ayllu*.

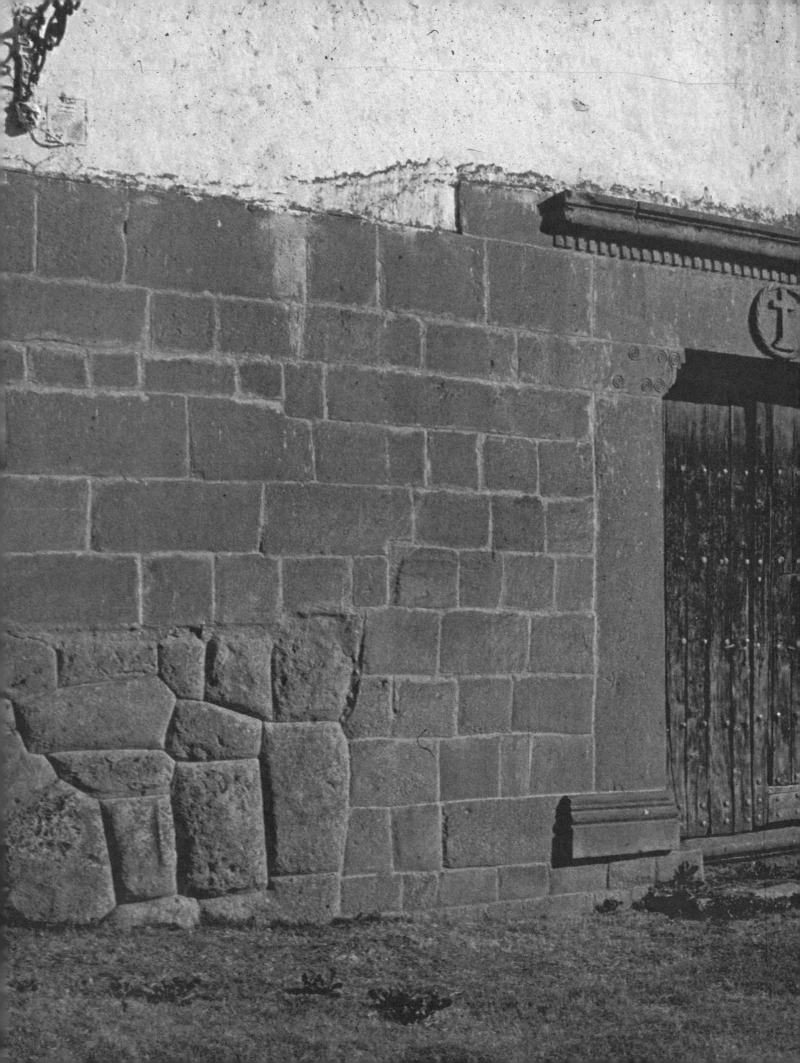

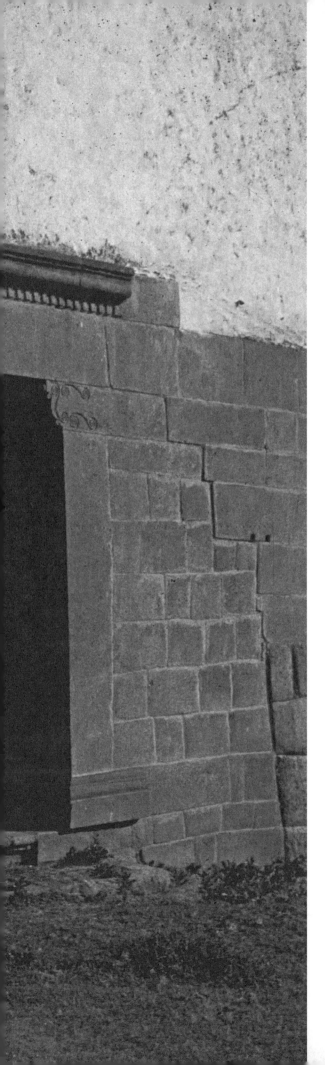

CONTENTS

ILLUSTRATIONS

ACKNOWLEDGMENTS

The lush gardens and dark, wood-paneled halls of Dumbarton Oaks Research Library were where this book began its long journey. The idea came into being during a fellowship I had there (2008–2009), and in regular conversations with the cohort of Pre-Columbian fellows, my chapters began to take shape. Whether gathered together during our daily lunches or bonding over beers in the evening, we talked about our work. And it was in response to their probing questions about Inca architecture and the methods commonly used to understand the built environment that I realized the core structure of my monograph. Thus I owe a great deal to the then director of Pre-Columbian Studies Joanne Pillsbury and the Pre-Columbian Fellows, Antti Korpisaari, John Janusek, Michael Love, Andrew Scherer, and Veronica Williams, as well as fellows in other sections, especially Rina Avner, Fotini Kondyli, Bella Sandwell, and Riikka Vaisanen, for their indulgence in talking with me about my subject and for their kindness and camaraderie. I am also grateful to the Senior Fellows who frequented the halls, such as Tom Cummins, Gary Urton, and Chip Stanish, who helped make that a wonderful, enlightening year.

Though this book began during my stay at Dumbarton Oaks, I drew upon data that I had collected over several years, starting with my dissertation. Therefore, I also have a deep appreciation for the people who helped me first undertake this research. To begin with, special thanks go to Susan Niles, John Rowe, and Jean-Pierre Protzen. Despite my initial reluctance, they gathered together in Cuzco one morning to take me to Chinchero for

my first visit as a young graduate student. Their collective enthusiasm convinced me that this was the site where I needed to work. Over the years, they continued to advise me, and their combined wisdom permeates almost every page of this volume.

Jean-Pierre invited me to join him in Bolivia to investigate Tiahuanaco architecture. On the dusty, dry plains of the high desert, Jean-Pierre trained me in his careful, methodical approach to the study of design and construction, one where every stone is closely studied, drawn, mapped, measured, and redrawn. He was endlessly patient with me as I learned alongside him each day in the field. I am honored to carry on the methodologies that he developed and treasure the memories of the summers I spent with him and his wife, Elsbeth, in the Andes. I am particularly obliged to Elsbeth, who taught me how not just to survive, but to thrive while being in the field. For both of them, I offer praise, thanks, and affection.

I would like also to acknowledge Edward Franquemont posthumously. Despite the high altitude, freezing nights, and lack of running water, at Ed's encouragement I lived in Chinchero rather than in the comforts of Cuzco. His advice was critical in two ways. First, it allowed me to see the architecture of Chinchero in a profoundly different way. As I hope will become apparent in the following pages, it is only by living in these spaces, walking them daily, and studying/restudying each individual structure that I came to know these places intimately, and the importance of their distinct design, construction, and experience began to unfold. Without Ed's sage advice, the knowledge that lies at the very core of this book would never have been gathered.

The second reason Ed's advice was so important was that it allowed me to get to know some remarkable people. For over a year (and many subsequent summers), I lived with Ed's *comadre* and *compadre*, Simeona and Genovevo Sallo; their children, Betty, Nelly, Dino, Andy, Danilo, Soraya, and Eric; and their grandchild, Rudy. From gathering together every morning at the crack of dawn for some of Simeona's steaming cream of wheat, to

sitting together at day's end as the last embers of the evening's fire died out, I spent every moment that I was not working in Chinchero with Simeona and her family. Simeona took care of me when I was sick and kindly but firmly educated me about life in that community. During this time, Simeona and her husband, children, and grandchild became my family in every sense of the word. I thank them from the heart for the care and friendship they showed me and am honored that they included me in their lives over these many, many years. Even though I was clearly an outsider, they made me feel like I belonged.

In Chinchero itself, there are many other people to recognize, but one person in particular stands out: Jacinto Singona. He was my daily field companion for more than a year. Together we measured every existing Inca stone that we could find in and around Chinchero, along with many colonial ones. As I had only the smallest of funds for equipment, we measured everything with simple, handheld tools. Together we not only measured and mapped all the excavated and exposed Inca remains and hiked along distant Inca roads in search of quarries, but he and I also entered every single home in the town of Chinchero, bearing gifts of flour, in search of Inca and colonial-period walls. Although many days the sun shone gloriously, the high winds always came, sometimes with hail or intense thunderstorms. Together, we also learned important insights from people in the community, among them elders like Tomás Huaman and Stanislau Ailler, who regularly shared their immense knowledge of the landscape and architecture with us. I am forever indebted to Nilda Callañaupa for having recommended Jacinto to be my coworker. His kindness, carefulness, and perseverance made him the ideal field companion—and friend. During our long days working, we shared many of our thoughts on life and family, and I came to know his wonderful wife, Augusta, my *comadre*, and their four sons.

Of course, no field work would have been possible without support from authorities at the Instituto Nacional de Cultura; I am grateful to the many directors and archaeologists who provided

critical assistance in getting me permits and offering important advice during the decade I worked at Chinchero. Among these, special thanks go to Arminda Gibaja, Julinho Zapata, Gustavo Manrique Villalobos, Jean Jacque Decoster, Americo Carillo Rosell, and Amelia Perez Trujillo. In Lima, I am indebted to Marcia Koth de Paredes, Ada Visage, and Cecilia Esperanza from the Fulbright Office and Chris Ward from the US Embassy for all their help in supporting my research. Also, I very much appreciate architect Juvenal Baracco from the Universidad Ricardo Palma for his critical support of this project.

Doing field and archival work can be expensive, and I am happy to acknowledge the following institutions for providing the crucial funds needed to conduct research as well as write this book in the United States and Peru: the American Philosophical Society; the Center for the Advanced Study in the Visual Arts, the Department of Academic Programs, and Department of Prints and Drawings at the National Gallery of Art, Washington, DC; the Committee on Research at the University of California, Riverside; the Cotsen Institute of Archaeology at the University of California at Los Angeles; the Dumbarton Oaks Research Library and Collections; the Edilia and François-Auguste de Montêquin Junior Fellowship from the Society of Architectural Historians; the Fulbright Scholarship from the Institute of International Education; the Getty Foundation; the John Carter Brown Library; the Institute of the Humanities and the Institute for Research on Women and Gender at the University of Michigan; the Michigan Society of Fellows; and the National Endowment for the Humanities.

This research often took me far outside of my academic training and intellectual comfort zone. I owe particular gratitude to the many friends and colleagues who read all or portions of the manuscript and pointed out critical areas that needed clarifying, expanding, correcting, or reconsidering. They saved me from straying down many a false road, and I appreciate all the time they spent slogging through extremely rough early drafts and sharing with me their critical insights. These include Tamara Bray, Luis Carranza, Melissa Chatfield, Carolyn Dean, Pablo Garcia, Christine Hastorf, John Janusek, Claire Kim, Gordon McEwan, Jeremy Mumford, Daniel Stolzenberg, Gabriela Venegas, Charles Walker, and Jason Weems. Preeti Chopra deserves special mention for caving in to my pleas and rereading the manuscript more than any dear friend should ever be asked to do.

Many people helped me turn the manuscript into a book. Among them are the colleagues who shared images with me, such as Richard Kagan, Susan Niles, Jean-Pierre Protzen, Jonathan Reynolds, and Izumi Shimada. Teodora Bozhilova's exceptional computer skills made possible the publication of many of the original drawings in this volume. Words cannot convey how thankful I am for the help from professionals who worked so tirelessly to compile and edit the text and move the publication process along. This includes the magical editorial skills of Ann Karlstrom, who helped me make sense of some rather hairy chapters, and Mary Crettier who transformed a very early version of Chapter 1. I feel very fortunate to have worked with the wonderful team at the University of Texas Press. Theresa May's and Kerry Webb's faith in this project and great patience made stressful deadlines manageable. They were supported by the outstanding Angelica Lopez, Gretchen Otto, and Kathy Clayton, whose skill, speed, and finesse masterfully made the manuscript into a book. While each of these people helped improve the manuscript, no text is perfect and I alone bear the responsibility for any shortcomings that remain.

Finally, on a personal note, I would like thank those people not already mentioned who have helped me weather the many years it took to undertake this project. They include Meredith Cohen, Finbarr Barry Flood, Karen Kevorkian, Ivonne del Valle, Carla Savage, Zoe Strother, and Dell Upton. I am fortunate to have such wonderful, caring friends. And of course, I thank my amazing family, Sterling, Fölke, and Scott, for their never-ending patience, support, and love. I would not have made it this far without you.

ON QUECHUA ORTHOGRAPHY

Andean people were sophisticated in their visual and material literacy, using a variety of objects and designs to convey their messages. However, unlike in Mesoamerica, they did not develop a written communication system. Alphabetic writing was introduced into the Andes in the sixteenth century: colonial-period authors, both indigenous and European, were the first to contend with Quechua orthography. Given that Quechua itself has many regional variations and many writers were not sensitive to the subtleties of pronunciation, the colonial sources vary in their spellings. This has rendered some confusion as to the original pronunciation of and distinction between words, as well as their original meanings. Fortunately, in recent decades, linguistics scholars have been able to bring much more clarity to our understanding of Quechua during the colonial period, particularly regarding what was spoken in the Inca heartland.

However, because much of the argument in this text is based on how these early writers understood Quechua (and how these colonial-period interpretations impacted subsequent scholarship), I have chosen to use the most commonly accepted of the sixteenth-century spellings. Whenever possible, I have also included the current phonetic interpretation of the Quechua. There are some exceptions to my use of colonial-period spelling, such as when I refer to a contemporary word or reference place names. In the latter cases I have used the current spelling, so as not to confuse readers who are familiar with the region.

At Home with the Sapa Inca

INTRODUCTION

This book began as an attempt at *reqsiy*, the Quechua word meaning "to know a place or a people."[1] In particular, the goal of the project was to become familiar with the Inca estate of Chinchero and the landscape in which it was embedded.[2] As the project moved forward, it led to an examination of Chinchero's creation, its dynamic use as a private residence and state center, its role in a complicated battle over succession, its transformation into a royal memorial and prison, and finally its desecration and subsequent reconstitution as a Spanish colonial town. Growing as such endeavors do, this desire to become acquainted with Chinchero unfolded into the much greater journey to knowing the place and its people in more profound ways.

This journey required a study of the life and influence of Topa Inca (Thupa 'Inka), one of the most formidable Inca rulers, who played a critical role in shaping the landscape of Chinchero (in life and in death). Also of importance are those who lived in or visited the royal estate, as well as the various individuals and groups who played a part in drastically altering Chinchero's urban fabric after the Spanish invasion. While we cannot fully "know" Chinchero and the people who built, lived, and altered it, the journey of trying to know provides critical insights into a dynamic and complex architectural center and the defiant and diverse individuals who shaped and experienced it.

Topa Inca and the Written Records

Much of what we know about Topa Inca and Chinchero comes from colonial-period sources such as Spanish conquistadors and church administrators. In these writings, Topa Inca's life is remembered in fragments.[3] His adult name was Topa Inca Yupanqui. He was born into privilege in the early fifteenth century, the son of a powerful *sapa inca* (ruler) named Pachacuti Inca Yupanqui and his principal wife, Anahuarque, a woman from the town of Choco, located near the capital of Cuzco.[4] Topa Inca had many siblings, perhaps as many as three hundred, via his father's official and unofficial sexual liaisons. Little is known of Topa Inca's childhood, other than a reference that he may have spent his formative years living in the sacred complex known as the Coricancha ("Golden Enclosure") in Cuzco.

When Topa Inca was a young man, he married a relative. Whether she was a full or half sister (or perhaps even a cousin) is unclear, but it appears he married her because of his father's wishes. Although incestuous marriages are often associated with the *sapa inca*, only the last two imperial Inca rulers (Topa Inca and his son Huayna Capac [Wayna Qhapaq]) appear to have married close relatives. Mama Ocllo became Topa Inca's principal wife. She was a powerful consort and bore him several children. Like his father, Topa Inca also took on secondary wives and multiple mistresses, though not in the same quantity as Pachacuti. One of Topa Inca's favorites was a woman named Mama Chequi Ocllo, with whom he had at least one son.

Knowledge of Topa Inca as an adult is derived mainly from accounts of his success on the battlefield. The colonial writers devoted considerable time to the details of his many conquests, which was no small feat, given that Topa Inca spent most of his adult life away in battle. Along with his father and several of his brothers, Topa Inca was instrumental in expanding the Inca Empire, which was called Tahuantinsuyu, or "Land of the Four Quarters." It is these military victories that seem to have prompted his father, Pachacuti, to change

his mind about the imperial succession and designate Topa Inca as his heir, having him replace a brother, Amaru Topa, who had previously been appointed as legatee (the Inca did not practice primogeniture). By incorporating extensive and diverse new lands that stretched across the western rim of South America, Topa Inca came to rule one of the largest empires of the early modern world. He lived a long life and, sometime in the late fifteenth century, built a royal estate at Chinchero.

Chinchero and the Written Records

Inca rulers built lavish estates to serve as private retreats, temporary capitals, and memorials to their rule. Some *sapa inca* built more than one. Pachacuti had two estates in the Urubamba Valley (Pisac and Ollantaytambo) and another at Machu Picchu. Topa Inca had a side valley that spread up a canyon and covered part of the plains above. Here his principal wife, Mama Ocllo, had lands and Topa Inca built Urcos (today called Urquillos).[5] Toward the end of his reign, Topa Inca ordered a new residence be built for him in a canyon above Urcos (Urquillos), on the edge of the Pampa de Anta plains. This retreat was called Chinchero, which aptly described its location in two ways. It was within the region of Chinchasuyu (Chin) and was built upon the side of a hill (*chiru* means "on a side"). The written records describe Chinchero's construction, with Topa Inca gathering his noblemen together at the site and ordering them to build an impressive royal retreat.

According to colonial writers, Topa Inca lived in Chinchero for several years. It appears that he spent that time with his favorite secondary wife, Mama Chequi Ocllo, and their son Capac Huari (Qhapaq Wari). As his father had done before him, Topa Inca changed his preference for successor, from Huayna Capac (son of his principal wife and close relative Mama Ocllo) to Capac Huari. Sometime in the late fifteenth century, Topa Inca died at Chinchero. His death led to a succession dispute between two sons, Huayna Capac and Capac Huari, which lasted two years. Huayna Ca-

pac emerged the victor, putting to death his stepmother Chequi Ocllo and banishing his half brother Capac Huari to exile in Chinchero. What happened afterward is met with silence in the colonial writings. We have no references to the royal estate for the next several decades.

Fortunately, the colonial sources have much to say about Inca estates in general, including what happened to them after the death of the royal patron. When an Inca ruler died, the *sapa inca* was "not at the end of his career but at the beginning of candidacy for ancestral greatness."[6] In the form of a *mallqui* (*mallki*, ancestor mummy), Inca rulers were consulted on important matters and were feasted and venerated. They also continued to travel, participate in ceremonies, and own properties, which they visited with their retinue of servants.[7] Thus, even after death, Chinchero was likely the royal sanctuary of the great leader Topa Inca. Here his *mallqui* would have been served fine foods and drinks and venerated with great fanfare. When he was not in residence, his family (*panaca*) would have tended the grounds. Certainly life at Chinchero would have been altered by the confinement of Capac Huari within its borders. However, in many ways the royal estate would not have been so different from when Topa Inca was alive.

But Chinchero changed dramatically when Europeans arrived in the Americas. Their diseases raced across the continent, decimating indigenous populations. One of these diseases infected Huayna Capac and killed the Inca ruler quickly. His death, along with that of his intended heir, created a vacuum in leadership. According to the written sources, two remaining sons (the half brothers Atahualpa and Huascar) began a war over succession, which, in addition to European diseases, wiped out half the population in Tahuantinsuyu, if not more.

The destruction brought by the Europeans affected Chinchero in particular. Topa Inca's *panaca*, which cared for his mummy and his royal estates, suffered more than most. According to colonial records, Topa Inca's *panaca* sided with Huascar, who was captured by orders of Atahualpa and eventually executed in 1532 (one of the first firm dates we have for the Inca). In retaliation for their support of his half brother, Atahualpa killed many of Topa Inca's *panaca*, the very people who would have tended to the buildings and lands of Chinchero and who would have brought Topa Inca's mummy to the royal estate to be sung to and feted. Topa Inca's *mallqui* was burned, an act considered horrific and shocking to the indigenous population. The onslaught of European diseases and the subsequent conflagration of the *sapa inca* in the civil war devastated the lavish royal estate of Chinchero and its royal patron.

Devastated, but did not destroy. Written records indicate that Topa Inca's *huauque* (*wawqi*), or brother statue, endured and his ashes were secretly collected and venerated once more. His form changed, yet again, but his essence remained. A few of his descendants survived Atahualpa's purge and the Spanish invasion. Most were very young, one of whom was the daughter of Capac Huari. Scattered across the Urubamba Valley, the Pampa de Anta, and Cuzco, these remnants of Topa Inca's *panaca* laid claim to the former ruler's possessions, such as the royal estate of Chinchero and its surrounding lands. But they were not alone. References from church books and state orders indicate that ownership of these areas was deeply contested and fluid. Authorities, both secular and religious, vied for rights to lands and labor, resulting in a deeply entangled and often shifting web of indigenous and European players. Somehow during this time, Chinchero transformed from an Inca royal estate into a settled colonial town.

Architecture, History, Knowledge

The written records provide an opening for us to begin to know the built environment of Chinchero and the people who shaped it. These writings give us a tantalizing outline of Chinchero's patron, builders, and inhabitants, as well as insights into what led to the royal estate's creation, destruction, and reconstitution. However, as use-

ful as the colonial period records are, they are also often contradictory or biased, and thus have their limitations. For example, to create this coherent summary of Chinchero's history, I have had to elide some of the counter-narratives that suggest a different sequence or result of events. Part of the problem is that none of the written records come from people who built or lived in the royal estate. And only a few of the writings come from colonial-period inhabitants. Instead, the majority of the writers were Spaniards, who brought a dramatically different understanding and agenda to Inca history. In the few instances where Inca elites were consulted about the history of Chinchero and Topa Inca, they were rarely from Topa Inca's *panaca*; therefore, their perspectives were still those of outsiders who also had distinct agendas (such as aggrandizing the accomplishments of their own *panaca*).

The historical documentation is not improved much by writings covering Chinchero's colonial history. Written mostly by Spanish administrators and religious leaders, these documents are deeply embedded with Spanish desires to possess native lands, labor, and souls. While the early modern writings offer provocative and tantalizing clues into Chinchero's history, they too are limited in that they exclude the viewpoint and experiences of the people who built and lived in the royal estate and town.

By contrast, the architectural remains are a living testament to the people who constructed, experienced, and redefined Chinchero. In its stone blocks, terraced walls, extensive canals, and shaped hillside are multiple gestures of history. The result is an architectural palimpsest of desires, actions, reactions, and remembrances. As such, Chinchero's surviving architecture can provide insights into the past of the royal estate and its inhabitants and into the violent changes wrought by the European encounter. Hence, the built environment of Chinchero serves as an important resource in our journey to know the place and the people who lived there.

Using Inca architecture as a tool for insight has its own constraints, however. To begin with, there is the issue of knowledge. Despite its visibility in the twentieth century, Inca architecture is not well understood. A case in point is the World Heritage site Machu Picchu. From written records, scholars have been able to determine that this majestically situated site served as a royal estate for Pachacuti in the fifteenth century, but there is little information about what actually occurred in and around individual structures. Some observers (past and present) may venture guesses, but we do not actually know where the ruler, his wives, their children, his courtiers, state officials, or servants lived. We do not know where the administrative offices or royal reception areas were situated. Nor do we know how the structures may have been used after the collapse of the Inca state. In sum, we have little idea how the buildings at this royal estate, or at other Inca settlements that lack written texts, were used, understood, or experienced. We can only understand Inca architecture in the broadest of terms. In other words, a primary source of information into Inca history (pre- and post-1532) lies unexplored.

Architecture and Preservation

Another issue concerning the study of Inca architecture is preservation. The colonial invasion and the subsequent centuries of neglect, rebuilding, expanding settlements, and modern reconstruction ruptured most of the Inca's purposely laid sequences of spaces. Although there are many Inca remains today, most of the original complexes exist only in portions, such as a collection of buildings, sections of Inca roads, or neighborhoods in a city. Machu Picchu (a popular tourist destination) has been estimated to be at least *seventy percent* modern construction.[8] The Inca site most celebrated for its "pristine" preservation has only slivers of its original built environment remaining. Its highly altered physical form represents the condition of most Inca settlements, such that impe-

rial architectural phrases stand isolated, no longer part of the long narratives of architectural experiences that once gave them definition.

For this reason, Chinchero provides a rare opportunity. The original constructed passage to its heart, as designed and laid out during imperial Inca times, remains largely intact.[9] From its long roads and elaborate shrines, to its grand plaza and processional spaces, Chinchero's built environment allows us to trace the entire, carefully choreographed journey visitors would have taken from the distant roads to the grand plaza.

The preservation of Chinchero's architecture reveals how the trip would have varied according to the traveler, with its open roads and resting places unfolding only as far as a visitor's rank permitted. We can see how layers of architectural encounters were articulated according to status. Socially constructed spaces were meant to re-inscribe the landscape as Inca, conveying who belonged and who was excluded. These spaces were also meant to express the distinct agenda of the patron, Topa Inca Yupanqui, whose desires did not always coincide with those of the Inca state. Of course, we cannot know if the people allowed to travel the roads or pass by Topa Inca's shrines reacted in the ways that the designers intended; architecture can inform and suggest but not determine how people experience space. Even the most cautiously designed spaces can neither ensure a specific reaction from a visitor, nor anticipate all possible transgressions.[10]

Therefore, the aim of this philosophical and archeological inquiry into Inca architecture is not to proclaim ultimately that we *know* how people in the past actually experienced Chinchero. Instead, by tracing Chinchero's carefully choreographed architectural sequences and manipulated landscapes, we can begin to understand the ways the built environment was used to *try* to construct distinct experiences and places at Topa Inca's estate. In doing so, a richer, more nuanced interpretation of Chinchero and its patron emerges, revealing the sophistication of Inca architectural practices and how an aging ruler used the built environment to attempt to shape what happened after his death. Although his legacy was very different from what he had anticipated, Topa Inca and his magnificent estate were remembered for centuries after his death.

Architecture, Space/Place, Experience

This expedition to know Chinchero is methodologically crucial to understanding Inca architecture. For it is only by applying an approach that highlights the experience of architecture that we can begin to know Chinchero—in particular, to comprehend the ways in which Chinchero's built environment was designed to function during the imperial Inca and Spanish colonial periods. This means we must trace the fine details of architectural gestures at the royal estate in order to understand how distinct places were made and specific experiences and meanings were fostered on both the small and large scale.[11] In doing so, we move from becoming acquainted with Chinchero (*reqsiy*), to knowing Chinchero in a more profound way that includes the direct experience of space and place as well as knowledge of sacred practices. In Quechua, these types of "knowing" were called *rikuy* and *yachay*.[12]

This ideographic approach to architecture draws heavily from phenomenology and is useful for three reasons.[13] First, it directly addresses the three-dimensional aspects of architecture. A building is not an object that can be grasped from a single vantage point. One cannot understand a structure by gazing at a façade or simply studying its plan. Instead, one must consider the spaces that are created. For example, to examine the façade or plan of Rome's Pantheon is to miss the central focus of the structure. The immense interior space is far more than the sum of its parts. This was also the case with Chinchero's impressive buildings.

Second, this approach also considers how architectural spaces create and articulate movement. This is important because spaces do not ex-

ist in isolation; each relates to and informs the other.[14] For example, at St. Mark's Square in Venice, the two plazas, tower (*campanile*), and basilica can each be studied in isolation. But to do so would be to completely misunderstand this impressive complex, because the experiences of these distinct features are intimately linked. With each step through this complex, the spaces (and thus the architectural elements) unfold in new ways. This is also the case with Topa Inca's royal estate. The spaces of Chinchero unfold as one alternately moves and lingers under the direction of the built environment.

And finally, this approach foregrounds the multisensory experience of the built environment, highlighting the ways people create and transform their spaces to give meaning to their world.[15] This entails exploring how humans perceive and inform space within distinct contexts.[16] It also requires questioning what messages are being expressed in the architectural experiences and who composed them. The latter may range from powerful elites who manipulate spaces to proclaim their power[17] to the disenfranchised who transform space to resist authority.[18] This method also involves the designers and builders of Chinchero and their specialized ways of knowing (*yachay*) Chinchero.[19]

This way of looking at architecture is of particular value in the study of Chinchero because, for the Inca, architecture was theater. It was designed, constructed, and laid out to proclaim imperial authority. Yet these messages were also highly localized, thus the architecture was suited not only to a particular geography, but also to a specific political and cultural landscape. Architectural gestures, from the large to the small, were used to articulate messages of conquest, power, and relationships with the sacred. As part of a grand, extended drama, by means such as the manipulation of vision, sound, and movement, desired experiences were carefully staged. By evoking qualities of both familiarity and the unknown, Inca architecture was used to foster a sense either of belonging or of exclusion for distinct people within imperial Inca space.

Aims of the Book

The objectives of this book are threefold. The first is to demonstrate the complex ways that the Inca gave weight and meaning to space. The Inca did not rely upon a heavy-handed use of dense construction to convey their power, but instead manipulated space in subtle, often sophisticated ways in order to impose their authority, identity, and agenda. For example, in the immense, dramatic landscape of the Andes, they created long, extended processions, abrupt pauses, focused sightlines, and exposed stages. This theatrical use of space defined political, religious, and familial relationships for the living and the dead.

The second objective is to reveal how an ideographic approach to site analysis (one that draws from phenomenology) can reveal important clues about the people who planned and experienced a landscape. In the case of Chinchero and Topa Inca's momentous reign, a period for which we have scant written sources, an ideographic approach provides vital insights into the ways distinct elements such as outcrops, streams, terrace walls, doorways, windows, and roofs were manipulated to create dynamic settings that reiterated the power of Topa Inca, the choice of his preferred heir, and the ruler's close relationship with sacred forces. In studying these architectural details we also see the false paradigms that have profoundly misguided how we understand Inca architecture.

The third objective is to trace the legacy of Topa Inca's estate during the Spanish invasion. As indigenous peoples and Europeans struggled for control of the architectural and urban fabric of Chinchero, the armature of the royal estate was devastated. But by understanding the fundamental architectural categories that gave meaning to place during Topa Inca's reign, we can see how, from the ashes of the European catastrophe, an indigenous town arose that remained rooted in Inca ways of understanding space and place. It continued to pay homage to a landscape that defined home for Topa Inca.

The topics explored in the book move along a path from the general to the particular, from the

paradigms of Inca scholarship and a summary of Inca cultural practices to the events of Topa Inca's reign and the many individual elements of Chinchero's built environment. The Inca used architecture to try to create particular experiences and impressions. This book concentrates on the intentions behind these carefully controlled designs, what they tell us about the Inca's use of architecture in their conquest strategies, and how, after the Spanish invasion, different groups manipulated Inca architecture at Chinchero for very different ends.

The book begins with an analysis of the way Inca architecture is represented in existing studies, which serves as an intellectual foundation for the rest of the monograph. The first chapter, "*Pirca*—Wall," examines two basic assumptions. The first is that the function of Inca architecture is clearly legible in its forms; the second, that the *kallanka*, a structure long believed to have been associated with ceremonies and feasting, held great significance for the Inca. Although scholars have tended to use the presence of a *kallanka* as a touchstone in the interpretation of Inca sites, I demonstrate that this building type is in fact a fabrication of the 1970s and also that the assumption on which it is based—a modernist notion of form revealing function—is not valid in the Inca context. Regardless of their function, the vast majority of Inca structures are rectangular in form. These simple forms allowed the rapid establishment of settlements across the Andes, but to more fully understand the architecture, we must look at how it conveyed meaning and hierarchy for the Inca.

In the second part of the chapter, I pursue the question of how the Inca viewed their architecture and apply my findings to the study of Chinchero. Recent scholarship derived from careful examinations of physical evidence and ethnohistorical documents has revealed three key categories that the Inca valued: facture (the process of making), materiality, and patronage. For the Inca the very act of making was profoundly meaningful: it implied devotion, revealed skill, and reiterated power dynamics. At Chinchero the entire site was built of *caninacukpirca*, finely bonded masonry that was used only in the most elite of Inca installations. This style of masonry marked the process of making as a celebration of the sacredness of stone as well as the Inca's power to transform it. Moreover, the primacy of materials has deep roots throughout the Andes. At Chinchero, the andesite and limestone that were used to build the estate clearly distinguish it from nearby sites. These materials carried with them a sacred meaning that tied the architecture to the landscape. The chapter ends with a discussion of patronage through an analysis of the colonial-period writings on Chinchero, the majority of which describe the process of building the royal estate and thus the importance of patronage in Inca architecture. Topa Inca's wishes were carried out by noblemen and laborers in a physical enactment of their allegiance and subservience to the *sapa inca*. At a time when elites and laymen alike had attempted to usurp his power, this symbolic act of building served to reinforce Inca royal authority and hierarchy.

After facture, materiality, and patronage, I argue that a fourth architectural category, spatial practice, was also important for the Inca. Thus the second chapter, "*Pacha*—Place and Time," begins with a summary of what we know about such practices and the crucial role they played in defining the Inca built environment. One of the reasons why the Inca were highly successful in controlling so vast and rugged a territory as the Andes lay in their ability to make subtle yet deeply meaningful architectural gestures that transformed the experience of place. Topics covered in this chapter include the Inca understandings of movement, landscape, and royal estates, as well as how space and experience were manipulated in the design of Cuzco, the Inca capital.

In the second half of the chapter these phenomenological insights are applied to Chinchero—why the location of this royal estate was significant and how the experience of approaching it was carefully constructed to communicate Topa Inca's authority. The primary audience for these spatial and temporal gestures appears to have been the powerful Inca nobility residing in

the adjacent Urubamba Valley, particularly those potentially allied with Topa Inca's principal wife and presumed heir. Through the manipulation of movement, vision, and natural rock formations, the built environment conveyed messages of regal exclusivity and of Topa Inca's intimate relationship with sacred forces.

The next three chapters examine the main plaza and its surrounding buildings as an example of place-making as a means to articulate the *sapa inca*'s authority. In the third ("*Pampa*—Plaza"), fourth ("*Puncu*—Doorway"), and fifth ("*Uasi*—House") chapters the architectural and spatial dimensions of the main open-air space (Pampa) are analyzed, providing insights into the construction of royal authority as a theatrical display. Here, materiality, facture, patronage, and spatial practices are compared with evidence derived from archaeological excavations and writings from the colonial period to show not only how the Pampa and adjacent buildings functioned together, but also what they reveal about the particulars of Topa Inca's rule. In doing so, function is re-examined and problematized as a fifth category. While it may have been overemphasized and simplified in the scholarship, function did play a role in defining the experience of Inca architecture.

Given the attention the Inca gave to the construction of experience, it is not surprising the buildings adjacent to the main plaza also served as critical stages for political theaters. In this section of the book, key building types associated with the main plazas at royal estates are studied and compared with the physical remains at Chinchero, such as the *cuyusmanco* (ruler's day room), *carpa uasi* (royal auditorium), *camachicona uasi* (meeting place for government officials), and *suntur uasi* (viewing tower associated with palaces). At Chinchero, these buildings played key roles in defining state performances and were deeply tied to the constructed experience of the main plaza. In addition, the role of sight and architectural openings is examined, revealing that viewing stages, doorways, and windows were not simply pragmatic design expressions, but deeply symbolic experiences. In the Andes today, sight is still understood to enable a very particular way of knowing a place (*rikuy*).[20]

The types of buildings that line Chinchero's plaza have often been misunderstood. This is the result of the legacy of the Spanish authorities who first wrote on Inca building types in the colonial period. Chapter 5 unpacks this complicated misunderstanding. I argue that European writers, struck by the unusual spatial patterns of Inca architecture, conflated several distinct types of Inca structures and wrote about them under the rubric of "galpón." In fact, this name, believed by many scholars to be indigenous to the Andes, can be traced back to the Spanish adoption of a word from an indigenous language (Pipil Nawat) in what is now Nicaragua, an illustration of the many complicated and often overlooked cultural exchanges of the early colonial period.

The sixth chapter, "*Pata*—Platform," moves the journey to the residential portion of Topa Inca's royal estate, a space that few people would have received permission to enter. Accessed only by Topa Inca, his family, trusted advisors, and servants, this was the most privileged space of the royal estate, which contained a small assortment of finely made buildings (*uasi*) on (and around) an elevated platform (*pata*). This terraced platform, or "step," is described in terms of layout and function, in light of writings from the colonial period on Inca private life. Buildings associated with the private life of the Inca at royal estates are examined, such as the *punona uasi* (house of sleep and sex), *uaccha uasi* (house for children by low-status wives), and the *aca uasi* (excrement house). Structures that may have been located in or were functionally related to this area are also explored, such as the *capac marca uasi* (house of the royal treasury), *masana uasi* (house for drying clothes), *aka uasi* (corn beer house), and *churacona uasi* (warehouse).

Unfortunately, our analysis of these structures and their related spaces is greatly hampered by architectural destruction. Thus the journey to and through Chinchero begins to fragment. However, the surviving architectural phrases hint at the blurred lines between the public and private as

well as between life and death. In doing so, they reveal how aspects of private life would have permeated the public portions of Chinchero and how imperial performance would have penetrated the sanctity of domestic life.

The final chapter, Chapter 7, "*Llacta*—Community," describes the transformation of Topa Inca's private retreat into a town during the sixteenth and seventeenth centuries. It begins with Topa Inca's sudden death at Chinchero and the ensuing power struggle that resulted in an ending very different from what Topa Inca had planned. After bitter accusations and behind-the-scenes negotiations between the two wives, their sons, and related Inca nobility, Capac Huari was banished to Chinchero and his mother executed. Chinchero, built as a personal retreat, temporary capital, and monument to Topa Inca's rule, was transformed into a royal prison.

Soon thereafter, the arrival of Europeans in the Americas brought disease, civil war, and death. At Chinchero, the imperial landscape was intentionally ruptured and Topa Inca's career as a *mallqui* unexpectedly ended. A gridded plan was laid down on top of the meticulously crafted Inca design, devouring most structures in its path. Surviving royal buildings were alternately modified, damaged, buried, or destroyed. A Christian church was erected on top of the largest imperial *cuyusmanco*, and the theatrical Pampa became an agricultural field. However, indigenous residents began their own reconfigurations of the space, such as the construction of an Inca-style wall in the façade of the new church and Inca niches next to Spanish-derived arches in the new plaza and within their own homes. While the Spanish authorities attempted to control the population of Chinchero by redefining the urban landscape, indigenous residents reinscribed the architecture and space of the new town in typically Inca ways.

The seventh chapter also reveals the incorporation and naturalization of Christian ideas into the sacred Inca landscape and the reinterpretation and revitalization of Inca identity among the population of Chinchero, which included Inca, Ayarmaca, former *yanacona* (Inca servants), and other indigenous migrants seeking refuge within Chinchero's borders. Cut off from their sacred and agricultural landscapes by encroaching Spanish land grants and beleaguered by regular attempts on the part of these landholders to usurp Chinchero's growing independence, the residents of the former royal estate turned defiantly inward, creating a secure yet vibrant sanctuary where newly reconstituted references to Topa Inca's grand estate became a rallying point for self-definition and independence.

In sum, this book is itself organized as a journey in trying to know Chinchero and its patron, Topa Inca. Chapter 1 is a preparation for the trip, providing a background on the ways in which scholars have examined Inca architecture and the categories that the Inca may have used to give meaning to their built environment. Chapter 2 begins the journey, walking the roads that lead up to Chinchero and the architectural gestures that informed movement. Chapter 3 moves to the dramatic entrance and main theatrical space at Chinchero, the Pampa (plaza). Chapter 4 highlights some of the key architectural stages positioned around the plaza that would have allowed one to watch and be watched. Chapter 5 goes inside three of the plaza structures, providing our first clues to interior Inca space and ritual. Chapter 6 encounters the first ruptures in the journey as it transitions from the public to the private, exploring the royal residence and how intimate issues such as sex and defecating can change how we think of Inca space. Chapter 7 describes the end of the journey in a fragmented landscape. By moving across the architecture of ruin and renewal in Chinchero, the chapter examines not only the entangled nature of the end of the imperial Inca period and the beginning of colonial rule, but also that of the architecture of royal estates with that of colonial-era indigenous towns.

This journey in trying to know (*reqsiy*, *rikuy*, and *yachay*) spans the lifetime(s) of an Inca ruler, two colonizing powers, and three hundred years. While also using written records, collected oral histories, and excavated remains, this book follows the faint and often shifting traces of archi-

tectural change at Chinchero in order to examine how this estate was a defiant sanctuary for the ruler and his mummy, one that was specifically designed *not* to surrender to the state, time, or even death but instead to celebrate a powerful present and redefine the future of Inca rule. While Topa Inca's vision for his life as *mallqui* and for the identity of his successor may not have become a reality, his architectural legacy profoundly informed a new town, in which a diverse indigenous population struggled to survive amidst the horrors of the Spanish occupation. In teasing out the constructed architectural experiences and the layered histories of those who inhabited Chinchero, we can begin to understand how a place was made and its meaning was shaped.

1 | PIRCA | WALL

On the slopes below the Peruvian town of Chinchero, tourists come to gaze at the blocks of finely carved stone that have been laid together in cascading terraces (fig. 1.1). At the top of a hill, these same visitors gather (out of breath) to photograph similar stones the Inca used to build a series of *pirca* (walls)[1] around an immense plaza (fig. 1.2). These *pirca* also formed the distinctive rectangular buildings that were part of an impressive royal Inca estate. Although some walls were subsequently dismantled and rebuilt during the colonial period to define a new indigenous town, the surviving Inca *pirca* have inspired a thriving tourist industry, fantastical myths, and serious scholarly study.

At Chinchero today, these *pirca* create the outlines of imperial Inca buildings, the plans of which seem simple and straightforward. But, despite the large number of similar structures that have survived across the Andes, the purpose of these buildings and how they were used is still very little understood (fig. 1.3). This is a striking paradox. The apparent legibility of Inca buildings masks the reasons for our poor understanding, primarily because our reading of Inca architecture has been hampered by modern preconceptions.

One of the most critical and pervasive paradigms of scholarship on Inca architecture is the belief that specific building forms served specific functions. An examination of this false paradigm through the architectural lens of Chinchero raises fundamental questions about the relationship of form to function, revealing how the scholarly misreading of a single structure can drastically alter

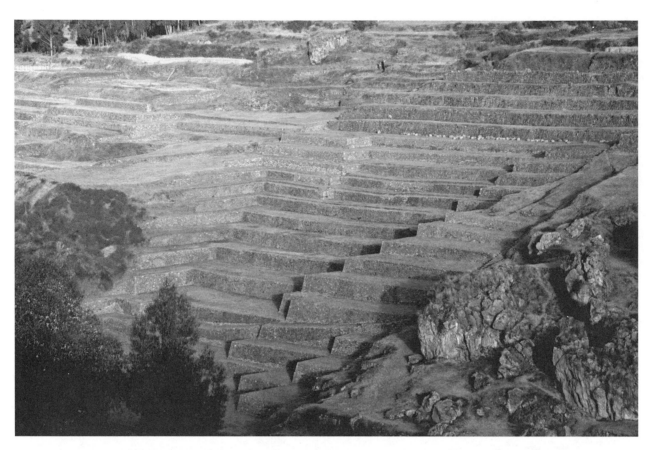

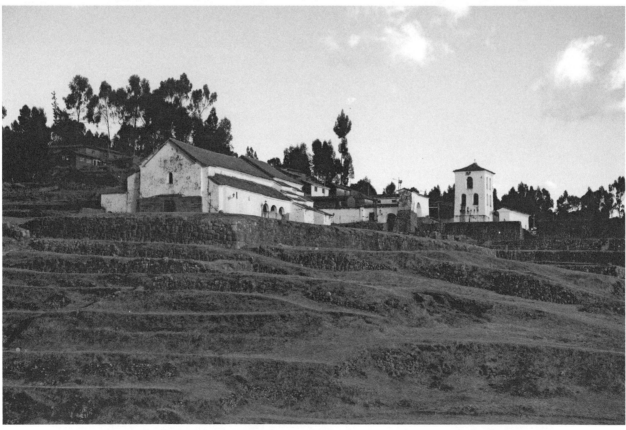

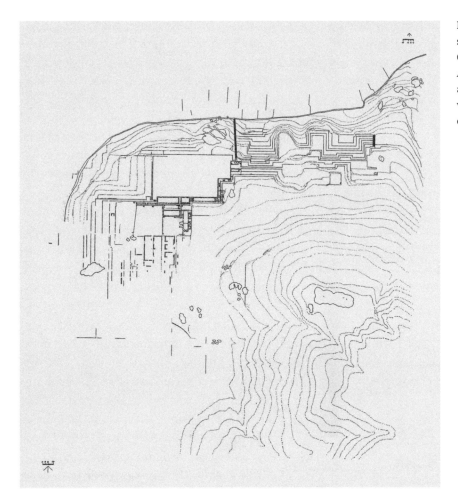

Figure 1.3 | Site plan showing the surviving imperial Inca walls at Chinchero (most are terraces). A few early colonial structures that are integrated with imperial Inca walls are also shown (such as the church). Image by the author.

the way an entire architectural corpus is understood. In this case, contemporary scholarship has been led astray by ideas that were formed during the Conquest.

This misreading of architecture has been the basis for many archaeological studies of Inca sites, and correcting it would produce two obvious benefits. First, it would direct attention to well-grounded research that has revealed key aspects of Inca design priorities (shared architectural elements), construction practices (from harvesting stones to final touches), and settlement planning. These studies have also highlighted the important role of royal patronage and the landscape in investing the Inca built environment with meaning. Second, it would open up the study of Inca architecture to research focusing on other spheres of material culture pertaining to the Inca as well

Figure 1.1 | (*opposite above*) View of Inca terraces that lie below the town of Chinchero. Since I conducted my study of the site, some of these terraces have been "reconstructed." The original Inca terraces subtly undulate across the landscape, while modern "Inca" terraces are perfectly rectilinear. Photo by the author.

Figure 1.2 | (*opposite below*) View of the terraces below the main "plaza" (northwest side). Also visible is the colonial church and town, built on top of imperial Inca walls with reused imperial Inca stones. In this section of the hillside (northwestern), the terrace wall that outlined the plaza was finished during the imperial Inca period, yet those below were in the beginning stages of construction when work on them stopped. Photo by the author.

as to other Andean groups. Ranging from Nazca textiles to Tiahuanaco carvings, such investigations also provide new perspectives on Inca architecture. For example, they can provide important insight into issues of architectural legibility, not only in terms of what we can read today in the remains, but also what the Inca wanted their contemporaries to recognize and what the Inca wanted to conceal.

This chapter is the preparation for the voyage to Chinchero. It provides the intellectual background needed to consider Topa Inca's built environment and its colonial legacy. This discussion includes ideas that have hindered our understanding as well as approaches that open new avenues of thinking. It is only by appreciating these disputed architectural categories, from naming practices and form, to materiality and patronage, that we can fully appreciate the journey to and through Topa Inca's majestic royal estate.

Architecture and Empire

Architecture was an essential element in the Inca program of colonization, with structures erected in all of the regions where establishing a presence was desired. Their buildings were designed to be easily recognizable, and even today the most uninformed tourist can quickly identify an Inca structure. This apparent consistency, due to the combination and repetition of a number of basic architectural elements, is so striking that for many decades scholars believed that Inca architecture had not changed across either space or time. While this misconception has since been disproved, it reflects the effectiveness of the Inca message.

The primary features of Inca buildings included a unique form of bonded (mortarless) masonry (polygonal and ashlar), battered walls, trapezoidal openings, gabled or hip roofs, and freestanding, single-space structures.[2] Not all of these features were always used in an Inca building. The Inca also used combinations of these core elements to create structures that were recognizably Inca.

These features are still visible in the Inca capital of Cuzco, in provincial administrative centers such as Huánuco Pampa, and at royal estates such as Chinchero. Graziano Gasparini and Luise Margolies describe this distinctive corpus as the "architecture of power."[3] Carolyn Dean has pointed out that repetition of the essential features of Inca architecture created "a sense of the [Inca's] solidity, their permanent, unyielding presence in the lands they occupied."[4]

Some of these design elements, such as the wall batter and the precisely fitted polygonal masonry, are unusual in the Andes, where a vast number of distinct cultures produced very different styles of architecture.[5] Thus the specific combination of these unusual elements with less rare features distinguished Inca structures and led, in turn, to the transformation of more common or shared Andean practices. One such example is the single-room rectangular structure (fig 1.4), a form that was common in parts of the central Andes predating the Inca but which the Inca combined with their distinctive bonded masonry, wall batter, trapezoidal shapes, and/or arrangement of openings to create their own style of building.[6]

These architectural elements can be found in Chinchero.[7] This royal estate was built in the late fifteenth century by the *sapa inca*, or ruler, Topa Inca (fig. 1.5), who led the period of greatest expansion for the Inca realm (fig. 1.6).[8] Although most of the built environment of Chinchero is made up of terraces, a small collection of buildings can be found alongside or near the main imperial Inca plaza (fig. 1.7). While they vary in size and proportion, all of them are rectangular, adorned with trapezoidal niches and doorways, and made of exquisitely carved polygonal masonry walls that are battered (fig. 1.8). These buildings have all the marks of elite Inca architecture. For visitors to Topa Inca's private estate (whether in the fifteenth century or today), there is no confusing it with the architecture of any other Andean culture before or after the European invasion, thus revealing how the Inca effectively developed a distinctive architecture to symbolize their empire.

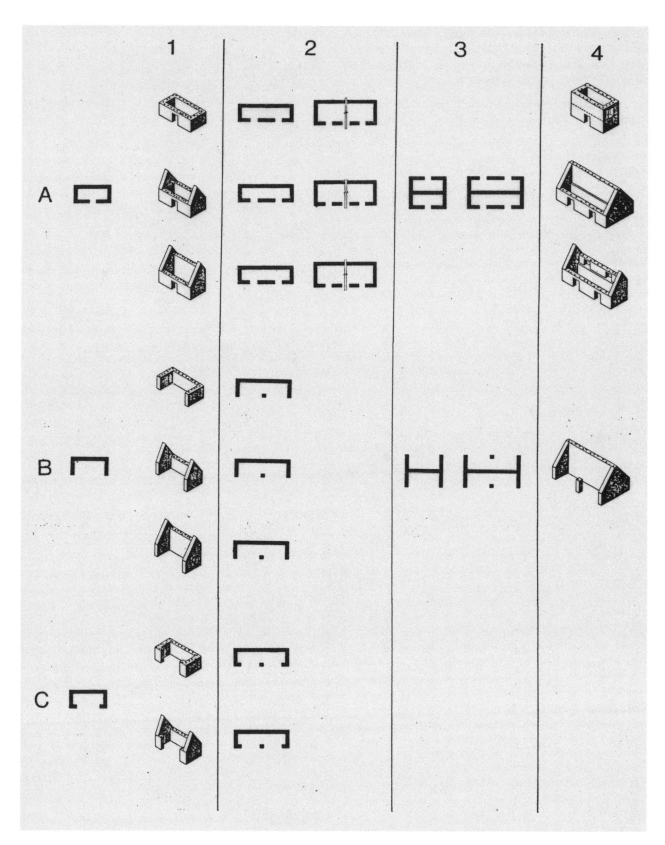

Figure 1.4 | Drawing showing how the standard Inca building form was modified by alterations in its openings and roofs. Image by Jean-Pierre Protzen.

Figure 1.5 | Portrait of Topa Inca. Felipe Guaman Poma de Ayala, "The Tenth Inka, Tupac Inka Yupanqui." *El primer nueva corónica y buen gobierno* (1615/1616), GKS 2232 4, Royal Library of Denmark, Copenhagen, 110[110].

Figure 1.6 | Map of Tahuantinsuyu (Inca empire) showing the highway system called *capac ñan*. Image by Jean-Pierre Protzen.

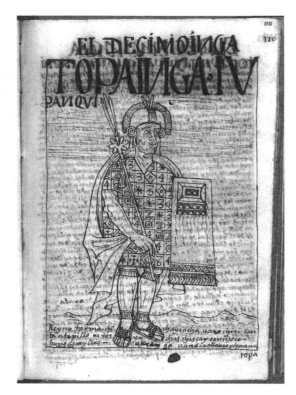

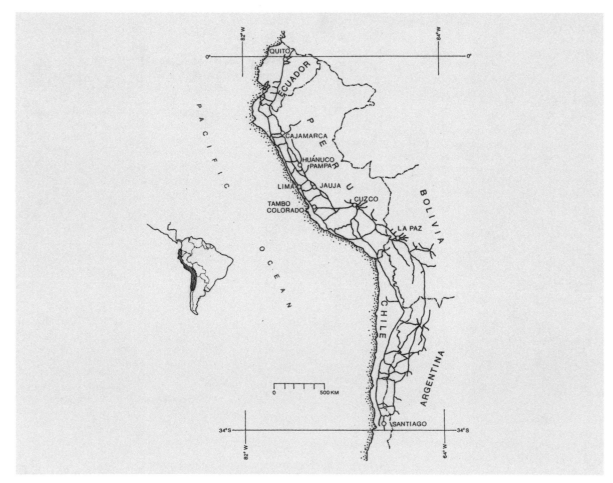

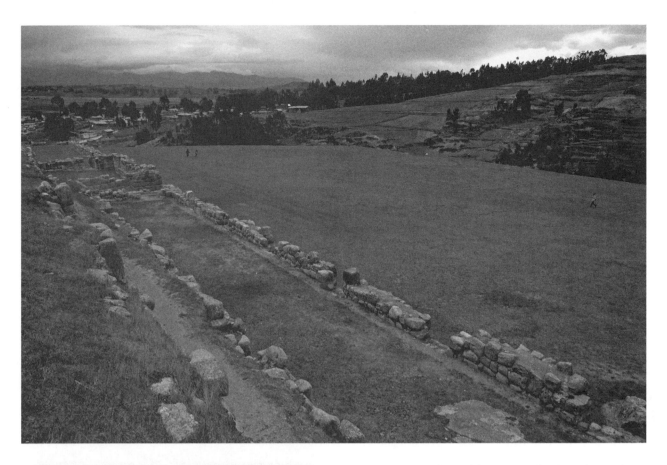

Figure 1.7 | View of the Chinchero main plaza (Pampa) and the three buildings that lay to the south. These buildings are called CP3, CP4, CP5 and run diagonally from upper left to lower right in the photograph. Photo by the author.

Figure 1.8 | Doorway to structure CP0. Visible is the standard imperial Inca wall batter and finely bonded (polygonal) masonry. Photo by the author.

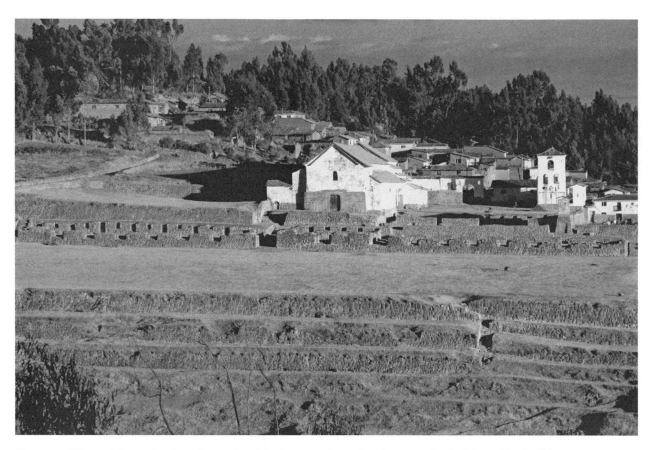

Figure 1.9 | View of the main plaza (Pampa) and its long southern façade, comprised of three Inca buildings laid in a row (CP5, CP4, CP3). Photo by the author.

Building Type

Many cultures have distinct building types that have come to define their built environment. These range from the ancient Puebloan *kiva* to the Roman amphitheater. For scholars today, the *kallanka* is considered to be the hallmark building of the Inca. It has become central in Inca scholarship for three primary reasons. First, its large form has been seen as a diagnostic feature for the Inca presence. Second, the distribution of this building type over a large geographic region is understood as an expression of the Inca's complex social organization. And third, its form has been linked with specific types of state function—for example, banquets and other state-sponsored rituals (more common near Cuzco) or as temporary housing for those on official business (usually in the provinces).[9]

While there are many subtle variations in the definitions of what constitutes a *kallanka*, most scholars have agreed that it is a large rectangular structure containing a single room.[10] Buildings of this type have been found in many Inca sites—for example, at Huánuco Pampa. Some of these, such as the rectangular hall at Inkallacta in present-day Bolivia, are enormous. There are several of these structures at Chinchero (fig. 1.9); among them are two impressive buildings that line the main plaza, CP3 and CP5 (fig 1.3, 1.7).[11] These buildings feature the distinctive polygonal masonry, trapezoidal openings, and consistent wall batter that are typical of Inca architecture, but their rectangular shape, large size, and the fact that their interior consists primarily of a single space are what have defined them as *kallanka*.

The interpretation of the *kallanka* as a space for

state functions suggests that the primary purpose of the long rectangular buildings next to Chinchero's plaza was to house ritualized feasts. The specific type of feasts or related social activities they housed is unclear, as scholarly discussions of the *kallanka* have tended to focus on broader concepts such as state-sponsored gatherings, rather than the details of distinct feasting events.[12] It makes sense, however, to assume that state activities such as ritual feasts would have taken place at Chinchero, the private estate of Topa Inca. Wherever the *sapa inca* moved, so too did the Inca capital; the *sapa inca*'s body was the mobile Inca state.[13] Therefore, royal estates had to be designed as temporary capitals that could accommodate state functions when the *sapa inca* visited. The Inca state was based on *ayni*, or reciprocity, and feasting is believed to have been one of the key expressions of reciprocity between the ruler and his subjects. This led scholars to assume that this state-sponsored activity would have taken place in a *kallanka* such as those found at Chinchero.[14]

There is one critical problem with this reading: the *kullanka* as a building form never existed. This term came into common usage among scholars in the 1970s, making one of the chief diagnostic tools of Inca archaeology a product of the academic imagination of the twentieth century. The original meaning emerged during a study of Inca definitions of space and landscape.[15] *Kallanka* originates in the Quechua language of the Inca and can be dated at least to the early colonial period. Dictionaries from this time describe the *callanca* (*kallanka*) as an ashlar block that is used as the foundation or for the threshold of a building.[16] The *callanca* is in fact a large ashlar stone, and a *callanca uasi* (*uasi* is the Quechua word for building or "house") is a building in which large ashlars have been used in the foundation or for the thresholds.[17] In other words, a building cannot be a *callanca* (an ashlar stone), but it can be a *callanca uasi* (a house of ashlar stones), and, most important, a *callanca uasi* (*kallanka wasi*) is a building defined not by its form but by the method of its construction.[18] The very name *callanca uasi* reflects the importance attached to the method of construction, making facture a key marker of a building's identity.

With this corrected definition of the Quechua term *callanca* (*kallanka*), a look back over the Inca landscape will determine which buildings could be designated as *callanca uasi*. The results are surprising, and they reveal the ways in which this Inca architectural category differs from the one invented by modern scholars. For example, not only are the long rectangular buildings at Huánuco Pampa not *callanca*, they are also not *callanca uasi* (fig. 1.10). However, there are several *callanca uasi* at this site, such as the viewing platform. This royal platform, like the one at Vilcashuaman, has *callanca* (large ashlar blocks) in its foundation and is therefore a *callanca uasi*. The long rectangular buildings at Chinchero are not *callanca uasi*, but the small rectangular buildings and the curved wall of the Coricancha are *callanca uasi* (fig. 1.11). The Coricancha (Qorikancha) was the most sacred building complex in Cuzco and was therefore one of the most sacred in Tahuantinsuyu. All of the structures at the Coricancha are made of ashlar blocks. *Callanca uasi* can be found throughout the Inca architectural corpus—but not where formerly expected.

The confusion over the definition of *kallanka* highlights several problems relating to the ways in which we have reimagined the Inca architectural past. Recognizing that the word was a construction term forces us to acknowledge a misreading, a scholarly invention that was no doubt reinforced by the twentieth-century notion that form must follow function, one of the tenets of modern architecture.[19]

While many cultures and empires had distinct building forms that were replicated across their territories and were directly linked to specific functions, the Inca did not—at least not the *kallanka* as it has been constructed in modern scholarship. Hence, we cannot point to a single, common building form, connect it to a discrete function, and use it to "diagnose" the Inca presence in the Andes. This revelation forces us to reconsider other ways the built environment may have carried meaning for the Inca.

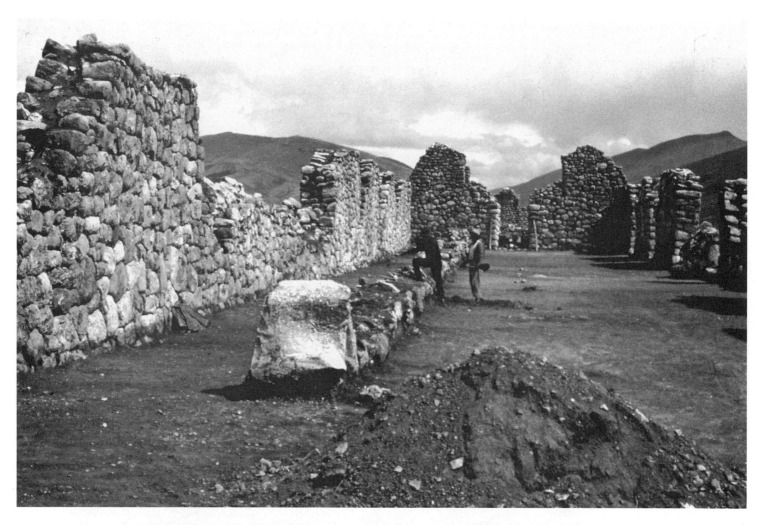

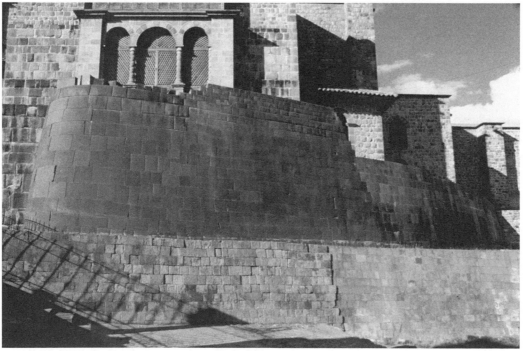

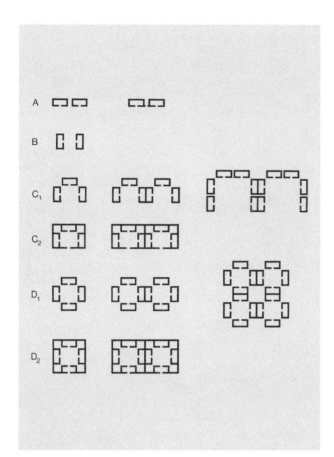

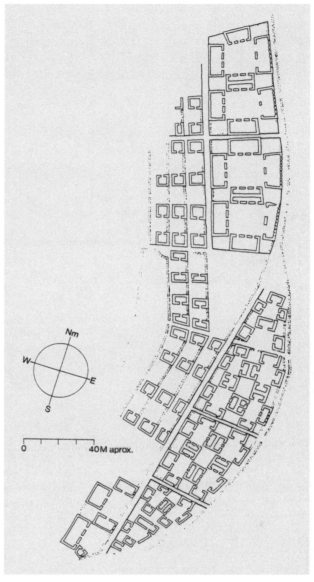

Figure 1.12 | Diagram showing the possible combinations of a standard Inca structure. C1, C2, D1, and D2 show building groupings the Inca called *cancha*. Image by Jean-Pierre Protzen.

Figure 1.13 | Plan of Patallacta, showing how the standard rectangular structure was deployed in a local context (according to landscape and use). Image by Jean-Pierre Protzen.

Form

Although the Inca did not have a specific building form called a *kallanka*, they did place meaning in architectural form. They had a basic form that pervaded all types of architecture and was manipulated in subtle ways. Specifically, this was a rectangular structure enclosing a single space. It was a common form in the Andes and the Inca used it to create complex assemblages that housed a diversity of functions (fig. 1.12). As Gasparini, Margolies, and Jean-Pierre Protzen have demonstrated, this rectangular form was combined in different ways for different uses, whether as a way station (fig. 1.13), a large military retreat, an imperial city, or an elite Inca palace compound. This simple

Figure 1.10 | (*opposite above*) Photograph of the interior of an Inca "kallanka" at Huánuco Pampa. Note that the stone masonry is not ashlar (*callanca*) but instead is made up of polygonal blocks. Photo by Craig Morris.

Figure 1.11 | (*opposite below*) The curved wall of the Coricancha (now set within the Dominican church) is made with finely worked ashlar (*callanca*) blocks. Photo by Jean-Pierre Protzen.

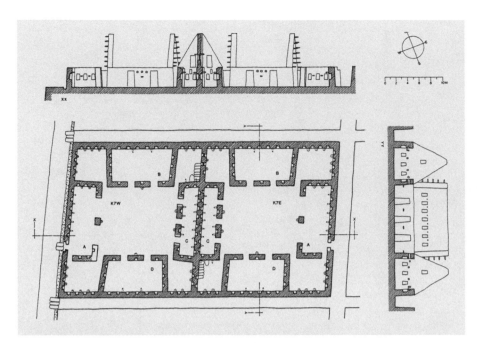

Figure 1.14 | Plan and sections of two adjoining *cancha* at the royal estate of Ollantaytambo. Together these *cancha* comprise a block in the royal estate. Image by Jean-Pierre Protzen.

Figure 1.15 | Plan of the densest portion of the royal estate of Ollantaytambo. The blocks are made up of *cancha*. Image by Jean-Pierre Protzen.

system suited a rapidly expanding empire, enabling a newly trained labor force to erect a multitude of structures across environmentally and culturally diverse landscapes in a relatively short time. Inca architecture was built by a largely unskilled force consisting of large groups of male workers who were brought in for their labor service (*mita* or *mit'a*). All people in the Inca empire had to contribute a goods and/or labor tax, depending on what was mandated by the state.[20]

Although the Inca used a standardized, easily replicated system of building, their architecture was skillfully adapted to local conditions and requirements. The practice of taking an ideal form and altering it to fit a particular location is evident in Inca site plans. Protzen has noted that the building clusters called *cancha* (*kancha*), not the roads or streets, were the driving elements of the Inca's settlement patterns (fig. 1.14). When these architectural units of varying size were spread across a flat terrain, they tended to form a gridlike pattern, with variations dependent on the dimensions of the individual *cancha* (fig. 1.15). On sloping or hilly ground, however, the *cancha* order became diffuse, sometimes disappearing altogether, as the shapes of the different *cancha* units were shifted to adapt to the topography and to include other structures.[21] The same is true of Inca building forms; while the primary unit may have been a rectangular structure, its height, width, length, and architectural detailing were adjusted to local needs.

This variability, in size in particular, has been underappreciated in Inca scholarship and has led to the mistaken belief that the *kallanka* was a building form distinguished by its size. The large rectangular building forms mistakenly called *kallanka* do not constitute a discrete and separate category. In fact they only occupy one end of the range of rectangular buildings that constitute the core of Inca architectural forms. One reason for this confusion is that the Inca often manipulated scale (among other architectural aspects) in order to make a visual impact on the visitor. Another reason is that over time, the Inca built increasingly large doorways, niches, windows, and so on, and then larger buildings as well.[22] Thus, in trying

Figure 1.16 | Scale drawing of the surviving structures at Chinchero. Note that (1) they are all rectangular structures, (2) their width and length vary, and (3) no distinctively "large" size exists that is in sharp contrast to the other structures. Instead, all structures exist on a continuum. Image by the author.

to read the Inca built environment, many scholars have fallen prey to the Inca's architectural illusions that have masked temporal changes.[23] The simple rectangular building form was a standard element. It came in all sizes and configurations, and it did not equate with a specific function.

The architectural remains at Chinchero illustrate this flexibility in Inca building forms. Fifteen imperial Inca buildings survive, and as we see in figure 1.16, there is no clear division between the so-called *kallanka* and the rest of the extant imperial buildings.[24] Indeed, all of the structures fit on a continuum of rectangular forms with changing dimensions.[25] Although their form is not related to their function (that is, they are not unique building forms that readily reveal their specific functions), the ubiquitous rectangular building forms at Chinchero proudly displayed the royal estate's Inca identity, and (as we shall see) their individual sizes and details were the result of the unique place of each within the estate.

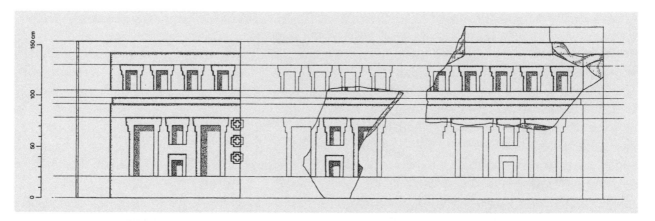

Figure 1.17 | Reconstruction drawing showing how Tiahuanaco stones originally fit together, with their design motifs crossing individual stones. Pumapunku: "Escritorio del Inca" (left), Fragment B (middle), and Fragment A (right). Image by Jean-Pierre Protzen.

Form *did* give meaning to the Inca built environment, but not in the strictly functional sense that has often been assumed. So, the Inca's presence across the Andes was signaled not by the presence of a "*kallanka*" building form but by their building kit of rectangular structures combined with their distinctive masonry and design elements. The repetition (and variation) of the standard rectangular building form situates Chinchero within the Inca architectural canon.

Facture

By its very nature, construction informs how a building appears, is used, and is valued. Despite its importance, the act of making has received limited attention from many (but not all) scholars of Andean architecture.[26] The case of the *callanca/ kallanka*, where a construction term has been mistaken for reference to a building form, is a clear example of this. The neglect of facture is problematic, particularly in the case of the Inca, where the process of making was a critical component in giving meaning to a place. To understand the architecture of Chinchero, we must consider its construction.

In almost every culture in the Andes, facture is as important as form and sometimes (often) more so. For example, Tiahuanaco was the last Andean culture, prior to the rise of the Inca, to have a high-quality stone masonry tradition. They created an architecture composed of intricately carved motifs that, despite extending across several stones (each made separately), were replicated exactly to the millimeter in three dimensions (fig. 1.17).[27] At the raised platform complex known as Pumapunku (AD 900–1100), the masons carved the stones in ways that were much more exacting than was warranted by the final product. Here, too, the process of making—facture—was given precedence over form. While many of the carvings were visible, some of the precision cuts were intentionally concealed; only the mason would have known of their existence. Discovering such practices has raised questions about the meaning of facture at Tiahuanaco. Perhaps the process of carving the stones in such a way had a religious significance, but it is also possible that the quality and significance of this concealed workmanship was important only within the small world of highly skilled masons.

Evidence of the long-standing emphasis on facture is visible in a Nazca tassel (AD 550–750) of a highly stylized and finely woven composite design currently held by the Dumbarton Oaks Research Library and Collection. The most impressive thing about the object is not the finely woven exterior, but the elaborate weaving of the fill *inside* the tassel—something that would not have been visible

from the outside, nor was it meant to be. Textile specialist Mary Frame has observed, "The extraordinary complexity of the tassels goes far beyond functional or depictive purposes."[28]

The Inca valued facture, though they expressed it in unique ways, making it a useful category with which to examine Inca sites. For example, the majority of the surviving buildings at Chinchero are made of stone, and they reveal three types of construction: polygonal, ashlar, and mortared masonry.[29] Both polygonal and ashlar are bonded masonry, meaning they are worked to fit together without mortar—the stones are effectively bonded directly with one another. Of the types of bonded masonry, polygonal masonry was most widely used within the estate. All of the surviving terraces and the buildings are made of polygonal blocks, the finely fitted construction of which was unique in the Andes. The uniformity of the construction allowed the architecture to be read as a cohesive whole and as distinctly Inca.

The two types of bonded masonry, polygonal and ashlar, require no mortar because the blocks fit perfectly to one another. The Inca named this caninacukpirca, or "a well-worked (bonded) wall."[30] As the word canin is related to the act of nibbling or biting, the use of this term emphasizes not only the type of masonry, but also the process of carving the stone.[31] As Dean has shown, bonded masonry was understood as a state of being ("bonded masonry") as well as a process of making ("nibbled or biting").[32] Caninacukpirca—both a state of being and an act of making—proclaimed the power of the Inca.[33]

Europe of the early modern period marveled at the perfectly fitted Inca stones, comparing them favorably—and often declaring them superior—to European construction. The awe felt by European viewers was most likely also shared by the Andean contemporaries of the Inca. While other groups in the Andes had impressive stone-working techniques, there were no contemporaries who could rival the Inca's perfectly bonded walls.[34] Bonded masonry symbolized Inca domination because it ordered the sacred Andean landscape according to Inca principles.[35]

As Protzen has shown, the process of carving was deceptively simple. The Inca began with a modest tool kit and a simple technique that was clearly rooted in Andean stone-working traditions.[36] But the superior quality of the stone that they used, together with expertise in the carving technique, resulted in masonry walls that were distinctive in character as well as impressively bonded—and they also exhibited the process of making. The stones were left in a form that Dean describes as "liminal"; unlike ashlar (callanca) masonry, in polygonal masonry the stone is neither in the natural state nor in the repetitive, rectangular (clearly man-made) state. By leaving stones at a stage that evokes the power of both the natural form and the Inca mason's skill in shaping it, this unique type of bonded masonry spoke of their ability to collaborate with—and transform—nature.[37]

To highlight this ability, the Inca also preserved traces of their working process. Protuberances—or bosses—were left on the surface of the stone as a means of enabling the masons to position the blocks in the wall.[38] Although bosses are used in stone-working cultures throughout the world (fig. 1.18), they are usually intended as an aid in moving the stones; once construction is completed, they are eliminated. The Inca did both. Sometimes the masons worked the bosses down, eliminating all traces, and at other times bosses were left scattered across the walls as a visible record of the facture that emphasized their ability to work the stone.[39] These highly visible traces of the carving process are an enduring demonstration of how Andean spaces were transformed into Inca places.[40]

An understanding of this working method provides important insight into the construction at Chinchero. The use of the highly esteemed bonded masonry in the public areas of the royal estate suggests that it was of utmost importance in communicating to visitors the power of Topa Inca. However, unlike at Pachacuti's estates at Machu Picchu and Ollantaytambo, no bosses are evident at Chinchero. As we shall see in later chapters, this subtle change in the celebration of

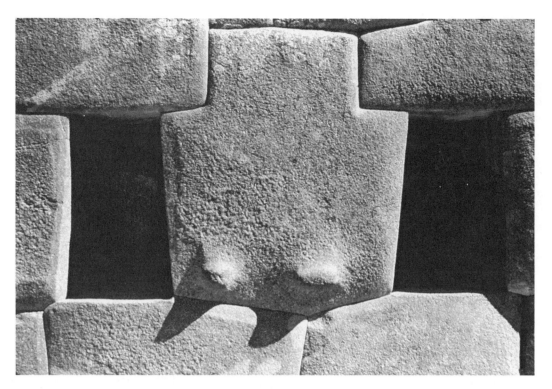

Figure 1.18 | Two bosses on a polygonal stone at Ollantaytambo (set between trapezoidal niches). Photo by Jean-Pierre Protzen.

facture relates to the unique political conditions of Topa Inca's reign.

A second type of construction, mortared masonry, was also used at Chinchero. Today, this type is known as *pirca*, but in early colonial Quechua dictionaries, this word simply meant "wall." The Inca had many terms to describe types of walls. In these dictionaries, walls were defined (and given names) according to their age, condition, material, or facture. For example, an adobe wall was a *tica pirca* and a stone wall was a *rumi pirca*.[41]

At Chinchero, mortared masonry served as a foil for bonded masonry, helping to define place and to denote hierarchy. Therefore, on Topa Inca's royal estate, bonded masonry was used in only the most important buildings (such as those used by the *sapa inca,* or to mark shrines, such as at Cuper Bajo); mortared masonry was used for structures of a lower status (such as those in the storage site of Machu Colca).[42] Mortared masonry also served as a foil at Ollantaytambo; however, in this royal estate the structures are directly juxtaposed on the Temple Sector.[43] For the Inca, a single object

did not have a fixed entity but was instead defined by what it was coupled with or compared to. Architectural meaning was relative; hence construction methods were used to articulate identity and status.

Specific types of bonded masonry were also used to further refine meaning.[44] At Chinchero, the interior of the estate was made of polygonal and ashlar masonry. Most of the estate was made of polygonal masonry, but ashlar masonry of very finely carved blocks was also used for a select few of the walls. Unfortunately, we have no knowledge of exactly how and where these walls may have been, as none of the ashlar blocks remain in situ (fig. 1.19).

The structure(s) (*callanca uasi*) that were once made up of these ashlar blocks were torn down by the early sixteenth century. Given the number of long ashlar lintel-pieces and roof ties, in addition to the numerous large (*callanca rumi*) and small (*chheccoscaa rumi*) ashlar blocks found today, the original imperial construction would have been either an immense, gable-ended building or

several smaller buildings that each had multiple doorways or large niches. This structure (or structures) would have been the only actual *callanca uasi* at Chinchero, whatever the form.

Like the polygonal masonry buildings, the *callanca uasi* was held in high regard, perhaps even the highest (fig. 1.20). For example, bonded masonry was used for most elite Inca structures, particularly those associated with the ruler. But of these rarified structures, ashlar masonry tended to be reserved for the most sacred, elite buildings: the Acllawasi ("House of the Chosen Women") and the Coricancha ("Golden Enclosure") in Cuzco, the "Sun Temple" (a.k.a. "Torreon") at Machu Picchu, and the viewing platforms in Huánuco Pampa and Vilcashuaman. The diverse buildings in which they were used indicate that this masonry style was not linked to a specific function, but instead was an indicator of relative status.

While the modern imagination has often fixated on the distinctive polygonal masonry of the Inca, it appears that they valued ashlar construction equally, or perhaps even more. Though walls of ashlar and polygonal masonry were referred to collectively as *caninacukpirca*, ashlars were the only type of carved blocks that were given the additional names *callanca* and *chheccoscaa*. This additional terminology, coupled with the use of ashlars in the most sacred and significant buildings in the Inca Empire, suggests that this type of bonded masonry may often have been held in highest esteem.[45]

The emphasis on *callanca* rather than polygonal masonry for buildings of high status makes sense if we consider the process of making them. The largely unskilled labor force brought in to do rotational work was guided by a *pirca camayoc* (a "wall specialist," such as a skilled contractor or mason),

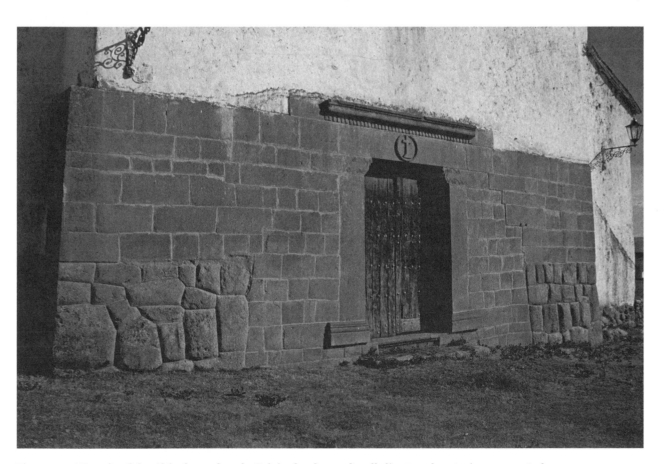

Figure 1.19 | Façade of the Chinchero church. Original polygonal walls lie at each exterior corner. In between and above are re-used imperial Inca ashlar blocks (topped with adobe) that created a distinct northern façade for the colonial church. Photo by the author.

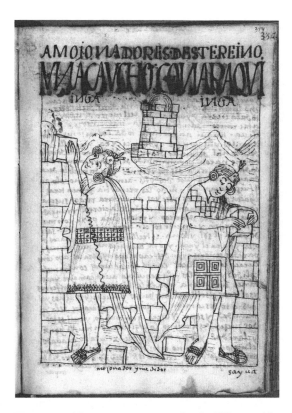

Figure 1.20 | Inca men constructing buildings with ashlar blocks. Felipe Guaman Poma de Ayala, "Surveyers," *El primer nueva corónica y buen gobierno* (1615/1616), GKS 2232 4, Royal Library of Denmark, Copenhagen, 352[354].

who trained them to make both mortared and bonded walls.[46] Protzen has noted that while polygonal masonry is impressive, its facture is actually far more forgiving than that of ashlar masonry.[47] One of the most common mistakes that novice stonemasons make is over-hitting a corner and thus unintentionally breaking off a slice of the stone.[48] If this happens in the process of making a *callanca* (which is defined by its regular rectangular form), the block that has been damaged can no longer be used. However, if the same mistake occurs in the creation of a polygonal block, it simply means a complementary face has to be created for the adjacent stone.

Thus, the creation of polygonal masonry was a dynamic, evolving process that allowed for the incorporation of unplanned variations. By contrast, the making of ashlar masonry mandated that all stones had to be rectangular and laid in regular courses, though there might be occasional devia-

tions.[49] Mortared and fieldstone masonry, by comparison, were the easiest, most forgiving wall type to make, as well as the cheapest (in terms of labor and materials). At Chinchero, the two types of bonded masonry, ashlar and polygonal, defined the royal core and came to symbolize elite Inca space. Beyond lay a vast landscape of mortared masonry, serving as a foil to the exclusive royal center.

Materiality

Until recently, materiality, like facture, had been given little consideration in the architectural literature of the Andes. Yet like form and facture, materials convey meaning in the region, particularly for architecture. Recent Inca scholarship has highlighted the importance of materials and the complex ways in which we must consider them. As a consequence, when making the journey to and through Chinchero, we must consider the multiple and perhaps unexpected ways in which materials gave significance to the royal estate.

On a very basic level, the materials of stone determined what type of *pirca* could be made. They determined whether a structure could be made of bonded masonry or mortared masonry. Only certain types of stones could be shaped into Inca bonded masonry, with its precise polygonal and ashlar blocks. By contrast, almost any stone material could be used to make mortared masonry. Therefore, the value of the different masonry types (and thus the buildings that they formed) lay not only in their facture but also in the materials of which they were made.

Attaching great importance to materials and particularly valuing stone, the Inca went to great lengths to obtain specific types for their buildings.[50] They even venerated particular stones, in accordance with a long-standing Andean tradition in which certain stones embodied and conveyed the sacred. Stone was the material of the *apu* ("sacred mountains") and it was often used by Pachamama ("earth mother") and other sacred forces to mark out sacred places in the high Andean landscape.[51]

Several scholars have shown how the Inca celebrated this pan-Andean lithic view of the world and manipulated it for their own benefit, often through architecture.[52] The built environment was used to highlight unusual outcrops of rock regarded as sacred. For example, in Cuzco a series of special stones, or *pururauca*, was designated as being associated with Inca military prowess.[53] Inca narratives relate how Pachacuti called upon stones in his domain to rise up and join him in battle. Upon hearing his call, the *pururauca* transformed themselves into warriors and helped to defend the city; after the battle, they reverted to stone. Hence, not only were sacred stones venerated by the Inca and incorporated into the imperial landscape but, in addition (and perhaps in an act of reciprocity), many of the stones were seen as having actively supported the Inca Empire. A priest appointed to care for these sacred stones made ritual offerings, reminding the city's residents of the power of the Inca and the support they had received from these sacred forces. The *pururauca* were not only a physical reminder of a powerful past, but also a warning for a potent future, as they effectively mapped out a dormant stone army that could rise up at a moment's notice to defend Inca rule.[54]

Stone was also the material of the *huauque* (*wawqi*), or brother statue, of the ruler.[55] This was a free-standing stone, apparently uncarved, to which the bodily sheddings of the ruler were attached (for example, his hair and nail cuttings). This lithic statue, together with the ruler's exuviae, could be carried around the empire in the same way as the ruler. As Dean has so clearly demonstrated, the *huauque* did not *represent* the ruler, but *presented* him.[56] Wherever the *huauque* went, it was treated as if it were the ruler himself.[57] For Topa Inca, this tradition meant that his *huauque*, named Cusichuri, could visit Chinchero and be feasted, consulted, and venerated like Topa Inca himself.[58]

The Inca used bonded stone masonry more frequently in the Inca heartland (specifically, Cuzco and the royal estates) than in most other parts of the empire. Chinchero's armature of stone projected the high status of the estate and its royal patron. The terraces, the main entranceway, and the buildings surrounding the main plaza were all made of high-quality stone in bonded masonry. This highlighted the importance of the royal retreat as part of the Inca heartland and marked Chinchero proper as sacred. The fact that most of the royal estate was of stone also set it off from many places in the provinces, which were often made of other materials, alone or in mixtures.

As with facture, material hierarchy can also be seen *within* the royal estate of Chinchero. Most of the buildings at Chinchero are of a high-quality, local limestone, shaped into polygonal blocks.[59] However, at least one structure was made of andesite in ashlar masonry. This material is not indigenous to Chinchero; the nearest possible source is a quarry on Antakilke, a local *apu* (fig. 1.21) that is difficult to reach. The length the masons went to in harvesting these stones suggests that the material invested their structures with particular significance. The materials (andesite versus limestone) as well as their facture (ashlar versus polygonal) not only distinguish these buildings, but also provide valuable clues concerning their importance to the Inca.

Because of the importance of materiality to the Inca, they controlled access to materials that they regarded as special. For example, the Inca often restricted the ability to see or view certain materials as a way of defining hierarchy. At Machu Picchu, views of sacred mountaintops, special stone outcrops, and important buildings were strictly controlled as visitors moved along carefully designed pathways.[60] Sightlines were manipulated to allow visitors to view powerful natural elements at particular moments or to prevent them from doing so at others. In that way, sacred lithic materials were not available for everyday visual consumption and could be accessed only with Inca permission and oversight.

This use of sight to regulate access to sacred materials was an important aspect of Chinchero's design. From the first glimpse of its impressive stone masonry to the spectacle of the sacred *apu* viewed from the main plaza, the lithic land-

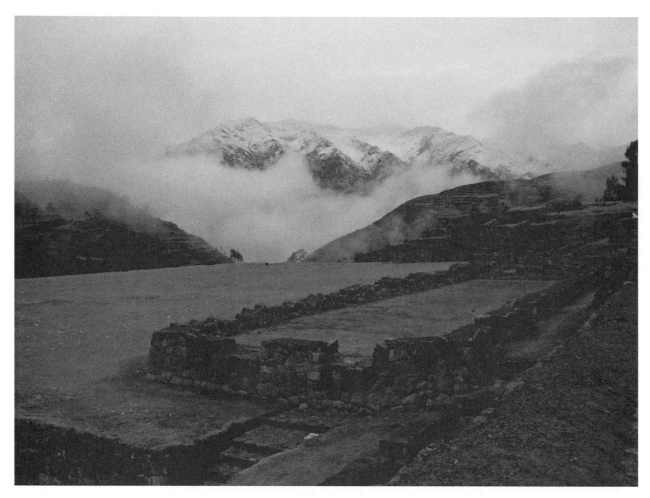

Figure 1.21 | View across the main open space (Pampa) at Chinchero, looking toward Antakilke (a sacred mountain, or *apu*). In the foreground is the imperial Inca structure CP3. Photo by the author.

scape was stage-managed to reinforce awareness of the ruler's sacred authority over his people and lands. The manipulation of sight was important not only because the building materials were venerated, but also because the act of seeing was deeply symbolic, connected to the sacred and to time. Constance Classen, whose research revealed the importance attached to the bodily senses for the Inca, has demonstrated that the Inca considered sight to be closely aligned with the venerated *Inti* (Sun). Thus, in manipulating vision in their architecture, the Inca also emphasized their special relationship with the powerful sun, which they considered an ancestor.[61] Classen has also shown how sight was tied to a pan-Andean conception of time, according to which we see into the past because it is before us. In other words, to view an im-

perial estate such as Chinchero was to view Inca history.

For the Inca, however, sacred materials could not be fully comprehended by sight alone. Certain materials were considered animate beings that engaged all the senses of those who interacted with them. An object that had an "essence" was said to possess *camay*,[62] and this living essence appears to have been carried in the materials of the object, rather than in its form.[63] Particular rocks were thought to have a living essence that embodied "the animate 'spirit' of a specific person or place."[64] The Inca regarded sacred stones as beings that had the capacity to speak, move, and consume, although they did so only in front of a select few, such as the *sapa inca*.

Examples of such animated stones and the way

the Inca used them were the outcrops of sacred rocks or caves in the Andes that came to be considered oracles. Only the oracles' guardian priests were allowed to hear their prophecies, and because the oracles foretold the future, the act of hearing also came to be associated with the future.[65] When these oracles "spoke" to the priests who served the *sapa inca*, the Inca were able to establish themselves as having sole power to "hear" the future.[66] In this way, they were able to use sacred stones (and their association with the future and with hearing) as a means of controlling the conquered populations. Given that many of the priests of the most important shrines were Inca elites (or appointed by them), this made the ability to hear even more closely tied with Inca nobility.[67]

The Inca practice of appointing priests to serve specific sacred places and objects, called *huaca* (*wak'a*), has a long tradition in the Andes. *Huaca* were critical nodes in the Andean sacred landscape. As Frank Salomon has noted, *huaca* were made of "energized matter" and these powerful forms of sacredness acted "within nature not over and outside it, like Western supernaturals do."[68] *Huaca* priests had considerable power and status in a community, as they alone could hear the oracles, and they oversaw critical *huaca* rites and rituals.[69] Hereditary priests of *huaca*, in particular, wielded great authority, such that the community had to work the priests' agricultural lands, and priests could make pronouncements about community members' rights.[70] When the Inca state took over a region, they assigned a priest to each *huaca* and determined what rituals were conducted, what was said (and heard), as well as what sacrifices were offered.[71] Servants and lower priests were assigned to *huaca*, and sometimes *huaca* were given spouses.[72] With this system, the Inca state consolidated sacred place-making practices across the Andes.

At Chinchero, there are several distinct outcrops of stone that were given a special architectural setting by the Inca, and these will be discussed in the following chapters (fig. 1.22). Most of these rock groups face the main Inca road leading to Chinchero from the Urubamba Valley. Travelers would have been able to see these outcrops from a distance as they approached, but the architectural setting was designed to prevent them from getting close to the stones. Such outcrops then served as a reminder to visitors that, although select persons may have been allowed to see them, only Topa Inca and his priests could talk to the *huaca* and hear their response. Elite Inca landscapes such as Chinchero, with their lithic materials, were aural landscapes as much as they were visual.

While proximity to the sacred stones enabled the *sapa inca* and his priests to see and hear the oracles, it also opened the possibility of touching them. In the Andes, it was believed that the powers of sacred stones could be transferred to those who touched them. The sense of touch was particularly potent for the Inca: it was understood as a sense that had the capacity to cross boundaries.[73] As Classen has shown, the act of touching created the "power to either join or separate, attract or repel."[74] That extraordinary power is one reason that Inca rulers and elites are often described (and depicted) in the act of making Inca architecture, especially fine-quality stone masonry (that is, touching and transforming the stones; see fig. 1.20); however, in reality, vast teams of laborers were the builders. At Chinchero, the only person with the freedom to touch all of the sacred lithic groups would have been Topa Inca himself.

In the Andes, the sense of taste as a means of touching certain materials was considered to be transformative. For the Inca, the tasting or ingesting of a substance enabled a person "to become one with it."[75] Taste was also closely linked to stone architecture. Remember that to work a stone into bonded masonry was to "nibble" it.[76] Thus, Inca narratives include episodes that describe Inca elites nibbling (that is, building) bonded stone masonry (touching and tasting powerful stones), highlighting their ability to transform and become one with sacred landscapes and materials.[77]

By incorporating in their architecture the understandings of seeing, hearing, touching, and tasting the material world, the Inca conveyed a message that spoke of their close relationship with nature and their power over their subjects.[78]

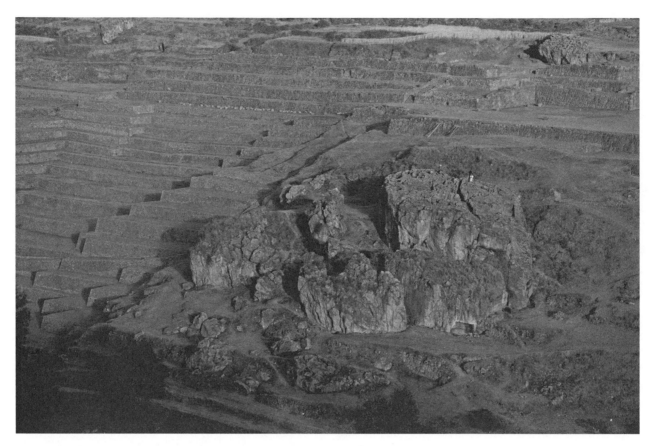

Figure 1.22 | View of two outcrops that would have been readily visible to the visitor, but not able to be "heard" or touched. Titicaca is in the center and Pumacaca at the top right. The main entrance to Chinchero, a long staircase, lies to the east (left in photo) of the Titicaca outcrop. To best appreciate the large size of Titicaca, note the three people walking on top of the outcrop. Photo by the author.

This analysis of the many ways in which the Inca gave meaning to their physical interactions with sacred materials reframes our understanding of how the royal estate at Chinchero was conceived and experienced. The materials from which it was built were animate substances that the royal patron and select visitors were meant to experience viscerally.[79] Thus, travelers approaching Chinchero would have seen the terraces along the main road as much more than an impressive engineering achievement; they would have encountered a vibrant visual, aural, and tactile landscape that celebrated the power of Topa Inca over time and space. However, such visitors, like most to the royal estate, would likely have been allowed only a fragment of this sensory experience, whereas Topa Inca had the power to see, hear, touch, and be transformed by all aspects of the sacred lithic landscape at his royal estate.

The importance of the senses in understanding the Inca built environment, in particular its materials, is a reminder of how different Inca priorities in architecture were from those of today. In particular, this understanding challenges us to reconsider what we mean by materiality. For the Inca, it did not just refer to the physical composition of an object, such as a stone block or wall. Instead, it also referred to one's engagement with the physical object: how it was seen, touched, heard, or tasted. In doing so, the object's meaning became layered and dynamic, creating complex maps of value that stretched as far as the senses reached.

Patronage

Of course *whose* senses the architectural materials were engaging was of great importance, and perhaps no one's was more important than that of the patron. From Louis XIV at Versailles to Thomas Jefferson at Monticello, patrons have played an important role in determining a building's outcome and meaning. In the Andes, the Inca emphasized the role of the royal patron in building imperial landscapes, particularly when it came to private estates. Thus patronage is the last architectural category that must be considered before the journey to Chinchero can begin.

The Inca understood architecture as an embodiment not only of the state, but also of the patron, the *sapa inca*. This was clearly displayed in royal estates, which allowed greater flexibility in design and layout than more standardized types of Inca sites, such as administrative centers. Susan Niles has shown how the Inca understood architecture as the material manifestations of history, and they designed royal estates "not only to serve the domestic and ritual needs of its creator but also to enhance [the ruler's] reputation and to confirm his place in Inca dynastic succession."[80] Inca rulers, such as Pachacuti and Huayna Capac, manipulated architecture at their royal estates to enhance their own power in very different political circumstances.[81]

During the imperial Inca period, each *panaca*, or royal family group, sang their own oral histories celebrating the deeds and accomplishments of their royal founder (a *sapa inca*). In these performances the built environment was portrayed as a reflection not only of the presence and might of the imperial Inca state, but also of the power and ingenuity of particular royal patrons and elites. Architecture was seen as an expression of legitimacy, conquest, and "greatness."[82]

The oral histories provide important clues to the way in which Inca architecture such as the royal estates was closely linked to particular rulers. Each *sapa inca* created his own *panaca*, and each of these family groups strove to portray their royal ancestor as the most accomplished and successful of all rulers.[83] The sung narratives, which extolled architecture as one of the main indicators of a ruler's power, emphasized the process of building (facture) rather than the building itself as a static object (form). As Niles has shown, a *sapa inca*'s failure to build was equivalent to his failure as a ruler. In contrast, a *sapa inca* who was a great builder was seen as a transformer of the Andean landscape.[84]

Also in the early colonial sources—which were often drawn from Inca narratives—the *sapa inca* is frequently portrayed as the ultimate architect: conceiving, designing, laying out, and building important Inca sites. For example, in the writings of Juan Diez de Betanzos, the ruler Pachacuti is credited with taking part in every aspect of the redesign and rebuilding of the capital of Cuzco.[85] Like his ancestors, who flattened mountains to found the initial settlement of Cuzco, Pachacuti, "changer of the world," transformed the capital into his own image, designing the major imperial monuments and determining the location of individual dwellings. In these narratives, the ruler's ability to reimagine and remake the physical world around him is a demonstration of his power. It is the *sapa inca* who conceives of a site, and it is the *sapa inca* who touches the sacred materials of stone and turns them into the distinctive Inca masonry.

The emphasis on the role of the royal patron as transformer of the built environment also appears in the colonial-period writings concerning Chinchero. It is Topa Inca who is credited with the design and construction of this new royal estate.[86] Juan Diez de Betanzos relates that Topa Inca initiated the idea of building the estate, chose the site, and ordered the lords to build what he ordained. He is described as visiting the site and announcing what was to be done.[87] As with most Inca sites, this oversight went beyond the mere laying out of a few houses. Since Chinchero was set on the side (*chiru*) of a hill, its construction demanded extensive earthwork and resurfacing.[88] Betanzos's narrative shows the conception of Chinchero as much

more than simply an estate built to accommodate a leader and associated state functions. It was a physical manifestation of the *sapa inca* himself, in particular his power to radically remake the landscape; after his death, it served as a memorial to his rule and a home for his mummy and his brother statue.[89]

Topa Inca's involvement may have been critical in the design and layout of his estate, but his nobles were the ones who executed his plans. Such a division of labor was probably common practice for the Inca, reflecting the realities of building as well as the power structure of the elites. It is unlikely that the Inca rulers, absent for years on military campaigns, would have had sufficient time to build all that they are credited with in the written sources. Thus, the image of the ruler as constructing the world was itself a construction. The responsibility of building fell to others, who worked in the name of the royal patron.

Architects came from the highest level of Inca society. A ruler's siblings were often given prominent positions as generals, governors, overseers of state shrines, and architects, suggesting that the role of architect was one of considerable power and prestige. They had a regular staff to work with, such as the *pirca camayoc* ("wall specialist"), which was one of the few occupations that was not temporary.[90] Though throughout history kings (and gods) have often been portrayed as architects, those who carried out the construction of buildings—that is, the actual architects—often came from the next levels of society.[91]

Chronicles relating to Chinchero describe how Inca nobles gathered together to learn of Topa Inca's desires and then eagerly carried them out. This division of labor enacted an important hierarchy of power that was crucial to the state's authority. Throughout the history of the Inca Empire there are many tales of intrigue in which certain nobles attempted to usurp the power of the *sapa inca*. Thus, architecture was used to remind noblemen of their subservience to a ruler and deplete them of resources. Examples of a similar dynamic can be seen in other parts of the world, such as the building of English country houses (which could accommodate the Queen) in the Elizabethan period and in the building of the city of Edo in Japan.

For Topa Inca, the building of Chinchero by nobility had an additional meaning, because he was attempting to shift favor from one son to another as his successor. By having Inca nobles participate in the building of this new estate (to be shared with Chequi Ocllo and their son), Topa Inca implicated the nobles in supporting the move. This allowed imperial Inca building traditions at Chinchero to serve not only the state, but also the desires of an individual, Topa Inca. As we will see in subsequent chapters, these Inca nobles were a key problem for Topa Inca—one that threatened not only his rule and his choice of successor but also the lives of a favorite wife and son.[92]

2 | PACHA | PLACE AND TIME

The journey to Chinchero begins with three long, undulating roads. Ranging from flat, stone-lined streets to steep stairways and elaborate viewing places, the carefully constructed passage to Chinchero's main plaza leaves contemporary visitors exhausted and humbled. Whether an imperial Inca visitor reacted the same is unknown, but in terms of design, traveling to Chinchero was as important as being there. These roads were exclusive landscapes that the Inca state controlled and carefully constructed to convey meaning for the traveler, the dynamic experience that is the focus of this chapter.

For the Inca, roads reinscribed the landscape by manipulating the experience of bodies across *pacha*, the Quechua word that conveyed place *and* time.[1] This complex understanding of space and time was not exclusive to the Inca; it was shared by many in the Andes. As Frank Salomon described, *pacha* "simultaneously denotes a moment or interval in time and a locus or extension in space—and does so, moreover, at any scale."[2] The entire landscape both recorded and participated in time. Carolyn Dean has noted that, for the Inca, "landscape was a memoryscape wherein rocks and other natural and built formations were actors in known narratives."[3] This complex understanding of the interrelationship between space and time is still a key component of many Andean communities today, such that the past is understood to be visible in space, and successful leaders in a community must become "masters of time."[4]

It perhaps is not surprising that *pacha* also signified change. Hence, *pacha*, or "world as a given

arrangement of time, space, and matter, is not supratemporal . . . it clearly admits change, even cataclysm."[5] The importance of *pacha* to the Inca can be seen linguistically: one of the most important rulers adopted the name Pachacuti (space and time changer) to signify his supreme power, which included his ability to transform the landscape, spatially, materially, and temporally. An example is the extensive road network the Inca built across their territories. Roads regulated how rapidly travelers could move across space and when they had to slow down or stop. In doing so, Inca roads are an example of place-making. According to Yi-Fu Tuan, space "is that which allows movement" while "place is pause; each pause in movement makes it possible for location to be transformed into place."[6] As we shall see, Topa Inca used roads to transform the vast space of the Pampa de Anta (the "Plains of Anta") into a series of imperial Inca places that proclaimed his royal authority and divine rights.

Andean Landscapes and the Creation of Place

To understand Inca roads (and the importance of the Inca installations they connected), one must first comprehend the dynamic and rugged terrain through which they passed. The Andes mountain chain runs roughly northwest to southeast along the western rim of South America. The extremely vertical landscape makes travel inherently challenging. The mountain range also encompasses or borders every environmental zone, from lush jungles to snow-capped glaciers and barren deserts. These topographic and climatic divergences often made basic subsistence practices a challenge. Despite the difficult terrains and climates, communities participated in networks of exchange and travel for much of Andean history. The dominant effect of this landscape on daily lives helps to explain why mountains, rock formations, and other striking natural elements were viewed as powerful sacred forces that required veneration and acknowledgment throughout life's activities.[7] The

everyday experiences of these commanding natural features played a critical role in defining the meaning of place for local communities.[8]

Understanding how local populations depended upon and perceived the landscape, the Inca sought to control movement as part of their conquest strategy. To begin with, they built an extensive network of way stations, communication posts, and administrative centers across the empire. As the lands within Tahuantinsuyu were rugged and vast, Inca sites had to be carefully placed for effectiveness—in locations that were visually prominent or had deep significance to local populations. To access these installations, the Inca built and carefully regulated an impressive system of roads, which in effect severed critical transportation systems, many of which had previously been used by local populations (fig. 1.6).[9] Travelers caught on an Inca road without official permission were punished, sometimes by death.

By contrast, these same roads and imperial installations allowed the *sapa inca* and his armies to move efficiently and effectively across long distances. He could swiftly stifle revolt in far reaches of the empire while also gaining quick (and often exclusive) access to diverse goods, people, and places. In addition, the Inca used architectural gestures to signal control, such as reshaping landscapes with Inca terraces, incorporating outcrops (*huaca*) that were venerated by local populations into their sites, and framing the views of sacred mountains (*apu*), radically redefining how people moved (and experienced space and time) in the Andes.[10] The amount of energy the Inca devoted to these activities suggests that they understood the profound power of place-making practices. As Tim Creswell has observed, "place, at a basic level, is space invested with meaning in the context of power."[11]

Royal Landscapes and the Inca Place-Making

The design of royal estates mirrored the layout of Inca installations in Tahuantinsuyu. Like

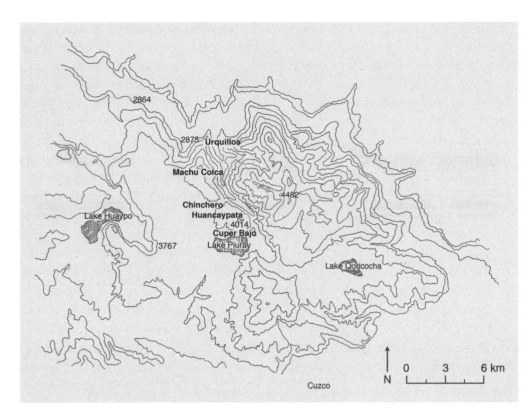

Figure 2.1 | Map of the Chinchero region showing the location of some of the major sites associated with Topa Inca's estate. These include: Urquillos (Urcos, residence), Chinchero (residence), Huancapata (plaza), Machu Colca, (storage center), and Cuper Bajo (shrine) next to Lake Piuray. Not shown are Moray (terraces) and Maras (salt mines) that lay beyond the map to the west. Image by the author.

the careful placement of individual way stations (*tambo*), shrines, and administrative centers across a large and diverse region, these estates were not bounded entities but were, instead, a collection of distinct installations that represented the *sapa inca*'s authority, and access to them was carefully regulated via Inca roads.[12] In the case of the royal retreats, authority resided with the ruler rather than the state.[13]

Topa Inca's royal estate comprised a series of sites that marked control of the landscape while servicing the needs of the *sapa inca* (fig. 2.1). It encompassed residential centers (Urcos/Urquillos and Chinchero), salt mines (Maras), agricultural terraces (Moray), storage compounds (Machu Colca), as well as a way station (Peccacachu), a ceremonial plaza (Huancapata), and an elaborate shrine (Cuper Bajo) by a venerated lake (Piuray). By building on the former homeland of a rival ethnic group (Ayarmaca) and commandeering roads, the Inca re-inscribed the landscape as exclusively their own.[14] And, by creating an estate to share with a favored secondary wife and their son, Topa

Inca used Chinchero to emblazon his personal preferences upon state concerns.

Chinchero Landscapes and Topa Inca

The location of Chinchero was noteworthy for three main reasons: First, it was part of the prior lands of the Ayarmaca (former Inca rivals). Second, it was near the lands of Topa Inca's principal wife. And, third, it neighbored the lands of powerful Inca nobles. Therefore the journey to and through the royal estate was a walk through a conquered land, past a diminished wife, and close to powerful noblemen who helped run the empire. The layout of these sites, in particular the roads that approached Chinchero, constructed an imperial landscape that heightened Topa Inca's power and assisted his plans for the future.[15]

When Topa Inca built Chinchero, the Inca had controlled the Pampa de Anta throughout several generations of rulers. However, that control did not erase its prior identity with the Ayar-

maca people, who considered this area part of their homeland.[16] Before the growth of Tahuantinsuyu, the Ayarmaca and the Inca were just two of many local communities that vied for authority and expansion in the region. They exchanged elite women as brides to foster political connections, which temporarily stemmed conflict between the two groups. However, the conflict increased to the point that the Inca demanded the dispersal of the Ayarmaca from their homeland. Although the Ayarmaca would eventually become "Inca by privilege," their subservient status was reiterated when Topa Inca erected Chinchero on a portion of their land.[17] By building on a hillside in the fertile plains of the Pampa de Anta, the Inca used architecture to naturalize this former rival's territory as their own. (However, the Ayarmaca's connection to this region was never fully severed, and, after the demise of the imperial Inca state and during the colonial period, many returned to the region.)[18]

Royal marriage was the second issue that gave meaning to the royal estate, in particular the location of Chinchero relative to Urcos (Urquillos). When Topa Inca moved his residence from Urcos (Urquillos) adjacent to the Urubamba Valley, where his primary wife had lands, to Chinchero, which he built to share with his favorite secondary wife, this deeply symbolic change of location made clear a changing allegiance from one wife to another. Building his new estate above the lands of his principal wife was a spatial declaration that the new residence and its associated lady were superior. To make sure that visitors to the estate experienced this relationship, Topa Inca built a road that led to Chinchero by going directly past—and above—Urcos. Thus, the visitors to Chinchero physically experienced the hierarchy of Chinchero over Urcos (and thus Chequi Ocllo over Mama Ocllo) in space and across time.

The Inca noblemen who were to experience this relationship formed the third reason that the location of Chinchero had great meaning. By having Inca elites build his estate, Topa Inca forced these noblemen to map onto the landscape his partiality for a secondary wife, and by designing roads that directed Inca elites to walk past (and above) Urcos to Chinchero, he forced noblemen to experience his marital preference in space. Thus, Topa Inca manipulated traditional Inca spatial practices not to express state colonization, but instead to serve his own needs as patron. And he went to such great lengths not just because of his preference in women, but also because of his plans for his sons. Having Inca noblemen support this change in marital preference was crucial to Topa Inca's intention of making his designated successor the son of Chequi Ocllo, rather than the son of Mama Ocllo. This is because these same noblemen were the ones who would have to formally vote for the next *sapa inca*, so incorporating them into the approval of Capac Huari was of great concern for Topa Inca.

The location of imperial Inca installations and the roads that connected them mapped out Inca authority. In the case of Topa Inca's royal estate, the placement of royal residences, way stations, shrines, and roads reinscribed the Ayarmaca homeland as Inca and encapsulated Topa Inca's political and family concerns.[19] However, it was one thing to map out Inca authority on the Andean landscape with distinct settlements; it was another to construct the potent movement and pauses that defined Inca space and place. For Inca architects, the latter began with the articulation of roads.

The Cuzco Road: Movement, Place, and the Authority of the Inca State

Roads played a key role in creating the theatrical movement that conveyed the Inca's message of power and authority. Roads leading to Chinchero came from two directions—Cuzco and the Urubamba Valley.[20] Since Chinchero functioned as a temporary capital when Topa Inca was in residence, one might assume that the road from Cuzco was the most important road leading to (and through) the royal estate. It was intended to be an impressive experience for privileged travelers, such as important state officials, high-level

administrators, ritual specialists, performers, and Inca elites living in the capital. Servants would have accompanied many of these elite travelers.

Weaving up and out of the Cuzco Valley before entering the flat plains of the Pampa de Anta, the road from Cuzco to Chinchero would have taken about six hours to complete (fig. 2.2). Thus the road made the estate accessible within half a day's journey, yet consumed enough of travelers' time so that they could adequately dwell upon their subservience to Topa Inca. Architectural gestures were created along the road to mark movement across both time and space, with gestures becoming more frequent and elaborate as one neared the sacred destination. For example, at the point where the royal road to Chinchero separates from that to Yucay is a *huaca* of the *ceque* system (a conceptual landscape of sacred places radiating out from Cuzco). This hill, called Churuncana, was where important sacrifices for Inca victories were made.[21] Another example lay further along the road, a few kilometers south of Chinchero.

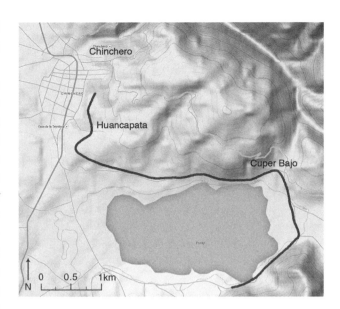

Figure 2.3 | Map showing a portion of the Cuzco-Chinchero road, passing by Lake Piuray, Cuper Bajo, and Huancapata. Map data © 2014 Google.

Here an Inca shrine was built next to the northeastern shores of Lake Piuray (fig. 2.3).[22] This lake was an important source of fresh water for Cuzco, and the Inca built water channels to speed its arrival in the capital.[23] As the Inca considered Lake Piuray to be sacred, they consecrated a *huaca* on a hill over which water from the lake was brought to Cuzco.[24]

The lake shrine, today called Cuper Bajo, is an elegant terraced site. The largest feature is an immense raised platform with curving walls. In front of this platform is an impressive terrace made of polygonal limestone masonry (fig. 2.4), with a series of door-sized niches, an attached stairway, and a tall fountain, all of which face the lake (fig. 2.5). This configuration suggests ritualized movement of an individual or a small group of people. If this was considered an important *huaca*, the Inca would have assigned a priest to preside over it. Otherwise, select travelers may have been called upon to make offerings on their own. Regardless of who was allowed to walk through or touch this sacred architecture, anyone who was able to see the site would have been alerted to its special status by the existence of the fountain and finely carved, bonded limestone masonry, as well

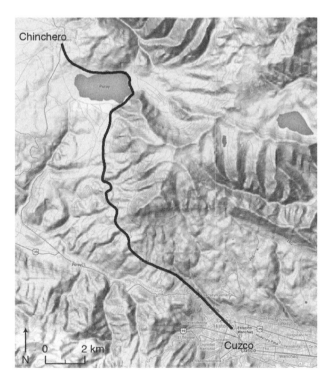

Figure 2.2 | Map showing the approximate location of the Inca road from Cuzco to Chinchero. Lake Piuray has been misspelled on the map. Map data © 2014 Google.

Figure 2.4 | Site plan of Cuper Bajo. The miniature wall lies closest to Lake Piuray. Behind is the full-scale terrace wall with staircase, large double-jamb niches, and fountain. Behind both of these is the massive platform with its large rounded corner facing northeast (the Lake). Scale is approximate. Adapted from a map by the Instituto Nacional de Cultura Peru.

Figure 2.5 | Full-scale terrace wall with a row of large double-jamb niches and a fountain at Cuper Bajo. This wall is made of fine polygonal masonry, as is the large curved terrace wall visible in the background above. Also pictured is Jacinto Singona. Photo by the author.

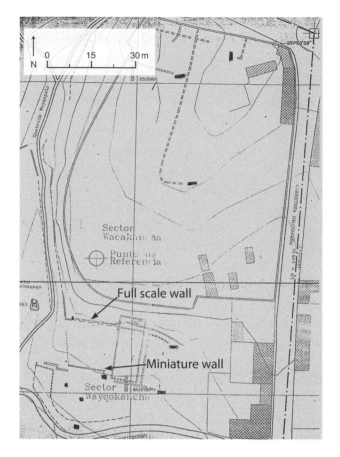

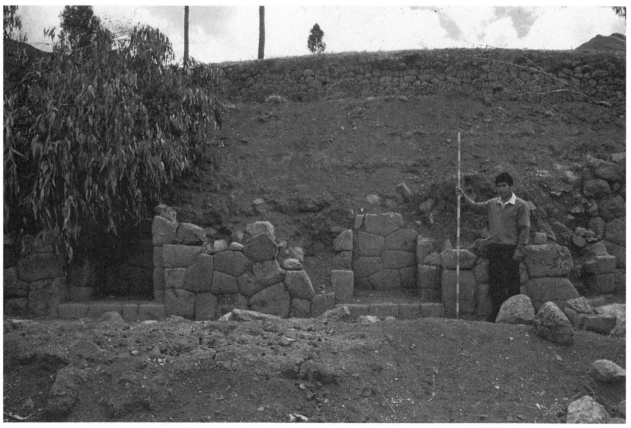

as its location next to (and within sight of) a sacred lake.

Other elements also signaled Cuper Bajo's importance. Although much of the shrine has been severely damaged, provocative clues remain that hint at its former magnificence.[25] While I was working in Chinchero, Stanislau Ailler, an elder in Cupir (Cuper), a member of one of three Chinchero lineage groups (*ayllu*), and a guardian for the I.N.C. (Instituto Nacional de Cultura), noticed that residents in a nearby town were collecting small, multicolored polished stones in their houses. When Ailler asked from where the stones came, residents pointed to an area in Cuper Bajo where they had recently begun farming. Ailler examined the area and saw more stones. All of these were finely worked, like polygonal Inca masonry, with hammered faces and polished, multi-angular sides. However, they were in miniature and of unusual colors. Realizing the importance of this find, Ailler notified the I.N.C. office in Cuzco, who sent an archaeologist to investigate. They found a thirteen-meter-long wall (one meter high) composed of finely worked sandstone, such that each block is a distinct, natural (not painted) color of red, green, yellow, or white (fig. 2.6).[26] In front of this wall, the I.N.C. investigators found a long water channel.

This wall is unique in Inca architecture for its materiality and scale: There are no other miniature Inca walls in existence, despite the fact that the miniature was highly valued (and considered especially potent) in the Andes, particularly for the Inca.[27] There are also no known extant examples of multicolored stone walls from the imperial Inca period, even though colors were deeply symbolic and were ascribed special meaning by the Inca.[28] In addition, the miniature wall at Cuper Bajo is the only sandstone structure on Topa Inca's estate. While the particular meaning of this polychrome miniature wall may now be lost to us, it is clear that Cuper Bajo's architecture, in particular its use of materials, space, and scale, conveyed a specific and powerful message to the select visitors allowed to see it. For the traveler on

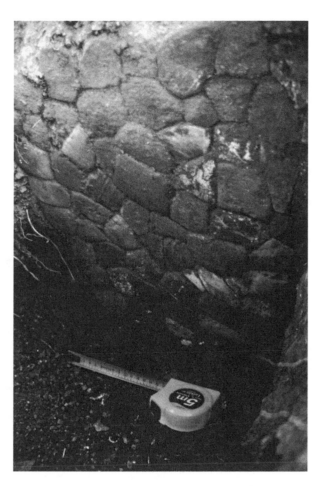

Figure 2.6 | Miniature, multi-color terrace wall at Cuper Bajo. Photo by the author.

the road from Cuzco, the transition to the revered lands of Topa Inca had begun.

A visitor continuing on the road left the miniaturized architecture of Cuper Bajo to encounter the opposite thirty minutes later—the large plaza and immense outcrop of the Huancapata (fig. 2.3). Terraces surround the plaza on three sides, with one side open to the Inca road. Limestone blocks formed the polygonal bonded masonry, though only the lower courses remain today (fig. 2.7). The generous size of the plaza suggests that large groups from the capital were expected to travel to Topa Inca's new home and gather here before entering the sacred retreat. In Cuzco, visitors had to undergo important rituals before they could set foot in the sacred space of the capital. Given the elite nature of private estates, it is possible that

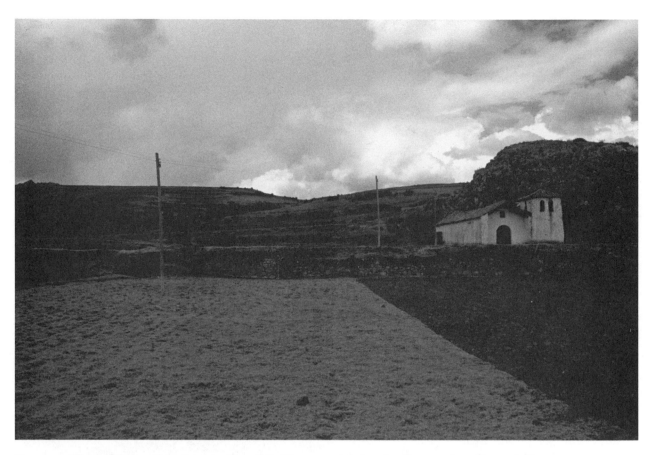

Figure 2.7 | View of the northwestern portion of the Huancapata, showing the remains of imperial Inca walls as well as rough cuts into the landscape (the first stage in constructing terraces). Two terraces are faced with polygonal masonry; one is at the bottom, lining the *pata* (open space), and the other is much higher. Photo by the author.

visitors also undertook specific rituals before entering royal retreats.

The most striking feature of the Huancapata is the huge stone boulder that gives the large open-air space its unique spatial identity and name (fig. 2.8). The outcrop lies in the largest wall on the plaza (opposite the arriving visitor), composing most of it, and today dwarfs the colonial-period church nestled next to it.[29] Evidence suggests that this impressive outcrop was deeply meaningful to the Inca and may have been the reason the Huancapata was built here. For the Inca, *huanca* (*wank'a*) was a sacred monolithic rock, thus a type of *huaca*.[30] Specifically, *huanca* was a sacred outcrop that proclaimed possession.[31] As Dean explains, *huanca* were "rocks that were understood to be the petrified owners of places, such as fields, valleys, and villages. . . . The *wank'a* was a sym-

bol of occupation and possession."[32] Thus, this impressive outcrop set next to a large Inca plaza gave the site its name and marked it as Inca territory. As *huanca* existed before the Inca arrived, it is possible that this sacred outcrop previously marked Ayarmaca territory, making its reconfiguration in Inca space even more poignant, as it proclaimed the Inca presence and Topa Inca's possession of former Ayarmaca lands.[33]

Pata is the Quechua word for "step, platform, or terrace"; therefore, a translation for Huancapata is "terrace or platform of the *huanca*." This would have been an apt description of the site once it was finished. Around the main outcrop and large open-air space is a series of long, regular cuts into the surrounding hillside (fig. 2.7). This is the first stage in the construction process that would have created new terraces rising up behind and around

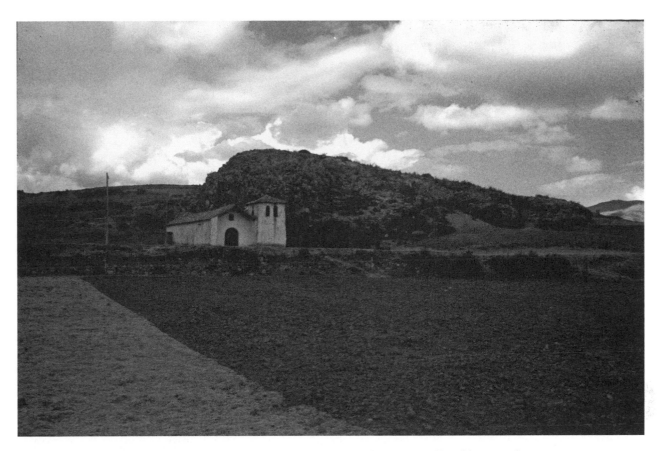

Figure 2.8 | View of the northeastern portion of the Huancapata with terrace wall and large rock outcrop. Also visible is a colonial-period church (Capilla del Señor del Huanca). This building was likely built to consecrate the *huaca* as Christian. Photo by the author.

this area. The construction evidence suggests that while Huancapata's main plaza may have been in use, the rest of the site was just beginning to be built when work was abruptly abandoned; the final plans for the impressive plaza, outcrop, and terraces were never realized during imperial Inca times.

The fact that the Huancapata was never completed provides a critical clue to the priority of the builders of Topa Inca's estate. Not only was this immense reception area not finished, but neither was the southern portion of Chinchero, to which this road led. This portion of the residential core had the same large cuts into the hilly landscape as the Huancapata, revealing its early stage of construction. In other words, there was no place in Chinchero for travelers from Cuzco to arrive. While the evidence suggests that Topa Inca had

plans for a grand approach to Chinchero from the imperial capital, it was still years away from being fully implemented.[34]

However, what *was* completed along this road highlights the sophisticated ways in which the Inca manipulated movement to create meaning in the landscape. In particular, we see how the Inca designers played with the tension between movement across the Inca estate (space) and pauses (places) where time in the landscape was extended so a traveler could focus on a material Inca statement.[35] The pauses along the road from Cuzco to Chinchero celebrated the sacred power of the Inca state through architecture (the multicolored miniature wall at Cuper Bajo) and nature (the *huanca* outcrop).

Specifically, the miniature wall declared (through form, facture, and scale) the unique

power of the Inca state, albeit one that was in tandem with sacred natural forces (the lake). By contrast, the Huancapata emphasized Inca power over the disposed Ayarmaca by redefining a sacred element in the landscape (the territorial outcrop) with Inca architecture (terraces and plaza). These pauses in the landscape created distinct markers of Inca authority. As these statements of Inca power were on the road leading to Topa Inca's royal estate, these were also statements of the power of the royal patron.

Yet, despite the road's important location and its critical message, the fact that it was left unfinished challenges the assumption that the most important road on the royal estate must have been the one leading from the capital—a reminder to be cautious in making conjectures about the power of the state in defining how Inca landscapes were designed and used. This restraint supports Susan Niles's argument that the desires of an individual patron, in particular those of a *sapa inca*, could drive the design of an Inca site.[36] As we shall see, the specific concerns of Topa Inca emphasized the importance of a very different pair of roads. The prioritizing of these roads may at first seem surprising, but, considering the personal circumstances of Topa Inca's golden years, this preference makes perfect sense.

Urubamba Valley Roads

The direction of travel that most concerned the builders of Chinchero came from the north. Unlike the road from Cuzco, the two roads leading from the Urubamba Valley appear to have been complete—as was an impressive reception area in the northern portion of Chinchero (fig. 2.9). Today local residents still use both of these roads. The lower Inca road begins within Urcos (Urquillos), and runs along the narrow but lush Urquillos Valley before ascending to Chinchero. This was the road most likely used by Topa Inca and his immediate household when moving between the two residences. The upper road runs alongside Urcos

before beginning a long ascent up the mountain face. Travelers such as the Inca noblemen living in the Urubamba Valley—but not in Urcos—would probably have taken this route.

The starting point for both roads is Urcos, which was a dense settlement that was part of Topa Inca's royal estate.[37] Today called Urquillos, the settlement was called Urcos or Urcosbamba in colonial documents. The surviving Inca architecture indicates a well-laid-out grid of finely made buildings, similar to Pachacuti's estate at Ollantaytambo. Unfortunately, we know little of this retreat, neither what the settlement looked like during imperial Inca times nor what activities took place here.[38] We do know that Topa Inca's principal wife had lands nearby, and, given that Urcos (Urquillos) appears to be a residential area, this is likely where Topa Inca's principal wife and their son also had quarters.

Those allowed to enter Urcos had the option

Figure 2.9 | Map showing the approximate locations of two roads between Urcos (Urquillos) and Chinchero. The first (lower road) goes through the Urcos (Urquillos) Valley before rapidly ascending. The second (upper road) rises slowly up the exposed mountain face before reaching the bottom of the Chinchero Valley. The two roads share the final leg of the journey, through the Chinchero Valley. Map data © 2014 Google.

to walk to Chinchero via the lower road. This is an intimate pathway; it passes through the royal buildings of Urcos before proceeding across the narrow, lush green valley, past abundant terraces, and alongside a channeled river before dramatically rising into the forests, past a natural waterfall, and terminating at the far eastern end of a narrow valley tucked into the mountainside. This valley belongs to Chinchero and runs along the bottom of the estate's dramatic terraced hillside. Throughout the journey, the landscape is rich in plant life that protects and shields the traveler from the elements.

No grand architectural gestures signaled the approach to Chinchero, perhaps because the traveler never actually left the lands of Topa Inca's royal homes. Instead, the emphasis was on the bodily experience as dictated by the Inca roads. The person who walked along this highly restricted road would have experienced a verdant landscape filled with the sounds of birds and rushing water. This bucolic journey ended on a dramatic note, with a final steep and exhausting climb to the entrance of Chinchero, leaving no doubt as to which residence was the real seat of Topa Inca's authority.

The passage along the upper road was very different. Like the lower road, it began in Urcos; however, rather than fully penetrating the estate and its lush landscape, the road carried the traveler to the outskirts of the residential area and the adjacent hillside, where a long, steady ascent began. For the traveler following this path, Urcos rapidly diminished below. As the entirety of the trip (about four hours) was on the unprotected mountain face, the traveler was exposed to the penetrating sun and sometimes savage winds.

As on the lower road, architectural monuments did not define the experience. Instead, a collection of architectural gestures directed the traveler's body as it moved across space. On the upper road, there were occasional lookouts to behold the dramatic views of distant mountains, such as the sacred *apu* Pitusiray, as well as moments of immediate interest such as a small area of vibrantly colored sandstone formations next to the roadway. Both of these are important. First, Pitusiray was one of the most sacred *apu* in Tahuantinsuyu. It lies between two *suyu* (quarters of the empire), and its twin peaks are said to illustrate the sewing together of the two *suyu*. Second, the sandstone formations are of the same color and consistency as the individual blocks in the miniature wall in Cuper Bajo. Thus the same rare material marks the two (directionally opposite) roads leading to Chinchero.

There is only one significant architectural monument along this road—Peccacachu (fig. 2.10). It lies about two-thirds of the way to Chinchero. For nobles who regularly made their pilgrimage to see Topa Inca, this would have been a familiar marker on the road that would signal how far in time and space they had left to reach their destination. But for novice travelers, this monument would have come as a surprise and would have been a reminder of their vulnerability within the imperial landscape. Eliciting this latter reaction appears to have been of critical importance to the Inca designers, as Peccacachu was built behind a fold in the mountain, hidden from oncoming travelers (fig. 2.11). This concealed setting magnifies its ability to surprise the traveler, suggesting that the site may have been a *tambo*, or guard station. Its secreted setting would have allowed imperial guards to quickly apprehend travelers not sanctioned to be on the Inca road. Peccacachu also signaled the approach of sacred space. A series of terraces and a tall water fountain reflected its high status. The buildings were made of bonded limestone masonry topped by finely shaped adobe blocks, a combination of materials that came into fashion for elite architecture during Topa Inca's reign.

After leaving Peccacachu, the traveler would have continued along a wide and well-made road, paved with finely worked stone blocks (fig. 2.12). Far above Urcos, the final portion of the journey led to the bottom of the Chinchero Valley, next to the point of entry for the lower road.[39] The visual climax for travelers on both roads would

Figure 2.10 | Site plan of the *tambo* of Peccacachu. Much of the western portion has been destroyed as a result of farming. However, the base and wall sections of the eastern portion were still intact when this plan was made. Two fountains, one above the other, run down the wall that lies between the two halves of the *tambo*. Image by the author.

Figure 2.11 | The remains of Pecca- cachu today. Travelers coming from Urcos (Urquillos) would have turned around the fold in the mountain and suddenly been confronted with the *tambo*. As seen in the fore- ground, the road continues on to Chinchero. Photo by the author.

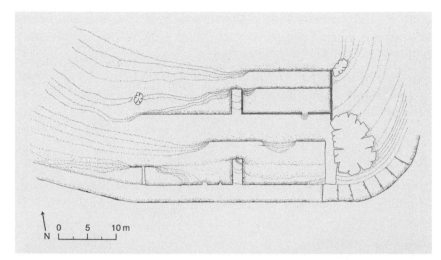

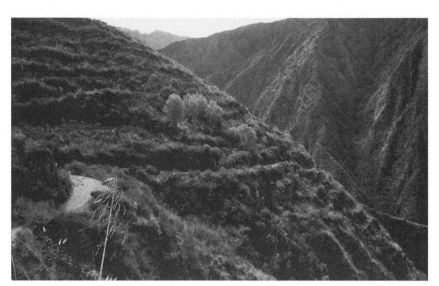

have been a grand surprise.[40] They were suddenly faced with a towering hillside (*chiru*) reshaped by a profusion of large Inca terraces that would have dwarfed even the tallest and proudest of visitors (fig. 2.13).

Terraces

Even today, this view is breathtaking. But during Inca times, it would also have had great signifi- cance. Finely carved polygonal limestone blocks redefined the hillside's elevation, making visi- ble Topa Inca's profound relationship with Pa- chamama (earth mother) and other sacred forces

of the land (fig. 2.14). What may have grown on these numerous terraces is unknown. It is fertile terrain and, until the I.N.C. prohibited local resi- dents from farming them in the 1990s, the ter- races yielded rich harvests.[41] Crucial food supplies may have been cultivated here, providing the in- gredients to feed not only the ruler and his fam- ily, but also visiting dignitaries and royal fam- ily groups (*panaca*).[42] Some of these terraces may have also been used for ornamental plants. The Spanish writers marveled at the lavish gardens of the Inca, especially those found at royal resi- dences. Yet the most important aspect of Inca ter- races may have lain deep below the surface. The geologically young Andes suffer from landslides,

Figure 2.12 | A portion of the Inca road on the way to Chinchero. Photo by the author.

Figure 2.13 | Travelers from Urcos (Urquillos) would have entered the Chinchero Valley along the Inca road (shown in the lower left of the site plan). Image by the author.

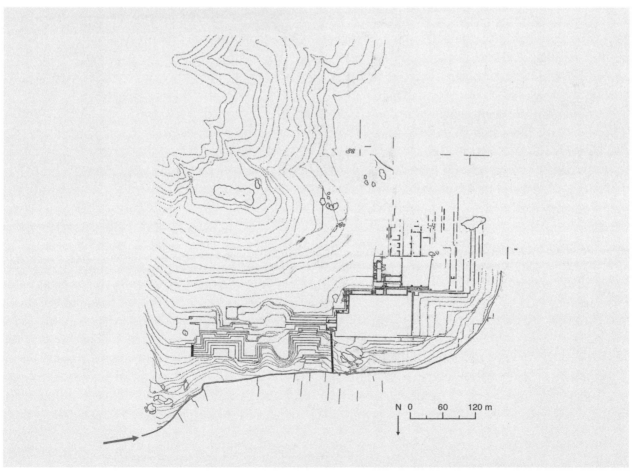

N 0 60 120 m

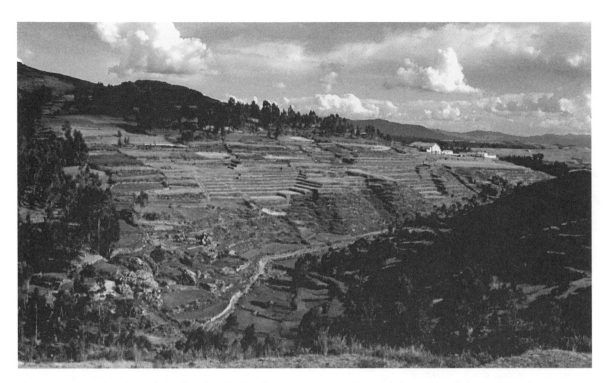

Figure 2.14 | Terraced northern façade of Chinchero. An Inca road runs below the terraces, along the valley bottom. Travelers from Urcos (Urquillos) would have entered from the east (bottom left in image). Photo by the author.

which, along with a plethora of underground water movement, made this unstable landscape difficult to build upon. However, Inca terraces helped to control underground water sources and stabilize lands.[43]

In sum, the Inca terraces would have delivered a strong, threefold message to the newly arrived traveler. In addition to symbolizing Topa Inca's relationship with sacred natural forces, the terraces at Chinchero proclaimed his power to produce valued plants and made visible his ability to stabilize a fragile land. In the Andes, where *ayni*, or reciprocity, was the source of immense power, the use of terraces to welcome the traveler to Chinchero made a very bold statement of the personal power of Topa Inca.

Chinkana: The "Hidden" *Sayhua* at Chinchero

These remarkable Inca terraces were also dotted with stone outcrops (fig. 2.15). At first glance, these stones seem to convey the simple but important message of the relationship between Topa Inca and sacred natural forces (the latter often manifested in unusual outcrops); however, on closer examination the stones reveal complex spatial practices that operated on multiple levels. Through the manipulation of space, materials, and the bodily senses, these stones became key places in which Topa Inca's authority was acknowledged and Inca history and hierarchy were reiterated.

The first sight of the lavish terraces alerted travelers that they were entering the hallowed lands of Topa Inca's favored residence, but it was a group of stones at Chinchero that formally marked this spatial transition. This lithic collective, called Chinkana (a name also given to outcrops at other Inca sites), is located at the entrance to the Chinchero Valley and was a *sayhua* (*saywa*), a very distinctive type of sacred rock to the Inca. While *huanca* symbolized a territory, *sayhua* symbolized boundaries and "were petrous embodiments of passage and transitions, which is inherent in travel, and they memorialized land rights."[44] Thus

at Chinchero, the Chinkana stones marked the traveler's spiritual and spatial transition into the new residence of Topa Inca and his favorite wife, Chequi Ocllo. Topa Inca is credited as being one of the first rulers—if not the very first—to use *sayhua* in organizing imperial space in Tahuantinsuyu.[45]

For travelers, Chinkana marked a critical place —their entrance into Chinchero. However, for a small selection of high-status people coming from within the royal residence, Chinkana also served as a ritualized landscape that had its own spatial practices. For example, several of the stones have geometric carvings, most of which cannot be seen by people arriving from Urcos (fig. 2.16).[46] Another stone has a long "band" carved around its middle (fig. 2.17). Whether this carved impression was an important symbol or if something was set inside it is unclear. The Inca placed gold bands around special stones, and Topa Inca, after conquering the Chimu region in the north, collected gold and brought it back for use in the Cuzco area.[47]

Regardless of whether there was a gold band around these stones, the Chinkana outcrop displays a remarkable range of carving types, some shared across boulders, others articulating singular stones, that were visible only to select visitors who were allowed to approach the stones.

Another example of this exclusive landscape is a series of connected pools carved into the outcrops. Their purpose may have been to collect water, blood, *aka*, or *sacaya* as part of Inca rituals. (*Aka* was an alcoholic maize drink, and *sacaya* was a sacrificial offering for *huaca* made from maize and *ticti*—the residue left after *aka* has been brewed.)[48] Liquids were an important aspect of Chinkana. Behind the stone, a bustling creek drops down the mountainside in a series of fountains. Some were natural; others were channeled using fine Inca stone walls. This stream was diverted to flow around a large portion of Chinkana's perimeter (fig. 2.18). Here, a series of waterfalls captures the rushing water, creating distinct

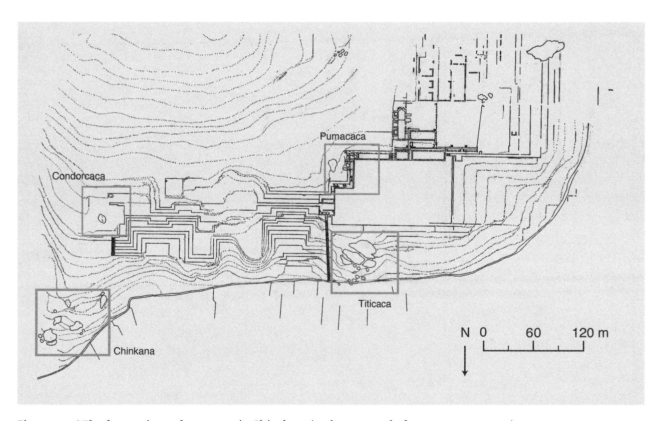

Figure 2.15 | The four major rock outcrops in Chinchero (each composed of two or more stones) are outlined: Chinkana, Condorcaca, Titicaca, and Pumacaca. Image by the author.

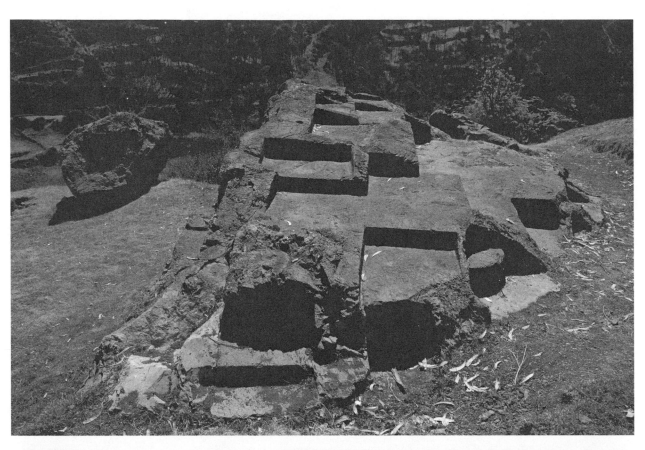

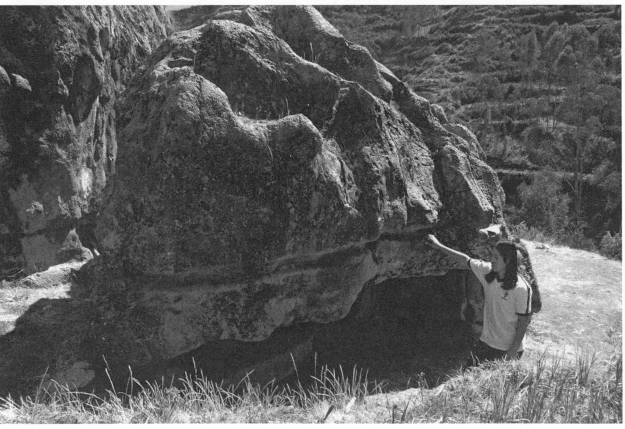

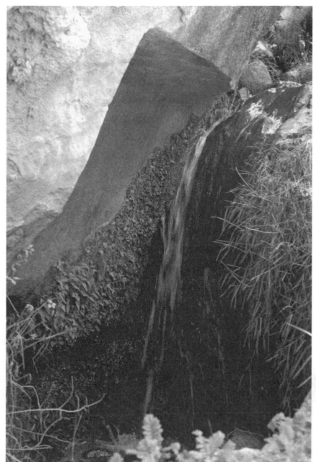

Figure 2.18 | Largest rock at Chinkana, showing a band of geometric carvings with running water channeled below. Photo by the author.

Figure 2.19 | Portion of water course and geometric carving near the bottom of the largest rock at Chinkana. Photo by the author.

sounds before ending in a basin of swirling mass. The result is an auditory delight of gently flowing waterfalls and rustling streams (fig. 2.19). Water was highly valued in the Andes. It was understood (along with light) as being one of the most tangible manifestations of *sami* (*camay*), or the animating essence of the world.[49] It also could have connotations of maleness and fertility.[50] The Inca used it to evoke status—creating fountains, water channels, and other liquid landscapes to ar-

ticulate elite space. Water emphasized the multi-sensory aspect of elite Inca landscapes, as it could be seen, touched, tasted, and heard. The inclusion and articulation of water at Chinkana (as at Cuper Bajo and Peccacachu) gave the place an even more formidable presence (and deeper meaning).

The design of Chinkana indicates that sanctioned visitors were to be actively engaged, and the spatial practices of its intimate landscape were complex. Select people coming from *within*

Figure 2.16 | (*opposite above*) Stepped geometric carvings (a.k.a. "seats") on one of the smaller outcrops at Chinkana. Photo by the author.

Figure 2.17 | (*opposite below*) Eastern portion of a Chinkana stone showing the continuous band that wraps around the large outcrop. Photo by the author.

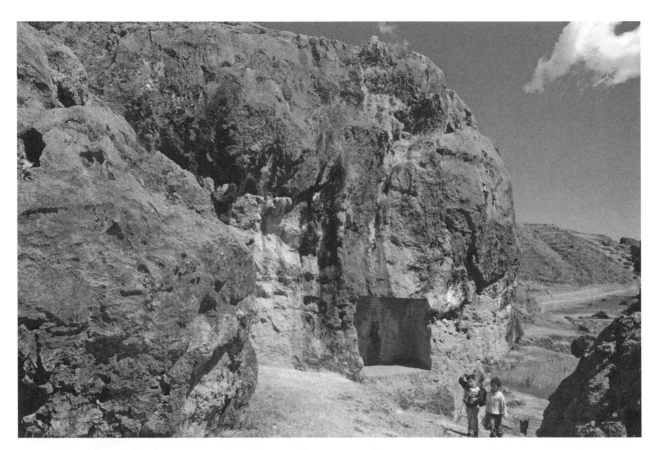

Figure 2.20 | View of the northern face of the largest outcrop at Chinkana. The entrance to the cave lies about one-third down the face of the stone (directly above the large rectangular cut). It appears as a heavily shadowed, natural indentation in the stone. Photo by the author.

the estate, such as Topa Inca and his priests, could walk around the outcrop (and rushing water), climb on, and even go through it. For example, on the west side is a well-made stairway that leads up the stone and then curves down along the rock edge, ending in a large niche from which one can see along the valley and across Chinchero's north terraces. Although people along the Inca road could see this stone, they could only pause, perhaps make their own reverential gestures, and then walk past it.[51] But for those lucky enough to be allowed to come in contact with the stone (entering from within the estate), a complex system of movement engaged the visitor's body in multiple ways.

But Topa Inca and his special guests may not have been the only ones who moved through and gave meaning to this lithic and liquid place. A dramatic stairway wraps around the stone, narrow-

ing as it goes. Just beyond where it disappears lies a narrow slit in the stone, inside of which is an impressive cave. It is impossible to use this staircase, suggesting that it was a symbolic or spiritual entrance to the cave. But there is another, hidden pathway that goes over the top and wraps partially around the outcrop, where a crack in the stone leads to a tunnel, which in turn ends in the tall, narrow cave inside the outcrop (fig. 2.20). Here, a smooth, well-paved floor has been created and the interior walls are partially shaped to indicate the Inca presence. At the far end of this narrow but tall cave is a large fissure that provides a view of the hill opposite, in clear sight of travelers proceeding on the Inca road.[52] Just outside of this view is the narrowing staircase, which may have indicated passage between worlds.[53] Given the importance of caves to the Incas (they were considered places of origin) and the efforts made

to modify this space, it was likely used for ritual purposes and may even have housed sacred objects and beings, such as mummies.[54] For the Inca and other Andean groups, caves were important spaces, in which mummies were kept, visited, venerated, and fed.[55]

Given its complicated entrance, knowledge of Chinkana's cave may have been highly restricted. *Chincana* (*chinkana*) means "hidden" in Quechua and alludes to being lost in water.[56] This cave, with its special carvings, articulation of water, and evocation of the senses, suggests that a special form of rituals occurred here—and that this stone had unseen powers that could engulf errant visitors, a perception that continues to the present day. At Chinchero, Chinkana is one of the few stone outcrops still considered to be an active *huaca*, and it is the most powerful at that.

In the Andes, sacredness was most often found in geography rather than in the cosmos.[57] This divinity or sacred essence was called *camay*, which was a continuously active force.[58] *Camay* could inhabit places and people, as well objects (natural and man-made).[59] These *huaca*, or sacred, material manifestations, came to define the Andean landscape.[60] As the Spanish soon came to learn, *huaca* were frustratingly hard to categorize, for they could be "any material thing that manifested the superhuman: a mountain peak, a spring, a union of streams, a rock outcrop, an ancient ruin, a twinned cob of maize, a tree split by lightening. Even people could be *huaca*."[61]

Regardless of their form or materiality, all *huaca* were understood to be powerful and alive.[62] Therefore it is not surprising that in Chinchero today, residents tell stories of people who have gone too close to Chinkana at night and have not been seen since.[63] Hence, people who made contact with the stone at an inauspicious time were lost to it. This is a reminder that the timing of one's movement on the landscape was deeply meaningful in the Andes, particularly when it came to *huaca*. People were obliged to venerate and offer gifts to *huaca* at specific times.[64] In Tahuantinsuyu, it was also customary to make offerings to *sayhua* as one passed, whether one could touch them or not. In doing so, the visitor acknowledged that the *sayhua* marked important historical events and transitions between territories.[65]

Thus, if Chinkana was a *sayhua*, travelers would have made offerings to the *huaca* from the road below, acknowledging their subservience and the transition into the core of Topa Inca's sanctified estate. By contrast, someone coming from within Chinchero made offerings at Chinkana itself, acknowledging with one's body the sacred powers of the landscape, the great achievements of Topa Inca's ancestors, and one's close relationship with both. This rarified visitor was most likely Topa Inca himself and a few sanctioned priests.

Besides status and timing in relationship to the landscape, the Chinkana stones also reveal how the Inca manipulated directionality in movement to convey meaning in space. As noted earlier, most of the worked areas of the Chinkana stones are not visible to arriving visitors. Instead, most of what they would have initially seen was the unworked portions of the stones. By contrast, for people leaving the estate, most of what they would have seen of the Chinkana stones were carved portions. The result is that to the arriving visitor, the stones appear as largely natural, standing as powerful sacred *huaca* that were gently modified by Topa Inca. But for the departing visitor, the stones appear heavily carved, revealing Topa Inca's ability to profoundly reshape sacred forces. For those returning down the Inca road, the hand of Topa Inca lingers most forcefully, imprinting on the departing traveler the dominant power of the patron.

Chinkana reveals how the Inca could design very distinct experiences in one small space. These experiences unfolded according to one's status and location. Visitors who traveled the northern roads to and from Chinchero were confronted with *huaca* that marked a sacred boundary, Topa Inca's authority, and his relationship with the sacred landscape. By contrast Topa Inca (and select visitors coming from within Chinchero) were given a very different experience of Chinkana, one that engaged all the senses and allowed bodily contact with sacred materials and origin places. With minimal architectural gestures, the design-

Fig 2.21 | View of the (reconstructed) eastern staircase that lies between Chinkana and Condorcaca. Also pictured is Andy Sallo. Photo by the author.

ers of Chinkana created a dynamic, complex, and deeply meaningful place for very different individuals, living and dead. Chinkana is an important reminder of the need to be cautious when ascribing a singular movement, actor, or meaning to an imperial Inca place.

Condorcaca: The *Saycusca* Stops Here

While a person making the journey to Chinchero via this northern road could view parts of the Chinkana outcrops, nothing of Condorcaca ("crag of the Condor") would be visible.[66] The "hidden stones" of Chinkana were connected via a nearby stairway to the Condorcaca outcrops.[67] From the road, a stairway rises before disappearing into the high terraces, with no view of the distant Condorcaca (fig. 2.21).[68] However, a knowledgeable visitor may have guessed at its location, because on the

northern façade of Chinchero all the terraces that concentrated around outcrops were fully completed, indicating that the articulation of these places was one of the priorities of the builders.

The two outcrops of Condorcaca comprise primarily sharp peaks and valleys on their upper portions that show no obvious signs of having been carved (figs. 2.22–23). As Dean has demonstrated, stones in their natural state could be considered as sacred as carved ones. Evidence that some of Condorcaca's natural formations had been considered sacred includes the fact that they were intentionally destroyed, most likely during the colonial period. In this iconoclastic attack, several of the peaks on the largest stone were hacked off and thrown down the hillside.

In addition to these natural formations, both stones have a small selection of geometric cuts that form platforms or seats (figs. 2.22–24). Ac-

cording to local residents, the larger stone is said to represent the most important *apu* of the Inca state, and the smaller outcrop is believed to symbolize the main *apu* of the Chinchero area.[69] This is not necessarily a figurative reading of the natural formations, but instead may reflect a longstanding understanding of *huaca* in the Andes. During imperial Inca times, stone *huaca* were often understood to represent (or present) sacred mountains.[70]

Clues to the relationship between these stones and sacred mountains can be found in the Inca carvings. On the largest stone, there are two groups of geometric carvings, sometimes referred to by scholars as "seats." One consists of a single seat that faces west, toward the most sacred mountains of the Inca state, Salcantay (fig. 2.23). The second group is composed of a row of seats

that face north-northeast, toward Pitusiray (the sacred mountain discussed earlier) and Antakilke (the local *apu* venerated in Chinchero; see fig. 2.24).[71] The latter is a unique view. It is the only place *inside* Chinchero from which the imperial *apu* Pitusiray can be seen.

The fact that this stone sits in such an auspicious location was not an accident. Despite its seemingly natural appearance, the large stone of Condorcaca is not part of the bedrock (like most outcrops), but instead was brought to this specific spot by the Inca. While the siting was perfect for viewing the *apu*, the newly created *pata* was not. Sometime in the last five hundred years, the earth beneath the western portion of the stone gave way, causing it to sink considerably on one side.[72]

When this side of the stone became buried, it hid a small group of important Inca carvings. A

Figure 2.22 | The smaller of the two Condorcaca stones is nestled in the corner between two tall, polygonal limestone terrace walls. This image shows natural peaks and a single stepped geometric carving (a.k.a. "seat"). Photo by the author.

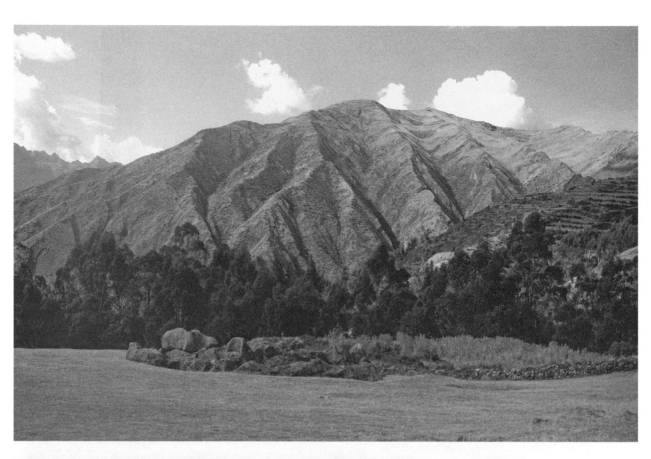

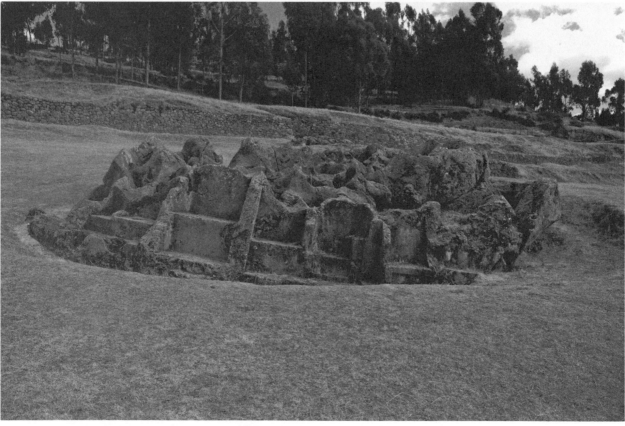

Figure 2.25 | Heavily weathered carvings on the large Condorcaca stone of a *puma*, *condor*, and two projecting depressions, or "offering cups." The puma is shown on the left, positioned upright with its face and legs directed toward the double cups (tail stretching out below). The condor is shown on the right, its triangular tail almost touching one of the cups, its wings spread wide, and its head reaching down to the surrounding earth (before the stone started sinking, the head would have faced upward). One of the condor's legs and claws (right) is also shown, stretched behind as if in flight. Photo by the author.

puma and condor were depicted, separated by a projection that contains two cuplike depressions that may have been used to hold offerings (fig. 2.25).[73] The Inca considered the condor and puma to be powerful sacred beings. The bird carved in the stone is depicted in flight, with wings outstretched. As it flies away, its tail almost touches the right offering cup. The Andean condor (*Vulture gryphus*) is a scavenger, feeding primarily upon dead animals.[74] For the Inca, the condor was understood as a symbol of the transition between realms, able to transcend the world of the living and the inner world of the ancestors. By contrast, the puma carved in the stone is shown facing the condor, with all four of its feline feet reaching out toward the cups. The Inca consid-

Figure 2.23 | (*opposite above*) The large stone of Condorcaca lies in the open, on the flat plain of a *pata* (view is from the small stone shown in fig. 2.22). Visible is the long, low shape of the outcrop's natural peaks and a stepped geometric carving ("seat") facing west (left in the photo). Photo by the author.

Figure 2.24 | (*opposite below*) View of the large stone of Condorcaca, as seen from the north (behind is the small stone of Condorcaca). Visible is a long row of geometric carvings (seats) and the stone's dramatic slope (due to the collapse of its soil foundation). Photo by the author.

ered the puma (*Puma concolor*, a hunter) to be connected to elite Inca men, such as the *sapa inca*.[75] In the case of Chinchero, this would mean Topa Inca. So the iconography of the condor, puma, and offering cups on the Condorcaca outcrop ritually ties Chinchero's royal patron to the sacred *huaca* and the divine ancestors.[76]

The fact that a *huaca* would have made reference to ancestors would not have been unusual in the Andes. In colonial Huarochiri, people considered certain *huaca* as "apical ancestors of their patrilineage," and for others *huaca* was a "major-founder huaca."[77] *Huaca* could also give a group of people special powers and their "life energy."[78] Considering that the land on which Chinchero had been built likely belonged to the Ayarmaca, one must wonder how these *huaca* fit into Ayarmaca history and identity. The fact that they may have been important sacred places for the Ayarmaca heightened their significance for the Inca. At Chinchero, the Inca were not creating new sacred places, but instead, they were redefining the lithic numina of conquered people. The Inca claimed these spaces as their own by marking them as essential to Inca history and Topa Inca's relationship with the sacred.

This incorporation of local *huaca* into the Inca landscape was not unusual. For example, one of the *huaca* of the Cuzco *ceque* system was an outcrop the Ayarmaca venerated as their source of origin.[79] Thus, the Inca co-opted one of the most sacred spaces of the Ayarmaca people by making it a critical node in Inca place-making practices. They did this not by erasing the Ayarmaca presence, but by articulating it and subsuming it under imperial Inca narratives. In doing so, they revealed the complicated and entangled relationship between Inca and Ayarmaca history and space.[80]

It is unclear how the Ayarmaca or other local groups may have viewed the outcrops around Chinchero, but for the Inca, the Condorcaca carvings would have been easily visible to the few people allowed access to this stone, and the message of the iconography would have been clear. What is surprising is that this stone later sank: the Inca were used to moving stones, even large ones like this *huaca*.[81] Mobile stones were an important part of the Inca landscape, both physically and metaphorically.[82] Illustrative of this importance are the stones called *saycusca* (*sayk'uska*). During the process of transporting stones as part of the Inca construction process, when a few blocks suddenly stopped, refusing to go any further, they were called *saycusca*. In rejecting Inca desires to move them, these defiant stones highlighted the power of materials and the negotiability of facture in creating Inca architecture. As Dean has shown, by telling stories of *saycusca*, the Inca were not proclaiming their failure, but doing just the opposite. The few *saycusca* that refused orders emphasized the fact that most stones *agreed* to be moved by the Inca and become part of their imperial place-making practices.

Saycusca served as material metonyms of their previous location.[83] For example, when construction was completed, a block from a quarry was brought out and placed in a newly completed site to serve as the *saycusca*.[84] Because the block was understood as a *presentation* (as opposed to a *representation*) of the sacred quarry, offerings were made to the *saycusca* as a way to show their thanks for the lithic materials the quarry had provided.[85]

Was this the reason for the large stone of Condorcaca?[86] It is possible that it was brought here to commemorate the building of the estate, but there is too little evidence to say for sure. What is clear is that we cannot assume stone *huaca* are "natural" (original to their location) and that Inca design always worked around permanent elements in the landscape. Instead, we must recognize that some of these "natural" landscapes were constructed: stones were carefully selected, transported, and placed in specific locations so that they could connect with sacred places, claim territory, mark facture, and bear witness to specific histories for the Inca.

The movement of *saycusca* is also an example of how the Inca understood spatial practices as going beyond people, living or dead, to include elements such as stone. For the Inca, the journey of these *huaca* created powerful places in the Inca landscape, such as their starting and resting points.

The large boulder of Condorcaca marked a moment in the past when it decided to end its travels on this terrace at Chinchero and the Inca recognized this place as sacred with their carvings.[87] In doing so, the *saycusca* brought an important *apu* into the royal estate, inscribing Topa Inca's new residence within the sacred landscape of Tahuantinsuyu and the divine world of the ancestors.

Titicaca: The Architectural Landscape of a *Huaca*

Though the consecrating of Chinchero's space at Condorcaca may have gone without the notice of arriving travelers, they would not have been able to miss the impressive outcrop Titicaca, even from afar (fig. 2.26).[88] But, like the Chinkana collective, Titicaca constructed distinct experiences depending on the access one's status allowed.[89]

Titicaca is the largest single stone in the residential core (fig. 1.22). Immediately visible to arriving travelers, it serves as a beacon as they leave Chinkana and walk along the Chinchero Valley floor. Titicaca stretches up the hillside and accompanies the visitors as they make their final, labored steps to the heart of Chinchero. Like Chinkana, Titicaca lies tantalizingly close, but always beyond the visitor's reach.

The journey along the Inca road to Titicaca may

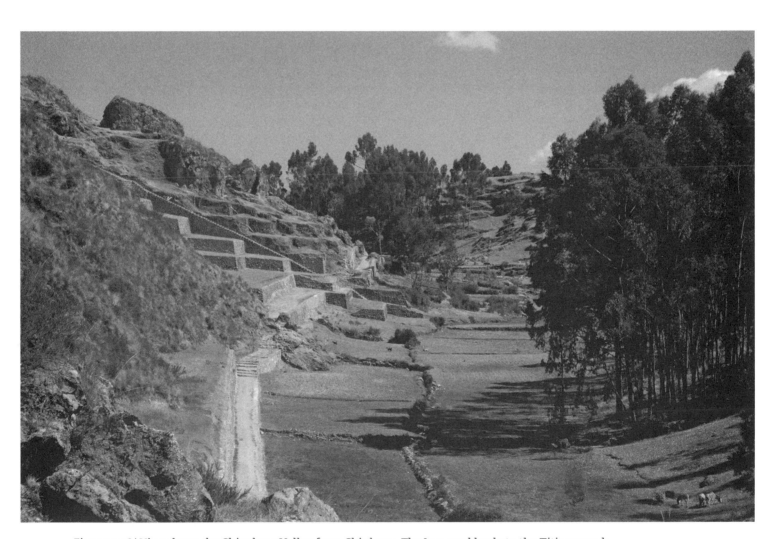

Figure 2.26 | View down the Chinchero Valley from Chinkana. The Inca road leads to the Titicaca rock outcrop and entrance staircase (both are visible in the distance, left in the photo). Staircase and neighboring terraces have been recently reconstructed. Photo by the author.

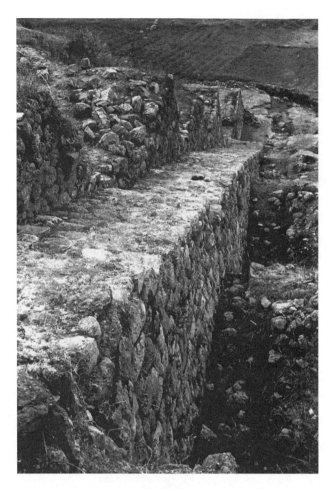

Figure 2.27 | View of the beginning (bottom) of the main staircase (before recent reconstruction). The stepped water course with accompanying fountains ran down the eastern side of the staircase (in the photograph, to the right). Several of the adjacent terraces (just out of sight to the right of the photograph) were still under construction during imperial Inca times. These consisted of a series of construction ramps that have since been destroyed by the I.N.C. and replaced by "modern Inca" terraces. Photo by the author.

have been more intimidating during Topa Inca's time than it is now. Currently there is a wide Inca road framed by terraces. But, if Martin de Murúa's description of another royal estate is correct, this carefully bounded road may have been stationed with guards, serving as an additional symbol of the control and authority of Topa Inca.

The road leads directly to the foot of a very long stairway made of finely carved limestone blocks, which shoots directly up the terraces, getting steeper as it goes higher (fig. 2.27). This engi-

neering is subtly done, and therefore not apparent to most people, who merely look at the stairs. Because the change in grade is not visually obvious, the increasing pressure on the body during the climb comes as a surprise to travelers today, leaving them more exhausted than they anticipated when they arrive at the top. While Chinchero residents refuse to use the stairway today (preferring to weave up the terraces in a gradual manner), during imperial Inca times this daunting stairway was the only way to penetrate the royal estate. Its carefully designed architecture did not allow deviations from the path.

The play between visual and physical displacement was reiterated as the traveler walked up the narrow stairway from the road below. Following the sights and sounds of a cascading series of water fountains that ran along the finely built stairway, visitors would have passed through each of the layers of terracing, having been granted closer views of each terrace level, yet barred from touching them. The fountains, found primarily at elite sites, would have also signaled to the visitors their increasing proximity to sacred, elite space as they approached the main plaza at the royal estate.

This combination of rushing water and terraces conveyed notions of fertility and masculine power, both of which celebrate the authority of Topa Inca at Chinchero. Motion and altitude were associated with maleness (in contrast to stability and depth, which embodied femaleness).[90] Water, when in motion, was considered to be male, and when interacting with the female earth was a potent fertile force. Salomon calls this a "biotic system," such that Andeans imagined "the hydraulic embrace of moving water and enduring earth (as) sex."[91] Thus, the long stream of water rushing down the terraces that accompanied a visitor walking the steep staircase was both a powerful sensory experience as well as one that proudly proclaimed the potency of Topa Inca. It is a striking example of why exposed waterfalls such as these tended to be reserved for elite Inca sites such as the royal estate of an important Inca ruler. Given that Chinchero was built to acknowledge Topa Inca's preference for one of his sexual partners, Chequi Ocllo,

and their offspring, Capac Huari, the rushing water on the main stairway would have been a particularly compelling symbol.

Like Chinkana, the Titicaca outcrop appeared differently depending on one's access and vantage point. For the visitor traveling along the road, Titicaca appeared natural, with some Inca modifications. Yet on the top (and other sides) a plethora of carvings created distinct spatial practices (fig. 1.22). There were geometric planes on which people could stand or objects could be placed, carved pathways for liquids to be poured and flow through, and figurative carvings of a serpent.[92] Titicaca also has natural peaks and valleys. For those allowed to travel to Titicaca from *inside* the royal estate, the outcrop opened up a heavily altered landscape that was very different from the largely natural one seen by those following the Inca road.

Figure 2.29 | After climbing up through the narrow enclosed entrance, one emerges high up on the Titicaca stone, looking down a long, exposed hallway cut into the bedrock. During imperial Inca times, this stepped hallway would have been framed by masonry walls. Thus, one entered the primarily "natural" rock outcrop to emerge in the middle of Inca architecture (which in turn, is physically rooted in the outcrop). Also pictured is Jacinto Singona. Photo by the author.

Figure 2.28 | The entrance to Titicaca is a narrow fissure in the rock into which stairs have been carved. Also pictured is Jacinto Singona. Photo by the author.

The elite person coming from within the royal estate entered the outcrop by passing through a darkened tunnel on the north side of the stone (fig. 2.28). Stepping over subtly carved steps, the select visitor exited to the top of the outcrop into an open passageway bounded by finely made polygonal walls (fig. 2.29). These walls also created terraces on top of the stone, so that one walked inside a carved stone only to emerge into a man-made landscape of Inca walls and garden plots (fig. 2.30). This corridor of finely made limestone

walls is almost gone today, but the long rows of bedding joints remain etched in the natural stone base, along with a few stones still in situ (fig. 2.31).

It is this end result that sets Titicaca off from the other sacred rocks at Chinchero. One goes into a narrow fissure of a natural outcrop and emerges onto a long, finely made masonry hallway. Thus what appears on the outside to be a natural outcrop with some modifications was experienced from the inside as an imperial architectural center with some natural features. Whether it was Topa Inca, his priests, or select family members, the lucky few who passed into Titicaca entered a place that visibly demonstrated the supreme power of the *sapa inca* to redefine a sacred landscape and material.

This heavy-handed architectural presence at Titicaca is similar to what departing visitors to the estate would have experienced as they walked by Chinkana and is linked with an important change in stone masonry practices at the estate. In all of Chinchero, there is not a single boss on any stone walls. These bosses, rounded projections used to move stones during construction, marked architectural facture at Machu Picchu and Ollantaytambo and became one of the defining features of Inca architecture built under Pachacuti. These nuanced gestures carried important messages that tied the Inca state (and ruler) with *huaca* and other sacred natural forces. However, at Chinchero, instead of petite but powerful carvings that signified the collaboration between powerful *huaca* and the Inca, Topa Inca left heavy architectural imprints. On top of Titicaca, on the departing wall of Chinkana, and across the many lithic masonry walls of Chinchero, Topa Inca confidently used architecture to emphasize his own power, even if that meant making potent *huaca* subservient to his imperial agenda.

Pacha: Inca Roads and the Making of Place

The Inca were brilliant at manipulating movement through their empire, whether in the form of long-distance roads undertaken by a diversity of travelers, or local passages traversed by special elites (dead or alive) according to the ritual calendar. When they could not completely control movement, the Inca were masters at articulating action in a way that aggrandized their authority, as can be seen in the carving of sacred animate stones who journeyed through imperial lands. While these architectural gestures may have developed as part of colonizing practices to reinscribe the landscape as Inca, individual patrons such as Topa Inca used these design traditions to celebrate their own authority.

For Chinchero, this meant the creation of grand roads and intimate pathways to create distinct and increasingly exclusive theatrical experiences for visitors and inhabitants. Sight, sound, touch, hearing, and even taste were manipulated to convey distinct meanings to different individuals. Movement was constructed and marked not only for humans (living and dead), but also for things, such as *huaca* and water.

These processional movements allowed for a "kinesthetic mapping of space."[93] For most travelers, the places created along roads conveyed messages about Inca conquest and possession, imperial oversight, boundaries, and sacredness. These markers redefined the landscape as Inca while also reminding visitors of their "outsider" status. By contrast, those select few who were able to get

Figure 2.30 | (*opposite above*) The bedding joints of the former Inca walls are still visible in the natural bedrock, revealing where masonry blocks had once been placed. Terraces on top of the stone were also built in this way, creating a miniature Inca built environment growing out of the natural stone. Photo by the author.

Figure 2.31 | (*opposite below*) Some of the original stone blocks that were used to form walls on top of Titicaca are still *in situ*. The one shown here belonged to a side wall that reached from the long hallway to the edge of the stone and helped to define a terrace on top of the outcrop. Photo by the author.

close to these constructed places witnessed the presence of important *apu*, sacred quarries, divine ancestors, and the authority of Topa Inca. These nuanced and highly localized architectural narratives communicated a deep interaction with the sacred landscape that would have been readily understood by the elite insiders.

But for the newly arriving visitors, this journey was just the beginning. Although the noble traveler from the Urubamba Valley and his retinue of family members, servants, and performers were about to achieve the goal of entering the heart of Chinchero, the main theatrical place lay ahead. Having endured hours of being directed by carefully designed Inca roads that controlled movement and evoked the senses, the visitor entered the focal point of the estate for the public, the main plaza. However, instead of finding an intimate or comfortable setting that marked the end of the exhausting journey, the traveler was flung suddenly into a place of vast openness, completely exposed. It is this enormous void that will be the subject of the next chapter.[94]

3 | PAMPA | PLAZA

After walking for hours along narrow Inca roads, all movements carefully controlled and confined, the visitor finally reached the heart of Topa Inca's estate. Stepping off a long, steep stairway, the traveler was suddenly standing in a vast space (figs. 3.1–3.2). An expansive view opened to reveal a large field framed by a distant mountain range. On a clear day, the impressive snow-capped peaks of *apu* Salcantay were visible. To the right, across the Chinchero Valley, lay an unmodified hill, and to the left, the only visible architecture. Walls of finely worked polygonal limestone blocks had been carefully positioned along two sides of the plaza, reminding visitors that this impressive natural setting was an Inca landscape. Punctuated by sacred mountains and Inca architecture, this im-

mense space served as the political, cultural, and religious stage for Topa Inca.

From *Pampa* to Plaza

What was this large, open space? Today, scholars refer to it as the "plaza," as it was the space in which important gatherings took place during imperial Inca times. But "plaza" comes from Spain and was used to refer to "place."[1] This definition does not tell us what the Inca thought of these areas. To understand what this space meant in Chinchero, we have to look at how the Inca defined such areas.

The Inca had several words for sizable open-

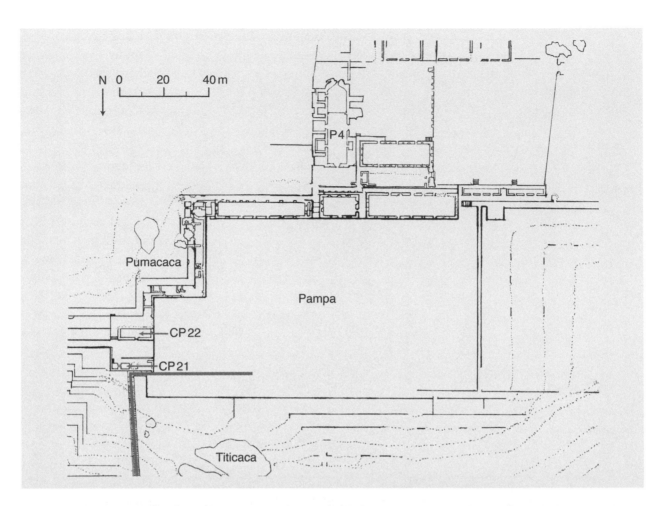

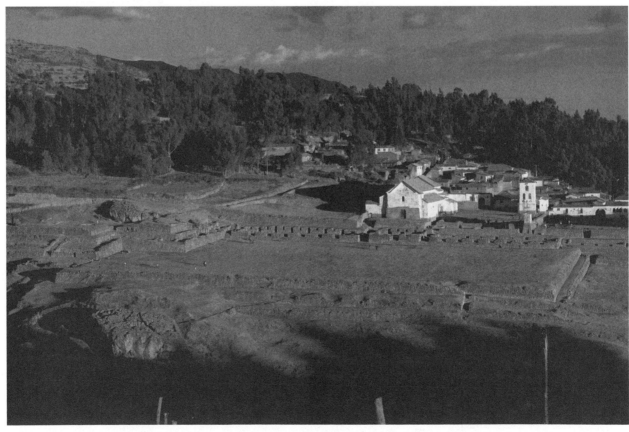

air spaces, because in the Andes they were as important as covered places (i.e., interior rooms), if not more so. Most of the Inca activities described in the colonial writings took place outside built structures, and the colonial author Garcilaso de la Vega writes that many buildings around plazas were erected for the event of inclement weather.[2] Scholarship on contemporary Andean practices has shown that open spaces are considered akin to interior spaces; they are conceptually distinct units in which specific activities took place. In other words, when we consider Inca exterior spaces they should not be viewed as an afterthought (secondary to interior space) but instead as a design priority.

In Quechua, large open spaces fell into one of three classifications: *cancha*, *pata*, or *pampa*. A *cancha* [*kancha*] was a physically bounded space (see fig. 1.14).[3] In rural contexts, it could take the form of a simple open space enclosed by a wall, like a corral. However, in urban centers it could also denote architectural compounds that contained both open spaces and buildings, usually a courtyard bounded by single-room structures and/or an enclosing wall. As discussed in Chapter 1, the number and arrangement of the buildings could take many forms, but the consistent features of the *cancha* were a central open space and exterior boundary wall (either complete or partial). In Inca settlements, individual *cancha* could comprise an entire city block and therefore delineate the urban grid.

By contrast, a *pata* was an open-air space defined not by walls, but by the relationship between horizontal and vertical space.[4] A *pata* was a single step (i.e., a vertical riser and a horizontal runner). A stairway was a *pata pata* ("many steps"), so the long, steep stairway at Chinchero was a *pata pata*. But *pata* is not just a step on a stairway; it is a spatial relationship that operates on multiple scales. A terrace, for example, is a *pata*, as is a small platform.[5] For the Inca, when these "steps" or "platforms" had their own distinct identity, they were given their own name. For example, in the previous chapter we discussed the Huancapata (the "*pata* of *huanca*"), which was a flat plane set into a terraced hillside on the road to Chinchero. This was not very different from the Cusipata (Kusipata) and Haucaypata (Hawkaypata), commonly referred to by scholars as the "dual plazas" of Cuzco. Set into the terraced terrain of the capital city, these open spaces were the center of many of the most important activities in Tahuantinsuyu.

While walls defined the *cancha* and steps defined the *pata*, openness seems to be the key feature of the *pampa*. The colonial dictionaries gloss the term as a "field."[6] Evidence suggests that these "fields" could vary greatly in size, from the intimate Huayllapampa ("savannah field") nestled in the Chinchero Valley, to the immense Pampa de Anta, which stretched for twenty kilometers west of Chinchero.[7] These large open spaces were not just rural phenomena; they were also important aspects of urban life.[8] An example is the Rimacpampa inside Cuzco. This open space in the urban center was located in one of the most sacred parts of the capital, where two rivers came together (known as a *tinkuy* in Quechua), and it was where many important Inca rituals took place. Like the *cancha* and the *pata*, the *pampa* was under-

Figure 3.1 | (*opposite above*) Plan showing how visitors entered the Pampa via the main staircase (*pata pata*). The staircase heads directly south before turning sharply west and entering the Pampa. Three buildings near the Pampa are indicated: CP21 (two-room, sunken structure) CP22 (Pumawasi), and P4. Also shown are a series of colonial walls making up the church (around P4) and the remains of small chambers on the eastern terraces. In addition, a small Imperial Inca water canal that runs west-east down the center of the *cancha* is indicated (to the east of the Pampa). Image by the author.

Figure 3.2 | (*opposite below*) View of the Pampa from the hill opposite Chinchero. The main entrance (recessed) is hidden and visitors are rendered minute by the immense space of the Pampa. Also visible is the colonial-period church built on top of the imperial Inca building P4. Photo by the author.

stood as spatially distinct, but it was defined by its openness.

What is interesting about these categories of open-air spaces is that location, size, use, or materials do not define them. A *cancha*, *pata*, or *pampa* can be rural or urban, small or large. No specific functions are attributed to them, nor are distinct materials assigned to them. Instead, each of the open-air areas is defined solely by its spatial relationships. A *cancha* is articulated by the relationship between negative and positive space, a *pata* is defined by the correlation between horizontal and vertical space, and a *pampa* is defined by its spatial liberation. Although this way of understanding space may make it difficult to label Inca open-air areas today, it highlights the priority the Inca placed on space, in particular the sophisticated ways in which they understood spatial relations.[9]

At Chinchero, the large open-air space that greeted travelers from the Urubamba Valley was not a *cancha*, but could have been either a *pata* or a *pampa*. It is part of a larger system of terraces (*pata*), yet its spatial quality is that of a singular open space (*pampa*). We cannot be sure which term was used during imperial Inca times, but residents have no problem proclaiming its identity today. The people of Chinchero call the large open space at the former Inca estate the Capillapampa ("fields of the church"), although records suggest it may have previously been called the Chukipampa ("field of the *chuki*, or Inca lance").[10] Hence, in this book we will refer to this space as the Pampa.

Activities

The Pampa at Chinchero is not unusual for Inca settlements.[11] Every Inca administrative center and most royal compounds had at least one designated open-air space in which religious and political activities could be performed. Throughout Tahuantinsuyu, these spaces and their related architecture were the stages upon which imperial Inca authority could be displayed and loyalty to the state dramatized. They were the theaters of communication between the state and local inhabitants.

These open-air spaces were of particular importance in Cuzco, where there were numerous *cancha*, *pata*, and *pampa* for imperial rituals and activities. For example, the most sacred architectural complex for Tahuantinsuyu was the Coricancha, or "Golden Enclosure," in Cuzco. Here, two adjacent open spaces were surrounded by single-room structures (many of which were encased in gold plates). These buildings were made of fine ashlar masonry and were used in the veneration of sacred natural forces, such as Inti (the sun) and Illapa (thunder). Only select elites could enter the *cancha*, making these bounded open-air spaces two of the most exclusive areas in the empire.[12]

As for the *pata* and the *pampa*, Cuzco had many, and the chronicles reveal the key role these spaces played in initiating young men into adulthood, ancestor worship, remembering history, sanctifying new rulers, and celebrating the religious calendar. For example, after the death and mourning of a deceased ruler, the new *sapa inca* was celebrated in a *pata* at the outskirts of town called the Hurincaypata (Hurinkaypata). All the elites and the heir apparent gathered in this open space at the edge of the capital. Sacred objects were placed in the *pata*, along with offerings such as fine textiles, metals, seashells, and feathers. Over two hundred children and a thousand llamas were also brought there to be sacrificed.[13] These sacrifices were then taken to other parts of Tahuantinsuyu where they became part of imperial Inca offerings sanctifying new lands.[14] Thus, the *pata* spatially inscribed the sacred authority of the ruler and his heir. Initiating the new *sapa inca* on the perimeter of the capital was a metaphor for the political entry of a new ruler on the imperial landscape.

These ceremonies marked not only important people and events, but also the calendar. In Cuzco, each month had its own religious feast with an accompanying set of performances in distinct open spaces. For example, in May religious ceremonies were celebrated in the Rimacpampa. According to Juan Diez de Betanzos, Inca noblemen came to the *pampa* "dressed in red tunics that reached

to their feet. [The *sapa inca*] ordered great sacrifices to the idols for this fiesta. They were to burn much livestock, food, and garments. And at these [*huaca*] they would make many offerings of jewels of gold and silver."[15] In this *pampa*, Inca noblemen ordered sacrifices and performed for the *sapa inca*. They then left their offerings at the *huaca*, using the *pampa* as a place to mark both the ritual calendar as well as their allegiance to the *sapa inca*.

Most of these performances were multisensory events that revolved around singing and dancing. For the Inca, song and dance were one and the same, referred to by the single word *taquis*.[16] The songs sung during these *taquis* were accompanied by musical instruments that included an array of drums (*huancar*), ranging from the very large to small, that were played by both men and women.[17] Along with these drums the Inca had the *huancar tinya* (tambourine), *quepa* (gourd trumpet), *antara* (short flute), *ayarichic* (serial, bonded flutes), and the *quenaquena* (cane flute), among others. In addition, the dancers wore instruments such as bells of different sizes, like the *zacapa* (made from beans) and *chanrara* (made from silver and copper).[18] Together, these instruments and voices created a dynamic and diverse aural array.

As for the dances, they were diverse, each with its own particular members, costumes, and movements. Sometimes the identities of the dancers were obscured, as in the *guacon*, a dance restricted to masked men who carried the dried remains of wild animals, and the *guayayturilla*, a dance of both men and women who painted their faces.[19] The forms these dances took also varied. In the *guayayturilla* the dancers moved in single file. By contrast, the *cachua* was performed in a circle, with men and women dancers linking hands. Dancers also carried very different objects to articulate the meaning of their performances. In the *haylli* men and women carried farming implements, the men with their *tacllas* (plows) and the women with their *atuna* (adzes). Who was chosen to perform these dances was often determined by the Inca state. For example, some dances were restricted to only the Inca. The number of performers could vary from several hundred, such as the *guayyaya*, to just a few, as when the *sapa inca* danced with two *palla* (noblewomen), a rhythmic dance with many turns and exchanges.[20] These complex songs and dances took place in the imperial theaters, the *cancha*, *pata*, and *pampa*, and all under the watchful eye of the Inca state.

In sum, the *cancha*, *pata*, and *pampa* were the loci of many aspects of life. They housed numerous and varied ritualized and quotidian activities that encompassed a range of people singing, dancing, playing instruments, and giving speeches. These multisensory political and religious ceremonies incorporated beautiful objects and decorated animals and often involved offerings or sacrifices. The activities that took place within them were connected to the ritual calendar (time) and a larger, sacred landscape (space), requiring the entrance, exit, and reentrance of various players and things. As a consequence, these open-air areas had to be designed to enable a variety of complex and highly regulated processions and rituals to take place within and outside them, while allowing an audience to gather around to observe and learn.

The Pampa at Chinchero

Unlike for Cuzco, we have no descriptions of distinct ceremonies occurring within any royal estate. Though no writings tell us what *specifically* happened in Chinchero's Pampa, we do have two avenues of assistance. First, by association we can *infer* what may have occurred. Because these retreats served as temporary capitals, elaborate ceremonies involving the *sapa inca* would have been performed at Chinchero when Topa Inca was in residence. Therefore, one day the Pampa might be filled with finely dressed dancers and skilled musicians performing for the ritual calendar, while the next day it would be teeming with decorated military officials, visiting dignitaries, or *panaca* members offering their allegiance to Topa Inca. In many of these events, the sacred *aka* (corn beer) would have been shared, offerings burned, and sacrifices made.

The second aid to understanding what ceremonies might have occurred in Chinchero's Pampa lies in the details of the built environment. While the large open spaces that served as imperial theaters may look simple, they were not. As stages for state ceremonies, they had to be carefully designed to suit all types of performances involving diverse participants and evoking all the senses.[21] Today, the subtle architectural gestures of Chinchero's Pampa hint at its spatial complexity and the important role Topa Inca played in this critical theater.

Setting the Stage

Understanding the Pampa as an open-air theater requires considering the multiple spaces involved in theatrical production.[22] Although the focal point for the audience is the stage, many other spaces are needed, particularly for events that must take place before a performance begins. The first type of space is one in which finishing adjustments to clothing and props can be made and where people can gather in group formations. In Cuzco, these activities happened in a complex network of streets and roads. Performers in the capital city would have been readying themselves at the same time that they were moving to the designated *pata* or *pampa*, using transition spaces as final preparation spaces.

Visitors to Chinchero would not have had access to multiple streets and roads to prepare themselves, because coordinating the performance at the Pampa also had unique security concerns. At the royal estate there was only one entrance point to the northern façade; this enabled the Inca to control the movement of visitors and keep them separate from the rest of the estate. While this single entrance was useful for security (and for constructing a particular experience for the visitor), the long, steep stairway did not allow groups of people to gather in complex formations. To provide a preparation area, the designers of Chinchero subtly massaged the vast space

of the Pampa to accommodate the needs of both theatrical production and state control.

A visitor stepping onto the Pampa did not actually walk into a singular space but, instead, onto a long, rectangular forecourt that, in turn, opened onto the main performance space This design gave the appearance of singular space while also providing a designated area for visitors to quickly gather in their formations and make any last-minute adjustments to clothing and props (fig. 3.3). A series of terraces provided a partial barrier, obscuring what occurred in this space from the view of the people gathered along the southeastern side of the Pampa. Through this subtle design maneuver, the architects of Chinchero created an important preparation space from which performances on the Pampa could begin.

Besides obscuring views, the terraces reinforced security by making it difficult to exit the Pampa. This is the second type of space that is critical for theatrical production. In most performances, it is important to regulate who can go backstage. The importance of this for Inca productions is underscored by the carefully controlled stairway upon which visitors entered the royal estate and the Pampa. In addition, at Chinchero security was created not only by this tightly controlled access point, but also through oversight in a small area that lay behind the Pampa's forecourt. The design of this *cancha* allowed for the control of visitors as they moved from the stairway into the forecourt, but it also enabled close monitoring *before* they reached the Pampa. This small space lay behind the preparation area for the Pampa and at the apex of the grand *pata pata*, providing a panoptic view of a traveler's final stage in reaching Chinchero (fig. 3.1). Despite its modest size, this space may have been critical to security.

Impressive terraces and two parallel buildings framed this *cancha*. The northern building (CP21) next to the long *pata pata* has three unusual features. First, it is set inside a terrace wall, effectively hiding the existence of a bottom floor (fig. 3.4). Second, entrance to the building was through an underground staircase that would

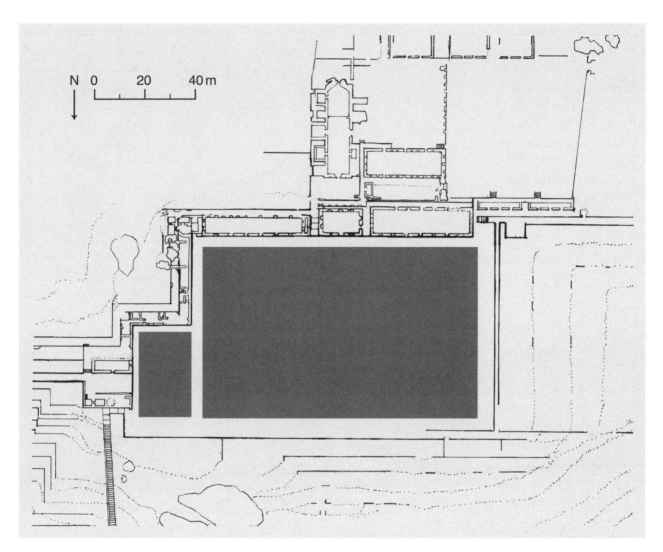

Figure 3.3 | Plan of the Pampa with two blocks indicating its distinct areas: (1) the small forecourt or arrival area, and (2) the large performance space. Image by the author.

not have been visible to anyone unless they were standing right next to it (fig. 3.5).[23] Third, the interior is not the standard single-space rectangular plan, but rather is made up of two distinct rooms joined by an interior doorway (fig. 3.6). These two basement rooms were capped by another floor, which had its own separate doorway.[24]

The result of this unusual design is that visitors walking up the staircase or standing in the Pampa would not have been aware of the basement and the building's additional capacity for a significant quantity of materials or people.[25] Nor would they have known how to enter the building, even if

they saw the structure from the Pampa. Martin de Murúa described the main public space of a royal Inca estate as having storehouses manned by guards and filled with armaments so that the *sapa inca* and his estate could be easily protected. If this structure at Chinchero also held weapons and was surrounded by guards, it would have provided multiple levels of security for the royal estate.

But this small area off of the Pampa's forecourt did more than provide oversight of (and perhaps additional types of security over) the estate's entrance; it also marked a sacred transition. Enclosed by buildings on two sides and a steep ter-

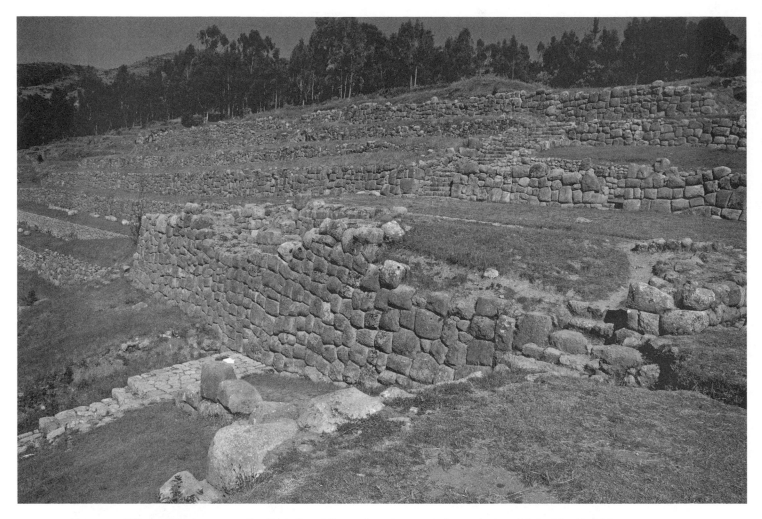

Figure 3.4 | View of the terrace wall, which faced the main entrance staircase (*pata pata*), inside of which is the basement level of CP21. Photo by the author.

race wall on a third, this *cancha* was bounded by a low-lying terrace wall and channel that opened to the Pampa's forecourt. This enclosure marked the separation between the Pampa and the terraces, serving as an important transitional space. For Inca performances, this would have been the third type of space critical to theatrical production.

This transitional space had sacred features. On the south side of this *cancha* is a finely made Inca building (CP22) that looks like many other elite Inca structures in its materials, construction, form, size, and layout (figs. 3.7–3.8). Yet this very unusual building transformed the surrounding space through a rare offering that was buried beneath its floor. Although the Inca often made offerings when laying an important building's foundations, this building's special and unique offering is a puma.

Figure 3.5 | (*opposite above*) View of the interior of CP21 (eastern room, south wall with staircase). The staircase begins at the edge of the interior wall and then extends back, beyond the footprint of the building, never rising above ground level (thus concealing the staircase from afar). Photo by the author.

Figure 3.6 | (*opposite below*) Interior of CP21 showing the two small rooms, dividing wall, and interior doorway. Photo by the author.

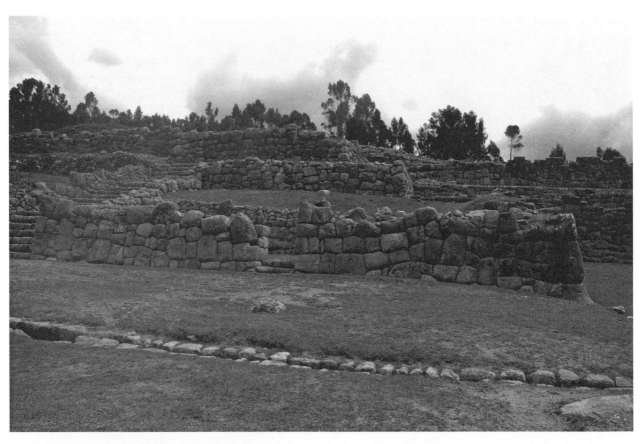

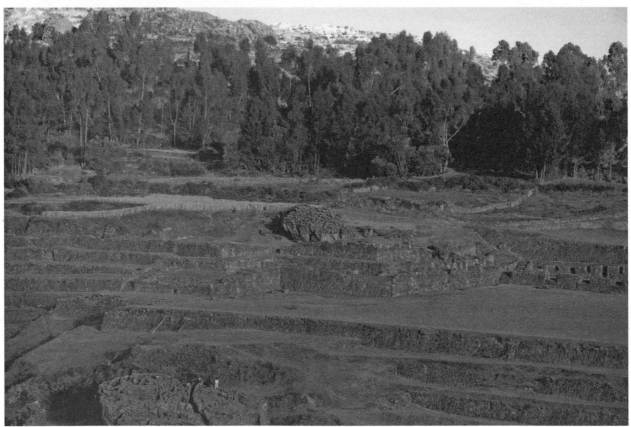

The puma was the symbol for Inca elite men, particularly for the *sapa inca*, suggesting a close association between Topa Inca and the Pumawasi (*puma uasi*, "Puma's House"), as it is called by residents today. Locating sacred spaces near important entrances would not have been unusual for the Inca. For example, before anyone was allowed to set foot inside the sacred Inca capital, they had to remove their shoes and undergo a series of rituals. These purification rituals also took place at the entrance to sacrosanct spaces such as the enclosures of the Coricancha. It is therefore possible that people had to undergo similar rituals when they entered the main open spaces of royal estates, as these, too, were considered sacred precincts. At Chinchero, the Pumawasi would have been perfectly situated to allow oversight of ritual purification ceremonies for arriving visitors. Serving this function, the building would have been associated with the last spatial stage for most people making the journey to (and through) the sanctified center of Topa Inca's royal retreat.[26] The structure may have also been associated with rituals conducted on the Pampa, thus facilitating the next stage in the visitor's journey to the Pampa.[27]

An example of the type of large-scale performance that may have occurred on the Pampa is what the Spanish called a victory *cantar*. We have a description of one that occurred in Cuzco for Pachacuti. Here, one of the main *pata* was filled with flowers and birds. Inca noblemen and local indigenous leaders, followed by Inca noblewomen and local leaders' wives, marched in a procession into the colorful open space. To the beats of four large drums, these elites joined hands and sang the exploits of Pachacuti over the Chanca. After taking a break to drink and eat the fine things provided by the Inca, these elites performed again. This reportedly went on for six days.[28] If victory *cantares* took place at Chinchero, then a large contingent of elite men and women proceeded up the long *pata pata*, stopping briefly in the forecourt to arrange themselves before making their grand entrance for Topa Inca in the immense Pampa. Filled with colorful flowers, birds, and the sounds of large drums and song, the Pampa would have been transformed from a vast empty space marked by Inca architecture and sacred mountain peaks to a dynamic imperial stage filled with elite, finely adorned actors singing and dancing for Topa Inca.

Architectural gestures to control movement at the Pampa's entrance reveal the ways that the Inca sparingly, but effectively, used architecture to mark increasingly exclusive spatial transitions. First, in order to regulate access to Chinchero's imperial theater, the Inca devised a final "checkpoint." Anyone not granted official permission to enter this space could be easily removed. Second, in order to signify that visitors were about to enter Topa Inca's sacred theater, the designers of Chinchero consecrated a building with a puma, a potent reference to the divine rights of the *sapa inca*. Third, to allow the sanctioned visitors to prepare for their performance on the Pampa, a staging area was provided. In a narrow space and without many buildings, the Inca were able to design a fully functional, highly secure, and meaningful entrance to Topa Inca's impressive theater.

Figure 3.7 | (*opposite above*) View of the north façade of the Pumawasi (*puma uasi*) building (CP22). Photo by the author.

Figure 3.8 | (*opposite below*) View of the eastern side of the Pampa with terraces (and Pumacaca outcrop). Note how both CP21 (with its concealed basement) and CP22 (Pumawasi) do not appear as distinct buildings, but instead as parts of a series of terrace walls. During imperial Inca times, these buildings would have been completed with finished walls and roofs; thus they would have dramatically stood out. Yet the ways in which the foundations and lower walls of these structures merge with the surrounding terracing reveals the integrated ways in which the Inca approached building and landscape modification. It is also a reminder that one cannot discuss terrace walls as inherently different from building walls, as one often emerged directly out of the other. Photo by the author.

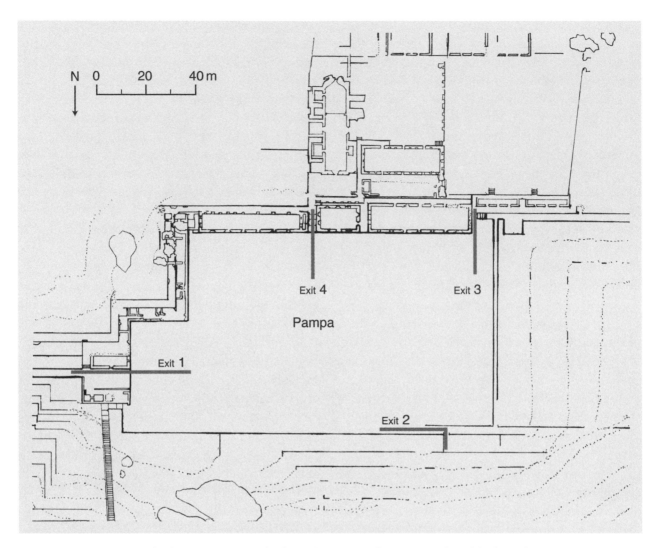

Figure 3.9 | Plan showing the four secondary exits from the Pampa. They are numbered in the order of their discussion in the text. Both imperial Inca and colonial architecture is drawn. Image by the author.

Exiting (and Reentering) the Stage

For the numerous types of rituals and ceremonies that could have occurred in the Pampa, the imperial stage had to be designed to service a variety of users and performances. Most visitors entered the Pampa before a ceremony began and then left the royal estate when their participation was complete, but other individuals needed to enter, exit, and *reenter* the Pampa during rituals (some multiple times). This is typical of any complex performance, where actors leave and return to the stage according to specific scenes. Thus, the fourth and

final type of space that was needed in Inca theatrical performances was the entrance to (and exit from) the stage (fig. 3.9).

This repeated movement required specific access points, and because visitors' movements were strictly controlled and monitored, these points needed to be inaccessible (or at least seem that way) to the majority of visitors on the Pampa. Clues to the identity of these privileged people—what rituals they may have participated in and where they went when they left (and later reentered) the Pampa's stage can be found in the physical remains at the site. Specifically, there

are four access points that wrap counterclockwise around the Pampa, starting at the forecourt. The first lies right next door to the Pumawasi.

Exit One: Procession of the Royal Ancestors

The first exit would not have been open to most people. To begin with, the majority of the visitors arriving up the long *pata pata* probably would not have noticed it, because the access point lay beyond a short wall, directly behind arriving visitors (who were facing the expansive performance space and impressive sacred mountains). The few visitors who did spot the access point would have also observed that it was hard to reach, situated in

the secure *cancha* containing the sanctified Pumawasi building.

Beyond the partially hidden and well-monitored access point awaited an exclusive sacred landscape. Articulated with finely made polygonal limestone terraces, this pathway was wide enough to carry several people abreast and offered sweeping views down the Chinchero Valley (figs. 3.10–3.11). It also led directly to the sizable *pata* on which sat the two Condorcaca stones (fig. 3.12). From here, one could proceed down the impressive staircase that led to the Chinkana area, with its many sacred stones, cave, and watercourses (fig. 2.15). The small, select group of people (such as religious specialists and Topa Inca) who

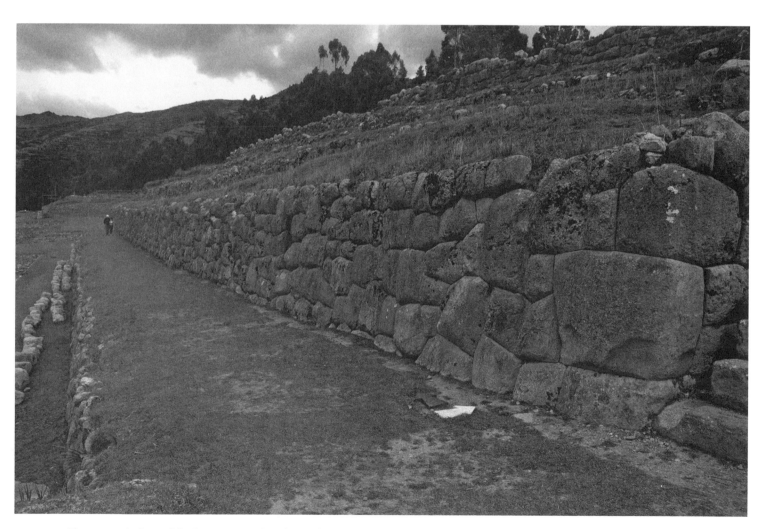

Figure 3.10 | View of the long terraced pathway from the *cancha* to the Condorcaca and Chinkana stones. Photo by the author.

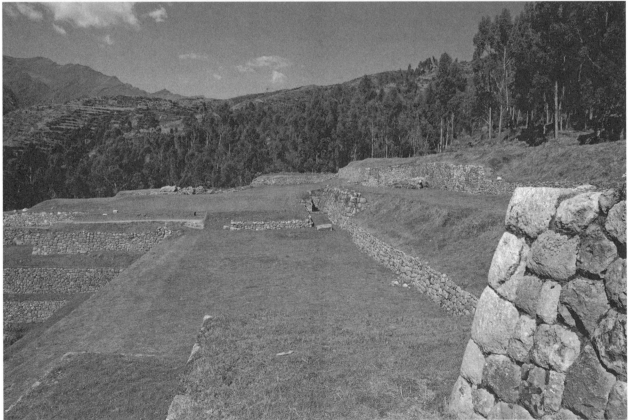

had access to these outcrops would have walked down this pathway during rituals on the Pampa.

This movement between the Pampa and an outlying sacred area was typical for the Inca and can be seen in Betanzos's earlier quote. He described how sacrifices made in Cuzco's Hurincaypata were taken out of the *pata* and offered to *huaca* in the surrounding landscape. Bernabé Cobo also describes several such scenes, where sacrifices made in Cuzco were carried out afterward and offered to specific *huaca*.[29] At Chinchero, an elite person would have been able to sacrifice textiles or llamas in the Pampa and then carry them down to one of the stone *huaca* to be left as an offering. This made the Pampa not a final, confined theater for the elites but, instead, a central performative node in a larger, dynamic landscape. It is also an example of how *pacha* allowed for the successful motion of the Inca world. As Frank Salomon has noted, in the Andes "ritual and sacrifice is to ensure a steady circulation of biological energy through *pacha* by conducting social exchange amongst its living parts."[30]

While Topa Inca and his religious specialists were the select few who would have had access to Chinkana and Condorcaca, ancestral mummies may have also been important participants in this processional route (fig. 3.13). For the Inca, these ancestral mummies (*mallqui*) were not simply the remains of deceased family members but, instead, were valued members of society who were venerated and consulted on important matters.[31] As we shall see, these mummies did not stay in one place, but also traveled to and within Chinchero, becoming active in imperial place-making practices.

One place many would have visited (and even stayed) was Chinkana. Caves were often considered places of origin in the Andes and associated with mummies. Thus, visiting *mallqui* could have moved from the Pampa to the cave in Chinkana and back again. If undertaken, this ritualized pilgrimage would have been a defined journey with specific, meaningful pauses along the way. For example, after making offerings below the cave of Chinkana, near the rustling stream and sacred carvings, the *mallqui* and their attendants would have been carried to Condorcaca, with its carvings of a puma (*sapa inca*) and condor (divine ancestors), before coming to a building containing the physical remains of a puma (Pumawasi). From there, the *mallqui* would have traveled to the Pampa, in full view of Topa Inca, who (as we shall see later) sat next to two carvings of puma.

The processional route from Chinkana to the Pampa tied Chinchero's royal patron with the divine ancestors and the sacred landscape. Once on the Pampa, ceremonial performances would have further reiterated the close ties between Topa Inca and the Inca royal families. Whether or not they visited Chinkana, the *mallqui* who came to Chinchero would have arrived on the Pampa surrounded by their attendants and family members. They would have proceeded across the vast space and then been seated next to each other according to hierarchy. During these ceremonies, fine food and drink would have been brought out as offerings to the *mallqui*. After being placed before the mummified ancestors, the food would have been burned in a fire (whose wood was selectively harvested and carved before being placed in the pyre), and the drinks would have been poured upon a sacred stone.

The veneration of ancestors was crucial to Inca society. In the words of Susan Niles, "the prestige of the living was directly related to the reputation

Figure 3.11 | (*opposite above*) The path from the Pampa to Condorcaca lies to the far right of the photograph, above the wall with the loose stones. Although this pathway and the terraces above it are original, several of the terraces below have recently been "reconstructed" (i.e., they are new terraces). The new terraces are distinct in their light color and very rectilinear forms. Photo by the author.

Figure 3.12 | (*opposite below*) View of the two Condorcaca stones from the terraced pathway. Photo by the author.

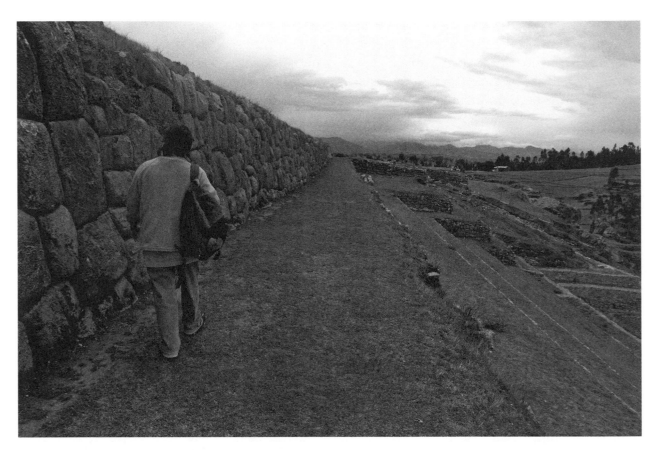

Figure 3.13 | View of the terrace pathway from the Condorcaca outcrop to the *cancha* (and Pampa). The Pumawasi building (CP22) lies directly ahead, yet is not easily recognizable because its northern façade is flush with the left terrace wall. Another building, CP21, is also not easily seen, as its northern and eastern walls appear as terrace walls to the right of the pathway. Photo by the author.

of the dead."[32] These *mallqui* would have been consulted on important matters. Each mummy had a special assistant; thus, every action of the *mallqui* was carried out with the aid of a royal attendant. These attendants held powerful positions and often came from the most prominent Inca families.[33] By integrating the movement of these important relatives (dead and alive) within his estate, Topa Inca was demonstrating his close allegiances with these powerful family members.

However, this may not have been the only reason so much attention was given to this high-status processional route. After Topa Inca died, he too would have been transformed into a *mallqui*, one of the divine ancestors, and his journeys to and around specific parts of Chinchero, such as between Chinkana, Condorcaca, and the Pampa, would have been more frequent. The iconography, which venerated both *mallqui* and *sapa inca*, would no longer have referenced two groups of pilgrims, but one and the same. By constructing such an important sacred processional route that connected himself to the divine ancestors, Topa Inca was not only creating a way to honor his family members, but he was also designing a potent journey for his next stage of existence. After a lifetime spent in battle, Topa Inca was not surrendering to death, but laying the foundations for his venerated future.

Exit Two: The Architectural Illusion
of Royal Excursions

The other major stone *huaca* at Chinchero, Titicaca, was not part of this journey. Perhaps this is because it lay on the other side of the arrival stairway, and

crossing this *pata pata* would have interfered with tight control of newly arriving visitors. Nevertheless, Titicaca was also connected to the Pampa via the second exit from the public stage. Unlike the first access point nestled behind the visitor within a cluster of architecture, this second exit lay directly ahead, within the vast expanse of landscape views. Despite (or perhaps because of) its prime location, it, too, was largely invisible to arriving visitors. It lay tucked beneath the northern boundary of the Pampa and descended to the next terrace level. From there it was only a short but well-protected walk along the pathway to Titicaca.

Although there are no security buildings to control this exit from the Pampa, the Inca used two strategies to mask its existence.[34] First, no physical evidence of Titicaca's access point is visible to people standing on the Pampa (fig. 3.14); the entire narrow staircase lies below ground level (figs. 3.2, 3.9). Second, perspective was used to shield the staircase's presence from visitors coming up the main *pata pata*. Specifically, the Titicaca staircase is slipped inside the end of a long, receding perspective line. These design gestures are so effective that, unless one is on the edge of the long *pata pata* looking down the terrace wall or on the Pampa no more than a few feet from the small staircase, the access point to Titicaca is not visible.

These design strategies suggest that only a few knowledgeable people were intended to use this approach to Titicaca. Like the other two stone *huaca*, Titicaca was a rarified landscape that few people could experience. It did not have a cave, but it was augmented with fine polygonal walls that created twisting hallways and curving agricultural terraces—a sinuous microcosm of an Inca landscape. Although it did not have any carvings of puma or condor, this stone outcrop did have a

Figure 3.14 | The view of the Pampa as seen from the *cancha*. Note that the location of the second exit from the Pampa, which lies in the far northwest corner, is invisible to the untrained eye. Photo by the author.

carving of a serpent. The Inca venerated snakes: according to Cobo, the Inca named a constellation for serpents and used them as weapons, and the people of Chinchasuyu, where Chinchero lay, raised snakes for *huaca*. In Cuzco, three metallic snakes had their own shrine, lands, and attendants who cared for them and offered them sacrifices.[35]

Although we cannot say specifically what type of activity was carried out here, its architectural details suggest that it was an intimate yet controlled, ritualized setting for a small collection of people. Access to Titicaca would have remained obscured for most participants on the Pampa, but Topa Inca (living or dead), religious specialists, and other select elites could have moved with ease along the fine, secluded pathway that linked the grand spaces of the Pampa to the intimacy of Titicaca's lithic landscape. Although the majority of visitors who performed in the Pampa experienced the space as a bounded stage, select elites taking part in Chinchero's public rituals understood the Pampa as an extended space with many avenues for movement and connections to other ritual stages.

This second access point highlights an important spatial strategy that the Inca used to convey hierarchy in their performance spaces, specifically the articulation of familiarity and strangeness. Select elites would have known where the exit was and would have been comfortable as they moved about the Pampa during ceremonies. By contrast, the majority of visitors to Chinchero would have been unable to perceive this exit and therefore would likely have been surprised and perhaps bewildered to observe people disappear off the edge of the Pampa, only to reappear later. This access point ritually connected a sacred *huaca* to the Pampa but did so in a way that created very different spatial experiences depending on one's status and knowledge.[36]

Exit Three: Private Life and the Everyday

Because of the important role of Topa Inca and other elites in the Pampa ceremonies, it is not sur-

prising that a third access point allowed movement between the Pampa and the most private sector of the royal estate—Topa Inca's residential quarters. Situated at the far southwestern corner of the Pampa, this exit/entrance appears as a small opening next to the furthest building on the Pampa (figs. 3.9, 3.15). For the majority of visitors to Chinchero, this likely seemed to be an innocuous, dead-end space, if it was noticed at all. But for people "in the know," it was the opening for an extremely privileged experience.[37]

Archaeological studies and early colonial writings indicate that the relationship between the large public space of the Pampa and the smaller (very exclusive) private space of the residence was typical of many Inca royal estates. For example, at another (unnamed) royal estate, Murúa described a large open-air space through which one passed to reach the second, smaller open-air space. While most visitors could enter the first space, Murúa wrote that only the ruler, his family, and a few select associates could enter the second sector, which housed the ruler's private quarters with its heavily guarded entrance. Also at Chinchero, only select elites, such as those who had special access to the sacred stone outcrops connected to Chinchero's Pampa, would have also had access to the pathway leading to Topa Inca's private quarters.

This pathway had both formal and quotidian uses. During special rituals, most visitors would have filed down the long *pata pata* to leave Chinchero when ceremonies had concluded. This would have left the privileged few, who would have proceeded off to the private sector of the estate, staying as guests in Topa Inca's retreat. However, on most days when the ruler and his family were in residence, Topa Inca, Chequi Ocllo, and Capac Huari (along with their attendants) would have traversed the Pampa as part of their return to their private quarters—transforming the ceremonial space of the Pampa into transitional space.

This third access point highlights another important aspect of Inca spatial practices—that of the everyday. Scholars usually define the large open-air spaces in Inca settlements according to the extraordinary activities that took place upon

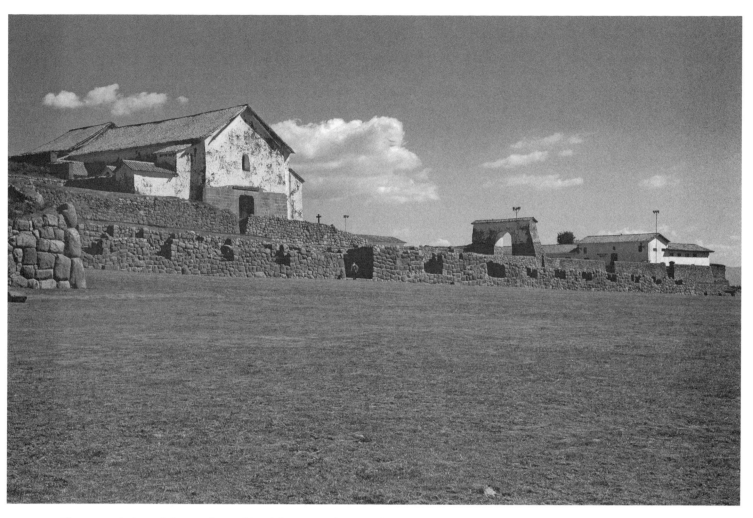

Figure 3.15 | View of the southern side of the Pampa (as seen from the arrival forecourt). The third exit (to the private sector of the estate) is located on the far right, behind the long row of buildings. This hidden entrance is in contrast to the very noticeable large opening in the façade, which is the fourth and final exit point from the Pampa. Photo by the author.

them. Yet, many of these spaces also contained the more mundane, oft-repeated practices. And it is in these habitual, everyday activities that space inscribes itself on the body in an unconscious fashion. David Seamon describes this as a "place-ballet," such that these repeated, familiar body experiences create a sense of belonging.[38] Thus, while the Pampa may have been a place of imperial spectacles that celebrated the authority of the *sapa inca*, for Topa Inca, Mama Chequi Ocllo, Capac Huari, and elite servants, strolling across the Pampa was an important part of the everyday rituals that made Chinchero their home.

Exit Four: The Coveted Stairway and Its Architectural Theatrics

The fourth and final access point on the Pampa was strikingly different from all the others. The three exit/entrance points we have discussed so far would have been beyond the knowledge or reach of most people making the journey to Chinchero; the fourth would not. Located in the middle of the architectural borders of the Pampa, a wide stairway leading directly to the Pampa would have been visible to everyone in the large open theater (fig. 3.16). Today, this entry creates a striking void

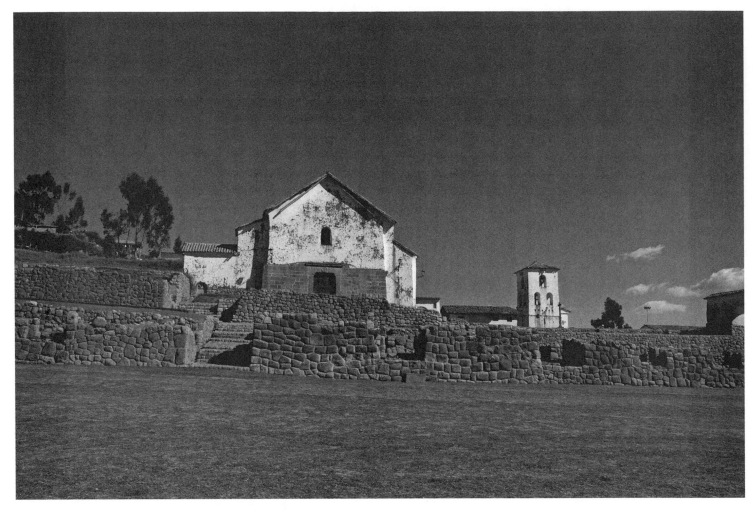

Figure 3.16 | View of the central portion of the Pampa's south wall. Easily recognizable is the (recently reconstructed) central staircase, which would have been the only exit clearly visible to visitors during imperial Inca times. Photo by the author.

in the mass of stone terraces and buildings. During imperial Inca times, this stairway would have been a central focus of Pampa performances.

Bounded laterally by two impressive Inca buildings and framed above by the highest structure at the royal estate, the wide, gently rising stairway became even more prominent to the visitor moving across the Pampa. For most visitors to Chinchero, this stairway offered the only option for leaving the confines of the Pampa to meet with Topa Inca or his emissaries. Whoever was granted this access would have been on full display to everyone on the Pampa; the stairway was an exit, but it was also a highly visible stage.

Part of the reason this stairway is such a key

theatrical component of the Pampa is the visual importance given to the Inca buildings that frame it. During imperial Inca ceremonies, these structures served as the architectural façade for all the performances on the Pampa, visually signifying Topa Inca's power and authority (these buildings will be discussed in the next two chapters). For this reason Chinchero's designers took extra steps to ensure that the buildings appeared impressive to the performers on the Pampa. Great care was always taken when constructing fine Inca building for the *sapa inca*, but in the case of Chinchero, even more attention than normal was needed. The vastness of the Pampa's open space would have dwarfed most elite Inca structures, render-

ing the lithic symbols of Topa Inca as small and insignificant. In order to aggrandize the Pampa buildings, the Inca had to devise three architectural strategies.

First, they used the same materials and construction across all the architecture to give the impression that these distinct structures were one large, unified whole. They built all the terraces and buildings of limestone shaped into polygonal masonry with seamless facture (no construction seams). This is true not only for the structures that physically bordered the Pampa, but also for the terraces located behind it. These secondary terraces continue the theme of unity and give architectural depth (and thus visual weight) to this side of the Pampa. The lack of construction seams also reveals that the architectural corpus of the Pampa was planned as a unit; it was not the result of growth over time through later additions.

Second, the foundations of structures were manipulated to increase the apparent height of buildings for a more impressive visual impact. Specifically, buildings were constructed on top of terraces, so that the buildings' floors sat well above the Pampa. People on the Pampa would have no idea that the buildings were erected upon a raised platform; there were no seams to betray the construction. This gave the impression from the outside that the buildings were twice as tall as they actually were.[39]

The illusion of size was heightened by the third strategy, which involved artfully handling the scale of architectural elements: for example, windows in the buildings were constructed at twice to three times their normal size. These enormous openings reached to the interior floor of the massive buildings, yet from the Pampa, they appeared as normally proportioned windows in normally proportioned Inca structures. These design and construction strategies gave Topa Inca's buildings a great presence on the Pampa, despite the vastness of the open space.

Not only did this architectural illusion solve an immediate design problem, but it also created a distinct perceptual experience that can still be felt today. For a contemporary visitor standing on the Pampa, the buildings appear much closer than they actually are because of the difference between their apparent and actual size. As one walks toward the buildings (and the celebrated fourth access point), time and space seem to stretch out considerably, a disorienting experience that seems to leave the Inca structures majestically beyond reach. One can imagine how this mystifying effect must have been compounded during imperial Inca performances, when there were multiple movements occurring at the same time. For the lucky few allowed to enter Topa Inca's stairway, the walk to the access point would have been an unexpectedly drawn-out procession. This manipulation of body-place relationships would have reinforced the message that Topa Inca, the sacred ruler of Tahuantinsuyu, controlled both time and space.[40]

This manipulation of movement in space was not unusual for the Inca, as it was also manifested in the Inca dance called the *guayyaya*. Participants entered the *pata* or *pampa* carrying their royal standards along with that of the *sapa inca* (which was called the royal *champi*). A non-Inca man carried a large drum, which was beaten by a woman, setting the rhythm in which the dancers moved. Cobo described the *guayyaya* as a very dignified and solemn dance undertaken in large numbers (two to three hundred people). The royal participants formed a line, and, with joined hands, they slowly approached their leader in a back-and-forth motion. According to Cobo,

> They start this dance at a distance from the [*sapa*] Inca or the cacique who was presiding over it, and they all began together by taking their steps in time with the music, one step backwards and two steps forward, and in this way, they progressed forward until reaching the Inca. Sometimes, on very solemn occasions, the Inca himself took part in these dances.[41]

This rhythmic back-and-forth motion would have magnified the spatial experience of Chinchero's Pampa, such that people walking toward Topa Inca's architecture would have had the same experience of moving steadily toward the royal

stage, yet finding the goal remaining stubbornly out of reach. Given that this dance was performed only for a leader such as the *sapa inca* and could be danced only by *panaca* members, it is likely that it was performed at Chinchero, and since the focus of Chinchero's design was directed at these same elites, this special type of moment may have directly influenced the Pampa's design.

The architectural manipulation of the Pampa's spatial experience also highlights Inca awareness and manipulation of scale in their material world. On the one hand, we see the use of scale to proclaim value. This ranged from the potency of the miniature in the multicolored, minipolygonal wall at Cuper Bajo, to the power of the immense, in the grand outcrop of Huancapata and its impressive *pata*. On the other hand, we see how the use of scale of building heights and openings created an illusion of size and distance that was disorienting to people moving through the Pampa.[42] The manipulation of scale has a long history in the material cultures of the Andes, so it is not unusual that the Inca incorporated this practice into their architecture, not only to convey meaning, but also to define the experience of place.

Pampa as Stage

Niles has noted that "the remembrance of history was central to Inca royal politic" and "events believed to be historical were commemorated in the built and imagined landscape . . . and reenacted in the rituals that took place in these spaces."[43] Open-air spaces were critical aspects of the Inca landscape and they were used by the state to articulate its needs to large gatherings of people. However, these areas were not simple, generic spaces upon which the Inca enacted their authority. Instead, they were complex, carefully designed theaters that enabled intricate imperial performances. Like many imperial spaces in other parts of the world, such as the Diwan-i-aam (Hall of Public Audience) and the courtyard of the Mughals (South Asia), the Pampa at Chinchero was a large, judiciously planned space in which the ruler could

greet visitors. In this regal theater, the immediate and adjacent landscape (natural and man-made) was manipulated to choreograph the movement of the varied participants.

For the visitor to Topa Inca's estate, the "open" space of the Pampa was not free flowing, but rather an autocratic theater that attempted to control the visitor's experience and create hierarchies among participants. These visitors consisted of a range of people, from powerful Inca noblemen and their families to visiting dignitaries, servants, and performers. The Pampa was designed to address these differences, such that status determined the experience of the place. Insider status was defined by one's spatial knowledge and mobility, while outsider status was registered by ignorance of place and prohibition of movement. Hidden access points created layers of exclusions that fostered perceptions of familiarity and strangeness. Impressive Inca buildings distorted perceptions of the body with regard to time and space, thus constructing experiences that viscerally registered the profound authority of Topa Inca, whether living or dead.

While these grand theatrics can be understood in terms of the needs of a living ruler and the pomp and circumstance that came with his rule, the design of Chinchero was likely planned with a keen eye for the future. First was the issue of Topa Inca's life as a *mallqui*. Even after death, Chinchero would have continued to serve as his home, so the journeys made during his lifetime would have been repeated after his death. Topa Inca would have held ceremonies on the Pampa, been fed and venerated, and traveled when necessary. However, his new status as *mallqui* would have given a more prominent role to divine ancestors at the estate, one that the designers of Chinchero seem to have actively embraced. In both life and death, the design of Chinchero celebrated and aggrandized the authority of Topa Inca.

Second was the issue of succession. Inca rulers did not practice primogeniture. Although it was often stated that they chose only the sons from their primary wife, this was in reality not always the case. The colonial sources are filled with

stories of one heir being replaced by another after their military skills had been tested, and they note challenged successions filled with intrigue and conflict.[44] It is perhaps to avoid such future turmoil that particular attention was given to Chinchero's impressive reception space, for it was here that Topa Inca's power could be performed and his preferences made apparent. During cere-monies on the Pampa, the important status of the favored son Capac Huari could be conveyed to the visitor, boldly proclaiming the future of Inca rule. As we shall see in the next chapter, this procla-mation of the ruler's desires for the future did not take place exclusively *in* the Pampa, but also along its architectural periphery.

4 | *PUNCU* | DOORWAY

A collection of dark limestone walls defines the Pampa on two sides. Today, this architecturally dense area stands in sharp contrast to the open space of the Pampa. However, during imperial Inca times this strict division would not have been experienced as absolute. Instead, there would have been carefully controlled exchanges between these two areas. Through a creative use of viewing spaces and openings such as *puncu*—doorways[1]—Inca designers constructed dynamic stages and frames for movement within the architectural border. The viewing platform, *cuyusmanco*, and *carpa uasi* are examples of this. At Chinchero, this spatial spotlighting was done in order to aggrandize the actions and prestige of the royal patron while conveying his preferences and visions for the future. Thus, while Topa Inca and his se-

lect guests occupied the perimeter, observing performers in the Pampa, the large gathering of actors, in turn, watched the *sapa inca* enact his own theater.

Viewing Platforms

The most open structure (and most obvious stage) set within the dense Pampa façade was the viewing platform. It was also the space that Topa Inca would have occupied most often. Sometimes visitors could watch Topa Inca walk across the Pampa, make sacrifices to the *apu* (sacred mountain peaks) and carry these valued offerings to nearby *huaca*. However, these royal acts in the Pampa would have been special, as most of the

time Topa Inca would have sat upon the platform located on the boundary of the Pampa, observing visitors performing below.

Viewing platforms from which the *sapa inca* could watch events were ubiquitous across Tahuantinsuyu. Although they could be found in a great diversity of site types, these viewing platforms were almost always located at the center or the side of large open spaces so that the ruler had a clear view of events taking place in the *pampa* or *pata*.[2] These platforms could be single- or multi-tiered, but their defining features were their openness for unobstructed viewing.[3] On the one hand, these platforms signified the ruler's central role as audience to see all the important public events in Tahuantinsuyu. He was the figure for whom all performances were given, whether he physically appeared or not. When the ruler was not in attendance, these platforms would have stood as stone manifestations of his presence, reminding imperial subjects of his power and authority. On the other hand, the viewing platforms also allowed the *sapa inca* to be seen. They were exclusive stages, making the *sapa inca* the main actor as well as the main audience.

We can see these two functions of the platform in an early colonial description concerning Topa Inca's son Huayna Capac, who decided to make an appearance in the towns near Cuzco. Like any actor who takes his craft seriously, Huayna Capac made sure he had the perfect costume, brought the necessary props, and had the dates of his performance officially announced. According to Juan Diez de Betanzos, Huayna Capac ordered that his subjects be notified of his impending visit and gifts be gathered so that he could distribute them later to the residents. He mandated that a collection of local clothing be made for him and that each of these outfits be ready at the outskirts of their respective towns. Betanzos writes that when Huayna Capac put on these clothes, he "looked like a native of that province."[4]

Once he was outfitted in the local dress, a long performance began—one that was carefully choreographed—with speeches, drinking, and offerings. Huayna Capac participated as both audience member and main protagonist in this imperial performance:

[Huayna Capac] entered the most important town, where they had in that plaza a certain seat that resembled a high platform and in the middle of the platform, a basin full of stones. On reaching the town, the Inca climbed up on that platform and sat there on his chair. From there he could see everyone in the plaza, and they could see him. They brought out before him many lambs whose throats they slit in his presence, and they offered them to him. Then they poured out much [*aka*] into that basin which was there for sacrifices. The Inca drank with them and they with him. Then he came down from there, danced and sang with them, clasping their hands, joining to make a circle, and he ate with them. After this, he gave them what he brought and did them favors. Then he ordered them to bring him an account of the number of widows and orphans.[5] He wanted them and also the poor people brought out before him. . . . For the ones reported to be poor, the Inca gave provision from the storehouses. . . . Thus they did not live in want because the orphans as well as the widows and the rest were given enough to live on from then on without want.[6]

Perched on his platform in the town's *pampa* or *pata*, Huayna Capac gave a masterful performance of his regal magnificence. By skillfully managing space, action, and objects, he created a distinct message.[7] As a man of the people, he joined in the dance; as a benevolent emperor, he gave to the poor; as a powerful ruler, he watched as the town sacrificed and celebrated his presence. To articulate his munificent message, by wearing local clothing, the *sapa inca* took advantage of a long-standing Pan-Andean tradition in which textiles were highly valued and revealed identity.[8]

In this example related by Betanzos, the performance took place on (and between) two stages; the central stage of the viewing platform (in this case, an *usnu*) and the large open space of the *pampa/pata*. In local towns throughout the empire, these two stages were the spaces in which imperial relations with individual communities were

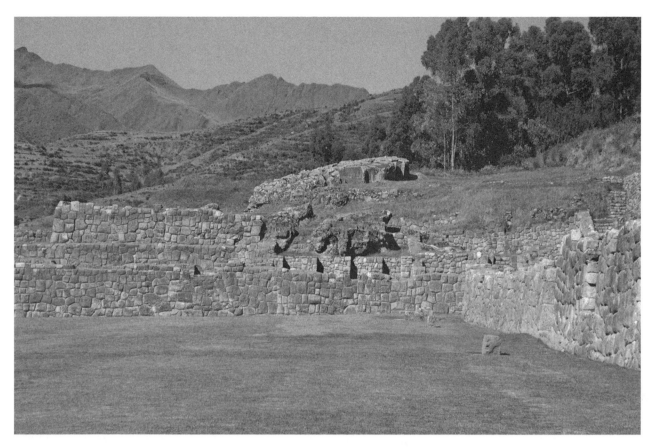

Figure 4.1 | Nestled in the terrace walls is the collection of outcrops that make up Pumacaca. This *huaca* has three lithic components: (1) the stone in the terraces that served as the viewing platform, (2) the large rock above that covers part of the hilltop, and (3) a collection of small stones set between the other two. Photo by the author.

mediated. In the case of the royal estate of Chinchero, the primary relations being mediated were between Topa Inca and the powerful Inca nobles. While these interactions would have normally revolved around myriad political, religious, and state concerns, the remains of the viewing platform suggest that one issue in particular was utmost on Topa Inca's mind. The choice of his son Capac Huari as heir apparent seems to have taken center stage.

A Special Stage

At Chinchero, Topa Inca had a finely crafted viewing platform. Located on the eastern side of the Pampa is a large outcrop that seems to burst out of a terrace wall. It is perfectly located for comfort (shelter from winds), access (next to the most

important imperial buildings), and visibility (unobstructed views of the *apu* and Pampa). In other words, the location of the viewing platform makes it the best seat in the house. The stone platform has been altered to suit the royal needs. It is multi-tiered, but its floors have been flattened and finely worked, while the sides have a coarse surface. This stone is one of several that are collectively called Pumacaca ("crag of the puma").[9] One is very large, has geometric cuts along its side, and is the highest and furthest from the Pampa. Another is rather small, with geometric "seats" carved into it (fig. 2.15). Together, these stones make up the fourth and final sacred outcrop on Chinchero's northern façade (figs. 4.1–4.2).

The lowest stone, emerging out of the terrace, was Topa Inca's viewing platform. Portions appear to have been left natural, while others were

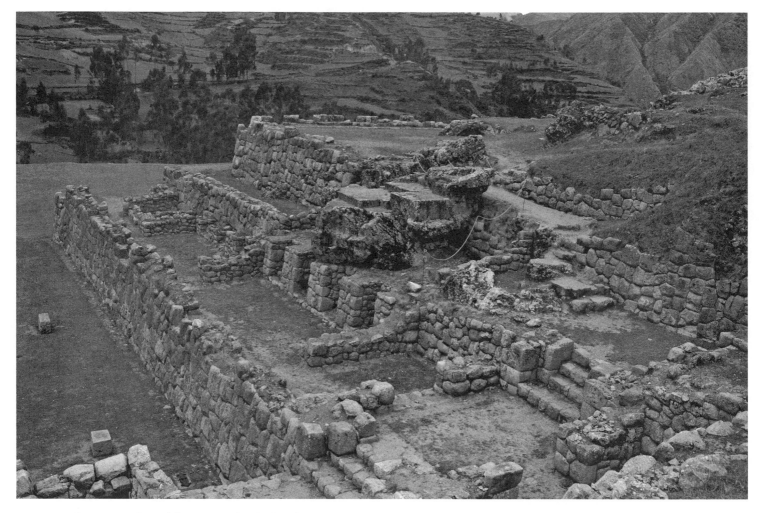

Figure 4.2 | View of the terraces bordering the eastern side of the Pampa from above, including the portion of Pumacaca's outcrop which served as Topa Inca's viewing platform. The platform consists of two large stepped planes. Two puma sculptures lie at the edge of the lower level and two seats are carved above the highest level. Photo by the author.

heavily worked, ostensibly commenting on the blurred boundaries between the sacred and the man-made. However, this contemporary description does not relate to the way the stone looked during imperial Inca times. The majority of areas that appear natural are actually worked. Upon closer inspection one can find numerous bedding joints, revealing where individual stones were once laid.

This evidence offers clues to the former appearance and extent of these walls. Though it is now hidden from the casual viewer, a portion of the original wall remains, revealing that it was of the same high-quality polygonal limestone masonry

as the surrounding terraces. Uncovered during excavations, the wall's foundation indicates that it once wrapped around the stone's three exposed sides (northern, western, and southern), effectively encasing the outcrop in fine Inca walls. The result was that a visitor looking up from the Pampa would not have known that this viewing platform contained a rock outcrop. In fact, the person(s) allowed to stand on the platform (Topa Inca and his select elite guests) would have been among very few people to know about the platform's special facture and materiality.

Although few people would have had this rarified knowledge, not all of them would have been

elite. The men who built this platform would have known, and these masons (*pirca camayoc*) cleverly played with this information. For example, the masons made parts of the outcrop materially visible but disguised in form: They carved a segment of Pumacaca into the shape of a polygonal block (fig. 4.3). They then laid regular polygonal blocks around it, thus allowing this protruding portion of Pumacaca to appear like any other masonry block. When the platform walls were complete, only the construction crews (or those they informed) would have known that at least one of the masonry blocks was actually part of the Pumacaca outcrop.

This knowledge allowed the masons to see Pumacaca differently than the majority of visitors to the Pampa. Most people standing on the Pampa would have recognized a beautifully made limestone wall, but the masons who constructed it would have seen that at least one of those finely

carved blocks was actually part of the sacred outcrop. Given the importance of sight to the Inca, and the power of seeing the sacred stone in the limestone walls of Pumacaca, it is likely that this *rikuy* (sight knowledge) was also passed on to Topa Inca. However, we cannot be sure. The only thing that is definite is that a small collection of masons would have seen sacredness in this royal landscape that was not visible to most others, and in doing so, these builders would have experienced the potency of a bodily sense coveted by the Inca.

The masons who constructed these walls also made two separate seats facing the top of the Pumacaca platform (fig. 4.4). Many Inca viewing platforms had seats. Betanzos describes the platform Huayna Capac used during his town visit as having seats on top. The multi-tiered platform at Vilcashuaman also has seats. These were provided so the ruler and his invited guest(s) could rest during the long performance and comfortably watch the

Figure 4.3 | View of Pumacaca's viewing platform stone. At the center is one of the protruding portions of the bedrock that was shaped into a polygonal stone. Once the wall was complete, this protrusion would have appeared as one of the exterior wall stones. A portion of the original wall that covered the exterior of the outcrop can be seen at the lower right. Photo by the author.

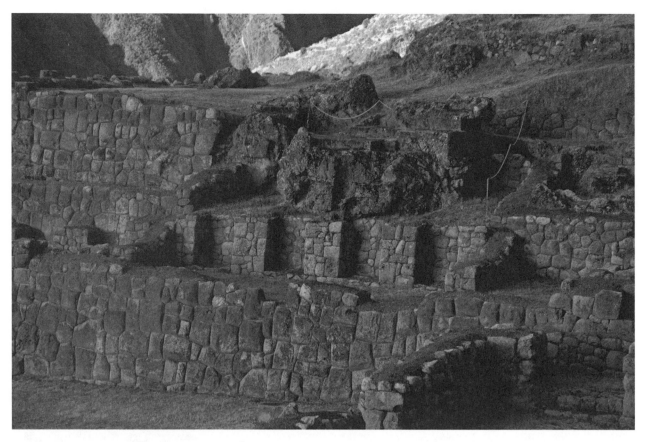

Figure 4.4 | The two seats are carved in the uppermost right of the Pumacaca stone. The two sculptures lie to the far left of the bottom plane. See figure 4.2 for another perspective of the stone. Photo by the author.

elaborate ceremonies taking place. At Chinchero, one seat is larger and noticeably higher than the other, making clear the spatial hierarchy of those seated.

But who were these guests? Viewing platforms are always described as hosting the ruler, and some colonial sources indicate that he also sat with his sons, in particular his intended heir, seated according to their status.[10] In the case of Chinchero, this is supported through the only figurative carvings on Pumacaca. Although heavily damaged by centuries of exposure to the elements and the victim of vandalism (resulting in the removal of their heads), the general form and positions of these two carvings are still visible. In the northwest corner of the platform are two pumas carved in the round and shown in repose, each with crossed legs. The chests of the two puma are

oriented toward the west (the Pampa), in the same direction as the platform seats. One is a fully grown, muscular puma, poised at the far northwest corner with his paws elegantly crossed; behind him at the opposite corner is a young puma, emulating the larger one's position (fig. 4.5). The Inca rarely used figurative imagery in their art, and when they did, it had great significance. Here that imagery depicts an adult puma with his cub—a parent and child.

As discussed previously, the puma was the symbol of an Inca elite male. The *sapa inca* and his fellow noblemen wore puma and jaguar pelts in important rituals. When Inca boys came of age, they donned puma skins, and puma imagery adorned ceramics and textiles associated with Inca noblemen. The royal seat or throne (*tiana*) of the *sapa inca*, was often made with feline sculp-

ture.[11] And most of the three-dimensional images on fine ceramics excavated at Chinchero are of puma. Hence, the two pumas on the Chinchero platform appear to represent a royal Inca man and his son, who is coming of age. Given that Topa Inca built Chinchero at the end of his reign to share with the son he hoped to make heir, the choice of iconography suggests that this platform was designed for Topa Inca to sit with his son Capac Huari. By presiding with his son over the events in the Pampa on the imperial viewing platform, Topa Inca would not only have proclaimed his own special status and authority but also allowed his favored son to do the same. And, if all worked out as Topa Inca planned, his *mallqui* would continue to sit upon this viewing platform, with Capac Huari next reigning as *sapa inca*.

Before moving on to our next architectural example of viewing places, it is important to reflect once more upon the critical role of procession and movement in giving meaning to Inca places. If we consider the viewing platform in isolation, it seems like an anomaly (an outcrop hidden behind masonry walls). It does not use facture to make visible the collaborative relationship between the Inca and the sacred landscape. Instead, the platform seems to hide it (at least from most viewers). However, its construction and appearance make sense when one considers the context of this scene within the larger play. Visitors to Chinchero would

Figure 4.5 | View from above, looking down on the Pumacaca platform. The two felines are heavily weathered and have been decapitated; hence, their details are not clearly discernible from afar. Both lie at the edge of the lower level with the front of their bodies facing west (toward the Pampa). The large *puma* is positioned at the far northwest corner, his paws crossed in front of him. Behind him is the smaller puma, which is curled along the platform's northeast corner with its hind legs stretched out toward the platform and its front paws folded in the same way as the adult *puma*. Photo by the author.

have walked along an Inca road marked by views to sacred *apu* before going past outcrops that articulated a cooperative relationship between the *sapa inca* and the sacred forces of nature, such as lithic *huaca* Chinkana and Titicaca. But once the visitor reached the Pampa and stood in the presence of the Inca ruler, the Pumacaca platform declared the *sapa inca* as triumphant. This view was then reiterated to select elites as they experienced the heavy architectural imprint (inside and above) of Titicaca and to departing visitors as they witnessed Chinkana's western façades. From this perspective, the sacred outcrops are transformed into architectonic geometry. Thus, the viewing platform was the climactic setting in Chinchero's imperial theater—one that starred Topa Inca and his son Capac Huari.

Royal Building Types

The viewing platform is not the only architectural example of how the Inca used sight and views to direct attention onto the *sapa inca*'s presence and actions, even when he stood on the periphery of a *pampa* or *pata*. For example, Inca designers manipulated different types of *puncu* (*punku*, openings) in buildings in order to frame the *sapa inca*'s activities at critical moments for gathered viewers. This was done in structures such as the *cuyusmanco* and *carpa uasi*, which were standard building types within royal estates.

Despite the fact that they were often mentioned in colonial-period documents and are often referred to by scholars today, these structures (their appearance, function, and meaning) have been greatly misunderstood. Therefore, before we can talk about their unique design and spatial qualities, we must first revisit the colonial sources and consider how these references compare with the architectural remains. In doing so, provocative clues into these building types emerge, especially regarding their openings, revealing how these very different and distinct structures framed the *sapa inca* physically and conceptually.

The colonial-period author who wrote the most about building types on Inca estates is Felipe Guaman Poma de Ayala. Guaman Poma was an indigenous author and artist from the central Andes who had extensive interaction with Spanish authorities and was Christian.[12] During the late 1500s, he worked and traveled with Spanish authorities, as well as spending considerable time with indigenous groups in the Andes (particularly in Huamanga and Cuzco).[13] Like most colonial authors, Guaman Poma did not have firsthand experience with imperial Inca rule, but he interviewed people who did, and his detailed observations and insights are of great use to scholars today.

Guaman Poma provides the only extensive list of buildings that *could* be found at a royal estate.[14] Given that private estates were not only imperial installations but also the expression of their royal patron and his or her personal tastes, variability was likely higher in royal estates than in administrative sites.[15] Most royal estates probably did not have all of the structures on Guaman Poma's list; they would have had only those buildings that served the needs of the patron for a particular time and place.

Guaman Poma lists fourteen different kinds of buildings as belonging to royal estates (an accompanying drawing shows five of these). After listing these structures as part of the Inca leader's royal estate, Guaman Poma goes on to state that other notable elites also had buildings of similar quality on their own estates.[16] The frequency of this practice highlights the fact that a ruler's impressive royal buildings were deeply meaningful to a larger audience and were necessary for proclaiming authority.[17] Guaman Poma listed the buildings that defined Inca royal estates, as well as the titles of the four noble groups who had high-quality houses:

Royal courts and palaces and houses of the Inca were called cuyusmango, quinco uasi, muyo uasi, carpa uasi, suntor uasi, moyo uasi, uauya condo uasi, marca uasi, punona uasi, churacona uasi, aca uasi, masana uasi, camachicona uasi, uaccha

Figure 4.6 | Guaman Poma's drawing of a palace. He labels this image "Palacios Reales Incap Uasi Cuyusmanco" (royal palaces, Inca building *cuyusmanco*), thus giving the Spanish (*palacios reales*) and the Quechua (*Incap uasi cuyusmanco*) for royal palaces. In this depiction he shows (and labels) five major building types within an Inca palace: *cuyus mango*, *carpa uasi*, *churacona uasi*, *quenco uasi*, and *suntor uasi*. Felipe Guaman Poma de Ayala, "The Inka's Palaces, Riches and Retinue," *El primer nueva corónica y buen gobierno* (1615/1616), GKS 2232 4, Royal Library of Denmark, Copenhagen, 329[331].

uasi; the following nobles, capac apoconas, apoconas, curacaconas, allicac conas, had houses that conformed in quality and the lands over which they had in this kingdom, and did not have more than this. (author's translation)[18]

In this written description (and his drawing; fig. 4.6), Guaman Poma begins with the *cuyusmanco* (*cuyus mango*), a building type he considered the most important at Inca royal estates. After the viewing platform, this would have been the second most important architectural spotlight for Topa Inca.

Cuyusmanco

Presently, there is some confusion in the scholarship over what exactly was a *cuyusmanco*. This confusion derives from the fact that *cuyusmanco* could refer to both a single structure and a complex. For example, both Martin de Murúa and Guaman Poma refer to the *cuyusmanco* as a palace (building). Murúa depicts two almost identical buildings ("dos casas"), which he labels "Palaces of the Inca and Coya" and "Cuyusmanco."[19] Guaman Poma lists the *cuyusmanco* as one of the distinct types of buildings found at royal estates.

However, Guaman Poma also uses the word *cuyusmanco* (*cuyusmango*) to refer to a royal complex (that had a *cuyusmanco* in it). This association can be seen in the title he gave his drawing of an Inca royal estate, "Royal Palaces: The House of the Inca Cuyusmanco" (fig. 4.6).[20] In other words, for Guaman Poma the *cuyusmanco* was a synecdoche: a *cuyusmanco* could be a building (a structure within a royal estate), but it could also refer to an entire site (the royal estate).[21] Thomas Cummins has noted that Andean art lends itself to synecdochic meaning.[22]

While this information highlights the *cuyusmanco*'s importance in royal architecture, it does not clarify its function, which is misperceived in the literature. In the few scenes in which Guaman Poma depicts a *sapa inca* in front of a building, it is always a *cuyusmanco* (fig. 4.7).[23] González Holguin tells us the building's function, defining the *cuyusmanco* as the house of a "judicial court" or "house of a town councilman."[24] Because of the reliance on Holguin as an academic source, the *cuyusmanco* has often been understood as a building devoted to judicial acts and town council meetings.

This interpretation is problematic, however, as no one has questioned why a meetinghouse for *town* councilmen would be a key component of a royal estate. A place to hold meetings to discuss legal matters or to meet with councilmen from Tahuantinsuyu seems plausible, but a question remains as to why an imperial Inca building would be devoted to officials from the *towns*? Were town

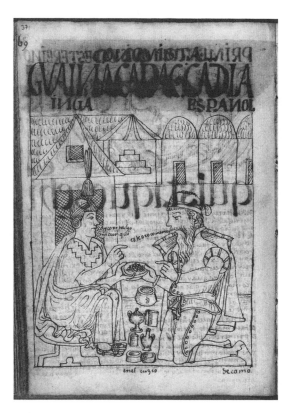

Figure 4.7 | Guaman Poma's imagined meeting between Huayna Capac and Pedro de Candia taking place at an Inca palace complex. Huayna Capac sits in front of the distinctive opening of a *cuyusmanco*. In the background is a *carpa uasi* with an *usnu* shown inside. Felipe Guaman Poma de Ayala, "The First Notice of Huayna Capac Inka of the Approach of the Spaniards," El *primer nueva corónica y buen gobierno* (1615/1616), GKS 2232 4, Royal Library of Denmark, Copenhagen, 369[371].

councilmen so important, more so than any other Inca governing body, that they warranted their own meeting hall on the *sapa inca*'s property? Perhaps, but we must also consider that the reference to the "town," an important Spanish governmental unit, raises a question as to the definition's temporal reference.

This is a crucial point. Both Murúa and Guaman Poma discuss the *cuyusmanco* in terms of imperial Inca history. By contrast, Holguin's Quechua dictionary was intended to define the term according to how it was understood in the late sixteenth century. In the early colonial period, some Quechua terms retained their imperial Inca meaning or shifted only slightly, while others dramati-

cally changed or fell out of use as society began to be restructured by the violent European encounter. The difference between the definitions of the *cuyusmanco* may reflect such a temporal shift in the building's use.

A relevant point of comparison comes to us from colonial New Spain. The Spanish invasion of Mesoamerica caused the demise of autonomous Mexica rulers and radically transformed indigenous governance. Royal palaces were the leisure and state centers of Mexica society, much like Inca palaces were in the Andes. But after the Spanish invasion, Mexica palaces became associated with indigenous town councils that mediated between local populations and Spanish authorities. Town gatherings were held within, and thus became associated with, the former Mexica royal palaces.[25]

In Cuzco, we see this kind of reuse of imperial Inca architecture. The Huacaypata was one of the dual *pata* that formed the core open space of the capital city. Around this *pata* were the palaces of some of the most powerful *sapa inca*—Viracocha, Pachacuti, and Huayna Capac. In some of these royal compounds were *cuyusmanco*. In the early colonial period, powerful conquistadors moved in and occupied these structures. Francisco Pizarro lived in Huayna Capac's palace, while his cousin Pedro Pizarro resided in Pachacuti's. Early records tell us that Francisco Pizarro hosted some of the first town meetings in one of the buildings on Huayna Capac's Cuzco compound that fits the description of a *cuyusmanco*.[26] Thus, Holguin's inclusion of the definition "town council" likely reflects the realities of early colonial Cuzco, where Europeans recast an imperial Inca *cuyusmanco* as the *cabildo*.[27] Since the *cabildo* was also where the Spaniards carried out judicial functions, both parts of Holguin's definition reflect the early colonial period realities of the *cuyusmanco* in Cuzco.[28]

This evidence is a reminder of how important the study of architectural transformations in the colonial period is to understanding indigenous spatial practices both before and after the arrival of Europeans in the Andes. Rather than being seen as impure or false readings of a precontact architectural practice, colonial-period interpretations

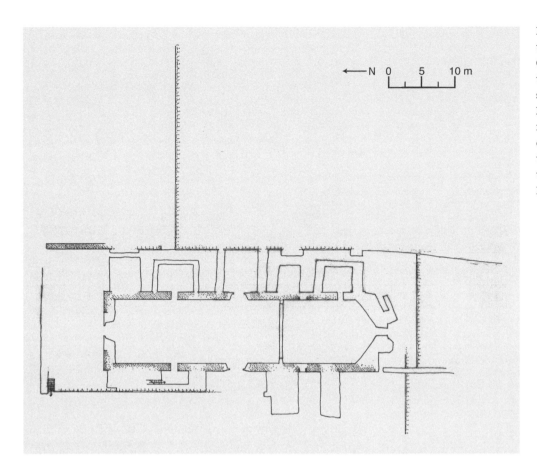

can highlight critical changes in the architectural
fabric, revealing the nuanced and dynamic role of
the built environment in Andean communities. In
the case of the *cuyusmanco*, a temporal compar-
ison transforms what we know about an impor-
tant imperial Inca structure as it also highlights
how Inca building types were reused in the colo-
nial period.

The Spanish found Inca spaces baffling and
soon made adjustments to the *cuyusmanco* into
which they moved. Holguin noted the Inca build-
ing's unusual features, describing the *cuyusmanco*
as having "three walls with one uncovered" (three
walls and one open face). This corresponds to Gua-
man Poma's drawing of the *cuyusmanco* structure,
which is depicted with an immense opening on its
short side.[29] These descriptions and illustrations
corroborate the physical evidence that looms over
Chinchero's Pampa.[30] Today, local residents point
to an impressive colonial church and declare that
it is built on the foundations and lower walls of an
Inca palace. While this might be easily dismissed
as urban lore designed to appeal to tourists, the
architectural remains suggest that they were once
part of an important imperial Inca structure. The
high-quality limestone (made in the imperial Inca
period but now comprising the lower walls of the
colonial church) has been finely carved into polyg-
onal masonry. These Inca walls rise about one me-
ter above the present-day surface and originally
would have been continued with adobe blocks
(fig. 4.8). The walls form the outline of a long rect-
angular imperial Inca building that appears to
have contained a single interior space with regu-
larly arranged doorways along its two long walls
and an unusually large opening on one of its short
sides. (The Inca did not have fixed doors; instead
they had a matted reed frame that they placed
against the doorway when needed.)[31] It is also the
highest structure at the entire site and the only
one that can be seen from both open spaces at the
royal estate (the immense Pampa and the smaller

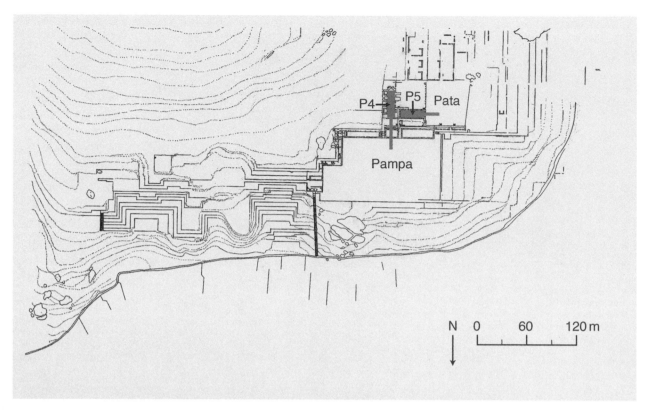

Figure 4.9 | Site plan showing the two *cuyusmanco* (P4, P5) and the sightlines of each (from their large doorways). P4 is the highest structure at Chinchero and its wide opening looks over the Pampa. P5 is set lower and faces the *pata*. P4 was converted into a Catholic church in the colonial period (the walls of this colonial structure are also indicated on the site plan). Image by the author.

pata). Although this structure occupies the periphery of the open areas in terms of horizontal space, it dominates both vertically. In Quechua terms, it spatially occupied the *hanan* or upper position of prestige (the complement of the *hurin*, or lower, in Inca complementary pairs).[32]

Although this building was connected to and dominated both open spaces, it had a clear priority in terms of directionality: its distinctive opening overlooked the Pampa. For someone with a European sensibility, this immense opening could easily have been read in the way Holguin described, as an open end. However, for someone sensitive to subtleties in Inca architecture, the framing of this opening by short walls and a closed gable would have been readily noticed, as it was by Guaman Poma. As we shall see, the latter's observation was a critical distinction for the Inca.

The structure on which the Chinchero church is built is one of only two buildings at the site to match these descriptions. The first *cuyusmanco* (P4), which has the colonial church on top, lies above and is perpendicular to a very similar structure (fig. 4.9). These two *cuyusmanco* likely worked in tandem. The first overlooked the Pampa; the second (P5) opened up to the *pata*, a more intimate open space.

These two adjacent *cuyusmanco* would have addressed very different primary audiences. The first (and larger) would have faced the visitors who gathered for the pomp and ceremony of public rituals in the vast Pampa; the second (and smaller) would have addressed a far more select audience, namely Topa Inca, his family, and special visitors who gathered for the exclusive activities in the *pata*. While only the higher *cuyusmanco* had vi-

sual access to the Pampa, both buildings had visual and physical access to the second, more exclusive space.

Cuyusmanco can be found in other royal estates with similar spatial patterns. For example, there appears to have been at least one (if not more) at Quispiguanca, the royal estate of Huayna Capac.[33] It would have been placed on an elevated terrace, with the distinctive doorway facing the *pata* (or *pampa*) below—similar to Chinchero. A *cuyusmanco* was also central to the site of Tambokancha-Tumibamba, which was a late Inca estate also located on the Pampa de Anta.[34] Set at ground level, the *cuyusmanco*'s unique opening faced the main open space.[35]

Despite the fact that *cuyusmanco* directly faced open spaces, these buildings were often not easy to reach. At Chinchero, the main exit from the Pampa, the wide stairway, faces the *cuyusmanco*, giving the impression of easy access (fig. 4.10). However, it does not run in front of the building but rather slightly to the side (east). An invited visitor using this stairway would have to pass between two important imperial buildings (CP4 and CP5) before suddenly encountering a disguised room to the left (fig. 4.11).[36] Concealed in a terrace wall, a double-jamb entrance to a room has been excavated, indicating its high prestige status. Given its proximity to the *cuyusmanco* entrance, this structure probably also held security

Figure 4.10 | The *cuyusmanco* P4 (now a church) dominates the Pampa. Access from the Pampa was via the staircase ("access point four"). Photo by the author.

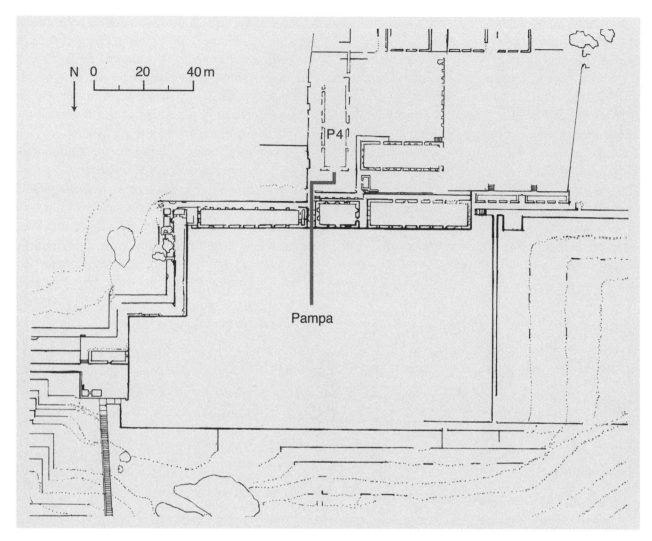

Figure 4.11 | Site plan showing only the imperial Inca remains at Chinchero (with Inca drainage systems removed for clarity). The original pathway from the Pampa to the largest *cuyusmanco* is indicated. The area in front of *cuyusmanco* P4 has been heavily modified, thus the ending of the marked pathway is only presumed. Image by the author.

functions. Once allowed to pass beyond this area, the traveler would have likely walked up the final steps (now destroyed) in order to access a small forecourt in front of the *cuyusmanco*. In sum, despite the fact that the *cuyusmanco* was close to the Pampa, access to it was highly controlled.

This spatial control also had a visual component. At Chinchero several structures stood in a row between the *cuyusmanco* and the Pampa (fig. 4.10), acting as architectural guards. While the *cuyusmanco*'s roof above the royal estate would have been easily seen, its large doorway would have been visible only intermittently. A visitor moving across the Pampa would have at times seen the *cuyusmanco*'s distinctive opening and at other times would have had a view obscured by the three structures. A similar visual design trick can be found at other royal estates. For example, Machu Picchu looms in and out of view for visitors walking the Inca trail.[37]

The manipulation of sight with regard to the *cuyusmanco* (and the powerful significance this carried) was not limited to the building appearing and disappearing as one moved across the Pampa.

Additionally, the designers of Chinchero made the main doorway (when it was in line of sight), easy to see but not easy to see through. To begin with, the positioning of the *cuyusmanco* allowed its large, centered doorway to serve as a framing device for action. The person whose actions were being framed was the *sapa inca*. Descriptions we have from the colonial period often depict the *sapa inca* sitting in front of a building's entrance (rather than inside or to the side) when greeting visiting dignitaries. This is not surprising given the Inca and Andean practice of conducting most activities outside. However, whenever Guaman Poma depicts the *sapa inca* in front of a building, he is almost always placed in front of a *cuyusmanco* and in front of its distinctive doorway (fig. 4.7). Thus, the *cuyusmanco* was directly associated with the *sapa inca*, and its large doorway served as a framing device for his actions.[38]

While the doorway's frame highlighted the ruler, the darkness of the building's interior emphasized exclusivity, serving as a striking backdrop for the ruler to those observing from the Pampa. In all of Guaman Poma's drawings, the *cuyusmanco*'s doorway is shown in complete darkness, with zero visibility into the building's interior. Never is the *sapa inca* (or anyone else) shown inside an imperial Inca *cuyusmanco*. In fact, the only other person who is ever shown standing on the threshold of a *cuyusmanco* is a guard (called a *puncu camayoc*) who prevents both movement and sight into the building's interior (fig. 4.6).[39]

These drawings likely depicted both the physical reality and conceptual understanding of the building. At Chinchero, the interior of the deep rectangular structure of the highest *cuyusmanco* would have appeared completely dark to people on the Pampa, despite its large northern-facing opening. This contrast in light would have obscured sight into the building, providing a vivid separation between insiders and outsiders. It is an architectural strategy that rulers in other parts of the world have also employed. For example, the Ninomaru Palace in Kyoto (Japan) had a prominent and elaborate doorway that visitors could readily see but were forbidden entrance. Similarly, the grand doorway used at Chinchero did not indicate access but, instead, made visible most people's *inability* to enter an exclusive space.[40]

The darkened background of the *cuyusmanco* also served as a visually striking backdrop that framed imperial actions under the bright Andean sun. When occupied, it focused attention on Topa Inca's actions, as well as on his rare ability to penetrate an exclusive space. But even when empty, this unique stage (re)-presented the *sapa inca* in the same way the viewing platform did. In doing so, it multiplied the *sapa inca*'s presence for those gathered on the Pampa. Thus, this large imperial Inca building was a critical part of Pampa performances, creating a theatrical setting in which the ruler appeared as grand, highly protected, and enigmatic.

One reason that this building type may have played such a crucial role in Topa Inca's estate is that it appears to have been introduced during his reign. The *cuyusmanco* can be found at the royal retreats of Topa Inca and his son but not on any of the royal estates of his father, Pachacuti. At Ollantaytambo, Pisac, and Machu Picchu, there is no evidence of a *cuyusmanco*. Like the use of *sayhua* to serve as boundary markers, the *cuyusmanco* appears to have been introduced into the architectural canon of the Inca during Topa Inca's rule in the late fifteenth century. How it came about is unclear. It is possible that this building type was inspired by architecture found in a newly conquered region, or that it originated within and evolved from other Inca architectural practices.

The appearance of this building type as part of the Inca architectural lexicon during the reign of Topa Inca is a reminder that Inca architectural categories and spatial practices were dynamic across time, and we must not assume that what existed under one ruler was the same for a previous generation.[41] In terms of the *cuyusmanco*, the introduction of a new building type at the royal estate likely reflected the introduction or evolution of rituals concerning the *sapa inca*, which the *cuyusmanco* staged and thus came to symbolize. Whatever these rituals were, they appear to have been profoundly connected to the *pata* or *pampa*

and to have relied upon the architectural articulation of openings to convey their meaning.

Carpa uasi

Another royal building type was also defined by its opening: a doorway. According to Guaman Poma, the *carpa uasi* closely followed the *cuyusmanco* in importance and was similar in appearance. It was also associated with the *sapa inca*. However, as we shall see, the subtle ways in which the Inca manipulated the opening of the *carpa uasi* constructed a spatial experience distinctly different from the one created by the *cuyusmanco*.

Like the *cuyusmanco*, the *carpa uasi* had a single large opening at one end; Holguin described it as "house of three walls and the other one uncovered."[42] Guaman Poma, however, noted a subtle difference in the articulations of the large openings in these two building types (fig. 4.6).[43] In his drawing of an imperial palace, Guaman Poma depicts a *carpa uasi* with a completely open face on its short end.[44] There are no walls to frame a doorway, and the gable is also open. In contrast, he portrays a *cuyusmanco* with two narrow walls forming a sizable doorway on the short face, as well as a closed gable that has a small, high, window. To prevent any confusion between the building types, he inscribes each building with its proper name.[45]

Guaman Poma also uses spatial relationships to indicate the difference between the buildings. In his drawing, he places buildings in relative positions (e.g., next to, above, below, etc.) in order to illustrate their importance.[46] Positioning the *cuyusmanco* (the building), which was the most important structure at the *cuyusmanco* (the estate), to the pictorial right in his drawing, with the *carpa uasi* next to it, he shows that the *carpa uasi* was the second most important building in an Inca royal estate.[47]

The name *carpa uasi* seems to have been an accurate description of the building's appearance. *Carpa* is defined as "tent," "ramada," or "covering," while *uasi* means "house,"[48] making the *carpa uasi* a type of "tent house."[49] While this might seem in-

congruous with Guaman Poma's drawing, if we think of how the *carpa uasi* must have been experienced, it is not.

Although we tend to think of Inca architecture as fundamentally about the stone masonry walls, in visual terms Inca architecture was foremost about the thatch and wood roofs. Our impression is formed from the remains of Inca architecture, where the organic materials of the roofs have rotted away over time, while the impressive stone masonry walls persist because stones are materially and structurally durable and because the bases of Inca walls were reused in colonial buildings.[50] This was undoubtedly also influenced by a European sensibility that tended to view a building's wall as the primary focus, often relegating the roof to an afterthought. This is in sharp contrast to architectural traditions in parts of East Asia, where the roof has traditionally been the primary focus in architecture.

From colonial sources and physical evidence, we know that Inca roofs, which were gabled or hipped, were immense, impressive structures.[51] In proportion alone, Inca roofs would have greatly surpassed Inca walls. It has been estimated that an average Inca roof would have taken up over two-thirds of a building's height, dwarfing the finely made walls on which they were built.[52] The size of the eaves would have been adjustable, most likely varying according to the scale of the roof. Large structures like the *carpa uasi* may have also had extensive overhangs that would have covered up a large portion of the relatively short supporting walls.[53]

The visual dominance of the *carpa uasi*'s roof would have been exaggerated because of its completely open façade on one end. The open side would have exposed the massive and elaborate interior of the roof frame, as Guaman Poma's drawings illustrate. Anyone approaching the building's main entrance (the open gabled end) would have seen most of the roof, both exterior and interior. The viewer would have seen not only the impressively sculpted exterior, but also partway into the interior, where finely woven grasses held together intricately laced frameworks of high-quality raf-

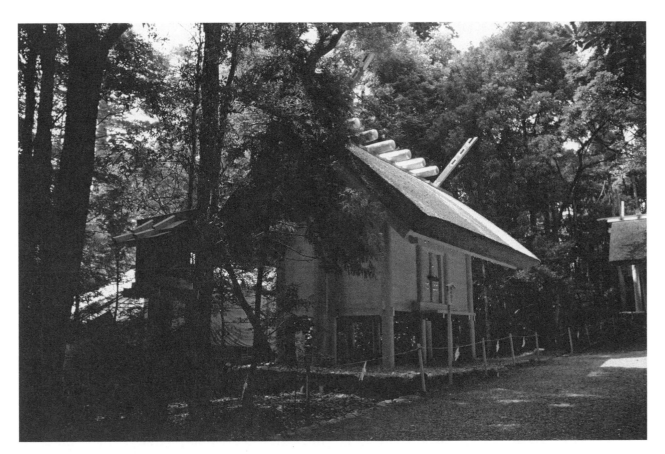

Figure 4.12 | This building, part of a *shinto* shrine in Ise, Japan, has a distinctive roof, which is made of carefully worked and laid thatch reeds. Photo by Jonathan Reynolds.

ters and purlins. These wooden members were covered with a finely woven mat, over which were placed layers of thick, finely combed and cut thatch.[54] These resplendent roofs averaged about four feet in thickness. While nothing remaining in the Andes seems to fit the Spaniards' magnificent descriptions of Inca roofs, Vince Lee has noted that the closest example today (though not related) is the roof of the well-made Ise shrine in Japan (fig. 4.12).[55] This finely sculpted roof gives us a glimpse into how impressive carefully cut and laid thatch can be. It is in sharp contrast to the thin, dilapidated, and scraggly thatched roofs that have been reconstructed over imperial Inca remains today.[56]

Garcilaso de la Vega provides a description of one of the magnificent Inca roofs on a large structure at the royal estate of Huayna Capac in Quispiguanca:

The timber that served as roof beams was laid on top of the walls and lashed down with strong ropes made of long, soft straw like esparto grass. . . . Over these main timbers they placed those, which served as joists and rafters binding them together in the same fashion. Over all this they placed the straw thatch which was so thick that in the royal buildings we are referring to it would be almost a fathom in depth, if not more. It projected more than a yard beyond the walls so as to carry off the rain. Where the straw projected it was clipped very evenly.[57]

Large, finely sculpted thatched roofs, some likely with sizable overhangs, would have dominated Chinchero's built environment. Like a series of sculpted grass mountain peaks, these structures would have been the first architectural element to be noticed at the royal estate. Although the tall

stone gable ends of the buildings and the many finely worked terraces would have clearly made visible the distinctive power of Inca masonry from afar, the long side-walls of the buildings (which were relatively low in height) would have been seen only upon closer approach. By contrast, the thick, carefully worked thatched roofs that covered much of the Inca stone walls visually dominated the royal estate. Their high quality would have been as impressive as the finely worked stone, perhaps even more so.

Given the value of textiles in the Andes, it is not surprising that the Inca placed so much emphasis on the woven element of their architecture.[58] The relationship between the woven roofs and textiles can be seen in the fact that during special festivals, colorful textiles were placed on Inca roofs. The series of steep thatched roofs would have been transformed into a mountainscape of colorful textiles.[59] This roof tradition was not confined to the Inca. In other parts of the Andes, roofs were woven with colorful feathers, an architectural weaving that must have been stunning to behold.[60]

These remarkable roofs would have also impacted spatial dynamics. Specifically, the large eaves of some of the Inca buildings would have created a transition zone around the long sides of the Inca buildings. Under these eaves, a shadowy liminal space marked this area as distinct from the exposed sunny exterior sections of the site and the dark interiors of buildings. As we shall see, the Inca made use of this liminal zone, most frequently to shroud movement.

If the carpa uasi was such an important royal building, where was Chinchero's? At Topa Inca's royal estate, no buildings survive that conform to the carpa uasi's design.[61] One reason for its absence may be that its immense puncu (doorway) made the structure unstable. As Susan Niles has shown, the removal of an entire wall and gable would have made the structure vulnerable to collapse, especially in the earthquake-prone Andes.[62] This may explain why there is only one existing carpa uasi known today. This building is in Huaytará, which is located along an important

Inca road that ran between Cuzco and the coast (fig. 4.13). Topa Inca traveled along this road when conquering the region. Afterward he ordered an extensive building campaign in these newly conquered lands. This location suggests that Topa Inca commissioned the carpa uasi before he began work at Chinchero.

As depicted in the drawings and described in the writings, the long, rectangular, single-space building at Huaytará has one end completely open. The walls are in excellent shape and survive to their original height, which reaches above the door-sized niches. Although some scholars have assumed (and even drawn in) partial walls on the north side, in fact, the physical evidence clearly shows that the north ends of the long side walls are neatly finished.[63] In other words, this structure exactly matches the written and drawn descriptions.

The survival of a carpa uasi today is critical, not only because it confirms the written sources, but also because it can provide important new details. At Huaytará, the walls are not at right angles to each other as they are in most Inca architecture. Instead, the open gable end is wider than the opposite closed end.[64] The result is a subtle trapezoidal footprint for the building. The trapezoid was a characteristic motif for the Inca, who used this form in their niches, doorways, and sometimes the shape of open spaces. However, it is extremely rare to find a trapezoidal building plan.[65]

This small and subtle design detail provides an important clue to the function of the carpa uasi.[66] The trapezoidal layout may have been more than an Inca motif. Instead, this subtle widening of the structure at the open end allowed for greater visibility between the people inside and those outside the building. This is striking, as Inca architecture did not place many openings in buildings through which one could easily see the interior (as noted earlier, one could easily see out of a cuyusmanco, but not into it). Normally, doorways were the only significant openings in the buildings. Windows (if they existed) were usually small and set very high in the gable ends and would have likely been used for ventilation and illuminating the ceilings. For

Figure 4.13 | View of the interior of Huaytará. The photo is taken from the north end of the structure, where the completely open gable end would have been (making it a *carpa uasi*). Photo by Jean-Pierre Protzen.

special circumstances, medium to large windows were placed in a series or to frame a specific exterior view. Thus, when a building's interior was opened up to full view, as with the *carpa uasi*, it was extremely unusual.

Guaman Poma emphasized this with his drawings. He drew only exterior views of most imperial Inca buildings (even putting a guard in the opening to a *cuyusmanco* to prevent seeing in). But for the *carpa uasi* he made a critical exception by depicting the building both outside and inside (figs. 4.6, 4.7). This interior visibility coincides with a description by Pedro Pizarro of the house that Hernando Pizarro occupied with some friends soon after their arrival in the Andes. This imperial Inca building (located in one of the *sapa inca*'s royal compounds) consisted entirely of "a very long room, with an entrance in the back, from which one saw all that was inside because the

doorway is so big that it stretches from one side to the other, and up to the roof."[67]

The immense opening in the *carpa uasi* and its emphasis on visual access may be explained by colonial dictionary definitions that describe the building's function. For example, Domingo de Santo Tomás defines *carpa* as a place of activities, specifically "an auditorium, a place to listen."[68] If this definition refers to an imperial Inca use (as opposed to a colonial-period one), it implies that a *carpa uasi* was a large covered area where people gathered to listen, such as to talks and songs, or to observe rituals.[69] Having a completely open wall (that was stretched wider than usual) would have allowed greater visibility between those inside and outside the structure (i.e., performers and audience).

But if the *carpa uasi* was primarily about viewing, what was being viewed and by whom? Given

that the Inca used speeches and songs as key parts of their oral tradition, there would have been many occasions for the need of such a structure. However, Guaman Poma's drawing provides a more specific clue. The one object he shows inside the *carpa uasi* is an *usnu*.[70] This type of viewing platform had special features for rituals (basin of stones and/or canal for fluids) and was associated with the *sapa inca*.[71] Guaman Poma employs this same arrangement in another image, showing an imagined meeting between Huayna Capac and Pedro de Candia. This meeting is set in the open space of an Inca palace compound (and, as in the previous image, the *carpa uasi* is shown as the second building on the pictorial right, next to the *cuyusmanco*). The *carpa uasi* is the only building in which the interior is shown, and the distinctive stepped platform is the sole object shown inside.

The *Carpa uasi*, the *Usnu*, and the Three-Faced Building

Does this drawing indicate that an *usnu* typically existed inside a *carpa uasi*? Not necessarily, for Guaman Poma's drawings convey conceptual understandings as much as (if not more so than) physical realities, which is typical of Andean visual production in the colonial period. In both prints and paintings, Andean artists often intentionally modified physical reality in order to convey meaning symbolically, and though Guaman Poma often took care to depict important objects and scenes realistically, he also made adjustments in images if it helped to articulate an important concept.[72]

We can apply this understanding to a close reading of Guaman Poma's drawing of the *carpa uasi*. The *usnu*, according to multiple sources, took on many forms, but it had a consistent use: It was a special type of viewing platform (one that had a basin of stones or a hole) on which the *sapa inca* could be seen as he performed specific rituals.[73] By placing an icon for an *usnu* inside the *carpa uasi*, Guaman Poma may not have been suggesting that an *usnu* actually existed inside the structure but, instead, that this building (described by other co-

lonial writers as an open-faced auditorium) was where specific rituals of royal performance took place. Those that were intended for a very large audience occurred with the ruler upon an *usnu* in a large open space, and those that were intended for a more exclusive audience (or were forced inside because of rain or hail) occurred with the ruler inside the *carpa uasi*.[74]

Part of the reason we cannot be more confident of the *carpa uasi*'s specific use is because only one survives. However, important insights can be gleaned from a similar form and spatial arrangement that is still in evidence at other Inca sites. For example, at Machu Picchu, several *cancha* have buildings with one face removed.[75] Although all of them are small, rectangular structures lacking one of the long faces (rather than a gable end with its crucial tension beam), the spatial experience would have been similar. In each of these cases, the absence of one of the walls created a fluid exchange between observers in the comfort of the shaded interior and those outside in the courtyard. The absence of the wall would have allowed visual access and exchange, but at the same time a spatial differentiation (and a hierarchy) between the building's interior and the open courtyard— just as with the *carpa uasi*. Interestingly, Guaman Poma and Holguin both mention that a *carpa uasi* is defined by having one wall missing, yet *never* say that it has to be at a gable end. Thus, it is possible that these structures were *carpa uasi*.[76]

At Machu Picchu, all but one of the intimate courtyards with an open-faced building are oriented around or next to an unusual outcrop. Given the importance of these *huaca*, this building type may have been related to specific rituals that involved sacred stones.[77] This building type is associated with one of the most important outcrops at Machu Picchu, a carved stone that is today called the Intihuatana stone (which sits on a viewing platform). Below and adjacent to this stone is a building that currently has three windows and thus has been linked to the origin story of the Ayar brothers emerging from the three "windows" in a hill (fig. 4.14).[78] Made of some of the finest bonded masonry at the royal estate, this open-

Figure 4.14 | View of one of the three-walled structures at Machu Picchu. It is located below the outcrop that today is called the Intihuatana stone. Photo by the author.

faced building, its materials, location, and facture all suggest that it may have been of prime religious and political importance at the site. While actions performed at the Intihuatana would have been easily viewable, the events performed before and after would have taken place within the semi-privacy of the open-faced building and courtyard.

Buildings such as these at Machu Picchu suggest that this early private estate may have had *carpa uasi*; however, their openings were on the *long* face of the structure, not the short gabled end. After all, none of the written descriptions indicate that the distinctive openings of the *carpa uasi* (and *cuyusmanco*) had to occur on the short side of a structure. However, if Guaman Poma's drawings, which always depict these openings as being on the gable end, were reflective of imperial reality, then Machu Picchu did not have a *carpa uasi* (nor *cuyusmanco*), but a possible precursor to one.

If this was the case, the structural evolution makes sense in terms of engineering principles. The shift from the long face to that of a gable end would have been required when the Inca created larger structures.[79] This is because an increasingly large opening on the long end, where crucial tension forces were placed, made the structure vulnerable to collapse.[80] The shift of focus from the long to the short wall helped stabilize the building, albeit bringing with it new engineering issues.

Another possibility is that the *carpa uasi* was not an Inca invention but instead was inspired by the architecture of newly conquered regions.[81] The removal of one wall of a rectangular building makes more sense in lower altitudes, where temperatures increase and cooling winds are welcome. In the lush environments of the Amazon basin, buildings often lack one or more (sometimes all) walls, thus providing shade as well as access to breezes. Although we cannot know how this practice of removing a wall in a building came

to be an important part of the Inca architectural lexicon, whether engendered spatially (by contact with other cultures), temporally (owing to shifting interests and needs of patrons over time), or in response to physical constraints (such as structural failure), it is clear that change was an important aspect of Inca architecture.[82]

If a *carpa uasi* ever existed at Chinchero, it has since collapsed or been destroyed. Given the many written descriptions of *carpa uasi*, their association with royal residences, and the importance that Guaman Poma placed on them in his drawings of imperial Inca palaces, it is possible that Chinchero had a *carpa uasi*, or at least one was intended to have been built. Perhaps this could explain the numerous ashlar andesite stones that survive at the site today—ones that have been reused in colonial-period buildings. These rare materials at Chinchero are all that remain of what must have been a very important imperial Inca structure. Both its materials and the fact that it was completely destroyed by a person or group—down to its foundations—indicate a high level of importance. The *absence* of a *carpa uasi* can be seen as a reminder that when examining architectural remains, even those of well-preserved sites such as Chinchero, we must acknowledge that important elements may be lost to us.

Regardless of whether Chinchero had a *carpa uasi* or not, this building type provides an important clue to how the Inca understood architectural space. As discussed at the beginning of this book, one of the glaring problems for scholars is the question of Inca architectural form. Studies have shown that size and shape (i.e., building plan) did not define function. Instead, the Inca used simple rectangular structures to house a variety of functions. Despite this repetition in form, Inca buildings are not replicas of each other—they greatly differ from one another, specifically in their openings, such as doorways.

In the case of the Inca viewing platform, *cuyusmanco*, and *carpa uasi*, we see how large-scale openings had deeply symbolic meanings. For the Inca, seeing was a powerful tool, so they used architecture to create stages for seeing and being seen and for framing people and actions. In doing so, they created highly charged spaces that conveyed hierarchical relationships and dialogue across very distinct spaces.

George Simmel has discussed the power of this type of architectural manipulation. For Simmel, the door was a potent device because it was at the threshold that the "bounded and boundaryless adjoint one another . . . as the possibility of a permanent interchange."[83] The Inca used the tension of the *puncu* in the *cuyusmanco* and *carpa uasi* to create a dynamic flow between the interior and exterior and thus between the ruler and his people.[84]

The use of openings to make visible a spatial hierarchy and thus activate a distinction among the buildings and people on Chinchero's Pampa exemplifies the power of sight and bodily experience in the acts of knowing and remembering. This linking of vision and understanding would not have been a rarified Inca expression, but instead, part of a long-term and pervasive Andean practice. Regina Harrison first brought this relationship to scholarly attention when she discussed how *rikuy* in colonial-period Quechua texts expressed seeing as a way of knowing.[85] Most recently Zoila Mendoza has revealed how *rikuy*, for twentieth-century Andean pilgrims, is used to explain how sight is a critical way in which one could learn, know, and remember.[86]

For the architects of Chinchero, sightlines were constructed to convey a potent understanding of hierarchy and authority. This is because a doorway visually and spatially underscores "how separating and connecting are only two sides of precisely the same act."[87] Thus, whether it was the architectural spotlight of (1) an exposed stage (viewing platform), (2) an open-faced auditorium (*carpa uasi*), or (3) an immense doorway into the royal hall (*cuyusmanco*), these carefully constructed apertures reveal the critical way that viewing spaces were used to amplify imperial authority and the sophistication of Inca spatial awareness. In the case of Chinchero, these tactics were designed to accentuate the power of Topa Inca and set in motion his plans for the future.

5 | *UASI* | HOUSE

Although the *cuyusmanco* and *carpa uasi* were read-ily distinguishable because of their unusually large doorways, most Inca buildings were not. At first glance, the simple, single-room, rectangu-lar structures of the Inca appear remarkably sim-ilar and rarely display any easily identifiable fea-tures that could disclose their identity or function. The three impressive *uasi* (buildings or "houses")[1] that line the Pampa at Chinchero (CP3, CP4, and CP5; see fig. 5.1) illustrate this point. These finely made limestone structures make up the major-ity of the southern façade of the Pampa. Together, their regularly spaced openings and continuous polygonal masonry project a unified front; a pow-erful statement of Topa Inca's authority. However, closer examination reveals that the three build-ings making up this façade vary greatly from one another.

This little-understood architectural variability has made defining the function of surviving Inca structures very difficult. A close study of architec-tural details and spatial practices along with data gleaned from excavations can provide provoca-tive clues into the prior use and meaning of indi-vidual Inca buildings. But, as we shall see in the case of the three *uasi* on Chinchero's Pampa, the importance of these insights can easily be lost be-cause our contemporary understanding of *uasi* has become entangled in the legacy of colonial-period misinterpretations of Inca architecture. This chap-ter in our journey to understand Chinchero's *uasi* takes us along a rather complicated and circuitous

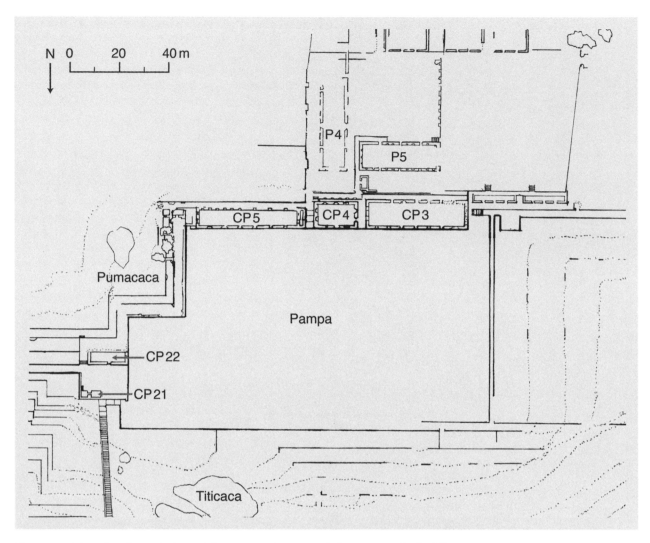

Figure 5.1 | Plan showing only imperial Inca remains around the Pampa. The buildings CP3, CP4, CP5, CP21, and CP22 (Pumawasi) are marked, as are the locations of the two *cuyusmanco*, P4 and P5. Note that the imperial Inca drainage system between CP21 and CP22 and on the terraces has been eliminated in this drawing for clarity. Image by the author.

route, but it is one that all scholars trying to find meaning in Inca buildings must take.

The Meeting Place:
A Possible *Camachicona uasi*

The first of these buildings is rectangular in form and made of polygonal masonry hewn from limestone (figs. 5.2, 5.3). It is the only building bordering the Pampa that has a direct and clearly visible pathway connecting it to the Pampa. And it is

the only one of the grand buildings that is connected via a processional route to the viewing platform. Together, this evidence suggests that CP5 was designed for people to move purposely (if selectively) into it from two extreme spatial centers: the small exclusive platform of Topa Inca and the vast Pampa where large groups of visitors and performers could gather.[2]

CP5 functioned as a critical meeting space between Topa Inca and a selection of visitors. The lucky few who were allowed to enter this space to meet with the *sapa inca* would have first walked

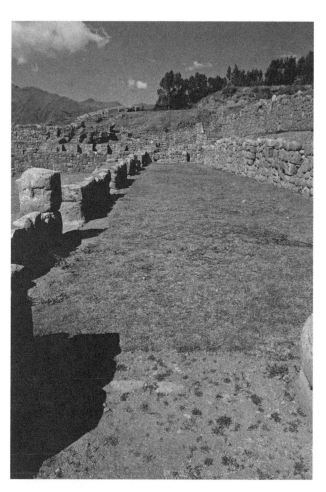

Figure 5.2. View from inside the western entrance of CP5. Note that this doorway aligns with the entrance on the opposite (eastern) wall (and the processional pathway and staircase beyond it). The south terrace wall with its row of alternating large and small niches is the best preserved of CP5's walls. Photo by the author.

Figure 5.3 | The north façade of CP5, as seen from the Pampa. Visible are the large, evenly spaced, double-jamb windows. To the west of the structure (far right) is the dark void in which lies the staircase that leads from the Pampa to the entrance of CP5. Another staircase, partially visible to the east (far left in the photo), is modern and was built to facilitate tourist access. Photo by the author.

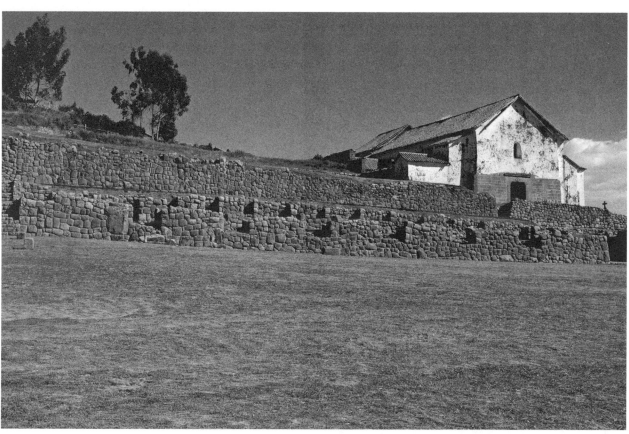

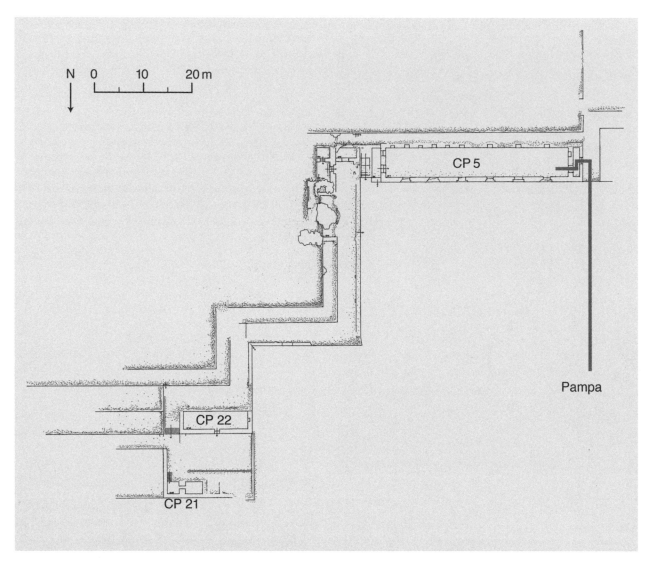

Figure 5.4. Plan of the imperial Inca remains in the eastern portion of the Pampa with the pathway from the Pampa to CP5 marked. A visitor would have to walk a long distance across the Pampa, up the stairs, and then into an ancillary room before entering the main room of CP5. Not shown are the individual steps in the staircases. This is because, even though there is clear evidence on the adjacent walls of stairs having once been present, the imperial Inca steps have been removed and recently replaced with modern ones. Image by the author.

across the vast Pampa and gone up a gently rising and highly visible stairway to reach a landing in front of the building's entrance (fig. 5.4). Upon passing through the doorway to CP5, the visitor would have stepped into a small ancillary room with no windows. This room would have impeded physical and visual access into the main part of the structure, as its two doorways (to the outside and to the main room) are offset. Thus the narrow room served as a baffled entrance for the building, not only preventing direct access to the main room, but also creating a space for visitors to ready themselves before entering the grand interior of CP5.[3] Given the Inca predilection for theatrics, staging areas such as this would have been necessary, while also providing critical spaces for oversight and control.

As discussed earlier, movement could have important transformative aspects for the Inca. This was particularly the case for elite, sacred spaces,

such as a royal estate. In CP5, the narrow entrance room would have served as a transitional zone for visitors as they left the Pampa, allowing individuals to register their moves from the public realm into an enclosed area of greater prestige. The importance of this space can be seen in the way it was consecrated. Beneath this portion of the building, an important offering was ceremoniously buried during its construction.[4] A finely made ceramic vessel filled with animal bones was interred, along with a collection of other valued objects that included a conch shell, knife, necklace, and silver figurine. While this offering no doubt was meant to consecrate the entire structure, it is significant that the builders chose to bury their sacred offering exactly where those people arriving from the Pampa would have to pass over it to enter this imperial Inca building.

Topa Inca would have, on occasion, also entered this side of CP5. This entrance lay below the grand doorway of the *cuyusmanco*. However, another, very different, entrance appears to have been designed for him and one or two select guests (fig. 5.5). This exclusive portal connected via a pathway to the

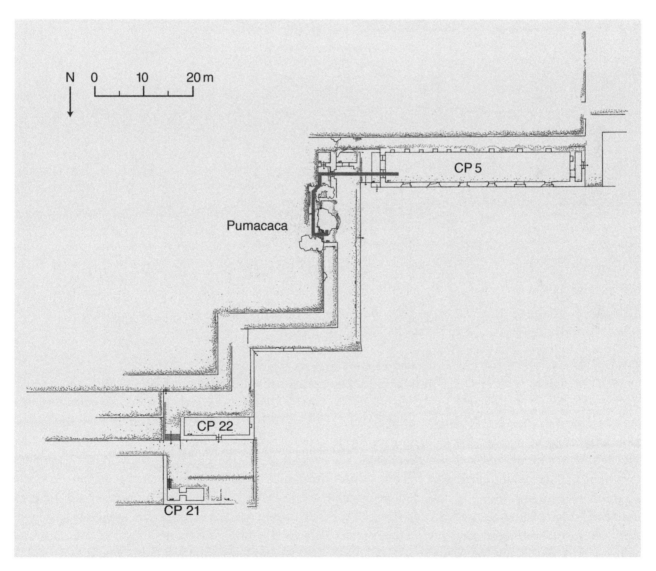

Figure 5.5. | The processional pathway between CP5 and the Pumacaca outcrop (viewing platform) is indicated. Note how this pathway and CP5's eastern doorway line up perfectly with the western entrance to the central space of CP5. Image by the author.

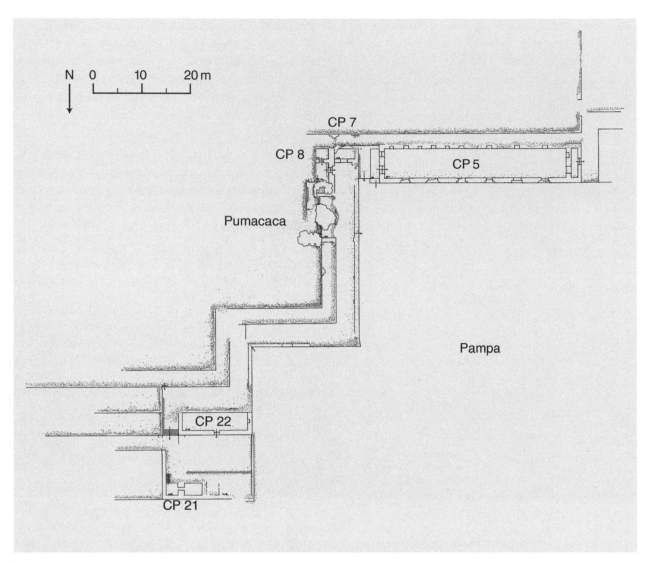

Figure 5.6 | The locations shown are of CP21, CP22, Pumacaca, CP5, and the small rooms, CP7, CP8, which lie between Pumacaca and CP5. Image by the author.

two-seated viewing platform and thus would have been used almost exclusively by Topa Inca and his son. One can imagine Topa Inca, after reviewing a ceremony on the Pampa from the platform adorned with a puma and cub, walking down the carefully laid stairway followed by his son Capac Huari. After moving along a bounded walkway past two small well-made structures (CP7, CP8), they would have entered the finely constructed building we call CP5 (fig. 5.6). This theatrical, processional movement would have been clearly seen by those gathered on the Pampa.

But they were not the only ones for whom this

processional movement was visible. Most people inside CP5 would have also seen this regal movement, as it was perfectly staged for their benefit as well. There was no antechamber inside the (eastern) side of this building, allowing the (eastern) entrance to open directly into the main interior space. Once Topa Inca and his son turned the corner and headed toward CP5, most people gathered inside the long, narrow building (i.e., all but those seated along the far south wall) would have had a direct line of sight to the royal approach (fig. 5.7). They would have been able to watch Topa Inca and his son outside as they passed through two

Figure 5.7 | View from inside CP5 looking to the door through which Topa Inca would have entered, likely with his son Capac Huari. Visible through the doorway is the final portion of the processional route from the Pumacaca viewing platform, allowing people inside CP5 the ability to observe the *sapa inca* making his processional journey to meet them. Today burn marks on the wall adjacent to the door are also visible. The lower stones are fractured and their exterior surfaces have broken off. This was caused by the intense heat that occurred when the burning roof collapsed into the interior of the structure. All of the lower stones in CP5 have these burn scars. Photo by the author.

double-jamb gateways and down a series of steps. In other words, the majority of those gathered inside CP5 would have been able to watch the carefully staged and no doubt impressive approach of the *sapa inca*. When Capac Huari accompanied him, this theatrical procession from the viewing platform to CP5 would have been a powerful scene that enacted Topa Inca's intended succession.

Upon entering the main room, both Topa Inca and his visitors would have stepped upon a well-laid clay floor; a section of this floor (close to the Pumacaca entrance), however, was formed from a carefully leveled rock. In light of the fact that this stone could have been completely removed if the Inca designers had so desired, we must understand that the Inca wanted this stone to be here. In doing so, they not only created a smooth floor but they may have also helped to consecrate the space. By preserving the stone as part of the floor, the Inca co-opted the potentially sacred material, and its essence, using it to enhance the value of the structure. In addition, complementary openings (niches to the south, windows to the north) lined the interior of both long walls in exact opposition to one another, giving a sense of order to the interior of CP5.[5] This system of architectural complementarity in terms of apertures is a characteristic of Inca architecture.

As impressive as this building must have appeared to visitors, part of the structure's most important features lay unseen. Inca architecture was as much about engineering infrastructure as it was about design; hidden from view underneath the floor was an extensive canal system that transported water. This hydraulic system, which was built into the terrace upon which the building sat, helped stabilize the structure by rerouting underground water and moving it across the site to where it was needed. Underground water movement was a considerable obstacle to building in the high Andes, but for the Inca engineers this was just one problem, for which they could devise a variety of solutions. Whenever (and wherever) the Inca built, they carefully considered basic engineering issues and went to great lengths to create the most stable sites. Chinchero was no exception.

While the hydraulic engineering aspects would have been hidden from view, the building's play with scale would have been readily apparent to those who were granted access to the interior. Although the *uasi* appeared to be of average building scale from the outside (deceptively so), once inside, the visitor would have encountered surpris-

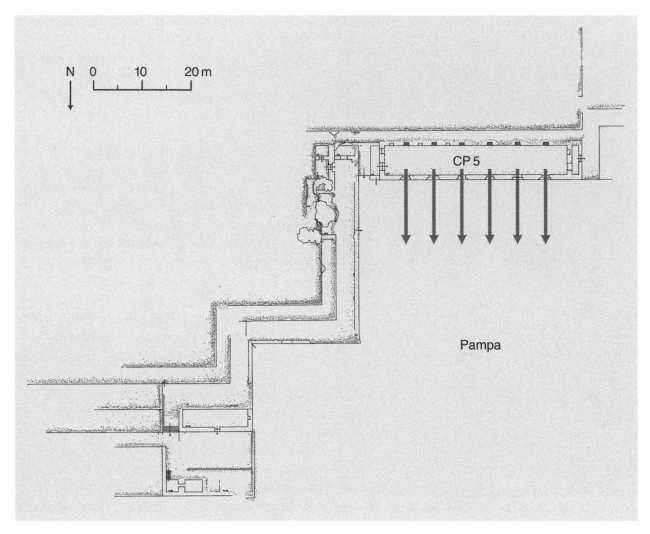

Figure 5.8 | Arrows mark the views from the large windows in CP5 to the Pampa. These windows are parallel to large niches on the opposite (south) wall of CP5 (also marked). In between these large niches were smaller niches set high on the wall. Only a few of these survive (where the wall is high enough for the small niches to be preserved). Image by the author.

ingly (and unusually) large windows lining one side of the building. Through these grand openings (which reached to the interior floor), visitors could easily see out onto the vast Pampa and watch events taking place there (fig. 5.8). However, to people on the Pampa, the large windows offered only tantalizing glances into the action inside the structure.

For George Simmel, this is what gives windows their power. Like the door, a window connects "inner space with the external world." But, unlike the door, windows manipulate seeing in a dramatically unbalanced way; a window "is directed al-most exclusively from inside to outside. . . . The one-sided direction in which this connection runs, just like the limitation upon it to be a path merely for the eye, gives to the window only a part of the deeper and more fundamental significance of the door."[6] Thus, for those people lucky enough to have been allowed to enter the enclosed, elevated space of CP5, windows allowed them to visually realize their spatial status. From here the *sapa inca*, his son, and select visitors could look out (and down) upon the gathered masses, who in turn could look up to see only fragments of the building's interior and glimpses of those inside.

This example helps explain an important aspect of Inca architecture that has often been noted: the judicious placement of windows. Inca architecture, like much architecture of the highlands, tends to eschew windows, preferring instead solid walls with a single doorway. This makes sense given the cold, windy conditions that characterize the high altitude of the Inca heartland. The three exceptions in which windows are placed in Inca buildings are (1) when small windows are created high in the gables to serve as ventilation shafts and to illuminate ceilings; (2) when individual eye-level windows are carefully placed to frame specific views, such as of a sacred mountain peak; and (3) when windows are evenly spaced in series along a building façade, usually paired with a row of windows, doors, or niches on an opposite wall.

Although the first two types of window placement have obvious aims that have been amply discussed in the literature, the reason for the third has always remained somewhat ambiguous. The most common interpretation of serial openings in Inca buildings has been that they were a design trait that arose from the Inca preference for repetition and symmetry. However, the evidence from Chinchero suggests that this may only partially explain this type of window design. Instead, serial windows may have been used to create a specific experience of the structure, namely their ability to convey hierarchy in space via sight. For people gathered in CP5 or outside on the Pampa below, the series of repeated windows were the lenses through which a strict hierarchy could be experienced. The windows were stages as well as signifiers of status and hierarchy in Inca space.

This emphasis on windows as important markers of spatial relationships makes sense given what we already know about the articulations of openings in Inca buildings. The Inca placed double or triple jambs on the exterior of openings (doorways and windows) to convey to the visitor that the space that lay beyond the double jambs was more sacred than the space in which the viewer stood. In CP5, double jambs framed each of the windows facing the Pampa, announcing the sacredness of the space (and thus the activities) that lay within the impressive Inca building. For people gathered on the Pampa, the double jamb and double lintel window frames signaled that the glimpses through these openings were special views of sacred space.

But what exactly was CP5? From the material evidence we know that CP5 was a high-status building, one that followed the Inca architectural canon and was designed to bring a select group of people from the Pampa inside to meet with someone (most likely the *sapa inca*) coming from the viewing platform. The material evidence does not indicate exactly who these select people may have been. However, one clue lies in a building type described by Guaman Poma, the *camachicona uasi*. Like the *cuyusmanco* and *carpa uasi*, the *camachicona uasi* appears to have served aspects of the Inca state at a royal estate. *Camachicona uasi* means the house of those who govern or counsel.[7] In particular, it refers to an action (*camachi*, "to reason, mandate, orate, or govern") and to people in the plural (*cona*, e.g., "a gathering"). Thus the *camachicona uasi* was a building where government officials came together to discuss and debate state mandates. According to Guaman Poma, the *camachicoc* were key members of the Inca royal council and this building was one of the key structures at royal estates (fig. 5.9).

From the colonial descriptions, it is clear that most activities of the state occurred outdoors, particularly in the public *pampa* or *pata*, unless it rained and proceedings moved into the buildings constructed nearby to house these events. Thus, the *camachicona uasi* was not necessarily where all state negotiations occurred or where government officials gathered with Topa Inca, but rather a place next to the main *pampa* or *pata* where state discussions could be held during the rainy season or when a more intimate or restricted setting was needed for private negotiations. At Chinchero, the only building with direct access to the Pampa is CP5.

Although this may have been a secondary meeting space (if they preferred negotiations in the Pampa), visitors invited into CP5 would have been presented with an impressive scene, as the

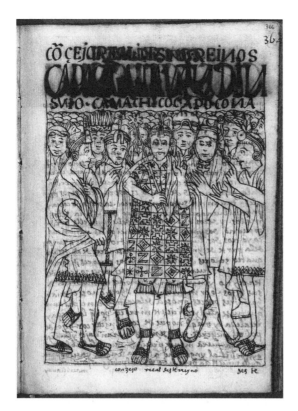

Figure 5.9 | Guaman Poma drawing depicting the "concejo real destos reinos, Capac Inga Tavantin svio Camachicoc apocona" (the royal council of these kingdoms, the *capac inca* of Tahuantinsuyu with his lord governors). This drawing depicts the *sapa inca* meeting with the *camachicona* (lord governors) who were members of the elite royal council of the state. In a royal estate, this elite council would have met with the *sapa inca* in the *camachicona uasi*. Felipe Guaman Poma de Ayala, "Royal Council," El *primer nueva corónica y buen gobierno* (1615/1616), GKS 2232 4, Royal Library of Denmark, Copenhagen, 364[366].

well as silver or gold drinking cups (*kero* and *aquilla*), and even finely woven textiles decorated with geometric designs (*uncu* and *lliclla*) could have been positioned around this room so that they could be used in the ritual drinking and exchanging of gifts that marked official meetings. It is possible that some of these objects may have also been placed temporarily in the multitude of niches that lined the south wall. CP5, made up of Inca stone walls, a stone and tamped clay floor, and elaborate windows and niches, may have usually been devoid of objects or people.[8] But when events took place, nearby storage structures (perhaps CP7, CP8) would be accessed and a sea of ritual finery would rapidly transform the room.[9]

This finery would have changed according to the events taking place. While CP5 may have served as a *camachicona uasi*, this may not have been its only function. Instead, it may also have housed other types of gatherings that brought people from the Pampa together with Topa Inca. This is because we cannot assume that an Inca building's function was fixed.[10] Not only could the standard Inca building type be deployed in a variety of settings to house distinct functions, but a single structure could itself serve multiple purposes. Perhaps this building also serviced other groups of people who also wished to come to Chinchero to meet the *sapa inca*. Hence, as we struggle to define the specific uses of Inca buildings we have to remember that those functions may have been multiple and varied rather than singular and fixed.

These dynamic events would have all occurred under an impressive Inca roof. Inside, the structure of the roof would have been exposed, and its fine construction and materials would have made for a striking sight. The resulting ceiling would have been made up of finely woven organic elements and illuminated by high gable windows. While nothing of CP5's roof remains today, we can trace the collapse and burning of the large rafters that once held up an impressive Inca roof. A continuous, undulating burn line runs along the length of the south wall, revealing that a fire destroyed the structure at some point. Limestone

interior of the building was a colorful and dynamic processional space. Select officials would have walked up the stairs and entered the building, passing over the offering buried below. Inside, they would have watched Topa Inca and his son proceed ceremonially from the viewing platform, down the long walkway, and into CP5.

Inside, objects would have animated the spaces and the rituals. We know from colonial descriptions that Inca places could be transformed by a diverse series of objects. If CP5 was a *camachicona uasi*, then we know that things like finely shaped and painted ceramics holding corn beer (*aka*), as

is one of the few stones that cracks and disintegrates in high temperatures, allowing the heat of the fire to be marked in the wall. The burn line wavers up and down as it moves along the limestone, indicating how far up the wall the fire went. This shift reveals the height of the burning timbers that had collapsed together on the floor. Specifically, when the building was set on fire, the tall, thick roof would have burned intensely in place. But once the principal timber rafters weakened, they would have come crashing to the floor below and burned in a dense pile. Thus, the pile of burning materials was the thickest where there had been a concentration of roof material (i.e., the rafters). In between the principal rafters (where there had been less roof material), the burn marks are lower on the wall. From the systematically spaced high burn marks, we can approximate the location of the imperial Inca roof system.[11]

The grand roof and the space it created is also an important reminder of the fact that Inca architecture had to be renewed on a regular basis. Owing to the endurance of Inca stone masonry, in particular ashlar and polygonal bonded masonry, there is a misperception of Inca architecture as durable, except for the ravages of the Spanish invasion and tourism. However, during imperial Inca times, not only were most Inca buildings not of stone (rather, most were of adobe, which also must be constantly renewed), but Inca buildings consisted largely of wood-framed and thatched roofs, and these roofs needed regular maintenance.

The renewal of adobe walls and thatched roofs may have served multiple purposes for the Inca, as it has for many other cultures. For example, the Ise shrine in Japan is rebuilt every twenty years. This act of rebuilding expresses the Shinto concept of the death and renewal of nature, as well as the impermanence of all things. But the rebuilding also serves two important pragmatic ends, namely, the passing down of construction knowledge to a younger generation (along with its accompanying rituals) as well as the updating of a rapidly aging structure. The organic material of

the roof degrades rapidly, such that its impressive sharp, combed roof turns dark and rounded quickly. Thus, the need to rebuild an aging structure and pass down knowledge of how to do so is coupled with sacred rituals reflecting ideas of life, death, and regeneration.

It is likely that the Inca had a very similar situation. In their writings, the Spanish chroniclers describe the roofs of important imperial Inca structures as fine and made up of carefully combed and laid thatch. These descriptions of roofs in pristine condition suggest that important roofs were regularly remade. Today, roof-making in domestic contexts is a complex endeavor that is also coupled with important rituals that link the making of the roof, and the people who will live under it, with part of the larger sacred world.[12] One can imagine that the roofs of the finest *uasi* of the *sapa inca* would have been considered to be especially sacred and needed to be in the most pristine of conditions. For that reason, these roofs must have been frequently renewed and done so with accompanying rituals.[13]

When we consider the meaning of facture in Inca architecture, we must consider not only the finely made stone walls that define Inca architecture for us today, but also the majestic wood-framed and thatched roofs that would have presented Inca architecture to most visitors during the fifteenth and early sixteenth centuries. Whether gathered inside gazing up at the carefully carved rafters and purlins intricately woven together with colorful grass ropes, or standing outside on the Pampa looking over the sea of carefully laid, combed, and cut reed gables that echoed the shape of the *apu* peaks, Inca roofs would have played important roles in conveying meaning to royal landscapes.[14] In terms of materials, special woods, like certain types of stone, were considered sacred.[15] Hence, the carefully chosen rafters and purlins may have sanctified space in the same way that specially chosen andesite and limestone did. In terms of facture, the renewal of Inca roofs is a reminder that meaning was conveyed by those who built *uasi*, as well as by those who rebuilt it.

In terms of the architecture of royal estates, these repeated acts of facture paralleled the renewal of royal patronage. For Topa Inca, this not only would have kept his buildings at Chinchero pristine, but would have reiterated his power as *sapa inca* and his vision for the future. Specifically, it meant that the very elites who helped to build Chinchero and thus physically enacted their support of Topa Inca's plans for succession would have had to reenact their support for his royal legacy on a regular basis.

The steeply pitched roof of CP5, along with its carefully placed doorways, windows, and niches, capped off a large, royal processional space; one that highlighted the authority of Topa Inca while bringing him together with visitors coming from the Pampa. Yet CP5 was just one part of a long series of carefully crafted architectural spaces around the Pampa that highlighted processional movement and celebrated the power of the *sapa inca*. Whether standing in front of a building such as P5 and performing in the liminal space between the interior and exterior or proceeding into, through, and looking out of the long majestic space of CP5, these theatrical architectural settings celebrated the prestige and power of the *sapa inca* in front of a captive audience. In the case of Chinchero, when his son accompanied Topa Inca, this performance was as much about the future of imperial rule as it was about the present. As we shall see next, that future lay in the hands of powerful royal family members, for whom Chinchero had its own special building.

A Place to See: Royal Relatives and the Luxury Box

One finely carved limestone building (CP3) occupies much of the southern boundary of the Pampa (fig. 5.10). It, like CP5, is of a standard long, rectangular plan and its northern façade is punctuated only by openings from which to view. Unlike CP5, CP3's formidable polygonal masonry wall has no access point from the Pampa. These architectural details indicate that movement was not intended between the building and the Pampa, but sightlines between the two spaces were shaped and directed.

To access this long, rectangular building, one had to enter the walkway that ran along the western façade of the building. There lies an elevated doorway nestled behind CP3 that was hidden from people gathered in the Pampa.[16] To complicate matters, this narrow entrance did not actually open directly into the building but, instead, onto a long pathway that ran alongside CP3's southern façade. During imperial Inca times, this hallway was a liminal space formed by the building's southern wall, a neighboring terrace, and the building's eaves. This hard-to-find entrance and long hallway served to regulate access to CP3 as well as to shield it from view by people gathered on the Pampa.

However, once one passed through this hidden entrance and down the narrow hallway, visitors' access to CP3 was almost unregulated, as many doorways opened directly into the building

Figure 5.10. (*opposite above*) Plan of the imperial Inca structures on the southwestern portion of the Pampa (and in the private *pata*). Surviving buildings are labeled: CP0, CP1, CP2, CP3, CP4. The location of the *cuyusmanco* P4 is shown (though the structure is not drawn) as is the plan of the *cuyusmanco*, P5. The foundations of two buildings that were excavated and reburied have their approximate locations marked as P10 and P11. CP0 is a small structure whose entrance has been partially excavated. Image by the author.

Figure 5.11. (*opposite below*) Plan of the imperial Inca structures in the area between the Pampa and private *pata*. There was only one entrance from the Pampa to CP3. This went from the Pampa, past the western façade of CP3, to a small opening leading to a pathway behind CP3. Those allowed through this opening would have walked down a long exterior hallway which passed seven evenly spaced doorways into CP3. While the entrance to CP3 was carefully concealed from those on the Pampa, the small area in which it was situated was a critical nexus point. Image by the author

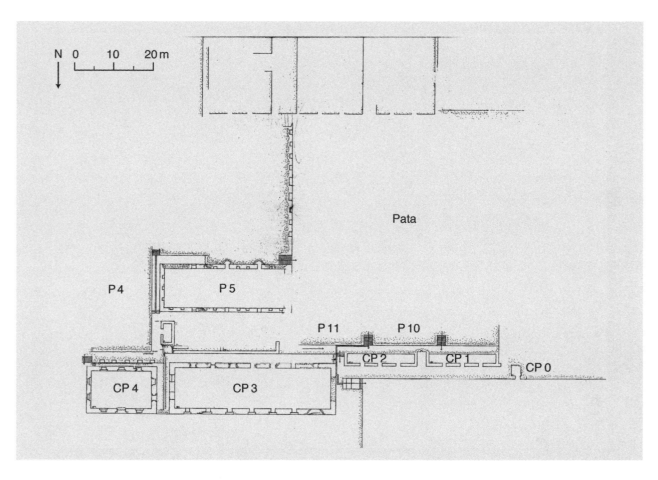

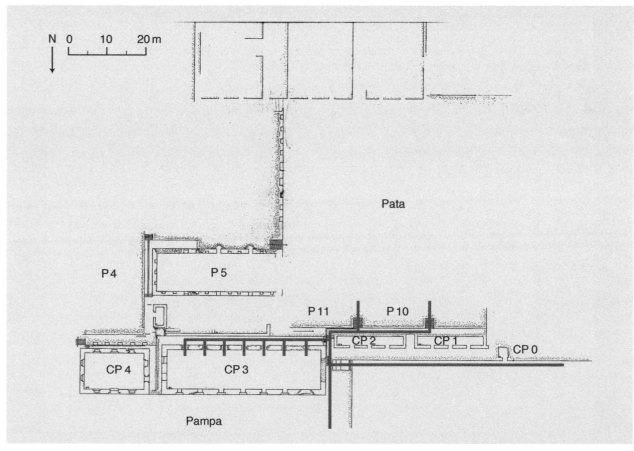

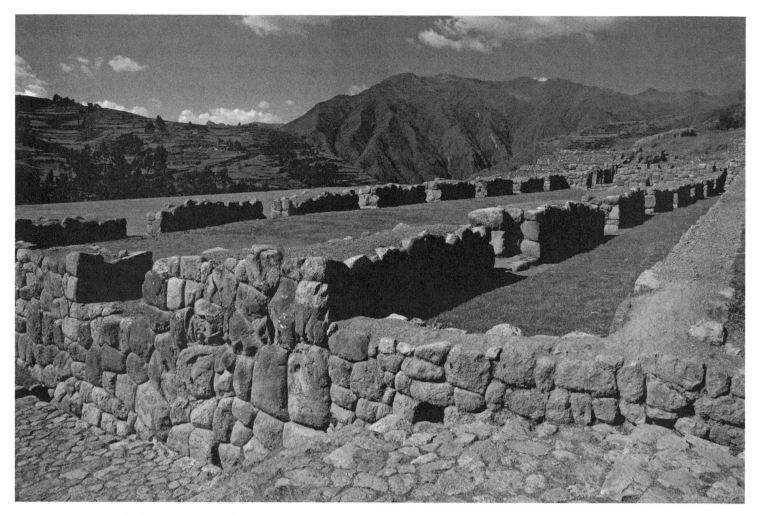

Figure 5.12 | View of CP3 from the southwest. While CP3 is original, the staircase and low wall behind (adjacent to) CP3 are modern constructions. Photo by the author.

(fig. 5.11). These multiple entranceways along CP3's southern façade are in sharp contrast to the two processional, controlled entranceways of CP5, and they suggest a fluid experience of CP3's interior, accommodating multiple users at once. This is surprising, given that hierarchy of movement and seating was important to the Inca and other Andean groups, especially in a ceremonial context.[17] The spatial layout of this area indicates that CP3 was unusual—it was designed as a space for a very exclusive audience, but for those allowed in, there was relative freedom of movement.

The inside of CP3 was a large, well-made, single space. People entering the building would have stepped onto a finely tamped clay floor inside a long, narrow room (fig. 5.12). The room was de-fined on its north side by a row of large windows through which one could see the Pampa (on the outside, these windows were double-jamb, on the inside, single-jamb). An arriving visitor would have readily seen the order and symmetry characteristic of Inca architecture: The layout of the large windows on the northern wall matched the doorways on the southern wall (through which one entered the building). However, part of this symmetry was an illusion, as two of the pairs of openings at the far end are slightly offset. This is unusual for Inca architecture, and it is unclear why it was done this way or if it held any special meaning.

The location and secluded nature of the entrance to this building suggests that (unlike CP5) CP3 would not have been used by people coming

from the Pampa, but rather by an exclusive population coming from the southern side of the estate. This is the area where Topa Inca and his family would have lived. This private part of the royal estate was centered on an open space with only one access point, which lay just beyond CP3 and would likely have been heavily guarded. Thus, only the ruler; his favorite consort, Mama Chequi Ocllo; their son, Capac Huari; and select guests and servants could pass by (or into) the entrance to CP3.

Given the population this *uasi* was intended to serve, its design makes sense. The design of CP3 hid the entrance to the building from those on the Pampa, thus allowing elites from the private sector of the estate to pass into the *uasi*'s spacious interior without being watched (and enabling a certain anonymity for the building's inhabitants). While people on the Pampa could catch glimpses of what went on inside this *uasi*, those gathered inside CP3 had prime views of the Pampa readily available (fig. 5.13). As Simmel noted, these windows allow those gathered inside to control vision. The series of windows allowed them to see clearly what happened outside while restricting

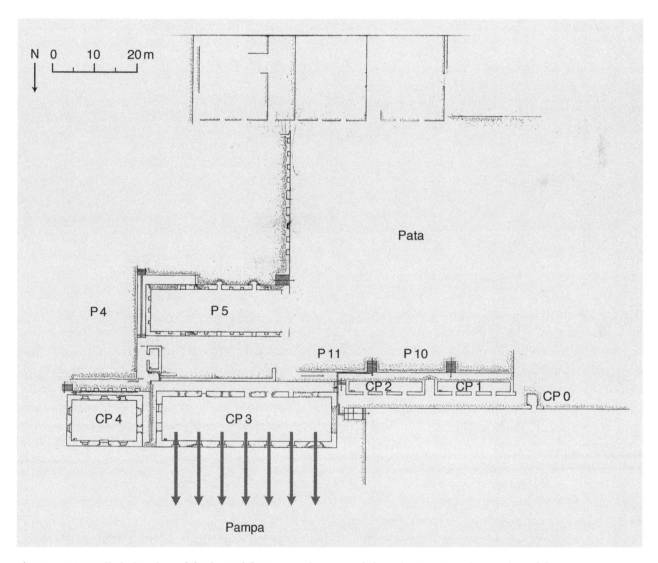

Figure 5.13 | Detailed site plan of the imperial Inca remains around the private *pata* and a portion of the Pampa. Drainage canals are also depicted, as are the direction of steps. Major buildings are numbered, with the exception of P4, which is not drawn but whose location is indicated. Views from CP3 toward the Pampa are marked with arrows. Image by the author.

what those gathered outside could see inside the elevated building. This is similar to luxury boxes in sports stadiums today, which provide great views of the games (and audience) in a comfortable, secluded refuge for wealthy patrons. By contrast, players on the field (and those packed into the crowded stands) can only catch glimpses of the elites relaxing within their exclusive suites.

So what type of building was this structure? Unlike *cuyusmanco* or *camachicona uasi*, there does not appear to be any known Quechua name for an Inca building type that could apply to this elite space. Although we do not know the name of this structure, we do know from numerous descriptions by the chroniclers that elite Inca would often gather around open spaces to watch ceremonies taking place there. They are described as having the prime seats to watch events on the *pata* or *pampa*, and thus were the principal audience for imperial events. Given the importance of the *panaca* (family group) at royal estates, it makes sense that the presence of royal elites would have been particularly pronounced in these settings and that some *uasi* were constructed for their viewing pleasure.

At Chinchero, having a space in which family members could gather to watch events on the Pampa would have been important for several reasons. First, close family members held key positions of power in Tahuantinsuyu. This would have included relatives who were military leaders, high priests and priestesses, chief administrators, and governors. Hence, a family reunion could also be a state gathering. Second, Topa Inca needed to cultivate his close family ties to maintain order and to ensure his plans for succession, in particular among the powerful elites in his father's *panaca*, who lived in the Urubamba Valley. And third, Topa Inca needed to lay the groundwork for the formation of his future family group, for it was his descendants who would form his own *panaca*, and those descendants would feed and dress his *mallqui*, serve as caretakers of his estate, and carry on his memory. It is perhaps for this latter reason that the interior of CP3 was designed as a single, open space with multiple doorways off of the entrance

hallway. This suggests a free-flowing movement within the building, where elites could comfortably enter together and move about, partaking in intimate conversations as they gathered to watch ceremonies on the grand imperial Pampa.

In terms of architectural space, CP3 reveals the complex and layered ways in which openings were used to manipulate movement and perception, even in singular spaces. From designing rows of imposing windows on a building masquerading as twice its size, to hiding its main entrance through a side alley, the Inca masterfully manipulated architecture to convey senses of accessibility or exclusivity for a diverse and shifting collection of observers and participants. However, whether one was allowed in or kept out, the message of Topa Inca's authority was consistently conveyed.

Galpón

In the few buildings we have examined so far, we have already seen how each was carefully designed to serve a very distinct purpose within the royal estate. However, several of these *uasi* (CP3, along with CP5 and P4) have not been recognized for their distinctiveness but rather have been grouped together as the same under the rubric of *kallanka* (as discussed earlier) or *galpón*. This grouping has been applied not only to the buildings at Chinchero, but also to Inca buildings found throughout the Andes. Not only are these terms inaccurate (*callanka* is a construction term), but they also mask the subtle but critical distinctions in Inca architecture and spatial practices. While *kallanka* is a term that became part of scholarly misunderstandings in the twentieth century, *galpón* goes back to the colonial period and European misinterpretations of the architecture that they encountered in the Andes.[18]

One problem was that Spaniards did not apprehend the details that defined architectural difference for the Inca, such as their openings. For example, we have seen this in Holguin's mistaken conflation of the appearance of the *cuyusmanco* and the *carpa uasi*. Another problem came from the significant difference in Spanish versus Inca

spatial practices. In Spanish building traditions, most structures had multiple interior spaces (with doorways, hallways, and other interior connections), while the Inca tended to embrace single-room structures. European writers expressed surprise that Inca structures, especially the very largest ones, were usually not subdivided. Spaniards called these large, single-space, rectangular structures *galpones*. According to Pedro Pizarro,

> A *galpón* is a very large chamber, with an entrance at the back of the *galpón* from which you can see everything that is inside because it is so big, from one wall to another and up to the ceiling, everything at the entrance is open. The Indians have *galpones* so they can have their drunken events. They have others where the back is closed and there are many doors along the side walls of the building, and all of this is one room. These *galpones* were very large, without having any divisions, but free space. (author's translation)[19]

As is evident from this description, Pizarro made no distinction between the *carpa uasi* and other long rectangular buildings (those without large openings on the short façades). Bernabé Cobo also conflated distinct structures, using *galpón* to define a building from the eastern Andes.[20] He described this large post-and-lintel building with all open faces as "a one-room house, or *galpón*."[21] Ironically, this type of structure may have been related to the *carpa uasi*.

In addition to Pizarro and Cobo, other colonial writers conflated several distinct Inca building types. Inca Garcilaso de la Vega writes,

> In many of the Inca's houses there were large halls some two hundred paces in length and fifty to sixty in breadth. They were unpartitioned and served as places of assembly for festivals and dances where the weather was too rainy to permit them to hold these in the open air. In the city of Cuzco I saw four of these halls. One was in Amarucancha . . . the second was at Cassana . . . the third was at Collcampata (the smallest) . . . and the largest was that of Cassana, which was capable of holding three thousand persons. It seems incred-

ible that timber could have been found to cover such vast halls. The fourth . . . now serves as the cathedral church . . . all their buildings were of one story.[22]

Garcilaso's description does not note the subtle yet critical difference between the *cuyusmanco* and the *carpa uasi* or any other large rectangular Inca buildings, so we do not know to which building type he was referring. What is most interesting in his description is not what he tells us about Inca architecture but, instead, his reading of it. Although Garcilaso was the son of an Inca *ñusta* (princess) and spent much of his youth in the Andes, his father was a Spanish conquistador, and Garcilaso wrote his account when he was in his sixties, having spent his entire adulthood in Europe.[23] Thus, his memory and his reading of Inca architecture were filtered through the lens of a Christian who had spent the majority of his life in Spain.

Garcilaso saw the spatial organization of these *galpones* as one of the primary distinguishing features. For Garcilaso, it was the form (rectangular), space (open and undivided), and size (large) that defined a *galpón*. Expansive, undifferentiated interior space was unusual in the Iberian Peninsula. If a large building had a single space, it constituted a distinct building type, such as a church (in the provinces, a basilica plan was common). Someone accustomed to multiple rooms inside a single structure might logically be struck by single buildings composed solely of a large interior space and consequently might assign a single type to all of them. For the Inca, who often conceived interior building space as unitary, this would not have been a distinguishing feature and certainly not one that defined one building type from another.

Garcilaso noted that occasionally small antechambers (such as inside CP5) could be added inside large single-space buildings. However, the thing most critical to him about these structures was their very large central spaces that were not further subdivided.[24] Thus Garcilaso, like Holguin, grouped together *cuyusmanco* and *carpa uasi* (as well as other Inca buildings, like CP3), because of

their open interior space and large size, which he labeled as *galpón,* failing to notice or record characteristics that distinguished these buildings for the Inca.[25] Today, scholars have continued the erroneous Spanish practice of conflating these two—and possibly more—building types. In replacing the word *galpón* with *kallanka,* the category remains the same, referring to all large rectangular buildings, regardless of their openings, that have a singular interior space.[26]

Before returning to the architecture that lines Chinchero's Pampa, it is important to note one other element about the *galpón,* specifically how it reveals the dynamic flow of ideas and people and their transformation across the Americas. Today, *galpón* is a word found primarily in the Andes. Scholars working in indigenous languages assumed it was an Iberian word that came with the Spanish and became naturalized in South America. Spanish scholars assumed that it was an indigenous Andean word that had been adopted into modern Spanish. Neither, however, is correct.

The Spanish linguist Joan Corominas traced the origins of the word.[27] He found that it was first written down by Spaniards in Mexico but was also used throughout the Andes. It soon fell out of use in Mesoamerica but continued in the Andes, such that it has become a commonly accepted term in many parts of western South America. Corominas also found that the word was originally written as *kalpol* or *galpol* (and then *galpón*) and that in early Spanish writings, *g* and *k* were often interchanged, as were *n* and *l.* Indeed, Garcilaso used the term *galpol* to describe a type of large, single-room Inca building type that is now written as *galpón.* Corominas argued that *galpón/kalpol* likely was derived from the Nahuatl word *kalpulli* (which was a Mexica clan organization). Despite the fact that many scholars argued against this version of the word's history on the grounds that there are no references in the Nahuatl dictionaries that define the term *kalpulli* as an architectural type, Corominas offered some final support for his Mexica thesis that provides a clue to the word's actual origins.[28]

Corominas ended his discussion of the term *galpón* by stating that a remnant of the Nahuatl term could still be found in Guatemala and Honduras, in the form of a local word, *kalpol.* Corominas describes this term as a local variant of the Nahuatl word and translates this regional *kalpol* to mean "a council or place where they meet." However, he seems to have overlooked the fact that this term actually has a more specific, architectural reference—a definition that makes clear why the Spanish would have begun using it to describe the old Inca and Mexica buildings that continued to populate the new Spanish territories.[29]

This part of the Americas (now comprising such modern nations as Nicaragua, El Salvador, Honduras, Panama, and Guatemala) was an important center of Spanish power in the early colonial period, and it was here that many Spaniards arrived, after passing through the Caribbean, to have it serve as their base in the Americas. For example, Francisco Pizarro and his crew lived here before setting off on the journeys that led to the invasion of the Inca Empire. Spaniards in this area would have been exposed to local indigenous people and languages. The major language in this region was Pipil Nawat, even among other indigenous peoples with distinct languages. Today, it is confined to a small and little-studied group in western El Salvador.

Lyle Campbell, an American linguist who has specialized in Pipil Nawat, states that *kalpol* (which can be written with a *g* but pronounced with a *k*) is a common Pipil Nawat word. *Kal* means "large house" and *-pol* is a suffix indicating something old or dilapidated.[30] Thus, the Spanish used a word (*kalpol*) that referred to a large, old, run-down building to describe what many Spaniards would have considered was a large, old, ruined Inca building. This is because when the Spanish landed on the Andean coast and moved inward, parts of the Inca Empire they moved through had been decimated by the onslaught of European diseases and a brutal Inca civil war. Hence, many of the once pristine imperial Inca structures that the Europeans would have first seen in the Andes would

have been damaged by warfare or neglect, allowing their present condition to match perfectly with the Pipil Nawat definition of *kalpol*.

The fact that this indigenous word became naturalized for Spanish speakers can be seen in its linguistic change. In Pipil Nawat, *-pol* means old or dilapidated. But in Spanish, *-pón* is used to mean large. Hence, in the writings of the chroniclers, *kalpol/galpol* soon became *galpón*, Hispanicizing a Native American word in a way that caused the meaning to shift. "Large house" was retained (*kal*) but the reference to "old" and "dilapidated" (*-pol*) was removed so that scale (large, *-pón*) could be reiterated. This version of the word's definition is used today.

The Spanish transformation and transportation of indigenous names from one part of the Americas to another was not unusual. The Spanish used the word *cacique* (a Caribe word for "local chief") to describe the Andean *kuraka* (a Quechua word for the hereditary *ayllu* leader). And the Spanish used the term *duho* (a Caribe word for "throne") to describe the Inca *tiana* (a Quechua term for the *sapa inca*'s royal seat or a type of dwelling).[31] Christian Spaniards had a long history of essentializing Indians and, for that matter, all conquered peoples, including Muslims, in the Iberian Peninsula. This manifested itself in linguistic practices, such as the Spanish Christians using a word from one conquered group to describe a similar aspect in another conquered group. With regard to the term *galpón*, the Spanish used a Pipil Nawat term to describe what they interpreted as a similar indigenous architectural type in the Andes. In the process, they created a category in the colonial period in the Andes that did not exist for the Inca, yet has become embedded in contemporary scholarship.

The use of the word *galpón* is another reminder that there were more than two broad categories of players in the early modern Andes, Inca and Iberian, and more avenues for exchange than a single transatlantic pathway. In particular, it is a reminder of the complicated and perhaps unexpected ways in which people and ideas moved in the early modern period. Spaniards spent considerable time in what is now termed Central America and were greatly influenced by local indigenous culture, namely the Pipil. Europeans made up a small minority of the population in this region and thus may have begun to learn a few key native words to help them adapt to their new surroundings. It is in this situation that Pizarro and some of his men may have first heard the Pipil word *kalpol*.

However, we also have to be cautious in assuming that it was solely the Spanish who brought the term *kalpol* to the Andes. Instead, we must also consider the possibility that a Pipil speaker or an African slave who had learned the local indigenous language may have been the first to utter the phrase in South America. This is because the Spanish did not arrive on Andean shores alone but, instead, brought indigenous and African people with them on their journey. Many of these people were forced to participate in the arduous journey, either by kidnapping or enslavement, and were often given dangerous jobs that resulted in an extremely high death rate for both groups. Despite their radically reduced numbers, it is quite possible that some Pipil speakers survived the trip to South America (along with African slaves who had learned Pipil), and thus may have been the first to use the term *kalpol* to define a type of Inca building.

Whether introduced to South America by indigenous, African, or Spanish people, the presence of this Pipil word in the Andes began a long tradition that resulted in modern scholars (including myself) using the term *galpón* to describe a variety of Inca buildings. As we have seen with the three *uasi* that rest along Chinchero's Pampa, instituting a false category such as the *galpón* has hidden the rich diversity of Inca architecture. The *galpón*, like the *kallanka*, is an example of the ways in which outsiders have created names (and categories) for Inca architecture. It is also an example of how this seemingly benign act has led to grave misunderstanding of Inca architecture, space, and, ultimately, Andean cultural landscapes. But, most important for our study, it is another example of the

ways in which spatial practices defined Inca architecture. The story of the *galpón* reveals a complex linguistic and cultural journey across space that is critical to recognize if we hope to understand Inca architecture.

A Room of His Own: The *Suntur uasi*

This question about how we categorize Inca architecture, in particular the role of form, also plagues the study of the last of the major buildings lining Chinchero's Pampa. Just to the east of CP3 is a small but highly elaborate *uasi* (CP4) that had even more restricted access. To reach the main entrance one would have had to pass through the elevated *puncu* next to CP3, go down the long narrow pathway behind CP3, and turn a sharp left before ending at a small platform (fig. 5.14). It is only at this moment, nestled between CP3 and CP4, that people on the Pampa would have had a clear view of the person, or people, about to enter this unique structure.

The entrance to CP4 exhibits the extraordinary architectural motif of a double jamb (fig. 5.15). This elaborate face is customarily placed on only one side, normally the outside, of an entrance to a building or courtyard. So positioned, it signifies that a more privileged, sacred space lies just beyond.[32] At Chinchero, double-jamb openings can be found in the north façades of all three buildings that line the Pampa and on the doorways

leading from CP5 to the Pumacaca platform. What is most unusual about the doorway to CP4 is that the double jamb is on *both* sides.

Doorways with double-jambs on both sides ("reversible") are extremely rare in Inca design.[33] With the exception of Chinchero, *all* known reversible double-jamb doorways are associated with the entrance to an exterior space (open space, hallway, etc.). For example, the main gates that marked the entrances to Tambo Colorado (a large way station associated with Topa Inca) and Ollantaytambo (Pachacuti's royal estate) were reversible double jambs.[34] The reversible double jamb at Chinchero is unique in that it marks the entrance to a single building and not an exterior space, and it must have resonated with special meaning.

Few people, however, would have passed through this doorway. While CP3 had multiple entrances, CP4 appears to have had only one, suggesting that this *uasi* was a far more exclusive and controlled space. Considering the building's small size, complex approach, and unique, high-status doorway, it is safe to assume that only a very small portion of the elite visitors who passed through the secluded entrance behind CP3 would have been allowed to enter CP4.

These select people would have found a small but elaborate interior.[35] Unlike any other structure at Chinchero, each of the niches and the doorway had a double jamb (fig. 5.16).[36] The only single-jamb opening in the interior was the lone window.[37] The many surviving elements of these diverse

Figure 5.14 | (*opposite above*) There are two major pathways leading to CP4. Both would have started at the entrance to the hallway behind CP3. One pathway goes down the hallway to the south of CP3 and then turns to the left (north), ending in front of CP4. The other pathway goes from the entrance hallway, through the interior of CP3 (any of the doorways), and then exits at the eastern wall, ending up in front of CP4. The majority of these movements would not have been visible to people on the Pampa. Image by the author.

Figure 5.15 | (*opposite below*) Detailed plan of remains around CP4. Note the symmetrical layout of the structure, the reversible, double-jamb entrance (western wall, to the right in the image) and the very narrow pathway behind CP4 (lined with a water channel and bounded by a terrace wall with five tall niches). This pathway leads to the hidden entrance to CP3 that is located in a large, double-jamb niche in CP4's south wall. The small, irregular projections of the jamb that are visible today would have once blended seamlessly with the original imperial Inca floor (which was higher than what is exposed today). These irregular edges are also indicated in the drawing. Image by the author.

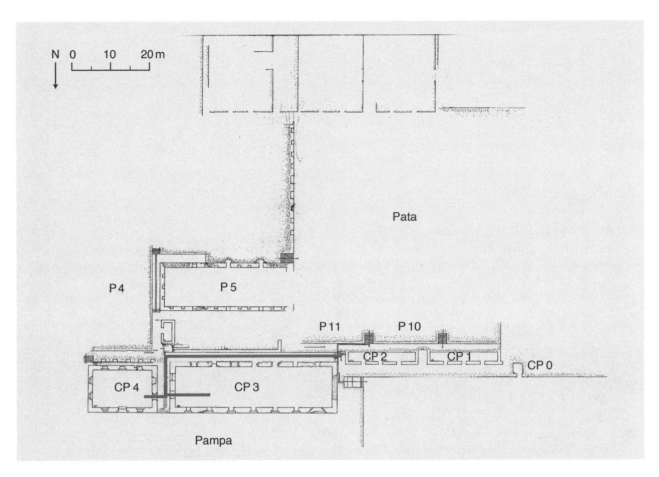

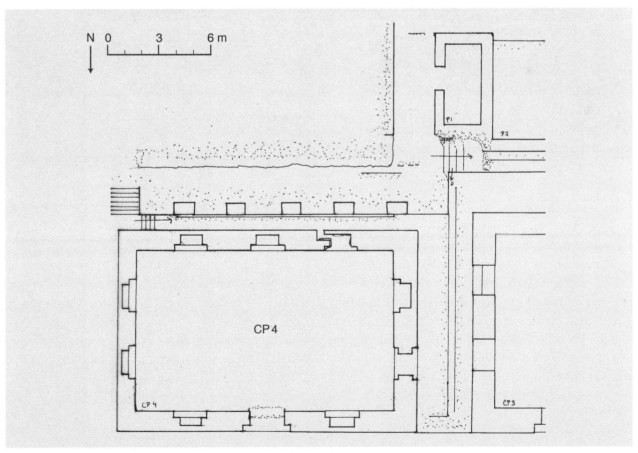

Figure 5.16 | View of the inside of CP4, revealing three large, double-jamb (double-threshold) niches in its eastern wall and a portion of its northern wall. The scars on the lower walls are the result of the collapse of the large roof as it burned. Photo by the author.

openings (the niches, window, and doorway) are of a similar size and are regularly spaced, giving a sense of order to the small but elaborate room.

Alongside the reversible double-jamb doorway, the restricted view through this single window is another clue to the special status of this building. The other two buildings on the raised terrace had multiple windows opening onto the Pampa, but CP4 had only this one (fig. 5.17). Yet, having this window, and only this window, was important to the Inca designers. Next to it are two large niches;

the designers could have easily made windows on this wall, but instead chose to have niches (fig. 5.18). This design creates two conditions. First, it constricted, and thus made it easier to control, what people on the Pampa saw going on inside CP4 (effectively framing and highlighting who stood in front of the window, while obscuring most other activities occurring within the structure); and second, it allowed the interior of the building to have a more intimate, private atmosphere than expected for a structure bordering the Pampa.

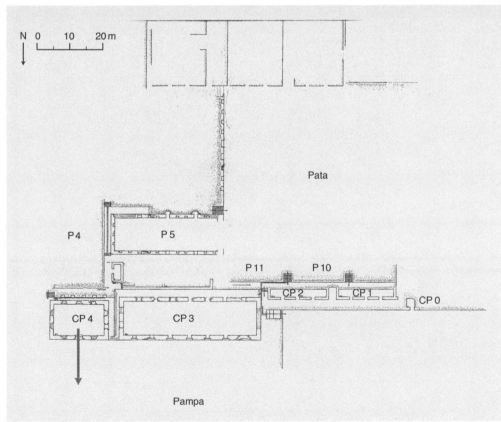

Figure 5.17 | The northern façade of CP4. Note the lone large double-jamb window that faces the Pampa. Photo by the author.

Figure 5.18 | In contrast to the multiple views offered by CP3 and CP5, CP4 had only one window. This sole viewing opportunity looked out onto the Pampa and is indicated with an arrow in this plan. Image by the author.

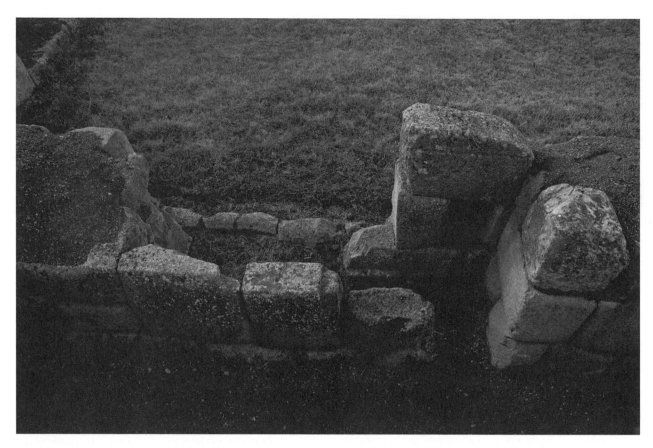

Figure 5.19 | View from above the hidden entrance in one of CP4's large double-jamb niches. Photo by the author.

There is one final aspect that makes this structure unique, not only for Chinchero but also in all of Inca architecture. As previously mentioned, the visitor to CP4 would have perceived an ordered, high-status Inca space. But this was an illusion, as the architecture holds a secret that could be revealed only upon close examination. What appears to be a normal double-jamb niche is, in fact, a hidden doorway (fig. 5.19).[38] This is not just rare in Inca architecture—it is the only known example in existence.

What use did this secret doorway have? And who or what appeared and disappeared into this room? One clue lies in the very narrow hallway behind the secret doorway. In this restricted space is a series of tall but finely made niches that have a small water channel in front of them (fig. 5.20). The entrance to this hallway of niches was camouflaged, suggesting that this was not some-

thing that most visitors to this area of the site were meant to know about. The niched hallway is a liminal space that would have been framed by two walls (the niched terrace wall and the south wall of CP4) and likely covered by a large roof eave. Dim light, a steep stairway, and narrow size helped conceal this space's existence and restrict entrance to it. For the uninitiated visitor, the access would have been all but invisible.

These two very different entrances to CP4 suggest that two very different types of visitors were intended to experience this room. One was a select elite, such as Topa Inca, appearing in view of those on the Pampa on the small exterior platform or through the single window. The other was perhaps a servant or priest, slipping down the narrow steep steps into the hidden hallway lined with niches, before disappearing into the secret entrance.[39] Servants may have had to access the

objects in the secluded niches (such as vessels that stored *aka*) to serve special rituals in CP4, or priests may have appeared suddenly in the hidden doorway as part of a special ceremony. Or perhaps, the priest was never seen, but his or her voice was heard through the entranceway, speaking as an oracle during a private ceremony with Topa Inca. Whatever the reason for this unusual architectural arrangement, it is clear that this room supported a purpose beyond simply watching events unfold on the Pampa or enjoying intimate ritual feasts.

While people on the Pampa would have had no idea about CP4's unique interior, they would have readily seen from its exterior that this was an exceptional structure. Clues to its distinct appearance lie in its foundation and can be traced in the excavated remains. The foundation walls begin well over a meter below the Pampa. These deep foundations would have supported an exceptionally large roof, so this small structure may have been planned to be unusually tall. When excavating this structure, José Alcina Franch and his team found remains of adobe, most likely laid on top of the finished limestone walls. This masonry practice can be found in other Chinchero buildings in which a base of fine stone masonry was topped off with several courses of adobe. In addition, ex-

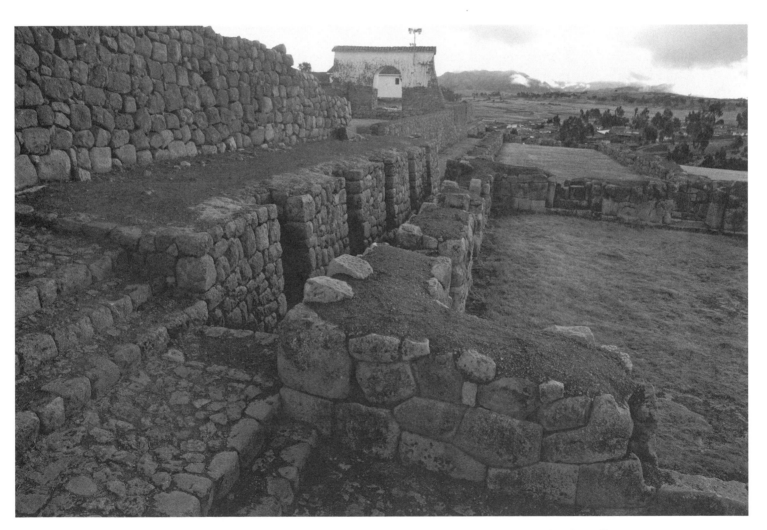

Figure 5.20 | Behind CP4 lies a very narrow pathway and a long terrace wall. This wall contains five tall niches, in front of which runs a small canal. This terrace wall was "reconstituted" by the I.N.C. Unlike the other terrace wall behind it, which is a completely modern invention, an original Inca five-niche terrace wall did once exist but was dismantled and rebuilt by the I.N.C. Photo by the author.

cavators found an extremely thick ash layer inside CP4, which was ritually sealed soon after it burned. This ash layer is believed to have come from the burning of the roof, suggesting that this modest-sized structure had an extraordinarily tall roof. Given its small footprint, this building must have appeared from the outside like a tower.[40]

The only known building type that looked like a tower in Inca architecture is a *suntur uasi* (*suntur wasi*), which is also one of the types described by Guaman Poma as being part of a royal estate. In Cuzco, there were two *suntur uasi* in the main plaza, both in front of the royal residence of Topa Inca's son Huayna Capac.[41] These were single-room structures with enormous roofs estimated to be as much as seven times the height of the building beneath.

The *suntur uasi* is often referred to as being round in form. Guaman Poma describes it as a "round house," and Holguin, who describes *suntu* as a "pile," also calls the type a "round house."[42] In the nineteenth century Ephraim George Squier described such a building (referred to as the *sondor-huasi*) in Azangaro as

> a circular building, apparently of compacted clay, sixteen feet in exterior diameter. The walls are fourteen inches thick and eleven feet high, perfectly smooth outside and inside, and resting on a foundation of stones. The entrance is by a door, opening to the north, twenty-eight inches wide and six feet high.[43] Within, extending around the walls is a bench of cut stones, except at the point immediately opposite the door, where there is a kind of dais of stone and compacted clay, with supports for the arms at each end like those of a sofa.[44] Sunk in the walls at about four feet above the floor are two series of niches, and at the height of eight feet are four small windows.[45]

The two *suntur uasi* located in Cuzco's Huacaypata are also described as being round in plan with immense, tall thatched roofs.

CP4 had a massive thatched roof but it was not round in plan. Therefore, if having a circular plan was part of the definition of the *suntur uasi*, then CP4 at Chinchero was not one. In that case,

it may have been a building type that was related, but it is also possible that a round plan was not *the* defining element of the *suntur uasi*. For example, the anonymous author translates *suntur uasi* as "a house made in the manner of a pyramid."[46] This means a building with a pavilion roof (a.k.a. pyramidal hipped roof). Such a roof needs the support of four straight walls that are similar in length. Covered in thatch (which would have given a rounded appearance to the roof, masking the hard corners of the pyramidal wooden frame below), this overall rounded appearance may have defined the *suntur uasi*, rather than that of a round plan.[47] This is another reminder that emphasizing building types according to floor plans can be misleading.

In both examples (curved and straight walls), the roof would have been the most visible element of the structure. Given that it would have been unusually tall, even by Inca standards, the roof of the *suntur uasi* would have been the building's most elaborate and impressive aspect. Squier's very detailed and effusive description conveys the significance of the roof:

> The dome of the Sondor-huasi is perfect, and is formed of a series of bamboos of equal size and taper, their larger ends resting on the top of the walls; bent evenly to a central point, over a series of hoops of the same material and of graduated sizes. At the points where the vertical and horizontal supports cross each other, they are bound together by fine cords of delicately braided grass, which cross and re-cross each other with admirable skill and taste. Over this skeleton dome is a fine mat of the braided epidermis of the bamboo or rattan, which, as it exposes no seams, almost induces the belief that it was braided on the spot.[48] However that may be, it was worked in different colors, and in paneling conforming in size with the diminishing spaces between the framework, that framework itself being also painted.[49] I shall probably shock my classical readers, and be accounted presumptuous, when I venture a comparison of the Azangaro dome, in style and effect, with that of the cella of the Temple of Venus, fac-

ing the coliseum, in the Eternal City. Over this inner matting is another, open course, and strong, in which was fastened a fleece of finest ichu, which depends like a heavy fringe outside the walls. Next comes a transverse layer of coarser grass or reeds, to which succeeds ichu, and so on, the whole rising in the center so as to form a slightly flattened cone. The projecting ends of the ichu layers were cut off sharply and regularly, producing the effect of overlapping tiles. From this it will appear that the Inca roofs were not really so rude and unsightly as we are apt to imagine from our knowledge of modern thatched building, associated as they are with poverty and squalidness. Certain it is, that, if the Sondor-huasi may be taken as an example of how ordinary structures like itself were ornamented interiorly, we can readily conceive that the interiors of the more important buildings and temples were exceedingly beautiful.[50]

This impressive, intricately woven roof highlights, again, the importance of the roof in Inca architecture. This is critical, as our present tendency is to dismiss the roof as a secondary or tertiary appendage of a building type. By contrast, for the Inca a distinctive roof may have been one of the defining elements of a building type.

The roof would have also played an important role in defining the interior character of a *uasi*. Squier's extensive details reveal the intricate attention given to these interiors, in this case to the elaborate ceilings. Thus, when discussing the *cuyusmanco, camachicona uasi*, or the *suntur uasi*, we must consider not only how walls and floors defined the character of individual spaces, but also the important role that elaborate Inca roofs would have played in dramatically defining imperial Inca spaces.

Highly placed windows would have helped to illuminate (and animate) these lofty interiors. Guaman Poma depicted a narrow, tall *suntur uasi* in the forefront of a plaza in a palace compound (fig. 4.6).[51] While we cannot tell if it is round or square in plan, it appears to be a tall, single-story building with one doorway and a window above, just as Squier described.[52] And although we cannot say whether

the Chinchero building had windows above, it did have at least one window and one "official" doorway. In addition, it would have had unusually tall walls. The abundant remains of adobe bricks found by Alcina Franch and his team suggest that the wall continued upward considerably. Adobe, as a lighter material than stone, would have allowed Inca masons to build much taller walls (and thus have more room for high windows) than they could have with heavy stone blocks.

Colonial writings indicate that another tall, straight-walled structure existed at an Inca royal estate. Huayna Capac's estate at Quispiguanca had a very similar structure. According to Garcilaso,

> [This building] was more than seventy feet square and covered with a pyramidal roof. The walls were three times the height of a man and the roof more than twelve times the height of a man. It had two small chambers on either side. This building was not burnt by the Indians when they launched their general rebellion against the Spaniards, because it had been used by the Inca kings to watch the chief festivities, which were performed in a very large square, or rather ground, in front of it.[53]

Except for the existence of the two antechambers, this building is remarkably similar to CP4. The building at Quispiguanca had tall walls, about 15 to 20 feet high, and an immense roof that was approximately 60 to 70 feet high. In addition, the Quispiguanca roof was pyramidal, which is what CP4's roof would have been. It is not discussed as round, and the footage seems to indicate it had normal straight walls (as all excavated buildings at Quispiguanca have). Like CP4, this building at Quispiguanca was situated in a large open space where performances on the royal estate occurred.[54] At Quispiguanca, it was a venerated building, as it was from this elite structure that the *sapa inca* watched events in the open space unfold.

This last piece of information provides support for a prior assumption that it was from this elite towering building, with its unique doorways and carefully restricted access, that Topa Inca watched events unfold on the Pampa. This exclu-

sive use also reveals why this structure had the unique features of a reversible double-jamb doorway and the hidden niche entrance. It was a venerated space *specifically* for the *sapa inca*, inside of which highly exclusive rituals occurred. Thus, it is not surprising that this was the only building ritually sealed after the royal estate was burned.

It is because the *sapa inca* once sat in this house to watch events that the space was transformed into a potent place. This was not unique to the *suntur uasi* but was something that came to define Inca place-making practices. Cobo relates that there were many places in Tahuantinsuyu that were considered *huaca* because "the places were those where these lords most commonly sat or that they frequented during their lives. For this reason, the number of shrines and [h]uacas greatly increased. . . . In addition to worshipping all of these places, they normally cast offerings to them."[55] In other words, the Inca sacred landscape grew each time a *sapa inca*'s presence in space and time (*pacha*) was deemed especially important and was ritually remembered with specific place-making practices. Thus, the tower buildings at Quispiguanca and Chinchero may have been designed as critical spaces to host the royal patron as well as venerated places for regal remembrance.

The placement of these "tower" buildings at Chinchero, Quispiguanca, and Cuzco provides important clues as to how these buildings fit into larger spatial practices at royal estates. In all three examples, the structures sit on the edge of a large open space. In Cuzco, the two *suntur uasi* sat in front of Huayna Capac's palace compound, while at Chinchero and Quispiguanca they sat at the edge of the open spaces, with the majority of the royal buildings (such as the private compound) behind them. This suggests that the *suntur uasi* mediated between the private royal residence and the public *pampa* and *pata*.

The existence of these similar "tower" structures at Topa Inca's estate and at that of his son Huayna Capac (Quispiguanca and Cuzco), as well as at a later possible elite residence (Tambokancha-Tumibamba), indicates that these buildings played

an important role in the later years of the empire.[56] There is no evidence of such a structure existing in any of Pachacuti's private estates (round or straight-walled), so the *suntur uasi* (or something similar) appears to have become an important part of royal estates *beginning* with Topa Inca's reign, as did the *cuyusmanco*. Taken together, this could mean that new types were introduced into the architectural canon of Inca royal compounds during his reign, making it a decisive time of architectural change and innovation. Whether adapting architectural practices from newly conquered regions, altering existing building types to suit new needs, or inventing completely new forms, Inca architecture under the patronage of Topa Inca was innovative and dynamic. Considering the hidden doorway at Chinchero, it also may have accompanied the introduction of new ritual practices related to Inca kingship at royal estates.

In terms of architecture, the *suntur uasi* provides a compelling example of the sophisticated ways in which the Inca crafted theatrical experiences in the most intimate and exclusive settings. These settings were not for the majority of the people who journeyed to Chinchero and were allowed no further than the Pampa. Nor were they even for many of the select visitors who were granted the special privilege of entering CP3 or CP5. Instead, this small but elaborate *uasi* held a private theater for only a very select audience, most likely Topa Inca and a few guests, such as Capac Huari and a priest. After Topa Inca's death, it may have served as a *huaca*, a sacred part of *pacha* to be venerated in remembrance of Topa Inca's actions. The building's unusual features, hinting at the movement of goods and people, is a reminder of how structures such as these were likely designed for specific rituals that unfortunately are now lost to us.

The Subtleties of the Inca Uasi

While Inca buildings shared many design and construction practices, they were also marked by subtle, purposeful distinctions. These understated variations provide critical clues into spa-

tial practices. For the *uasi* on Chinchero's Pampa, these variations disclose how Inca designers attempted to define authority through the control of access, layers of exclusivity, the creation of theatrical processions, and the manipulation of sight and oversight. These subtle architectural variations, rather than their overall form, reveal who had access to these structures and what messages they were designed to convey.

In a study of these *uasi*, we see how openings, in particular, their placement, size, and articulation, expressed royal authority. Doorways served as critical stages in front of which Topa Inca could enact his authority while windows actively defined hierarchy through sight. Windows shifted the balance of power squarely to the person looking out, and in the case of the three grand *uasi* on the Pampa, this gave Topa Inca and his invited guests a clear visual and spatial power over those on the Pampa.

These three *uasi* on the Pampa also highlight an important transition in terms of the public and the private. One building (CP5) marks the end of the journey for most visitors to Chinchero. The pilgrimage to Chinchero was designed as a series of stages in which people were increasingly prevented from pushing forward. CP5 was the ultimate access point for those lucky enough to be able to enter; it was also the space in which those select few could have the opportunity to meet Topa Inca up close, albeit in a highly controlled and staged setting.

By contrast, another building (CP3) marks the beginning of the private spaces of Chinchero. Reserved for close family and friends, this space is the first of many devoted to the private life of Topa Inca. Here select family members and visitors could gather to watch events unfold on the Pampa. While initial access to this space was highly restricted, a plethora of subsequent doorways welcomed these elites with ease of movement. These Inca nobles, the extended family members of Topa Inca, would decide the fate of Topa Inca's sons and the future of imperial rule. This space was more than a luxurious viewing box; it was a space in which critical relationships could be solidified and understandings for future actions agreed upon. Of course, Chinchero's patron, Topa Inca, would have hosted and led these negotiations. For that reason, it is no surprise that between these two buildings loomed a structure dedicated to the ruler himself, symbolizing Topa Inca's powerful presence in both sectors of the estate. As Niles has said, "The Incas sought to make history visible," and Topa Inca used his estate to write his official autobiography.[57]

In the next chapter, we will see how the spaces of private life came to define a critical aspect of royal estates, one that has often been overlooked in the scholarly literature. It was here, in the most private of spaces, where complicated issues of the body (sleep, sex, eating, defecating), of family (wives, lovers, children, siblings), and of service (storage, washing, treasury) informed, shaped, and redefined the built environment of the royal estate.

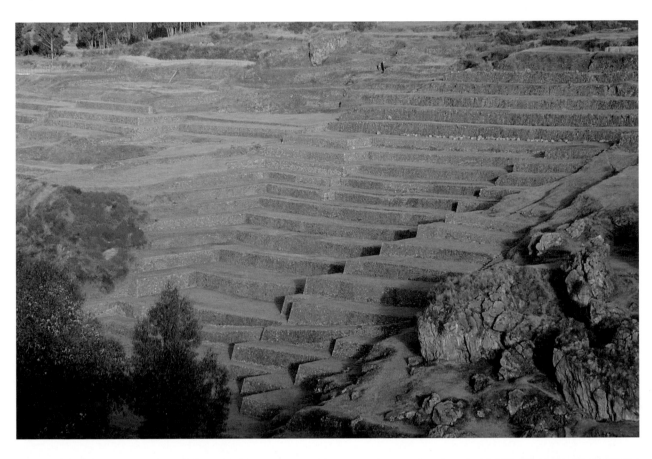

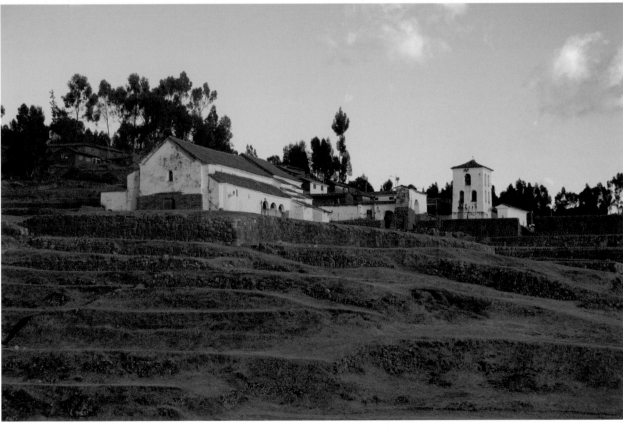

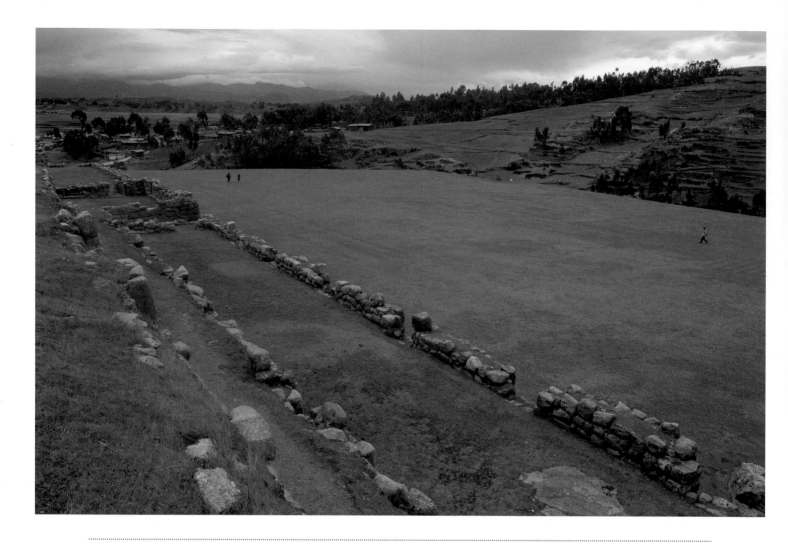

Figure 1.1 | (*previous above*) View of Inca terraces that lie below the town of Chinchero.

Figure 1.2 | (*previous below*) View of the terraces below the main "plaza" (northwest side).

Figure 1.7 | (*above*) Main plaza (Pampa) and three buildings to the south.

Figure 1.19 | (*opposite above*) Façade of the Chinchero church.

Figure 1.21 | (*opposite above*) View across the Pampa, looking toward Antakilke.

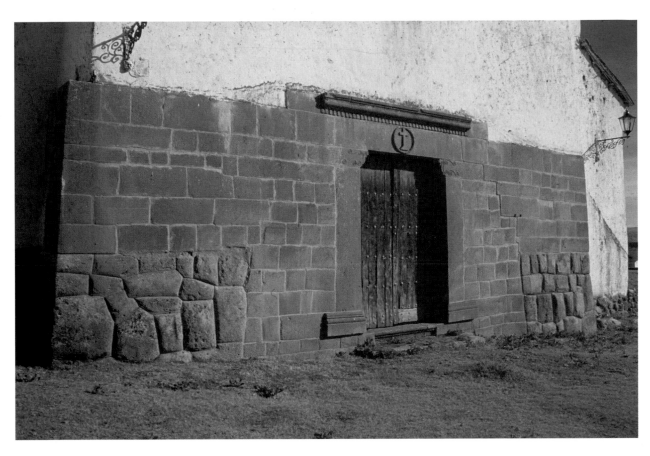

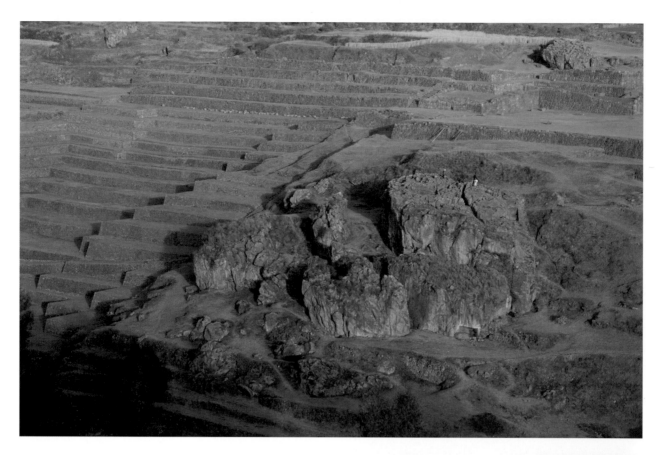

Figure 1.22 | (*above*) View of two outcrops, Titicaca and Pumacaca.

Figure 2.6 | (*right*) Miniature, multi-color wall at Cuper Bajo.

Figure 2.14 | (*opposite above*) Terraced northern façade of Chinchero.

Figure 2.15 | (*opposite below*) Four outcrops in Chinchero: Chinkana, Condorcaca, Titicaca, and Pumacaca.

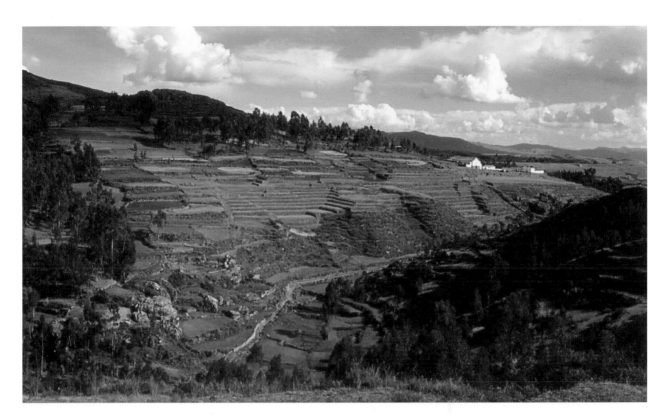

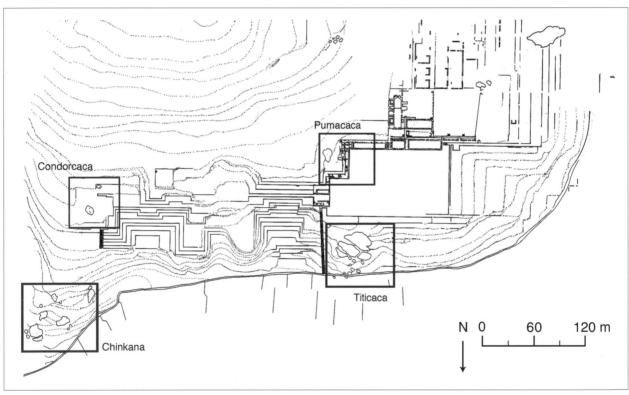

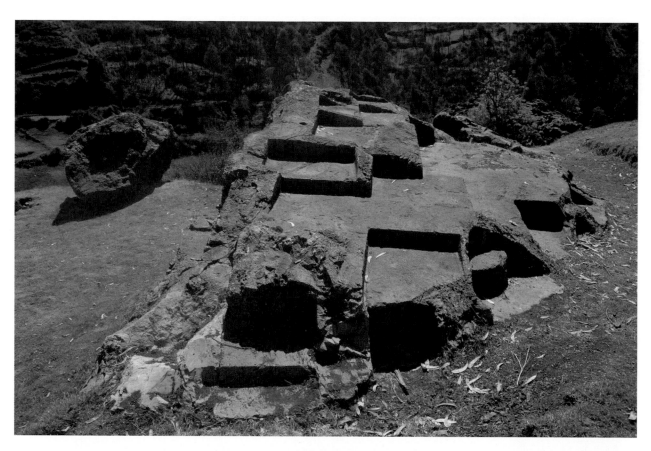

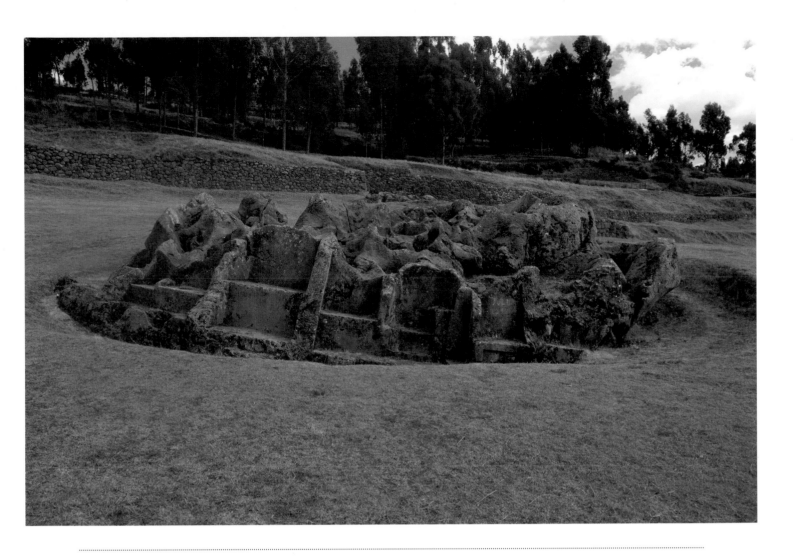

Figure 2.16 | (*opposite above*) Stepped, geometric carvings at Chinkana.

Figure 2.23 | (*opposite below*) The large Condorcaca stone.

Figure 2.24 | (*above*) Condorcaca, row of stepped carvings.

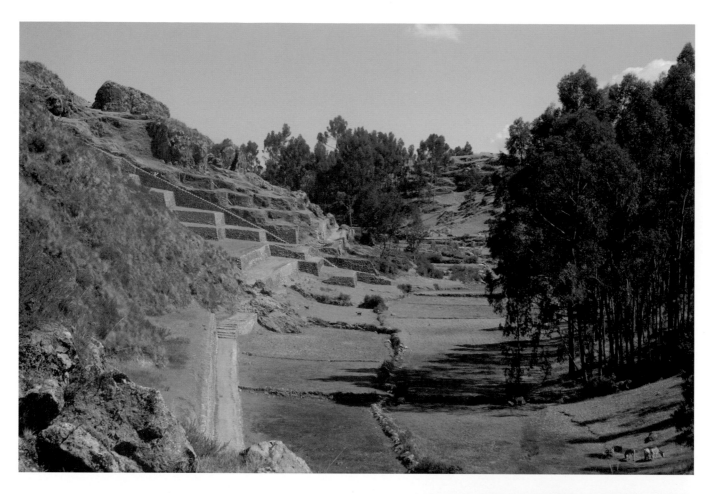

Figure 2.26 | (*above*) Inca road in the Chinchero Valley.

Figure 2.28 | (*right*) The entrance to Titicaca.

Figure 3.2 | (*opposite above*) View of the Pampa.

Figure 3.11 | (*opposite below*) Path from the Pampa to Condorcaca.

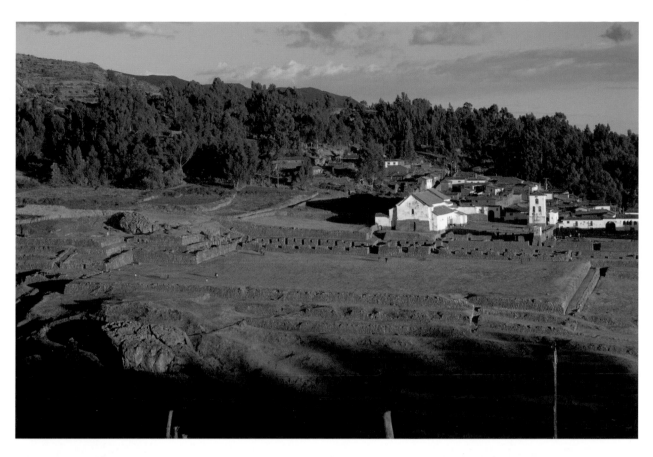

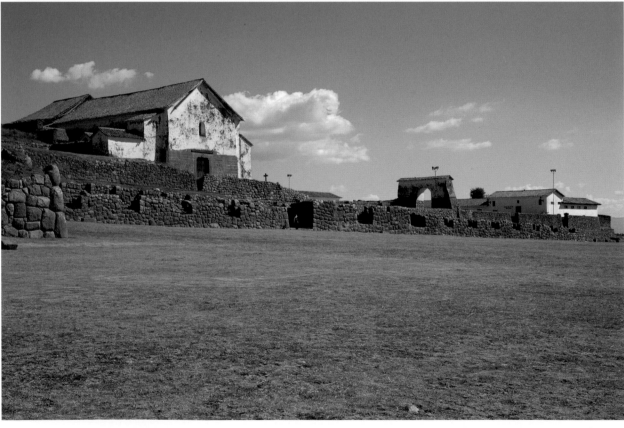

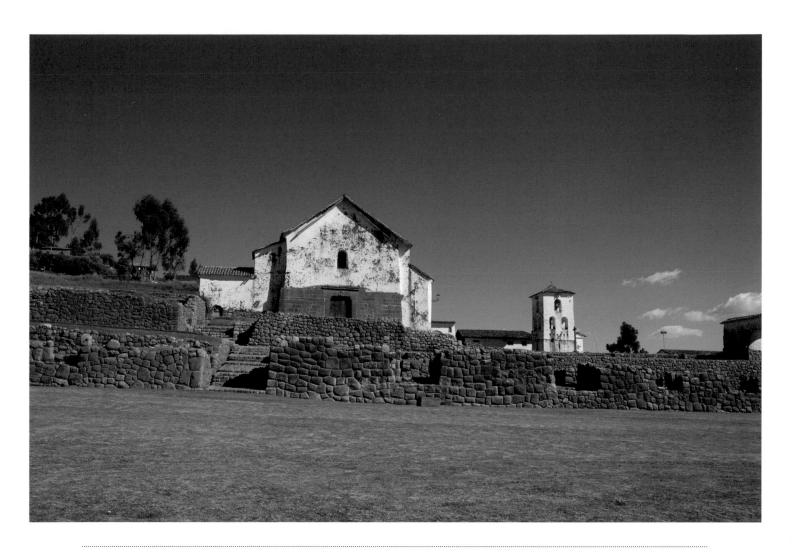

Figure 3.13 | (*opposite above*) Terrace pathway from the Condorcaca outcrop to the Pampa.

Figure 3.15 | (*opposite below*) View of the southern side of the Pampa.

Figure 3.16 | (*above*) View of the Pampa's south wall.

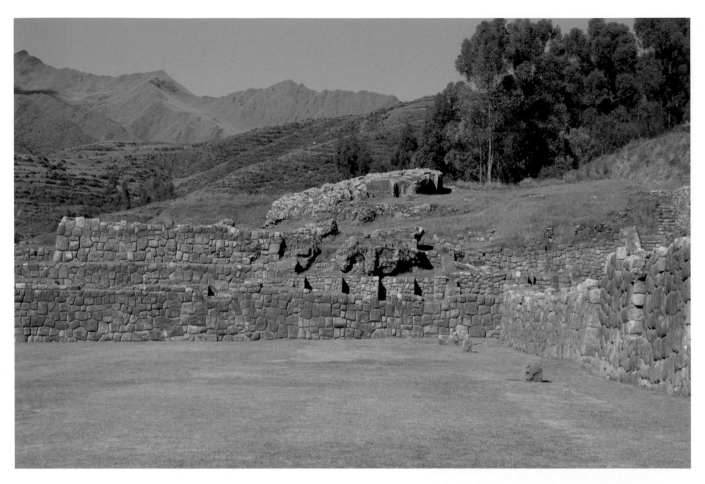

Figure 4.1 | (*above*) Pumacaca, three lithic components.

Figure 4.6 | (*right*) Guaman Poma's drawing of a palace.

Figure 4.14 | (*opposite above*) One of the three-walled structures at Machu Picchu.

Figure 5.16 | (*opposite below*) View of the inside of CP4.

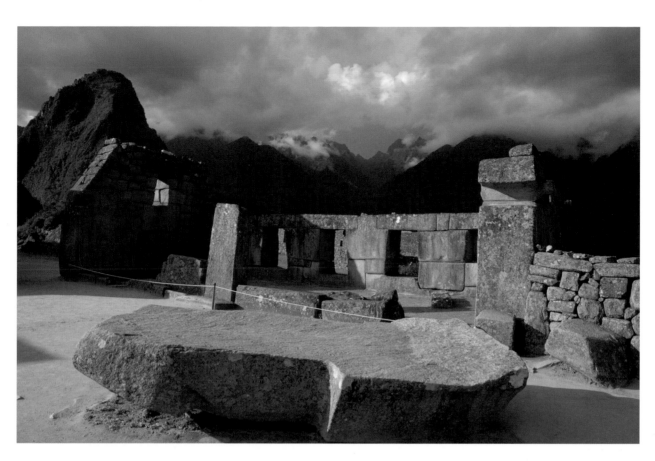

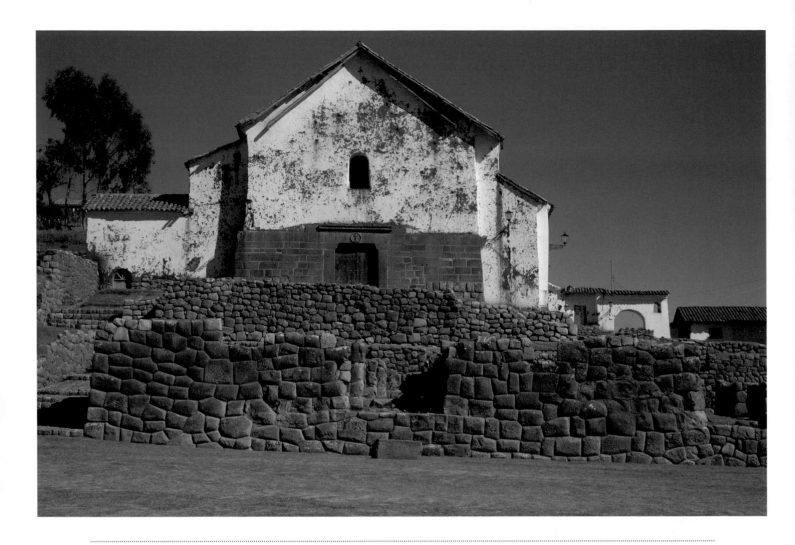

Figure 5.17 | (*above*) The northern façade of CP4.

Figure 6.1 | (*opposite above*) Color-coded site plan of private *pata*. Five gray color blocks mark the approximate location where the foundations of imperial Inca buildings were excavated and reburied. The red lines indicate the path leading from the Pampa to the private *pata*. Freestanding Inca walls (as opposed to embedded terraces) are marked in green.

Figure 6.7 | (*opposite below*) The long wall with tall niches.

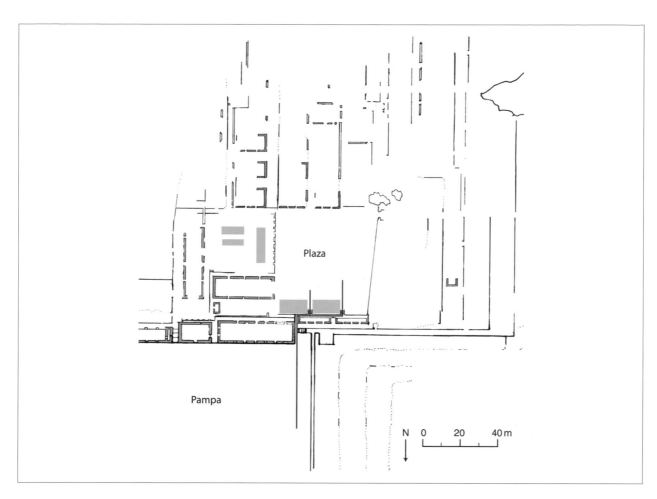

Plaza

Pampa

N 0 20 40 m

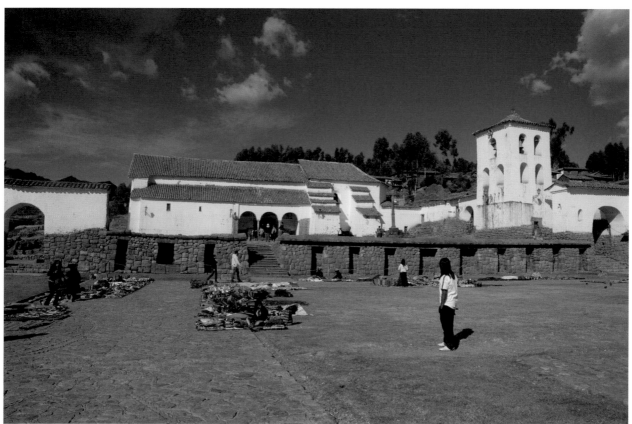

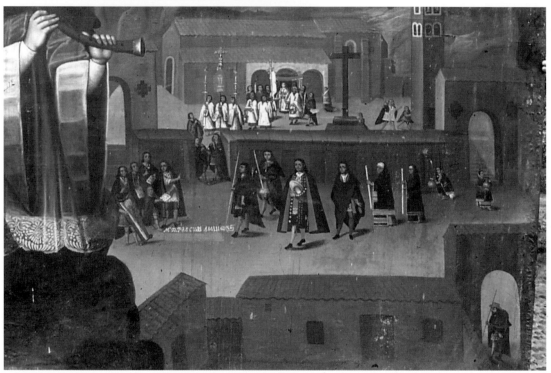

Figure 7.14 | View of some of the murals on the church ceiling.

Figure 7.16 | Detail of Chivantito's *Virgin of Montserrat*.

6 | PATA | PLATFORM

Although Chinchero's most impressive architecture formed the grand entrance to the ceremonial Pampa, this majestic stage set was not the nucleus of the royal estate. That designation belongs to a small collection of buildings on a series of elevated terraces, or *pata*,[1] hidden out of sight. One of these *pata* was an open space that served as the nexus for Topa Inca's private life. This was where the *sapa inca* would have spent much of each day and most of his nights.[2] It was in this highly restricted and impressive setting that close family members and a few very select visitors came to exchange gifts and confidences with Topa Inca. Moving among them would have been a cadre of skilled and trusted servants who serviced these private events, waited on the ruler and his family's every need, and cared for their fine posses-

sions. It was also in this intimate setting that the ruler spent time alone with his family, where he dressed, ate, slept, and had sex. Despite its importance, we do not know what the Inca would have called this critical portion of the royal estate. Hence in this book we will refer to it simply as the "private *pata*."

Unfortunately, this portion of Topa Inca's estate has been greatly damaged over the centuries, rendering its built environment into scattered fragments. To further compound the problem, no comprehensive study has been undertaken on the architecture of the private sector of any other extant royal estate. There are three main reasons for this lack of scholarship. The first and perhaps most important reason lies in the simple fact that we have no idea how to recognize it. Since the Inca

did not have distinct building forms that were coupled with specific functions, there are no particular forms that we can find in the archaeological record that can identify where private life occurred or what intimate functions happened in those particular spaces. The second reason is that many Inca sites (like this section of Chinchero) are damaged—the areas where we think private life may have once been centered are now lying in pieces. The third reason that we know so little about the private lives of Inca rulers is that Spanish writers during the colonial period spent the majority of their time documenting Inca religion and state concerns, making it difficult to find colonial sources that discuss the intricacies of Inca private life.

However, there are ways we can bridge this knowledge gap. Although it is no longer possible to conduct a full spatial analysis of Chinchero's residential sector (as we did for the roads and pathways to Chinchero and its Pampa), we can examine the remaining wall fragments as they relate to the limited colonial writings about the architecture and spaces of royal private life. This is useful, as it raises important questions not only about the design, use, and meaning of Topa Inca's estate (Pampa, *pata*, and surroundings), but also about Inca perceptions of privacy, family, class, and the everyday.

Private Space

If we cannot recognize the architecture of Inca private life, how can we locate it? One option lies in spatial practices. Craig Morris was one of the first scholars to note that Inca palaces tended to be divided into two consecutive spaces, one public and one private.[3] Working separately, Susan Niles discovered this dual pattern in the architectural remains at Quispiguanca, the royal estate of Huayna Capac.[4] Both Morris and Niles found that the public and private sections of royal estates were concentrated around large open spaces. Ian Farrington found a similar pattern in Cuzco, revealing that even in the relatively dense quarters

of urban palaces, this dual division was considered of prime importance.[5]

References to this twofold arrangement can be found in the colonial writings of Martin de Murúa.[6] Murúa described a dual division in a royal estate (we do not know to which estate he was referring). The first section was composed of a large open space where most people would have entered, and the second was a smaller, more exclusive sector. About the latter he wrote,

> There was another great plaza or patio for the officials of the Palace, and those that had regular occupations inside, who were waiting there for the orders [to be] given to them according to their function. Next came the vestibules and rooms and chambers, where the Inca lived and all this was full of delight and joy, because there were groves of trees and gardens with a thousand types of birds that went about singing; and there were tigers and lions and leopards and all of this type of wild beasts and animals that they discovered in this kingdom. The chambers were large and spacious, worked with marvelous skill, because among themselves they did not use wall hangings, nor the tapestry that we have in our Europe, their walls were well worked with riches and adornments of much gold and embossing of figures. . . . There was in the Palace of the Inca a room of treasure, that they called *capac marca huasi* that signified a rich chamber of treasure, which served as what we here call the Royal Coffers. (translation by Jean-Pierre Protzen)[7]

Murúa's description provides a sense of the spatial layout of the private sector, the types of amenities that were there, and the people who were allowed access to them. He described this area as being much smaller than the first plaza, with fine buildings lining its grand central space. It had richly appointed interiors, lavish gardens, servants, and storage for royal goods. Murúa also wrote that this space was accessed from the main "plaza" by only

> the grand Inca with the four *orejones* [who] entered the second doorway that also had a guard composed of Indians native to the city of Cuzco, *orejones* and relatives and descendants of the Inca,

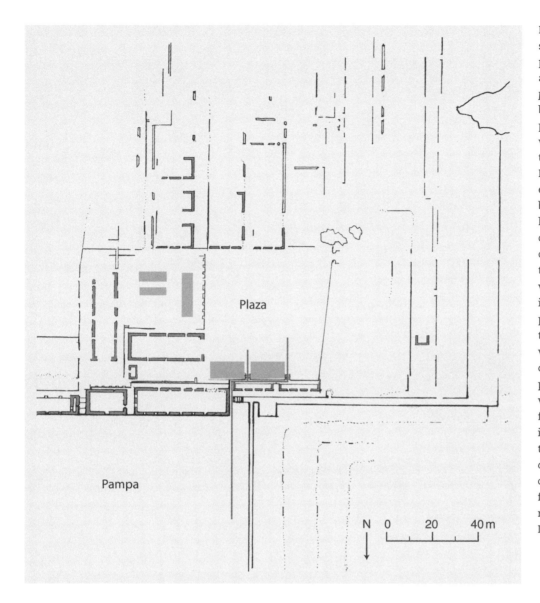

Figure 6.1 | Site plan showing only the imperial Inca remains around the private *pata*. Five gray color blocks mark the approximate location where the foundations of imperial Inca buildings were excavated and reburied. The lines leading in and out of the plaza indicate the path from the Pampa to the private *pata*. Freestanding Inca walls (as opposed to embedded terraces) are filled in with gray. As many of Chinchero's imperial Inca buildings were part of or arose from terrace walls, it is likely that some of the terrace walls indicated on this map once served as the foundations of imperial Inca buildings. Image by the author.

whom he trusted. . . . At this second door there were one hundred captains of those who must have distinguished themselves in war and who were practiced in it, who were kept there for the case that there should be a war on an expedition [and that they could be] dispatched on short notice and without delay.[8]

While Murúa wrote in general terms about this portion of the estate, rather than in particulars, his description makes clear that the royal estate in question had a dual organization and that the center of private life was in the second space, focused around the smaller "plaza."[9]

Although it was not the estate Murúa was describing, Chinchero had a very similar layout. There are two "plazas" (the Pampa and a *pata*). Each had a single entrance that was highly regulated, but at Chinchero the entrance to the private sector was hidden. The few people who learned of its location (and were permitted access) would have had to pass between two Inca buildings, turn down a single narrow hallway bounded by high Inca walls, and finally climb one of two grand staircases that left the traveler suddenly exposed on top of the open *pata* (fig. 6.1). In other words, the entrance to the private sector of Topa Inca's estate was carefully designed to control access,

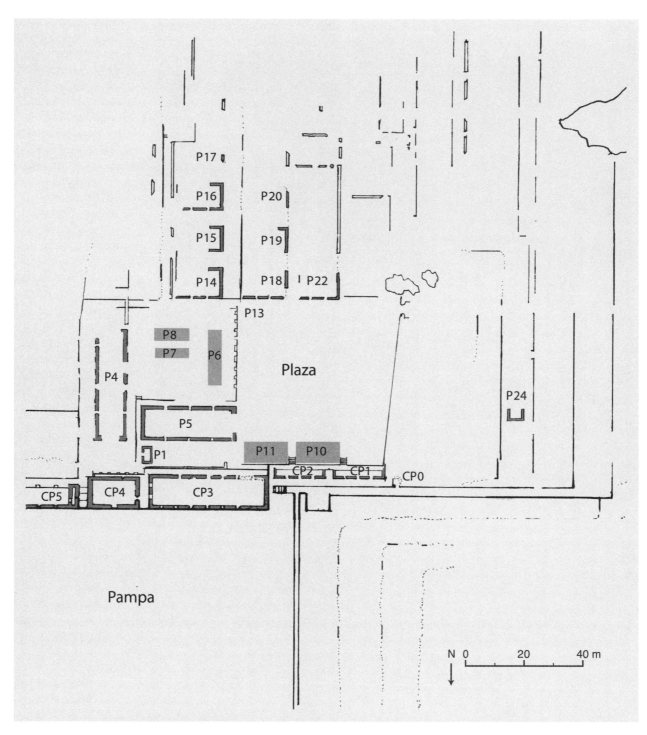

Figure 6.2 | Numbered site plan of the private *pata* area showing the location of buildings discussed in this text. Image by the author.

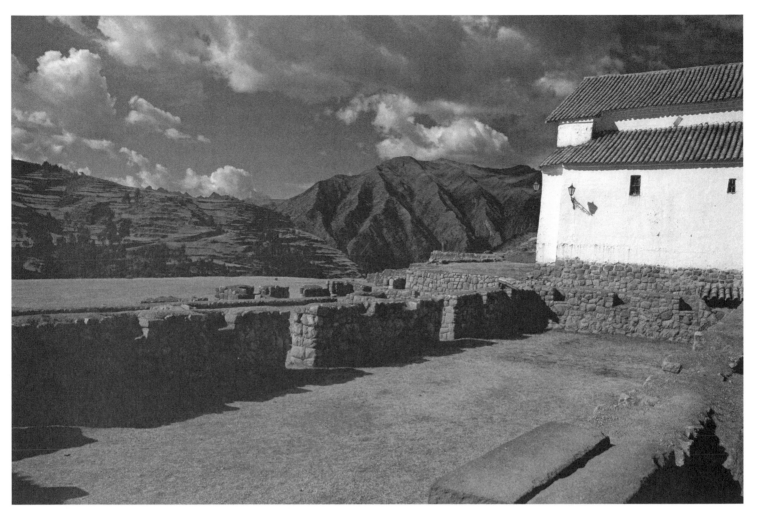

Figure 6.3 | View toward the northeast, into the interior of the *cuyusmanco* (P5). Note the burn scars on the bottom of the walls, which occurred when the burning roof collapsed. Photo by the author.

with or without many military guards standing at attention.

Once at the top of the staircase, the visitor would have been faced with a scene similar to the one described by Murúa. Inside the private sector was a well-appointed open space surrounded on three sides by finely made structures (fig. 6.2). Two small rectangular buildings (now destroyed) bounded both sides of the north entrance.[10] Far to the visitor's left (east) was an impressive Inca *cuyusmanco* (P5) whose large doorway faced the *pata* (figs. 6.3–6.5). Next to it was the entrance to a long narrow passageway and staircase that led to another grand *cuyusmanco* (P4), which overlooked the Pampa. Above and well behind these structures

lay Antasaqa, an immense, uncarved *huaca* that overlooked the royal estate and the vast surrounding valley (fig. 6.6). On the opposite side of the entrance was a finely made (though unfinished) Inca wall (P13) with multiple niches (figs. 6.7–6.8). This wall helped enclose three long rectangular buildings (P6, P7, P8), now destroyed and buried.

While the east side of the private *pata* had an impressive façade of finely made polygonal limestone buildings, the south and west sides incorporated open space and thus the views beyond. On the south side, three Inca buildings (P14, P18, P22) formed a formidable stone façade punctuated by doorways and streets, before ending in a steep drop-off (figs. 6.9, 6.10). The latter revealed that the

Figure 6.4 | View of one of the regularly sized and spaced doorways in the north façade of the *cuyusmanco* (P5). After it was burned, this building was reused in the colonial period for a short time before it was buried when the church was built. The doorway shown is perfectly aligned with the one on the opposite wall, a common practice in many imperial Inca buildings. Photo by the author.

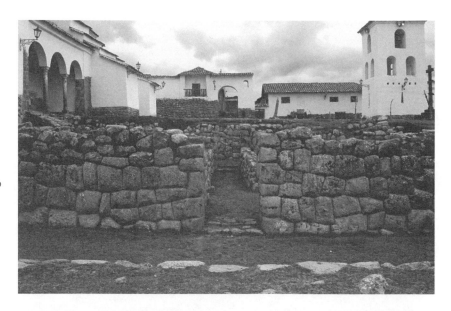

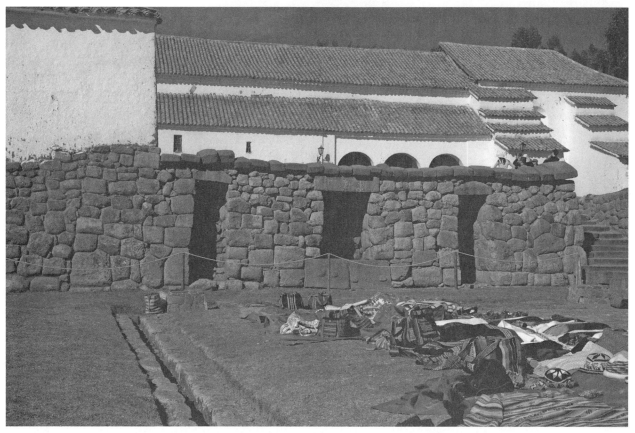

Figure 6.5 | The outline of the *cuyusmanco*'s (P5) distinctive large opening can still be found in Chinchero today. However, it is not readily recognized, as it later became embedded in early colonial construction. This photograph shows the original opening of the *cuyusmanco*. The bottom two-thirds of its western wall (which once formed the large opening) has been continued with poorly worked stones. The large opening itself was filled in with similar stones to create three large Inca-style niches. On the northern corner of the *cuyusmanco*, a colonial-period arch was built with stone and adobe. To the south of the *cuyusmanco* (to the right in the photo) is the opening that led down a finely made hallway, which in turn, led to the other *cuyusmanco* (P4) and likely to the entrance to the enclosed *punona uasi* compound. In the colonial period, this hallway was turned into a staircase (using andesite lintels from a destroyed Inca building) and its adjacent buildings were filled in to create a raised atrium for the Church of Nuestra Señora de Montserrat. Photo by the author.

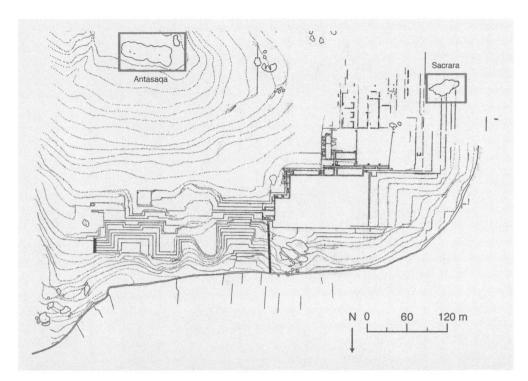

Figure 6.6 | Map of Chinchero showing the location of the two rock outcrops marking the eastern and western boundaries of the private sector of the royal estate: Antasaqa and Sacrara (respectively). Both of these outcrops became involved with Christian rituals and place-making practices during the colonial period. Image by the author.

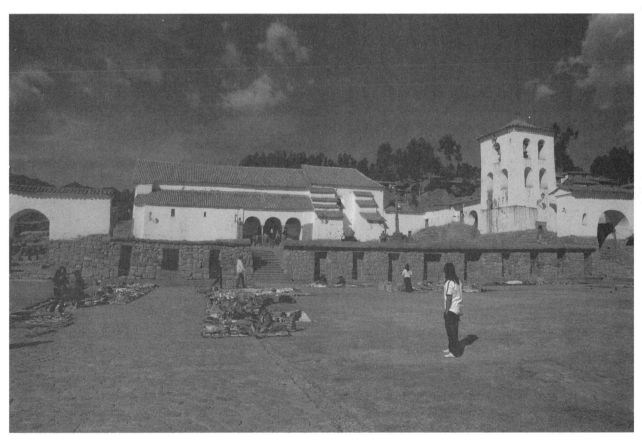

Figure 6.7 | The long wall with tall niches (shown to the right of the colonial staircase) was begun in the imperial Inca period but not completed. It was the western wall of a compound that may have contained the *punona uasi* of Topa Inca. Later, during the early colonial period, two arches dedicated to the Virgin of Montserrat were erected on either end of this Inca niche wall. Behind this wall is the western façade of the Church of Nuestra Señora de Montserrat, built on top of the *cuyusmanco* (P4). Photo by the author.

Figure 6.8 | Close-up of one of the imperial Inca niches in the long wall lining the eastern side of the private *pata*. The stones on the bottom half of the wall are made with finely carved and laid polygonal limestone masonry. By contrast, the stones on the top portion are poorly worked and fitted. In addition, the top faces of these imperial Inca stones (the last layer laid) are only minimally worked—there are no bedding joints where the next layer of stones would have been placed. This reveals that the imperial Inca wall was never completed. Instead, it was abandoned during imperial Inca times and continued some time later. This second phase of building most likely occurred when the church was built, and this freestanding imperial Inca wall was turned into a terrace wall to support the church atrium. Photo by the author.

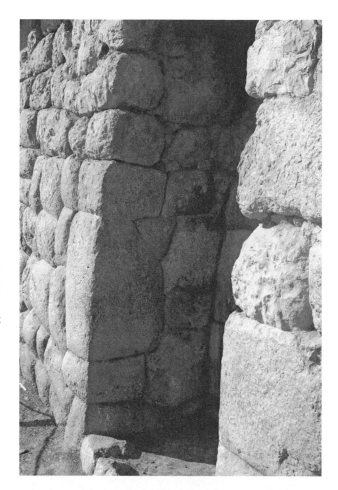

Figure 6.9 | The imperial Inca walls, made up of polygonal limestone blocks, are visible at the bottom of the colonial buildings bordering the private *pata*. Some of these walls were later burned (see right side of photo), indicating that parts of the private *pata* were set ablaze. In the colonial period, these Inca walls were topped off with adobe (and in some cases with reused imperial Inca blocks). The colonial-period arch visible in the photograph is called the arch of Ayllupongo; it frames the entrance to the imperial Inca street Chequpunku. Photo by the author.

Figure 6.10 | View of the terrace wall that supported the south side of the private *pata*. The top of the imperial Inca terrace wall is now continued with modern stones and a large freestanding adobe structure that lines the plaza. Photo by the author.

Figure 6.11 | Close-up view of a few of the glaciated peaks that are visible from the private *pata*. Photo by the author.

open space of the private sector was a small terrace (*pata*). The terrace wall was prominent along the south and west sides of the *pata*, suggesting that there were unobstructed views to the broader landscape (fig. 6.11). This included the Anta plains and the sacred glacier peaks of distant *apu*, as well as the impressive *huaca* Sacrara (fig. 6.12). This sizable outcrop is nestled at the foot of the western terraces, marking the western edge of Topa Inca's architectural residence (fig. 6.6).[11] Like the Pampa,

Figure 6.12 | The large outcrop called Sacrara. During the imperial Inca period, this *huaca* marked the edge of the architectural portion of Topa Inca's private residence. In the colonial period, a chapel (Yana-cona) was built on top of the outcrop. Photo by the author.

the *pata* was an open space defined by impressive imperial Inca architecture and breathtaking vistas of the sacred landscape.

Cuyusmanco

Also like the Pampa, the private *pata* had a *cuyus-manco*. The remains of the impressive *cuyusmanco* (P5) are the first thing one notices inside the private sector of Chinchero today. Originally, this structure would have opened directly out to the *pata* (the building's opening was subsequently filled in during the colonial period), its steep gable and wide opening dominating the surrounding space. This building is similar in form, construction, and layout to its counterpart overlooking the Pampa (P4); both of these long rectangular build-ings have the same directional and spatial rela-tionship with an adjacent open space.[12] Each was made of polygonal limestone masonry topped by adobe bricks, with symmetrical doorways run-ning along the long walls and a grand opening on one short wall. As discussed in Chapter 4, the *cu-yusmanco* was a distinct building type that sym-bolized the authority of the *sapa inca* and was likely used in state functions. But, if this was a state building, why was it in the private sector of Topa Inca's royal estate?

Murúa's initial description of the private estate implies one possibility. While he suggests that this exclusive area of the estate was reserved for the *sapa inca*, his family, close friends, palace of-ficials, and servants, he also alludes to another group. Murúa states that the *sapa inca* entered this section of the estate with four of his *orejones*.[13]

Given that Inca nobles held the most powerful positions in the Inca state, from military leaders and governors to architects and religious officials, it is likely that these *orejones* were Inca state officials. The fact that they could enter the private sector of a royal estate reveals that this domestic sphere was not devoid of state function; to the contrary, it was intimately entangled with it.

As Thomas Cummins and Stephen Houston have shown, the Inca state was understood as fundamentally intertwined with the *sapa inca*, such that the capital of Tahuantinsuyu was considered to be wherever the *sapa inca* was.[14] For Topa Inca, this meant that he was the Inca state in even the most private parts of his royal estate. This is an important point, as it challenges how we understand "private" space at a royal estate. The terms "public" and "private" can denote an emphasis on either sector at Chinchero; however, we must remember that while the spaces we call the Pampa and the private *pata* were strictly controlled and regulated, the private and public activities that took place at Chinchero could transcend these boundaries.

The issue of state officials in the private sector of the royal estate also opens up more pragmatic concerns. Bringing a small group of high-level officials into this more personal sector of the estate would have enabled discreet negotiations. The Pampa (with its immense space and choreographed views) was all about seeing and being seen, but the small, restricted space of the *pata* was designed for exclusivity and occlusion. Thus the two *cuyusmanco* serviced royal state encounters, but on very different scales.

We are given a sense of what such a state space in a ruler's private quarters must have been like by Agustín de Zárate, who described a reception with the *sapa inca* Atahualpa within his residential compound at his "camp" outside Cajamarca. Zárate described this area as an open space framed by buildings (a *cancha* arrangement). Waiting to receive his visitors, Atahualpa (the grandson of Topa Inca) sat on a short chair for the ruler (likely a *tiana*), at the threshold of the door to his day room.[15] For this reception in the open space,

buildings were not penetrated by the visitors, but rather served to frame the scene and articulate the status of the ruler.[16]

In many ways, this scene is a small-scale version of what we have seen at the Pampa. There, Topa Inca could sit in front of his *cuyusmanco* to welcome visitors arriving onto the Pampa. In these royal encounters with visiting officials, critical negotiations would have taken place. While some of these encounters would have been about the large-scale colonization practices of the Inca state, other receptions may have had to do with internal affairs. As the leader of a rapidly growing empire built largely on colonization, the *sapa inca* had to be constantly on guard against revolts, not only from newly conquered provinces, but also from within elite Inca communities. The quest for power could drive brother against brother, and cousin against cousin.

The Inca heartland was particularly vulnerable to internal coup attempts during two events: (1) when the ruler was called away in battle (which often lasted many years) and (2) during transitions of power, when a ruler died and the appointed heir prepared to succeed him (it could take a year or two before a formal investiture made the new ruler official). During these precarious times family loyalties were called into question and a desire for power pervaded family exchanges. The *sapa inca* had to be very careful as to who within the small network of Inca elites could be trusted. Hence, spaces for subtle negotiations between the *sapa inca* and powerful relations were of critical importance to both the maintenance of power and smooth imperial successions.

The scene that Zárate describes could have occurred in Chinchero's Pampa as well as in its private *pata*, as Topa Inca tried to sway important family members visiting from his father's estates in the Urubamba Valley. While the architecture of Atahualpa's compound may not have been exactly the same as at Topa Inca's estate, it is likely that the spatial arrangement was similar. The description that Zárate provides suggests that, in Atahualpa's residential area, the day room in front of which he sat had a doorway that opened out onto the cen-

tral open space. He also describes this building as a "gallery," a single-room, rectangular building. However, he does not describe its openings (such as a large one on its gable end), suggesting that this "camp" building was not a *cuyusmanco* but instead a standard Inca form with one or two regular doorways. The fact that Atahualpa's private compound likely did not have a *cuyusmanco* suggests that these were not part of imperial "camps" or that one was not essential for the ruler's private compound in general.[17] If the latter was the case, then why was there one at Chinchero?

An answer may lie in the political and personal controversies that defined the last years of Topa Inca and the period when Chinchero was built. As discussed at the beginning of this book, Topa Inca was the first historical (versus mythical) *sapa inca* to marry a close relative (she was likely a half-sister).[18] Mama Ocllo is described in the colonial accounts as a powerful consort who wielded control over her own lands and worked well with her husband (fig. 6.13).[19] She is also described as suffering from bouts of jealousy over her husband's other women. Perhaps to compensate, she doted on her son, Huayna Capac. As the principal wife, she had good reason to assume that her son was the front-runner to inherit the *mascaypacha* (royal fringe) upon Topa Inca's death. But everything changed when Topa Inca decided to build Chinchero.

Colonial sources tell us that Topa Inca built this new estate as a place to spend his final years with close friends; his favorite consort, Mama Chequi Ocllo; and their son, Capac Huari. This controversial change, when Topa Inca had shifted his preference for a successor from Huayna Capac to Capac Huari, would have reverberated among the Inca elites, particularly in the most powerful *panaca* of the time, Pachacuti's Iñaca.

As he shifted his allegiance to the son of Mama Chequi Ocllo, Topa Inca would have had to tread a very careful path. Not only was Topa Inca not choosing the child of a principal wife, which was the tradition in Inca history (though not always practiced), but he was also choosing a child whose mother had a lesser status than the principal wife.

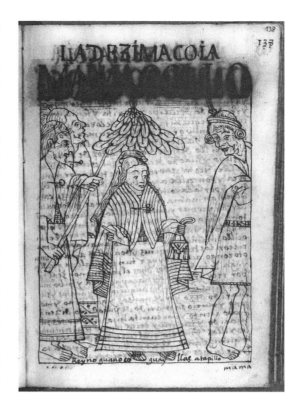

Figure 6.13 | Guaman Poma drawing of Mama Ocllo, Topa Inca's principal wife. Felipe Guaman Poma de Ayala, "The Tenth Qoya, Mama Ocllo," *El primer nueva corónica y buen gobierno* (1615/1616), GKS 2232 4, Royal Library of Denmark, Copenhagen, 138[138].

While we do not know the lineage of Chequi Ocllo, the colonial records reveal she did have important supporters in Cuzco (not in the Urubamba Valley or in the provinces), indicating she likely belonged to an imperial *panaca*, although not Iñaca.

If the royal couple were half siblings (sharing the same father), Topa Inca and Mama Ocllo would have shared many powerful brothers and sisters in Pachacuti's *panaca*. Many of these siblings would have resided in the rich lands of their father in the Urubamba Valley and held some of the highest positions in the imperial administration. In order to garner their support and ensure the success of his favored younger son, Topa Inca would have had to find out which of his close relatives would support this change in succession and which ones would likely support the desires of Mama Ocllo. One can wonder about the delicate negotiations that must have taken place as Topa Inca and Mama Ocllo

each tried to woo their mutual siblings, cousins, aunts, and uncles to their respective causes. Any misplaced confidence could tip their hand, leading to disastrous results if the person they favored did not emerge victorious.

The one advantage that Topa Inca had over Mama Ocllo was his status as *sapa inca*. And this status was symbolized in the *cuyusmanco*.[20] Given the fragile and secretive discussions that would have occurred between Topa Inca and other powerful elite Inca nobles, this potent architectural symbol of Topa Inca's majesty would have served as a critical stage on which the ruler played out his delicate negotiations. For most visitors to Chinchero, the authoritative message of the Pampa would have been clear. This space, which celebrated the power of Topa Inca, reiterated to the visiting Inca nobility that Topa Inca's chosen heir was the son sitting by the ruler's side. But, for those few visitors with whom Topa Inca needed a more personal setting, the intimate and hushed confines of the private *pata* (and its *cuyusmanco*) awaited.

Storehouses

The *cuyusmanco* in the private *pata*, with its distinctive opening, fine masonry, and lofty roof, must have been impressive. Yet, this would have been only one part of the stage upon which Topa Inca enacted his regal performance. A critical part of this theater would have been the lavish goods required to meet the specific needs of the individual scene and players, in both display and gifting. According to Zárate, this royal reception space was filled with opulence. Atahualpa sat in front of his day room dressed in an exquisitely woven *uncu* (tunic), *yacolla* (cloak), and *mascaypacha* (red royal fringe), while women brought pairs of *aquilla* (precious metal cups) filled with *aka* (corn beer).[21] In this lavish setting, building and objects worked together to convey identity and authority.

One reason for these rich goods was to convey the *sapa inca*'s power, but another reason was *ayni*. *Ayni* was Quechua for Andean reciprocity, which informed all levels of Andean existence. From the poorest of subsistence farmers to the most elite of Inca leaders, the ritual exchange of gifts bound one man with another and one family or community with another. The Inca state made great use of *ayni*. John Murra has shown how the Inca gave gifts (such as high-quality textiles) to create obligations to the state.[22] For the Inca ruler, this was a critical element in securing loyalty. Thus, when Topa Inca invited elite Inca noblemen to sit in front of his *cuyusmanco*, or perhaps even to enter into it with him, they would have witnessed a procession of fine objects that evoked the senses of sight, sound, taste, and perhaps touch. Some of these would have been gifts that bound the participants into acts of obligation with the Inca state (and the *sapa inca*). Others, such as the lavish goods distributed in the private *pata*, would have been critical in gaining the allegiance of key Inca elites to Topa Inca's personal desire, namely, his favored heir apparent, Capac Huari.

Storage buildings would have been necessary to house all the finery that Topa Inca would have needed to properly stage ceremonies in and around the *cuyusmanco* and private *pata* (and for that matter, the Pampa and its *uasi*). The importance of these storehouses in royal Inca landscapes is evident in the earliest eyewitness accounts of the Inca capital. In the imperial city, Pedro Sancho wrote,

> [there] are storehouses full of mantels, wool, arms, metals and clothes. . . . There are houses where the tribute is kept . . . and there is a house where are kept more than a hundred dried birds because they make garments of their feathers . . . and there are many houses for this [work]. There are bucklers, oval shields made of leather, beams for roofing the houses, knives and other tools, sandals and breast-plates for the warrior in such great quantity that the mind does not cease to wonder how so great a tribute of so many kinds of things can have been given. Each dead lord has here his house and . . . his service of gold and of silver and his things and clothes for himself. . . . The caciques and lords maintain their houses of

recreation with the corresponding staff of servants and women.[23]

According to Sancho, Inca royal storehouses contained everything from construction pieces (wooden beams) and tools (knives), to armor (leather shields, breast plates) and clothing (sandals, mantles). In addition, he declared that royal storehouses held luxurious materials (feathers, wool, gold, and silver) and the spaces needed to work them. From other descriptions, we know that Inca storehouses also housed food, drink, and almost every type of object produced in the empire. The Inca collected these goods and redistributed them throughout Tahuantinsuyu, as they were needed by local populations and for *ayni*. Many of these goods were also kept on royal estates. For the *sapa inca*, these valued things (and the buildings that contained them) were critical to governance. For Topa Inca, they would have been central to carrying out the elaborate ceremonies of the Pampa, as well as the more intimate performances involving both display and exchange in the *pata*.

Marca uasi

Although the objects themselves have long since been scattered, the storehouses that once contained them left a permanent mark on Inca landscapes. Colonial writers were impressed not only with the quantity of objects in royal storehouses, but also with their quality. To properly curate these collections, the Inca developed distinct storage buildings, some of which lay within the private sector of the royal estate. For example, Murúa described one such building just beyond the main "plaza," near the entrance to the private sector:

> There was in the Palace of the Inca a room of treasure, that they called *capac marca huasi* that signified a rich chamber of treasure, which served as what we here call the Royal Coffers where they guarded the jewels and precious stones of the King. Here were all of the rich clothes of the Inca of the finest *cumbi* cloth, and all of the things be-

longing to the ornateness of his person; there were rich jewels of inestimable price, pieces of gold and silver tableware that were placed in the sideboards of the Inca. (translation by Protzen)[24]

According to Murúa, the *capac marca uasi* was a royal treasury, a storage building for the most precious of the *sapa inca*'s possessions. *Capac* is a Quechua word that is associated with royalty and may be related to, or a colonial spelling variation of, *sapa*.[25] For example, the name for the royal highway was *capac ñan* (royal road) and another name for the *sapa inca* was *capac Inca*. In Murúa's description, the *capac marca uasi* was the royal *marca uasi*. Guaman Poma lists the *marca uasi* (*marca wasi*) as one of the standard building types that could be found on royal estates.

Although these depictions seem straightforward, many other colonial sources describe the *marca uasi* as architecture, but in very different ways: alternatively, a "double house with multiple stories," "the extra room, or upper stories of a house," and a building that comes from the Puna.[26] These descriptions seem confusing, as Inca structures rarely had multiple stories. Even if one included these, what exactly was a "double house"? How did these "extra room, or upper stories" appear? If this was a distinctive building type, did it come from the Puna (where *marca* is also an Aymara word), thus making it an example of imported or adopted architecture?

The answers to these questions lie in contemporary architecture. Today, Chinchero residents have a mixture of modern concrete architecture and traditional adobe and stone buildings, the latter of which are similar in layout and construction to those in imperial Inca times, and in these buildings *marca* can be found. According to local residents, a *marca* is a loft built into storage buildings (fig. 6.14). These lofts are constructed at one end of a rectangular building, starting at the gable end and spanning the length between the two long walls.[27] They are often located about five feet off the floor, effectively bisecting the interior horizontally. Many *marca* can be found in Chinchero's early colonial remains.[28]

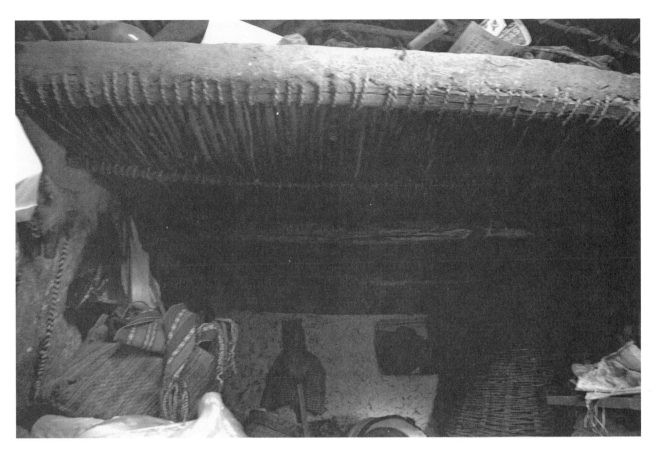

Figure 6.14 | A *marca* inside a Chinchero resident's home. The areas above and below the *marca* are being used for storage. Although the organic material has been remade over the centuries, the adobe building dates to the colonial period. Photo by the author.

Surviving lofts are made of wooden beams and finely woven natural fibers, using a technology similar to Inca roofs, and the result is a covering that is visually striking and strong. These lofts serve as a very useful storage system, as one could see many of the objects that were being stored. Residents relate that buildings (*uasi*) with *marca* used to be much more common in Chinchero. Unfortunately, the only way to tell whether an imperial Inca building had a *marca* would be for the building to have been preserved to a height of more than five feet, a rarity in the imperial Inca architectural remains at Chinchero today.

The existence of *marca* in colonial and contemporary storage houses at Chinchero provides a critical clue to the prior appearance of the *capac marca uasi* in Topa Inca's royal estate. In other words, the description of the *marca uasi* having an "extra room," "distinctive upper story," "multiple stories," or even being "double" did not apply to what was seen on the *exterior*, but what was within the *interior* of the building, in the form of lofts or attic space to store goods. Indeed, a closer look at the Spanish word *sobrado* (used to describe a *marca* in the colonial dictionaries) reveals that it refers not to a second-story living space, but instead to an uninhabitable space placed near the roof, such as an attic or loft.[29] This storage space appears to have been common in Chinchero and probably was at many imperial Inca sites. If *all* the colonial architectural definitions are correct, this may have been a distinct building type that was imported from the Puno. If true, the question is, was this another example of architecture imported during Topa Inca's reign, or was it brought into the Inca heartland during the time of Pachacuti (or his forefathers)?

Given the quantity of goods a *sapa inca* needed

to have within easy reach, it is likely that there were many royal storage buildings within the private sector. These would have held not only necessities, but also objects that held meaning and were associated with the ruler. For the Inca, objects and places gave meaning and carried memory (and hence history).[30] Thus, there may have been more than one *capac marca uasi* at Chinchero to store the personal treasures of Topa Inca.[31] At least one of these, as Murúa suggested, lay within the *pata*.

This is not to suggest that the *marca uasi* was the only storage type within a royal estate. While the *capac marca uasi* in the private *pata* may have stored the fine garments and ornaments of the ruler, there were other storehouses that held particular goods, such as food and drink, needed to run a lavish royal estate. One example is the *churacona uasi*.

Churacona uasi

Guaman Poma lists the *churacona uasi* (*churacona wasi*) as another building type typically found, often in multiples, in an Inca royal estate. He represented these as a series of identical narrow buildings (fig. 4.6).[32] The repeated nature of the structures makes sense, in that the Quechua word *cona* denotes plural (i.e., many *chura*). In another drawing, he depicts the same narrow structures aligned neatly in a row (fig. 6.15). These are shown as a collection of *colca*, which was a Quechua term referring to generic storage structures or storage centers.[33] Topa Inca is shown reviewing the *quipucamayoc*'s woven accounts of the *colca*'s holdings. (The *quipucamayoc* was an official who could make, read, and conserve the threaded cords of the *quipu*, which contained detailed accounts of the Inca state's possessions.) The depiction of the *churacona uasi* as an important type of *colca* makes sense, given the early colonial definition of the term. Holguin defines the *churacona uasi* as "separated warehouses."[34] Although scholars have often assumed that these storage structures were round, there is no evidence in any of the sources that *churacona*

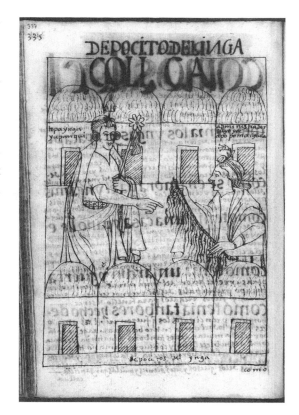

Figure 6.15 | Drawing by Guaman Poma that shows Topa Inca discussing the holdings in his *colca* with an official. Note how the *colca* buildings are drawn in the same way Guaman Poma depicts *churacona uasi*. Felipe Guaman Poma de Ayala, "The Inka's Storehouses," *El primer nueva corónica y buen gobierno* (1615/1616), GKS 2232 4, Royal Library of Denmark, Copenhagen, 335[337].

uasi deviated from the standard Inca quadrilateral form.[35] Instead, the colonial drawings and writings suggest that the *churacona uasi* were a series of identical, narrow buildings that served as warehouses to store goods needed by the *sapa inca*.

Unfortunately, there are no series of narrow buildings (round or square) aligned in a row within Chinchero, neither in the private *pata* nor in the public Pampa. However, before we dismiss the *churacona uasi* (a building type that could be found at private estates but was not built at Chinchero) we must remember an important point made by Susan Niles: royal estates did not consist of a single site but of many distinct sites scattered across a landscape.[36] One of these sites was usually a storage center.

An example of this arrangement can be seen in

the work of Jean-Pierre Protzen, who conducted a study of storage buildings at Pachacuti's royal estate at Ollantaytambo. At a site near the residential center of Ollantaytambo, Protzen found two types of structures. He named these Type 1 and Type 2. Type 1 consisted of "two to four rectangular chambers . . . built side by side, arranged in a line. Each chamber has its own access in the form of a small, square opening near the floor." These structures are small in their footprint, ranging in size from 1.45 × 1.50 meters (small and almost square) to 3 × 7 meters. He noted that this type of storage building had been found in other Inca settlements, such as Huánuco Viejo and Hatun Jauja.[37] These Type 1 storage buildings, a series of small, identical rectangular chambers laid in a row, are very similar to Guaman Poma's drawing of *churacona uasi* and Holguin's description of them as "separated warehouses."

Similar structures can be found near Chinchero. To the northwest lies a site called Machu Colca (*machu* is Quechua for "old" or "big"),[38] which is a large collection of storehouses that belonged to Topa Inca and serviced his estate at Chinchero.[39] Machu Colca lies on a steep hillside, overlooking the Urubamba Valley (fig. 2.1). Among these buildings is a series of four almost square, seg-

mented chambers built in a row, perfectly matching Protzen's description of Type 1 storage buildings (fig. 6.16). Thus, at two royal estates there are buildings that match the layout and form of the *churacona uasi* depicted in the colonial sources.

So, what was stored in these distinctive structures that was so important to royal estates? Craig Morris has suggested that they held tubers. Tubers, such as potatoes, are an important food source in the Andes and a staple in highland diets.[40] However, storing tubers is difficult because temperature and humidity have to be carefully regulated. Therefore, it makes sense that a distinctive storage unit would have been devised to hold these crops.[41] The fact that the lands around Chinchero are rich for tuber growing is further support for the idea that the royal estate of Chinchero would have tuber storing capabilities such as the *churacona uasi*. Supplemented by other local products, they would have been part of what must have been a diverse menu at Topa Inca's estate.[42]

A study of the *marca uasi* and the *churacona uasi* provides important insights into the way two very different types of goods were stored and transported to (and within) royal estates. One type of storage could take the form of buildings such as the *marca uasi* that allowed quick access to impor-

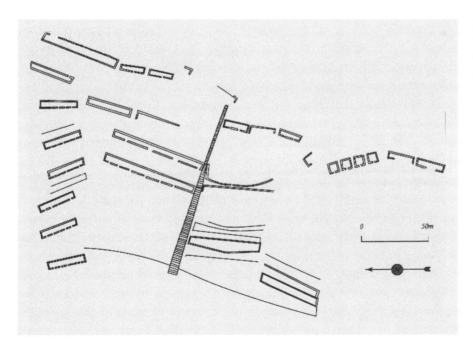

Figure 6.16 | Map of Machu Colca (before reconstruction by the I.N.C.). Image by Susan A. Niles and Robert N. Batson.

0 50m

tant, valuable possessions, such as fine clothes and ornaments. Another type would be storage in outlying warehouses, such as the *churacona uasi*, where large quantities of goods could be held over long periods of time. While these warehouses were not within the palace proper, they were close enough to enable access in a relatively short amount of time, thus enabling supplies to be regularly replenished. These *colca* would have kept many different goods, not just the tubers in the *churacona uasi*.

We can gain insight into these other types of storage buildings by turning again to the structures studied by Protzen. The two types he found match what exists at Machu Colca.[43] According to Protzen, Type 2 was "a narrow, rectangular structure about three meters wide and from 10 to 38 meters long. Its long front, or downhill, wall is considerably lower than its uphill wall, resulting in an asymmetric, steep gabled roof. Both walls are perforated by many tall windows."[44] At Machu Colca, this type of storage building made up the majority of the site.

What specifically was held in these numerous, long storehouses is unclear. They are all similar in form (long and rectangular), but the Inca used the same long rectangular form for many different functions. These structures likely held a variety of objects. To run a lavish royal estate, the *sapa inca* would need to have the supplies for the day-to-day running of extensive agricultural lands, for a large staff of servants, and for a collection of elite family members, and of course he would have to be prepared to supply the needs of visiting dignitaries and host large ceremonies that involved offering fine foods, wines, and gifts.

Tamara Bray has called this lavish type of dining "Inca haute cuisine," which consisted of a variety of hard-to-find delicacies. This would have included such things as select maize (for food and drink), llama meat, and duck.[45] These, along with Andean staples such as potatoes, would have been of the highest quality, requiring not only skilled selection, but also storage and transportation.[46] Other than tubers, which required very specific environmental controls, most of these foods could

have been stored in rather simple structures, requiring only basic ventilation and protection from harsh weather. Each of the Type 2 structures at Machu Colca, though similar in form, could have held different types of these foods. When these goods were needed for immediate use at Chinchero, they could be transferred to temporary storage within the estate proper. Thus, it is possible that some of the structures on the Pampa (next to CP5) and near the private *pata* (such as CP1, CP2, and P1) may have been storage structures that held goods needed for impending activities in the public and private arenas.

Aka uasi

One thing that must have been stored at all royal estates and would have been a critical aspect of events occurring in Chinchero's Pampa and *pata* (and *cuyusmanco*) is the alcoholic corn beverage *aka*.[47] *Aka* was central to imperial Inca life, and its use has a long history in the Andes. Because of its importance, *aka* was involved in many state rituals, thus the Inca state often determined who could drink *aka* and when. From colonial records we know that these sanctioned occasions tended to celebrate and reiterate Inca authority and often took the form of *ayni*, or reciprocity. It was ritually drunk at gatherings, ranging from large-scale ceremonies involving thousands of diverse participants, to small assemblies of just the Inca ruler and a few visiting dignitaries.[48] *Aka* was often exchanged and consumed during religious rituals, as an offering to sacred forces, and it was drunk during special family occasions. For all of those lucky enough to have done so, it was considered a high honor to have drunk *aka* with the *sapa inca*.[49]

Women made the *aka* and served it to the men in vessels called *queru* (*qero*).[50] To invoke the blessing of sacred forces, a portion of the *aka* was spilled on the earth as an offering to Pachamama, the earth mother, and a *queru* filled with *aka* was raised as a gift to an *apu*, a sacred mountain. For large gatherings, one would make toasts by bringing two *queru* filled with *aka*. One of these tumblers

was offered to a guest, while the other was kept by the host (queru were usually made in pairs).[51] After aka was poured in each cup, the companions drank together, an example of the Andean concept of hanan and hurin (complementary pairs). Ritualized drinking such as this is just one example of the sapa inca's use of aka as a highly regulated and valued commodity that implicated the blessings of sacred forces in Inca acts and bound participants to him in reciprocal relationships.

The making, transportation, storage, and use of aka required a diversity of vessel types, and some of these, such as the queru, were highly elaborate and of high prestige.[52] Aka was made in large containers that could be secured by being partially buried in the earth. When the aka was ready to be transported, it was poured into special narrow-necked vessels, whose design prevented spillage and evaporation.[53] These could be transported to a pampa and pata for ceremonies or placed inside of or near a building in order to be used as needed by the participants. Also, these aka-filled vessels could be sent to storage facilities that were close to the center of activities. These vessels were also transported to other parts of the empire and given as special gifts; their iconography serving as a symbol of Inca power and authority.[54]

As aka was vitally important to the state, it is natural that the Inca would have developed a building type just for its storage and that this structure would have been an important part of royal estates. This structure may have also had space to accommodate aka's production. Typically Chinchero's aka would have been made at an acllauasi (acallwasi) (most likely in Cuzco), as aclla (the chosen women) were said to make aka for the ruler. However, given Cuzco's distance and the amount of aka that would have been required for festivities on Chinchero's Pampa, it is likely that a local production area was also available on Topa Inca's estate. The Spanish chronicler Bernabé Cobo mentions a "wine room" in an imperial Inca palace. This was most likely a room for aka (the Spanish often referred to the alcoholic corn beverage as wine).[55] Where this was located within the royal estate is unclear. Given the importance of

the drink to the Inca, it is probable that they had several aka uasi per estate.

A place to temporarily store (and possibly make) the sacred alcoholic beverage would have been necessary. In particular, when large-scale events took place within royal centers, rooms to hold the numerous large vessels of fresh aka would have been critical. These would not have been long-term storage rooms, such as wine cellars today, as aka could not be stored for more than a few days without spoiling. Cobo states that it lasted no more than a week, and thus fresh aka must be continually made.[56] Therefore, rooms would have been needed to hold the many large vessels and other related equipment and supplies needed to make aka. Cobo states that to make aka, "store it and drink it, they have more instruments and containers than they have for their meals."[57] Thus, considerable space was needed to hold the sacred drink as well as for the all the equipment related to its production.

These rooms, or aka uasi, may have been built within the core of a royal estate to hold the vessels of aka that were ready to be drunk, and aka uasi may have also been built in nearby storage centers to hold the equipment and supplies needed to make aka for large-scale events, such as those taking place on Chinchero's Pampa. These outlying spaces likely served as more than just storage facilities; instead they may have also functioned as or facilitated food-production spaces. Or the production of aka may have paralleled the production of food. Although Guaman Poma makes no mention of specific buildings used for the production of food, written and excavated evidence suggests that foodstuffs were stored in outlying storage centers, but meals were produced in multiple spaces in both the public and private sectors of Inca settlements, even at royal estates. At Chinchero, food production may have occurred in multiple spaces in the private pata and perhaps even in some spaces of the Pampa.

At Chinchero, there may have been aka uasi outside and inside the royal center. If outside, then Machu Colca could have supplied the Pampa and private pata with aka as needed. For example,

the Type 2 storage buildings that held a variety of goods may have also held *aka*. Careful excavations of these structures must be undertaken to see what types of materials could have been stored in each of these buildings and whether any evidence of production activities in or around these structure can be found. Though an *aka uasi* was likely also to have been built within the core of the estate for ease of access, exactly where these may have been built remains unclear at Chinchero.[58]

We can say far less about the *aka uasi* than may appear evident at first. This is because the colonial reference most often cited to support the idea of an *aka uasi* at royal estates comes from Guaman Poma, who lists an "*aca uasi*"—not an *aka uasi*—as one of the key building types found at royal estates. In the colonial period there was confusion over the *c* and *k* sounds for Spanish writers. However, this colonial spelling practice conceals the fact that in the colonial period, both the *aca uasi* and *aka uasi* existed as separate building types. Indeed, Garcilaso complains that Spanish writers in the colonial period were often mistaking these two words, in both pronunciation and spelling.[59] This confusion means references to the *aka uasi*, the house of *aka* or alcoholic corn beverage, could have actually been references to the *aca uasi*, the house of *aca*, or excrement.

Aca uasi

The critical difference distinguishing the two building types revolves around pronunciation. If one pronounces the word by hitting the tongue far back on the palate (an uvular consonant)—as *aka* (*aqha*)—it means a type of corn beverage. If one pronounces *aca* with a hard *c* sound (a velar consonant), it means either "excrement" or "the slag of metal."[60] Yet many scholars have overlooked this subtle but critical difference between *aka* and *aca*, creating a very different vision of the royal estate than appears to have been intended by Guaman Poma (and other colonial writers). Instead of a lavish royal estate with rooms full of intoxicating corn beverages for sacred rituals and po-

litical feasts, one sees a sumptuous royal estate that was very sanitary, equipped with rooms to service an unglamorous but nevertheless urgent need.[61]

In the early colonial period, there were different types of architecture associated with both *aka* and *aca*. Holguin lists an *aca uasi* in his dictionary, which he defines as a latrine or toilet.[62] Given that Inca gatherings, small or large, would have been in dire need of a system to remove human waste, it makes sense that the Inca would have developed latrines or a building to collect human waste. Latrines are a critical aspect of architecture across the world, particularly of elites. Despite this, Inca latrines have rarely been discussed in the scholarly literature. While researchers have written extensively about the extraordinary ritual drinking and wine rooms that were important to imperial life, they have been largely silent on the everyday realities of bodily elimination and its architecture.[63]

However unglamorous it is as a topic, the *aca uasi* brings to light a fundamental problem of the human body in space. Obviously, the *sapa inca* would have to relieve himself, as would his family members, elite guests, ceremonial performers, and all the servants. The architecture of the Pampa and private *pata* would somehow have to address these needs. Where did these residents, visitors, and servants go? Did the sacred *sapa inca* squat in the street or in a field? What about all the guards and servants? Reports by early chroniclers describe noticeably sanitary Inca settlements. Even during a huge festival in Cuzco, where men drank copiously and turned a river yellow, it is only urine (and its visual aspect) that is mentioned.[64] In the colonial writings, there is no reference to excrement in Inca streets or mention of cities pungent with sewage (at least not until the Spanish moved in).[65] Clearly, the Inca had a system of fecal (and urine) removal for both individuals and for the masses that kept their environment visibly clean and stench-free. For a people who understood the body and its senses as potent and conveying meaning, this would have been an important factor.

What sewage system the Inca may have had is unclear. They were brilliant hydraulic engineers, able to move clean water around rugged terrain with great ease.[66] This water was used for drinking, cooking, bathing, and watering plants [67] The resulting gray water was then guided through a site in a carefully graded filtration system. However, there is no evidence that they had a similar system for black water (sewage), which would have facilitated the removal of bodily wastes. This water would have had to be placed well below and far away from the clean and gray water systems, as it could easily contaminate the food and drink supply.

So where did it go? There is no evidence of underground sewage collection systems for the Inca.[68] This would suggest that wherever the royal elite and their thousands of servants were going to relieve themselves, it happened above ground in portable units.[69] For example, people may have been using pots that were emptied later in the day. Thus waste materials could be collected and stored in some type of solid containers, with the addition of a lid to prevent olfactory unpleasantness and the collection of flies.[70]

But was the *aca uasi* a latrine in the sense we have today—a place where individuals went to relieve themselves of bodily waste (i.e., going to a specific building to make individual deposits in a closeable pot)? Or was it a place where vessels storing human waste were gathered together (like chamber pots that, once filled, were then collected and taken to be stored in another room)? Holguin's definition leaves open the possibilities of both uses. So there could have been a room in which people went to relieve themselves, or there may have been rooms in which fecal matter that was deposited in pots across the site was gathered and stored.

If the former was true, we may wonder who had access to these latrines, how private they were (built for single or group use), and how these latrines may have differed depending on the rank of the user. If the latter was the method, the question is where and how these collection vessels were kept and used and who collected them.

Another question is whether only feces were collected, and not urine. It is possible that excrement alone was stored (thus raising the question of what happened to urine).[71] As *aca* refers to both human and animal feces, yet another question is whether feces from both were collected and stored together. In the Andes, there is a long history of using animal and bird excrement as fertilizers.[72] However, the Inca seem to have considered human waste as particularly special and treated it separately. Garcilaso relates that not only did the Inca use human excrement as fertilizer, but they considered it to be the most prized fertilizer and used it specifically to grow the sacred corn. He states that the Inca placed "manure on the land in order to fertilize it. It is noteworthy that in the valley of Cuzco (and almost all the highland area) they treated their maize fields with human manure, because they said it was the best. They used great care and diligence to obtain it, and dry it and pulverize it in time for the sowing season."[73] This extensive use of human waste for corn fields is not surprising given that the Inca used corn as a valued food and for their sacred *aka*. Given *aca*'s (excrement) importance in the creation of *aka* (drink), it makes sense that the Inca would invest much time and effort in the collection, treatment, and redistribution of human excrement.

The practice of collecting human waste at the end of the day (therefore called "night soil") so that it can be properly treated at a safe distance from human habitation is a common method for creating rich fertilizer in many parts of the world. If this was the case with the Inca, then the *aca uasi* may have served as a temporary warehouse beyond the residential center to store *aca* that was to be reused in another capacity. However, if *aca* were stored in a warehouse, it would only have been for very short periods of time. Excrement cannot be left in open air near human populations, because vectors, such as flies, can quickly spread lethal bacteria. Neither can excrement be completely sealed in containers for significant periods of time, as gases can quickly build up to lethal levels.

A likely solution is that the Inca quickly rede-

posited the human waste in a similar way to that in which they used animal waste—for fertilizer. Once spread on a fallow terrace or field and exposed to the sun, excrement can be rid of deadly bacteria and turned into a rich fertilizer. Fecal material not only enriches the soil, but it also helps to break down the thick clumps of clay that characterize the agricultural terraces of Chinchero today. Thus, people could either directly deposit excrement in the fields (a practice still found in many parts of the Andes) or they could collect it to be spread later in the day. In more densely populated areas, such as Cuzco, going directly to the field would not have been possible, thus the collection of human waste would have been necessary. These materials could have been housed for short periods of time in closed containers in an *aca uasi*, or house of excrement, before being brought to distant fields where they could be spread and exposed to the sun and air (which Garcilaso's description suggests). Once turned into fertilizer, the material could be readily collected and used to enrich the agricultural terraces of the Inca.[74]

Regardless of what happened to the *aca* materials, the chamber pots (or textiles) that may have been used to transport the wastes would have reflected degrees of status and hierarchy. For example, Topa Inca and his favorite consort, Chequi Ocllo, likely had clean, finely made containers that were regularly emptied. By comparison, the guards and servants probably had less-than-stellar vessels or pick-up times (or were required to make their own deposits after long walks to distant fields). This system would mean a city of roving containers whose contents were readily moved across the Pampa and *pata*. The movement of this "urban *aca*" would have been just one of the many duties that the servants had at Chinchero. They would also have cooked Topa Inca's food and guarded his lands, buildings, and family, as well as washed and dried his clothes. Many of these tasks would have required specific buildings that would have been part of Chinchero's private sector. For example, Guaman Poma mentions the *masana uasi* (*masana wasi*) as a palace building used for drying clothes.[75]

Aca uasi and Servants

The Inca had a servant class, called the *yanacona,* who would have cared for the more privileged members of society (among other duties).[76] In royal estates, the *yanacona* were often collected from areas that had recently been conquered.[77] A *yana* cut ties with his or her *ayllu* (lineage group) and served the Inca in a variety of capacities, and some of them were given great trust by the *sapa inca.* For example, according to Murúa, the treasury at the royal estate required special guards:

All of this richness was under the responsibility of fifty stewards, and the head of these was a *tucuiricuc,* or *cuipucamayoc,* who was like a head inspector or accountant of the Inca, who was in charge of the keys to certain doors, although they were made of wood, as is their tradition, he could not open the door without his companions being there with their [own] different keys. They gave this head treasurer, or accountant, a great reward and many benefits, because the Inca gave him many clothes of his own, livestock and farmland, and these gifts of his were carried in two parts and one was for his companions. (translation by Protzen)[78]

The special servants, most likely *yanacona,* could have provided oversight for the *marca uasi, churacona uasi, aka uasi,* and even the *aca uasi* (if needed).

There was a hierarchy of workers, in both age and gender, serving at royal estates, of which *yanacona* were one only group. While the *coya* is described as having a large collection of women who took care of her needs, the *sapa inca* is said to have been attended to by a contingent of boys and young men. In addition to the military men mentioned earlier, Murúa writes,

There were another twenty-five valets, who were boys of twelve to fifteen years old, sons of *curacas* and principal Indians, who were very well treated and dressed in rich clothes given to them every week by a majordomo who had a reward for them and who was privileged to go in a litter when he wanted. These boys cleaned the clothes he should wear and they prepared it for him, and also they

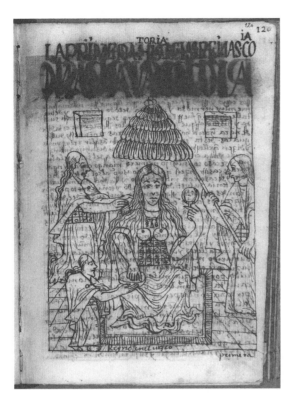

Figure 6.17. Guaman Poma's drawing of the first *coya*, Mama Huaco. She is shown surrounded by servants taking care of her basic needs. Felipe Guaman Poma de Ayala, "The First Qoya, Mama Huaco," *El primer nueva corónica y buen gobierno* (1615/1616), GKS 2232 4, Royal Library of Denmark, Copenhagen, 120[120].

served him the plates at the table wherever the Inca ate. (translation by Protzen)[79]

These young valets were not *yanacona* but instead were from elite families. This reveals the extreme levels of class and gender that existed among people who serviced the ruler and his family. This male contingent (along with the military men who guarded the Inca) would have been in sharp contrast to the many females who cared for the *coya* (fig. 6.17). For Chinchero, the question is whether Mama Chequi Ocllo, as a secondary wife, also garnered her own contingent of female servants.

The work of serving likely required an extensive collection of buildings and pathways that must have been central to the running of elite Inca settlements. During work times, the servants would have permeated all aspects of royal life, weaving

in and out of the most private of spaces to care for Topa Inca and his family. However, when not in service, they may have lived beyond the confines of Chinchero in a settlement on the outskirts of the residential core, as they did in Cuzco.[80] Thus, when we consider the architecture of private life of the Inca, we have to consider that this was as much an architecture of servants and service as it was of fine interiors and lavish gardens for the *sapa inca* and his family.

The ability of servants to permeate the public and private aspects of royal life created problems for the *sapa inca*'s need to regulate movement. While pathways and control points may have been carefully laid out in order to determine where certain visitors were allowed to go in Chinchero, servants were the one group that could cross many of these boundaries. Although they could not come and go as they pleased, they still needed to serve the ruler and his family in some of the most private and sacred of spaces. Because of this, it was not just the *sapa inca* who had access to the many spaces on the Pampa and private *pata*; a collection of servants would have regularly pierced and disrupted the otherwise strict physical boundaries dividing public from private.

These boundaries included the confines of the royal body. While collecting chamber pots or cleaning latrines may seem like a low-ranking job today, for the Inca, bodily excretions of the *sapa inca* may not have been considered mere waste but rather a special material requiring distinct treatment. From the colonial records, we know that anything that came into contact with his body, or that was removed from it, had to be treated with reverence. No clothes that touched his body could ever be used again—they had to be burned. Parts of his body that fell away had to be disposed of properly. For example, fingernail clippings were burnt and any hairs that dropped from his head were to be eaten by a servant.[81] This was done so that no one with ill intent could possess a piece of the royal body and perhaps curse and cause harm to him. The *sapa inca*'s body and its by-products were considered powerful. All these things that came from or touched the sacred *sapa inca*'s body

required a special architecture to store them. Pedro Pizarro writes,

> The Indian took me to a hut where there was a great quantity of chests, for the Spaniard was now gone away, and he [the Indian] told me that it was from there that he had taken a garment of the Lords. And, on my asking him what he had therein those chests, he showed me some in which there was everything which [the Sapa Inca Atahualpa] had touched with his hands, and garments, which he had rejected, in fine, everything that he had touched. I asked him: For what purpose do you have all these things here? He answered that it was in order to burn them, for each year they burned all these things, because all that was touched by the Lords, whoever were sons of the Sun, must be burned, made into ashes and thrown into the air, for no one must be allowed to touch it. Standing guard over these things was an important man who guarded the things and collected them from the women who served [the sovereigns].[82]

The Inca developed storage units to house (and appointed guards to protect) all things that touched the sacred *sapa inca*'s body. As discussed in Chapter 1, touch was considered one of the most powerful of bodily senses. This is because touch had the power to transform and transmit, such as *camac*, from one thing to another. *Camac* was not an abstract sacred essence, but something tangible and alive, "a being abounding in energy as physical as electricity or body warmth."[83] As the venerated ruler, Topa Inca had a powerful sacred essence, so it is no surprise that anything that touched his sacred royal body required special treatment. But if all things that touched the *sapa inca*'s body were considered newly embedded with sacredness and had to be collected, did this include his excrement as well?

If his waste was regarded as a sacrosanct material, we have to consider that the collection of his feces in a single room may not have been solely about sanitation, but part of a larger practice of collecting royal bodily sheddings (exuviae). If this was the case, then Topa Inca's *aca* must have been stored in an *aca uasi* separate from everyone else's, and there must have been a distinct method for its treatment and disposal.

Besides materiality, facture would have also been important as it related to *aca*, in particular to the privacy of the sacred royal body and its actions. For a man who would leave his guests to change a shirt away from prying eyes, it is likely that the *sapa inca* used a secluded space in which to defecate (and perhaps urinate). Hence designing the private *pata* in such a way as to prevent most people from accessing a space in which the *sapa inca* had to perform personal acts would have been similar to the ways architectural gestures were used in the terraces and Pampa to grant exclusivity to *huaca*.

Toilets, or the architecture of excrement, would have been an important aspect of a royal estate, especially within the private *pata*. This building (or buildings) would have tackled key sanitation concerns—keeping the estate fresh smelling, visually pleasing, and, most important, free from deadly bacteria. The *aca uasi* would also have attended to religious concerns, as it collected material from all inhabitants (from the sacred ruler's body to the servants themselves) and would have thus reflected distinctive class and gender divisions.

The *aca uasi* also highlights the importance of examining seemingly mundane or unpleasant aspects of daily life. We cannot let our own discomfort about a material or act prevent us from examining how the Inca may have viewed a bodily excretion and how its collection and storage may have dramatically informed the design and use of Inca settlements. As Cecelia Klein has so vividly argued for the Aztec, "shit" could be holy.[84] Not acknowledging this pervasive product leads to a misreading of the built landscape—a sanitized version of what we wish to see, rather than how it was.

Punona uasi

In terms of Chinchero's private *pata*, there would have been a range of buildings: from a building for state meetings (*cuyusmanco*), to places to cook,

store goods, clean and dry clothes (*masana uasi*), and hold excrement (*aca uasi*). There was also a collection of buildings devoted to family life. For example, Guaman Poma lists the *punona uasi (punona wasi)*. He provides no accompanying drawing, but the Quechua dictionaries describe the *punona uasi* as a "house of the bed," connecting this structure with both slumber and sex.[85] The architecture of Chinchero's *pata* surely would have included a place for Topa Inca to catch up on sleep and engage in sex.

In the colonial period, the Spanish were shocked by Andean sexual practices, where sex before marriage was not frowned upon as it was in Christianized Europe. Relative to their European counterparts, women in many parts of the Andes seem to have had more equality with men in terms of their engagement in and enjoyment of sex. However, the Inca state made attempts to control the sexual activity of women in whom Inca men were interested. Laws were created to punish adulterous women with death. Attractive young female virgins (like other valuable goods) were collected from across the empire and stored in exclusive compounds called *acllauasi*; these girls would be used later as highly skilled weavers or as political gifts. Women from newly conquered areas or regions that revolted against Inca rule suffered the most. Juan Diez de Betanzos described a house in Cuzco where women were forcibly taken from recently invaded lands and required to have sex with Inca men. The establishment of a house of forced prostitution was intended to satisfy the sexual cravings of unmarried Inca men, diverting their urges to have affairs with married Inca women and *mamacona* (secluded women) that would have complicated the smooth running of life in the capital.[86]

This building for sexual violence is a rarely discussed example of the Inca architecture of conquest. We tend to think of buildings signaling conquest as located in the provinces, particularly in areas the Inca had recently invaded, but this one was situated in the capital. The women inside not only were torn from their homelands during Inca incursions, but they also relived that conquest through their own bodies on a daily basis.

By building this structure within the confines of Cuzco, the Inca created a visible marker, an architectural monument to their control over conquered peoples and particularly over females. The daily, repeated enactment of that subjugation on the women who were condemned to live within its walls reveals that the Inca also viewed sex as a means of and symbol for violent invasion and domination.

By contrast, the *punona uasi* highlights a very different expression of Inca sexual activity; there sex was linked with sleeping and the family unit. The *punona uasi* was the space that housed the core unit of the family and allowed for rest and the most private of acts—reproduction. In poorer households, the entire family slept in a *punona uasi*, but in elite households, the husband and wife slept together in their own room. In the Andes, the union of man and woman formed the sacred coupling: the pairing of very different yet compatible elements that defined the order of the universe.

However, for an Inca ruler who had multiple wives and (what the Spanish referred to as) mistresses, the *punona uasi* could be a complicated building. To begin with, it does not appear that the *sapa inca* and the *coya* typically shared a *punona uasi*, but instead, had separate rooms. This is not surprising given that most marriages between a *sapa inca* and a *coya* were political in nature.[87] They were arranged as part of alliances, the same way marriages were made for rulers and other elites in Europe at the time. As the Inca consolidated their power, the most serious threats to rule came not from outside, but from other Inca elites. To address this increasing concern, heirs apparent (starting with Topa Inca) were given wives who were close family members, such as a sister or cousin. These marriages were a key part of the new ruler's investiture. Sex was expected to the extent that it would produce a son who could inherit the *mascaypacha* and become the next Inca ruler.

Because these marriages were arranged for political purposes (rather than compatibility or attraction), it was probably expected that rulers would look elsewhere for female sexual compan-

ionship and that the female royal consorts would seek out their own private spaces within royal estates that were apart from the *sapa inca*. According to Murúa, the *coya* had a separate palace within the estate that rivaled that of the *sapa inca* in architectural splendor:

> The palace of the queen was located in this enormous construction, and it was almost as large as the [*sapa inca*'s]; and since she held a preeminent office, she went about dressed with ornaments of *cumbi* [finely woven cloth] which represented the position she held in the palaces. She had shrines, baths and gardens, both for herself and for her *ñustas*, who were like ladies-in-waiting, of which there were more than two hundred. She was responsible for marrying them to lords who achieved honorable offices under the [*sapa*] Inca. It was truly marvelous when the great queen walked about; she was served, in every way, with the majesty shown toward the [*sapa inca*].[88]

This separation means that there were normally two private compounds within the royal estate, the most elaborate belonging to the *sapa inca* and the other to the *coya*. Thus, they each had their own *punona uasi*. Although the *coya* was not allowed to have sex with anyone other than her spouse, the *sapa inca* was relatively free to have sex with anyone he chose.[89] Whether he could bring those women back to his *punona uasi* when the *coya* was in residence, however, is another matter.

Colonial records suggest that landed estates were assigned to the *sapa inca*'s secondary wives. This was apparently done to quell factional disputes. Arguments often erupted among the women, and the key issue of contention was whether their lands were equal to those of the others.[90] Therefore, in each of their respective estates his wives had their own *punona uasi*, where it is most likely the *sapa inca* would visit them. Given the number of secondary wives and mistresses the *sapa inca* tended to have, the housing of these women and their children must have been an important aspect of the imperial Inca landscape. Thus, when we think of Inca landed estates, we must consider not only those that belonged to the ruler and his nobles, but also those that belonged to his many women. In the heartland, the mapping of the Inca landscape was as much about sexual conquest and control as it was about military invasions and negotiated occupations of new territories.

Love and passion can be very complicated emotions, especially when mixed with politics, and the resulting drama frequently played out at royal estates such as Chinchero. When Pachacuti named his son Topa Inca as his successor, he ordered his son to marry Mama Ocllo, who appears to have been a half-sister. This occurred when Topa Inca and Mama Ocllo were both rather young, perhaps still teenagers.[91] Nevertheless, they made a powerful political unit. At the time, elite Inca women could wield significant power. A *coya* did not passively follow her husband as the *sapa inca* moved about the Inca Empire, nor did she stay hidden inside palaces. The *coya* had her own elaborate residences, traveled, and had a say in the running of Tahuantinsuyu. But her roles as wife and sexual companion were complicated (and over both she had little control). During her marriage, Mama Ocllo saw her husband favor numerous women, some of whom he took on as secondary wives, others as mistresses.

Mama Chequi Ocllo was one of these women with whom Topa Inca is said to have fallen in love, and Chinchero was built as a new royal estate for him and this secondary wife. This must have been a long-standing relationship, as their son, Capac Huari, appears to have been a teenager or young man when his father died (and Chinchero had been occupied for only a few years). Building a royal estate to be shared with a woman who was not the *coya* would have had great political implications.[92] Thus, at Chinchero the *punona uasi* was not only where Topa Inca slept, but it was a powerful symbol of sexual preference that had critical implications for the empire.

The *punona uasi* was located in the private sector, next to the day room of the ruler, or at least this was the case in Atahualpa's private compound.[93] Zárate wrote,

The prince's lodgings, which stood in the middle of the camp and, though small, was the finest of its kind he had seen in the Indies. It consisted of four rooms built around a courtyard. . . . The apartment in which Atahualpa spent the day was a gallery looking down on a garden, and beside it was the room in which he slept, which had a window facing the courtyard. . . . The gallery also had an entrance from the court.[94]

According to Zárate, Atahualpa's private area had four spatial components. First, a series of buildings were laid out around a courtyard—a typical *cancha* arrangement. Second, one of these structures was a day room for the Inca that had an opening onto the "court" (this was the building Atahualpa sat in front of when he received the Spaniards).[95] Third, next to the day room was the sleeping room in which Atahualpa spent his nights. And fourth, Zárate goes on to say that the remaining two buildings were for storing the goods readily needed by the Inca, such as food and furnishing for both day- and nighttime activities.

If this spatial practice was typical for the private quarters of the *sapa inca*, we may find a similar arrangement at Chinchero.[96] Specifically, one of the three buildings next to the *cuyusmanco* may have been a *punona uasi* (P6, P7, P8). These three buildings lie just south of the *pata*'s *cuyusmanco*, behind an extended wall of finely made niches. It is interesting that these buildings also lie next to (and below) the grand *cuyusmanco* that overlooks the Pampa.

Because these buildings have since been torn down to their foundations and buried, there is little we can say about their former appearance and use, but their context is nevertheless illuminating. If the *punona uasi* had been placed next to the open space (and main reception area) of the *pata*, its function as an expression of the union between a husband and wife would have been emphasized. Yet, by enclosing the *punona uasi* within a wall (as these three buildings are), the privacy of the couple as well as their authority would have been underscored (figs. 6.2, 6.7). Perhaps this is why the wall was elaborated with large-scale niches, sig-

naling to those on the private *pata* the significance of what lay beyond (P13). This wall was only about three-quarters finished (in height) when Topa Inca died, suggesting either that this wall was not of prime importance to the patron, or that it was not part of the original plan and was being erected as an addition.

While the exterior of these buildings and dividing wall were the soft grays of polygonal limestone masonry (and perhaps the subtle beiges of adobe), inside was a vibrant contrast. According to Zárate, the interior of the *sapa inca*'s private quarters was colorful. He writes, "The walls were plastered with a red bitumen finer than ochre, which was very bright. The wood used for the roofing of the house was stained with the same dye."[97] Inside this red room would have been a place to sleep. This dramatic contrast between exterior and interior space falls in line with Inca architectural patterns in that it powerfully marked important spatial transitions.

Despite this visual explosion, the interior furnishing would have been minimal. The *punona uasi*, the center of Inca private life and the source of tensions between the *sapa inca* and the *coya*, was a striking yet simple room. According to Pedro Pizarro, "These Lords slept on the ground on large mattresses of cotton. They had large counterpanes of wool with which they covered themselves."[98] While most Andeans slept on (and under) blankets (called *chusi*), the *sapa inca* slept on a mattress, revealing another example of how vertical space was used to map out the authority of the ruler.

If one of the three buildings inside Chinchero's enclosure was a *punona uasi*, what were the other two? One structure is larger and runs parallel to the courtyard, while the other two run perpendicular and are small in size. Thus, we can surmise that the largest room was likely the sleeping and sex room. If Zárate's description was valid for other residences, at least one (if not both) of the two remaining rooms was a storage building to house the goods needed by the royal couple. Thus, all the finery needed by Topa Inca and Mama Chequi Ocllo would have been within easy reach.

For most Andeans, a *punona uasi* was not only where the husband and wife slept, but also where the entire family rested. While it is possible that elites also shared this practice, it is more likely that the children of the *sapa inca* slept in their own structure. Where they slept is unclear. If the royal couple at Chinchero were alone in the enclosure, then Capac Huari's *punona uasi* must have been close by, perhaps in one of the finely made buildings to the south (P14–P17). But if Capac Huari slept within the enclosure (thus emphasizing his elevated status), it may have been in one of the two smaller buildings within the enclosed wall.

Uaccha uasi

The question of where children slept would not have been a minor feature of a royal estate, not only because the *sapa inca* (and his various women) normally had an abundance of children, but also because he housed "orphans" at his royal estate. According to Guaman Poma, a *uaccha uasi* (*wakcha wasi*) was one of the key building types normally found on royal estates. This structure has been translated as the house of orphans or the poor.[99] The *sapa inca* maintained the image of a benevolent father to his subjects, providing orphanages or almshouses across the empire. However, that an important ruler would do so within the confines of his exclusive, private residence is unexpected. It is hard to imagine Topa Inca's impressive *pata* teeming with orphan children. Was this a symbolic gesture of concern for the most vulnerable of his empire's population? Or was this building temporary housing for those allowed to approach the *sapa inca* and plead for favors?

The answer is neither. Instead, the *uaccha uasi* is another example of contemporary misunderstanding. While *uaccha* does translate as "orphan" (*uaccha* is orphan and *uacchacona* are orphans), its meaning to the Inca was something very different from that of the word today. The difference is clarified by Juan Diez de Betanzos, who was married to an Inca *ñusta* (princess) and was fluent in Quechua. He wrote that the "*guacchaconcha* (were) rel-

atives of unfortunate people and low offspring."[100] However, he was not referring to random children in the Andes, but children of Inca elite men (such as the *sapa inca*) and women who were not Inca noblewomen. From an Inca perspective, these children were orphans not because they were parentless, but because their mothers were of low birth. They were not recognized as the rightful heirs of the elite Inca male, even though they were his children.[101]

During the imperial Inca period, the issue of the *uacchacona* would not have been a small one. Pachacuti was rumored to have fathered several hundreds of children. According to Pedro Sarmiento de Gamboa, Topa Inca was less prolific, but still "had two legitimate sons and sixty bastard [ones] and thirty daughters."[102] These children were ranked according to the status of their mother. Children of Inca elites were highest ranked, with preference given to those of the *coya*, especially if she was a close relative of the ruler. At the bottom were the children of the *sapa inca* whose mothers were considered to be of a low status. Given that his mother was able to call on help from powerful people in Cuzco (i.e., most likely Inca elites), Capac Huari was likely not a *uaccha*; however, numerous half-brothers and -sisters were.

What is perhaps most revealing about this royal building type is that all of the *sapa inca*'s children were welcome within their father's royal estate, no matter what the status of their mother. While they were not housed along with the favored high-status offspring, the *sapa inca*'s "orphan" children had a special collection of buildings in which they could stay, whether living with or visiting their father. Thus, while their status was spatially mapped within the royal compound, they were all included in their father's royal center. The evidence of a *uaccha uasi* as a standard building type found in private royal estates testifies to the importance of children for Inca rulers and the complicated by-products of the *punona uasi*.

These "by-products" no doubt caused tension between the *sapa inca* and the *coya*. Although the *sapa inca* may have been proud to house all of his

many children, the *uaccha uasi* was most likely not a source of comfort to the *coya*. Not only was it a reminder of her spouse's promiscuity (something that she was not allowed) but it also opened up threats to her son's inheritance. For a royal lineage fraught with challengers to the throne from among the many royal descendants, the *uaccha uasi* reveals one way in which even those officially pushed aside from inheriting power could find ways to gain the ruler's ear (and heart).

For Topa Inca, the *uaccha uasi* highlights the very issue he was trying to circumvent. Specifically, the building would have been a visible reminder of the important role of the mother in determining the status of the child. For this reason, it is a particular tragedy that we don't know whether Chinchero had a *uaccha uasi* and where it may have been placed. Given the care that was taken to manipulate the visitors via roads, pathways, rock outcrops, vistas, and access points, it is likely that the choice to include this building and the sleeping quarters of Capac Huari would have been carefully thought out. If Capac Huari had been placed inside the *punona uasi* enclosure, it would have sent a powerful message to visiting family members of his new status. And if Topa Inca chose to build a *uaccha uasi* close to his *punona uasi*, it would have sent a signal that other (lower-caste) children were specially embraced. Unfortunately, not enough surviving remains exist to allow us to know whether these buildings were included in Chinchero's *pata* and, if so, where they may have been.

Nevertheless, the *punona uasi* and *uaccha uasi* are reminders of how we must consider the importance of domestic life in reading royal estate architecture such as Chinchero. Here we see how concepts of the body and gender roles came to-gether through the physical needs of drink, food, sleep, and sex to define Inca royal space. And, by understanding the important roles that distinct building types played in Inca royal estates, we are also reminded, yet again, how our own contemporary desires regarding how we wish to see imperial landscapes have shielded us from seeing its unexpected yet vibrant realities.

The domestic sphere, centered on a *pata*, would not have been a distinct part of the ruler's life separate from state activities. On the contrary, one permeated the other. Topa Inca was never able to abandon his identity as the supreme and sacred leader of Tahuantinsuyu, even in the most private of spaces. But even if he could have "escaped" into private life, family was not necessarily a safe haven away from imperial rule. Instead the private sphere was a platform for enacting complex family dynamics that could have serious repercussions for the rest of the empire. As Inca history reveals again and again, those closest to the ruler could be the very people who sought his demise. Because of this, the private sphere could be as threatening as the public.

The porous boundaries between the private and the public greatly influenced the layout and design of imperial royal estates. It is clear in the design of the approach to Chinchero and the layout of the Pampa, but it is equally evident in and around the private *pata*—a vulnerable space that had to exude the ruler's sacred authority. In terms of architecture, this platform for domestic life had to project a most powerful façade to potential threats from within. These threats, which drove the design and experience of this lavish but defiant retreat, came to a violent conclusion shortly after Topa Inca's death.

7 | LLACTA | COMMUNITY

In 1532, Francisco Pizarro and his crew made their second landing along the north coast of Tahuantinsuyu.[1] But this time the Spanish did not quickly retreat; they came prepared for a sustained presence. And conditions could not have been more perfect for the Spanish. Instead of the consummately organized and elaborately controlled empire that had existed during the reign of Topa Inca, a landscape depopulated by the introduction of European diseases and decimated by a brutal Inca civil war lay before the invaders.[2] The destruction initiated by these foreigners created an unimaginable hell for most Andean peoples. The arrival of the Iberians in the Americas occasioned a *pachacuti*, a moment when the world turned upside down.[3]

This devastation also wreaked havoc upon Chinchero. The once majestic royal estate was radically transformed into a colonial-period town. Gone was the carefully constructed theatrical stage that reached out to the larger landscape in order to venerate Topa Inca. In its place was a fragmented urban settlement in which diverse architectural gestures became intimately entwined. While the history of these changes is hard to trace in the written record, the physical remains reveal the potent ways in which imperial Inca architecture gave shape and meaning to the new town, and the legacy of Topa Inca's architecture reached well into the colonial period.

The Panaca

The devastation brought about by Spaniards began well before they set foot in the Andes. Their

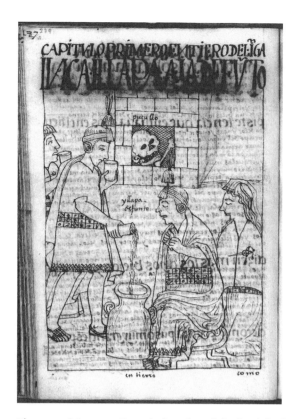

Figure 7.1 | Guaman Poma's drawing of the burial of a *sapa inca*. (Felipe Guaman Poma de Ayala, "Burials of the Inka," *El primer nueva corónica y buen gobierno* (1615/1616), GKS 2232 4, Royal Library of Denmark, Copenhagen, 287[289].

arrival far to the north, along the shores of the Aztec empire in what is now Mexico, is closely tied to the events that followed Topa Inca's death at Chinchero. Although we know little about the particular funeral arrangements for Topa Inca, we do know what happened upon an Inca ruler's death. When a *sapa inca* died, the Andean landscape was infused with sacrifices and sanctified with rituals. During this period, the body of the newly deceased ruler was transformed into a *mallqui* (mummy), and Inca nobles voted on and confirmed one of the *sapa inca*'s sons as successor (fig. 7.1). The one-year ritual marking the death of the ruler was called the *purucaya* and involved a series of ceremonies and performances devoted to the remembrance and honor of the deceased ruler. During this ritual the new *sapa inca* made a pilgrimage to important buildings to hear song narratives about his ancestors and their achievements. These buildings served as critical mnemonic devices for the

official histories of their royal patrons. In addition, noblemen and -women carrying objects once held by the royal patron made a pilgrimage to important places where they, too, sang of their ruler's great achievements.[4] As Susan Niles notes, "These histories were spoken and sung, punctuated by drum beats, and they were inscribed on the landscapes in the paths they walked."[5] For the Inca, place and space were critical to the remembrance of Inca history.

During this time, the newly mummified *sapa inca* was not considered deceased, but instead transformed into a living ancestor. In his newly desiccated form the *sapa inca* as *mallqui* would conduct his days traveling, eating, drinking, and offering advice and permissions, as he had done in his corporeal form. An Inca ruler never really passed away but was transformed into an important sacred ancestor who continued to inhabit and contribute to the world.

As a *mallqui*, the *sapa inca* lived on in his royal residences. Although parcels of land could be added or given away by his *panaca* (and subsequent *sapa inca*), the core of the ruler's royal retreat stayed the same, both physically and spatially. The newly desiccated Topa Inca would have been dressed in the finest of clothing, set on his viewing platform to watch events on the Pampa, feasted with relatives (living and mummified) in CP3, moved in a procession through the terraces to make offerings at Titicaca, Chinkana, and Condorcaca, and at various points turned to for advice. Chinchero would have continued to serve as the royal sanctuary in which to venerate Topa Inca, only now the patron was not the current ruler but a powerful and venerated ancestor mummy.

Because of these traditions, as the empire turned to crown a new *sapa inca*, Chinchero's architecture and spatial practices should have remained largely unchanged. His favored son, Capac Huari, should have become the new *sapa inca*, approved and supported by Topa Inca's powerful siblings, while the rest of his children should have become active in his powerful *panaca*. This *panaca* would have curated Topa Inca's "mummy and his reputation, working to provide for his food and

drink and preserving and performing the narratives that told of his deeds."[6] These oft-performed stories would have formed Topa Inca's official history.

At first, all seemed to be going according to Topa Inca's plan. Pedro Sarmiento de Gamboa writes that "at the time of [Topa Inca's] death, or sometime before, he had appointed as successor a bastard son of his named Capac Guari [Huari], the son of a mistress named Chuqui Ocllo [Chequi Ocllo]."[7] In order for Capac Huari to succeed Topa Inca, he had to be approved as the new *sapa inca* and voted on by the very people that Topa Inca had designed his estate to impress. Elites in Cuzco supported Capac Huari's right to inherit the *mascaypacha*—at first. Chequi Ocllo had a crucial ally in a lady named Curi Ocllo, who lived in Cuzco and garnered fast support for Capac Huari in the Inca capital.[8] But, before his coronation as *sapa inca* could take place, Topa Inca's well-laid plans for imperial succession began to unravel.[9] Mama Ocllo accused her nemesis, Chequi Ocllo, of using witchcraft to charm and then kill Topa Inca.[10] As the story spread among the nobility, support for Capac Huari and his mother began to falter. The deciding factor emerged when a handful of Topa Inca's (and Mama Ocllo's) powerful brothers, the very ones to which his architecture of Chinchero was addressed, shifted their allegiance to Huayna Capac and his mother, sealing the others' fate. Sarmiento writes that "Chuqui Ocllo was charged with being a rebel and having killed Topa Inca, her lord, with spells, and [thus] they killed her. They banished Capac Guari [Huari] to Chinchero, where they fed him and he never again entered Cuzco until he died. They also killed the woman Curi Ocllo, who had advised that they should support Capac Guari as the next *sapa inca*."[11]

Unlike the smooth transition that marked Topa Inca's appointment as heir in place of his previously appointed brother, the post-mortem challenge between Topa Inca's sons led to intense conflict among Inca nobles. One in particular was Guaman Achachi, who sided with Mama Ocllo and was instrumental in gathering support from his powerful *panaca* Iñaca.[12] Although the final resolution lay in the hands of critical elite males, the role of a few powerful women who instigated events behind the scenes was crucial. Mama Ocllo emerged victorious; Curi Ocllo and Chequi Ocllo were put to death.

Despite his "win," the transition to power was not an easy one for Huayna Capac. Not only did he know that many members of the Inca elite favored his half-brother, but everyone knew that he was not his father's choice as heir. This manifested itself in many ways. For example, it was common for the heir apparent to live on the estate of his father until his own imperial residence was built. Yet, Huayna Capac did not live in his father's urban palace of Calispuquio, nor in Chinchero, where his half-brother was imprisoned; instead, he chose to live with an uncle in Ucchollo, in Cuzco.[13] This living arrangement suggests that Topa Inca's *panaca*, Capac Ayllu, continued to favor Capac Huari over Huayna Capac, even after the latter was proclaimed as successor. Some of these elites challenged Huayna Capac during his first years in rule, and he had to put down several coup attempts by high-ranking Inca nobles.[14]

Perhaps for this reason, Huayna Capac began rewriting Inca history.[15] These new stories emphasized Huayna Capac's right to rule Tahuantinsuyu. For example, despite the fact that the Inca did not practice primogeniture, Inca narratives emerged that described Pachacuti holding up his grandson Huayna Capac soon after the latter's birth and proclaiming him heir. These narratives attempted to minimize the fact that Huayna Capac was not Topa Inca's choice by saying that he was the choice of his venerated grandfather, Pachacuti. In other stories, Topa Inca and Capac Huari were erased altogether. And, since buildings were understood to be manifestations of memory and, therefore, testaments to history, it is no surprise that some of Topa Inca's buildings and settlements were systematically erased. At several sites in the north, Huayna Capac chose not to augment settlements built by his father, but to tear them down and build them anew.[16] In fact, the survival of any of Topa Inca's stories or architecture is remarkable.

Despite the traumatic events of imperial suc-

cession, it appears that at first the architecture of Chinchero remained the same; there is no evidence of alterations during this period. Yet it is likely that spatial practices were impacted in at least three ways. First, the struggle over succession must have cast a pall over the status of Topa Inca and affected how his mummy (and memory) were venerated. One can imagine that Huayna Capac and his supporters may have been less than enthusiastic about visiting and making offerings to Topa Inca's *mallqui* and *huauque* (brother statue)—at least no more than was required.[17] After all, Topa Inca was the one who shifted his preference from Huayna Capac to Capac Huari, beginning the showdown between the half-brothers and, most dramatically, between their respective mothers.[18] It is therefore possible that there may have been fewer ceremonies, or at least less elaborate ones, at Chinchero because of the succession dispute.

Second, the day-to-day running of Topa Inca's estate would have been conducted by his *panaca*, named Capac Ayllu, whose activities may have reshaped spatial practices at the royal retreat. This *panaca*, composed of Topa Inca's surviving wives and children (minus the new ruler), would have been assigned key roles related to the care and veneration of Topa Inca's *mallqui*, such as sitting with the *mallqui* on the viewing platform, carrying him in a procession into CP5, and participating in the unique ceremonies within CP4. They would have also been in charge of Cusichuri, the brother statue of Topa Inca, as the ruler's *huauque* was always kept with the *mallqui* after a ruler's death.[19] As the authority of specific *panaca* members grew, the spaces in which they traditionally gathered (for example, CP3) when Topa Inca reigned would have taken on more importance after his death.

One of the family members of Topa Inca's *panaca* would have been Capac Huari. His presence at Chinchero is the third reason that spatial practices were likely altered after Topa Inca's death. While all other royal Inca estates made the transition from being the home of a ruling *sapa inca* to being the home of his venerated *mallqui* and *huauque*, Chinchero alone became a royal prison. What

kind of prison we do not know. Was Capac Huari denied the lavish lifestyle he enjoyed when his father was alive, or did the richness of royal life continue, except that now this favored son was forbidden to leave? Perhaps Capac Huari was placed in a confined space, akin to the "cage" in Topkapi Saray in Ottoman Istanbul, where the younger brothers of the sultan were kept (near the latter's luxurious quarters). Or perhaps Capac Huari had free range and control over Chinchero as long as he stayed within its borders, like Napoleon did on the Island of Elba.

Since we do not know whether Capac Huari continued to sit on the viewing platform and sleep in his old *punona uasi*, or whether he was banished from these high-status spaces to the confines of less prestigious quarters where he could hear but not see the pomp and circumstance of imperial rituals, we cannot say how dramatically spatial practices may have changed once Chinchero began to serve as a royal prison. Regardless of what happened to Capac Huari, it is clear that although Chinchero's architecture may not have been physically altered, the spaces would not have been used in exactly same way as when Topa Inca ruled.

The Iberian Pathogens

Change eventually came to the physical armature of Chinchero—and it was dramatic—but not for many years after Topa Inca's death. In 1509, Europeans brought smallpox to Hispaniola, and when they landed on the mainland in 1520, they brought this, along with other deadly diseases, to the rest of the Americas. These newly introduced pathogens spread across the continent and down to the Andes much faster than the Spanish sailed or walked. The diseases devastated Tahuantinsuyu, rapidly killing Huayna Capac and his favored son and heir, creating a sudden vacuum of leadership in the Inca state, which led to a bloody power struggle. Thus, without a single Spaniard present in the Andes, the Spanish began the most brutal civil war the Andes had ever seen.

In Chinchero, we do not know who or how many people were killed by smallpox, measles, and other "Old World" diseases, but it is likely that the number was significant. Most indigenous people died rapidly upon initial contact, and, of course, this meant that at Chinchero death came not only to the royal residents, but also to the *yanacona* (servants), priests, and guards.

The few who did survive the epidemic had to face the horrors of the civil war. Two of Huayna Capac's surviving sons, Atahualpa and Huascar, each argued that he alone was the *sapa inca*'s favored son, born of a legitimate, elite wife, and therefore had the right to inherit the *mascaypacha* (the "royal fringe," which indicated Inca rulership). Caught in the crosshairs of these warring siblings, people in the Andes were forced to choose sides. As Huascar's mother, Raura Ocllo, was a member of Topa Inca's *panaca*, Capac Ayllu supported Huascar's claim.[20] As the founder of Capac Ayllu, Topa Inca (in the form of a mummy), also favored one grandson (Huascar) over the other (Atahualpa).

Because of this, Atahualpa's anger focused squarely on Topa Inca. On Atahualpa's command, his generals sought out, captured, and burned Topa Inca's *mallqui*.[21] According to Sarmiento, Atahualpa's general Cusi Yupanqui

> found that the house of Tupac Inca Yupanqui [Topa Inca] sided with Huascar. Cusi Yupanqui committed the punishment of the house to Chalco Chima and Quiz-Quiz. They seized the steward of the house, and the mummy of Tupac Inca, and those of his family and hung them all, and they burnt the body of Tupac Inca outside the town and reduced it to ashes. And to destroy the house completely, they killed many *mama cunas* and servants, so that none were left of that house except a few of no account.[22]

This was a horrifying turn of events in Inca history.[23] While rulers could fall in and out of favor (even violently), their *mallqui* were always preserved and venerated.[24] But Atahualpa singled out Topa Inca for the definitive revenge, turning his *mallqui* to ash. Although this act was carried out

under an Inca's order, European diseases had set in motion the series of events that led to the incineration of Chinchero's royal patron.

Disease and war also led to the destruction of Topa Inca's *panaca*. The adult members of Capac Ayllu were responsible for maintaining his mummy, oral history, rituals, and royal estate.[25] Topa Inca's servants (*yanacona*) and religious specialists (such as the *mamacona*, who made his special clothes and sacred *aka*) also cared for the *sapa inca*'s body and possessions (and therefore his essence and remembrances), and in Atahualpa's eyes anyone who could extend the life or memory of his grandfather had to be killed.

But even this was not enough. Atahualpa also appears to have attacked the lithic monuments to Topa Inca's memory.[26] Given the close link between Topa Inca and Chinchero, it is likely that the most important buildings of the royal retreat were set ablaze at this time: the two impressive *cuyusmanco* whose distinctive doorways framed the *sapa inca* (P4, P5), the processional space (CP5) in which he greeted people from the Pampa, the luxury boxes in which he and his family gathered (CP3) to peer at events through the grand windows, and finally the imposing tower with the hidden doorway in which Topa Inca conducted secret rituals (CP4). In other words, the most important buildings that would have proclaimed Topa Inca's authority and served as material remembrances of his history were targeted and destroyed.[27] Given that the two *suntur uasi* in Cuzco took eight days to burn down, the destruction of Chinchero's buildings must have taken at least a week, indicating the extended punishment meted out by Atahualpa to Topa Inca's royal estate. Like his *mallqui*, the last of the giant timber rafters holding up the immense roofs were reduced to a fine ash. All that remained of the royal estate's buildings were the bottom courses of finely carved limestone walls, their lithic interiors cracked and crumbled (figs. 5.7, 5.16, 6.3).

However damaged, some of these stone walls survived Atahualpa's burning rage. These numerous building fragments and scattered stones attract tourists to Chinchero today and have pro-

vided the framework for our analysis of the estate. Atahualpa's attempt to destroy the legacy of Chinchero by demolishing the buildings that carried his memory was incomplete, much like his attempt to kill off all of Topa Inca's family and servants. As Sarmiento mentions, a few of these individuals survived Atahualpa's purge and, like Chinchero's remaining buildings, they did not disappear into Inca history but stayed to play a critical role in carrying on Topa Inca's legacy.

When Atahualpa began what he thought was his victorious journey home in 1532, a small band of Europeans entered Tahuantinsuyu. Under the pretense of a friendly encounter, Pizarro and his team captured and eventually killed Atahualpa. Through this new vacuum of power in Inca leadership, the Spanish people rapidly spread, seeking to reinscribe the Andes (and Chinchero) in their own image.

A Landscape in Transition

One of the first things the Spanish did after killing Atahualpa and seizing treasures of gold and silver was to grab territory. In this war- and disease-ravaged landscape, it was not difficult. Around royal estates such as Chinchero, legal and illegal claims of land were staked by Spaniards as they fought not only the indigenous claimants but also each other for titles.[28] Inca elites actively tried to retain their hereditary lands. For Topa Inca's descendants, this was difficult; so many adults in his *panaca* were dead, and Chinchero's residents were reduced to a small number.[29] Although some Inca nobles gained ownership of parcels, most of Topa Inca's royal lands were eventually carved up into Spanish land grants. The long series of architectural gestures, such as way stations, sacred shrines, and storage houses, were cut off from Chinchero proper. The palace area, nestled around the Pampa and private *pata*, was transformed: the theatrical crescendo at the end of a long architectural journey within the imperial Inca landscape became a burnt and sparsely populated settlement within the Viceroyalty of Peru.

Despite the chaos that surrounded it and the violence wreaked upon it, Chinchero slowly began to rebuild in a manner that continued to be a reflection of Topa Inca's legacy. For example, the Pampa remained the spatial center of Chinchero, and two of the three buildings lining the Pampa continued to stand as important markers of authority and sacredness for Chinchero's residents.

However, these buildings did not function in exactly the same way as they had during imperial Inca rule. Specifically, sacred space was rearticulated. As a people that practiced sacredness inclusively rather than exclusively, the Inca were quick to venerate new sacred elements if the forces behind them proved powerful. Given the might of the Spanish, many indigenous people readily adopted Christianity and incorporated it into their larger sacred world.[30] The grand Inca building CP5 was converted into a Catholic church (likely by 1550).[31] Its long interior space was cleaned of ash and reimagined as a nave, while the remains of CP5's short eastern wall were knocked down so that a semicircular room could be added as the sanctuary. In addition, small walls were erected nearby, perhaps as burial units for Chinchero's newly Christianized residents (fig. 3.1).

The construction of these walls (most along the terrace below the Pumacaca viewing platform) ranged widely in technique and quality of stone, reflecting both the difficulty in reaching quarries with high-quality materials and the variability in knowledge and skill among the masons. The most skilled masons devoted their attention to the new curved wall added to CP5 to create the church's sanctuary. Although the blocks used to make this new wall were not of the same high quality that defined construction during Topa Inca's reign, considerable effort went into procuring and working the new stones so that the walls seemed to blend well with the imperial Inca masonry. In their pristine condition, the original imperial Inca blocks of CP5 would have stood out from these lesser-quality colonial additions. But now, scarred by Atahualpa's fire, their damaged appearance allowed them to blend more easily with the rougher stones used in the colonial-period structure.

Perhaps significantly, the new stones used to create the sanctuary for the Christian church overlay the same space through which the *sapa inca* had proceeded from his viewing platform to CP5, making the eastern side of CP5 ritually significant during both imperial Inca and Spanish colonial times. This is just one of many spatial similarities between CP5's uses as *camachicona uasi* and as church. During both the imperial Inca and Spanish colonial periods, processions of a sacred figure of veneration led to and from CP5: first the *sapa inca* and later the Christian god.

The addition of the Christian god at Chinchero does not mean that the *sapa inca* was replaced or forgotten after the Spanish invasion. This building for Inca state meetings was rehabilitated as a Christian church, but its neighbor, the *suntur uasi*, remained exclusive to Topa Inca. This severely burned building was ritually bricked up, and its interior was carefully filled in. By transforming imperial Inca buildings into shrines, the Inca "linked myth and history, making both real and tangible, by localizing action, event, and narrative at places on their sacred landscape. . . . [These buildings] helped to tie the Inca royal families to their remembered ancestors and to a past that they claimed they shared."[32] In that way, the spaces and places transformed by the ruling *sapa inca*'s actions continued to serve as potent places of remembrance after he died.[33] For Chinchero, this remembrance meant the *suntur uasi* would be preserved as a shrine, even after it was burned and ritually sealed.

We cannot say precisely when this occurred, but it likely transpired soon after the burning (1533) or when Topa Inca's ashes and *huauque* were destroyed (around 1558).[34] Despite Atahualpa's best efforts, Topa Inca did not cease to exist when his mummy was cremated. Instead, his ashes were gathered up and placed in a small jar, a powerful act that allowed his essence to continue, even though he was no longer a *mallqui*. As Frank Salomon has noted, "The Andean dead were felt to have personal existence as long as any part of their bodies, even clothing or an effigy, was conserved."[35] Topa Inca, through the presence of his ashes and *huauque* Cusichuri, was carefully guarded.[36] His ashes and *huauque* were secretly transported, conserved, and venerated for about twenty-five years after Atahualpa's generals burned his mummy.[37]

This preservation meant that Topa Inca, now in the form of a loose aggregate of ash contained in a jar, and his brother statue Cusichuri, still in the form of a portable stone covered in Topa Inca's bodily sheddings, could have visited Chinchero during the early years of the Spanish invasion and been able to witness some of the horrors inflicted on the royal estate by Topa Inca's own grandson and the Iberians. In these clandestine visits, Topa Inca's ashes and Cusichuri would have been able to offer some comfort and guidance to the few survivors remaining at Chinchero—that is, until the Spaniards discovered Topa Inca's ashes and *huauque* at his palace, Calispuquio, in Cuzco.[38]

There are two reasons why Topa Inca's ashes and brother statue persisted for several decades after the Spanish invasion. The first is because it took the Spanish that long to realize that sacredness for the Inca was not carried by form, but instead by materials and essence. Once the Spanish realized that these ashes and the small stone with bodily sheddings were sacred, they ordered these materials to be summarily destroyed.[39] With the destruction of Topa Inca's ashes and *huauque*, the essence of Topa Inca may have finally been destroyed, for there is no mention of Topa Inca surviving in any form or state of materials after this Spanish seizure.

The second reason that Topa Inca's ashes and *huauque* survived for several decades after the initial Spanish invasion is that some members of Topa Inca's family survived Atahualpa's blazing rage. This small group of Inca elites from Capac Ayllu, who cared for Topa Inca's ashes and *huauque* and maintained his buildings, lands, and song narratives, are the only reason a few of the stories survive today. Clearly this hardy band of Topa Inca's descendants was not "of no account" as Sarmiento had described them. Rather, this ragtag remnant of Capac Ayllu proved itself to be exactly the opposite.

Many of these survivors were deemed non-threatening because they were children.[40] However, others may have been dismissed because they were the descendants of Capac Huari. As a prisoner of the state, Capac Huari would not have held much power within the *panaca*, and the children (and grandchildren) of such a disfavored man would likely have been marginalized, especially as long as Huayna Capac was in power. Capac Huari and his offspring would have played little if any role in the decision-making of the *panaca*. But this marginalization may have been the one thing that saved Capac Huari's descendants and their servants from the extreme violence exacted on everything and everyone connected to Topa Inca. If true, then this skeleton crew of survivors had especially close ties to Chinchero.

The survivors helped bring Chinchero's Pampa back to life. If Topa Inca was brought back to Chinchero (in the form of his ashes and *huauque*), it was under the guidance and care of this surviving *panaca*. During this time, Topa Inca would have likely spent time in CP4, the *suntur uasi*, undertaking sacred rituals away from the prying eyes of the Spanish extirpators of idolatry. Christianity did not displace the *sapa inca* from Chinchero, but instead became a new addition to the sacred lithic spaces of Topa Inca's Pampa.

Who Makes a Town?

The fact that the architecture and spaces of Chinchero enabled and celebrated the continued presence of Topa Inca and his descendants in the face of Spanish opposition may help explain why the royal estate was suddenly changed in radical, almost violent ways in the latter half of the sixteenth century. Many of Chinchero's streets, buildings, and gathering spaces were rebuilt, altered, or destroyed in the making of a new Spanish-style town. Since we have no written records for Chinchero that describe exactly when these changes were made, who specifically ordered the alterations, or why they chose to do so, we have to rely

on Chinchero's material remains and the few written records that relate to the area and its people. What is clear from this evidence is that the dramatic early colonial changes were driven by a need to turn the remains of Topa Inca's lavish royal estate into a Spanish-style town.

In Europe, towns were central to Spanish life and were considered critical to creating *civitas* and *policía*—a civilized and well-ordered society. The Spanish brought these ideas with them to the Americas, actively founding new towns in areas they conquered. However, many of their practices were similar to those of the Inca. For example, the focal point of the new Spanish urban settlement was an open space, the plaza. With a carefully constructed *urbs*, or architectural backdrop of civic and Christian structures, the Spanish plaza was created to be the theater in which the Iberian state and the Roman Catholic Church enacted their authority over a conquered populace, as well as a space where indigenous people could observe and be taught proper behavior.

While some of these towns were constructed on virgin terrain, many were built on top of, or carved out of, existing indigenous settlements or cities. The colonizing spaces and structures of the Spanish kingdom had to be imposed upon a native landscape with its own distinct spatial and architectural traditions. This colonial dynamic became even more fraught when the settlements being converted were those that had functioned as the key nodes in an indigenous empire, such as the royal estate at Chinchero.

The Spanish created a special type of town, a *reducción* ("reduced town"), which was meant to consolidate indigenous populations into urban settlements so that they could be more easily controlled and evangelized.[41] The urban design of these reduced towns embraced the ideas laid out in the *Law of the Indies* (decreed in 1573), which described how cities were to be built in the Americas, explicitly linking architecture and urban form to a civilized and Christianized society.[42] These new towns were to have several key architectural elements, such as gridded streets, a main plaza, and a church (among other structures), forming the

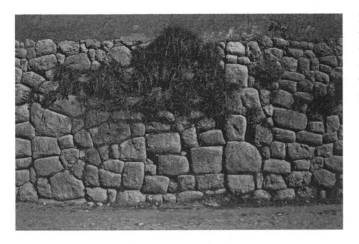

Figure 7.2 | A view of one of the imperial Inca streets that was sealed in the early colonial period. The threshold of the original road is still visible, as is the original building wall on the left of the photograph. This Inca street was filled in with reused imperial Inca blocks. Photo by the author.

urbs, or built environment, in which the *civitas*, or ordered community, could thrive.

This collection of ordinances from King Philip II of Spain mandated every aspect of town planning—from site selection to layout—and explicitly linked the built environment to the spread of Christianity and Spanish imperialism. Most important, the ordinances expressed the idea that architecture and urban form had a direct impact upon human behavior and therefore played a critical role in designing a healthy, prosperous, and "civilized" society.[43] For the Spanish, this was a rational system used to create order in a disordered world. It was a stage set for the performance of Christian, civilized citizens of the Spanish state. But for Andeans, it was a form of organized repression.[44] The *Law of the Indies*, or at least the ideas that drove its creation, appears to have influenced Chinchero's dramatic reconfiguration.

The Violence of the Grid

Although Chinchero is not listed as one of the official *reducciones*, the extraordinary changes in its armature suggest that some individual or group had both the desire and power to drastically reshape the royal estate so that it followed these newly emerging urban ideals. One of the most obvious examples is the imposition of a gridded street plan upon the estate's terraced landscape.

Many buildings and terraces of Topa Inca's es-

tate were destroyed in order to create this grid. Although this profound reshaping of the landscape required tremendous effort, it was critical to Spanish ideas of an ordered society in what they saw as a barbarous land.[45] These new streets also had practical applications, as they helped control local populations and prevent indigenous uprisings. Spacious and ordered streets allowed for easy oversight of the resident population and facilitated the movement of Spanish troops.

By contrast, narrow, sometimes irregular Inca streets confused the newly arrived Europeans and hindered mounted armed guards from riding abreast of one another to quickly quell indigenous uprisings. An example was the siege of Cuzco, where Inca soldiers swiftly jumped from rooftop to rooftop across narrow streets, pursuing and killing bewildered Spaniards who became trapped among the narrow and relatively unfamiliar Inca roads.[46] Easily evading capture, the nimble Inca warriors set fire to the city and almost destroyed the last Spanish holdout.[47] With the arrival of reinforcements, the Spanish eventually regained control of the city, retaining the lesson of the danger of narrow Inca streets and immense Inca thatched roofs.

At Chinchero, the transformation of the royal estate's architecture and layout was extreme; streets were sealed and terraces dismantled (figs. 7.2–7.3).[48] Only a few pathways of Topa Inca's estate were left intact to become part of the new urban plan, such as the roads that began with

Figure 7.3 | Soqta Qucho Qataq, one of the roads that was inserted into the former royal estate. This colonial road cuts through several imperial Inca terraces and one imperial Inca building (wall and doorway). All were made of finely bonded polygonal limestone. Photo by the author.

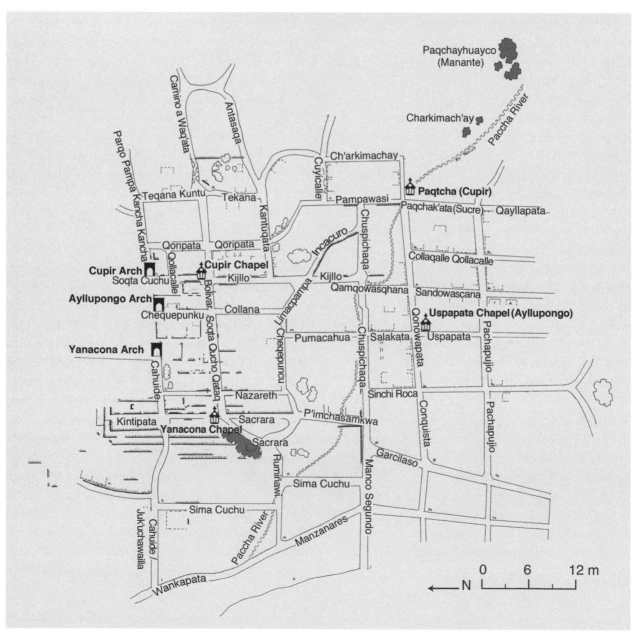

Soqta Cuchu and Cheque Punku. (In Chinchero today, a road's name changes almost every block, which was a tradition practiced in both medieval Spain and Tahuantinsuyu.)[49] The result of these urban renovations was a relatively ordered grid of wide streets spreading across—and devouring—what had been an elegantly terraced hillside (fig. 7.4).

The Plaza: Creation or Re-creation?

For the Spanish, the focal point of their new towns was the plaza, and in Chinchero the Pampa was a perfect fit, or so it should have been. At approximately 280 feet wide by 500 feet long, the Pampa was within the dimensions later mandated by the *Law of the Indies*. Ordinance number 113 states that "[the plaza] shall be not less than two hundred feet wide and three hundred feet long, nor larger than eight hundred feet long and five hundred and thirty feet wide. A good proportion is six hundred feet long and four hundred wide."[50] Chinchero's Pampa fit the prescription of the ordinance well ahead of its time.

Despite this, the vast Pampa, with its fine church and impressive stone architecture, was suddenly abandoned, and the focal point of the colonial town changed dramatically sometime during the waning years of the sixteenth century. During this time, a new plaza was established, as were a new church (1607) and a new gridded plan. The plaza was centered on Topa Inca's private *pata* (figs. 3.1–3.2). This was an interesting choice for a new town plaza, as the *pata* fell far below the minimum size called for in the *Law of the Indies,* which by this time had been in effect for decades.[51] The *pata* and adjacent atrium had a total expanse of a mere 115 by 95 feet. It seems perplexing at first that the Pampa, which had met the ordinance's size requirements, was rejected in favor of the *pata*, which fell far below the minimum needed, but it begins to make sense when one considers that a similar situation occurred in Cuzco.[52]

In 1571, the viceroy Francisco de Toledo announced that the Haucaypata and Cusipata (the main performative *pata* in Cuzco) formed too large an open space and needed to be subdivided. In his announcement, Toledo does not cite specific measurements to support his argument. Instead, he declares that the Inca dual "plazas" were simply too large for public spectacles, such as festivals, to be enjoyed.[53] While it is possible that the impressive imperial Inca space was much larger than what Toledo himself was used to in Spain, it is likely that during ceremonies the substantial dual plazas publicly revealed the relatively small number of Spaniards in town compared to the large number of indigenous subjects. During a time of violent indigenous revolts, Toledo and other Spaniards may have felt uncomfortable with large public spaces that could enable indigenous collective action.

However, population is just one of the likely factors motivating the Spanish subdivision of the plaza in Cuzco (and the move to the smaller *pata* at Chinchero). Instead, the primary reason for these changes is that, like the Inca, the Spanish were acutely aware of the power of architecture and space as tools of conquest and control, so they shifted their architectural agenda according to local practices. For example, noticing the importance of the large open spaces to Inca political, religious, and cultural life, Spanish authorities reduced the size of Inca *pata* and *pampa* by dividing them up. In Mexico, however, the Spanish did just the opposite. Thomas Cummins observed that in the Aztec capital, the Spanish *created* large plazas where there had been architectural density. The Spanish, who made up only a small por-

Figure 7.4 | (*opposite below*) Map of the modern town of Chinchero. Many of the streets are colonial ones that were inserted into the royal estate and dramatically shifted spatial patterns. Today the streets are not labeled; the spellings shown on the map are derived from interviews with local residents. Image by the author.

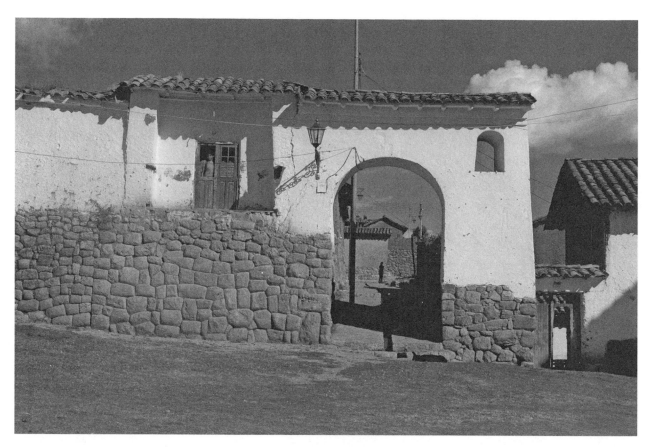

Figure 7.5 | View from the atrium down the street Soqta Cuchu. The entrance is framed by a colonial-period arch (Cupir). Visible through the arch is a colonial-period chapel (Cupir). Photo by the author.

tion of the population in town, did this because they recognized the specific power of the buildings for the Aztec.[54] In Tenochtitlan, the Mexica deeply valued the buildings in their ceremonial core, between which there were only relatively small open spaces. In response, the Spanish leveled the sacred Aztec buildings and left a spatial void in their place to represent their power. These divergent acts in Tenochtitlan and Cuzco reveal the Iberians' sophisticated awareness of indigenous architectural practices and how space could be altered to dramatically signal conquest.[55] For local residents in Chinchero, the abandonment of the Pampa (and reuse of the private *pata*) would have readily signified the considerable power of Spanish authority to re-center indigenous space.[56]

To serve as the new Spanish-style plaza, Chinchero's private *pata* had to be reconceived as the spiritual and political center of the new town.[57] Although the overall dimensions and supporting ter-

races of the private *pata* remained the same, many of the buildings that bordered it were significantly altered. The grand *cuyusmanco* (P5), which once greeted the special visitor who was allowed into the private sector of Topa Inca's estate, was closed and filled (figs. 6.4, 6.5). Since the *cuyusmanco* was occupied at the time (thick colonial-period stucco once covered its burnt limestone walls), its occupants had to be displaced, along with others who lived in or used adjacent structures. These neighboring buildings, including Topa Inca's likely *punona uasi*, were almost completely destroyed to their foundations (P1, P6, P7, P8). Two buildings in the *pata* may have been removed at this time as well (P10, P11). On top of these filled-in Inca structures was built an atrium, which could serve the new (second) church (fig. 6.7).

As Topa Inca's private *pata* took on new meaning in its early colonial context, so did its adjacent pathways and concomitant spatial practices. One

royal estate street (Soqta Cuchu) was preserved and extended during the colonial period to serve as the main road connecting Cuzco (where most powerful Spaniards lived) to the atrium of the new church (fig. 7.5).[58] This street conversion was not only practical, but it also expressed an urban ideal. The *Law of the Indies* declared that streets should emanate from a town plaza, thus allowing *civitas Cristiana* to be carried out into the town. However, unlike the four streets suggested by the ordinances, only three streets reached out from Chinchero's new atrium and plaza, because the new plaza was not situated in the center of the town (as preferred in the ordinances) but instead lay on the edge of the new city.[59] To the other side lay the vast expanse of the Pampa and its sacred imperial landscape. Interestingly, the builders of the new Spanish-style city chose not to extend the urban fabric onto Topa Inca's Pampa and sacred outcrops, but left them alone, well beyond the reach of this new urban renovation.

Arches: Procession, Possession, and Place-Making

To further articulate Chinchero's urban transformation and Spanish authority, European-style markers were placed around the new plaza (fig. 7.6). Specifically, these denoted access points: two between the plaza and atrium and three between the new town center and its connecting streets. Unlike Topa Inca's Pampa, where all but one access point was carefully concealed, the new colonial plaza accentuated entrances and exits. Through the use of arches (a construction type that was never used in imperial Inca design), the Spanish presence was architecturally and spatially enunciated.[60] The arches served as signifiers not only of movement, but also of conquest.

As markers of access, these arches shaped spatial practices in the new town. The first two (located at either end of the long wall that divided the plaza and atrium) were designed for Catholic

Figure 7.6 | View into the private *pata*/colonial plaza from the west, showing two of the new colonial-period arches. The first (Yanacona arch) frames the entrance to the plaza; the second is one of the two arches dedicated to the Virgin of Montserrat, the patroness of the Chinchero church. The street on which the photo was taken is called Cahuide, named after an important Inca general who fought the Spanish to his death in Cuzco. Photo by the author.

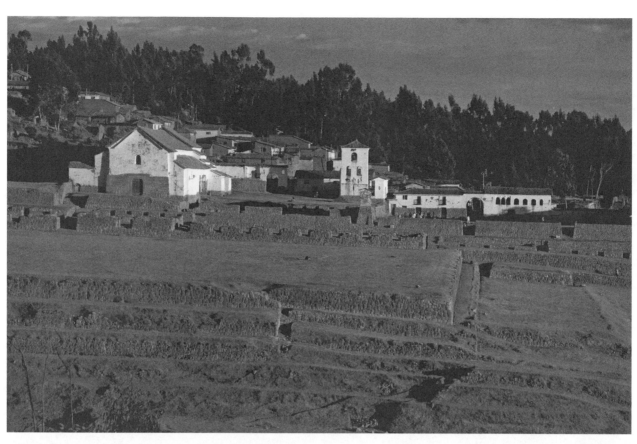

ceremonies, such as the movement of the town's titular saint (figs. 6.7, 7.6–7.8). The two arches are named after the Virgin Mary, and her image was carried from the church down into the plaza and through each arch during Christian rituals.[61] In Spanish processions during the early modern period, architectural gestures such as these were used to express concepts of conversion and faith in Catholic liturgy and theology.[62]

The remaining three arches were likely intended to do the same (fig. 7.4). They denoted the points where the three streets connected to the new town center. But these did not simply articulate the entrance to Christian space (i.e., the church overlooking the atrium and plaza) but instead brought the Christian center out into the town. Specifically, these three streets ran from the plaza and atrium to the three Catholic chapels in town (figs. 6.9, 7.5–7.7).

Crosses and Chapels: Marking the Sacred as Sacred

The new urban chapels in Chinchero helped to reinscribe the remains of Topa Inca's private retreat as a Christian landscape. Building a Christian shrine on top of a non-Christian sacred place was a relatively common practice in Europe before 1492.[63] This practice was continued in the Andes, especially after Toledo and the ecclesiastic Councils of Lima declared on several occasions that it was a productive way to convert local people. Specifically, it was suggested (though not adopted by all) that churches, chapels, or crosses should be placed on top of sacred spaces in order to re-place and eradicate prior indigenous beliefs and practices.[64] For example, in Cuzco the Dominicans built a church over the most holy shrine in the empire, the Coricancha, and the church of Santa Ana was built on top of an important collection of huaca (fig 1.11).[65]

At Chinchero, chapels and crosses were built across the colonial town on the buildings and shrines of Topa Inca's estate.[66] For example, a chapel (Cupir) is located along Soqta Cuchu, just one block from the colonial plaza (fig. 7.5). The Cupir chapel sits upon an imperial Inca structure, of which only a few steps remain. As this narrow Inca street is a difficult setting upon which to build a chapel, a small projecting pata was added so that the Christian structure could be built. The desire to build upon this awkward site suggests that the space itself may have had important meaning, perhaps related to Topa Inca's royal estate. Interestingly, this chapel had close connections to a sacred outcrop that defined the eastern boundaries of the private sector of Topa Inca's estate. In a tradition that continues today, a large painted crucifix that normally resides in this chapel was taken to the top of the huaca Antasaqa to mark special events in the Christian calendar (figs. 6.6, 7.9). Thus, an architectural element that visiting Spaniards may have seen as signaling the Christian conquest, actually celebrates both Christianity and Topa Inca's sacred landscape.

This unexpected entanglement can be found in other colonial structures. Another chapel, Yanacona, was built to the west of town, at the foot of the street Soqta Qucho Qataq (nicknamed by some residents in town Conquista, which is the name of another colonial street in town). This street

Figure 7.7 | (opposite above) View from the hill facing Chinchero, looking south onto the colonial town center. Visible to the right is the new plaza and to the left is the new colonial church and tower, resting on the new atrium. Note how the Pampa, its buildings, and terraces were left alone in this colonial scheme. Photo by the author.

Figure 7.8 | (opposite below) View from the plaza looking northeast. Visible are the Inca niches built in the colonial period (inserted into the opening of the cuyusmanco, P5) and one of the two new arches dedicated to the Virgin of Montserrat. In the background is the apu Antakilke after a snowstorm (the clouds are billowing up from the Urcos/Urquillos Valley below). Photo by the author.

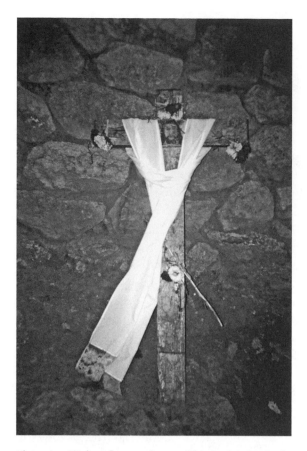

Figure 7.9 | Painted cross that resides in the Cupir chapel for part of the year; for the other part of the year, it sits on top of the *huaca* Antasaqa, a large outcrop that overlooks Chinchero and the surrounding landscape. Photo by the author.

was created in the early colonial period by tearing down six terraces and one exquisitely constructed building from the royal estate (figs. 7.3–7.4). The Yanacona chapel is located on top of an enormous limestone outcrop that dominates almost an entire block of the street Sacrara (i.e., a third of the street's length; see figs. 6.6, 6.12). The street gets its name from the massive outcrop upon which the church is built. *Sacrara* is the Quechua word for a very powerful *huaca* still talked about in Chinchero today. The name derives from *sacra*, which means a strong malevolent spirit—which the Spanish later ascribed to the devil.[67] So another outcrop that helped define the boundary of Topa Inca's private residence (to the west) has been physically linked with a colonial chapel. However, here we see how an immense and potent indigenous sa-

cred element of imperial Inca Chinchero (the outcrop) is acknowledged yet denigrated (equated with the devil) in the colonial landscape.

While these two examples deliver a somewhat ambiguous collective message, the two remaining chapels bring some clarity to the colonial context. The third colonial-period chapel in town, Ayllupongo, is located in the center of the southern portion of Chinchero, along the road Uspapata (fig. 7.4).[68] Unlike the other two Christian shrines, there is no physical evidence that this chapel was built on an estate structure or outcrop. However, the chapel does sit on a promontory that would have afforded a rare vista of the estate.[69] And, not far away, a crucifix was placed over the fountain (*paqcha*) that creates the main stream running through Chinchero and would have been considered sacred during imperial Inca times. This modest but expressively painted crucifix is dated to 1620, suggesting that this reading of landscape reaches far back in the colonial period. The crucifix used to lie in a large niche (also named Paqcha) built of andesite blocks that were reused from an imperial Inca structure that is now destroyed.[70] Therefore, while the chapel appears to sit on "virgin" land, its grand views and connection to a fountain would have made it a special space during imperial Inca times.

Whether intended or not, this chapel, like the other two, hints at Inca understandings of place. Each of these three chapels (Cupir, Yanacona, and Ayllupongo) was built within the confines of the new colonial town on areas that would have been meaningful during imperial Inca times (fig. 7.4). These places were connected to spaces and materials sacred to the Inca, such as fountains and *huaca*. Thus while the new urban armature reflected Spanish notions of Christian civility and conquest, it was rooted in Inca understandings of place and sacredness.

This colonial reconfiguration of space recentered sacredness at Chinchero, but it did so in a manner that also paralleled place-making practices at Topa Inca's private estate. During imperial Inca times, access points in the royal estate connected the Pampa (and the people on it) with

the local *huaca* and other sacred natural features. During the Spanish occupation of the Andes, the streets with arches in the colonial town connected the plaza (and the town's residents) with its urban landscape and sacred chapels. These changes in the colonial town emphasize a procession and sacredness that was similar to imperial Inca practices.

This colonial rendering of sacred space with links to Topa Inca's sacred landscape can also be found beyond Chinchero's borders. Although Spanish authorities concentrated on urban infrastructure as part of their conquest strategy (which left the larger landscape relatively untouched by Spanish architectural gestures), an exception was made for a chapel placed to the south of the town, about a half-hour's walk away, in an area with no local population. The location of this small chapel, nestled next to a gigantic outcrop in the midst of a depopulated rural landscape, may have been surprising to a first-time visitor. However, for anyone familiar with Topa Inca's estate, it would have made perfect sense (figs. 2.7–2.8).

The chapel was located in a critical space on the imperial Inca road that originally connected Chinchero to Cuzco, and the "plaza" and outcrop were important parts of Topa Inca's sacred space. Specifically, the chapel was located at Huancapata, an important lithic marker of possession for Topa Inca (fig. 2.3). During the colonial period, this road potentially served a similar function, connecting powerful Spanish institutions and people in Cuzco (along with some Inca elites) with people in the Chinchero region, and it may also have functioned as an important passageway for Spanish expansion and colonization in the region.

Yet, if the intent was to make visible Christian (or Spanish) conquest over the Inca landscape, indigenous residents likely perceived it very differently. The *huaca* of Huancapata is immense, looming over and dominating the sizable imperial Inca *pata*. In fact, the chapel built directly up against it appears diminutive and tucked under the *huaca*. Given the Inca understanding of the power of touch and the proximity of these two sacred entities, this would have negated the mes-

sage of Spanish dominance for indigenous viewers. Instead, the positioning of the chapel suggests Christian markers joining with indigenous sacredness, an understanding that would have made sense to the inclusive religious practices of many indigenous Christians.

At the chapel of Huancapata, the congregation would have been the members of the Ayllupongo *ayllu*, within whose territory the chapel lies. (The *ayllu* is a critical lineage and community group around which most activities in the Andes, as well as concepts of identity, revolve.)[71] Although the boundaries of the colonial urban settlement were tightly circumscribed under Spanish colonial rule, the territory of its indigenous residents extended from the urban core into the countryside. The relationship between the chapel and Ayllupongo continues today, where the residents serve as the guardians of the chapel as well as the *huaca*. During special occasions, members of the *ayllu* travel from Chinchero to Huancapata to make offerings to both the Christian and the indigenous shrines.[72]

The important role the *ayllu* played in this outlying chapel was not unusual for Chinchero. In fact, these lineage groups determined the colonial naming practices of many of the most important parts of the new Spanish-style town. The chapels (and most of the arches that lined the plaza) were not named after Christian saints, but rather after the indigenous lineage groups in town: the Ayllupongo, Cupir, and Yanacona.

Besides providing naming practices, these lineage groups also determined the general locations of the chapels and the spatial practices associated with them. Each of these *ayllu* occupied a distinct sector in town: Ayllupongo (the *ayllu* most closely linked with Inca ancestry) in the center, Cupir in the east, and Yanacona (descendants of Topa Inca's servants) in the west. And it is within these territories that their respective arches and chapels were built (even if the chapel was located outside the town, as was the case with the Huancapata).[73] This relationship between a community, a place, and specific spatial practices has a long history in the Andes and on the Inca royal estate in particular. At Chinchero, the boundaries of the

ayllu lands are still walked each year, with participants starting and finishing in the group's namesake arch. Ceremonies also take place in each of the *ayllu*'s respective chapels.[74] Similar spatial practices, which also incorporate Inca sacred places and relate to colonial land claims, can be found in other parts of the Andes today.[75]

Though chapels and arches were used to carve out a Christianized landscape from Topa Inca's royal lands, they also came to articulate indigenous identity and reiterate relationships to the land.[76] These chapels, like the impressive walls of Topa Inca's royal buildings, reveal critical spatial practices at Chinchero. This concept is very similar to practices important to other Andean groups, such as the K'ulta. This group's social memory is not found on paper, but instead "it is to be found in the landscape around them. Through the ways that they walk on it, pour libations to it, name it, and live on it [they] embody in that landscape the lineaments of genealogy and the heritage of their social groups."[77]

Chinchero's specific *ayllu* divisions may date back to the occasion of the sixteenth-century *pachacuti*, but the spatial practice reaches back to the fifteenth century and the time of Topa Inca's impressive royal estate. Despite the dramatic upheaval in which the new urban form and religion were introduced into Chinchero, these changes became entangled with long-standing ideas of space and sacredness that defined Topa Inca's royal estate. The few remaining written records of Chinchero reveal much about how we need to reconsider our assumptions not only about colonization, identity, sacredness, and space, but also about how Chinchero changed in relationship to the larger landscape.

Occupation and Isolation in the Written Records

The importance of the local *ayllu* in Chinchero's colonial landscape casts doubt on a once predominant assumption—that colonial-period towns in the Andes had Spaniards living in them who wielded almost complete control over local indigenous people. In Chinchero, one can imagine a Spanish priest ministering to his flock in the church and the Spanish magistrate dealing with local disputes in the plaza, surrounded by the cacophony of nearby mercantile activity. Indians, living in the *urbs*, with the new Spanish-style plaza, would see and experience *civitas* and *policía* on a regular basis.

Although this may have been the Spanish ideal, the reality was far different: local native groups wielded influence in the placement, naming practices, and use of the new Christian structures. Though the written record is fragmentary, what remains suggests that Spaniards had a limited role in defining the experience of Chinchero. This concurs with recent work by scholars such as Jeremy Mumford and Steve Wernke, which has revealed how the Spanish attempts to control other indigenous towns ranged from limited success to abject failure.[78] In terms of Chinchero, no written evidence survives to indicate that any Spaniards actually lived in town (at least not for long enough to be marked in the surviving records). Even priests assigned to the parish are described in the colonial sources as being reluctant to spend much time there. One reason that Chinchero's carefully laid out, Christian, Spanish-style town became entangled in local indigenous practices may be that European players rarely showed up on the new Spanish-inspired stage. Another reason is that Europeans were not the only power brokers around.

The time of the greatest Spanish impact on Chinchero was during the early colonial period. The main buildings of the royal estate lay burned, and its residents were merely a skeleton crew of caretakers. During this time, Chinchero became an *encomienda*, or Spanish land grant. The land titles for this area are fragmentary, but we do know that at one point Chinchero was part of Luis de Céspedes's *encomienda*. However, after Céspedes sided with a faction of rebellious Spaniards led by Gonzalo Pizarro in 1544, the crown gave Céspedes's *encomienda* to Alonso de Loayza y García. In 1583, the *encomienda* was no longer in exis-

tence; the lands around Chinchero became part of a *repartimiento*, and the indigenous population part of a forced labor system.[79] It is unclear how long each of these Europeans had possession of Chinchero's lands and/or people, or what actions these outsiders may have taken to transform the royal estate. But what is clear is that these episodes of ownership, especially when led by an *encomendero*, could have enabled the dramatic changes seen in Chinchero's armature.

Whoever had legal title to these lands and labor had a diverse local population to try to control, some of whom had significant power. Inca elites (in the Ayllupongo lineage group) and Inca servants (the Yanacona *ayllu*) lived among other indigenous groups (the *ayllu* Cupir, and distinct communities on the Pampa de Anta such as Cuper Alto, Cuper Bajo, and Ayarmaca). While the specific boundaries of these communities and *ayllu* are unclear (there was much migration and movement in the region during the epidemic, civil war, and initial Spanish invasion), we do know that multiple indigenous communities lived within Topa Inca's vast royal estate before the boundaries of the new Spanish-style town were defined, and this local population was familiar with Chinchero's land and its history. Some groups, such as the Ayarmaca, had an even longer history, having preceded the Inca's arrival in the area, and likely had an even closer relationship with parts of the sacred landscape, such as at Huancapata.[80]

Indigenous elites played commanding roles in the early colonial Andes, particularly in the Inca heartland. Spaniards had to battle not only each other, but also these indigenous elites, for control over lands and people. For example, in 1550 the "Indians of Chinchero" were forced to work in the town of Yucay (Huayna Capac's former royal estate). However, they were not called to serve a Spanish conquistador; instead, they were assigned to Francisco Chilche, who was Cañari (an indigenous ethnic group conquered by the Inca).[81]

During the early colonial period, when the Pampa was still the center of Chinchero life, the elites, in particular descendants of Capac Huari and Huayna Capac, claimed land and occupied parts of Topa Inca's estate. As in imperial Inca times, Inca women became important power brokers in the early colonial period. In 1575, the *ñusta* (Inca princess) Beatriz Clara Coya claimed royal lands in Yucay and around Chinchero (she was a great-granddaughter of Huayna Capac).[82] As one of the richest women in the Andes, she was a young and much-sought-after bride among Spanish men (eventually she married Martín García de Loyola).[83] In a will from 1579, another Inca descendant, Guaco Ocllo (the aged daughter of Capac Huari), declared that she, too, had possession of lands in Chinchero, as well as many of the parcels that once belonged to her grandfather, Topa Inca, including his urban palace in Cuzco, Calispuquio, where the Spanish had discovered his mummy (and brother statue) twenty years earlier.[84]

But this was not the only way that written records suggest indigenous people were active in shaping the colonial Chinchero landscape. The general absence of Europeans also provided the space for indigenous action. For example, in the diocese of Chinchero, which covered much of Topa Inca's original estate, there were not enough priests to minister to all the residents. In the Andes, priests were assigned multiple parishes and thus each week had to make long, often arduous, journeys to several indigenous towns. For Spanish clergymen, these long treks at high altitude were particularly difficult.[85] Some priests tried fervently to avoid Chinchero. One wrote emotionally of his extreme distaste for visiting the town, claiming that being made to go there was cruel punishment. He stated that the people were hostile, and that if he spent any extended time there it would lead to his early death because the cold, high-altitude climate was torturous to his health. This dearth of Christian ministry would have opened a space for indigenous sacred practices to flourish and for Christian notions to become firmly entangled with the local *huaca*.

Other Europeans shared this aversion to Chinchero, some expressing a low opinion of both its climate and land. For example, in 1689 it was noted that the sole income of the town was derived from raising potatoes. During Topa Inca's reign, the

fact that Chinchero was a rich tuber-growing land made it valuable, as tubers were a staple Andean crop. But for the Spanish, who thought of the potato as a low-status food, this made the land undesirable. To make matters worse, Chinchero's lands grew a potato that could be turned into *chuño*, a nutritious freeze-dried food that many Europeans found particularly distasteful.[86] So only indigenous people lived at Chinchero, and church officials lamented that no Spanish people were involved (*asisten*) in the town.[87]

This neglect of Chinchero by Spaniards reflects a larger practice in the region. At first, the lands around Chinchero were divided up.[88] *Estancias*, or ranch lands, were established at Chuso and Cupir.[89] By 1689, there were six *haciendas*, or agricultural estates, existing in the diocese of Chinchero. Two were run by religious orders (Mercedarians and Jesuits) and four by Spanish individuals.[90] These subdivisions were still in existence in 1722.[91] During this time Chinchero was still described as a *repartimiento*.[92] By 1784, there were only three *haciendas* left in the Chinchero diocese;[93] two years later only one remained.[94]

The result of the Europeans' fluctuating yet growing disinterest in Chinchero was that indigenous leaders were often left to administer both Spanish and indigenous concerns.[95] Set for the performance of Spanish authority, the new urban stage may have occasionally seen dramatic Iberian actions, but for most of its history the colonial theater was filled with indigenous actors.[96]

The Church: Framing the Inca, Again

To fully appreciate the important role that indigenous people played in the reshaping of Chinchero during the colonial period, one must look not only at the larger urban and landscape transformation, but also closely at the smaller architectural gestures. Particularly in the details of walls, niches, and doorways, we can see the continuing legacy of Topa Inca and his royal estate. This architectural resurrection of Topa Inca was not an accident of time but, instead, a carefully crafted pronouncement by Chinchero's indigenous population.

An example can be found in the construction and design details of the Church of Nuestra Señora de Montserrat (Our Lady of Montserrat; fig. 1.2). When this church was first dedicated in 1607, Tomas Chama, an indigenous resident, was the majordomo, and Mejia, a Spanish priest, led mass, not only in Chinchero but also in the town of Maras (which had been part of Topa Inca's vast estate).[97] Chama, as a resident of Chinchero, probably had a far more important role in the appearance and running of this new church than Mejia, a visiting priest.

This tall, whitewashed church was meant to be the religious center of the new Spanish-style town, replacing the first church that had been set along the Pampa (fig. 1.9). This second church was the religious centerpiece of the huge urban upheaval that resulted in the atrium, gridded streets, arches, and chapels. Situated above the new town plaza, the church would have physically dominated the performance of political and religious life in town (fig. 6.7). While Europeans who visited the town may have remarked on its similarity to European architecture at the time, the new church was deeply dependent on Topa Inca's architecture.

For example, the church's shape was defined by Topa Inca's *cuyusmanco* (fig. 4.8). Like the first church of Chinchero (which was built upon the remains of CP5), Nuestra Señora de Montserrat was built upon the burned remains of P4, perhaps the most important public structure of Topa Inca's royal estate. This grand *cuyusmanco* had a long rectangular form, with small openings on its two long sides and one grand opening on its northern gable end. The foundations of the *cuyusmanco* determined the form of the church and its system of movement. Although the south wall of the Inca structure was removed in order to create a (raised) rounded apse for the colonial church (as was done to CP5), the east and west walls of the church's nave followed the original *cuyusmanco*. An unusually tall and well-built Inca terrace wall served as

a back wall to the main chapel, determining the chapel's length.[98]

The *cuyusmanco*'s important openings were also reiterated in the new church.[99] Two of the doorways were preserved: the northeastern opening was reused as the entrance to the baptistery, and the northwestern doorway was reused as the entrance to the balcony staircase. Three of the *cuyusmanco*'s remaining entranceways were reused but also resized. One was enlarged and became the main entrance on the west side of the church, while the second, also enlarged, became the entrance to the major chapel on the eastern side. The third doorway, the only one facing north, was elaborated to serve as a major access. However, rather than enlarging this already immense entranceway, they *reduced* its size and inserted doors into it (fig. 1.19).

The choice to elaborate this particular doorway is intriguing. The main façade of the church was the western one. Overlooking the atrium and plaza of the new town, it would have been the theatrical backdrop for most colonial-period performances. Yet the builders decided to put great care into creating a unique doorway for the northern façade, which faced away from the new town. Specifically, it faced the large Pampa, the space that served as the locus for performances honoring Topa Inca (and was left relatively unaltered during the colonial period). Why was so much effort expended on a part of the church that faced a space imbued with the memory of Topa Inca? The façade's details hold provocative clues.

During imperial Inca times, the original *cuyusmanco* stone masonry wall rose to about four feet. On top of these limestone polygonal walls, the builders would have placed adobe, which could have risen to the gable ends of Topa Inca's public *cuyusmanco*. However, by the time this church was erected, the adobe blocks had either disintegrated or were removed, leaving only the sturdy stone masonry walls of the *cuyusmanco* to define the church. Interestingly, the builders did not simply build on top of these imperial remains. Instead, the masons used the finely worked stones

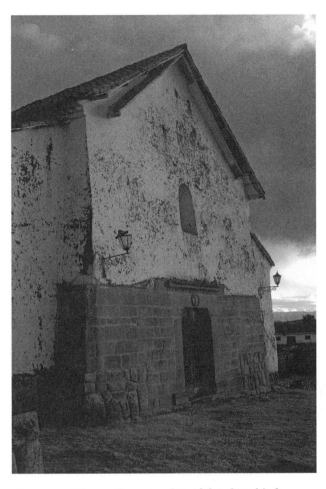

Figure 7.10 | The northern portion of the church's façade was built upon imperial Inca walls (which were augmented with adobe and reused imperial Inca ashlar blocks). This façade projected out from the rest of the church, allowing its Inca articulation to be clearly legible. Photo by the author.

from another of Topa Inca's buildings and, with the help of mortar, created a new Inca-style wall and doorway around the original.

This colonial wall projects about fifteen centimeters from the rest of the façade, allowing the Inca aspects of the colonial construction (both imperial and colonial) to be read as a distinct structure (fig. 7.10). The builders did not simply use the remains of the *cuyusmanco* as a foundation upon which to build a European style structure; they created a façade whose distinguishing element was a one-story Inca building that projected out toward Topa Inca's Pampa.[100] Given that the orig-

inal *cuyusmanco* was a structure that symbolized (and framed) the authority of the *sapa inca*, its re-iteration in the colonial period was a particularly charged choice.

The blocks used to make this impressive façade are also significant. These are the andesite ashlar blocks that probably came from the eastern side of the steep Antakilke Mountain, a local *apu*.[101] The building or buildings from which the andesite stones would have been removed has been thoroughly destroyed, which suggests these structures may have been of particular importance to Topa Inca (or at least perceived that way by whoever destroyed them). The materiality and facture of these blocks from Topa Inca's estate would have had great significance to anyone familiar with Inca architectural practices. Taken together, these colonial additions emphasize the continued presence of Topa Inca and his royal architecture (materials, building, and spatial orientation) in the colonial-period town and its new Christian center.[102] It also reveals that despite Spanish efforts to re-center the new colonial town, the vast open space of Topa Inca's Pampa (and its associated sacred outcrops and pathways) was still a critical focal point for Chinchero's residents.

The Power of Apertures

The articulation and expansion of Topa Inca's architecture in the new colonial town was not confined to the new church but can be seen also in other parts of town, such as the wall dividing the new plaza and atrium. During Topa Inca's reign, a wall (P13) was built separating the open space of the *pata* from three buildings that likely made up the royal *punona uasi* (figs. 6.2, 6.7). This wall was about two-thirds complete when construction suddenly stopped (most likely upon the death of Topa Inca).[103] The wall contained nine door-sized niches of finely worked polygonal limestone masonry.

Unlike the surrounding structures from Topa Inca's estate that were torn down or filled in during the colonial period, this wall was not de-stroyed when the main open space of the private *pata* was turned into the new town plaza. Instead, it was preserved and augmented. High-quality stones (perhaps from destroyed imperial buildings) were finely worked to continue the wall, and although the quality of the stonework is not as fine as during Topa Inca's reign, it is remarkably well done. The builders took an incomplete Inca wall and aggrandized it to serve as the focal point of their new plaza.[104]

The construction of Inca niches was not confined to this wall. North of Topa Inca's original niched wall, three new niches were added to the short façade of the other *cuyusmanco* (P5).[105] These three niches were inserted into what had been the building's grand opening, which overlooked the private *pata* (fig. 6.5).[106]

The question is why the builders chose to create Inca niches in a colonial-period construction, particularly in a location that was so important to the performance of *civitas Cristiana*. These new colonial Inca niches continued Topa Inca's original wall (P13), creating an almost continuous façade of Inca-style niches along the eastern side of the town plaza. The architectural result is that the performative space of the colonial-period town was not solely a European stage; several of the key theatrical backdrops, especially the church and the dividing wall, remembered and enunciated Topa Inca and his royal estate. This was not a subtle gesture against Spanish rule. This was a defiant statement about Inca architecture, authority, and legacy at Chinchero.

This declaration was not limited to the public sphere; it permeated every aspect of private life. In particular, this continuation of Inca architectural traditions, such as spatial practices and the articulation of openings, was an important aspect of domestic architecture in Chinchero. When I first conducted fieldwork there, many colonial-period homes could be found throughout the town fabric of Chinchero.[107] Unfortunately, most of these have now been destroyed to make way for modern construction. Of the buildings I was able to study, all were rectangular, single-room structures and most were made of a single story (there

Figure 7.11 | View of the interior of one of the colonial homes in the western portion of Chinchero, showing a combination of niche forms arranged in an irregular pattern. This building, like most of the colonial-period domestic architecture in town, has since been destroyed. Photo by the author.

was evidence of many *marca* and a few surviving two-story walls). Most were laid out in an enclosed arrangement (i.e., *cancha*) or in a row with a surrounding wall. This arrangement can be found in many imperial Inca sites but was not predominant in Chinchero until the colonial period. Its increase at the site may have been an attempt by local residents to maintain privacy, despite the fact that the Spanish found these enclosed *cancha* arrangements suspicious.[108]

The single-room structures and *cancha* arrangements of Inca homes were very similar to imperial Inca practices, but there was much variation in architectural openings (fig. 7.11). Not only were there typical Inca openings in the form of trapezoidal doorways, windows, and niches, but colonial-period homes also had the arched windows, niches, and doorways introduced by the Spanish.

These reveal a highly adaptive and creative aspect of domestic life. This experimentation reveals both the importance of openings (which had been evident during Topa Inca's day) and the new freedom that individuals could exercise in home design following the demise of the Inca state and its strict oversight of the architectural canon.[109]

An example of this is a collection of buildings that line Calle Sandowascana,[110] just past the street Pachapujio ("fountain-fountain"; see fig. 7.12).[111] All the buildings (which unfortunately have since been destroyed) were single rooms and freestanding. The sole doorway to the enclosed *cancha* was trapezoidal.[112] To the south of the entrance was a building whose entrance door was straight, not trapezoidal, and the building had small, high ventilation windows in its gable ends, typical of imperial Inca construction. Inside

Figure 7.12 | View of two of the domestic buildings along Calle Sandowascana. The entrance to the compound lies in between two single-room, rectangular structures. Photo by the author.

there were many niches; however, rather than being standardized as in imperial Inca times, the colonial-period niches came in a variety of sizes, and several were pointed or arched. Next to this structure was a building that had a large rounded arch paired with a smaller version. It also had a rounded niche on a side wall and two ventilation openings placed high in the gable end. While the placement of these ventilation openings may have been typically Inca, their articulation was not. Their asymmetry reveals how the patron experimented, making one square and the other rectangular.[113]

The most striking thing about the colonial-period homes of Chinchero is that the smallest of structures, which are otherwise faithful to impe-

rial Inca spatial practices, exhibit a dynamic experimentation with openings. For example, just to the north of these structures lay another building group. Here, three single-room buildings were arranged in a row, with entrance doors along one of their long sides facing onto the private shared space. The first building had well-preserved niches set in an ordered horizontal arrangement that had been typical in imperial Inca architecture (fig. 7.13), but some of these niches were trapezoidal, while others were rectangular. The building also had two extremely large windows, one of which had a pointed arch,[114] as well as ventilation openings high up on the gable ends, in the same shape and location as in imperial Inca architecture.[115]

Domestic architecture at Chinchero paralleled

public architecture in many ways; despite the sea of change brought by the Spanish invasion, architectural and spatial practices reveal themselves to be firmly rooted in their antecedents in Topa Inca's estate. However, the absence of Inca state oversight allowed for a creative experimentation with domestic openings that would not have been allowed during Topa Inca's reign. Given that architectural openings had great meaning for the Inca in terms of articulating authority and identity, this bold experimentation within Chinchero's domestic homes suggests that architectural openings continued to convey far more than simply aesthetic preferences. Instead, these homes are a dynamic expression of social memory, which conveys "the embodied ways by which people constitute themselves and their social formations in communicative actions and interactions, making

themselves by making rather than inheriting their past."[116]

Performing in the Inca *Pata*

Perhaps the legacy (and dynamic adaptation) of Topa Inca's architecture and spatial practices in the colonial town can be seen most clearly in the artwork inside the colonial church. The opulence of the interior is not the result of European artists and patrons; native artists created the fine paintings, colorful murals, and elaborate altars, and most were commissioned by indigenous residents of Chinchero (fig. 7.14). One example is a painting from the late seventeenth century by Chinchero native Francisco Chivantito (figs. 7.15–7.16). It is of the Virgin of Montserrat, who was the patron

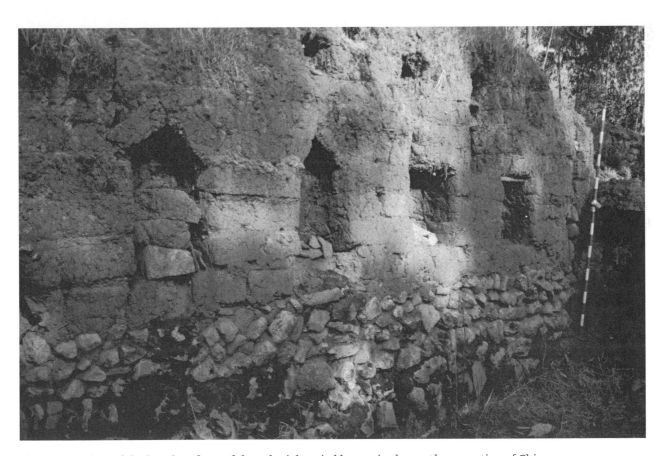

Figure 7.13 | View of the interior of one of the colonial-period homes in the southern portion of Chinchero, showing the long row of niches (two are missing their wooden lintels; some are rectangular, and others are trapezoidal) that once defined the single-room, rectangular structure. This building has since been destroyed. Photo by the author.

Figure 7.14 | View of some of the murals on the church ceiling, which was dedicated by its patron, an indigenous local resident. Photo by the author.

Figure 7.15 | Francisco Chivantito's painting of the Virgin of Montserrat for the Chinchero church. In the painting's lower left is the scene of Chinchero's plaza and atrium (viewer's right). Photograph courtesy of Richard Kagan.

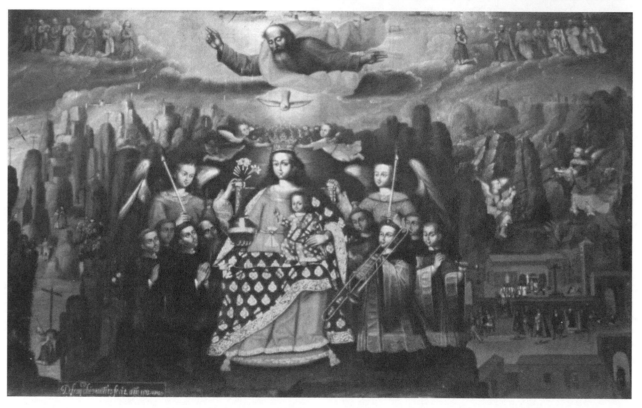

saint of the Chinchero church during the colonial period. This is a rich and complex painting (which I have discussed at length in other publications), but what is most relevant for this discussion is a scene of the town center that Chivantito depicted to the Virgin's left.[117]

For someone not familiar with Topa Inca's legacy in Chinchero, this scene reads as a perfect ex-

ample of *civitas Cristiana*. An array of indigenous elites and commoners gather in the plaza to greet a priest and acolytes. Several musicians play instruments and sing in preparation for the religious procession, which is winding its way to the plaza. In turn, an indigenous leader and his second in command stand ready to greet the approaching procession, supported by several women clothed

in their finest textiles. They appear to be good citizens of the Spanish state and faithful followers of the Catholic faith.

But this scene bears many striking resemblances to long-standing spatial and architectural practices at Chinchero. The men proceeding in from the atrium to the plaza are reminiscent of the visitors to Chinchero who marched into the adjacent Pampa in all their finery to perform for Topa Inca. The musicians in the painting, as part of the arriving religious procession, echo the performers who sang and danced into the grand Pampa for Topa Inca and his family. In the painting, the musical performers and the religious participants are headed toward the finely dressed indigenous men and women, the latter standing with their staffs of authority, revealing the continuing power of indigenous elites in Chinchero during the colonial period.

The scene illustrates the importance of not only indigenous elites, but also the architectural and spatial landscape. In the painting, the plaza is framed by an impressive architectural backdrop of finely carved stone masonry with a long wall of distinctive Inca niches, as well as a dramatic sacred landscape represented by Antakilke, the local *apu*. This is reminiscent of Topa Inca's Pampa, with its impressive open space defined by the *sapa inca*'s monumental lithic structures and views of the sacred *apu* (fig. 1.21).

During the colonial period, the town of Chinchero may have looked very different from the royal estate upon which it was laid—at least at first glance. Given the death of Topa Inca, the murders of his servants and members of his *panaca*, and the burning of his royal estate buildings and his mummy, it is easy to assume that all the players in Topa Inca's royal estate had changed. And taking into account the imposition of a new architectural style, urban form, religious system, and overlords in town, it makes sense to assume that Topa Inca's stage set had changed as well. If so, the colonial town of Chinchero should have had little to do with Topa Inca's royal estate.

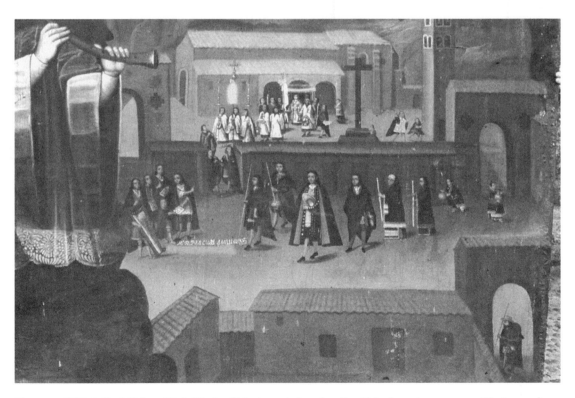

Figure 7.16 | Detail of Chivantito's *Virgin of Montserrat* showing the Chinchero town scene. Photograph courtesy of Richard Kagan.

Yet, upon closer examination, it is clear that Topa Inca's imperial home resonated throughout the colonial fabric. From the location of sacred spaces and ritualized movement, to the continuation of Inca iconography and the reuse of sacred materials, Topa Inca's legacy permeated Chinchero's colonial landscape.

The reason that Topa Inca's royal estate continued to resonate so powerfully in the town's urban fabric is because Chinchero's *llacta*, or community, remained in some form, and their place-making practices transformed the new town.[118] As Abercrombie has noted, "Cultural meanings are always deployed in social action, in lived contexts, by real people who must experience and account for unpleasantness like asymmetries of power."[119] Made up of a diversity of indigenous people, from Inca elites and their servants, to the Ayarmaca and other neighboring indigenous groups, Chinchero's *llacta* redefined their local architecture, space, and landscape. They were not passive players subjugated by Iberian colonizers but active participants in defining their world. Chinchero's diverse indigenous players made and remade their architecture and space over an extended period of time.

Tracing these changes in the material remains has been difficult, writing about them even more so. This is because a written account "can never provide more than a partly adequate understanding of ways of knowing that reside in practice and daily habit as much as in verbal narrative."[120] Despite my best efforts, my words can only hint at the potent, multi-sensory, and ephemeral aspects of Chinchero's dynamic built environment. Chinchero's residents redefined their landscape under the duress of disease, civil war, a brutal invasion, and extended colonization. In particular, they used architecture and space as critical tools to mitigate threats from a volatile and violent world, both present and future. In doing so, they carried on the defiant legacy of their forebear, Topa Inca.

EPILOGUE

In the centuries since the colonial period, Chinchero's architecture and space have continued to change, yet aspects of Topa Inca's magnificent estate can still be seen and experienced today. On the north side of Chinchero, Topa Inca's terraces, designed to impress his powerful relatives, still cover the hillside, leaving today's tourist in awe (and, for those bold enough to climb, exhausted). These imperial *pata* were created to provide Topa Inca with critical lands to raise valued crops. The terraces serve the same function for contemporary residents who belong to the three *ayllu* in town: Cupir, Ayllupongo, and Yanacona. Despite the change in ownership, these terraces look much as they did during Topa Inca's reign, punctuated by the striking *huaca* and captivating views of the sacred mountains. Free from the pollution that has now covered Cuzco and is encroaching on the Urubamba Valley, critical sightlines at Chinchero and its associated royal roads can still be experienced in the same way that Topa Inca and his architects intended.

Although no longer hosting imperial performances, the impressive Pampa is still the scene of processions as families carry their crops across the flat plain. And the Pampa buildings, albeit in a ruined state, still manage to manipulate new visitors. These groups are no longer Inca nobles coming to honor the *sapa inca* but, instead, tourists in search of majestic Inca architecture. They can be spotted walking determinedly across the vast space toward the Pampa buildings, increasingly puzzled as the Inca structures remain stubbornly out of reach.

On the south side of Chinchero, the colonial-period armature that was imposed on Topa Inca's estate continues to define the town. The plaza and atrium are the center for most public spectacles, so both religious and secular activities take place against the dramatic backdrop of the long Inca niche wall and the church/*cuyusmanco*. The entangled web of imperial Inca and Spanish colonial streets connects these spaces to the rest of the town and to a larger sacred landscape. Not wide enough for cars, these walkways and paths have remained critical parts of daily and ritual life in Chinchero—places for everyday encounters as well as the extraordinary events of religious processions. These practices of space can be found throughout the Andes today, where movements through distinct places recall "the actual channels of social transmission which, like a journey, have both spatial and temporal coordinates"[1]—the "pathways of memory" that connect a community with both its recent and distant past.

Chinchero's urban fabric reveals the resiliency of Topa Inca's legacy as well as the desire of its residents. For in the end, it is the latter that enables the former. But this legacy and the aspirations of its residents are continually under threat. As part of a larger movement to redefine the landscape as more "authentically" Inca, Spanish names were erased from city streets in Cuzco and replaced with their prior imperial Inca names.[2] Some of this was based on careful research, some on conjecture.[3] This effort spread to the larger countryside and began to include names that sounded Spanish. Chinchero, with its "o" ending, was considered Hispanicized by the misinformed, and a movement began in Cuzco to rename it Chincheros, a non-Quechua name mistakenly believed to be "authentic" Inca Quechua.

We know that names evoke associations and images, so a change in nomenclature is an alteration in meaning. For Chinchero, this slight spelling change effectively erased the imperial Inca name's original meaning, and did so against the wishes of the town's residents. Backed by centuries of tradition, as well as a wealth of documentary and linguistic evidence, Chinchero's residents rejected the name change. Their wishes were ignored, however, and in the last decade, most maps, guidebooks, and even some scholarly publications have renamed the city Chincheros. In the last years, state authorities have adopted this name change and installed a new sign for the town, which residents quickly repainted. Just as in the colonial period, the linguistic ignorance of an outside authority has created a rapidly spreading legacy of misunderstanding and, most important, the denial of indigenous rights to self-definition—and to self-determination.

In the last few years, the townspeople's right to live at Chinchero has been called into question. The magnificence of Inca architecture has made Machu Picchu one of the world's top tourist destinations. But these modern, relatively wealthy tourists have complained about the inconvenience of having to fly to Lima, and then to Cuzco, before taking a train ride to Pachacuti's royal estate. Instead, they have demanded an international airport in the highlands, to which they can fly directly from Paris, New York, São Paulo, or Madrid. The site that the authorities in Cuzco have chosen is Chinchero.

The new international airport will mean the destruction of Chinchero's community and its pristine landscape. Despite promises to compensate all the town's residents for their displacement, only a fraction of its value will be paid for the land needed to build this enormous aviation center. A vote was never put to the entire town, and no one has provided the residents with a clear idea of what this airport imposed upon their homeland will mean. Nor have authorities explained how the airport will radically reshape the residents' relationship to their landscape and to one another. In the confusion, residents have started moving away.[4]

The question is, will this be the end of Chinchero, or will the town's residents find novel ways to redefine their *llacta*? If the residents do leave, what will happen to them as they are separated from the kin networks and landscape that have defined their community? And what will happen to the architecture and spaces that they leave be-

hind? Will these continue to exist or will they be engulfed by the airport and its associated infrastructure? Proponents of the airport have argued that while the community will have to leave, the architectural center of Topa Inca's estate can be fenced in. But does this actually preserve the Inca estate or its colonial manifestations? As the designers of Topa Inca's estate and its colonial inhabitants were so acutely aware, meaning is not conveyed in individual buildings, but in their spacial practices.

During the reign of Topa Inca, Chinchero's singular plan intricately tied the built environment to the larger landscape. Meaning was conveyed through carefully controlled movement, which strove to augment Topa Inca's authority and protect his family. This dynamic landscape was dramatically transformed by multiple individuals and groups after the arrival of European pathogens and people. Yet the negotiated spaces of the former royal estate continued to carry the legacy of Topa Inca through the spatial practices of his descendants and other indigenous groups. These practices have survived invasions, wars, and oppression. However, if the community of Chinchero is now forced from its lands and homes to appease tourists, and the architectural remains are fenced in, those practices will stop. It is at that moment that Topa Inca's magnificent legacy will finally come to an end.

NOTES

Introduction

1. *Reqsiy* "conocer algo" (to know something); *reqsiychiy* "hacer conocer a otro una persona o alguna cosa o lugar" (to become known to a person or some place or thing); *reqsirpariy* "conocer algo de una vez por todas o definitivament" (to know something once and for all or permanently). *Diccionario quechua-español-quechua / simi taqe qheswa-español-qheswa* (Cuzco, Peru: Municipalidad del Qosqo, 1995), 519.

2. I use "Inca" to refer to the ethnic group, the elite nobles, and the political entity, a practice that is common in the scholarly literature.

3. Many of the details discussed in this section pertaining to the life of Topa Inca are discussed in Catherine Julien's excellent analysis of his life history. In this section of her book, she compares specific aspects of Topa Inca's life as presented by colonial authors, revealing which ones may have been copying from the same source and which may have been drawing from Inca oral histories. In doing so, she reveals the sources that provide the most accurate descriptions of this important Inca ruler's life.

Julien, *Reading Inca History* (Iowa City: University of Iowa Press, 2000).

4. Choco is south of Cuzco. It is interesting to note that several of the *ceque* lines that emanated from Cuzco (and thus the sacred imperial landscape) are connected to or make reference to Choco. This is most likely because Pachacuti redefined the imperial sacred markers in the Inca heartland and, in doing so, also incorporated his wife's lands to heighten the importance of her hometown and ethnic group (despite not being Inca). For a discussion of these *ceque* lines and Pachacuti's role in remaking the *ceque* system as part of shifting imperial history, see Susan Niles, *The Shape of Inca History* (Iowa City: University of Iowa Press, 1999), 73–74.

5. Susan Niles, "The Nature of Inca Royal Estates," in *Machu Picchu: Unveiling the Mystery of the Incas*, ed. Richard L. Burger and Lucy C. Salazar (New Haven, CT: Yale University Press, 2004), 51, 54–55. Niles also notes that the Inca understood royal estates to be "strings of fields" rather than a single contained landmass (ibid., 53).

6. Frank Salomon, "The Beautiful Grandparents: Andean An-

cestor Shrines and Mortuary Ritual as Seen through Colonial Records," in *Tombs for the Living: Andean Mortuary Practices*, ed. Tom D. Dillehay (Washington, DC: Dumbarton Oaks Research Library and Collection, 1995), 343.

7. For a discussion of how dead bodies could become venerated beings (and the rituals involved), see Bernabé Cobo, *Inca Religion and Customs*, trans. Roland Hamilton (Austin: University of Texas Press, 1994), 39–43.

8. This is due to all the "reconstructions" at the site to suit the needs of tourism. This estimate was made in 1990 by Jean-Pierre Protzen, who compared existing architecture with original photographs taken by Hiram Bingham's expedition in the early twentieth century. Due to this modern construction, much of the site can no longer be studied as an imperial Inca landscape but as a modern creation (Protzen, personal communication).

9. These elements were intact when I mapped and measured the site. However, since that time portions of the site have been reconstructed (such as the terraces), fragmenting the original Inca journey.

10. Michel Foucault, *Discipline and Punish: The Birth of the Prison* (New York: Pantheon Books, 1977); Henri Lefebvre, *The Production of Space* (Malden, MA: Blackwell Publishing, 1991); Michel de Certeau, *The Practice of Everyday Life* (Berkeley: University of California Press, 1984).

11. Scholarly works that have shown the importance of examining the experience of place in the Andes include Catherine Julien, "On Passing through the Portals of Machu Picchu," in 32nd Annual Meeting of the Institute of Andean Studies (Berkeley, California, 1992 (January 10–11); Jerry D. Moore, *Architecture and Power in the Ancient Andes: The Archaeology of Public Buildings*, ed. Clive Gamble, Colin Renfrew, and Jeremy Sabloff, New Studies in Archaeology (Cambridge: Cambridge University Press, 1996); Lawrence S. Coben, "Other Cuzcos: Replicated Theaters of Inka Power," in *Archaeology of Performance: Theaters of Power, Community, and Politics*, Archaeology in Society Series, ed. Takeshi Inomata and Lawrence S. Coben (Lanham, MD: Altamira Press, 2006); Jerry D. Moore, *Cultural Landscapes in the Ancient Andes: Archaeologies of Place* (Gainesville: University Press of Florida, 2005); Susan Niles, "Inca Architecture and the Sacred Landscape," in *The Ancient Americas: Art from Sacred Landscapes*, ed. Richard F. Townsend (Chicago: Art Institute of Chicago, 1992); Niles, *The Shape of Inca History*; Niles, "The Nature of Inca Royal Estates."

12. Regina Harrison notes the difference between the two terms: "Yachay has a frequently cited denotation of *saber* (to know) and is distinguished from the verb *riksiy* (to be acquainted with a person). Yet . . . the verb is often restricted to a person who knows and teaches arts and skills, a manual and practical knowledge. In Ecuador, this verb root also refers to a person who has attained knowledge of the supernatural (*yachak*) and uses the powers to harm or to cure others." Harrison, *Signs, Songs, and Memory in the Andes: Translating Quechua Language and Culture* (Austin: University of Texas Press, 1989), 79. In addition, Zoila

Mendoza has pointed out how *rikuy* is a type of knowledge derived from seeing and hearing. Thus, it is a type of knowledge that is directly related to the experience of space. Mendoza, "Exploring the Andean Sensory Model: Knowledge, Memory, and the Experience of Pilgrimage," in *Approaches to Ritual: Cognition, Performance, and the Senses*, ed. Michael Bull and Jonathan Mitchell (New York: Bloomsbury Publishing, 2014).

13. This approach, focusing on the subjective experiences of spaces (versus a Cartesian understanding of them) is founded on the philosophical works of Edmund Husserl and Dermot Moran, *Logical Investigations*, 2 vols. (London; New York: Routledge, 2001); Edmund Husserl and Ludwig Landgrebe, *Experience and Judgment: Investigations in a Genealogy of Logic*, Northwestern University Studies in Phenomenology & Existential Philosophy (Evanston, IL: Northwestern University Press, 1973); Martin Heidegger, *Poetry, Language, Thought* (New York: Perennial Classics, 2001); Heidegger, *The Basic Problems of Phenomenology*, Studies in Phenomenology and Existential Philosophy (Bloomington: Indiana University Press, 1982); Maurice Merleau-Ponty and John O'Neill, *Phenomenology, Language and Sociology: Selected Essays of Maurice Merleau-Ponty* (London: Heinemann Educational, 1974); Edmund Husserl, *Ideas: General Introduction to Pure Phenomenology*, Routledge Classics (London; New York: Routledge, 2012); Franz Brentano, Oskar Kraus, and Linda L. McAlister, *Psychology from an Empirical Standpoint*, International Library of Philosophy and Scientific Method (London; New York: Routledge, 1973); Edward S. Casey, *The Fate of Place: A Philosophical History* (Berkeley: University of California Press, 1997); Casey, *Remembering: A Phenomenological Study*, 2nd ed., Studies in Continental Thought (Bloomington: Indiana University Press, 2000); Gaston Bachelard, M. Jolas, and John R. Stilgoe, *The Poetics of Space* (Boston: Beacon, 1994).

14. Yi-Fu Tuan, *Space and Place: The Perspective of Experience* (Minneapolis: University of Minnesota Press, 1977), 7.

15. Two scholars who have been critical to developing our understanding of experience and subjectivity in the landscape are Yi-Fu Tuan and Edward Relph: Tuan, *Topophilia: A Study of Environmental Perception, Attitudes, and Values* (Englewood Cliffs, NJ: Prentice-Hall, 1974); Tuan, *Space and Place*; Relph, *Place and Placelessness*, Research in Planning and Design (London: Pion, 1976).

16. Anne Buttimer and David Seamon, *The Human Experience of Space and Place* (London: Croom Helm, 1980); Heidi J. Nast and Steve Pile, *Places through the Body* (London; New York: Routledge, 1998); Hwa Yol Jung, *Transversal Rationality and Intercultural Texts: Essays in Phenomenology and Comparative Philosophy*, Series in Continental Thought (Athens: Ohio University Press, 2011); David Seamon, *A Geography of the Lifeworld: Movement, Rest, and Encounter* (New York: St. Martin's Press, 1979); David Seamon and Robert Mugerauer, *Dwelling, Place, and Environment: Towards a Phenomenology of Person and World* (Dordrecht, Netherlands; Boston, MA: Kluwer Academic Publishers, 1985).

17. Lefebvre, *The Production of Space*; John A. Agnew, *Place and Politics: The Geographical Mediation of State and Society* (Boston: Allen & Unwin, 1987); Paul Rabinow, "Interview: Space, Knowledge,

and Power," in *The Foucault Reader*, ed. Paul Rabinow (Pantheon Books: New York, 1984).

18. Tim Cresswell, *In Place/Out of Place: Geography, Ideology, and Transgression* (Minneapolis: University of Minnesota Press, 1996).

19. Harrison, *Signs, Songs, and Memory*, 79.

20. I thank Zoila Mendoza for first pointing out this important reading of *rikuy*. Mendoza, "Exploring the Andean Sensory Model."

Chapter 1

1. Diego González Holguin translates *pircani* as "hazer para edificar" (to make in order to build). Gonçález Holguín, *Vocabulario de la lengua general de todo el Perú llamada lengua qquichua o del Inca* (Lima, Peru: Universidad Nacional Mayor de San Marcos, 1952), 287. He also translates *pircca* "pared" (wall), *pirccak* "pircca camyok" (wall specialist). Ibid.

2. Graziano Gasparini and Luise Margolies summarized the standard aspects of Inca architecture. Gasparini and Margolies, *Arquitectura Inka* (Caracas, Venezuela: Centro de Investigaciones Históricas y Estéticas Facultad de Arquitectura y Urbanismo Universidad Central de Venezuela, 1977). These have been elaborated upon by Jean-Pierre Protzen, "Inca Architecture," in *The Inca World: The Development of Pre-Columbian Peru, A.D. 1000–1534*, ed. Cecilia Bákula, Laura Laurencich Minelli, and Mireille Vautier (Norman: University of Oklahoma Press, 2000). Protzen also noted that there is more variability in Inca architecture than scholars had previously recognized, in *Inca Architecture and Construction at Ollantaytambo* (New York: Oxford University Press, 1993).

3. Gasparini and Margolies were the first to coin the term "architecture of power" for the Incas and thus highlight the key ways in which the Inca manipulated their architecture as part of their conquest strategies. Gasparini and Margolies, *Inca Architecture*, trans. Patricia J. Lyon (Bloomington: Indiana University Press, 1980).

4. Carolyn Dean argues that each Inca site was making a direct reference to the Inca capital. She states, "Whatever the function of a specific building, whether administrative, military, or religious, they featured the same 'look,' a repetition of form and arrangement modeled, at least symbolically, after the built environment of Cuzco." This "look" was the combination of the core design and construction features of Inca architecture. Dean, *A Culture of Stone: Inka Perspectives on Rock* (Durham, NC: Duke University Press, 2010), 109.

5. Inca walls are not vertical but instead lean inward. Their angle is usually between 3 and 5 degrees. Protzen, *Inca Architecture and Construction*, 187. In addition (and perhaps to help stabilize the walls), most Inca walls are slightly narrower at the top than at the base. Ibid., 212.

6. Bernabé Cobo describes Inca and highland vernacular practices as being constituted primarily of single-room structures, thus suggesting that the Inca were not unusual in the region for their practice of associating a single space with a single structure. Cobo, *Inca Religion and Customs*, trans. Roland Hamilton (Austin: University of Texas Press, 1994), 190–93.

7. Pedro Sarmiento de Gamboa, *The History of the Incas*, trans. Brian S. Bauer and Vania Smith, Joe R. and Teresa Lozano Long Series in Latin American and Latino Art and Culture (Austin: University of Texas Press, 2007), 169; Sarmiento de Gamboa, *History of the Incas*, trans. Clements R. Markham (Mineola, NY: Dover Publications, 1999), 153; Juan de Betanzos, *Narrative of the Incas* (1551), trans. Roland Hamilton and Dana Buchanan (Austin: University of Texas Press, 1996), 159.

8. The conquests of three successive rulers—Pachacuti, his son Topa Inca, and his grandson Huayna Capac—have come to define what we know as the Inca Empire (and which they called Tahuantinsuyu). These periods of expansion are marked by military campaigns, yet the Incas employed diverse tactics, such as political negotiations and trade, to extend their influence and reach across the Andes.

9. Gasparini and Margolies, *Inca Architecture*, 196–218.

10. Gasparini and Margolies wrote about the *kallanka*, and their definition and discussion aptly summarizes modern scholarly understanding of the Inca *kallanka*. Ibid. To summarize, the word *kallanka* has been frequently used to refer to a large, single-space Inca structure in which feasts were held, with the function varying according to the building's location in the provinces versus the heartland. In recent years the global positioning of the *kallanka* has been eliminated. It has been defined as (condensing from John Hyslop) "a long hall, often with a gabled roof" (Terence N. D'Altroy, *The Incas* [Malden, MA; Oxford, UK: Blackwell Publishers, 2014]); or simply a "feasting hall" (Steve Kosiba and Andrew M. Bauer, "Mapping the Political Landscape: Toward a GIS Analysis of Environmental and Social Difference," *Journal of Archaeological Method and Theory* 20, no. 1 [2013]).

11. Chinchero's main structures have often been referred to as *kallanka* because of their building form. See Gasparini and Margolies, *Inca Architecture*, 214–18.

12. This is not to suggest that feasting on its own has not been explored in depth by scholars. For example, Tamara Bray has discussed the intricacies of distinct Inca feasting, from ceramic types to foods and beverages served. Bray, "Inka Pottery as Culinary Equipment: Food, Feasting, and Gender in Imperial State Design," *Latin American Antiquity* 14, no. 1 (2003).

13. Stephen D. Houston and Thomas Cummins, "Body, Presence, and Space in Andean and Mesoamerican Rulership," in *Palaces of the Ancient New World*, ed. Susan Toby Evans and Joanne Pillsbury (Washington, DC: Dumbarton Oaks Research Library and Collection, 2008). In particular, see page 374.

14. John Hyslop, *Inka Settlement Planning* (Austin: University of Texas Press, 1990), 18–19.

15. I discovered this while working with early colonial Quechua dictionaries at the John Carter Brown Library. Stella Nair, "Of Remembrance and Forgetting: The Architecture of Chin-

chero, Peru from Thupa 'Inka to the Spanish Occupation" (doctoral dissertation, University of California at Berkeley, 2003).

16. "Callancarumi. Piedras grandes labradas, de silleria para cimiento y vmbrales." Diego Gonzalez Holguin, *Vocabvlario de la lengua general de todo el Perv llamada lengua qquichua o del Inca* [1608], prologue by Raúl Porras Barrenechea, edición facsimilar de la versión de 1952 ed. (Lima, Peru: Universidad Nacional Mayor de San Marco, Editorial de la Universidad, 1989), 44; "Silleria labrar. Chhecconi." Ibid., 670. Santo Tomás supports the argument of the ashlars, referring to "Checconi.gui. __quadrar poner en quadro (alguna cosa)." "Checconi.gui. __to square, put in a square (something)." Domingo de Santo Tomás, *Lexicón o vocabulario de la lengua general del Perú* [1560], facsimile ed. (Lima, Peru: Universidad Nacional Mayor de San Marcos, 1951), 260. He goes on to suggest the work refers to worked blocks that were made for buildings, "Chiconi.gui. __labrar piedra para edificio." "Checosca _ piedra Labrada." "Checoc _ cantero, (?) Labra piedras." Ibid., 260.

17. "Callancahuasi. Casa fundada sobre ellas." Gonzalez Holguin, *Vocabvlario de la lengua . . .* [1608], 44. *Uasi*, the term for house, is what is used to describe the majority of Inca buildings. In Quechua, the word *uasi* is added to another word, such as *callanka*, to describe the specific type of house.

18. It is intriguing that part of the definition of *callanka* is that the ashlars are described as being in the foundation or threshold, rather than that they made up the entire building. There are two reasons for this. First, it was typical for Inca masonry blocks to get smaller as the wall increased in height (thus the *callanka rumi* became *chheccoscaa rumi*). Second, the Inca also built structures (increasingly common over time) that began with stone masonry but ended with adobe. This was most likely done when there was a dearth of appropriate stones for building or because the desire to create increasingly taller buildings made adobe more attractive as a material. Adobes are much lighter and thus better than heavy stone when making tall walls. This combination of stone and adobe within a single wall was used in at least two imperial Inca buildings in Chinchero (to be discussed later).

19. In addition, it has allowed scholars to mis-assign ethnic and political identity to sites (when the diagnosis has relied on this architectural category).

20. For the bulk of the construction force, labor was brought in to serve specific tours of duty. These men (most of whom were untrained) were brought in as part of a labor tax to work for the Inca state. They were supervised by a trained specialist who worked permanently for the Inca state.

21. Protzen, *Inca Architecture and Construction*, 53.

22. Arminda Gibaja de Valencia was one of the first scholars to notice the importance of scale in Inca design; in particular, she noted that there was a dramatic change after the arrival of Europeans in the Andes (where windows, doorways, and so on become larger in scale). Gibaja de Valencia, "Secuencia cultural de Ollantaytambo," in *Current Archaeological Projects in the Central Andes: Some Approaches and Results*, ed. Ann Kendall, BAR Inter-

national Series (Oxford, UK: BAR, 1984). Jean-Pierre Protzen has also written about this change, but he refined the timeline. He concurs with Gibaja de Valencia but notes that similar larger-scale elements are found at the private royal estate of Huayna Capac. Hence, we cannot assume that these larger scales are the result of the European invasion. Protzen, *Inca Architecture and Construction*, 261–63. Susan Niles concurred with Protzen, publishing clear data that the architecture of Huayna Capac used a much larger scale than the architecture built under his grandfather Pachacuti. Niles's careful study of Huayna Capac's private estate in the Urubamba demonstrated that this practice of enhanced architectural scale was most pronounced during Huayna Capac's reign in the early sixteenth century, before the arrival of Europeans in the Andes. Niles, *The Shape of Inca History* (Iowa City: University of Iowa Press, 1999); Niles, "The Nature of Inca Royal Estates," in *Machu Picchu: Unveiling the Mystery of the Incas*, ed. Richard L. Burger and Lucy C. Salazar (New Haven, CT: Yale University Press, 2004). Carlos Rivas and I have been studying building scale at private estates and have been able to demonstrate that building size, as measured by floor space (something not noted by scholars before) also increased across time. Our research reveals that this increase began under the patronage of Topa Inca but was accelerated during the reign of Huayna Capac. Stella Nair and Carlos Rivas, "The Evolution of the 'Great Hall' in Inca Royal Estates" (unpublished manuscript).

23. Change was an important aspect of Inca architectural practices. Sometimes they adapted local traditions or added new elements to the traditional mix, such as round buildings, curved walls, rectangular niches, and adobe and mortared masonry. However, whether added to or modified, the basic elements—polygonal and ashlar masonry, battered walls, trapezoidal openings, gabled or hip roofs, and freestanding, single-space structures—made up the core of the architectural tool kit.

24. These are buildings for which we have all four corners, and hence can accurately measure the building's width and length.

25. This use of rectangular forms, which are adjusted in length, width, and detail to accommodate local needs, is typical of Inca architecture, where buildings were shaped to fit the specific constraints of the land and needs at the site. Gasparini and Margolies argue that *usnu* probably also changed radically according to their context. Gasparini and Margolies, *Inca Architecture*, 271, 342.

26. The notion of a "final" form is problematic. Often scholars cite the first complete stage of the building as its final form, even though a building is altered, often considerably, over its lifetime. In addition, at many sites in the Andes, structures were never absolutely finished (but some portion was still being built). Yet these sites are discussed as if they were completed, resulting in the creation of an imaginary "complete" building or complex.

27. Jean-Pierre Protzen and Stella Nair, *The Stones of Tiahuanaco: A Study of Architecture and Construction* (Los Angeles: Cotsen Institute of Archaeology Press, 2013).

28. Mary Frame, "Late Nasca Tassels," in *Andean Art at Dumbarton Oaks*, ed. Elizabeth Hill Boone (Washington, DC: Dumbarton Oaks Research Library and Collection, 1996), 369.

29. The Inca also built with fieldstone masonry. For example, most of the terraces and other retaining walls at Ollantaytambo are of fieldstone masonry. Protzen, *Inca Architecture and Construction*, 212. However there are no fieldstone masonry remains that have survived at Chinchero (if they were ever built).

30. "Caninacuk pirca. Pared bien trauada." Gonzalez Holguin, *Vocabvlario de la lengva . . . [1608]*, 50; "Caninacun pirca. Yr trauada la obra." Ibid. "Caninacuchini. Trauar la bien." Ibid. "Caninacuchiscapirca. Pared trauada." Ibid.

31. "Canillayani. Tener con los dientes algo." Ibid. "Canin caninmi, o canillayaspam apani. Lleuar asido con los dientes." Ibid. "Canic. El que muerde." Ibid. "Caniycamayoc alco. Perro gran mordedor." Ibid.

32. Carolyn Dean was the first to note the importance of the term for bonded masonry, its implications for how the Incas understood architecture, and its relationship to the process of making. Dean, "The Inka Married the Earth: Integrated Outcrops and the Making of Place," *Art Bulletin* 89, no. 3 (2007), 509–11; Dean, *A Culture of Stone*, 76–81.

33. For the Inca, a hammerstone was a *vinirumi*. It is defined as "piedra durissima como azero con que labrauan piedras" (a hard stone like a hoe with which one works stones). Gonzalez Holguin, *Vocabvlario de la lengva . . . [1608]*, 319. An anonymous author describes a hammerstone as "piedra dura con que labran los yndios de canteria" (a hard stone with which the Indians work in the quarry) as "yhuaya." Anonymous, *Vocabulario y phrasis en la lengua general de los indios del Perú, llamada quichua, y en la lengua española*, 5th ed. (Lima, Peru: Universidad Nacional Mayor de San Marcos, Instituto de Historia de la Facultad de Letras, 1951), 172.

According to González Holguin, "cumpa galgas. Piedra que se echa cuesta a bajo. Cumpani. Desgalgar piedras cuesta a bajo. Cumpana. O cumpa. Almadena de hierro, o piedra grande. Cumpani. Quebrar, quebrantar con almadena de hierro, o gran piedra. Cumpani. Dar con piedra a dos manos. Cumpani. Achocar con piedra, o quebrar." Gonzalez Holguin, *Vocabvlario de la lengva . . . [1608]*, 54.

34. Earlier groups who developed fine stone-working techniques were the Tiahuanaco, Wari (Huari), and Chavin. Jean-Pierre Protzen and Stella Nair, "Who Taught the Inca Stonemasons Their Skill? A Comparison of Tiahuanaco and Inca Cut-Stone Masonary," *Journal of the Society of Architectural Historians* 56, no. 2 (1997). Protzen and Nair, *The Stones of Tiahuanaco*, x–xiii, 201–10. While the Tiahuanaco and Chavin builders used fine stonemasonry throughout their main settlements, the Wari reserved their finest stonework for tombs, such as at Cheqo Uasi, and the semi-subterranean temple at Moraduchayuq (both at the site of Huari). See William H. Isbell and Gordon F. McEwan, eds., *Huari Administrative Structure: Prehistoric Monumental Architecture and State Government* (Washington, DC: Dumbarton Oaks Research Library and Collection, 1991).

35. Dean, "The Inka Married the Earth," 79.

36. Protzen, *Inca Architecture and Construction*, 171–74; Protzen, "Inca Quarrying and Stonecutting," *Journal of the Society of Architectural Historians* 44, no. 2 (1985).

37. Dean, "The Inka Married the Earth," 309–12.

38. Protzen, *Inca Architecture and Construction*, 200–203.

39. Dean, *A Culture of Stone*, 112–21.

40. Dean, "The Inka Married the Earth," 310; Dean, *A Culture of Stone*, 115–21.

41. González Holguin lists a number of wall types: "Pared. Perca. Pared tuerta. Vicçuperca. Pared conbada. Chichupercca. Pared hendida. Rakrapirca, que se hiende, rakrayak. Pared calçar. Percacta, çaunani rumihuan çatiycui. Pared de adobes. Tica percca. Pared aportillada. Kassa kassapercca. Pared ya para caer. Ttuninayak. Pared derecha aplomada. Huypay chiscca percca. Pared de canteria. Chhecoscca percca. Pared leuantar. Perccacta viñachini, o vichayhuccarini. Pared trauada. Caninacuk percca. Pared alta. Çuni percca, ohahua. Pared baxa. Ttaksa percca. Pared con cimiento. Tecciyok percca. Pared sin cimiento. Teccinnak manatecciyok. Pared de piedra. Rumi percca. Paredero. Perccak perccacamayok. Paredones de casa. Mauccapercca perca." Gonzalez Holguin, *Vocabvlario de la lengva . . . [1608]*, 615–16.

42. This depended also on what materials were available. As will be discussed in the next section, bonded masonry requires a high-quality stone. If not available, the Inca used other materials, even mortared masonry, for their high-status buildings. The key issue is that construction techniques were relative to one another. For example, mortared masonry served as a foil on the journey to Machu Picchu. Sayacmarca and Phuyupatamarca are two important sites along the road to Machu Picchu. Although they may have been important, they were of lesser status than the royal center, hence they were made of mortared masonry. Mortared masonry did not signal on its own a lower status, but instead, when used in combination with bonded masonry, signified a lesser status by comparison.

43. Protzen, *Inca Architecture and Construction*, 82.

44. In discussing this architectural division, we must remember that aspects of the site have been lost. It is possible that mortared (or fieldstone) walls within the royal estate have been destroyed. However, if there had been mortared walls, they would not have been found within the core of Chinchero. We know this because this area (the Pampa) is well preserved. If mortared walls once existed at Chinchero, they would have occupied spaces that were of secondary or tertiary importance within the estate.

45. Several researchers have noted that the core of Cuzco, namely the area around the Plaza and the Coricancha, is almost exclusively ashlar. By contrast, polygonal masonry has been used primarily on the periphery of the capital city. Ian S. Farrington, *Cusco: Urbanism and Archaeology in the Inka World* (Gainesville: University Press of Florida, 2013), 121. See also Santiago Agurto Calvo, *Cusco, la traza urbana de la ciudad Inca* (Cusco, Peru: UNESCO and Instituto Nacional de Cultura del Perú, 1980); Agurto Calvo, *Estu-*

dios acerca de la construccion arquitectura y planeamiento Incas (Lima, Peru: Cámara Peruana de la Construcción, 1987).

46. Protzen has noted that there are Quechua references to at least three types of construction specialists in the colonial records: *quiro camayoc* (carpenter), *rumita chicoc* (quarryman), and *pirca camayoc* (masons, literally "wall maker"). Protzen, *Inca Architecture and Construction*, 12. Protzen also notes that the Spanish writers used this word to refer to architects and master masons who worked full time for the Inca state. Ibid., 12–13.

For a discussion on *camayoc* and their role in the Inca state, see Lisa DeLeonardis, "Itinerant Experts, Alternative Harvests: Kamayuq in the Service of Qhapaq and Crown," *Ethnohistory* 58, no. 3 (2011). *Camayoc* is derived from the Quechua word *camay*. *Camay* is a complex term discussed elsewhere in this book, but one way to consider its meaning is as Frank Salomon summarizes for the Huarochiri manuscript: "'to charge with being,' 'to make,' 'to give form and force,' or 'to animate.'" Salomon, *The Huarochirí Manuscript: A Testament of Ancient and Colonial Andean Religion*, trans. from the Quechua by Frank Salomon and George L. Urioste, transcription by George L. Urioste (Austin: University of Texas Press, 1991), 45, fn 31. He also notes that *camayuc* is a bureaucratic term from the Inca that meant "possessor of a specific force or energy [*camay*]." Ibid, 45, fn 33.

47. Jean-Pierre Protzen, personal communication.

48. For a discussion of a stone-working process using hand tools, see Stella Nair, "Stone against Stone: An Investigation into the Use of Stone Tools at Tiahuanaco" (Master's thesis, University of California at Berkeley, 1997).

49. The importance of the rule can be seen in the few cases in which it was modified. For example, on the famous curving wall of the Coricancha, the regular courses of ashlar are broken by a few rectangular blocks that have one corner "missing." The neighboring stone must "sit" inside this recess, creating a new course. What is interesting about the Coricancha example is that these stones are concentrated in the portion of the wall where it begins to turn. This would have been a particularly difficult portion to build, so the ashlar blocks with a missing corner may be evidence of the difficulty faced by the masons when constructing this wall. Other ashlar walls also contain evidence of the occasional missing ashlar corner. The fact that the Inca decided to leave these blocks in place suggests that the infrequent modifications were embraced by the Inca.

50. Protzen, "Inca Quarrying and Stonecutting," 162–69. Dennis E. Ogburn, "Evidence for Long-Distance Transportation of Building Stones in the Inka Empire, from Cuzco, Peru to Saragura, Ecuador," *Latin American Antiquity* 15, no. 4 (2004).

51. Salomon reports that in the modern era, *apu* are considered to be deities that live "inside" the peaks of mountains. Salomon, *The Huarochirí Manuscript*, 94, fn 410. In the early colonial period the term *apu* could be glossed as "lord," which applied to both sacred natural forces, like special mountain peaks, as well as important indigenous leaders. Salomon notes that this term was likely used to refer to "traditional legitimacy and connotes both religious and political authority." Ibid., 65, fn 170.

52. The important symbolic role that stone played in Inca landscapes and imperial agendas has been discussed by Dean in "The Inka Married the Earth" and *A Culture of Stone*, and by Susan Niles, "La arquitectura incaica y el paisaje sagrado," in *La antigua América: El arte de los parajes sagrados*, ed. Richard F. Townsend (Mexico City: Grupo Azabache, S.A., 1993).

53. For a discussion of *pururauca*, see Cobo, *Inca Religion and Customs*, 35–36.

54. Dean, *A Culture of Stone*, 130. See also Niles, *The Shape of Inca History*, 58–61. Niles notes that *pururauca* could be both male and female, thus military prowess and protection could come from both genders.

55. For a discussion of *huauque*, see Cobo, *Inca Religion and Customs*, 37–38.

56. Carolyn Dean, "Metonymy in Inca Art," in *Presence: The Inherence of the Prototype within Images and Other Objects*, ed. Robert Maniura and Rupert Shepherd (Aldershot, UK: Ashgate, 2006).

57. Cobo, *Inca Religion and Customs*, 37.

58. Sarmiento de Gamboa, *History of the Incas*, trans. Markham, 154. *Churi* is the Quechua term used to define the "child of a male." Salomon, *The Huarochirí Manuscript*, 122, fn 647.

59. The buildings facing the main plaza that survive today are all limestone polygonal masonry. The high-quality limestone was harvested at the site itself or nearby. Leveling the landscape so it could be built upon also provided the materials for making the buildings. Some of the buildings further into the estate would have had limestone polygonal masonry that was topped off with adobe. For example, the building that now forms the foundation for the Catholic church (and will be discussed in Chapters 3 and 4) was made only partially of polygonal masonry and would have been continued with adobe. This appears to have been a construction type that was used by the Inca during this period and continued (and became more common) under the patronage of Topa Inca's son, Huayna Capac.

60. Catherine Julien, "On Passing through the Portals of Machu Picchu," in *32nd Annual Meeting of the Institute of Andean Studies* (Berkeley, California 1992 (January 10–11); Johan Reinhard, *Machu Picchu: The Sacred Center* (Lima, Peru: Nuevas Imágenes S.A., 1991); Reinhard, *Machu Picchu: Exploring an Ancient Sacred Center*, 4th rev. ed., World Heritage and Monument Series (Los Angeles: Cotsen Institute of Archaeology, University of California, 2007).

61. Constance Classen, *Inca Cosmology and the Human Body* (Salt Lake City: University of Utah Press, 1993), 53–54.

62. For a discussion of *camay*, see Gerald Taylor, "Camay, comac et camasca dans le manuscrit Quechua de huarochiri," *Journal de la Société des Américanistes* 63 (1974). See also Salomon, *The Huarochirí Manuscript*. For a more recent discussion of the concept of *samay* and *camay*, which includes a list of the early colonial references and definitions, as well as modern scholarship, see Dean, *A Culture of Stone*, 45, 182, fn 17.

63. Thomas Cummins has shown how the sacred sand in Cuzco was understood as having a sacred essence, even when it was transformed. Cummins, "A Tale of Two Cities: Cuzco, Lima,

and the Construction of Colonial Representation," in *Converging Cultures: Art and Identity in Spanish America*, ed. Diane Fane (New York: Harry N. Abrams, 1996), 161. Carolyn Dean discusses how essence deeply informed value in Inca material culture. Dean, "Metonymy in Inca Art."

64. Dean, "The Trouble with (the Term) Art," *Art Journal* 65, no. 2 (2006): 29.

65. Marco Curatola and Mariusz Ziólkowski have demonstrated the critical role that oracles played in the Inca state and their long Andean tradition. Curatola, et al., *Adivinación y oráculos en el mundo andino antiguo*, Colección Estudios Andinos (Lima, Peru: Instituto Francés de Estudios Andinos, Fondo Editorial, Pontificia Universidad Católica del Perú, 2008). Classen has noted that the Inca often linked hearing and sight. For example, one could see the sun rise during a ceremony and then hear the people singing (which would have gotten louder as the sun rose). She also notes that one could see the skin of a killed enemy in the form of a drum and then hear the skin played. Classen, *Inca Cosmology*, 72. Classen argues that all the senses were important to the Inca and were powerful, but that the Inca showed preference for them in the following order: sight, hearing, smell, taste, and touch. Ibid., 136.

66. Thus hearing was important to Inca, but it complimented their power over sight. Classen points out that the *tucay ricuy* were the officials who carried out Inca rule in the province and whose name translates as "those who see all." Ibid., 54.

67. Priests of important shrines were appointed by the Inca state. The principal priest in charge of making these appointments was an Inca nobleman. Inca Garcilaso de la Vega, *Comentarios reales de los Incas*, 2nd ed. (Mexico City: Fondo de Cultura Económica, 1995), 1:90.

68. Salomon, *The Huarochirí Manuscript*, 19.

69. Ibid., 18. Some of these positions were hereditary; others rotated among members of the community. The latter served as authorities over things such as the calendar, listening to the oracles, and mediating between the *huaca* and the community. Most important, these priests impersonated the *huaca* for key ceremonies and reenacted their stories. Ibid.

70. Ibid.

71. Cobo, *Inca Religion and Customs*, 110–11.

72. Salomon, *The Huarochirí Manuscript*, 17. There were different types of priests. For example, a *guacarimachic* is a priest who talked to *huaca* and a *ayatapuc* is a priest who spoke with the dead. María Rostworowski de Diez Canseco, *History of the Inca Realm*, trans. Harry B. Iceland (Cambridge: Cambridge University Press, 1999), 157.

73. This may explain why all things that the *sapa inca* touched had to be heavily guarded and protected. For example, his clothing and anything that came from his body (hair, nail clippings) had to be gathered up and stored until they could be ceremonially burned. Classen, *Inca Cosmology*, 75.

74. Ibid., 52.

75. Ibid., 73.

76. As Dean notes, "The notion of nibbling also places an emphasis on the sense of taste, which contrasts with those non-Inka terms to describe the well-fitted stone wall which have relied on visual characteristics and so have been tied to the sense of sight. This could be seen as an aspect of Western 'ocularcentrism,' the historical privileging of sight over the other senses, and the concomitant dismissal of the other senses as lesser and lower. The preference for sight—and so terms referring to sight—obscured other, more Inka ways of thinking about and describing rockwork." Dean, *A Culture of Stone*, 80.

77. Even smell was critical in conveying meaning in Inca architecture. The Incas did this by involving incense in most of their political and religious rituals. Thus, when people gathered near the sacred *huaca* or within an Inca building for official activities, incense would have permeated the scene. In the process, all those who participated (and smelled the incense) would have been transformed by their experience. Classen, *Inca Cosmology*, 137. Smells could also signal particular conditions. For example, Classen notes that incense was used to venerate a *huaca*, while to refer to someone as "rotten smelling" was one of the worst insults that could be given. Ibid., 74–75.

78. Dean states that "essence was transubstantial, and so its significance was independent of form." Dean, *A Culture of Stone*, 5.

79. Seeing was important to the Inca, but as Classen points out, sight was tied to another sense: "The Inca sensory mode of the world is basically audiovisual. . . . Sight needed to be complemented by hearing, just as masculinity needed to be complemented by feminity." Classen, Inca Cosmology, 6.

80. Niles, *The Shape of Inca History*, xviii.

81. Niles has written extensively on the topic of Inca architecture and patronage, as well as the important role of the sung narratives in conveying Inca understandings of history and architecture. See ibid; and Niles, "The Nature of Inca Royal Estates."

82. Niles, *The Shape of Inca History*. In particular, see pages xviii, 1–84.

83. The colonial writings provide clues to these sung narratives because many of the Spanish chroniclers relied on indigenous informants who relayed their *panaca*'s histories. Although there is general agreement on the overall history, it is also clear that in some stories, particular monarchs are heavily favored over others, revealing the biases of their informants.

84. Niles, *The Shape of Inca History*, 74–75.

85. Juan Diez de Betanzos relied heavily upon his wife's family (*panaca*) for his history, and hence his writings are known to be relatively reliable for depicting the narratives of that group. For a discussion of Diez de Betanzos and the role of his wife's *panaca*, see Roland Hamilton's "Juan de Betanzos and Inca Traditions" (ix–xiv) in Betanzos, *Narrative of the Incas*.

86. Pedro Sarmiento de Gamboa states, "Habiendo Tupac Inca Yupanqui visitado y repartido las tierras y hecho las fortalezas del Cuzco y otras muchas, sin las casas y edificios sin número, fuése a Chinchero, un pueblo cerca del Cuzco, adonde él tenía unas muy ricas casas de su recreación, adonde mandó hacer grandes heredades para su cámara." Sarmiento de Gam-

boa, *Historia de los incas*, Biblioteca de Viajeros Hispánicos (Madrid, Spain: Miraguano Ediciones, Ediciones Polifemo, 1988), 136. This statement has been translated into English in slightly differing ways. "Having inspected and distributed the lands and built the fortress of Cuzco and many others, as well as innumerable houses and buildings, Topa Inca Yupanqui then went to Chinchero, a town near Cuzco where he had some very elaborate houses for his leisure. There he ordered great estates made for his household." Sarmiento de Gamboa, *The History of the Incas*, trans. Brian S. Bauer and Vania Smith, 169; and "Having visited and divided the lands, and built the fortress of Cuzco, besides edifices and houses without number, Tupac Inca Yupanqui went to Chinchero, a town near Cuzco, where he had very rich things for his recreation; and there he ordered extensive gardens to be constructed to supply his household." Sarmiento de Gamboa, *History of the Incas*, trans. Markham, 153.

87. Juan Diez de Betanzos states that Topa Inca built Chinchero two years after finishing the fortress (Sacsayhuaman) as a place for Inca elites in Cuzco to visit and as a place where he could be remembered. Betanzos, *Narrative of the Incas*, 159.

88. The location of Chinchero explains the name of the royal estate. It is located in the Chinchasuyu (*suyu* is "quarter") of the empire, and it is located on the *chiru* (side) of a mountain. Chinchero is a combination of these two (*Chinch* for Chinchasuyu, and *chero* for *chiru*). It was common for sites to be named in part from the *suyu* in which they lay. It was also common for sites to be named for landscape features or contexts. The anonymous author defines *chiru* as "lado o costado" in Anonymous, *Vocabulario y phrasis*, 37. The naming practice for Chinchero was typical for the Inca. Cobo, *Inca Religion and Customs*, 183.

89. Niles, *The Shape of Inca History*, 24–27, 45–84.

90. Other specialists included weavers and silversmiths. Cobo, *Inca Religion and Customs*, 240.

91. Spiro Kostof, ed., *The Architect: Chapters in the History of the Profession* (Oxford: Oxford University Press, 1997).

92. This dynamic celebrating and reinforcing of order and hierarchy, as expressed in facture, can also be seen in the relationship between the noblemen and the workmen. In creating Inca sites, the nobles, like the *sapa inca*, did not actually do any of the heavy lifting. According to colonial sources, this was done by a vast array of workers—the *mit'a* labor force.

Chapter 2

1. *Pacha* refers to earth and time together. It is a physical, temporal, and spatial descriptor. Colonial Quechua dictionaries define *pacha* as: the earth, time, and place. Some examples of *pacha* compounds form the words for: God, heaven, the underworld, the womb, earthquakes, seasons, and gypsum (a critical element in making fine plaster for architecture). For example, in *Arte, y vocabulario de la lengua quicua general de los indios de el Perú* (Lima, Peru: Imprenta de la Plazuela de San Christoval, 1754),

Diego de Torres Rubio defines *pacha* as "tiempo, lugar" [time, place] (93, recto); "pacha – lugar" (ibid., 131 verso); Pacha, allppa – "Suelo, tierra" [ground, earth] (ibid., 142, recto); "hanacpacha – el cielo, lugar alto" [the heaven, high place] (ibid., 84, recto); "Pacha – el vientro" [womb] (ibid., 221 verso); Pacha "vientre" [womb] (ibid., 230 verso); "Pachacamac – Dios" [god] (ibid., 123, recto); "Pachacamac – el hacedor del mundo" [the maker of the world] (ibid., 162 recto); "Tiempo" [time] (ibid., 143, recto); "Pacha cuyuy – Templar la tierra" [shake the earth] (ibid., 143, recto); "pachauti – el fin del mundo" [the end of the world] (ibid., 93, recto); "Ttipiy pacha – tiempo de cosecha" [harvest time] (ibid., 103, verso); "Rupay pacha – verano" [summer] (ibid., 145, recto); "Paraymitta, vl. Pacha – Tiempo de agues" [time of the omens?] (ibid., 96, recto); Pacha, pachachi – "yeso" [plaster, gypsum] (ibid., 146, recto); "Pachan, pachallan – el proprio enterro" [one's own burial] (ibid., 162 recto); "Pachallanmi – estarse entera una cosa [to be an entire thing] (ibid., 93, verso).

2. Frank Salomon, *The Huarochirí Manuscript: A Testament of Ancient and Colonial Andean Religion*, trans. from the Quechua by Frank Salomon and George L. Urioste, transcription by George L Urioste (Austin: University of Texas Press, 1991), 14

3. Carolyn Dean, *A Culture of Stone: Inka Perspectives on Rock* (Durham, NC: Duke University Press, 2010), 37. Stone in particular was active in space: "Not subject to death and decay, stone was life immobilized. It was animacy 'paused' for an unspecified period." Ibid., 5.

4. Thomas A. Abercrombie, *Pathways of Memory and Power: Ethnography and History among an Andean People* (Madison: University of Wisconsin Press, 1998), 346.

5. Salomon, *The Huarochirí Manuscript*, 15.

6. Yi-Fu Tuan, *Space and Place: The Perspective of Experience* (Minneapolis: University of Minnesota Press, 1977), 6.

7. Recent work that ties nature to the Inca landscape includes Susan Niles, "Inca Architecture and the Sacred Landscape," in *The Ancient Americas: Art from Sacred Landscapes*, ed. Richard F. Townsend (Chicago: Art Institute of Chicago, 1992); and Carolyn Dean, "The Inka Married the Earth: Integrated Outcrops and the Making of Place," *Art Bulletin* 89, no. 3 (2007).

8. Both Maurice Merleau-Ponty and David Seamon have argued that it was the "everyday moment in space" that gave meaning and identity to place. Seamon, "Body-Subject, Time-Space Routines and Place-Ballets," in *The Human Experience of Space and Place*, ed. Anne Buttimer and David Seamon (New York: St. Martin's Press, 1980); Merleau-Ponty, *Phenomenology of Perception* (London: Routledge Classics, 2002).

9. For more information on Inca roads, see John Hyslop, *The Inca Road System* (New York: Academic Press, 1984).

10. Although the specific ways in which people and goods moved across the Andes is currently debated, one thing scholars agree on is that both people and goods did travel, starting from the earliest of Andean history. One foundational argument proposes that since the Andes is a vertical landscape, most people can only grow a small percentage of the crops and goods they

need for subsistence. In response, people in the Andes developed intricate migration and trade patterns, as well as owning houses in at least one other environmental zone, in order to gain access to the goods needed for survival. John V. Murra, "El 'control vertical' de un máximo de pisos ecológicos en la economía de las sociedades andinas," in *Visita de la provincia de León de Huánuco en 1562*, ed. John Murra, Documentos para la Historia y etnología de Huanuco y la Selva Central (Huanuco, Peru: Universidad Nacional Hermilio Valdizan, 1972); Murra, *The 'Vertical Control' of a Maximum of Ecological Tiers in the Economies of Andean Societies* (Lima, Peru: Institutos de Estudios Peruanos, 1975). Part of the Inca's ability to control Andean populations was based on their power to prevent travel in the Andes, which made their subjects completely dependent on the Inca state for basic subsistence. However, more recent scholarship has argued against Murra's hypothesis and has proposed other systems in which goods and people could have moved across the Andes.

11. Tim Cresswell, *Place: A Short Introduction, Short Introductions to Geography* (Malden, MA: Blackwell Publishers, 2004), 12.

12. A *tambo* was a way station or overnight lodging. Guards were often stationed at a *tambo* to regulate movement on a road, but a *tambo* could also have accommodation for official travelers in small and large groups. The Inca may have used the *tambo* to house officials and troops traveling on Inca roads. In the colonial period, these were places that travelers could rent for a night's stay for themselves and their horses. Diego Gonzalez Holguin defines *tampu* as "venta o meson"; Gonzalez Holguin, *Vocabvlario de la lengva general de todo el Perv llamada lengua qquichua o del Inca [1608]*, prologue by Raúl Porras Barrenechea, edición facsimilar de la versión de 1952 ed. (Lima, Peru: Universidad Nacional Mayor de San Marco, Editorial de la Universidad, 1989), 337. In 1739, "venta" is defined as a window or "se llama assimismo la casa establecida en los caminos, y despoblados para hospedage de los passageros. Dixose asi, por que en ella se les vende lo que han menester" (also named this is a house established along the roads and empty to house passersby as guests. These are so called because they are rented to those who have need). Real Academia Española, *Diccionario de la lengua Castellana, en que se explica el verdadero sentido de las voces, su naturaleza y calidad, con las phrases o modos de hablar, los proverbios o refranes, y otras cosas convenientes al uso de la lengua [1739]* (Madrid, Spain: Imprenta de Francisco del Hierro, 1990), 2:449. A *meson* is defined in 1734 as "la casa donde concurren los forastéros de diversas partes, y pagandolo se le dá albergue para sí y las cabalgadúras" (the house that outsiders come to from different parts, which they rent as shelter for themselves and their horses). Ibid., 1:555.

13. Inca estates did not belong to the *suyu* in which they were situated but rather operated in a separate sphere because they were understood to belong solely to their patron, the *Capac Inca* (unique Inca). In other words, royal estates such as Chinchero were conceived of as separate and occupied a special status in space, like their royal patron. Thus, its name may have described its location (in Chinchasuyu and on the side of a hill), but it did not define its ownership.

14. Gordon McEwan has discussed how many Wari roads were reutilized by the Inca. It is unclear whether the Wari first created the roads at Chinchero, though it is likely that these were pathways for people before the Inca arrived. Gordon Francis McEwan, *The Incas: New Perspectives, Understanding Ancient Civilizations* (Santa Barbara, CA: ABC-CLIO, 2006).

15. Topa Inca was trying to create a meaningful place that had a distinct experience that fostered his own agenda. According to Cresswell, "place is how we make the world meaningful and the way we experience the world." Cresswell, *Place*, 12.

16. The colonial writings suggest that this entire region was home to the Ayarmaca and that their principal shrine was near Lake Guaypon, west of Chinchero. The Ayarmaca are believed to have had a fortress at what is now called Andinchayoc, near Topa Inca's estate. María Rostworowski de Diez Canseco, *History of the Inca Realm*, trans. Harry B. Iceland (Cambridge: Cambridge University Press, 1999), 9.

17. For a discussion of the history of the Ayarmaca, see María Rostworowski de Diez Canseco, "Los Ayarmaca," *Revista del Museo Nacional* 36 (1970). See also Rostworowski de Diez Canseco, *History of the Inca Realm*, 8–11.

18. Even after they were conquered and brought into the Inca state, the Ayarmaca continued to maintain their unique ethnicity and status. Building this site on their homeland no doubt sent a message of the Inca's continuing dominance over them. During the colonial period, some Ayarmaca were living in the Cuzco region, while others stayed in Chinchero. The latter seemed to have continued their own political structures, as some continued to sign their names as Tocay Capac, their name for leader.

19. This also happened in other parts of the Ayarmaca landscape. On a hill called Cinca (on the Inca road to Yucay) was an outcrop that was the Ayarmaca *pacarina* (place of origin). The Inca made this a *huaca* on their *ceque* system, reaching out from Cuzco to Chinchasuyu. Rostworowski de Diez Canseco, *History of the Inca Realm*, 10. This re-inscribing of the landscape likely began as a result of the conflict surrounding a kidnapped Inca boy, Yahuar Huacac, who was Topa Inca's great grandfather. When it was over, the Ayarmaca's leader, Tocay Capac, was defeated and the Ayarmaca were broken up into three groups: Pucyura, Chinchero, and San Sebastián. Ibid., 10.

20. These were official arrival roads. There were other service roads connected to Chinchero, such as the one that linked Chinchero to the storage area of Machu Colca.

21. Bernabé Cobo, *Inca Religion and Customs*, trans. Roland Hamilton (Austin: University of Texas Press, 1994), 60.

22. Cuper Bajo is the name for a shrine and a local *ayllu* (Lower Cuper) that lives in the area. They have a connection to the *ayllu* Cupir (Cuper), which resides in Chinchero.

23. In the early years of the Spanish conquest, the viceroy Francisco de Toledo recognized the importance of the lake, mandating that the Inca irrigation channels be improved to continue

the transportation of water to Cuzco. Francisco de Toledo, "Informaciones que mandó levantar el Virrey Toledo . . . (1572)," in *Don Francisco Toledo*, ed. Roberto Levillier (Buenos Aires, Argentina: 1935), 245. This practice has been continued to the present day, but the water level of the lake has dropped significantly, which has caused damage to the local communities. Because the communities that border the lake have *ayllu* relationships with Chinchero, the people of Chinchero have been active in leading protests in an attempt to get the government of Cuzco to curtail their use of the lake's water. Chinchero still has strong links to Lake Piuray and is considered the head of the lake communities.

24. This *huaca* was part of the *ceque* system. Cobo, *Inca Religion and Customs*, 60–61.

25. There may have originally been three terrace walls. In front of the largest terrace wall, half-scale stones have been found scattered along the ground. They are made of limestone and shaped to fit a polygonal wall. Although this area has been "restored," no proper excavation has occurred in this area, and therefore the original location of these half-scale stones has yet to be found. Nevertheless, the fact that they appear to be half-scale is highly unusual.

26. I believe these stones came from the mountain directly to the north of Chinchero, where sandstone outcrops in the same vibrant greens, yellows, and reds can be found.

27. For a discussion of miniatures in the Andes, see Dean, *A Culture of Stone*, 97–99.

28. It is possible that the Inca painted stone walls, though surviving evidence suggests this was unlikely. The one extant example of painting on Inca stone can be found at Raqchi, but it is unclear if this faded painting, which covers a selection of finely worked stone in the interior of a building, was actually made in the imperial Inca period. It most likely was created later, after the demise of the Inca state. By contrast, there is much evidence that the Inca painted adobe. Adobe walls were often polychrome. One extant example of a polychrome stone wall is the miniature wall at Cuper Bajo. In this case, the color was not painted or added in any way, but instead derived from the natural colors of the stone blocks themselves.

29. In the colonial period, a church was built against the rock outcrop, and up until the 1980s, women from Chinchero made special offerings here (Ed Franquemont, personal communication, 2000).

30. Salomon, *The Huarochirí Manuscript*, 126, fn 670.

31. For a discussion of *huanca* see Pierre Duviols, "Un symbolisme andin du double: La lithomorphose de l'ancêtre," in *Actes du XLIIe Congrès International des Américanistes: Congrés du Centenaire: Paris, 2–9 Septembre 1976*, ed. Société des Américanistes de Paris (Paris: Société des Américanistes, 1978); and Dean, *A Culture of Stone*, 44–46.

32. Dean, *A Culture of Stone*, 44.

33. Dean notes that *huanca* (*wanka*) could come in different forms, while Pablo Joseph de Arriaga found that they were often oblong monoliths. Ibid. Pablo Joseph de Arriaga, "La extirpa-

ción de la idolatría del Pirú [1621]," in *Crónicas peruanas de interés indígena*, ed. Francisco Esteve Barba, Biblioteca de Autores Españoles (Madrid, Spain: Ediciones Atlas, 1968). The outcrop next to the Huancapata is a long stone outcrop with one tall portion toward the center of the *pata*.

34. How travelers from Cuzco entered Chinchero is unclear. They may have taken the portion of the road that was completed and then walked through the open space of the Pampa de Anta, entering Chinchero on the northern façade along the roads from the Urubamba Valley. Or travelers from the capital may have reached Chinchero via the Urubamba Valley roads to begin with (traveling from Cuzco via Pisaq). Regardless, it is clear they were not using the Cuzco road to Chinchero as this direct entrance to Chinchero was unfinished.

35. These pauses can be found leading to many Inca settlements, particularly royal estates. For example, they can be found along the main road leading to Machu Picchu, as well as along the recently re-discovered secondary road. Jean-Pierre Protzen describes the experience along the road leading to Machu Picchu thus: "The site is veiled and unveiled in a sequence of vistas that reveal the lay of the land and the setting of the town, and that attract attention to details of nature or architecture framed by narrow passages or gates." Protzen, *Inca Architecture and Construction at Ollantaytambo* (New York: Oxford University Press, 1993), 42. The latter is described as having regularly spaced platforms, as well as caves and Inca buildings. Alfredo Valencia Zegarra, "Recent Archaeological Investigations at Machu Picchu," in *Machu Picchu: Unveiling the Mystery of the Incas*, ed. Richard L. Burger and Lucy C. Salazar (New Haven, CT: Yale University Press, 2004), 79.

36. Susan Niles, "Looking for 'Lost' Inca Palaces," *Expedition* 30, no. 3 (1988); Niles, "Inca Architecture and the Sacred Landscape"; Niles, *The Shape of Inca History* (Iowa City: University of Iowa Press, 1999); Niles, "The Nature of Inca Royal Estates."

37. His first estate is named as Urcos in the colonial records. This refers to the present-day town of Urquillos, below Chinchero, rather than the town of Urcos, far south of Cuzco. The records do not indicate when Urcos/Urquillos was built, but since they describe Chinchero as being built shortly before his death and was where he lived during his last years, Urcos/Urquillos must have been built earlier. While he had a palace in Cuzco (Calispuquio), Topa Inca likely had a royal estate relatively early on, as this would have shown his might, in terms of the act of building and of the real need to have a lavish center to host visitors and produce goods, which was critical for *ayni* and maintaining one's standard of living.

38. Since the late 1990s, the archaeologist Susan Niles has been working on a comprehensive study of Urcos (Urquillos) from the imperial Inca period to the present day.

39. This portion of the imperial Inca road is heavily damaged.

40. The final connection to the upper road that is used today is modern. It does not enter Chinchero at the valley bottom, but instead, on the hill opposite of Chinchero. While this is an im-

pressive vantage point, there is no evidence that an Inca road existed at this point. By contrast, the road entering the valley bottom is finely made and clearly articulated. People entering Chinchero from the lower road (Topa Inca and family) would have entered Chinchero on the southern side of the valley. It is likely that people traveling from both roads walked along the same final portion of the Inca road within the Chinchero Valley.

41. As noted in Christine Franquemont's study, the northern part of Chinchero is where the densest terracing occurs and is also the best climate for agricultural production in terms of quality and diversity of yields. This may explain why the area was terraced. Yet the richest area is in the neighboring Qhishwa zone to the north and east. This area has some terracing, which increases around the town of Urcos (Urquillos); however, the area closest to Chinchero has been left relatively unworked. If the terracing was due only to agricultural productivity, then this steep area could have been better harvested with terracing; instead it was largely left alone.

Productivity was an important aspect of Inca construction practices, but it was just one factor in deciding where to construct terraces. Another factor was the amount that was actually needed. The *pampa* to the west of Chinchero, while not as rich as the northern slope, could yield a vast amount of produce, and the area down the valley, in the *qhishwa* region, could be cultivated for Topa Inca's royal needs. All of this land was part of his royal estate. We do not know how many people lived at the royal estate or gathered at one time for activities, so we cannot estimate the amount of produce needed to feed people at Chinchero. Yet it is clear from the vast amount of arable land that there were abundant agricultural resources exploited by the royal patron. Franquemont, *The Ethnobotony of Chinchero: An Andean Community in Southern Peru*, Fieldiana Botany (Chicago: Field Museum of Natural History, 1990).

42. While servants would have worked most of these terraces, some may have been worked by Topa Inca and his family. Inca Garcilaso de la Vega states that in Cuzco, terraces were worked by Inca noblemen and -women, and at those places, songs were song and rituals were performed. Garcilaso de la Vega, *Comentarios reales de los Incas*, 2nd ed. (Mexico City: Fondo de Cultura Económica, 1995), 1:256.

43. Protzen has described how the Inca carefully constructed terraces. Strong retaining walls were built to hold back a mountain of earth. Fill was then brought in and a layer of rough stones and clay was laid down. Next, a layer of rich topsoil was spread out. This system created a filtration and irrigation system among the terraces. This subterranean system was in addition to the extensive water channels that were often built to control water flow at the surface. Protzen, *Inca Architecture and Construction*, 3–34. Pedro Sarmiento de Gamboa describes the building of terraces: "Pachacuti Inca Yupanqui, considering the small extent of land round Cuzco suited for cultivation, supplied by art what was wanting in nature. Along the skirts of the hills near villages, and also in other parts, he constructed very long terraces of 200

paces more or less, and 20 to 30 wide, faced with masonry, and filled with earth, much of it brought from a distance. We call these terraces *andenes*, the native name being *sucres*. He ordered that they should be sown, and in this way he made a vast increase in the cultivated land, and in provision for sustaining the companies and garrisons." Sarmiento de Gamboa, *History of the Incas*, trans. Clements R. Markham (Mineola, NY: Dover Publications, 1999), 98. See also Protzen, *Inca Architecture and Construction*, 32. Sarmiento's discussion of "earth, much of it brought from a distance" supports Protzen's argument that the Inca were very aware of the importance of obtaining and preserving important topsoil for their farming, regardless of the time and energy needed to transport and preserve it. See also Kenneth R. Wright et al., "Machu Picchu Ancient Agricultural Potential," *Applied Engineering in Agriculture* 123, no. 10 (October 1997).

44. Dean, *A Culture of Stone*, 46.

45. See ibid., 46–47.

46. John Rowe has argued that these geometric carvings were a visual complement to the uncarved portions of the stone, specifically the remains of the cortex. Thus, the Inca gestures on the stone commemorated its prior appearance as well as the Inca ability to alter and work with the sacred material (John Rowe, personal communication, 1997). Dean has shown how this play between the natural status of the stone and the evidence of Inca facture was an important aspect of their visual conquest of the landscape. Dean, *A Culture of Stone*, 46–47.

47. Niles, *The Shape of Inca History*, 70–71.

48. Salomon, *The Huarochirí Manuscript*, 146; ibid., 259; ibid., 91 fn 162.

49. For a discussion of *sami*, see Catherine J. Allen, *The Hold Life Has: Coca and Cultural Identity in an Andean Community*, Smithsonian Series in Ethnographic Inquiry (Washington, DC: Smithsonian Institution Press, 1988), 49–54.

50. Salomon notes that lands that grew crops of corn were associated with females, while water was associated with men, "with a sexual episode representing the origin of irrigation and consequent fertility." Salomon, *The Huarochirí Manuscript*, 139, fn 775.

51. Cobo notes that it was common for Andeans to articulate their pauses when they came to a *huaca* along a road by making offerings, performing specific gestures, reciting prayers, making certain sounds, etc. Salomon, *The Huarochirí Manuscript*, 118–21.

52. This unworked hill lies in opposition to the heavily terraced façade of Chinchero's northern slopes. The combination between the natural and the man-made is not unusual in Inca architecture and can be seen in Sacsayhuaman, where a heavily terraced hill lies in opposition to a largely natural rock of equal size. This pairing is likely an expression of complementary pairs, which organized the Andean world. This also highlights Dean's argument that for the Inca, something that was unworked could be deeply meaningful. Thus we must be careful in only ascribing value to objects and places that have been altered by labor. At Chinchero, the unworked hill appears to have been

of great value, as many of the viewing points on the various rock outcrops face it, yet what it means is unclear.

53. Dean argues that steps placed on Inca outcrops "allude to passage between different cosmic levels; in so doing, they signal the liminality of the places they mark. These are important sites where this world opened into the ancestral realm." Dean, *A Culture of Stone*, 34.

54. This continued to be a resting place for the dead, as burials were later placed near this outcrop. While I was working in Chinchero in 2001, a burial was looted to the east of this rock, in a terraced area. It was marked by impressive black and white stone slabs. I was told a resident in Chinchero who lives along the highway looted the area in the night and found fine ceramics and metals along with a human burial. I was not able to get any more details. When Stanislau Ailler, the I.N.C. guardian and concerned Chinchero elder tried to file a report of this incident, the looter retaliated by filing charges against Ailler. The case was eventually dropped by both parties and no materials were ever returned.

Interior rooms carved out of outcrops or mountain faces can be found at other royal estates, such as Machu Picchu. For example, Lucy Salazar has argued that the cave carved out of the bottom of the "Torreon" "conceptually corresponds to the underworld from which rivers and ancestors like the mythical Inca Manco Capac emerged from in Inca mythology." Lucy C. Salazar, "Machu Picchu: Mysterious Royal Estate in the Cloud Forest," in *Machu Picchu: Unveiling the Mystery of the Incas*, ed. Richard L. Burger and Lucy C. Salazar (New Haven, CT: Yale University Press, 2004), 40. This practice of housing the dead appears to have been mimicked by servants. Salazar notes that many of the burials found by Hiram Bingham (and which proved to be mainly *yanacona*) were at the edges of the royal estate, inserted next to or underneath outcrops that were subsequently walled in. Ibid., 43.

Dean notes that caves, along with other *pacarinas*, "were doorways between the ancestral world and this world, and they remained places of contact between realms." Dean, *A Culture of Stone*, 34. Chinchero's Chinkana may not only have been a powerful *huaca* but also a *pacarina* or origin cave.

55. Salomon, *The Huarochirí Manuscript*, 20. The importance of feeding the dead in caves was challenged by Christian burial practices; Andean peoples saw these underground burials as starving the dead and causing mummies to decay. Ibid., 130, fn 699.

56. "*Chincarini*: desaparecerse" (to disappear, to vanish); *Chincani, chincacuni* "Perderse o zambullirse en el agua" (lost or diving into water). Anonymous, *Vocabulario y phrasis en la lengua general de los indios del Perú, llamada quichua, y en la lengua española*, 5th ed. (Lima, Peru: Universidad Nacional Mayor de San Marcos, Instituto de Historia de la Facultad de Letras, 1951), 37. Note that in this anonymous author's dictionary, *Chincani* is mentioned as being lost in relation to water. Chinchero's Chinkana had a waterway wrapped around several of its sides and had carving to allow liquids to flow.

González Holguin defines "*Chincana pacacuna*. Escondrijo" (hiding place) "*Chincaycunivnupi, o chincarccuni*. Çabullirse en el ague o perder pie" (dive into water or loose footing). "*Chincanayani*. Estar a punto para huyrse" (be ready to flee). "*Chincanayac*. El que se quiere huyr, ausentar" (to want to run away, be absent). Gonzalez Holguin, *Vocabulario de la lengua . . . [1608]*, 110.

57. Salomon, *The Huarochirí Manuscript*, 16.

58. According to Salomon, *camay* was a "continuous act that works upon a being as long as it exists." Ibid.

59. Ibid.

60. In the Huarochiri manuscript, Salomon found that *huaca* was defined as "'superhuman person, shrine, holy, and powerful object'; huaca, *priesthood*." Ibid. He found that this divine essence (Latin *numen, numina*) could inhabit "mountains, springs, lakes, rock outcrops, ancient ruins, caves, and any number of humanly made objects in shrines; effigies, mummies, oracles and so forth." Ibid.

61. Ibid., 17.

62. Ibid., 19.

63. Jacinto Singona, personal communication, 2000.

64. Salomon states that in Huarochiri, people were obliged to offer "llama and guinea pig meat, brilliant colored mineral powders, thorny oyster shell, clothing, coca leaf, maize dumplings, and maize beer." He also notes the rules that governed rituals and priest behavior with *huaca*. Salomon, *The Huarochirí Manuscript*, 17.

65. Dean, *A Culture of Stone*, 46.

66. In both colonial and modern Quechua, *caca* is a term that means crag or cliff. Salomon, *The Huarochirí Manuscript*, 44, fn 24. But *caca* also references gender. Thus the *caca* of the condor may reference male relations vis-à-vis women. Some colonial sources indicate that it is a term used to refer to the male relatives of a female. For others it refers to male relatives who do not take part in a father-son inheritance (i.e., *caca* could refer to the male members of a *panaca*). For a discussion of the term, see ibid., 151. What is perhaps most pertinent for this discussion is that *caca* can be used to refer to familial relationships, in particular, those involving inheritance or relationship to a woman. It is interesting that three of the main *huaca* on the Chinchero have been designated as *caca*. See also note 89, this chapter.

67. The bottom portion of this stairway has been destroyed and what remains has since been redone. Therefore it is unclear how far down this stairway reached and what pathway was connected to it. However, it is close to the two stones and is still used today as part of the path connecting the two portions of the site.

68. While Condorcaca would not have been visible to the traveler below, the terraces around it would have been. This is because Chinchero seems to have been built according to the location of rock outcrops. To the traveler below, the terraced hillside seems almost complete, yet it was actually in various stages of production. The far western end, opposite from where travelers from the Urcos (Urquillos) would have arrived, is in the initial stages of landscape resurfacing, thus in the same stage as

the terraces behind Huancapata. Closer to where the travelers entered, on the eastern side of the valley, the terraces are mainly completed, with the exception of certain areas that are not connected to a rock outcrop. In terms of priority, we see a clear emphasis on articulating the estate that was experienced by the Urcos travelers, and within this, those areas around sacred rock outcrops. The principal audience of Topa Inca's estate seemed to have driven its construction stages, and the principal message of the patron was that of a sacred and powerful ruler.

69. Inca rocks could be carved in ways to mimic or reference the landscape; they could also be carved in abstract ways that conveyed the form of the original rock as well as describing the Inca's ability to alter it. These two carving types constituted the majority of altered Inca outcrops. However, a small percentage were figurative in nature. We know that the Inca made landscape and architectural models when new areas were conquered or new building campaigns were underway. Hence, a landscape model is possible at Chinchero. However, since it was rare for large-scale Inca rock carvings to be models of the landscape, and the surviving examples have been little studied, we cannot say for sure if or how this rock grouping at Chinchero may have modeled landscapes. Residents describe the landscape on the smaller stone as being carried on the back of a frog, an animal associated with lakes and fertility in the area. Whether the Inca also thought this is impossible to tell.

70. This can be seen in what we today call "echo" stones and the type of stones referred to in colonial texts as *apacheta*. For a discussion of *apacheta*, see Carolyn Dean, "Rethinking Apacheta," *Ñawpa Pacha* 28 (2006). For a discussion of these stone types and their relationship to mountains, see Dean, *A Culture of Stone*, 55–64. For a discussion of *apu* and perceptions of sacred mountains in the Andes, see Joseph Bastien, *Mountain of the Condor: Metaphor and Ritual in an Andean Ayllu* (Prospect Heights, IL: Waveland Press, 1978); Allen, *The Hold Life Has*; Peter Gose, *Deathly Waters and Hungry Mountains: Agrarian Ritual and Class Formation in an Andean Town*, Anthropological Horizons (Toronto: University of Toronto Press, 1994); Johan Reinhard, *The Ice Maiden: Inca Mummies, Mountain Gods, and Sacred Sites in the Andes* (Washington, DC: National Geographic Society, 2005).

71. Pitusiray was one of the most important *apu* in all of Tahuantinsuyu. Its name translates as "to sew together," as its twin peaks are said to be the sewing together of two *suyu*, or Inca quarters, Antisuyu and Contisuyu.

72. Bedrock will shift in events such as earthquakes. The Andes is an earthquake-prone area (part of the "ring of fire"). However, the large Condorcaca stone does not sit on bedrock, but on the earthen platform of a terrace.

73. Felines were important to the Inca and show up in Inca art and architecture as either a puma or a jaguar. Both were associated with elite Inca men. This representation is most likely a puma, as it does not show evidence of the spotted coat usually used to denote an adult jaguar. Both felines are predators found in the Andes.

74. Salomon, *The Huarochirí Manuscript*, 48, fn 54.

75. When boys underwent the grueling ritual to become men, those who survived the process were given puma pelts to wear. According to Cobo this was more than adornment; the full skin of the puma covered almost the entire man, including head and hands. The image was of a boy transforming into a puma. Cobo, *Inca Religion and Customs*, 133. There is also evidence to suggest that the puma was an important symbol in other parts of the Andes; in particular, it signified prosperity and perhaps sovereignty. Salomon, *The Huarochirí Manuscript*, 58, fn 125.

76. Carving these images into the outcrop may have been a powerful act in itself. As Dean argues, "When carved directly on the surface of the stone to which it is offered, the imaginistic carving may have served as a permanent record of petitions to the larger petrous numina. Imaginistic carving may also allude pictorially to characteristics of the place." Dean, *A Culture of Stone*, 32.

77. Salomon, *The Huarochirí Manuscript*, 17. Salomon notes that these *huaca* "were powerful social and political corporations." Ibid.

78. Ibid., 77, fn 287.

79. This was located on a hill called Cinca. Cobo, *Inca Religion and Customs*, 58.

80. The relationship between the Inca and the Ayarmaca was a long and complicated one. One of the months in the Inca calendar is named for the Ayarmaca. Ibid., 149.

81. Dennis E. Ogburn, "Evidence for Long-Distance Transportation of Building Stones in the Inka Empire, from Cuzco, Peru to Saragura, Ecuador," *Latin American Antiquity* 15, no. 4 (2004).

82. For example, the immense *huanca* stones (such as at the Huancapata) that claimed possession of territory did not always originate where they stood. Instead, these movable *huanca* would have been placed in a location by the Inca so that their lithic representation could act "as intercessors" in the landscape. Dean, *A Culture of Stone*, 44. This evidence comes from a colonial source. Hernando de Avendaño, "Relación sobre la idolatría; Letter Written in Lima (Los Reyes) on 3 April 1617," in *La imprenta en Lima (1584–1824)*, ed. José Toribio Medina (Santiago, Chile: Imprenta Elzeviriana [Impreso del Autor], 1904).

83. Dean, *A Culture of Stone*, 50–51.

84. Ibid., 53. Maarten J. D. Van de Guchte, "'Carving the World': Inca Monumental Sculpture and Landscape." Dissertation, University of Illinois at Urbana-Champaign (1990).

85. Dean, *A Culture of Stone*, 51. The critical distinction between presentation and representation for the Inca has been brought to light by Dean. "Metonymy in Inca Art," in *Presence: The Inherence of the Prototype within Images and Other Objects*, ed. Robert Maniura and Rupert Shepherd (Aldershot, UK: Ashgate, 2006).

86. The smaller stone is another mystery. It is part of the bedrock and has only one seat, which is directed to the northeast, facing the hillside and a small portion of the distant mountains. This hillside is often the focus of seated views. Most of the stone, other than the one seat, is uncarved. There is evidence

that one portion on the far eastern side had been carved but was subsequently destroyed. This iconoclastic act was likely done in the early colonial period by Christians participating in the extirpation-of-idolatry campaigns. Its destruction suggests that this portion of the stone was receiving offerings at the time, or was figurative (and thus recognizable to Europeans as a possible indigenous shrine).

87. This is similar to the statue of Vishnu that refused to move and inspired the construction of the Ranganatha Temple at Srirangam (in present-day India) around it. Sri Ranganathaswamy is a Hindu temple and is one of eight shrines where Lord Vishnu is said to have manifested himself. It lies on an island in the present Indian state of Tamil Nadu. It consists of 21 towers, 39 pavilions, 50 shrines, several bodies of water, and several enclosing walls. It is the largest temple in India and one of the largest religious centers in the world. It is said to have originated when the Ranganathan idol, which had been placed in the forest and then lost to the overgrowth, was found by accident by a Chola king. He then established the temple complex at the spot where he located the idol (most likely around the tenth century AD).

88. In Quechua, Gonzalez Holguin translates *titi* as "plomo" (plumb bob, lead or lead color). Gonzalez Holguin, *Vocabvlario de la lengva . . . [1608]*, 344. In Aymara, Titi is "las hijas de los officiales, en tiempo del Inga, y a los hijos llamaná Copa, que despues heredauan el officio de coger los dichos gatos" (the daughters of officials, in the time of the Inca, and the sons who were called Copa, who later inherited the office of catching these cats). Ludovico Bertonio, *Vocabulario de la lengua Aymara*, Serie Documentos Históricos (Cochabamba, Bolivia: Centro de Estudios de la Realidad Económica y Social, 1984), 1:353.

89. The anonymous author translates *caka* as "peña viva" (a living rock, or crag) and "cierto vaso de cuello largo a manera de redoma" (a real glass with a long neck, in the manner of a flask). Anonymous, *Vocabulario y phrasis*, leaf Aa 6 verso. According to the Real Academia Española in 1737, a *peña* was "la piedra grande ó roca viva, que nace de la tierra" (the grand stone, or living rock, that is born of the earth). Real Academia Española, *Diccionario de la lengua Castellana*, 5:208. It is interesting to note that *caca* is also an Aymara word, though its meaning is very different. *Caca* was translated in 1612 to mean "canas de la cabeça" (white or gray hairs on the head). Bertonio, *Vocabulario de la lengua Aymara*, 2:32.

In Quechua, González Holguin translates *puma* as "leon [lion] un juego de indios" (a game of the Indians). *Puma*, o *ñauraycuna puma* is "todas las fieras" (all of the wild beasts) and *pumascca* is "cosa muerta, o caçada de fieras" (something dead, or hunted beasts?). Gonzalez Holguin, *Vocabvlario de la lengva . . . [1608]*, 294. In Aymara, *puma* is "Leon. Urco puma: el Macho. + Cachu puma. La Leona" (Lion. Urco puma: the male + Cachu puma, the female Lion). Bertonio, *Vocabulario de la lengua Aymara*, 1:275.

90. Salomon, *The Huarochirí Manuscript*, 15.

91. Ibid.

92. Serpents were venerated by the Inca and given special shrines. Snakes could also be used as weapons. Cobo, *Inca Religion and Customs*, 31. They could be used for punishment and as prestige items. Garcilaso, *Comentarios reales de los Incas*, 1:273. It is unclear if this carving of a serpent on Titicaca means that the outcrop was devoted especially to serpents or if this was one of many markings on the outcrop that conveyed its sacred status.

93. Michael J. Sallnow, *Pilgrims of the Andes: Regional Cults in Cusco* (Washington, DC: Smithsonian Institution Press, 1987). Sallnow discusses group pilgrimage in the twentieth century, yet the bodily experience of the processions through the landscape he described would have had much in common with the constructed movement experienced by visitors traveling to Chinchero along the Inca roads.

94. Having large-scale architectural elements that dwarf a visitor is typical of many Inca sites, particularly royal estates. At Ollantaytambo, Protzen noted that the "visitor entering onto the esplanade will not fail to feel dwarfed and awed by the grandeur of this open space." However, he also noted that the practice of the space changes one's experience of it; thus it takes on "more of a human scale" as one walks through it. As we shall see, this play with strangeness and familiarity is a theme that was explored by the Chinchero designers as well. Protzen, *Inca Architecture and Construction*, 77.

Chapter 3

1. By 1737, *plaza* was understood as a word for "place" that had specific urban connotations. "Plaza. s. f. Lugar ancho y espacioso dentro del poblado, donde se venden los mantenimientos, y se tiene el trato común de los vecínos y comarcanos, y donde se celebran férias, mercados y fiestas públicas. Sale del Latino *Platea*, que significa esto mismo. La.t *Forum*, i. MEDIN. Grand. lib. 2. cap. 87. Tiene (Valladolid) una plaza mui grande y hermosa, que se llama la plaza mayor, al rededor de la qual están todos los oficios y Mercaderes. COLM. Hist. Segob. cap. 44. §. 3. Estando las plazas y carnicerías llenas de pan, carnes, frutas, y todo género de caza y pesca" (Wide and spacious place within a town where basic goods are sold, where communal dealings are undertaken by residents, and where fairs, markets, and public holidays are celebrated. . . . A large and beautiful square, around which are the trades and merchants. . . . Squares full of bread and butchers, meats, fruit, and all kinds of hunting and fishing). Real Academia Española, *Diccionario de la lengua Castellana, en que se explica el verdadero sentido de las voces, su naturaleza y calidad, con las phrases o modos de hablar, los proverbios o refranes, y otras cosas convenientes al uso de la lengua [1737]*, vol. 5. In the 1737 dictionary, there are fifteen entries for *plaza* or *plaza* used in combination. Some entries define *plaza* as a fortified space in a city, but most entries reference types of places, most often conceptual or general ideas of place, such as an appointment in government or a cry from a guard for space when the king arrives.

2. Inca Garcilaso de la Vega, *Comentarios Reales de los Incas*, 2nd ed. (Mexico City: Fondo de Cultura Económica, 1995), 1:365.

3. The anonymous author describes *cancha* as "corral, o patió" (farmyard, courtyard or patio). He also lists another entry with *cancha* translated as "empeyne." Anonymous, *Vocabulario y phrasis en la lengua general de los indios del Perú, llamada quichua, y en la lengua española*, 5th ed. (Lima, Peru: Universidad Nacional Mayor de San Marcos, Instituto de Historia de la Facultad de Letras, 1951), leaf Bb. González Holguin defines *cancha* the same way, as "el patio or corral" and "empeyne." Gonçález Holguin, *Vocabvlario de la lengua general de todo el Perv llamada lengua qquichua, o del Inca* (Ciudad de los Reyes, Peru: Francisco del Canto, 1608), leaf C 5 recto. The two definitions are distinct: *Empeyne* is the instep on a human foot. Real Academia Española, *Diccionario de la lengua Castellana . . . [1732]*, 3:408.

Domingo de Santo Tomás gives several entries for *cancha*: "palizada, defension de palos, o cerco para encerrar ganado" (a fence or embankment, defined by poles, or enclosure for closing in livestock); "cozral, como patio de casa, o patin" (corral, like a patio of a house, or paddle boat); "patio o cozral cercado" (patio or enclosed corral). *Domingo de Santo Tomás, Lexicón o vocabulario de la lengua general del Perú [1560]*, facsimile ed. (Lima, Peru: Universidad Nacional Mayor de San Marcos, 1951), 247.

4. The anonymous author describes *pata* as "poyo, grada, anden" (bench, step or platform, covered walkway[?]) and *pata* as "gradas, or escaleras" (steps, or stairs). Anonymous, *Arte y vocabulario*, Hh recto. In 1737, the Real Academia Española described *poyo* as "f. m. El banco de piedra, hyesso ú otra matéria, que ordinariamente se fabrica arrimado á las parédes, junto á la puertas de las casas, en los zaguanes y otras partes" (a plateau of stone, plaster, or other material that ordinarily is made alongside of walls, is part of the walls of houses, in the front hall, or other parts. Real Academia Española, *Diccionario de la lengua Castellana . . . [1737]*, 5:343. Therefore, the description of a *pata* by the anonymous author translates roughly as a stone wall with adjacent platform, steps, or a staircase. González Holguin defines *pata* as "poyo, grada, anden y relex de edificio" (stone wall with platform, step, and the relief or recess of a building [?]). Gonzalez Holguin, *Vocabvlario de la lengua . . . [1608]*. "Relex" is a specific architectural reference regarding the relationship between vertical and horizontal elements. González Holguin defines *pata* as "gradas o escaleras de edificio" (steps or stairs of a building). Gonçález Holguin, *Vocabvlario de la lengua general*, book 1, leaf S 3 verso. The Spanish word for *pata* is "anden," which González Holguin defines as "*pata*. Hazer andenes. *Pata patachani.*" (*pata*. To make *andenes*. *Pata patachani*.). He also translates *andenes* as "patapata." Gonzalez Holguin, *Vocabvlario de la lengua . . . [1608]*, 407.

The definitions of the word *pata* clearly refer to the stepped landscape, in particular to the walls and planes that define the steps. Steps consist of both risers (the vertical walls) and runners (the flat adjoining area). The term *pata* appears to define a stepped landscape, and therefore refers to both the risers and runners that make up that landscape.

5. The latter use of the term still can be found today. For example, the K'ulta have a raised platform in their homes (which they call a *pata*) that is used as a space for men to sleep or to pour their ritual fluids. Abercrombie, *Pathways of Memory and Power*, 332.

6. *Pampa* means a plaza, level ground, or field. The anonymous author defines *pampa* as a "campo, plaza. Fuelo llano, llanura" (a field, countryside, plaza, an area that is flat, a plain). Separate headings for *pampa* describe it as a "cosa llana" (a thing that is flat, a plain) and as a "cosa comun" (something that is shared, in common). *Pampa pampa* is described as "llanuras" (flat areas). Anonymous, *Arte y vocabulario*, leaf Gg 8 recto. González Holguin defines *panpa* as "plaça, suelo llano o llanada pasto, çauana, o campo" (plaza, flat or common ground, open meadow, savannah, or field), and *panpapanpa* is defined as "llanuras" (flat areas). *Panpa* is also defined as "cosa comun y universal" (something communal or universal). Gonçález Holguin, *Vocabvlario de la lengua*, book 1, leaf S 1 recto. Domingo de Santo Tomás lists three separate headings for *pampa*. He defines *pampa* as "hera donde trillan" (a place where threshing is done), "plaça lugar donde no ay casas" (plaza, place where there are no homes), and "campo raro, como vega" (a rare space, like a fertile lowland). He also lists *pampa, o cuzca* as "cosa llana generalmete" (something that is generally flat or a plain). Santo Tomás, *Lexicón o vocabulario de la lengua*, 335. Note that the term is written as both *pampa* and *panpa* in the early dictionaries (the "m" and "n" were interchangeable).

7. Residents of this plain call the area the Pampa de Anta. It is a vast valley (*pampa*), rich in agricultural production. Anta is a city, community, and *ayllu* that lies far to the west of Chinchero. While geographically distinct, it is considered to "belong" to Chinchero (Anta being one of its distant *ayllu*).

8. Frank Salomon also notes how *pampa* meant an open space but could, in an urban context, be used to describe a plaza. Salomon, *The Huarochirí Manuscript: A Testament of Ancient and Colonial Andean Religion*, trans. from the Quechua by Frank Salomon and George L. Urioste, transcription by George L. Urioste (Austin: University of Texas Press, 1991), 146, fn 838.

9. These spaces were likely also understood in relationship to one another, as can be seen from a contemporary example. In the domestic homes of the K'ulta in Bolivia, the low floor (*pampa*) at one end of the home is where females sleep, pour their libations, and cook over the fireplace. By contrast, the other end of the house has a raised platform (*pata*), which is where males sleep and their own libations are poured. Abercrombie, *Pathways of Memory and Power*, 332–33.

10. Today the area is called Capillapampa, or "field of the church." This is because the area was once used as farmland for the church. However, an undated I.N.C. map of the northern sector of Chinchero names the space Chukipampa. (Map is by T. Portugal and E. Castela O.) *Chuki* was a type of Inca weapon. Gonzalez Holguin defines *chuqqui* as "lança" (lance). Gonzalez Holguin, *Vocabvlario de la lengua . . . [1608]*, 122. The anonymous

author also defines *chuqui* as "lanza" (lance). Anonymous, *Vocabulario y phrasis*, 39.

11. John Hyslop, *Inka Settlement Planning* (Austin: University of Texas Press, 1990), 234–40.

12. For a discussion of the Coricancha, see Brian S. Bauer, *Ancient Cuzco: Heartland of the Inca*, Joe R. and Teresa Lozano Long Series in Latin American and Latino Art and Culture (Austin: University of Texas Press, 2004), 139–57.

13. Bernabé Cobo, *Inca Religion and Customs*, trans. Roland Hamilton (Austin: University of Texas Press, 1994), 154. Tamara Bray notes that children were sent out most often to different parts of the empire to be sacrificed (Bray, personal communication).

14. Cobo, *Inca Religion and Customs*, 154–55.

15. Juan de Betanzos, *Narrative of the Incas (1551)*, trans. Roland Hamilton and Dana Buchanan (Austin: University of Texas Press, 1996), 66.

16. Cobo, *Inca Religion and Customs*, 243.

17. Ibid., 243–44.

18. Ibid., 244.

19. Ibid., 244–45.

20. Ibid., 245.

21. For a discussion on ritual and procession in the Andean context, see Michael J. Sallnow, *Pilgrims of the Andes: Regional Cults in Cusco* (Washington, DC: Smithsonian Institution Press, 1987); Zoila S. Mendoza, *Shaping Society through Dance: Mestizo Ritual Performance in the Peruvian Andes*, Chicago Studies in Ethnomusicology (Chicago: University of Chicago Press, 2000); and Mendoza, *Creating Our Own: Folklore, Performance, and Identity in Cuzco, Peru*, English ed. (Durham, NC: Duke University Press, 2008). For their relevance within an archaeological context, see Jerry D. Moore, *Cultural Landscapes in the Ancient Andes: Archaeologies of Place* (Gainesville: University Press of Florida, 2005), 122–73.

22. The use of public spaces as performance spaces has been explored by scholars, most notably Jerry D. Moore, *Architecture and Power in the Ancient Andes: The Archaeology of Public Buildings*, ed. Clive Gamble, Colin Renfrew, and Jeremy Sabloff, New Studies in Archaeology (Cambridge: Cambridge University Press, 1996); and Lawrence S. Coben, "Other Cuzcos: Replicated Theaters of Inka Power," in *Archaeology of Performance: Theaters of Power, Community, and Politics*, Archaeology in Society Series, ed. Takeshi Inomata and Lawrence S. Coben (Lanham, MD: Altamira Press, 2006).

23. Stairways are typically on the outside of Inca buildings. They are usually located above ground and at the gable end (or short side) of a structure. It is possible that this stairway was placed on the long side of the building, as the eastern gable end was a terrace façade and would have been vulnerable to unsanctioned access from below. Having the entrance within the security of the *pata* may have been a priority for the Inca.

24. Evidence of a first floor can be seen on the top of the southern wall, where an inset has been perfectly preserved. This inset is where the ground or first floor would have been laid, covering the basement level.

25. The Inca did set buildings into terraces, but typically only one side was set against the hill (thus, one could enter the rooms on each floor directly from ground level). Occasionally the Inca made freestanding two-story buildings. But even then, the rooms functioned like separate single-floor buildings that happened to be stacked on top of each other.

26. This space may have served dual functions. It was the entrance area for those wishing to pass along the terraces and gain access to the venerated rock outcrops Condorcaca and Chincana. As discussed previously, these were special, high-status landscapes to which only very privileged people would have been allowed access—most likely Topa Inca, religious specialists, and select elites and family members. This small space off the Pampa would have guarded the entrance to this part of the site as well as mark the transition to a more sacred space.

27. As we will see, this area is next to the staging area for the Pampa. This structure may have facilitated Pampa rituals. Cobo mentions that clothing and instruments for a special ritual were kept together in a house in Cuzco, which was built for this purpose. This ritual was performed primarily by elite Inca men. Cobo, *Inca Religion and Customs*, 151–52. Later, when this ritual was allowed to be performed elsewhere, a special storage house was built in these areas to house the needed ritual paraphernalia. Ibid., 153.

28. For a discussion on this and other victory *cantares*, see Susan Niles, *The Shape of Inca History* (Iowa City: University of Iowa Press, 1999), 8–11.

29. For example, see Cobo, *Inca Religion and Customs*, 154–59.

30. Salomon, *The Huarochirí Manuscript*, 16.

31. For a discussion on Inca mummies, see ibid., 39–43.

32. Niles, *The Shape of Inca History*, xvii.

33. Cobo, *Inca Religion and Customs*, 40–41.

34. Due to its location, access to Titicaca had to be controlled—not by buildings and guards, but instead by its invisibility.

35. Cobo, *Inca Religion and Customs*, 31.

36. Scholars such as Edward Relph and David Seamon have discussed how spatial strategies are deployed to create an "insider/outsider" status. See also Pierre Bourdieu, *Outline of a Theory of Practice* (Cambridge: Cambridge University Press, 1977).

37. This access point also led to two possible storage structures (CP1, CP2), an unusual room hidden behind a terrace (CP0), and a small *pata* that was pulled out of the terrace like a stage.

38. David Seamon, "Body-Subject, Time-Space Routines and Place-Ballets," in *The Human Experience of Space and Place*, ed. Anne Buttimer and David Seamon (New York: St. Martin's Press, 1980). This also leads to what Seamon describes as "insider/outsider" perceptions of space.

39. The *pampa* is spatially like a valley. Within a framed space people can look up toward the buildings, terraces, and surrounding *apu*.

40. It also clarifies a common misunderstanding of scale in Inca buildings. These large windows have been interpreted by scholars as doors (i.e., because of their size). It has been suggested that ramps led up to each of the doorways. The Inca made

ramps for construction purposes, such as moving stones up (or down) a hillside, but they did not make ramps as finished portions of buildings. Scale and movement were important in Andean history—the manipulation of space and scale exhibited in these buildings fits into a long Andean tradition. For an example of ramps used to move building blocks at another royal estate, see Jean-Pierre Protzen, *Inca Architecture and Construction at Ollantaytambo* (New York: Oxford University Press, 1993), 92.

41. Cobo, *Inca Religion and Customs*, 245.

42. Niles has noted that Huayna Capac built very large-scale buildings at his estate to impress visitors. In particular, she describes how smaller buildings could be placed next to larger ones to exaggerate their size and how some, like those on Chinchero's Pampa, could be built on terraces so that they would appear taller than they actually were. Niles, "The Nature of Inca Royal Estates," in *Machu Picchu: Unveiling the Mystery of the Incas*, ed. Richard L. Burger and Lucy C. Salazar (New Haven, CT: Yale University Press, 2004), 66–67.

43. Niles, *The Shape of Inca History*, 4.

44. Spanish writers often state that the ruler was always the son of a primary wife. Yet given the intrigue and changes in favored heirs, it is likely that many of the sons chosen were *not* from the primary wife. Over time, marriage practices as well as inheritance patterns shifted for the Inca (in terms of inheriting the royal fringe). The Spanish writers tended to ignore this change, and instead saw the practices they witnessed as characterizing all of Inca history.

An example is the case of sister wives. This was practiced by, at most, only two imperial Inca rulers, Topa Inca and his son Huayna Capac. Only one imperial Inca ruler was the product of possible siblings (it is also possible that Huayna Capac's parents were cousins). Despite this, incest marriage is often reported by the Spanish as a long-standing Inca tradition. In practice, most Inca rulers married for political reasons and thus their wives were not their sisters or even fellow Inca, but they were usually from a neighboring ethnic group. In addition, when the Spanish write about Inca siblings, they do not distinguish between full and half siblings and sometimes even conflate first cousins with siblings. For example, Topa Inca is said to have married a sister by some sources, but it is unclear who her mother was (i.e., the same as Topa Inca or another of Pachacuti's wives). The fact that some sources report that Topa Inca did not meet Mama Ocllo until her wedding suggests that if they were siblings, they must have been the children of different mothers.

Chapter 4

1. González Holguin defines *puncu* as "puerta o portada." Diego Gonzalez Holguin, *Vocabvlario de la lengua general de todo el Perv llamada lengua qquichua o del Inca [1608]*, prologue by Raúl Porras Barrenechea, edición facsimilar de la versión de 1952 ed. (Lima, Peru: Universidad Nacional Mayor de San Marco, Editorial de la Universidad, 1989). This means a simple opening such as for an animal's cave or an ornamental doorway in a grand building façade. In the eighteenth century, *puerta* is defined as "la abertura que se hace artificiosamente en la pared, y llega hasta el suelo, y sirve para entrar y salir por ella. . . . Por extension se llama qualquir agujero, que se hace para entrar y salir por el, expecialmente e las cuevas de algunos animals" (the artificial opening in a wall that reaches to the ground and used to come and go. . . . By extension any hole that is made to enter and leave, such as in caves of some animals). Real Academia Española, *Diccionario de la lengua Castellana, en que se explica el verdadero sentido de las voces, su naturaleza y calidad, con las phrases o modos de hablar, los proverbios o refranes, y otras cosas convenientes al uso de la lengua [1737]* (Madrid, Spain: Imprenta de Francisco del Hierro, 1990), 5:424. *Portada* is defined as "el ornato de Architectúra ó Pintúra que se hace en las fachadas principals de los edificios sustuosos, para su mayor hermosura. . . . La portáda principal mui autorizada, con muchos ornatos y atavios de colúmnas de tres en tres" (the ornamentation of architecture or painting that is done on the main façades of sumptuous buildings to make them more beautiful . . . the main door, very prestigious, with many ornaments and the trappings of columns in threes). Ibid., 330. The anonymous author defines *puncu* as "puerta." Anonymous, *Vocabulario y phrasis en la lengua general de los indios del Perú, llamada quichua, y en la lengua española*, 5th ed. (Lima, Peru: Universidad Nacional Mayor de San Marcos, Instituto de Historia de la Facultad de Letras, 1951), 72.

2. For example, viewing platforms could be found in the center of the main open spaces in the administrative centers of Huánuco Pampa and Vilcashuaman, and along the side of open space at the way station of Tambo Colorado.

3. For example, single-tiered platforms can be found at Huánuco Pampa and Tambo Colorado, while a multi-tiered structure with carved "seats" at the top is found at Vilcashuaman. Graziano Gasparini and Luise Margolies, *Inca Architecture*, trans. Patricia J. Lyon (Bloomington: Indiana University Press, 1980), 264–80, 343.

4. Juan de Betanzos, *Narrative of the Incas (1551)*, trans. Roland Hamilton and Dana Buchanan (Austin: University of Texas Press, 1996), 169.

5. Ibid., 168.

6. Ibid., 169.

7. This was practiced in other cultures beyond the Americas. See Finbarr Barry Flood, *Objects of Translation: Material Culture and Medieval "Hindu-Muslim" Encounter* (Princeton, NJ: Princeton University Press, 2009); Phillip B. Wagoner, "Sultan among Hindu Kings: Dress, Titles, and the Islamicization of Hindu Culture at Vijayanagara," *Journal of Asian Studies* 55, no. 4 (1996).

8. The Andean region has witnessed one of the longest, most complex, and highest-quality textile traditions in the world. Thus, it is not surprising that textiles have proven to be one of the most important forms of material culture in the Andes and were highly prized by elites. See Rebecca Stone-Miller, ed., *To Weave for the Sun: Ancient Andean Textiles in the Museum of Fine Arts, Boston* (London: Thames and Hudson, 1992).

9. These stones project at least six meters above the Pampa floor (and are set back at least four meters).

10. Pachacuti Yamqui described the *sapa inca* Pachacuti sitting on a viewing platform with Topa Inca, his intended heir, and his other son, Amaru Topa Inca, who had first been named as successor before being replaced by Topa Inca. For a discussion of this event, see Susan Niles, *The Shape of Inca History* (Iowa City, Iowa: University of Iowa Press, 1999), 39–40.

11. While *tiana* is often discussed in contemporary literature as being the seat or throne of the Inca, Frank Salomon has pointed out that *tiana* primarily referred to a dwelling. It is a type of intimate architecture that denotes place. Salomon, *The Huarochirí Manuscript: A Testament of Ancient and Colonial Andean Religion*, trans. from the Quechua by Frank Salomon and George L. Urioste, transcription by George L. Urioste (Austin: University of Texas Press, 1991), 147, fn 846.

Both jaguars and pumas are represented in Inca art. However, it is not always clear which feline is being shown. Usually a determination is made due to the presence of spots, because an adult jaguar has spots while an adult puma has a solid-color coat. However, young puma also have spots, so unless it is clear that an adult animal is being shown, it is sometimes impossible to determine which spotted feline is being portrayed.

12. Felipe Guaman Poma de Ayala is believed to have been descended from people who were resettled by the Inca (*mitimae*), specifically, from Huánuco and moved to Huamanga. Rolena Adorno, "Guaman Poma de Ayala, Felipe (Ca. 1535–50–Ca. 1616)," in *Guide to Documentary Sources for Andean Studies, 1530–1900*, ed. Joanne Pillsbury (Norman: University of Oklahoma Press, 2008), 255.

13. Felipe Guaman Poma de Ayala traveled with Cristóbal de Albornoz (as he sought to identify and punish Andean religious practitioners) and witnessed the dramatic changes wrought by Viceroy Toledo (resettlement of native communities, etc.). It also appears he may have been in Lima when many new acts were promulgated to stamp out indigenous beliefs. For a biography on his life and influences, see ibid., 255–68.

14. Ann Kendall points out that this list does not mean that all these things were on every estate: "This list appears to be intended as the sum of the types of facilities that royal palaces in Cuzco were built to provide. It does not seem likely, however, that all the royal palaces in provincial capitals necessarily incorporated such extensive facilities, except for that of Huayna Capac at Tomebamba." Ann Kendall, *Aspects of Inca Architecture: Description, Function, and Chronology*, BAR International Series (Oxford, UK: BAR, 1985), 1:57.

15. It is likely that the components of estates evolved over time: buildings that were needed in earlier years may not have been so prevalent later or new functions and buildings were later introduced.

16. This can be compared to Stephen Blake's research on Shahjahanabad. He argues that the immense houses of important nobles echoed the palace fortresses of the Mughals (red fort) on a smaller scale. Blake, *Shahjahanabad: The Sovereign City in Mughal India, 1639–1739*, Cambridge South Asian Studies (Cambridge: Cambridge University Press, 1991).

17. This is similar to Shahjahanabad, a Mughal city built in the seventeenth century (which now lies underneath modern Delhi). Shahjahan was an active architectural patron. The city had impressive royal palaces, gardens, mosques, streets, and markets. For our comparison, what is most intriguing is that the city was filled with mansions for nobles and members of the royal court that echoed the palace of the ruler.

18. "Corte y palacio reales y casa del Inga, llamados cuyusmango, quinco uasi, muyo uasi, carpa uasi, suntor uasi, moyo uasi, uauya condo uasi, marca uasi, punona uasi, churacona uasi, aca uasi, masana uasi, camachicona uasi, uaccha uasi; lo propio tenían los señores capac apoconas, apoconas, curacaconas, allicac conas, tenían la casa conforme la calidad y señorío que tenían en este reino, y no salían a más negocio." Felipe Guaman Poma de Ayala, *Nueva corónica y buen gobierno*, ed. Franklin Pease, trans. and prologue by Jan Szeminski, vol. 1 (Lima, Peru: Fondo de Cultura Económica, 1993), 330–32. See also 248.

19. It is interesting that Martin de Murúa titles this building as "of the Inca and the Coya." It is unclear if he means that the ruler and his principal wife shared the same *cuyusmanco* or if each had their own *cuyusmanco*. There is evidence that Inca men and women tended to have their own structures—not just the ruler and his wife but also other Inca elites. For example, the wife of Amaru Topa, the brother of Topa Inca who had once been tapped to succeed their father Pachakuti, had her own house. The importance of Curi Ocllo's status can be seen in the fact that her house became a *huaca* along the *ceque* system; thus her remembrance became a critical aspect of Inca place-making practices. Her house also had a fountain, like Topa Inca's urban palace at Calispuquio. Bernabé Cobo, *Inca Religion and Customs*, trans. Roland Hamilton (Austin: University of Texas Press, 1994), 56.

Murúa describes the *cuyusmanco* as "el Palacio Real, llamado entre ellos Cuiusmanco" (the royal palace, which they call Cuiusmanco). Martin de Murúa, "Historia general del Perú," *Historia* 16 (1987), 346. The *cuyusmanco* he describes is a royal estate with two sectors: "Tenía el Palacio Real, llamado entre ellos Cuusmanco, dos soberias puertas, una a la entrada dél y otra de más adentro. . . . A la primera puerta, en la entrada della, había dos mil indios de guarda con su capitán un día, y después entraba otro con otros dos mil. . . . Más adelante de esta puerta, estaba otra gran plaza o patio para los oficiales del Palacio, y los que tenían oficios ordinaries dentro dél, que estaban allí aguardando lo que se les mandaba, en razón de su oficio. . . . Después entraban las salas y recámaras, y aposentos, donde el Ynga vivía. . . ." Ibid., 346–48.

20. Guaman Poma, in his drawing of an Inca palace, labels his drawing "Palacios reales, Incap uasi Cuyusmanco" (Royal palaces, Inca house Cuyusmanco). Guaman Poma de Ayala, *Nueva corónica y buen gobierno*, vol. 1, 247, fig. 329. The use of *Incap* was often used to indicate something grand because it belonged to

or was of the Inca. Thus *incap uasi cuyusmanco* could mean something like "the Inca's grand house *cuyusmanco*." Jan Szeminski translates *Incap uasi* (*Inqap wazin*) as "casa del Inca." Felipe Guaman Poma de Ayala, *Nueva corónica y buen gobierno*, ed. Franklin Pease, trans. Jan Szeminski (Lima, Peru: Fondo de Cultura Económica, 1993), 3:77. Hence the full translation is "Royal Palaces: The house of the Inca *cuyusmanco*."

The *cuyusmanco* shows up in several of Guaman Poma's drawings. For example, one image shows a *cuyusmanco* that has been converted into a Christian church as being burned by Manco Inca. Guaman Poma de Ayala, *Nueva corónica y buen gobierno*, vol. 1, 305, fig. 400.

21. There are also other references in the colonial texts of Quechua names for palace. For example, Diego Gonzalez Holguin also lists *Capay ccapakpa huacin* (royal, royal house). However, this appears to be an attempt to literally translate (in Quechua) the Spanish phrase "palacio real" (royal house). *Inkap uasi* has also been used and seems to be a Quechua way of describing quite literally the "house of the Inca." Thus, this is similar to saying in English "the royal house of the Inca" or "the ruler's house Inca" rather than saying the "palace."

22. This synecdochic practice may be part of a larger Andean tradition. Thomas Cummins states that "abstraction in Andean pre-Columbian art tends towards a more analytic set of forms that relate to some greater whole and that therefore might have had a synecdochic role." Cummins, "Queros, Aquilas, Uncus, and Chulpas: The Composition of Inka Artistic Expression and Power," in *Variations in the Expression of Inka Power: A Symposium at Dumbarton Oaks, 18 and 19 October 1997*, ed. Richard L. Burger et al. (Washington, DC: Dumbarton Oaks Research Library and Collection; distributed by Harvard University Press, 2007), 301, fn 25.

23. For example, one drawing shows an imagined scene between a Spaniard and the *sapa inca* (Huayna Capac, who died before the Spanish invasion of the Andes). Behind this scene, Guaman Poma has drawn several buildings in a layout similar to his previous depiction of a royal palace. Guaman Poma appears to be representing Huayna Capac at his own palace. The title of the drawing is "Conquista: Guayna Cápac, Cadia" (Conquest, Huayna Capac, Candia). He has written "Inga" over the left figure and "Español" over the right figure of Candia. Underneath he has written "en el Cuzco," suggesting this is where the imagined meeting took place. Guaman Poma de Ayala, *Nueva corónica y buen gobierno*, vol. 1, 280, fig. 369.

As Huayna Capac never met a Spaniard, this annotated drawing is a commentary on the perceived graciousness of Inca royalty and the crude manners and gold obsession of the Spaniards. It does not reflect an actual event but an imagined ideal. Huayna Capac is shown sitting on a *tiana* (royal seat) in front of a *cuyusmanco*, holding a golden plate filled with food in a gesture of offering to the Spaniards. Instead of asking whether the Spaniard wishes the food, Huayna Capac asks the Spaniard if he will eat the gold. The Spaniard, kneeling, reaches for the golden plate in the *sapa inca*'s hand and replies "we eat this gold."

The *sapa inca* says to the Spaniards, "cay coritachu micunqui." Szeminski translates this ("kay quritachu mikunku?") in Spanish as "comerías este oro?" (will you eat this gold?). Guaman Poma de Ayala, *Nueva corónica y buen gobierno*, vol. 3, 204. The Spaniard replies, "este oro comemos" (we eat this gold). Guaman Poma de Ayala, *Nueva corónica y buen gobierno*, vol. 1, 280.

24. González Holguin defines a *cuyusmanco huaci* as "la casa de Cabildo, o del juzgado de tres paredes y una descubierta" (the house of a town councilman, or of the judicial court with three walls and one uncovered). Diego Gonçalez Holguin, *Vocabvlario de la lengva general de todo el Perv llamada lengua qquichua, o del Inca* (Ciudad de los Reyes, Peru: Francisco del Canto, 1608), book 1, leaf D 1 verso. Neither the anonymous author nor Domnigo de Santo Tomás have a listing for a *cuyusmanco*, nor the word *cuyus*. The closest word to *manco* is *manca*, which the anonymous author translates as "olla" (round vase). Anonymous, *Arte y vocabulario en la lengua general del Peru, llamada quichua, y en la lengua española* (Seville, Spain: En casa de Clemente Hidalgo, 1603), leaf Ff 5 verso.

Joan de Santa Cruz Pachacuti discusses the *cuyusmanco* "va a la casa de cuyosmanco y manda que todos los Consejos de justicis, de Guerra y de hacienda acudiesen a la casa de Audiencia y cabildo" (to go to the house of the *cuyusmanco* and order that all of the legal, war, and estate advisors go to the Audience and town hall). Juan de Santa Cruz Pachacuti, *Relación de antigüedades de este reino del Perú*, ed., analytical text, and glossary by Carlos Araníbar (Mexico City: Fondo de Cultura Económica, 1995), 89–91. This is regarding the story of Huayna Capac being declared heir at a young age. The story is most likely an imagined narrative that was created to eliminate any doubt of his right to rule and any memory of his brother Capac Huari having been declared heir by their father. It is unclear in this narrative whether the *cuyusmanco* was where the announcement was made or if this is where both the announcement and meeting were held.

25. Susan Toby Evans, "Antecedents of the Aztec Palace: Palaces and Political Power in Classic and Postclassic Mexico," in *Palaces and Power in the Americas: From Peru to the Northwest Coast*, ed. Jessica Joyce Christie and Patricia Joan Sarro (Austin: University of Texas Press, 2006); "Aztec Palaces and Other Elite Residential Architecture," in *Palaces of the Ancient New World*, ed. Susan Toby Evans and Joanne Pillsbury (Washington, DC: Dumbarton Oaks Research Library and Collection, 2004).

26. The colonial sources are often contradictory regarding where palaces were and who they had belonged to (as well as who took them over during the Spanish occupation). It appears that the town council was later moved to another Inca building (located in Viracocha's palace in Cuzco) on the same plaza, which may have also been a *cuyusmanco*. However, there are also reports that the municipal council met at some point in the Cora Cora, which had belonged to Pachacuti. Whichever building it was, it was a *huaca* on the *ceque* system. Cobo, *Inca Religion and Customs*, 57.

27. Francisco Pizarro moved into Huayna Capac's palace

compound in Cuzco, and he used his house for the first "town meetings."

28. "For the Cuzco Cabildo, I also recall a presentation by Susan Niles for the Institute of Andean Studies at Berkeley, California, January 2010. For a discussion of the changes in colonial Cuzco, see Ian S. Farrington et al., *Cusco: Urbanism and Archaeology in the Inka World*, Ancient Cities of the New World (Gainesville: University Press of Florida, 2013).

29. The *cuyusmanco* depicted by Guaman Poma (illustration 329) is a gabled structure with a thatched roof, and a window set in its gable. Guaman Poma, *Nueva coronica y buen gobierno*, 1993, vol. 1, 247. For a discussion of the *cuyusmanco*, see also Kendall, *Aspects of Inca Architecture*, vol. 1, 61–62.

30. Guaman Poma's drawings, though seemingly simple, are drawn to convey very specific meanings.

31. Cobo is describing the modest cane frames that were propped up with stone in regular homes, not in a fine Inca house. However, this ephemeral covering is likely similar to what the Inca used to close off their doorways, due to weather or privacy concerns. Cobo, *Inca Religion and Customs*, 193.

32. *Hanan* is usually defined as something that is upper or larger, while *hurin* is something lower or smaller. *Hanan* is defined by González Holguin as "cosa alta, o de arriba" (something high or above) and *hanan pata* is "lo alto de la cuesta" (the high point of a hill). Gonzalez Holguin, *Vocabvlario de la lengva . . .* [1608], 148. The anonymous author defines *hanan hanan* as "cosa alta" (something high). Anonymous, *Vocabulario y phrasis*, 41. *Hanan* is a term often coupled with *hurin*. Together, they form a complementary pair that orders parts of the world. This is different from *hatun*, which meant something "significant" but did not imply being part of a pair. Jan Szeminski notes that Guaman Poma uses *hatun* to denote when an Inca administrator holds a higher position than another. Guaman Poma de Ayala, *Nueva corónica y buen gobierno*, vol. 3, 72. Salomon reports that for the Inca, *hatun* was an administrative term used to denote "an able-bodied tribute-paying adult." Salomon, *The Huarochirí Manuscript*, 115, fn 582.

33. Niles suggests that there may have been a second *cuyusmanco*, also overlooking the plaza, next to the first.

34. This fascinating site has only recently been discovered, and thus, little is known about it. There is a colonial reference to Topa Inca having built in this area. However, its architecture appears to be late; perhaps it was for an Inca nobleman during Huayna Capac's reign or even for an estate of Huascar. Regardless of who built it, the site seems to have received highly valued offerings, such as shark teeth and whale bones, and was ritually destroyed, possibly during the Inca civil war or later, to prevent its occupation by the Spanish. For information on the site, see Ian Farrington and Julinho Zapata, "Nuevos cánones de arquitectura Inka: Investigaciones en el sitio de Tambokancha-Tumibama, Jaquijahuana, Cuzco," in *Identidad y transformación en el Tawantinsuyu y en los Andes coloniales. Perspectivas arqueológicas y etnohistóricas, segunda parte*, ed. Peter Kaulicke, Gary Urton, and Ian Farrington, Boletín de Arqueología PUCP (Lima, Peru: Pontífica Universidad Católica del Perú, 2003).

35. The *cuyusmanco* was sited next to a *pata* or *pampa*, but there was variability in their vertical relationship, such that the *cuyusmanco* could be elevated above or be level with the *pata* or *pampa*.

36. There has been much change in front of the *cuyusmanco*. There is evidence that a raised platform (supported by surrounding terraces) once defined the area in front of the *cuyusmanco*'s main opening. While the two side walls are intact today, the northern portion is not. This wall is a post-imperial Inca construction. However, given the steep grade change, a terrace must have run along this side. There is an indication where this terrace was positioned—in the surviving corner of the western terrace wall (to which the northern one would have connected).

37. This movement also occurs inside of the site, which Jean-Pierre Protzen describes as "its poetic and dramatic succession of spaces, which the visitor experiences as he moves through the site." Protzen, *Inca Architecture and Construction at Ollantaytambo* (New York: Oxford University Press, 1993), 73.

38. The *cuyusmanco* may have been both the *hatun uasi* (the principal or significant house) and the *hatun llacta* (principal or significant settlement). González Holguin defines a *hatun* as "lo mayor, o major, o superior mas principal y mas conocido" (the biggest, largest, greatest or superior, or most principal, or most well known." Gonzalez Holguin, *Vocabvlario de la lengva . . .* [1608], 154.

39. *Puncu camayok*. "Portrero." Ibid., 295. A *camayok* was a skilled, ranked specialist, thus the door-guard was a skilled professional for the Inca. The anonymous author also defines *puncu puncucamayoc* as a "portrero." Anonymous, *Vocabulario y phrasis*, 72. Thus a *portrero* in the early colonial period was a special guard assigned to an entrance. Besides a *puncucamayoc*, the Inca also had a *huacicamayoc* (*uasicamayoc*) "el que guarda la casa" (he who guards the house). Ibid., 46.

40. The Ninomaru Palace (inside the Nijo Castle) comprises five concentric buildings. It is decorated in gold leaf with the intent to impress visitors with the power and wealth of the royal patron. It is laid out in such a manner as to use space to define the hierarchy of the visitor. The lowest-status visitors could penetrate only the outermost ring of the buildings, while the most elite of guests could penetrate the inner core. So that those excluded would be painfully aware of their status, the entrance to these core rooms was marked by a prominent and highly visible doorway. Therefore, Edo period visitors were subject to the power of space as expressed in the doorway in the same way that imperial Inca visitors were subject to the potency of the doorway to the *cuyusmanco*.

41. There is a long tradition of seeing Inca architecture as static. Europeans often saw architecture beyond Europe as unchanging. This view can also be seen in the present day. See "In-

troduction" in Marvin Trachtenberg and Isabelle Hyman, *Architecture from Prehistory to Post-Modernism: The Western Tradition* (New York: Abrams, 1986).

42. "Casa de tres paredes y por la otra descubrierta." González Holguin, *Vocabvlario de la lengua,* leaf C 5 verso. However, the openness of the interior seems to also be a key aspect of the *carpa uasi.* In another part of the dictionary, he defines a "corredor de casa" (corridor or hallway of a house) as a "carpa huasi" (449). Gonzalez Holguin, *Vocabvlario de la lengua . . . [1608].*

43. Guaman Poma de Ayala, *Nueva corónica y buen gobierno,* vol. 1, 247, fig. 329.

44. The title of the drawing is "Palacios Reales: Incap uasi Cuyusmanco" (Royal Palaces: Buildings of the Cuyusmanco). In each building is written a name, "churacona uasi, carpa uasi, quenco uasi, suntur uasi." Underneath the drawing is written "casas del Inga" (houses of the Inca) and "corte" (court). Ibid., vol. 1, 247, fig. 329.

45. Susan Niles was one of the first scholars to note this important difference. Niles, *The Shape of Inca History;* Guaman Poma de Ayala, *Nueva corónica y buen gobierno,* vol. 1, 247, fig. 329. Guaman Poma takes pains to distinguish building types in his drawings by their form and by labeling the images with their proper Quechua names. From studies that have been conducted on other aspects of visual Andean culture, the drawings and the descriptions by Guaman Poma correlate with evidence surviving today. Rolena Adorno et al., *Guaman Poma de Ayala: The Colonial Art of an Andean Author* (New York: Americas Society, 1992).

46. See Rolena Adorno, *Guaman Poma: Writing and Resistance in Colonial Peru,* 2nd ed. (Austin: University of Texas Press, 2000), 80–120.

47. For Guaman Poma, space is relational, rather than location specific. This was a long-term Andean artistic practice that reflected the importance of spatial relationships in determining meaning and continued well into the colonial period. Thomas Cummins, "The Uncomfortable Images: Pictures and Words in the *Nueva cronica i buen gobierno,*" in *Guaman Poma de Ayala: the Colonial Art of an Andean Author,* ed. Rolena Adorno et al. (New York: Americas Society, 1992), 45–59; Cummins, "Let Me See! Reading Is for Them: Colonial Andean Images and Objects 'como es costumbre tener los caciques Señores,'" in *Native Traditions in the Postconquest World* ed. Elizabeth Boone and Tom Cummins (Washington, DC: Dumbarton Oaks Research Library and Collection, 1998), 91–148. For a mid-colonial example, see Stella Nair, "Localizing Sacredness, Difference, and Yachacuscamcani in a Colonial Andean Painting," *Art Bulletin* 89, no. 2 (2007).

48. *Carpa* is translated by González Holguin as "toldo, o ramada" (tent or arbor). And *carpahuaci* is translated as "casa de tres paredes y por la otra descubierta, o corredor" (house of three walls and the other one uncovered, or hallway, porch). Gonçalez Holguin, *Vocabvlario de la lengua,* book 1, leaf C 5 verso. Santo Tomás defines *carpa* as "auditorio, lugar para oyr" (auditorium, place to listen) and "tienda de campo" (country store?,

tent?), and *carpaguacin* as "ataraçama." Santo Tomás, *Lexicón o vocabulario de la lengua general del Perú [1560],* facsimile ed. (Lima, Peru: Universidad Nacional Mayor de San Marcos, 1951), 250.

49. Vince Lee argues that Inca buildings were largely determined by their roofs; hence we can think of all Inca buildings as a type of tent architecture. Given the fact that the Inca were often on the road for years on military campaigns, they would have been very familiar with tents (fabric architecture). Vincent R. Lee, *The Lost Half of Inca Architecture* (Wilson, WY: Sixpac Manco Publications, 1988), 21. We have to consider that not only were the equivalent of standard Inca building functions also expressed in tents, but that some of these functions may have *first* been articulated with tents and later made with more permanent materials such as stone. For example, in the early colonial dictionaries there are not only entries for *suntur uasi* and *punona uasi,* but also for a *suntur carpa* and a *punona carpa,* suggesting that these distinctive royal estate buildings of the *sapa inca* had their equivalent in textile architecture. "Suntur carpa, o puñona carpa, pauellon." Gonzalez Holguin, *Vocabvlario de la lengua . . . [1608],* 332.

50. As will be discussed further, roofs were very significant to the Inca. The Spanish colonial regime's decision to not build Inca-style roofs may have come from their inability to control the meaning of the indigenous roof. This knowledge would have been coupled with the fact that the Spanish were also aware of a threat posed by the Inca roof's materials—the Inca burned the city of Cuzco via its thick thatched roofs.

51. Gabled and hipped roofs are two common types found throughout the world. Both have four sides. Gables have two steeply sloping sides and two vertical ones (the latter are the "gable ends"). Hipped roofs have all four sides steeply sloping. The Inca occasionally built with other roof types, such as shed and pavilion, depending on the context.

52. Depending on their slope and span, these roofs were often two to four times—and sometime even more—as tall as their supporting walls.

53. When an Inca building had unusually large eaves, they named it as a distinct type of *carpa.* For example, a *carpamazma* was a "casa có alar gráde" (casa con alar grande [house with large eaves]). Gonçalez Holguin, *Vocabvlario de la lengua,* leaf C 5 verso.

54. For a discussion of Inca roof systems, see Lee, *The Lost Half of Inca Architecture;* and Lee, "Reconstructing the Great Hall at Inkallacta," in 32nd Annual Meeting of the Institute of Andean Studies (Berkeley, CA. January 10–11, 1992).

55. Lee, *The Lost Half of Inca Architecture,* 1–24.

56. There appears to be a long history in the Andes of finely cut and combed thatched roofs. For example, at Tiahuanaco stones were carved to imitate thatch laid in bundles to form a roof. These stone carvings also have an organic example in at least one Tiahuanaco outpost in Omo. Paul Goldstein has found finely combed and bundled thatch that was part of a roof. The

bundled thatch appears to be a version of what was carved in stone at Tiahuanaco. Although we do not know whether the Inca bundled their thatch, it is clear that in the Andes, creating high-quality and visibly striking roofs was practiced before the Incas (Goldstein, personal communication, 2012).

Garcilaso describes the Inca as having roofs that were pyramidal in shape. Garcilaso de la Vega, *Comentarios reales de los Incas*, 2nd ed. (Mexico City: Fondo Cultura Económica, 1995), 1:190–91. Large towering roofs are also seen in Wari pottery. Specifically, pyramid-like roof structures are painted on the Pacheco offering pots. One is held by the Museo Nacional de Arqueología e Historia del Perú. This vessel dates to approximately AD 600–1000 and depicts plants such as potatoes (*ulluco* and *mashua*), maize, and grains (*tarwi* and *quinua*), all of which are used in Andean stews (which may have been served in this vessel). It is unclear what function or meaning the paired pyramidal structures depicted on this vessels may have had. Perhaps they stored the plants shown growing on the vessels, or these were the places in or around which these plants (i.e., meals) were consumed. What is clear is that these structures are depicted as narrow and tall, with one main entrance and two rows of windows below an immense pavilion (pyramidal) roof, similar to those depicted by Guaman Poma as a *suntur uasi*.

57. Kendall, *Aspects of Inca Architecture*, 2:61–62.

58. It is also likely that this material had meaning, though opposite in value, for the Spanish. For the Spanish, building materials were given values, such that durable materials like stone and brick were far more prestigious than ephemeral materials, such as adobe and wood.

59. This was a useful tradition as the thatch aged. María Rostworowski de Diez Canseco, *History of the Inca Realm*, trans. Harry B. Iceland (Cambridge: Cambridge University Press, 1999), 51.

60. "Both his own house and all his other houses looked like *cassa* and *cancho* feather-weaving, for they were thatched with wings of birds." Salomon, *The Huarochirí Manuscript*, 55. This particular roof was of yellow and red feathers. Ibid., 55, fn 97.

61. All of the structures have at least a portion of all four walls surviving. By contrast, a *carpa uasi* would have had only three walls, not four.

62. An example is Huayna Capac's estate in Quispiguanca. However, those buildings may have actually been *cuyusmanco*, rather than *carpa uasi*. The current condition of the buildings prevents a conclusive interpretation. See note 80.

63. This incorrect rendering of an Inca building is not unusual. Sometimes researchers make assumptions about how spaces and structures may have appeared and go well beyond the surviving evidence. Although some scholars clearly state what is imaged versus what exists, the majority of incorrect renderings of Inca buildings are in plans that purport to depict the surviving physical remains. This practice has led to further misunderstandings of Inca architecture, in both appearance and value.

64. Protzen and Max Uhle independently noted this aspect.

65. There are no known examples of this in the architecture built before Topa Inca.

66. It is possible that this trapezoidal floor plan was an experiment. Indeed, in a late Inca estate (discussed earlier) Inca forms such as the stepped cross motif have been used in plan form. Farrington and Zapata, "Nuevos cánones de arquitectura Inka." However, this was a rare example. A more plausible reason for the trapezoidal plan at Huaytará is that this may have been an intentional and standard aspect of the building's design. It has not been noted before because no other *carpa uasi* survives today.

67. "Un aposento muy largo, con una entrada a la culata de este galpón, que desde ella se ve todo lo aque ay dentro, porque es tan grande la entrada quanto dize de una pared a otra, y hasta el techo está todo abierta." Pedro Pizarro, *Relacion del descubrimiento y conquista de los reinos del Peru [1570]* (Lima, Peru: Pontificia Universidad Católica del Perú, 1978), 161.

68. Santo Tomás defines *carpa* as "auditorio, lugar para oyr" (auditorium, place to listen) and "tienda de campo" (country store?, tent?), and *carpaguacin* as "ataraçama." Santo Tomás, *Lexicón o vocabulario de la lengua*, 250. The anonymous author describes *carpa* as "toldo." Anonymous, *Arte y vocabulario en la lengua*, leaf Bb 2 recto. In 1739, the Real Academia Española defined "toldo" as "pabellión, ó cubierta de lienzo, ú otra tela, que se tiende, para hacer sombre an algún parage. Se llama tambien la tienda, en que se vende la sal por menór" (pavilion, or covered with a canvas, or other cloth, that is extended/spread out in order to create shade for some place. This word is also used for a store, where they retail/sell salt to the public). Real Academia Española, *Diccionario de la lengua Castellana, en que se explica el verdadero sentido de las voces, su naturaleza y calidad, con las phrases o modos de hablar, los proverbios o refranes, y otras cosas convenientes al uso de la lengua [1739]* (Madrid, Spain: Imprenta de Francisco del Hierro, 1990), 6:290. Therefore, *carpa* referred to an awning, canopy, tent, or a store that sells basic food supplies.

Jan Szeminski notes in a reference to a modern dictionary that *carpa uasi* may allude to religious activities. In the discussion of the *carpa uasi*, Szeminski states that it was "posiblemente destinadas a actividades religiosas, compárece *karap*—instruir a los adeptos e iniciados en el espiritismo, darles lecciones y enseñanzas" (possibly destined for religious activities, compare to *karpa*—to instruct those adept and initiated in spiritualism, to give them lessons and instructions). Guaman Poma de Ayala, *Nueva corónica y buen gobierno*, vol. 3, 39. Szeminski cites his information as from Jorge Lira, *Diccionario kkechuwa-español*, 2nd ed., no. 5 (Bogota, Columbia: Cuadernos Culturales Andinos, 1982), 101.

As the Inca did not have stores to sell goods, such as the country store mentioned in the colonial definitions, this reference likely alludes to the building's use in the colonial period. Its large, open interior would have served well as a market, especially during the rainy season.

69. As we saw with Diego González Holguin, some colonial-period definitions may be referring to the post-1532 period. In this definition by Santo Tomás, he gives two definitions for a form he describes as similar to what both González Holguin and Guaman Poma describe—that it is a covered house or pavilion, one that is defined by its covering. However, he also lists two other functions. One was an auditorium, the other a place to sell. While the former is very possible for the imperial Inca times, and with its performative aspects, particularly well-suited to a royal estate, the second use likely refers to a post-contact transformation. The Inca before the arrival of Europeans did not have a market economy, and hence there was no need for a structure in which to sell things. This would have been particularly unlikely for a royal estate. This last definition likely reflects the fact that, as we saw with the *cuyusmanco*, a structure built for a specific purpose during the imperial Inca period found a new use in the dramatically transformed world marked by the Spanish invasion. Garcilaso describes such a change in building use in Cuzco. He describes one of the large, single-room structures (i.e., a possible *cuyusmanco* or *carpa uasi*) as being turned into a row of shops, such that dividing walls have been inserted to break up the large interior space. Garcilaso de la Vega, *Royal Commentaries of the Incas*, 1989, 426.

70. Guaman Poma de Ayala, *Nueva corónica y buen gobierno*, vol. 1, 280, fig. 369.

71. Santo Tomás defines *osno, o cocongapac* as "altar, donde sacrifica" (altar, where they sacrifice). Santo Tomás, *Lexicón o vocabulario de la lengua*, 332. González Holguin defines *vsnu* as "Tribunal de juez de vna piedra hincada. Mojon quando es de piedra grande hincada" ([The place for the] court of law made of a stone drove [sic] into the ground. A boundary that is made of a large stone drove [sic] into the ground) (translation by Gabriela Venegas). González Holguin, *Vocabvlario de la lengua . . . [1608]*, 359. Thus, for the colonial dictionaries, the *usnu* is a raised location, most likely a stone, on which an offering is made and/or legal decisions are rendered.

For a discussion of possible *usnu* functions, see Gasparini and Margolies, *Inca Architecture*, 267–80. Guaman Poma defines *usnu* as "trono y asiento del Inga llamado Usno, en el Cuzco" (throne and seat of the Inca called Usno, in Cuzco). Guaman Poma de Ayala, *Nueva corónica y buen gobierno*, vol. 1, 303, fig. 398.

72. For example, Thomas Cummins, "Let Me See! Reading Is for Them: Colonial Andean Images and Objects: 'como es costumbre' tener los caciques Señores," in *Native Traditions in the Postconquest World* (Washington, DC: Dumbarton Oaks, 1988), 91–148.

73. Viewing platforms played a critical role in the Inca built environment and were crucial to imperial Inca ceremonies. Yet viewing platforms have often been overlooked in the study of the Inca built environment. This is because much of the focus has been on determining which of these were *usnu*.

74. John Rowe conducted one of the first chronological studies on the *usnu*. He found that the term *usnu* originally referred to a sacred stone that was laid on top of a platform and was the center of important ceremonies led by the *sapa inca*. He argued that later, the name *usnu* came to define the entire platform on which these stones were laid. Rowe, "Una relacion de los adoratorios del antiguo Cuzco," *Historica* no. 2 (December 1981): 209–61. Alternatively, some scholars have suggested that it was not the stone that was the original, defining element of the *usnu*, but instead, a hole through which the sacred fluids could flow when rituals were being performed.

Because of the importance of the *usnu* and our present confusion over its physical definition, there has been a tendency to declare any platform or even an unusual stone outcrop as a possible *usnu*. While debate and research are still elucidating what we know about the *usnu*, it is clear that the *usnu* was used for selective rituals. By contrast, generic viewing platforms were ubiquitous in imperial Inca settings and were built in places where the *sapa inca* might appear for a state visit. These architectural elements were vital stages for displaying the power of the *sapa inca* in action or repose.

75. These buildings are sometimes referred to in contemporary literature as *wayronas huaironas* or *masma*. Farrington, *Cusco*, 22. For example, "Luis Valcárcel calls this type of house *masma* which means corridor, gallery, or enclosure open on one of its sides. Although the large opening on one side suggests a connection between this house and warmer zones, similar structures also exist in very cold places like Qollpa, at an altitude of 3,800 meters. Possibly, the *masma*-type structure had other functions such as providing daytime workspace." Gasparini and Margolies, *Inca Architecture*, 169.

However, architectural definitions such as this are modern ones. There is no evidence the Inca used either of these terms to define the three-sided structure found at Inca sites, or in fact, any other Inca structure. In the early colonial period, *mazma* did not mean a building nor did it mean a corridor, gallery, or enclosure with one open side. Rather, it meant eaves. González Holguin defines *mazma* as "alar de la casa" (eave of a house). Gonzalez Holguin, *Vocabvlario de la lengua . . . [1608]*, 398. There is no reference to *wayrona*, but there is a *huayra*, which meant "viento or ayre" (wind or air), ibid., 194, and a *huayrancalla huaci*, which meant "cueua como casa grande" (cave like a large house), ibid., 195. Note that neither term defines a modest-sized imperial Inca building with three walls.

76. Jean-Pierre Protzen, "Inca Architecture," in *The Inca World: The Development of Pre-Columbian Peru, A.D. 1000–1534*, ed. Cecilia Bákula, Laura Laurencich Minelli, and Mireille Vautier (Norman: University of Oklahoma Press, 2000). Protzen defines three basic building types based on the rectangular single room; each is defined by the opening and then is further defined by its roof. Type A is an enclosed structure with one or many regular-sized doorways. Type B is a three-walled structure, with one face completely open. Type C is almost completely open on one face, but it has jambs at either end for a large doorway. Protzen notes that types B and C can be augmented by piers if the open walls are

too large for the end walls to support the roof structure. Prot-zen, *Inca Architecture*, 202. If we take into account that the colo-nial written descriptions never mention that the opening has to be on a gable end of a building, then Protzen's Type B is compatible with the *carpa uasi* and Type C with the *cuyusmanco*.

77. During rituals and special receptions, the *sapa inca* has a special seat called a *tiana*. Thus the *tiana* functioned as a sort of modest throne that served to mark the ruler's elevated status in terms of vertical space.

78. It is clear from construction seams that this building originally had five windows, but at a later date the two outer ones were sealed. The story of the Ayar brothers emerging from a hill with three "windows" at Pacaritambo is retold by Pedro Sarmiento de Gamboa, *History of the Incas*, trans. Clements R. Markham (Mineola, NY: Dover Publications, 1999), 43–47.

79. The relationship between these two versions of an open-face structure may have a structural component. At Machu Picchu, a long wall in a building was removed only in small to modest-sized structures such that the open spans did not compromise the ability to carry the roof loads. By contrast, the structures that Guaman Poma depicts and the building at Huaytará are large buildings with their short façade removed. At most, a single tie-beam holds the roof structures together. This shift in location for the opening was most likely the result of the limitations of the span that could be opened. As the buildings became larger, the long façade was too wide for an open expanse to successfully support roof loads; the only wall that could be completely removed was the short, gabled end. However, by opening up the entire wall (including the gable) of the short side, the Inca still made the roof structure vulnerable to collapse, which probably explains why these structures are found only rarely in the surviving architectural record.

80. This would have been the case for the possible *carpa uasi* at Huayna Capac's estate. According to Niles, "Indeed, if the buildings at Quispiguanca had roofs pitched at 60 degrees with thatching 1 meter thick, the maximum width of the structure would have been just under 17 meters (Blechshmidt 1997). The roof support structure would have imposed a great of thrust on the long walls of the buildings, causing them, potentially, to push outward. In most buildings, the end walls would help to tie the building together. In an open ended building, however, there would be nothing to counteract the tendency of the walls to push outward at their ends, making the end of the side wall closest to the wide doorway particularly subject to failure." Niles, *The Shape of Inca History*, 280.

81. While political issues may have contributed to the building's evolution during the Inca Empire, it is also possible that conquest or cultural contact may have played a role as well. Pachacuti and Topa Inca conquered many new regions. When the Inca found local practices that interested them, they incorporated them into the Inca world. This type of construction is not unusual in other parts of the Andes, particularly in the area that the Inca called Antisuyu. Located on the eastern slopes

of the Andes where it is warm (and shade is needed as well as breezes), thatched houses with open walls were (and are) typical. During the colonial period, Bernabé Cobo wrote about such a house in the eastern Andes with an impressive roof but open on all sides.

Cobo writes, "The *yunca* Indians who inhabit the provinces east of the Andes make their houses large, airy, and of wood. This is due to the extremely hot climate and the abundance of trees. They do not put up walls; instead they use posts or wooden columns which are set in the ground. On the posts they construct the roof, which they cover with tree leaves carefully placed for protection from the rain and the wind, or they cover them with the tops of giant bamboo plants or palm trees. The ridges of the roofs are very well made. According to its size and spaciousness, more or less ten or twelve persons live in each one of these houses. This is a one room house or *galpón*; it is very long and open on the sides, with nothing more for walls, than the posts mentioned above. Usually all of the members of one lineage and family live in each house." Cobo, *Inca Religion and Customs*, 190.

82. Here we see how the Inca way of incorporating local style in clothing when they were visiting a town parallels the incorporation of local architectural styles as a way of ruling over populations. For a south Asian comparison, see Thomas R. Metcalf's discussion of Indo-Saracenic architectural style. Metcalf, *An Imperial Vision: Indian Architecture and Britain's Raj* (Berkeley: University of California Press, 1989).

83. George Simmel, "Bridge and Door," in *Rethinking Architecture: A Reader in Cultural Theory*, ed. Neil Leach (New York: Routledge, 1997), 68.

84. According to Simmel, the door "transcends the separation between the inner and outer." Ibid., 67.

85. Regina Harrison, *Signs, Songs, and Memory in the Andes: Translating Quechua Language and Culture* (Austin: University of Texas Press, 1989), 78–79.

86. Zoila Mendoza, "Exploring the Andean Sensory Model: Knowledge, Memory, and the Experience of Pilgrimage," in *Approaches to Ritual: Cognition, Performance, and the Senses*, ed. Michael Bull and Jonathan Mitchell (New York: Bloomsbury Publishing, 2014).

87. Simmel, "Bridge and Door," 67.

Chapter 5

1. "Huaci. Casa" (building). "Hatun huaci. Casa grande sala" (grand room building). "Huchhuylla huaci. La casa chica" (little building). Diego Gonzalez Holguin, *Vocabulario de la lengua general de todo el Peru llamada lengua qquichua o del Inca* [1608], prologue by Raúl Porras Barrenechea, edición facsimilar de la versión de 1952 ed. (Lima, Peru: Universidad Nacional Mayor de San Marco, Editorial de la Universidad, 1989), 169. A *uasi* is a building. A *uasi*

could be any type of building, as *casa* was in Spanish in the early modern period.

The Real Academia Española of 1729 defines "casa" as "edificio hecho para habitar en él, y estar defendidos de las inclemencias del tiempo, que consta de paredes, techos y tejados, y tiene sus divisions, salas y apartamientos para la comodidad de los moradóres. Es la misma voz Latina *Casa*, que aunque significa la Choza o Casa pajiza, se ha extendido a qualquier género de casas" (buildings made to be inhabited and as a defense against the weather, with walls, ceilings, and roofs, and having divisions, rooms and secluded spots for the convenience of the residents. It derives from the Latin *Casa*, which signifies a thatched hut or house and has come to mean any type of house). Real Academia Española, *Diccionario de la lengua Castellana, en que se explica el verdadero sentido de las voces, su naturaleza y calidad, con las phrases o modos de hablar, los proverbios o refranes, y otras cosas convenientes al uso de la lengua [1729]* (Madrid, Spain: Imprenta de Francisco del Hierro, 1990), 2:205.

2. In a less direct manner, CP5 could also serve those who gathered in the large *cuyusmanco*. This is because anyone moving between the *cuyusmanco* and the Pampa had to pass by the entrance to CP5. Thus, this meeting space may have also served as an ancillary space for those highly exclusive meetings held at his *cuyusmanco*. In summary, CP5 had two entrances that served three distinct spaces (viewing platform, *cuyusmanco*, and Pampa).

3. The insertion of dividers into rectangular buildings was not common, but also was not unknown in Inca architecture. The division of spaces within the larger rectangular structure appears to have been done by the Inca for very specific purposes, such as spatial practices.

4. For a discussion of the excavation of this building, see José Alcina Franch, *Arqueología de Chinchero 1: La arquitectura* (Madrid, Spain: Ministerio de Asunto Exteriores, 1976), 55–63.

5. Terrace walls, when built properly, are more stable than freestanding walls. Because of this, the long southern wall is the best-preserved elevation in the building.

6. George Simmel, "Bridge and Door," in *Rethinking Architecture: A Reader in Cultural Theory*, ed. Neil Leach (New York: Routledge, 1997), 68.

7. Domingo de Santo Tomás defines *camachicona, o camachicuy* as "razonamiento" (reasoning). This may come from the root word *camay,* and its noun *camayoc,* which he defines as "oficial generalmente" (generally official). *Camachicuni.gui* is defined as "mandar alguna cosa" (to mandate something) and "predicar, devulgar" (to preach, disseminate) and "orar como orador, o predicador" (to orate like an orator, or preacher). Domingo de Santo Tomás, *Lexicón o vocabulario de la lengua general del Perú [1560]*, facsimile ed. (Lima, Peru: Universidad Nacional Mayor de San Marcos, 1951), 245. The anonymous author defines *camachini, camachicuni* as "mandar, ordenar" (to mandate or order) and *camachic, camachicuc* as "gouernador, o regidor" (governor or councilman). Anonymous, *Arte y vocabulario en la lengua general del Peru, llamada quichua, y en la lengua española* (Seville, Spain: En

casa de Clemente Hidalgo, 1603), leaf Aa 8 verso. The Real Academia Española in 1737 defines "regidor" as "el que rige ó gobierna" (he who rules or governs) and "la persona destinada en las Ciudades, villas ó lugares para el gobierno económico" (the person destined in cities, villages, or places for the economic government). *Diccionario de la lengua Castellana, en que se explica el verdadero sentido de las voces, su naturaleza y calidad, con las phrases o modos de hablar, los proverbios o refranes, y otras cosas convenientes al uso de la lengua [1737]* (Madrid, Spain: Imprenta de Francisco del Hierro, 1990), 5:544. González Holguin defines *camachic camachicuc* as "governador, o corregidor, o mandon, o el que manda, o el que rige" (governor, or magistrate, or foreman, or he who mandates, or he who rules). *Camachinacuni* is defined as "consultar tratar en cabildo, concertar, o ventilar algo muchos entre si" (to try to consult in the chapterhouse, or to arrange, or air something a lot between them). Gonzalez Holguin, *Vocabvlario de la lengua . . . [1608]*, 47. *Camachinaccuni* is defined as "consultar hazer cabildo, o acuerdo" (to consult in the town council, or agreement). Ibid., 48. All three colonial sources define the *camachi* as an official who orates and mandates.

8. Bernabé Cobo notes that most highland houses, Inca included, did not have many furnishings and that most of the objects in their rooms were large ceramic vessels. Cobo, *Inca Religion and Customs*, trans. Roland Hamilton (Austin: University of Texas Press, 1994), 194–97.

9. The absence of these objects could have contributed to the misunderstanding concerning the interpretation of Inca buildings. This would have been particularly difficult for viewers from Europe, where a building's form (e.g., a cross-plan Christian church) often provided critical clues as to the building's prior functions, whether it was filled with or devoid of objects. By contrast, almost all Inca buildings had rectangular footprints.

10. This is true for many historical Japanese buildings as well. Although certain functions were held only in certain spaces, a given space could house many functions over the course of a day or year.

11. These regularly spaced burn "piles" suggest the collapse of intricately tied truss units. Vincent Lee has argued that it is possible that Inca roofs did not have tie beams, but instead a series of connecting vertical members. However, the burn marks on this structure seem more indicative of a standard tie beam with adjacent vertical members that collapsed as a unit to the floor below. Lee, *The Lost Half of Inca Architecture* (Wilson, WY: Sixpac Manco Publications, 1988).

12. Denise Arnold, "The House of Earth-Bricks and Inka-Stones: Gender, Memory, and Cosmos in Qaqachaka," *Journal of Latin American Lore* 17 (1991); Peter Gose, "House Rethatching in an Andean Annual Cycle: Practice, Meaning, and Contradiction," *American Ethnologist* 18, no. 1 (1991).

13. It is also possible that these ritual renewals occurred in other parts of the architectural infrastructure at royal estates. For example, the extensive canals that define most of these sites would have to be regularly cleaned. Frank Salomon notes that

in modern times, these canal cleanings constitute an important community ritual. Salomon, *The Huarochirí Manuscript: A Testament of Ancient and Colonial Andean Religion*, trans. from the Quechua by Frank Salomon and George L. Urioste, transcription by George L. Urioste (Austin: University of Texas Press, 1991), 64, fn 161.

14. Even today, some indigenous communities in the Andes understand their roof as being analogous to a mountain. Arnold, "The House of Earth-Bricks and Inka-Stones," 22.

15. Salomon notes that for the Inca, *quishuar* was venerated by the Inca and had a *cancha* named for it in Cuzco. Salomon, *The Huarochirí Manuscript*, 64, fn 165.

16. According to a local resident, in the last century a powerful landowner decided to build a road so he could drive his car onto the large Capillapampa. In his attempt, he tore down many of CP3's walls, effacing much of the western side of the building. Fortunately, since the western and northern walls are part of the lower terraces, the landowner was not able to completely erase the building. Enough of the building's walls have been preserved to reconstruct its original configuration as a large rectangular structure. Three complete doorways have survived in the long south wall. There were more doorways in this section, and stones have been added recently to give this impression. Inca architecture was largely proportional and often elements were symmetrical. All the surviving great halls at Chinchero have symmetrical openings on their long walls, and physical evidence of more doorways along the south wall of this building supports this hypothesis.

17. Salomon notes that in many parts of the Huarochiri Manuscript, people are seated according to status. He also notes that this practice continues in many parts of the Andes today. Salomon, *The Huarochirí Manuscript*, 58, fn 121.

18. This is relevant for other types of architecture, not just Andean. For instance, many Europeans in the nineteenth century believed that only masonry architecture could be true architecture.

19. "Galpón quiere dezir un aposento muy largo, con una entrada a la culata de este galpón, que donde ella se ve todo lo que ay dentro, porque es tan grande la entrada quanto dize de una pared a otra, y hasta el techo está toda abierta. Estos galpones tenían estos yndios para hazer sus borracheras. Tenían otros cerradas las culatas y hechas muchas puertas en medio, todas a una parte. Estos galpones eran muy grandes, sin auer en ellos atajo ninguno, sino rrasos y claros." Pedro Pizarro, *Relación del descubrimiento y conquista del Perú [1570]* (Lima, Peru: Pontificia Universidad Católica del Perú, 1978), 160.

20. "With respect to their design and form, they were large houses of *galpones* with only one room, one hundred to three hundred feet long and at least thirty to a maximum of fifty feet wide, all cleared and unadorned without being divided into chambers or apartments, and with two or three doors, all on one side at equal intervals." Bernabé Cobo, *History of the Inca Empire: An Account of the Indians' Customs and Their Origin Together with a Treatise on Inca Legends, History, and Social Institutions*, trans. Roland Hamilton (Austin: University of Texas Press, 1991), 228–29.

21. Cobo, *Inca Religion and Customs*, 191.

22. Translation from Ann Kendall, *Aspects of Inca Architecture: Description, Function and Chronology* (Oxford, UK: BAR International Series, 1984), 61. The original Spanish text is "En muchas casas de las del Inca había galpones muy grandes, de a 200 pasos de largo y de 50 y 60 de ancho, todo de una pieza, que servían de plaza, en los cuales hacían sus fiestas y bailes cuando el tiempo con aguas no les permitía estar en la plaza al descubierto. En la ciudad del Cozco alcancé a ver cuatro galpones de estos que aún estaban en pie en mi niñez. Uno estaba en Amarucancha, casas que fueron de Hernando Pizarro donde hoy es el colegio de la Santa Compañía de Jesús y otro estaba en Casana, donde ahora están las tiendas de mi condiscípulo Juan de Cellorico. Y otro estaba en Collcampata, en las casas que fueron del Inca Paullu y de su hijo don Carlo, que también fue mi condiscípulo. Este galpón era el menor de todos cuatro y el mayor era el de Casana, que era capaz de tres mil personas. (Cosa increíble que hubiese madera que alcanzase a cubrir tan grandes piezas!). El cuarto galpón es el que ahora sirve de iglesia catedral." Inca Garcilaso de la Vega, *Comentarios reales de los Incas*, 2nd ed. (Mexico City: Fondo de Cultura Económica, 1995), 1:335.

23. According to González Holguin, a hereditary Inca princess ("Princesa heredera") was called "Ñusta incap koyap vssusin huahuan." Gonzalez Holguin, *Vocabulario de la lengua . . .* [1608], 642. In the anonymous dictionary, *ñusta* is defined as "princesa, o señora de sangre illustre" (princess or lady with illustrious blood). Anonymous, *Vocabulario y phrasis en la lengua general de los indios del Perú, llamada quichua, y en la lengua española*, 5th ed. (Lima, Peru: Universidad Nacional Mayor de San Marcos, Instituto de Historia de la Facultad de Letras, 1951), 65. *Huahua* is the Quechua term used to denote the child of a female. Salomon, *The Huarochirí Manuscript*, 122, fn 647.

24. Garcilaso de la Vega, *Comentarios reales de los Incas*, 1:335.

25. It is interesting to note that in English architecture, the term "hall" was also used to denote a primary living space. As Dell Upton states, "At what English vernacular builders would have called the 'upper' end, a large, usually square room called the *hall* was the primary living or social space. It contained the main entry and might also function as a kitchen in a particularly small house." However, the hall was part of a multi-room structure and not normally a single house. Dell Upton, *Architecture in the United States* (Oxford: Oxford University Press, 1998, 23). "A medieval lord would have entertained any and all comers in a single large room called a 'hall.'" Ibid., 30.

26. As discussed in Chapter 1, archaeologists Craig Morris and Donald Thompson popularized this term for scholars when they used the term *kallanka* to describe large Inca buildings in their book. Morris and Thompson, *Huánuco Pampa, an Inca City and Its Hinterland, New Aspects of Antiquity* (London: Thames and Hudson, 1985). *Kallanka* was a contemporary term used by the local residents. In the ensuing decades, many scholars have

used this term to describe *any* large Inca building. This has been motivated by a desire to designate Andean structures by their original Inca names. While *callanka* is a Quechua word that was used during the imperial Inca period, it did not describe a large or "great" hall. González Holguin defines *callancarumi* as "piedras grandes labradas, de silleria para cimientos y vmbrales" (large worked stone, ashlar building stone used for foundations and lintels) and *callancahuaci* as a "casa fundada sobre ellas" (a house built on top of these). Gonzalez Holguin, *Vocabvlario de la lengua . . . [1608]*, 44. Therefore, a *callanka* (*kallanka*) was any building that was built on a foundation and lintels made from sizable ashlar stones (not polygonal). Many of Topa Inca's buildings could fall in this category, large Inca buildings among them, but the term does not describe a "great hall" as a form.

27. Joan Corominas defines *galpon* as "cobertizo, barracón de construcción ligera, por lo general sin paredes', sudamer., probablemente del náhuatle *kalpúlli* casa o sala grande" (a shed, or light construction shack usually without walls, South American, probably from the Nahuatl, Kalpulli house or large room). He cites a reference to the term as early as 1550 from Fernández de Oviedo, to show its early use in Mesoamerica. Joan Corominas, *Breve diccionario etimológico de la lengua Castellana*, Biblioteca Románica Hispánica 5 Diccionarios (Madrid, Spain: Editorial Gredos, 1961), 2:638.

28. Corominas discusses the evidence for and against the term as derived from the Aztec *kalpulli*. What is interesting is that the sources he uses are all Spanish or non-Nahuatl speakers. The Nahuatl dictionaries (for Aztec) do not use the term. However, it is clear that Spaniards used it from an early time and used it to refer to architecture. Ibid., 2:638–39.

29. He defines the term as "reunión, conciliábulo, aqui en el de montículo que señala los antiguos pueblos aborigenes." Ibid., 2:639. This can be translated as "meeting, council, here on the mound which marks the ancient aboriginal peoples."

30. Lyle Campbell (personal communication 2011). By contrast, a Quechua practice was to refer to former homes as *ñaupa huasipi*. This means "at the old house." Salomon notes that "*ñaupa* is more strictly 'former.' The phrase may refer to dwellings from before the forced resettlement (c. 1580 onward in this area) or to preshispanic buildings." Salomon, *The Huarochirí Manuscript*, 150, fn 871.

31. Thomas Cummins, "Let Me See! Reading Is for Them: Colonial Andean Images and Objects 'Como es costumbre tener los caciques Señores,'" in *Native Traditions in the Postconquest World*, ed. Elizabeth Hill Boone and Tom Cummins (Washington, DC: Dumbarton Oaks Research Library and Collection, 1998), 109.

32. Protzen has noted that reversible double-jamb doors are usually associated with entering special *exterior* spaces—not the *interiors* of buildings (personal communications). Regular double-jamb (i.e., on one side only) are found more often. The double-jamb side faces the exterior; therefore the person moving from the larger, general space into a smaller, more defined space was signaled of the change in movement by the double-jamb entranceway. By contrast, the single jamb faced the inside of the building. Thus a double jamb being built on both sides of a doorway to the building at Chinchero was highly unusual. There have been only a handful of similar examples found throughout the vast Inca empire.

33. At Ollantaytambo, Protzen noted a loose building block, which may once have been part of a reversible-double-jamb entrance. Jean-Pierre Protzen, *Inca Architecture and Construction at Ollantaytambo* (New York: Oxford University Press, 1993), 222. The reversible double jamb appears to have been a special architectural device, most likely to denote a specific space, meaning of a space, or relationship between spaces.

34. For Tambo Colorado, see Max Uhle, Wolfgang W. Wurster, and Verena Liebscher, *Pläne Archäologischer Stätten Im Andengebiet, Materilien zur allgemeinen und vergleichenden Archäologie* (Mainz, Germany: P. von Zabern, 1999), 158–59. For Ollantaytambo, see Protzen, *Inca Architecture and Construction*, 43. There are two side-by-side gateways for Ollantaytambo, and each is reversible double jambed.

35. All of the walls and niches were constructed at the same time (there are no construction seams). There is one exception: the threshold for the northwestern niche. The bottom step was inserted after the construction of the niche. By contrast, the twin niche on the north side has an eastern edge, which is clearly embedded in the surrounding wall.

36. All of the thresholds in CP4 are at a similar level with one exception, the middle southern niche, which is much lower. In the other buildings, the double-jamb details on the large windows were only visible on the exterior of the building, from the Pampa.

37. It has a double jamb on the exterior, facing the Pampa.

38. As depicted in the building's plan and shown in the photograph of the opening, there is a thin stone lip projecting from the bottom of the jambs in the secret doorway. This appears to have marked the original level of the floor in this area.

39. The hallway is narrow. While this was a separate space, it may have been covered by CP4's roof eaves, making the hallway even less visible. There is a drain in front of the niches, yet it appears to stop suddenly. This may have been part of the water removal system at the site, or it may have been used to drain liquids stored in the niches.

40. José Alcina Franch, *Arqueologia de Chinchero: La arquetectura* (Madrid: Spain: Ministerio de Asunto Exteriores, 1976): 65–75.

41. As discussed previously, Inca roofs were impressive and even celebrated in constructions such as the *suntur uasi*. The two "towers" at the end of the Casana had a particularly thick roof with very large eaves that took over a week to burn. Pedro Pizarro states: "Estas casas tenían [Esta Caxana tenía] dos cubos, uno a un lado [añadido: de la puerta] y otro a otro; quiero decir casi a las esquinas desta quadra. Estos cubos heran de cantería muy labrada, y muy fuertes; heran rredondos, cubiertos de paxa muy extrañamente puesta: salía el alar de la paxa fuera de la pared una braça, que quando llouía se fauoresçían

los de a cauallo que rrondauan al amparo de este alar. Estas casas y aposentos heran de Guaina Capa [Huayna Capac]. Quemaron estos cubos los yndios de guerra quando pusieron / el çerco, con flechas y [O] piedras ardiendo. Hera tanta la paxa que tenían, que tardaron en quemarse algunos días [ocho días o más], digo antes que cayese la madera. Hauían hecho estos cubos terrados [cerrados] echándoles gruesos maderos arriua, y tierra ençima, como çuteas [azoteas]." Pizarro, *Relación del descubrimiento*, 161–62. (This Caxana had two turrets, one on one side of the door and the other upon the other side; I mean almost at the corners of this room. These turrets were of well-made masonry, and very strong; they were round, covered with straw very oddly placed: the straw eaves stood out beyond the wall a fathom length, so that the shelter of this eave favored the horsemen around the turret when it rained. These houses and lodgings belonged to Huayna Capac. The Indians burned these turrets when they shut them, with burning arrows or stones. So thick was the thatch that it took eight days or more for it to be entirely burned, or, I should say, before the wooden framework fell. They had shut these turrets by putting thick wood beams on top, and soil above, like rooftop terraces.) Translated by Gabriela Venegas. See also Pedro Pizarro, *Relation of the Discovery and Conquest of the Kingdoms of Peru*, trans. Philip Ainsworth Means (Boston: Longwood Press, 1977), 355–56.

42. *Suntu* is defined as "monton, *suntu çapa* lleno de montones" (pile; *suntu çapa*, full of things without order). *Suntu suntu* is defined as "montones juntos" (joined or adjoining pile of things) and *suntur huaci* is "casa redonda" (round house). *Suntur paucar* is defined as "casa galana y pintada" (a pretty and painted house). *Suntur carpa o puñuna carpa* is "pavellon" (pavilion). Diego Gonçalez Holguin, *Vocabvlario de la lengva general de todo el Perv llamada lengua qquichua, o del Inca* (Ciudad de los Reyes, Peru: Francisco del Canto, 1608), book 1, leaf X 6 verso. *Paucar* is a word used to define colors. For example, *pauccarccuna* is "diversidad de colores de plumas o de flores o deplumajes" (diversity of colors of feathers or flowers or plumage) and *pauccar ricchak* is "colores todos en comun de plumajes" (all the colors common to plumage). *Paucar puca* is "el fino colorado" (excellent or pure red or colored) and *paucar quillo* is "fino amarillo" (excellent or pure yellow). Ibid., book 1, leaf S 4 recto.

According to the anonymous author, *suntu* is a "monton" (a pile of things). Anonymous. *Arte y vocabulario en la lengua*, leaf Ii 4 verso. *Suntuni* is "amontonar" (to pile up) and *suntufca* "amontonado" (been piled up). *Suntur huaci* is translated as "cafa hecha a manera de piramide" (a house made in the manner of a pyramid). Ibid., leaf Ii 5 recto. *Suntur paucar* is translated as "pauellion de cama, o quitafol" (sleeping pavilion or sunshade). Ibid., leaf Ii 5 recto.

Jan Szeminski writes that one of the definitions of a *suntur uasi* is "casa que tiene techo cuadrado sin mojinete" (house that has a four-sided roof without a ridge). Felipe Guaman Poma de Ayala, *Nueva corónica y buen gobierno*, ed. Franklin Pease, trans. Jan Szeminski, vol. 3 (Lima, Peru: Fondo de Cultura Económica,

1993), 121. The information cited is from Ludovico Bertonio, *Vocabulario de la lengua Aymara*, Serie Documentos Históricos (Cochabamba, Bolivia: Centro de Estudios de la Realidad Económica y Social, 1984), 2:328. On this page, Bertonio actually writes "Sunturu vta. Casa que tiene el techo quadrado sin moxinete." This information describes a roof made up of four distinct sides, but whose ridges were concealed. This would have given the roof a dome-like appearance (despite the fact that its structural system was not that of a dome).

43. E. George Squier, *Peru: Incidents of Travel and Exploration in the Land of the Incas* (Cambridge, MA: AMS Press for the Peabody Museum of Archaeology and Ethnology, Harvard University, 1973), 393.

44. Ibid., 393–394.

45. Ibid., 394.

46. According to the anonymous author, *suntur huaci* is translated as "cafa hecha a manera de piramide" (a house made in the manner of a pyramid). Anonymous, *Arte y vocabulario en la lengua*, leaf Ii 5 recto.

47. For a discussion on the *suntur uasi* and pyramidal roofs, see Graziano Gasparini and Luise Margolies, *Inca Architecture*, trans. Patricia J. Lyon (Bloomington: Indiana University Press, 1980), 310–20.

48. Squier, *Peru*, 394.

49. Ibid., 394–395.

50. Ibid., 395.

51. Guaman Poma's drawings give us two other clues. One is that the roof has a rounded top, thus indicating it was not gable ended (giving more credence to its being round), and that it had eaves (unlike the storehouse roofs, which are round and have no eaves).

52. Two-story buildings existed in imperial Inca architecture but were rare. Protzen has suggested that the apparent second story in Guaman Poma's drawing may actually be windows near the gable end of a *one-story* building—a more common occurrence in Inca architecture (Protzen, personal communication, 2007).

53. El Inca Garcilaso de la Vega, *Royal Commentaries of the Incas and General History of Peru*, trans. Harold V. Livermore (Austin: University of Texas Press, 1966), 2:321.

54. The description of the tall tower-like appearance and pyramidal roof also indicates that this building was the type of *suntur uasi* described by the anonymous author.

55. Cobo, *Inca Religion and Customs*, 43. For a longer discussion of the ways buildings could be understood as shrines to memorialize royal elites and their accomplishments, see Susan Niles, *The Shape of Inca History* (Iowa City: University of Iowa Press, 1999), 51–56.

56. A similar structure existed near Chinchero at Tambokancha-Tumibamba, in what was likely a late-Inca estate. In the middle of the plaza, next to the *cuyusmanco*, is a square structure with unusually thick, curving walls. It has one door facing the plaza. However, it also has a small courtyard in front,

perhaps to act as a protective device, so that people in the plaza could not walk directly into the structure. There are two similar structures opposite it.

57. Niles, *The Shape of Inca History*, 82.

Chapter 6

1. As discussed in Chapter 3, the colonial definitions of the word *pata* refer to the stepped landscape. Steps consist of both risers (the vertical walls) and runners (the horizontal adjoining planes). The term *pata* therefore refers to both the risers and runners that make up that landscape.

2. While we do not know the exact term the Inca used to refer to this portion of the site, there are several descriptors they may have used. For example, González Holguin defined a "casa real" (royal house) as a "capac huaci tupa huaci" (royal house royal house). Diego Gonzalez Holguin, *Vocabvlario de la lengua general de todo el Perv llamada lengua qquichua o del Inca [1608]*, prologue by Raúl Porras Barrenechea, edición facsimilar de la versión de 1952 ed. (Lima, Peru: Universidad Nacional Mayor de San Marco, Editorial de la Universidad, 1989), 449. He defines "tupa" as "dize cosa Real que toca al Rey" (said for royal things that refer to the king) and "es nombre de honor para hórrarle, o llamarse honrrosamente, como nosotros dezimos Señor, A Tupay O Señor, A tupay Dios, O Señor Dios, A tupay San Pedro, O Señor San Pedro" (a name of honor, used to honor someone, name someone honorably, like we say "Sir . . ."). Ibid., 347. Thus, many types of grand, royal things could be called *capac*, *tupa*, or *hatun*, from buildings to cities to objects.

González Holguin defines a "hatun huaci" as a "casa grande sala" (house with a grand hall or room) and a "huchhuylla huaci" as "la casa chica" (little house). Gonzalez Holguin, *Vocabvlario de la lengua . . . [1608]*, 169.

3. Craig Morris, "Enclosures of Power: The Multiple Spaces of Inca Administrative Palaces," in *Palaces of the Ancient New World*, ed. Susan Toby Evans and Joanne Pillsbury (Washington, DC: Dumbarton Oaks Research Library and Collection, 2004), 299–324. An important source cited by Morris is Martin de Murúa's colonial description of the public and private spaces of an Inca royal estate. Martin de Murúa, "Historia general del Perú," *Historia* 16 (1987): 345–49.

4. Susan Niles, *The Shape of Inca History* (Iowa City: University of Iowa Press, 1999), 168.

5. Ian S. Farrington, *Cusco: Urbanism and Archaeology in the Inka World*, Ancient Cities of the New World (Gainesville: University Press of Florida, 2013), 159–60.

6. For a discussion of Martin de Murúa and the complicated history of his manuscript, see Juan Ossio, "Murúa, Martín De (?–1620)," in *Guide to Documentary Sources for Andean Studies, 1530–1900*, ed. Joanne Pillsbury (Norman: University of Oklahoma Press, 2008).

7. Murúa, "Historia general del Perú," 347–48.

8. Ibid., 346–47.

9. Ibid., 345–49.

10. The foundations for these buildings were uncovered when the plaza was reconstituted and paved by COPESCO in the 1990s.

11. This portion of the estate has been significantly altered since 1532. It is impossible to say for sure that there were no buildings on this section of the plaza. However, unlike other portions of the plaza, even those heavily altered, some record of its prior form has been found. While this area has been built upon post-1532, it likely did not have a significant building presence.

12. Each of these buildings has a single large doorway on one of its short sides that faces a large open space.

13. The Spanish called Inca noblemen "orejones" (big ears) for the distinctive ear plugs they wore. The Inca called these ear ornaments *pacu*, and the elite man who wore them a *pacuyoc inca*. Inca boys had their ears pierced as part of the initiation ceremony when they became men. The anonymous author defines *pacu* as "orejeras de los Ingas" (ear covering of the Inca), while *pacuyoc, inga* is "Inga Orejón" (ear, Inca). Anonymous, *Vocabulario y phrasis en la lengua general de los indios del Perú, llamada quichua, y en la lengua española*, 5th ed. (Lima, Peru: Universidad Nacional Mayor de San Marcos, Instituto de Historia de la Facultad de Letras, 1951), 67. González Holguin defines *pacu* as "orejera, lo que meten los yndios orejones en el hueco de la oreja" (ear covering, which the 'big ear' Indians put in the hollow of their ear); *pacu rincri* "la oreja horadada" (pierced ear); *pacuyoc*, "los indios orejones que los hazian por valor en la guerra o *pacurinri*, o *pacurincriyoc*" [the 'big ear' indians who conduct themselves with great valor in war). Gonzalez Holguin, *Vocabvlario de la lengua . . . [1608]*, 271. Interestingly, *pacu* had a second meaning as a metaphor for a hearth, "chimenea, por metáfora," according to the anonymous author. Anonymous, *Vocabulario y phrasis*, 67.

María Rostworowski argues that there were several groups of men who could wear ear plugs. For example, she lists *Rinriyoc Auqui*, noblemen who wore ear plugs; *Ccoripaco Ccoririncri*, captains who wore ear plugs; and *Pacuyok*, commoners who were allowed to wear ear plugs because of their success in war. María Rostworowski de Diez Canseco, *History of the Inca Realm*, trans. Harry B. Iceland (Cambridge: Cambridge University Press, 1999), 141.

14. Stephen D. Houston and Thomas Cummins, "Body, Presence, and Space in Andean and Mesoamerican Rulership," in *Palaces of the Ancient New World*, ed. Susan Toby Evans and Joanne Pillsbury (Washington, DC: Dumbarton Oaks Research Library and Collection, 2008).

15. Agustín de Zárate, *The Discovery and Conquest of Peru*, trans. J. M. Cohen (Harmondsworth, UK: Penguin, 1968), 95.

16. The extensive use of exterior spaces is typical of the Inca and many highland Andean groups.

17. A structure that may be a *cuyusmanco* or *carpa uasi* has been found at Caranqui, which appears to have been one of Atahualpa's royal estates (Tamara Bray, personal communication, 2014).

18. One of the problems in understanding their blood relationship is that the term "sister" did not necessarily mean the same as it does today. Rostworowski notes that "sister" in the early colonial Quechua sources was used to mean half-sister, full sister, cousin, or even a women of the same lineage as the man. Rostworowski de Diez Canseco, *History of the Inca Realm*, 104. However, given what we know about Mama Ocllo from the colonial sources, she seems to have been in Pachacuti's *panaca* and had very close ties with Pachacuti's powerful sons.

19. Some reports suggest that Topa Inca did not know Mama Ocllo until they married (indicating they likely had different mothers or were first cousins), while others suggest they were full brother and sister. For example, Bernabé Cobo states that Topa Inca was the only ruler to have married a full sister and that subsequent rulers married only half-siblings (on their father's side). Cobo, *Inca Religion and Customs*, trans. Roland Hamilton (Austin: University of Texas Press, 1994), 209. However, this emphasis on Mama Ocllo being Topa Inca's full sister (rather than half) may have been part of the revisionist history encouraged by Huayna Capac. As we shall see, he came to power under a cloud of suspicion (his father favored his half-brother Huayna Capac), and he seems, like most Inca rulers, to have tried to shift his official narrative to show him in a more favorable light. For Huayna Capac, this meant an effort to convey a more rightful inheritance of the throne. This was made much easier when much of Topa Inca's *panaca* was decimated by Atahualpa, and many of the *panaca* narratives were lost or marginalized.

20. No comprehensive study has been done of the royal buildings of a *coya*. At present, surviving evidence does not suggest *cuyusmanco* were part of royal female lands.

21. Zárate, *The Discovery and Conquest of Peru*, 95.

22. John V. Murra, "Cloth and Its Functions in the Inca State," *American Anthropologist* 64, no. 4 (August 1962): 710–28.

23. Pedro Sancho, *An Account of the Conquest of Peru* (Boston: Milford House, 1972), 158–59.

24. Murúa, "Historia general del Perú," 348–49.

25. For a discussion of the word *capac* and its relationship to imperial Inca life, see Catherine Julien, *Reading Inca History* (Iowa City: University of Iowa Press, 2000), 23–48. Julien states that *capac* was a status that was inherited by males each generation in a royal family line. Ibid., 23. The anonymous author defines *capac* as "rey, rico, poderoso, illustre" (king, rich, powerful, illustrious). Anonymous, *Arte y vocabulario en la lengua general del Peru, llamada quichua, y en la lengua española* (Seville, Spain: En Casa de Clemente Hidalgo, 1603), leaf Bb 1 verso. The author also lists *capac yahuar* as "sangre real" (royal blood), *capac ayllu* as "familia real" (royal family), *capac cay* "reyno y señorío" (kingdom or dominion, estate), *capac huaci* "casa real" (royal house), *capac ñan* "camino real" (royal road). Ibid. Domingo de Santo Tomás defines *capac, o capac çapa* as "rey o emperador" (king or emperor), *capac guacin* as "palacio, o casa real" (palace, or royal house), *capacñan* as "camino real" (royal road), and *capac ayllo* as "linage real o de reyes" (royal lineage or of kings) Santo Tomás, *Lexicón o vocabu-*

lario de la lengua general del Perú [1560], facsimile ed. (Lima, Peru: Universidad Nacional Mayor de San Marcos, 1951), 248.

There is no reference to *capay* or *capac* in González Holguin, but to *kapay, kapac* and *çapay, çapac.* González Holguin defines *kapac yahuarniyoc* as "de sangre real" (of royal blood) and *kapac ayllu, o kapak churi* as "de la cassa, o familia real, o noble" (of the house, or royal family, or noble). *Kapacyahuar* is defined as "de noble sangrey y linage" (of royal blood and lineage). *Kapac huacinchic* is defined as "la gloria" (fame, glory) and *çapay kapac Inca* is defined as "el rey" (the king). *Kapac, o çapaykapak* is defined as "el rey" (the king) and *kapaccay* is "reyno, o imperio" (the kingdom or empire). *Kapac huaci* is "cassa rreal grande" (the grande royal house). Diego Gonçalez Holguin, *Vocabvlario de la lengva general de todo el Perv llamada lengva qquichua, o del Inca* (Ciudad de los Reyes, Peru: Francisco del Canto, 1608), book 1, 127, leaf H 8 recto. *Kapac ñan* is defined as "camino real" (the royal road) and *kapac mama* is "matrona noble, o nuestra señora" (noble matron, our lady). *Kapac koya* is "reyna y sus hijas" (the queen and her daughters) and *kapac raymi* "ciertas fiestas solenes del mes de diziembre" (certain sun festivals in the month of December) Ibid., book 1, leaf H 8 verso.

26. *Marca* can be translated as a lawyer, the extra room of a house, a two-story duplex, or a house type from the Puna (high Andes). The anonymous author defines *marca* as "patron abogado" (a patron lawyer) and "fobrado (sobrado) de casa" (the extra room of a house). Anonymous, *Arte y vocabulario en la lengua*, leaf Ff 6 verso. González Holguin defines *marca* as "el valedor, o abogado o protector" (patron, lawyer, or protector) and as "el soberado, o los altos de la cassa" (the extra room, or the upper stories of a house). *Marca huaci* is defined as "casa doblada con altos" (double house with multiple stories). Gonçalez Holguin, *Vocabvlario de la lengva*, book 1, leaf P 2 recto.

Most of these definitions by different authors relate specifically to architecture, but *marca* was also defined by one colonial author as a region, town, or district. Santo Tomás defines *marca* as "comarca, o pueblo" (district or town), *marca o sucguamanc* as "puincia, o comarca" (province or region), and *marcayoc* as "comarcano" (nearby, neighboring). Santo Tomás, *Lexicón o vocabulario de la lengua*, 318.

27. The lofts usually run only on one side of the building, about a third of the length of the structure. But they can run on either side of the central doorway, creating two distinct interior lofts. Today, there is great flexibility in the lofts. They can also be placed on different levels on each side of the central doorway and be of different sizes.

28. Evidence of a likely imperial Inca *marca uasi* can be found in Ollantaytambo. See Fig. 2.22. Jean-Pierre Protzen, *Inca Architecture and Construction at Ollantaytambo* (New York: Oxford University Press, 1993), 61.

29. The key to understanding the references to a *marca* lies in the translation of "*sobrado.*" In 1739 *sobrado* is defined as "en los edificios lo mas alto de la casa. Díjose asi por ser aposento que está como de sobra, porque regularmente nadie le habita"

(in buildings it is the highest part of the house. It was said also to be room that is spare, because nobody lives there regularly). Real Academia Española, *Diccionario de la lengua Castellana* (Madrid, Spain: Imprenta de Francisco Hierro, 1990), vol. 6. Hence, a *sobrado* is not a regular upper floor, but instead is a high space in the house, such as an attic or loft, where things are stored. Today *sobrado* often refers to an attic.

30. Niles, *The Shape of Inca History*, 82–83.

31. Because the *capac marca uasi* appears to have been a common rectangular building distinguished by interior lofts (and preservation at this height is rare among the imperial remains), it is impossible to say exactly where the *capac marca uasi* may have been located inside of Topa Inca's royal estate.

32. In his drawing (329), and in his written description, Guaman Poma writes the building name as *churacona uasi*. Felipe Guaman Poma de Ayala, *Nueva corónica y buen gobierno*, ed. and prologue by Franklin Pease, trans. Jan Szeminski, vol. 1 (Lima, Peru: Fondo de Cultura Económica, 1993), 247–48.

33. *Collca* was defined as "depósito, o troje" (warehouse or barn) and "las cabrillas." Anonymous, *Vocabulario y phrasis*, 25.

34. The anonymous author described *churana churacuna* as "caxa, o otra cosa donde se guarda algo" (box, or some other thing where something is stored). Anonymous, *Arte y vocabulario en la lengua*, leaf Dd 2 verso. González Holguin defines *churcacuna huaci* as "despése almacé" (separated warehouses) and *churana o churaccuna* as "la caxa a la alazena, o donde se guarda algo" (the box or locker where something is stored). Gonçalez Holguin, *Vocabulario de la lengua*, book 1, leaf H 2 recto. Santo Tomás defines *churana* as "lugar donde algo se guarda" (place where something is stored). Santo Tomás, *Lexicón o vocabulario de la lengua*, 274.

35. The assumption that these buildings are round is based on a reading of the roofs that Guaman Poma has depicted. However, as discussed in the previous chapter regarding the *suntur uasi*, a narrow, almost square structure would also have had a rounded pinnacle on top, not a point as would have been typical of most gable-ended structures. Thus, we cannot assume that these narrow buildings were round in plan.

Although rectangular forms were favored by the Inca, they did build round structures, such as the rounded *suntur uasi* in the square of Cuzco. They built round storage structures at the Ollerirayoq site in the Lucre Basin (at the eastern end of the Cuzco valley). These were part of Huascar's royal estates. Gordon Francis McEwan, *The Middle Horizon in the Valley of Cuzco, Peru: The Impact of the Wari Occupation of the Lucre Basin*, International Series 372 (Oxford, UK: BAR, 1987). In addition, note the Inca storage structures at Huanaco Viejo.

As discussed previously, the Inca incorporated local influences into their architecture and thus had an adaptable architectural vocabulary. Circular buildings have a long history in the Andes, particularly for domestic contexts. In the Cuzco area this can be seen in the round homes at Andasmarca, and in Bolivia in the circular homes of the Chipaya in Oruro. In addition, round structures were built as tombs (i.e., homes for the dead), such as

the Chulpas around Lake Titicaca. This tradition of round buildings appears to have been adapted by the Inca at the site of Raqchi. There are more than 100 round buildings that once were widely thought to have been storage structures. Yet excavations have shown they were used as domestic structures. For a discussion of circular building within the Inca empire, see Graziano Gasparini and Luise Margolies, *Inca Architecture*, trans. Patricia J. Lyon (Bloomington: Indiana University Press, 1980), 138–42.

36. In addition, lands belonging to (or managed by) other *panaca* could exist within areas considered part of a royal estate. For a discussion, see Niles, *The Shape of Inca History*, 149–53.

37. Protzen, *Inca Architecture and Construction*, 111. For a discussion of storage houses at Ollantaytambo, see ibid., 111–35.

38. Susan Niles has shown that storehouses were an architectural symbol of power. Since movement within the Inca state was prohibited, subjects were unable to trade or collect a variety of goods they needed for their daily and ceremonial life. To compensate, the Inca supplied these goods to communities, thus reiterating the Inca's power over local communities. To emphasize this power, the Inca located these storage places in highly visible locations. In this way, conquered groups were reminded daily of the Inca's power over them. Niles, "Inca Architecture and the Sacred Landscape," in *The Ancient Americas: Art from Sacred Landscapes*, ed. Richard F. Townsend (Chicago: Art Institute of Chicago, 1992). In the context of Chinchero, the audience would have not have been a newly subjugated people, but rather other nobles. Nevertheless, given the often testy relationship between an Inca ruler and his noblemen, and Topa Inca's own program for swaying Inca elites over to his choice for successor, it would have been particularly important that Topa Inca proclaim his great power to his fellow Inca nobles. By placing his extensive collection of warehouses on the hills above the Urubamba Valley, Inca nobles living there would look up and see Topa Inca's manifestation of power.

39. Manuel Ballesteros-Gaibrois refers to a colonial manuscript in which an informant states that that there were storage facilities at Chinchero that held a considerable amount of things for the Yucay (Urubamba) Valley. This passage likely refers to Machu Colca as the storage center for Chinchero. Ballesteros, "Etnohistoria de la sierra peruana (Chinchero)," *International Congress of Americanists* 40, no. 2 (1972): 423. I did find a similar reference in the same collection of documents: "Llanos de ella hasta el río grande solía ser de los Incas pasados y otras muchas tierras del dicho valle que adelante haría mención y que la dicha quebrada llamada Urcosbamba y las demás tierras del Inca las sembraban antiguamente los indios de las provincias comarcanas al dicho valle y lo que de ellas se cogía lo traían a esta ciudad y ponían en depósitos en Chinchero y en otras partes y ahora las sembraban solamente los indios que había en el dicho valley de Yucay para solo don Francisco y que de algunos de los dichos indios fue informado y le dijeron que se holgaban de que los cristianos ocupasen aquel pedazo de tierra porque ellos tenían menos trabajo y más lugar para entender en sus haciendas y que los

quedaban oras muchas tierras que eran del Inca que se sembraban y habían de sembrar para el dicho don Francisco" ([These areas] were full up to the grand river only for the Incas of the past and other many lands of the said valley that we have already mentioned and that this said ravine was called Urcosbamba and these lands of the Inca were sown in ancient times by the Indians of the towns in these areas of the said valley and that which they harvested they brought to this city and put in storage in Chinchero and other parts and now only the Indians who had been in this said valley of Yucay sown only for don Francisco and that some of the said Indians informed him and told him that they were content that the Christians were using that piece of land because they had less work and more space to be occupied in their farms and that they had many more sown lands left from the Inca and to sow for said don Francisco). Horacio Villanueva Urteaga, "Documentos sobre Yucay en el Siglo XVI," *Revista del Archivo Histórico del Cuzco* 13 (1970): 50. This passage refers to working the rich agricultural fields of Topa Inca's lands in Urquillos and taking the resulting produce to Chinchero "and other parts" like Machu Colca, for storage.

40. Tamara L. Bray, "To Dine Splendidly," in *The Archaeology and Politics of Food and Feasting in Early States and Empires*, ed. Tamara L. Bray (New York: Kluwer Academic, 2003), 98–99.

41. Protzen notes that tuber storage would have been more difficult in the lower, warmer environment of Ollantaytambo. Protzen, *Inca Architecture and Construction*, 121.

42. For information on Inca food production and storage, see Terence N. D'Altroy and Christine Hastorf, eds., *Empire and Domestic Economy* (New York: Kluwer Academic, 2001); Terry LeVine, *Inka Storage Systems* (Norman: University of Oklahoma Press, 1992); Craig Morris, "Storage in Tawantinsuyu" (Thesis, University of Chicago, 1967).

43. At both sites the *churacona uasi*, or Type 1 storage, makes up the minority of structures.

44. Protzen, *Inca Architecture and Construction*, 111–13.

45. Studies have shown that maize production increased with the Inca presence, most likely due to the use of corn in ceremonies (food and drink). D'Altroy and Hastorf, *Empire and Domestic Economy*, 155–78.

46. Bray, "To Dine Splendidly," 101–2.

47. González Holguin also defines *aka* as "el açua o chicha" (water or *chicha*) and he defines *akahuaci* as "taverna, o donde la benden" (tavern or where they sell it). Gonçalez Holguin, *Vocabulario de la lengva*, book 1, leaf A 5 verso.

48. For a discussion of these rituals, see Cummins, *Toasts with the Inca: Andean Abstraction and Colonial Images on Qero Vessels*, ed. Sabine MacCormack, History, Languages, and Cultures of the Spanish and Portuguese Worlds (Ann Arbor: University of Michigan Press, 2002).

49. Sabine MacCormack, "Religion and Society in Inca and Spanish Peru," in *The Colonial Andes: Tapestries and Silverwork, 1530–1830*, ed. Elena Phipps et al. (New York: Metropolitan Museum of Art; New Haven, CT: Yale University Press, 2004), 107.

50. Food production and consumption was very gendered in the Andes, particularly so among Inca elites. Women sat back-to-back with the men and served their husbands as needed. Bray, "To Dine Splendidly," 104.

51. For a discussion of Inca *qero*, how they were made and what they meant, see Cummins, *Toasts with the Inca*, 14–38.

52. Dean E. Arnold, *Ecology and Ceramic Production in an Andean Community*, 1st paperback ed., New Studies in Archaeology (Cambridge: Cambridge University Press, 2003).

53. For a discussion of the types of vessels the Incas had, and the evidence suggesting that the vast majority of these vessels were used in food production, service, and storage, see Bray, "To Dine Splendidly," 107–21.

54. Tamara Bray, "Inca Iconography: The Art of Empire in the Andes," *Res: Anthropology and Aesthetics* 38 (2000): 120.

55. Bernabé Cobo, *History of the Inca Empire: An Account of the Indians' Customs and Their Origin Together with a Treatise on Inca Legends, History, and Social Institutions*, trans. Roland Hamilton (Austin: University of Texas Press, 1991), 248. However, González Holguin translates *aka uasi* as a tavern, presumably where they sell corn beer. This wine room may have been called *aka uasi*, literally, the "house of aka" and the colonial dictionaries referred to both imperial Inca and colonial periods' uses of the structure: as a place to store alcohol and as a place to sell alcohol. Today in the Andes, corn beer is sold in special taverns in most indigenous regions, with the exception of Colombia, where the beer companies of the twentieth century had them outlawed in order to get rid of their competition.

56. Cobo, *Inca Religion and Customs*, 194.

57. Ibid.

58. As for which building may have been an *aka uasi* within Chinchero proper, it is unclear. If an *aka uasi* existed in Chinchero, it probably was located inside or near the private sector, with easy access to the Pampa. This is because both areas would have needed access to this highly restricted beverage. Two possible candidates are CP1 or CP2. These buildings are located on the border between the Pampa and the private *pata*, in an area that is well protected from outsiders, yet near to both the Pampa and private *pata*. As we know so little about the *aka uasi* (where it would have been located, in what type of structures, how many an estate would have had, etc.), it is difficult to give an accurate estimation about Chinchero's possible *aka uasi*. In addition, no careful excavations have studied the micro-remains of Chinchero's buildings, such as those of plants, which may tell us much about how structures (such as CP1 and CP2) were used.

59. Garcilaso notes how easy it is to mix up the meaning of *aca*, given the Spanish way of writing it, while clarifying that *aca* means "excrement." In discussing the word "Tangatanga," ascribed to an "idol," Garcilaso writes: "Sospecho que el nombre está corrupto, porque los españoles corrompen todos los más que toman en la boca. Y que debe decir *acatanca*, quiere decir 'escarbajo,' nombre con mucha propiedad compuesto de este nombre *aca*, que es 'estiércol' y de este verbo *tanca*, pronunciada

la última sílaba en lo interior de la garganta, que es 'empujar.' *Acatanca* quiere decir 'el que empuja el estiércol.'" Inca Garcilaso de la Vega, *Comentarios reales de los Incas*, 2nd ed. (Mexico City: Fondo de Cultura Económica, 1995), 1:80–81. He brings this point up again, highlighting how part of the confusion between the words for corn drink and excrement is that Spanish writers spell both as "aca" (thus the reader has no way of knowing which word is being referenced). "Hacían, también, la bebida que el Inca y sus parientes aquellos días festivos bebían (que en su lengua llaman *aca*, pronunciada la última sílaba en las fauces, porque pronunciada como suenan las letras españoles significa 'estiércol.'" Ibid., 209.

60. The anonymous author defines *aca* as "estiercol de persona o animal, o escoria de metal" (manure of a person or animal, or the slag of metal). Anonymous, *Arte y vocabulario en la lengua*, leaf Aa 1 recto. *Aka* is defined as "chicha" (corn beer). Ibid., Aa 2 recto. González Holguin defines *aca* as "todo estiercol de persona, o animal no menudo. Lo menudo, vchha" (all of the feces of a person or animal not insignificant. The insignificant) and "el orin y escoria del metal" (the useless by-products and slag of metal). He defines *acahuaci, o canahuaci* as "las necessarias." Gonçalez Holguin, *Vocabvlario de la lengua*, book 1, leaf A 3 recto. Santo Tomás defines *Aca, o yzma* as "mierda" (shit). He defines *aca guara* as "pañales de niños" (diapers for babies). Santo Tomás, *Lexicón o vocabulario de la lengua*, 229. Diego de Torres Rubio defines "Aka – Chicha" "Akacuni – hazer chichi" "Aca – stercus hominis" "Acani – proueerse" "Acacuni – idem" "Aca huara – penal" [diaper?] "Acatanca – escaruajo pelotero." Torres Rubio, *Arte de la lengua Quichua [1619]* (Lima, Peru: Por Francisco Lasso, 1619), a recto. While González Holguin defines *aca* as feces, he defines *aka* as "el açua o chicha" (water or chicha) and he defines *akahuaci* as "taverna, o donde la benden" (tavern or where they sell). Gonçalez Holguin, *Vocabvlario de la lengua*, book 1, leaf A 5 verso.

61. Listing bathrooms when selling a home has become standard in the United States today—"two bedroom, two bath duplex, etc." The "bath" references toilets rather than bathing facilities.

62. He defines *acahuaci, o canahuaci* as "las necessarias." Gonçalez Holguin, *Vocabvlario de la lengua*, book 1, leaf A 3 recto. In 1734, the word *necessaria* was translated as "letrína ó lugar para las que se llaman necessidades corporales, de donde tomó el nombre. Lat. *Latrina*" (latrine or place for that which they call corporal necessities, from which its name comes). Real Academia Española, *Diccionario de la lengua Castellana, en que se explica el verdadero sentido de las voces, su naturaleza y calidad, con las phrases o modos de hablar, los proverbios o refranes, y otras cosas convenientes al uso de la lengua [1734]* (Madrid, Spain: Imprenta del Hierro, 1990), 4:656.

63. One of the few scholars to mention the act of defecating in the Andes is Frank Salomon, who notes that in the Huarochiri manuscript, Cuni Raya, in his desire to escape his sister, says he must leave her in order "to shit" (from the root word *ysmay*).

What is interesting about this story for our context is that in order for his excuse to be effective, his place of "shitting" had to be far enough away from his sister's sightlines (and beyond earshot) that he could successfully escape (which he does). It does not indicate where he went to defecate, but from this story, it is clear it was not close to wherever his sister was at that time. Salomon, *The Huarochiri Manuscript: A Testament of Ancient and Colonial Andean Religion*, trans. from the Quechua by Frank Salomon and George L. Urioste, transcription by George L. Urioste (Austin: University of Texas Press, 1991), 50, fn 71.

64. Miguel de Estete (presumed) "Noticias del Perú" [1540s]. In Horacio Villanueva Urteaga, ed., *Historia de los incas y conquista del Perú* (Lima: Imprenta y Librería Sanmartí, 1924.), 54–55.

65. Ian Farrington has noted that shortly after their arrival, the Spanish had a sewage crisis in Cuzco. In 1534 the Cabildo had to meet to discuss how the dumping of horse manure into the city river was causing pollution. Drinking water was also becoming contaminated. Farrington, *Cusco*, 97.

66. For a discussion of Inca hydraulic engineering, see John Hyslop, *Inka Settlement Planning* (Austin: University of Texas Press, 1990), 129–45; Kenneth R. Wright, Jonathan Kelly, and Alfredo Valencia Zegarra, "Machu Picchu: Ancient Hydraulic Engineering," *Journal of Hydraulic Engineering* 123, no. 10 (October 1997): 838-43; Kenneth R. Wright, Gordon Francis McEwan, and Ruth M. Wright, *Tipon: Water Engineering Masterpiece of the Inca Empire* (Reston, VA: American Society of Civil Engineers, 2006); Kenneth R. Wright, Gary D. Witt, and Alfredo Valencia Zegarra, "Hydrogeology and Paleohydrology of Ancient Machu Picchu," *Groundwater* 35, no. 4 (1997): 660–66.

67. John Hyslop notes that there is no evidence of "grey water" transportation at Inca sites. Hyslop, *Inka Settlement Planning*, 132. However, in their subsequent studies at Machu Picchu, the Wrights found evidence that gray water was directed down to one area of the estate, at the bottom of the massive terraces, before disappearing underground in a sea of natural boulders.

68. Richard L. Burger and Lucy C. Salazar argue that Machu Picchu had a toilet and that it was located in the "palace" of Pachacuti. Burger and Salazar. *Machu Picchu: Unveiling the Mystery of the Incas*, ed. Richard L. Burger and Lucy C. Salazar (New Haven, CT: Yale University Press, 2004). However, this is unlikely. While it is possible that a small side room was used for private acts, such as defecating, it is highly unlikely that the drain in the room was used to wash away human waste. Not only would this narrow tube have made it an awkward and likely messy portal for fecal deposit, but it lies directly above the beginning of the fountain of natural spring water that services the core of the site. If it had been a toilet it was perfectly positioned to contaminate most of the estate's water system. Unless Machu Picchu was soon abandoned due to collective intestinal distress, it is unlikely this was a toilet.

Chris Donnan did observe a possible sewage pit at the top of the Huaca del Sol. It appears to have been dug after the completion of the structure, which suggests that the need for one

atop the structure was realized after it was completed. As he clarified, one can imagine how difficult it would have been for a priest in his rich garments, with all eyes upon him, to have to race down the structure to relieve himself during ceremonies. A toilet on the platform would have been essential for ceremonies of any length. The pit is approximately two meters in depth (Donnan, personal communication, 2012).

69. As anyone who has gone camping knows, it is fine for a few people to relieve themselves in the outdoors, but if the number grows even slightly, the area rapidly becomes unsanitary. Thus it is unlikely that a bustling royal estate, with its many servants, visitors, and pageantry performers, could have relied on finding a nearby spot to relieve themselves as a regular course of action.

70. One wonders if among the many vessel types that the Inca had, particularly those associated with elite settings, one may have been used for waste collection and removal rather than for food.

71. Urine could have been collected and then poured into areas outside the estate. An abundance of urine can kill plants (as anyone along a dog walk knows); however, it can also be lightly distributed without causing much damage to the flora. In addition, leather production in the Andes has made use of urine in the curing process, so it is possible that human urine may have been collected and used in this capacity.

There is evidence of urinals, or vessels for collecting urine, in the colonial dictionaries. There is no mention of a separate room for urine collection, but the existence of urine vessels suggests that some effort was made to gather urine, perhaps just for the use of curing leather or for special circumstances (such as large festivals) or special people (such as the *sapa inca*). Julia McHugh has pointed out that currently the word *hispanawasi* (urine room) is meant to describe a modern toilet. This is not a reference to a Spanish toilet, which is another translation for the *hispanawasi*, but instead a modern derivation of *yspay*, to urinate. Today, a *hispanawasi* is meant to collect both excrement and urine, like a modern bathroom (Julia McHugh, personal communication, 2012). In colonial dictionaries, González Holguin translated *yspay* as "la orina" (urine). Gonzalez Holguin, *Vocabvlario de la lengva . . . [1608]*, 370. Interestingly, he translated *orinal* not as a urinal, but instead as "Ysppana. Mal de orina, or angurria que haze orinar mucho" (Ysppana. Urinary aliment, anxiety of having to pee a lot). Ibid., 610. He gives an extensive list of urinary conditions, as well as a urine specialist. Whether this was for someone diagnosing these conditions or someone who collected urine for leather or other purposes is unclear. *Orinador demasiado a mendua* (one who urinates too much too often) is called "ysppay pututu," while "ysppaycuy camayoc" is defined as *orinador a otros demasiado* (one who urinates upon others too much). Ibid.

72. Today, residents of Chinchero say that before toilets and outhouses were installed in (and around) homes during the last several decades, people used the corner of their patios and their terrace lands to relieve themselves (Pablo Garcia, personal communications, 2013).

According to Cobo, the Inca had developed a system of excrement fertilization that was unlike anything used in Spain. He states that they had a "very special technique" for guano. Cobo, *Inca Religion and Customs*, 211.

73. "Estercolaban las tierras para fertilizarlas. Y es de notar que en todo el valle del Cozco (y casi en toda la serranía) echaban al maiz estiércol de gente, porque dicen que es el mejor. Porcúranlo haber con gran cuidado y diligencia y lo tienen enjuto y hecho polvo para cuando hayan de embrar el maíz." Garcilaso de la Vega, *Comentarios reales de los Incas*, 1:258. Garcilaso states that corn fields were fertilized every year. Ibid., 254.

74. I thank Michal Stenstrom for alerting me to the many complications of human waste removal and steering me away from some of my erroneous assumptions on this matter.

75. Gonzalez Holguin defines *maçana* as "tendedero" (a place where clothes are spread to dry). Gonzalez Holguin, *Vocabvlario de la lengva . . . [1608]*, 220. Jan Szeminski, who wrote the Quechua translation for the Guaman Poma publication, suggests that the *masana uasi* was a place for cleaning clothes: "el lugar donde las lavanderas tienden ropa" (the place where the washers tend to the clothes). Guaman Poma, *Nueva corónica y buen gobierno*, vocabulary and translation by Jan Szeminski, vol. 3 (Lima, Peru: Fondo de Cultura Económica, 1993), 86. He bases his translation on information from Sebastián de Covarrubias, *Tesoro de la lengua Castellana o Española*, ed. Biblioteca Martin Riquer de la Real Academia Española, vol. 3, Serie Lengua y Literatura (Barcelona, Spain: Editorial Alta Fulla, 1989), 958.

While the colonial dictionaries clearly state that the items being dried are clothes, it is also possible that this building type may have also been used for drying other items, such as foods. Drying a variety of products was needed to preserve food over extended periods in the Andes. One of Chinchero's streets is named Ch'arkimachay, meaning a cave where meat is dried. Andean people no doubt had a variety of places to dry produce.

76. Sócrates Villar Córdova, *La institución del yanacona en el incanato*, Nueva Corónica, V 1, Fasc 1 (Lima, Peru: Universidad Nacional Mayor de San Marcos, Facultad de Letras y Ciencias Humanas, Departamento de Historia, 1966).

77. For example, Pachacuti likely staffed his estate with *yanacona* from Soras, Lucanas, and Chancas. Susan Niles, "The Nature of Inca Royal Estates," in *Machu Picchu: Unveiling the Mystery of the Incas*, ed. Richard L. Burger and Lucy C. Salazar (New Haven, CT: Yale University Press, 2004), 58. Given that Topa Inca spent his later years solidifying his conquest in the north, it is possible that he brought servants from these areas to work for him at Chinchero. Ibid., 59. However, given that there is a tradition of women in town wearing their hair in many braids, a style typically found near Lake Titicaca where Topa Inca had to put down revolts during his reign, it is also possible that his servants came from this area as well.

78. Murúa, "Historia general del Perú," 348.

79. Ibid., 348–49.

80. In Cuzco, servants lived outside the urban core in suburbs that lay in the direction of their ethnic origin. Although we do not know who, if any, of the servants lived within Chinchero proper, it makes sense that many servants would have lived outside of the private *pata*.

81. The conserving of fingernails was not a practice reserved for the *sapa inca*, but instead, was also practiced by parents of newborns. According to Cobo, when a child was weaned for the first time, its hair and fingernails were cut and the latter were preserved. Cobo, *Inca Religion and Customs*, 201–2.

82. Pedro Pizarro, *Relation of the Discovery and Conquest of the Kingdoms of Peru*, trans. Philip Ainsworth Means (Boston, MA: Longwood Press, 1977), 1:225–26.

83. Salomon, *The Huarochirí Manuscript*, 16.

84. Cecelia F. Klein, "Teocuitlatl, 'Divine Excrement': The Significance of 'Holy Shit' in Aztec Mexico," *Art Journal* 52, no. 3 (1993): 20–27.

85. The anonymous author defines *puñuna huaci* as "camara" (bedroom). Anonymous, *Arte y vocabulario en la lengua*, leaf C 6 recto. *Puñuna* is defined as "cama" (bed), *puñuni* as "dormir" (to sleep), and *puñuni* as "fornicar" (to have sex). Ibid., leaf IIh 4 verso. Santo Tomás defines *puñona* as "cama, leccho donde durmimos" (bed, where we sleep). Santo Tomás, *Lexicón o vocabulario de la lengua*, 343. González Holguin defines *puñuna* as "la cama" (the bed), *puñuni huarmictam* as "dormir con muger, fornicar" (to sleep with a woman, to fornicate), and *puñuccuni, o puñuni* as "dormir" (to sleep). Gonzalez Holguin, *Vocabvlario de la lengua . . . [1608]*, 296.

86. Juan de Betanzos, *Narrative of the Incas (1551)*, trans. Roland Hamilton and Dana Buchanan (Austin: University of Texas Press, 1996), 102.

87. González Holguin defines *ccoya* as "reyna, o princessa heredera" (queen, or hereditary princess). Gonçalez Holguin, *Vocabvlario de la lengua*, book 1, leaf D 6 verso.

88. Irene Silverblatt, *Moon, Sun, and Witches: Gender Ideologies and Class in Inca and Colonial Peru* (Princeton, NJ: Princeton University Press, 1987), 60. Silverblatt is translating a quote from Martín de Murúa, *Historia del origen y geneolagía real de los Incas*, ed. Constantino Bayle (Madrid, Spain: Consejo Superior de Investigaciones Científicas, Instituto Santo Toribio de Mogrovejo, 1946), 181.

89. For the Inca, sex before marriage was not frowned upon, but sex outside of marriage (i.e., with anyone other than a spouse) was forbidden. However, there was flexibility in this system, based on class and gender. For example, the *sapa inca* and select elite men to whom he granted such privileges were allowed to have more than one wife. For a discussion of sexual relationships among the Inca (focusing on women), see Silverblatt, *Moon, Sun, and Witches*, 101–8.

90. For an overview of women and land-holding during the imperial Inca period, see Terance D'Altroy, *The Incas* (Malden, MA: Blackwell Publishers, 2014), 131.

91. "Topa Inca Yupanqui succeeded his father when he was eighteen. He was *capac* for sixty-seven years." Pedro Sarmiento de Gamboa, *The History of the Incas*, trans. Brian S. Bauer and Vania Smith, Joe R. and Teresa Lozano Long Series in Latin American and Latino Art and Culture (Austin: University of Texas Press, 2007), 169–71.

92. For the Incas, whose movement through space was highly theatrical and deeply meaningful, the message of the preference would not have been lost on any visitor. By building his new estate above that of his principal wife and their son, he visually marked out his own preference for his secondary wife and their son, who he actively promoted to be his official heir. As Craig Morris has shown, for the Inca, spatial hierarchy was expressed not only horizontally, but vertically as well. The relatively close proximity between the two residences magnified Topa Inca's female preference and, no doubt, the tensions between the two women.

93. For a thoughtful summary of Zárate's life and work, including the sources he drew upon in his text, see Teodoro Hampe Martínez, "Zárate, Agustín de (ca. 1514–ca 1590)," in *Guide to Documentary Sources for Andean Studies, 1530–1900*, Joanne Pillsbury, Center for Advanced Study in the Visual Arts (U.S.) (Norman: University of Oklahoma Press, 2008), 757–59.

94. Zárate, *The Discovery and Conquest of Peru*, 94.

95. Zárate describes the Cajamarca day room as a gallery, which for Spaniards means a large, single-space room. Atahualpa's day room had a doorway onto the main courtyard and a window that opened onto a garden. Later in his reports, he notes that the *sapa inca* held meetings in the courtyard in front of the door to this structure. Thus, the day room of the *sapa inca* is described as a space for state functions (meetings) that occurred in front of and inside the building, as well as having visual access to a garden.

96. The articulation of Topa Inca's private quarters at Chinchero would have been more elaborate, as Cajamarca was not a royal estate but an Inca settlement in which the ruler had a private compound.

97. Zárate also describes the interior of another building in the compound, but it is unclear to which one he is referring: "The other room in front consisted of four bell-shaped vaults joined into one, and was washed with snow-white lime." Given that he mentions the building "in front," he most likely is referring to one of the two storage structures. Therefore, the unusual roof design may have something to do with what conditions were needed to store specific objects. Zárate, *The Discovery and Conquest of Peru*, 94.

98. Pizarro, *Relation of the Discovery and Conquest of the Kingdoms of Peru*, 226.

99. "Uaccha Uaci [casa de los necesitados]" (house of the needy). Felipe Guaman Poma de Ayala, *El primer nueva coronica y*

buen gobierno (1615), ed. John V. Murra and Rolena Adorno, Coleccion America Nuestra, America Antigua (Mexico City: Siglo Veintiuno Editores, 1980), 302. The anonymous author defines huaccha as "pobre, huerfano, menor" (poor, orphan, young). Anonymous, Arte y vocabulario en la lengua, leaf Ee 1 recto. The same author also defines the related words of huacchachanani as "fer huerfano, empobrecer" (to be an orphan, to become poor) and huacchayachini as "empobrecer a otro" (to make another poor). Ibid., leaf Ee 1 recto. González Holguin defines huaccha as "pobre y huérfano" (poor and orphan), huacchayani as "hazerse huérfano" (to become an orphan), and "yr empobreciendo, o faltarle los parientes" (to become poor, or to lack relatives). Gonzalez Holguin, Vocabulario de la lengua . . . [1608], 167. Huaccha is closely related to the word huachay, which means "parto" (delivery); huachac "la que pare" (the woman who delivers); huachascca, o huachaytucuk "lo parido o nacido" (the delivery or childbirth). Ibid., 168.

100. Betanzos, Narrative of the Incas, 71–72.

101. Another example can be seen in the Huarochiri manuscript. Salomon notes that while huaccha may be translated as "poor and friendless" and "literally, 'orphan,'" what is meant is "'poor' not so much in the sense of lacking property, as in the sense of lacking social ties that enable one to be productive." Salomon, The Huarochiri Manuscript, 46, fn 38. Salomon also contrasts huaccha ("friendless, poor') with capac ("rich social and superhuman connectedness"). Ibid., 54, fn 87. For the Inca, this suggests that the status of the mother of the sapa inca's children not only gave the children their class status, but also defined the social networks on which they relied for advancement and support in their lives. Rostworowski notes that for the Inca, wealth was defined by one's extensive kinship group, which was critical in the Inca practice of reciprocity. Thus, to have a mother who did not have an extended material family group to which one could belong rendered one poor or an orphan. Rostworowski de Diez Canseco, History of the Inca Realm, 106. Garcilaso discusses the different status of the royal children as based upon the status of the mother. Garcilaso de la Vega, Comentarios Reales De Los Incas, 1:218–19.

102. Sarmiento de Gamboa, The History of the Incas, trans. Brian S. Bauer and Vania Smith, 169–71.

Chapter 7

1. This was the second landing of the Spanish on the north coast of the Inca Empire. The first time was before the civil war, and the Spaniards were amazed at their initial glimpse of the rich empire. When they returned for a second visit, with more men, weapons, and supplies, the Spaniards found a very different environment—one decimated by a devastating and lengthy civil war, as well as by the ravages brought on by European diseases such as smallpox and measles. Pedro Pizarro, Relation of the Discovery and Conquest of the Kingdoms of Peru, trans. Philip Ainsworth (New York: Cortes Society, 1921), 139–40, 160–61.

2. For an analysis of the effects of war and disease on the Andean populations resulting from the European invasion, see Noble David Cook, Demographic Collapse: Indian Peru, 1520–1620 (New York: Cambridge University Press, 1981); and Cook, "Population Data for Indian Peru: Sixteenth and Seventeenth Centuries," Hispanic American Historical Review 62, no. 1 (1982): 73–120.

3. The anonymous author defines Pacha cuti, pacha tiera as "fin del mundo" (the end of the world). Anonymous, Arte y vocabulario en la lengua general del Peru, llamada Quichua, y en la lengua Española (Seville, Spain: En Casa de Clemente Hidalgo, 1603): leaf Gg 6 verso. González Holguin defines pacha cuti pacha tiera as "el fin del mundo, o grande destruicion pestilencia, ruyna, o perdida, o daño comun" (the end of the world, or grand pestiential destruction, ruin, loss or common damage). He defines nina pachacuti as "el fin del mundo por fuego" (the end of the world by fire). Gonzalez Holguin, Vocabulario de la lengua . . . [1608], 270.

In 1551, the chronicler Juan Diez de Betanzos wrote that pachacuti means "change of time." Betanzos, Narrative of the Incas (1551), trans. Roland Hamilton and Dana Buchanan (Austin: University of Texas Press, 1996), 76. In 1633, another chronicler, Bernabé Cobo, defined pachacuti as "change of time or of the world." Cobo, History of the Inca Empire: An Account of the Indians' Customs and Their Origin Together with a Treatise on Inca Legends, History, and Social Institutions, trans. Roland Hamilton (Austin: University of Texas Press, 1991), 133. In this century, the historian Sabine MacCormack argues that pachacuti referred to distinct eras that ended in "upheavals." See MacCormack, "Pachacuti: Miracles, Punishments and Last Judgment: Visionary Past and Prophetic Future in Early Colonial Peru," American Historical Review 93, no. 4 (October 1988): 960–1006. In this article, MacCormack contends that there was an increase in the use of the word after the European invasion. She argues that the word pachacuti came into use during this time to describe dramatic endings and shifts, such as the end of the world, the change from good to evil, and the Christian Last Judgment. Ibid., 966.

4. Carolyn Dean, "The After-Life of Inka Rulers: Andean Death before and after Spanish Colonization," Hispanic Issues On Line 7 (Fall 2010): 27–54. The canonization ceremony that they had for a deceased ruler was called a purucaya. Topa Inca's occurred one year after his death. Betanzos, Narrative of the Incas, 162. See also Susan Niles, The Shape of Inca History (Iowa City: University of Iowa Press, 1999), 45–51.

5. Niles, The Shape of Inca History, 51.

6. Ibid., 2.

7. Pedro Sarmiento de Gamboa, The History of the Incas, translated by Brian S. Bauer and Vania Smith, Joe R. and Teresa Lozano Long Series in Latin American and Latino Art and Culture (Austin: University of Texas Press, 2007), 169–71.

8. Chequi Ocllo's loyal and strong support from a lady in Cuzco (and her connections there) indicate that Chequi Ocllo was not a low-status woman, but was instead probably from one of the panaca in Cuzco. In addition, Capac Huari's considerable initial support to succeed his father among Inca elites gives fur-

ther proof that his mother, Chequi Ocllo, must have held high Inca status. If he had been the child of a mother who was not Inca, his appointment would have been very controversial and highly unlikely.

9. Sarmiento de Gamboa, *History of the Incas*, trans. Markham, 155.

10. Chequi Ocllo is described as being either a secondary wife or a mistress. Part of the confusion over Chequi Ocllo's status has to do with the destruction of Capac Ayllu (Topa Inca's family group) and the fact that during succession fights, the mothers of the various claimants were often disparaged. For a discussion of the latter in regard to Atahualpa and Huascar, see Niles, *The Shape of Inca History*, 13. For a discussion of the succession dispute between Capac Huari and Huayna Capac, see ibid., 88–92.

11. Sarmiento de Gamboa, *The History of the Incas*, trans. Brian S. Bauer and Vania Smith, 171–72.

12. María Rostworowski de Diez Canseco, *History of the Inca Realm*, trans. Harry B. Iceland (Cambridge: Cambridge University Press, 1999), 104.

13. Niles, *The Shape of Inca History*, 78.

14. Susan Niles, "The Nature of Inca Royal Estates," in *Machu Picchu: Unveiling the Mystery of the Incas*, ed. Richard L. Burger and Lucy C. Salazar (New Haven, CT: Yale University Press, 2004), 64.

15. Niles, *The Shape of Inca History*, 52. Rostworowski de Diez Canseco, *History of the Inca Realm*, 105–7, 179.

16. Lawrence S. Coben, "Other Cuzcos: Replicated Theaters of Inka Power," in *Archaeology of Performance: Theaters of Power, Community, and Politics*, Archaeology in Society Series, ed. Takeshi Inomata and Lawrence S. Coben (Lanham, MD: Altamira Press, 2006), 249–50.

17. Indeed, Huayna Capac seems to have spent much of his first years lavishing his mother, his great defender, with many gifts and offerings and was inconsolable at her death.

18. The violence resulting from the disputed succession caused deep rifts among Inca elites. While Huayna Capac richly rewarded his mother and those relatives who had supported his claims to the royal fringe, those who championed his half-sibling and rival faced a variety of imperial punishments.

19. Bernabé Cobo, *Inca Religion and Customs*, trans. Roland Hamilton (Austin: University of Texas Press, 1994), 37–38.

20. Rostworowski de Diez Canseco, *History of the Inca Realm*, 106–7.

21. Cobo, *History of the Inca Empire*, 151.

22. Sarmiento de Gamboa, *History of the Incas*, trans. Markham, 185.

23. Ibid.

24. Cobo states that even people who were not seen in a positive light when alive had their bodies treated with great respect and veneration once they were deceased. Cobo, *Inca Religion and Customs*, 39.

25. For a discussion of the treatment of the bodies of dead Inca rulers, in particular the important role of family members and servants, see ibid., 39–43; Dean, "The After-life of Inka Rulers"; and Brian Bauer, "The Mummies of the Royal Inca," in *Ancient Cuzco: Heartland of the Inca* (Austin: University of Texas Press, 2004), 159–84. For a discussion of the dead in Andean society, see Bill Sillar, "The Social Life of the Andean Dead," *Archaeological Review from Cambridge* 11, no. 1 (1992): 107–23; William H. Isbell, *Mummies and Mortuary Monuments: A Postprocessual Prehistory of Central Andean Social Organization* (Austin: University of Texas Press, 1997).

26. There is no mention of Chinchero during this period. However, excavation evidence suggests that the burning happened before there was a colonial occupation of the structures. It most likely happened at the end of the imperial Inca period, when Atahualpa and Huascar were vying for control of the Inca state. Several years later, Manco Capac, fleeing the Spaniards occupying Cuzco, set fire to Inca structures on his way to Ollantaytambo. Although it is possible that Chinchero was burned during this period, the evidence favors an earlier burning episode.

27. The role of Inca buildings in the memory of deceased rulers can be seen in Cuzco, where buildings in which a ruler was born, lived, slept, and died were made into shrines. Similar structures related to important Inca elites were also venerated. Niles, *The Shape of Inca History*, 52–56. These, along with specific places where the Inca undertook certain acts, such as bathing, were considered sacred. Ibid., 55.

28. For a discussion of land rights and shifting populations during this period, see ibid., 123–33; R. Alan Covey and Donato Amado González, *Imperial Transformations in Sixteenth-Century Yucay, Peru* (Ann Arbor: Museum of Anthropology, University of Michigan, 2008).

29. John Howland Rowe, "Probanza de los incas nietos de conquistadores," *Historica* 9, no. 2 (1985): 193–245.

30. Sabine MacCormack, *Religion in the Andes: Vision and Imagination in Early Colonial Peru* (Princeton, NJ: Princeton University Press, 1991).

31. There is mention of a church having been built in the parish of Chinchero by 1550. However, no name or specific location is given. The one most likely being referred to is the one built on the remains of CP5. Miguel de San Lucas, "De la religion bettlemica Presidente del convento y Hospital del Nuesttra Senora del la Almuderna," Unpublished document, Cuzco, Peru: Archivo Arzobispal del Cusco, 1711.

32. Niles, *The Shape of Inca History*, 56.

33. For example, see Cobo, *Inca Religion and Customs*, 43.

34. Unlike CP5, the ash in this building was never cleared, suggesting that it was not used after the building was burned. Whether it was bricked up immediately or later is unclear. During this time, small chambers were erected along the terraces below the Pumacaca viewing platform. These walls vary in quality (revealing that some masons had been trained in imperial Inca carving techniques while others had not) as well as in stone type. The latter may be a reflection of their lack of ability to ob-

tain high-quality stones over time. These small chambers were most likely used to house the dead.

35. Frank Salomon, *The Huarochirí Manuscript: A Testament of Ancient and Colonial Andean Religion*, trans. from the Quechua by Frank Salomon and George L. Urioste, transcription by George L. Urioste (Austin: University of Texas Press, 1991), 130, fn 693.

36. Brian S. Bauer, "The Mummies of the Royal Inca," in *Ancient Cuzco: Heartland of the Inca* (Austin: University of Texas Press, 2004), 162.

37. His ashes would have continued to contain his essence, and, according to Cobo, his *huauque* would have been treated like Topa Inca's body when he was still alive. Cobo, *Inca Religion and Customs*, 38.

38. Cobo states that Calispuquio Guaci (*uasi*) was Topa Inca's home in Cuzco and sacrifices to him were made here after his death. This house, as a sacred place of action and memory, was a *huaca* of the *ceque* system that defined sacred space in the imperial Inca capital. Ibid., 55. Another *huaca* was the fountain just below Topa Inca's house in Cuzco. As *puquio* means fountain (similar to *paqcha*), this fountain seems to have given the name to Topa Inca's Cuzco home. This house and fountain are an example of how place-making practices tied to Topa Inca and Inca history were enacted. Cobo states that water from this fountain was sacred, that the young men who successfully completed the Raymi festival came to wash in this fountain, and that the water the rulers needed to drink from was collected here. Ibid., 56.

39. Sarmiento de Gamboa, *History of the Incas*, trans. Markham, 154.

40. Rowe, "Probanza de los Incas nietos de conquistadores."

41. For a discussion of the reduced town and the important ways in which indigenous people mitigated Spanish control, see Jeremy Ravi Mumford, *Vertical Empire: The General Resettlement of Indians in the Colonial Andes* (Durham, NC: Duke University Press, 2012).

42. For a translation of the *Law of the Indies*, see Zelia Nuttall, "Royal Ordinances Concerning the Laying Out of New Towns," *The Hispanic American Historical Review* 5, no. 2 (1922): 249–54. See also Dora P. Crouch, Daniel J. Garr, and Axel I. Mundigo, *Spanish City Planning in North America* (Cambridge, MA: MIT Press, 1982).

43. Richard Kagan discusses the importance of the city and its link with ideas of civility and the spread of Christianity. Kagan, *Urban Images of the Hispanic World: 1493–1793* (New Haven, CT: Yale University Press, 2000). See also Kagan, "A World without Walls: City and Town in Colonial Spanish America," in *City Walls: The Urban Enceinte in Global Perspective*, ed. James d. Tracy (Cambridge: Cambridge University Press, 2000). Kagan discusses the *reducciones* and their use to Christianize and civilize the Andeans. Ibid., 144–45. The first 31 ordinances (1–31) are devoted to the rights of discovery, while the next 104 ordinances (32–135) are devoted to the rules for city planning. The final 13 (136–48) provide guidelines for converting Indians in the New World. The combination of rules for "discovery" (invasion), city planning,

and Christian conversion reflect how intertwined the three actions were understood to be at the time.

44. Don Francisco de Toledo is credited with implementing the *Law of the Indies* in Peru during his years of rule (1569–1581). Toledo traveled for five years (1570–1575) to inspect the status of the colony and afterward enacted a series of new laws to improve Spanish control and the spread of Christianity. Toledo set up a tribute system, enforced mandatory labor for indigenous people, reduced Andean communities into isolated, racially defined towns, and tried to eradicate native religion and discredit them as rightful rulers. See Steve J. Stern, *Peru's Indian Peoples and the Challenge of Spanish Conquest: Huamanga to 1640*, 2nd ed. (Madison: University of Wisconsin Press, 1993), 76.

For an analysis of sixteenth-century urban morphology, see Ralph Gakenheimer, "The Peruvian City of the Sixteenth Century," in *The Urban Explosion in Latin America: A Continent in Process of Modernization*, ed. Glenn H. Beyer (Ithaca, NY: Cornell University Press, 1967), 33–56. For a discussion of major Spanish cities across the Americas and their common characteristics, see François-Auguste de Montêquin, *The Planning of Spanish Cities in America: Characteristics, Classification, and Main Urban Features* (Hilliard, OH: Society for American City and Regional Planning, 1990). See also Richard M. Morse, "Some Characteristics of Latin American Urban History," *American Historical Review* 67, no. 2 (January 1962): 317–38. Morse argues that the earliest towns were irregular but became more ordered as time passed and that many Latin American towns were transient. Entire towns would be uprooted and moved according to economic needs. For a discussion of the history of urban planning in Spain, see Francis Violich, "Evolution of the Spanish City: Issues Basic to Planning Today," *Journal of the American Institute of Planners* 27, no. 3 (1962): 170–79.

45. See Kagan, "A World without Walls." In particular, Kagan points out how the gridded street was seen as equivalent to the creation of order. Ibid., 134, 140. Although deviation from the ordered plan mandated in the *Law of the Indies* was not unusual in the New World, Kagan points out that lack of an ordered grid plan was something that embarrassed the Spanish residents, who felt the need to apologize for irregularities. Ibid., 140.

46. The battle took place in 1536. Pedro de Cieza de Leon, *The Discovery and Conquest of Peru: Chronicles of the New World Encounter [~1553]*, trans. Alexandra Parma Cook and Noble David Cook (Durham, NC: Duke University Press, 1998), 449–66.

47. For a readable and informative account of the conquest of the Inca empire, and a description of how Manco Inca used the narrow streets of Cuzco to his advantage against the Spaniards, see John Hemming, *The Conquest of the Incas* (San Diego: Harvest/HBJ, 1970). For a description of the battle in Cuzco, see ibid., 189–235.

48. This alteration in the street pattern did not happen in Cuzco or in Ollantaytambo, suggesting that the seemingly nongrid plan of imperial Inca Chinchero did not suit the needs of the colonial period.

49. The streets in Chinchero tend to have different names for

each block or two. This was common in medieval Spain and was also typical of the Inca (the *cancha* was named, rather than the streets themselves). For example, Soqta Cuchu changes to Kijllo, Qamqowaskana, and Sandowascana. Chequipunku, in turn, becomes Collana and (after a slight turn) turns into Pumacahua, Salakata, and Uspata.

Soqta Cuchu means "Six Corner." This is a curious name for a street, particularly one that is relatively straight. It is possible that this name referred to an imperial Inca building that was originally located on this block. Chequi Punku means "Door of Separation/ Truth." For a full discussion of the early colonial definitions of these street names, see footnotes 134, 135, 139, 140, Stella Nair, "Of Remembrance and Forgetting: The Architecture of Chinchero, Peru from Thupa 'Inka to the Spanish Occupation" (Doctoral dissertation, University of California at Berkeley, 2003), 93, 95.

50. Crouch, Garr, and Mundigo, *Spanish City Planning*, 13. While the ordinance does state that the size of the plaza should reflect the size of the town's population, it also clearly states minimum and maximum limits. The ordinance reads: "The size of the plaza shall be proportioned to the number of inhabitants, taking into consideration the fact that in Indian towns, inasmuch as they are new, the intention is that they will increase, and thus the plaza should be decided upon taking into consideration the growth the town may experience. [The plaza] shall be not less than two hundred feet wide and three hundred feet long, nor larger than eight hundred feet long and five hundred and thirty two feet wide. A good proportion is six hundred feet long and four hundred wide." Ibid.

51. The Pampa was chosen before the *Law of the Indies* became an ordinance and the ideas were only just taking form in the Americas. It fit into the size that would later be mandated by the *Law of the Indies*. When the *pata* was chosen later, the *Law of the Indies* had been around for about twenty five years, yet it fell far below the minimum argued in the ordinances. This suggests not only that the *Law of the Indies* was largely suggestive (rather than compelling) but also that other factors, namely local spatial practices, may have played a much more important role in determining what open spaces would be chosen as the new town centers.

52. It is important to keep in mind that there was approximately half a century of Spanish occupation in Peru before the *Law of the Indies* was issued, allowing varying notions of Spanish urban planning to be expressed in the Andean landscape.

53. "Este día se trato que para el ornato desda ciudad y algun aprovechamiento de los propios de la y atento a que esta ciudad tiene muchas plazas y los dos principales que son la de la iglesia mayor y la del tranque donde estan las casas de cabildo están desproporcionadas y tan grandes que no pueden gozar bien en ellas las fiestas y otros autos públicos que se hacen en ellas y que sería bien reducir a mejor forma la dicha plaza donde están las casas de cabildo que es donde de ordinario se hacen las fiestas publicas y avientose tratado y conferido sobre ello se acordo por las dichas razones y para algun acrecentamiento de los propios destra ciudad que por el frente del monesterio de nuestra señora de las mercedes se haga un atajo de casas y tiendas dejando calle hacia la plaza de la iglesia mayor por las carnecerias y que ance mismo se dejen tres calles que salgan de la dicha placa del gato y . . ." (On this day it was discussed that for the ordinance of this city and for its use by its residents and observing that this city has many plazas and the two principal ones are the one by the main church and the council house, [the plazas] are disproportionate and so large that [people] are not able to enjoy the festivities and the other public legal proceedings that are conducted in [the plazas] and it would be well to reduce said plaza to a better form, where the council houses are, which is where they normally have public festivities and having discussed and conferred about this, it was agreed for these reasons and for some increase of people of this city that on the front of the monastery of Our Lady of Mercy there should be made a division of homes and stores fronting a street up to the plaza of the main church and by the butchers and that there remain three streets that begin from this plaza of the cat and . . .). Francisco de Toledo, *Gobernantes del Perú. Cartas y papeles. Siglo XVI. Documentos del Archivo de Indias*, ed. Roberto Levillier, vol. 7 (Madrid, Spain: Imprenta de Juan Pueyo, 1924), 70.

54. Thomas Cummins first raised this issue at an annual meeting of the College Arts Association in New York City, pointing out that the Spanish created large plazas in the old Aztec empire at the same time they destroyed or condensed plazas in the former Inca empire. He argued that this was consciously done by the Spanish as part of their context-specific conquest strategies.

55. In the Andes, Toledo's intent to subdivide the plaza was eventually frustrated by the local political interests of other Spaniards. One of the groups promoting its own interests was the Mercedarians, who wished to have their monastery, La Merced, keep its prominent place on the plaza. They opposed Toledo's plan and their interests helped to determine the three-plaza network that was carved out of the Inca dual plazas (Cusipata and Haucaypata). Carolyn Dean, "The Ambivalent Triumph: Corpus Christi in Colonial Cusco, Peru," in *Acting on the Past: Historical Performance across the Disciplines*, ed. Mark Franko and Annette Richards (Hanover, NH: Wesleyan University Press, 2000), 174.

56. Oscar Núñez del Prado studied the social structures of Chinchero in the 1940s, focusing on agricultural practices. At that time, the terraces were considered the best land and were allotted to the church and worked by local villagers. See Núñez del Prado, "Chinchero: Un pueblo andino del sur," *Revista Universitaria: Organo de la Universidad Nacional del Cuzco* 38, no. 97 (1949), 192–93, 200–21. It is not surprising that the church took over the Pampa and surrounding terraces. Once the scene of Inca pageantry, religious rituals, and political intrigue, the impressive Pampa was converted to farmland. The transformation of the space culminated in the renaming of the Pampa as Capillapampa ("field of the chapel").

57. Ordinance 112 states, "The main plaza is to be the starting point for the town." Crouch, Garr, and Mundigo, *Spanish City Planning*, 13. Ordinance 124 states that the temple should not be placed on the plaza but near it. While buildings related to the government should be built right on the plaza, "the Temple in inland places shall not be placed on the square but at a distance and shall be separated from any other nearby building, or from adjoining buildings, and ought to be seen from all sides so that it can be decorated better, thus acquiring more authority; efforts should be made that it be somewhat raised from ground level in order that it be approached by steps, and near it, next to the main plaza, the royal council and *cabildo* and customs houses shall be built. [These shall be built] in a manner that would not embarrass the temple but add to its prestige. The hospital for the poor who are not affected by contagious diseases shall be built near the temple and near its cloister, and the [hospital] for contagious diseases shall be built in an area where the cold north wind blows, but arranged in such a way that it may enjoy the south wind," Ibid., 15. Ordinance 126 states that "in the plaza, no lots shall be assigned to private individuals; instead, they shall be used for the buildings of the church and royal house and for city use, but shops and houses for the merchants should be built first, to which all the settlers of the town shall contribute, and a moderate tax shall be imposed on goods so that these buildings may be built." Ibid., 15–16.

58. Soqta Cuchu was likely preserved in the colonial period because it was the main road between Cuzco and the center of Chinchero. The road had ritual functions during the imperial Inca period. In the colonial period, an addition to the terrace road was built with considerable effort. In deciding to keep the road, it appears there was an effort to try to redefine the religious presence on the street as Christian.

59. Ibid., 14. Ordinance 114 states: "From the plaza shall begin four principal streets: One [shall be] from the middle of each side, and two streets from each corner of the plaza; the four corners of the plaza shall face the four principal winds, because in this manner, the streets running from the plaza will not be exposed to the four principal winds, which would cause much inconvenience," Ibid.

60. This use of arches is a central thesis in Valerie Fraser's book *The Architecture of Conquest*, and has been argued by scholars such as Harold Wethey and Pal Kelemen. Fraser, *The Architecture of Conquest: Building in the Viceroyalty of Peru 1535–1635* (Cambridge: Cambridge University Press, 1990).

61. In their excavations, the Spanish Mission found two pathways, or small streets, leading from the western entrance of the church to the two gates of the Virgin. These roads were close to the surface, which Alcina Franch interpreted as being due to the streets' continuous use. The existence of these roads in the colonial period supports the interpretation that these two gates were spatial and ritually connected to the church. José Alcina Franch, *Arqueología de Chinchero 1: La arquitectura* (Madrid, Spain: Ministerio de Asunto Exteriores, 1976), 91.

Due to the excavation and exposure of P5, the atrium and its colonial spatial practices were ruptured. The result is that the Virgin's statue is now carried up and down the staircase made out of the ashlar andesite lintels from a dismantled imperial Inca building. This is the most practical movement, as the excavation of the *cuyusmanco* (P5) prevented the use of the northern arch, and erosion has made movement on the southern arch risky. Regardless of the direction of the processions, the arches are still described as belonging to the Virgin and as being related to her movement in and out of the church. Susan Niles reports that in 1977 she observed dancers and marchers using both arches devoted to the Virgin during Holy Week (Niles, personal communication).

62. Thomas Cummins and Joanne Rappaport have shown that the liturgical and civic documents used to impose order on the New World had parallels in the construction of religious and civic buildings. Cummins and Rappaport, "The Reconfiguration of Civic and Sacred Space: Architecture, Image, and Writing in the Colonial Northern Andes," *Latin American Literary Review* 26, no. 52 (1998): 174–200.

63. In 601 AD, Pope Gregory argued that it was easier to convert people to Christianity if the power of place was kept. Sabine MacCormack, "From the Sun of the Incas to the Virgin of Copacabana," *Representations* 8 (1984): 30.

64. Toledo, *Gobernantes del Perú*, 171. See also Dean, "The Ambivalent Triumph," 173; Rubén Vargas Ugarte, ed., *Concilios limenses (1551–1772)*, vol. 1 (Lima, Peru: Tipografía Peruana S.A., 1951), 253; John H. Rowe, "La Constitución Inca Del Cuzco," *Historica* 9, no. 1 (July 1985): 99.

65. Brian S. Bauer, *The Sacred Landscape of the Inca: The Cusco Ceque System* (Austin: University of Texas Press, 1998), 66.

Samuel Y. Edgerton describes a similar dynamic in the southwest of what is now the United States. He believes that *kivas* were built in some early churches in order to show the low position of Indian beliefs in contrast to Christianity. Edgerton, *Theaters of Conversion: Religious Architecture and Indian Artisans in Colonial Mexico* (Albuquerque: University of New Mexico Press, 2001).

66. There is no evidence that allows us to date when these chapels were built. As they are small chapels, it is likely that they were erected with little written documentation. In the archives, there is a reference to a chapel being built at Chinchero, but the citation appears to be referring to Chinchero as a parish, effectively the estate of Topa Inca, and not the actual town of Chinchero. See de San Lucas, "De la religion bettlemica Presidente del convento," in which a passage relates that a church (Capilla) and *cofradía* were founded in June 1693 for the souls in purgatory, but no specific location is given. In the colonial documents, the church of Nuestra Señora de Montserrat is always described as a "templo."

67. Tomás Huaman, personal communication. González Holguin defines *çacra* as "cosa tosca, vil or baladi, o mal hecha, o basta o suzia" (rough thing, trivial or vile or poorly made, or

rough or dirty). Diego Gonzalez Holguin, *Vocabvlario de la lengva general de todo el Perv llamada lengua qquichua o del Inca [1608]*, prologue by Raúl Porras Barrenechea, edición facsimilar de la versión de 1952 ed. (Lima, Peru: Universidad Nacional Mayor de San Marco, Editorial de la Universidad, 1989), 75. Its contemporary equivalent is the Quechua *saqra*, which is defined today as "diablo, demonio" and "espíritu maligno." It is related to the verb *supay*. *Diccionario quechua-español-quechua / simi taqe qheswa-español-qheswa* (Cuzco, Peru: Municipalidad del Qosqo, 1995), 547. In the colonial period, *çupay* was defined as "el demonio" (the devil) and *çupan* as "la sombra de persona, o animal" (the shade of a person or animal). Gonzalez Holguin, *Vocabvlario de la lengva . . . [1608]*, 88. The Quechua *sacrara* may be related to the Aymara word *sacarara*, meaning "yerva llanten" (the screaming or crying herb). Ludovico Bertonio, *Vocabulario de la lengua Aymara*, Serie Documentos Históricos (Cochabamba, Bolivia: Centro de Estudios de la Realidad Económica y Social, 1984), 2:305.

68. Jacinto Singona defines *uspapata* as "ash terrace." (Singona, personal communication.) Bauer translates *uspa* as coming from the word *uchpa*, which means "ash" (Bauer, *The Sacred Landscape of the Inca*), and *pata*, meaning "terrace," so this would have been the "terrace of ash."

69. For a study of the importance of views of the landscape at Machu Picchu, see Catherine Julien, "La metafora de la montana," *Humboldt* 31, no. 100 (1990). Johan Reinhard's study of the sacred landscape of Machu Picchu also highlights the significance of visual connections between architecture and sacred spaces. Reinhard, *Machu Picchu: The Sacred Center* (Lima, Peru: Nuevas Imágenes S.A., 1991). Jean-Pierre Protzen discusses the importance of views and spatial progression in the Urubamba Valley. Protzen, *Inca Architecture and Construction at Ollantaytambo* (New York: Oxford University Press, 1993).

70. The anonymous author defines *paccha* as "fuente, chorro de agua, canal, caño, pico del vaso" (fountain, water spout, canal, water faucet, glass rim). Anonymous, *Arte y vocabulario en la lengua*, leaf Gg 6 verso. Jacinto Singona, a resident of Chinchero, told me that the cross is believed to have originally come from a chapel on the Inca road to Urcos (Urquillos), which had been called *Inticapilla* (chapel for the sun). If true, this suggests that the cross had been used to mark a sacred Inca site at another location. Susan Niles remembers seeing this chapel in 1977 (Niles, personal communication).

When I first visited the chapel in 2000, erosion, neglect, and trash had damaged the site, yet water streamed past the cross and down a small but steep slope. By 2011, the area had been completely redone. The cross was gone, the river was canalized, and a new, larger chapel had been built.

71. It can be described as a "corporate landholding collectivity self-defined as ancestry-focused kindred." Salomon, *The Huarochirí Manuscript*, 21. See also ibid., 21–23. For a brief description of *ayllu* see Karen Spalding, "Kurakas and Commerce: A Chapter in the Evolution of Andean Society," *Hispanic American Historical Review* 53, no. 4 (November 1973): 583. The anonymous author defines *ayllu* as "tribu, genealogia, casa, familia" (tribe, genealogy, family house). Anonymous, *Arte y vocabulario en la lengua*, leaf Aa 6 recto. González Holguin defines *ayllu* as "parcialidad genalogía linage, o parentesco, o casta" (genealogical or lineage faction, or breed line) and "el genero, o especie en las cosas" (type, kind, genus, or species of things). Gonzalez Holguin, *Vocabvlario de la lengva . . . [1608]*, 39.

72. Chinchero residents participate in the grueling *Qoyllur Rit'i* pilgrimage. This is an indigenous pilgrimage involving *huaca*, *apu* veneration, as well Christian observances involving a mass, a church, and a cross. The community of dancers carry the image of Señor de Huanca, a venerated image that is housed in the Huancapata chapel and cared for by the Ayllupongo community. This image is carried to a sacred outcrop and mountain peak as part of the Christian pilgrimage. For a discussion of the pilgrimage of *Qoyllur Rit'i*, in particular its relationship to Andean religion and Christian co-option, see Michael J. Sallnow, *Pilgrims of the Andes: Regional Cults in Cusco* (Washington, DC: Smithsonian Institution Press, 1987).

73. These territories are not confined only to the town, but extend well into the larger landscape (e.g., Cupir lands, which are shared with other Cupir *ayllu*, such as Cuper Alto and Cuper Bajo, extend from Chinchero to Lake Piuray).

74. The arch closest to the church (P17) marks the point of entry of the Inca road Soqta Cuchu and is known as Cupir Ayllu's Arch. This road leads to the section of the town belonging to the people of Cupir and their chapel. The arch leading from the Inca street Cheque Punku into the plaza is known as the arch of the Ayllupongo *ayllu* and it highlights the road that leads to Ayllupongo's sector of town and its own chapel. The arch for the Yanacona *ayllu* leads into the plaza from the colonial street Cahuide. Like the other arches, this one leads to the part of town belonging to its namesake *ayllu*, as well as the *ayllu*'s chapel. Thus, each of the three arches that mark the transition between the new colonial center and the town have been named for a local indigenous group, marking the direction of the town sectors in which each lineage group lives and where they have their individual chapels.

75. In discussing the K'ulta in Bolivia, Thomas Abercrombie relates that community members who mediate between the state and the community also have to "memorize lists of mojones and walk the border they define in a yearly commemorative ritual akin both to colonial land judges' demarcation and possession ceremonies and to Inca wak'a rites along ceque lines." Abercrombie, *Pathways of Memory and Power: Ethnography and History among an Andean People* (Madison: University of Wisconsin Press, 1998), 10.

76. Dean points out that the arch was used not only for Christian purposes in colonial Peru, but also to mark secular authority. The arch was used to signify Spanish authority in Lima, as well as being used for a variety of Christian ceremonies. Carolyn Dean, *Inka Bodies and the Body of Christ: Corpus Christi in Colonial Cuzco, Peru* (Durham, NC: Duke University Press, 1999), 18–21.

Arches were also used in the private homes in Chinchero, thus in secular contexts.

The distribution of public architecture among the *ayllus* has other parallels in the Andes. Gary Urton found that in the town of Pacariqtambo (in the Cuzco region) distinct *ayllus* were responsible for individual sections of the church wall. Urton, "La arquitectura pública como texto social: La historia de un muro de adobe en Pacariqtambo, Perú (1915–1985)," *Revista Andina* 6, no. 1 (1988): 225–61.

77. Abercrombie, *Pathways of Memory and Power*, 130.

78. Mumford, *Vertical Empire*; Steven A. Wernke, "Negotiating Community and Landscape in the Peruvian Andes: A Transconquest View," *American Anthropologist* 109, no. 1 (2007); Wernke, *Negotiated Settlements: Andean Communities and Landscapes under Inka and Spanish Colonialism* (Gainesville: University Press of Florida, 2013).

79. "El repartimiento de Cupirpongo Tambococha y Amantoy tiene en encomienda en segunda vida don Francisco de Loaysa" (the land distribution of Cupirpongo, Tambococha and Amantoy has been entrusted for a second time/generation to Don Francisco de Loaysa). Francisco de Toledo, *Tasa de la visita general de Francisco de Toledo*, trans., introduction, and transcription by Noble David Cook (Lima, Peru: Universidad Nacional Mayor de San Marcos, 1975), 162.

80. María Rostworowski de Diez Canseco, "Los Ayarmaca," *Revista del Museo Nacional* 36 (1970): 58–101.

81. "Los Indios de Chinchero (the Indians of Chinchero) are working for the *curaca* (*kuraka*) in the town of Yucay—a native Cañari named Francisco Chilche." Horacio Villanueva Urteaga, "Documentos sobre Yucay en el siglo XVI," *Revista del Archivo Histórico del Cuzco* 13 (1970): 35.

Salomon notes that while *curaca* referred to a "ruler" or leader of a community, in actuality the word "derives from a root denoting priority in rank (especially birth order), not sovereignty." He explains that the meaning of *curaca* changed during the Spanish occupation of the Andes, "toward Spanish ideas of nobility and estate-based privilege." Salomon, *The Huarochirí Manuscript*, 63, fn 150.

82. However, this information is not mentioned in later publications, nor is the argument that in 1595 land in Chinchero was redistributed again, and this time Indians were given land. Manuel Ballesteros-Gaibrois, "Etnohistoria de la sierra peruana (Chinchero)," *International Congress of Americanists* 40, no. 2 (1972): 424. Captain Martín García de Loyola must have had Chinchero for a very brief period before lands were redistributed. Parts of Chinchero were in the hands of Guaco Ocllo by 1579, and some buildings in Chinchero may have been given to Manco's son, Sayri Tupac. Ibid., 423.

83. Chinchero became part of a *repartimiento* of Loyola in 1575 because of his wife's inheritance as an Inca princess. She had major landholdings, especially of royal lands in the Urubamba Valley. Ibid, 424.

84. Juan de Quiroz and Ana Guaco Ocllo, "Sepan quanto esta carta de donacion vieren. Como yo Doña Angelina Guaco Ocllo" (Cuzco, Peru: Archivo Departamental del Cusco, 1579); Antonio Sanchez, "Estos domingo," unpublished document, Cuzco, Peru, Archivo Arzobispal del Cuzco, 1583–1584.

85. Heidi V. Scott, *Contested Territory: Mapping Peru in the Sixteenth and Seventeenth Centuries*, History, Languages, and Cultures of the Spanish and Portuguese Worlds (Notre Dame, IN: University of Notre Dame Press, 2009).

86. Magnus Mörner, "Continuidad y cambio en una provincia del Cuzco: Calca y Lares desde los años 1680 hasta los 1790," *Historia y Cultura: Revista del Museo Nacional de Historia* 9 (1975): 100–101, 103.

87. *Asisten* means to participate, attend, or assist in help. Today, a greater variety of crops are grown in Chinchero, including European plants such as wheat, suggesting that it may have been the *choice* of residents not to grow European crops in the early colonial period. It is unclear whether the predominance of Andean crops was because local residents preferred traditional Andean crops or because residents chose to grow only indigenous crops to make their land less appealing to Spaniards trying to take over. We have to consider the possibility that the perception of Chinchero's land as a tuber-only growing landscape did not reflect environmental restrictions but may have been an image that was carefully and intentionally cultivated by the local Chinchero residents.

88. The diocese of Chinchero fell under the control of the province of Calca and Lares in the Urubamba Valley (under the archbishop of Cuzco). Horacio Villanueva Urteaga, *Cusco 1689: documentos, economía y sociedad en el sur andino* (Cuzco, Peru: Centro de Estudios Rurales Andinos "Bartolomé de las Casas," 1982), 278. Chinchero was part of the Province of Calca and Lares until 1905, when it was moved to the church province of Urubamba. Mörner, "Continuidad y cambio en una provincia del Cuzco," 91.

89. Villanueva Urteaga, *Cusco 1689*, 279.

90. The names of their respective Spanish owners were M. Rodríguez, F. Durán, J. Bermudo De Rivera, and A. Ortiz.

91. He lists the inhabitants of the town and diocese along with their *ayllu* affiliation. The people living in the *estancias* of Chuso, Chiripata, Taucamarca, and Cupir are also listed, as are the *hacienda* of Guaypon (Huaypon), which was still being run by the Mercedarians, and the nearby town of Umasbamba, described as a *repartimiento*.

92. There is an addendum to the census for a count of people in the *estancia* of Sequeccancha. Sebastian Mendoza et al., "Repartimiento septimo del pueblo de Chinchero, doctrina de estte nombre, dista de la capital seys leguas. ___ que contras de los libros parroquiales de este pueblo caueza de doctrina, segun la certificacion puesta de la reconocimiento desde el año de 722, es lo siguiente," in *Libros de Matriculo, Industria, Indígenas y Eclesiásticas: Provincia de Calca (1722–1887)* (Cuzco, Peru: Archivo Arzobispal del Cuzco, 1772).

93. Mörner, "Continuidad y cambio en una provincia del Cuzco," 13.

94. Ibid., 90. Pablo Garcia has noted that one *hacienda* remained throughout the colonial period (Dissertation, in progress).

95. It is therefore not surprising that the old Inca roads leading out of Chinchero, Pisac, and Lamay were recorded as being in good condition, suggesting that Chinchero remained a key stopping point between the Urubamba Valley and Cuzco (and thus was a vibrant node in indigenous networks). Ibid., 105.

96. It is possible that at some point between the times of the various documents, a Spaniard had ownership or some level of control over Chinchero. Yet, even if this was the case, it appears to have been for only a short period and did not result in a Spanish population, other than the occasional priest, living in Chinchero. Therefore, while the surviving documents do not rule out extended Spanish ownership of Chinchero, they do suggest that Chinchero often functioned as a relatively independent indigenous town.

97. "As Priest of the parish of Montserrat and Maras, I, Don Mejia ordered that this church be built and built it, had it roofed, and [ordered] the following works. ____ the main chapel and with the craftsmanship of ___ God, the altars of Saint John, Saint Sebastian, and Saint James, the painting of the body [of the church], the choir, the baptistery and the sacristy. ____ Main entrance doors, bell tower. _____ Cibaria [altar or container where sacred relics are kept], monstrance [display container for Eucharistic wafer], processional cross, ____ an embroidered and decorated _____, silver altar trappings, altar frontal and religious statues by the grace of God. _____ By the hand of Don Diego _____, majordomo Tomas Chama, _____, the years from 1603 to 1607" (author's translation).

98. The buttress system on the church is unusually heavy for the chapel's small size. The exceptionally large buttresses may have been added over time, as they appear smaller on a 1693 painting that depicts the church. Also, Stephen Tobriner noted that the elevations of the church show the east and west walls to be of distinctly different construction, suggesting that one wall may have been damaged at a certain point and been rebuilt (Tobriner, personal communication, 2000).

99. There were originally three doors in each of the long walls in the imperial Inca *cuyusmanco*.

100. One reason the builders would have gone to such lengths to augment the visibility of the *cuyusmanco* on the north façade is that this part of the estate was the Pampa, the core performative space of Topa Inca. The new church overlooks not only the Pampa, but also the impressive terraces and the sacred *huaca* (Chinkana, Condorcaca, Titicaca, and Pumacaca), all of which were miraculously spared from the destructive colonial grid. Many of these *huaca* were venerated until the late twentieth century, suggesting that during the colonial period, this part of Topa Inca's royal estate continued to be held in great reverence.

101. Many people in Chinchero told me that the stones came from Antakilka, as that is the only source for andesite. Indeed, geologically, it is the only place where andesite exists within a

day's walk. Antakilka is a forbidding mountain due to its steepness and many sheer cliffs. Wherever they brought andesite from, it would have been an arduous and dangerous journey. Domingo de Santo Tomás defines *anta* as "cobre, o alambre" (copper, metallic thread). Santo Tomás, *Lexicón o vocabulario de la lengua general del Perú [1560]*, facsimile ed. (Lima, Peru: Universidad Nacional Mayor de San Marcos, 1951), 235. González Holguin defines *anta* as "metal o cobre. *Puca anta*, el cobre simple. *Chacrusca, o hichhascca anta,* bronze el metal de las campanas" (metal or copper. *Puca anta*, simple copper. *Chacrusca, o hihascca anta,* bronze the metal of the bells). Gonzalez Holguin, *Vocabvlario de la lengua . . . [1608]*, 28. There is no definition for *kilke* in either dictionary.

102. Valerie Fraser argues that lintels were used only for civic buildings in the colonial Andes, while arches were reserved for religious architecture. She states that this was done incorrectly only in rare cases in the first couple of decades after the invasion. Fraser cites only one late example, a case in 1610 when an Italian immigrant built one. She argues that he, as a recent immigrant, was unaware of the unwritten rule against lintel doorways in Christian churches. Fraser, "Architecture and Imperialism in Sixteenth-Century Spanish America," *Art History* 9, no. 3 (1986): 326, 328–29.

103. Jean-Pierre Protzen, personal communication. While I was showing Protzen the wall at Chinchero, he noted the unfinished surface on the tops of the uppermost layer of finely worked masonry in one niche. We subsequently examined all the stones on this layer throughout the nine-niched wall and found that all of them were in the same state of incompletion.

104. This is discussed in Alcina Franch, *Arqueología de Chinchero 1: La arquitectura*, 91–93.

105. José Alcina Franch suggested that there was a slow transition from the imperial Inca to the Spanish colonial period. Alcina Franch, "Excavaciones en Chinchero (Cuzco): Informe preliminar," *Internationalen Amerikanischenkongresses* 38, no. 1 (1969): 427.

106. Alcina Franch notes that this wall was built in the colonial period. Alcina Franch, *Arqueología de Chinchero*, 90–91. Only a portion of the original colonial stucco remains today, as the majority of it was mistakenly removed during the building's excavation.

107. Although most structures have been lost over time, a significant number remain in the southern part of town to varying degrees of preservation. According to local oral history, this area was occupied during the colonial period, when people living around Lake Piuray fled to Chinchero from the encroaching Spaniards. These immigrants are said to have just as quickly abandoned this portion of Chinchero once they were able to leave. Little has been built on this site since colonial times. Today, Chinchero residents state that no one wants to live in this part of town because there are no water sources. Most people who own land in this sector today do not live there. Instead, they use the existing buildings for storage and the land for occasional dry farming. Many of the colonial adobe buildings have

collapsed or deteriorated into indistinguishable piles; however a few buildings that have been re-roofed remain standing.

108. Thomas Cummins, "Forms of Andean Colonial Towns, Free Will, and Marriage," in *The Archaeology of Colonialism: Issues & Debates*, ed. Claire L. Lyons and John K. Papadopoulos (Los Angeles: Getty Research Institute, 2002).

109. The placement of arches alongside niches inside of indigenous homes is an important find. Traditionally arches have been seen as signs of Christian/European domination. Fraser argues that arches were used solely by the Roman Catholic Church to express power, and arches are never found in private homes in the Andes. Fraser, "Architecture and Imperialism," 326. Evidence at Chinchero indicates that Andeans actively co-opted the arch, not only as a symbol of the Church but also as a symbol of the Spanish, integrating the arch seamlessly into colonial domestic architecture.

110. This street name is not known by most of the Chinchero residents, as no one lives there anymore. I found only a few people who knew its name, which is *Sandowascana*. They reported that *Sando* is a Spanish word, while *wasqhana* is Quechua and meant rope (Jacinto Singona, personal communication). Until this name appeared, my crew and I called it Calle Excremento, in reference to the animal sewage on the street during the rainy season. It is not surprising that most people don't walk this road, preferring other streets in Chinchero.

There is no Spanish word "sando." If this was a Spanish word, it is possible that the word came from "sandio" (foolish) or "santo" (holy, saint). In the work of the anonymous author, there is not a *sando,* but there is a *sañu,* which is defined as "loça, o cosa de hecha de barro" (ceramic, or something made from clay). *Sañu huaci* is "casa de teja" (house of adobe bricks). Anonymous, *Arte y vocabulario en la lengua,* leaf Ee 5 verso. González Holguin also does not list a *sando* but there is a *sañu,* which he translates as "la loça cozida" (fired clay) and *sañuhuaci* as "casa de teja, o orno de teja o olleria" (house of adobe bricks, or oven of clay and ceramics). Gonçalez Holguin, *Vocabulario de la lengua,* book 1, leaf X 2 recto. Santo Tomás defines *saño* as "barro de ollas" (earthenware pots) and "loça, vasso de barro" (slab, tile, or vase of clay). Santo Tomás, *Lexicón o vocabulario de la lengua,* 350.

The anonymous author defines *huasca* as "soga o cordel" (rope or cord). Anonymous, Arte y vocabulario en la lengua, leaf Ee 5 verso. González Holguin defines *huasca* as "soga, o cordel gordo" (rope or thick cord). Gonçalez Holguin, *Vocabulario de la lengua,* 1, leaf M 2 verso. Santo Tomás defines *guasca o guacora* as "soga o cordel generalmente" (rope or cord generally). Santo Tomás, *Lexicón o vocabulario de la lengua,* 287.

111. Today, the street name is translated by residents to mean "fountain." Unlike the way the name is spelled on the Spanish Mission's map, a resident spelled the street name as *paqchapukyo,* thereby making a clear distinction between *pacha* (time) and *ppaqcha* (fountain) (Jacinto Singona, personal communication). The anonymous author defines *pacha* as "tiempo,

suelo, lugar, ropa, vestidura" (time, ground, place, rope, clothing). Anonymous, *Arte y vocabulario en la lengua,* leaf Gg 6 verso. González Holguin defines *ppaccha* as "fuente, chorro de agua, canal, caño" (fountain, water spout, canal, spring). Gonçalez Holguin, *Vocabulario de la lengua,* 1, leaf R 5 recto. Santo Tomás defines *paccha* as "fuente de agua, que sale de alto" (water spout, that falls from above), "pila de agua" (water basin), "canal de tejado" (roofed canal), and "chorro de agua" (jet of water). Santo Tomás, *Lexicón o vocabulario de la lengua,* 334.

The anonymous author defines *pucyu* as "fuente, manantial de agua, y mollera de la cabeça" (fountain, water spring, crown on top of the head). Anonymous, *Arte y vocabulario en la lengua,* leaf Hh 4 recto. González Holguin defines *pukyu* as "fuente o manantial, y vmappukyun la mollera" (fountain or water spring, crown, on top of the head). Gonçalez Holguin, *Vocabulario de la lengua,* 1, leaf T 2 verso. Santo Tomás defines *pucyo* as "fuente manantial, o pozo" (a fountain spring or well) and "manadero, o manátial gñralmete" (generally flowing or spring). *Pucyu* is defined as "algibe, o cisterna de agua" (tank or cistern of water), and *pucyo pucyu* is defined as "fontanal, lugar de fuentes" (springs or a place with springs). Santo Tomás, *Lexicón o vocabulario de la lengua,* 342.

112. This doorway was not proportioned like any of the imperial Inca doorways surviving at the site. Rather, it was similar in proportion to the two largest niches in the long imperial Inca niche wall currently dividing the church atrium and the lower plaza.

113. These buildings contain a variety of arrangements of niches, doors, and so on. For example, in Block 4, near the colonial plaza, there is a colonial adobe wall on top of the terrace. It was a two-story building. All the niches are of similar size in a single horizontal arrangement, which is typical. However, all the niches are well-made arches, obviously of Spanish influence. Another area, lower in town, on the street Simacuchu, has the remains of a badly deteriorated colonial house that has both arches and niches, with the remains of an Inca wall. It probably belonged to a *cancha* that had been reutilized in the colonial period.

The street name Simacuchu can be translated as "the corner by the *sima* plant" (Jacinto Singona, personal communication). According to C. Franquemont, *sima pasto* is a Gramineae, *Nasella pubiflora,* a plant use to thatch roofs, while *sima pasto* is a Gramineae, *Poa horridula,* which has no reported use. Christine Franquemont, "Chinchero Plant Categories: An Andean Logic of Observation" (Dissertation, Cornell University, 1988), 177.

114. In these openings, the threshold is very high, higher than the average doorway, but lower than the normal window-sill. Therefore, it is unclear whether these were doorways or windows.

115. Although there is little scholarship on Spanish vernacular architecture, especially of the early modern period, what is available suggests that an internal, large oven is a standard

feature of domestic homes. This oven is different from the large communal oven also referred to in scholarly sources. This type of oven was found in this building group.

116. Abercrombie, *Pathways of Memory and Power*, 21.

117. Stella Nair, "Localizing Sacredness, Difference, and Yachacuscamcani in a Colonial Andean Painting," *Art Bulletin* 89, no. 2 (2007): 211–38.

118. González Holguin defines *llacta* as "pueblo" (town). Gonzalez Holguin, *Vocabvlario de la lengva . . . [1608]*, 208. Santo Tomás states that *llacta o marca* is "ciudad, o pueblo generalmente" (city, or generally a town). He also defines *llacta* as "lugar generalmente donde es cada uno" (generally a place where everyone is). Santo Tomás, *Lexicón o vocabulario de la lengua*, 306. The anonymous author defines *llacta* as "pueblo" and *llacttachani* as "poblar" (populate). Anonymous, *Vocabulario y phrasis en la lengua general de los indios del Perú, llamada quichua, y en la lengua española*, 5th. ed. (Lima, Peru: Universidad Nacional Mayor de San Marcos, Instituto de Historia de la Facultad de Letras, 1951), 53. A *llacta* was a place where people gathered to live together and seems to have ranged in size from a city to a small village. It is defined by the closeness of people (rather than by the architectural attributes or density) and the relationship between its population and the architectural fabric.

119. Abercrombie, *Pathways of Memory and Power*, 19.

120. Ibid., 319.

Epilogue

1. Thomas A. Abercrombie, *Pathways of Memory and Power: Ethnography and History among an Andean People* (Madison: University of Wisconsin Press, 1998), 359.

2. For a discussion of the complex ways in which tourism has driven change in Cuzco, see Helaine Silverman, "The Historic District of Cusco as an Open-Air Site Museum," in *Archaeological Sites Museums in Latin America*, ed. Helaine Silverman (Gainesville: University Press of Florida, 2006); Silverman, "The Space of Heroism in the Historic Center of Cuzco," in *On Locations: Heritage Cities and Sites*, ed. D. Fairchild Ruggles (New York: Springer, 2012); Silverman, "Mayor Daniel Estrada and the Plaza de Armas of Cuzco, Peru," *Heritage Management* 1, no. 2 (2008): 181–218.

3. The impact of tourism on our understanding of Inca history and landscape is immense. In her study of contemporary tourism's relationship to Inca stones, Carolyn Dean concluded, "While stones were once understood to take form of their own volition, they now take form in the tourist imagination, and the tourist has become the primary producer of meaning." Dean, A *Culture of Stone: Inka Perspectives on Rock* (Durham, NC: Duke University Press, 2010), 22.

4. Pablo Garcia, "Blessing or Curse? The Chinchero Airport," *Cultural Survival* 2014, https://www.culturalsurvival.org/news /blessing-or-curse-chinchero-airport.

BIBLIOGRAPHY

Abercrombie, Thomas A. *Pathways of Memory and Power: Ethnography and History among an Andean People.* Madison: University of Wisconsin Press, 1998.

Adorno, Rolena. "Guaman Poma de Ayala, Felipe (Ca. 1535–50–Ca. 1616)." In *Guide to Documentary Sources for Andean Studies, 1530–1900,* edited by Joanne Pillsbury, 255–68. Norman: University of Oklahoma Press, 2008.

———. *Guaman Poma: Writing and Resistance in Colonial Peru.* 2nd ed. Austin: University of Texas Press, 2000.

Adorno, Rolena, Tom Cummins, Teresa Gisbert, Maarten van de Guchte, Mercedes López-Baralt, and John V. Murra. *Guaman Poma de Ayala: The Colonial Art of an Andean Author.* New York: Americas Society, 1992.

Agnew, John A. *Place and Politics: The Geographical Mediation of State and Society.* Boston: Allen & Unwin, 1987.

Agurto Calvo, Santiago. *Cusco, la traza urbana de la ciudad Inca.* Cuzco, Peru: UNESCO and Instituto de Cultura del Perú, 1980.

———. *Estudios acerca de la construccion arquitectura y planeamiento Incas.* Lima, Peru: Cámara Peruana de la Construcción, 1987.

Alcina Franch, José. *Arqueología de Chinchero 1: La arquitectura.* Madrid, Spain: Ministerio de Asunto Exteriores, 1976.

———. "Excavaciones en Chinchero (Cuzco): Informe preliminar." *Internationalen Amerikanischenkongresses* 38, no. 1 (1969): 421–28.

Allen, Catherine J. *The Hold Life Has: Coca and Cultural Identity in an Andean Community.* Smithsonian Series in Ethnographic Inquiry, edited by William L. and Ivan Karp Merrill. Washington, DC: Smithsonian Institution Press, 1988.

Anonymous. *Arte y vocabulario en la lengua general del Peru, llamada quichua, y en la lengua española.* Seville, Spain: En Casa de Clemente Hidalgo, 1603.

———. *Vocabulario y phrasis en la lengua general de los indios del Perú, llamada quichua, y en la lengua española.* 5th ed. Lima, Peru: Universidad Nacional Mayor de San Marcos, Instituto de Historia de la Facultad de Letras, 1951.

Arnold, Dean E. *Ecology and Ceramic Production in an Andean Community.* 1st paperback ed. New Studies in Archaeology. Cambridge: Cambridge University Press, 2003.

Arnold, Denise. "The House of Earth-Bricks and Inka-Stones: Gender, Memory, and Cosmos in Qaqachaka." *Journal of Latin American Lore* 17 (1991): 3–69.

Arriaga, Pablo Joseph de. "La extirpación de la idolatría del Pirú [1621]." In *Crónicas peruanas de interés indígena*, edited by Francisco Esteve Barba, Biblioteca de Autores Españoles, 191–277. Madrid, Spain: Ediciones Atlas, 1968.

Avendaño, Hernando de. "Relación sobre la idolatría; Letter Written in Lima (Los Reyes) on 3 April 1617." In *La imprenta en Lima (1584–1824)*, edited by José Toribio Medina, 380–83. Santiago, Chile: Imprenta Elzeviriana (Impreso del Autor), 1904.

Bachelard, Gaston, M. Jolas, and John R. Stilgoe. *The Poetics of Space.* Boston: Beacon, 1994.

Bákula, Cecilia, Laura Laurencich Minelli, and Mireille Vautier. *The Inca World: The Development of Pre-Columbian Peru, A.D. 1000–1534.* English-language ed. Norman: University of Oklahoma Press, 2000.

Ballesteros-Gaibrois, Manuel. "Etnohistoria de la sierra peruana (Chinchero)." *International Congress of Americanists* 40, no. 2 (1972): 421–31.

Bastien, Joseph. *Mountain of the Condor: Metaphor and Ritual in an Andean Ayllu.* Prospect Heights, IL: Waveland Press, 1978.

Bauer, Brian S. *Ancient Cuzco: Heartland of the Inca.* Joe R. and Teresa Lozano Long Series in Latin American and Latino Art and Culture. Austin: University of Texas Press, 2004.

———. "The Mummies of the Royal Inca." In *Ancient Cuzco: Heartland of the Inca*, 159–84. Austin: University of Texas Press, 2004.

———. *The Sacred Landscape of the Inca: The Cusco Ceque System.* Austin: University of Texas Press, 1998.

Bertonio, Ludovico. *Vocabulario de la lengua Aymara.* Serie Documentos Históricos. 2 vols. Cochabamba, Bolivia: Centro de Estudios de la Realidad Económica y Social, 1984.

Betanzos, Juan de. *Narrative of the Incas (1551).* Translated by Roland Hamilton and Dana Buchanan. Austin: University of Texas Press, 1996.

Blake, Stephen P. *Shahjahanabad: The Sovereign City in Mughal India, 1639–1739.* Cambridge South Asian Studies. Cambridge; New York: Cambridge University Press, 1991.

Bourdieu, Pierre. *Outline of a Theory of Practice.* Cambridge: Cambridge University Press, 1977.

Bray, Tamara L. "Inca Iconography: The Art of Empire in the Andes." *Res: Anthropology and Aesthetics* 38 (2000): 120–78, plus bibliography.

———. "Inka Pottery as Culinary Equipment: Food, Feasting, and Gender in Imperial State Design." *Latin American Antiquity* 14, no. 1 (2003): 3–28.

———. "To Dine Splendidly." In *The Archaeology and Politics of Food and Feasting in Early States and Empires*, edited by Tamara L. Bray, 93–142. New York: Kluwer Academic Press, 2003.

Brentano, Franz, Oskar Kraus, and Linda L. McAlister. *Psychology from an Empirical Standpoint.* International Library of Philosophy and Scientific Method. London; New York: Routledge, 1973.

Buttimer, Anne, and David Seamon. *The Human Experience of Space and Place.* London: Croom Helm, 1980.

Casey, Edward S. *The Fate of Place: A Philosophical History.* Berkeley: University of California Press, 1997.

———. *Remembering: A Phenomenological Study.* 2nd ed. Studies in Continental Thought. Bloomington: Indiana University Press, 2000.

Certeau, Michel de. *The Practice of Everyday Life.* Berkeley: University of California Press, 1984.

Cieza de Leon, Pedro de. *The Discovery and Conquest of Peru: Chronicles of the New World Encounter [~1553].* Translated by Alexandra Parma Cook and Noble David Cook. Durham, NC: Duke University Press, 1998.

Classen, Constance. *Inca Cosmology and the Human Body.* Salt Lake City: University of Utah Press, 1993.

Coben, Lawrence S. "Other Cuzcos: Replicated Theaters of Inka Power." In *Archaeology of Performance: Theaters of Power, Community, and Politics,* Archaeology in Society Series, edited by Takeshi Inomata and Lawrence S. Coben, 223–59. Lanham, MD: Altamira Press, 2006.

Cobo, Bernabé. *History of the Inca Empire: An Account of the Indian's Customs and Their Origin Together with a Treatise on Inca Legends, History, and Social Institutions.* Translated by Roland Hamilton. Austin: University of Texas Press, 1991.

———. *Inca Religion and Customs.* Translated by Roland Hamilton. Austin: University of Texas Press, 1994.

Cook, Noble David. *Demographic Collapse: Indian Peru, 1520–1620.* New York: Cambridge University Press, 1981.

———. "Population Data for Indian Peru: Sixteenth and Seventeenth Centuries." *Hispanic American Historical Review* 62, no. 1 (1982): 73–120.

Corominas, Joan. *Breve diccionario etimológico de la lengua Castellana.* Biblioteca Románica Hispánica 5 Diccionarios. Madrid, Spain: Editorial Gredos, 1961.

Covarrubias, Sebastián de. *Tesoro de la lengua Castellana o Española.* Serie Lengua y Literatura, edited by Biblioteca Martin Riquer de la Real Academia Española. Vol. 3. Barcelona, Spain: Editorial Alta Fulla, 1989.

Covey, R. Alan, and Donato Amado González. *Imperial Transformations in Sixteenth-Century Yucay, Peru.* Ann Arbor: Museum of Anthropology, University of Michigan, 2008.

Cresswell, Tim. *In Place/Out of Place: Geography, Ideology, and Transgression.* Minneapolis: University of Minnesota Press, 1996.

———. *Place: A Short Introduction.* Short Introductions to Geography. Malden, MA: Blackwell Publishers, 2004.

Crouch, Dora P., Daniel J. Garr, and Axel I. Mundigo. *Spanish City Planning in North America.* Cambridge, MA: MIT Press, 1982.

Cummins, Thomas. "Forms of Andean Colonial Towns, Free Will, and Marriage." In *The Archaeology of Colonialism: Issues & Debates*, edited by Claire L. Lyons and John K. Papadopoulos, 199–240. Los Angeles: Getty Research Institute, 2002.

———. "Let Me See! Reading Is for Them: Colonial Andean Images and Objects 'Como es costumbre tener los caciques Se-

ñores.'" In *Native Traditions in the Postconquest World*, edited by Elizabeth Hill Boone and Tom Cummins, 91–148. Washington, DC: Dumbarton Oaks Research Library and Collection, 1998.

———. "Queros, Aquilas, Uncus, and Chulpas: The Composition of Inka Artistic Expression and Power." In *Variations in the Expression of Inka Power: A Symposium at Dumbarton Oaks, 18 and 19 October 1997*, edited by Richard L. Burger, Craig Morris, Ramiro Matos Mendieta, Joanne Pillsbury, and Jeffrey Quilter, 267–97. Washington, DC: Dumbarton Oaks Research Library and Collection; distributed by Harvard University Press, 2007.

———. "A Tale of Two Cities: Cuzco, Lima, and the Construction of Colonial Representation." In *Converging Cultures: Art and Identity in Spanish America*, edited by Diane Fane, 157–70. New York: Harry N. Abrams, 1996.

———. *Toasts with the Inca: Andean Abstraction and Colonial Images on Qero Vessels*. Ann Arbor: University of Michigan Press, 2002.

Cummins, Thomas, and Joanne Rappaport. "The Reconfiguration of Civic and Sacred Space: Architecture, Image, and Writing in the Colonial Northern Andes." *Latin American Literary Review* 26, no. 52 (1998): 174–200.

Curatola, Marco, and Mariusz S. Ziólkowski. *Adivinación y oráculos en el mundo andino antiguo*. Colección Estudios Andinos. Lima, Peru: Instituto Francés de Estudios Andinos, Fondo Editorial, Pontificia Universidad Católica del Perú, 2008.

D'Altroy, Terence N. *The Incas*. Malden, MA; Oxford, UK: Blackwell Publishers, 2014.

D'Altroy, Terence N., and Christine Hastorf, eds. *Empire and Domestic Economy*. New York: Kluwer Academic, 2001.

de Montêquin, François-Auguste. "The Planning of Spanish Cities in America: Characteristics, Classification, and Main Urban Features." Hilliard, OH: Society for American City and Regional Planning, 1990.

de San Lucas, Miguel. "De la religion bettlemica Presidente del convento y Hospital del Nuesttra Señora del la Almuderna." Unpublished archive material. Cuzco, Peru: Archivo Arzobispal del Cusco, 1711.

Dean, Carolyn. "The After-Life of Inka Rulers: Andean Death before and after Spanish Colonization." *Hispanic Issues On Line* 7 (Fall 2010): 27–54.

———. "The Ambivalent Triumph: Corpus Christi in Colonial Cusco, Peru." In *Acting on the Past: Historical Performance across the Disciplines*, edited by Mark Franko and Annette Richards, 159–76. Hanover, NH: Wesleyan University Press, 2000.

———. "Copied Carts: Spanish Prints and Colonial Peruvian Paintings." *Art Bulletin* 78, no. 1 (1996): 98–110.

———. *A Culture of Stone: Inka Perspectives on Rock*. Durham, NC: Duke University Press, 2010.

———. *Inka Bodies and the Body of Christ: Corpus Christi in Colonial Cuzco, Peru*. Durham, NC: Duke University Press, 1999.

———. "The Inka Married the Earth: Integrated Outcrops and the Making of Place." *Art Bulletin* 89, no. 3 (2007): 502–18.

———. "Metonymy in Inca Art." In *Presence: The Inherence of the Prototype within Images and Other Objects*, edited by Robert Maniura and Rupert Shepherd, 105–20. Aldershot, UK: Ashgate, 2006.

———. "Rethinking Apacheta." *Ñawpa Pacha* 28 (2006): 24–32.

———. "The Trouble with (the Term) Art." *Art Journal* 65, no. 2 (2006): 24–32.

DeLeonardis, Lisa. "Itinerant Experts, Alternative Harvests: *Kamayuq* in the Service of *Qhapaq* and Crown." *Ethnohistory* 58, no. 3 (2011): 445–90.

Diccionario quechua-español-quechua / simi taqe qheswa-español-qheswa. Cuzco, Peru: Municipalidad del Qosqo, 1995.

Duviols, Pierre. "Un symbolisme andin du double: La lithomorphose de l'ancêtre." In *Actes du XLIIe Congrès International des Américanistes: Congrés du Centenaire: Paris, 2–9 Septembre 1976*, edited by Société des Américanistes de Paris, 359–64. Paris: Société des Américanistes, 1978.

Edgerton, Samuel Y. *Theaters of Conversion: Religious Architecture and Indian Artisans in Colonial Mexico*. Albuquerque: University of New Mexico Press, 2001.

Evans, Susan Toby. "Antecedents of the Aztec Palace: Palaces and Political Power in Classic and Postclassic Mexico." In *Palaces and Power in the Americas: From Peru to the Northwest Coast*, edited by Jessica Joyce Christie and Patricia Joan Sarro, 285–310. Austin: University of Texas Press, 2006.

———. "Aztec Palaces and Other Elite Residential Architecture." In *Palaces of the Ancient New World*, edited by Susan Toby Evans and Joanne Pillsbury. Washington, DC: Dumbarton Oaks Research Library and Collection, 2004.

Farrington, Ian S. *Cusco: Urbanism and Archaeology in the Inka World*. Gainesville: University Press of Florida, 2013.

Farrington, Ian, and Julinho Zapata. "Nuevos cánones de arquitectura Inka: Investigaciones en el sitio de Tambokancha-Tumibama, Jaquijahuana, Cuzco." In *Identidad y transformación en el Tawantinsuyu y en los Andes coloniales. Perspectivas arqueológicas y etnohistóricas, segunda parte*, edited by Peter Kaulicke, Gary Urton, and Ian Farrington. Boletín de Arqueología PUCP. Lima, Peru: Pontifica Universidad Católica del Perú, 2003.

Flood, Finbarr Barry. *Objects of Translation: Material Culture and Medieval "Hindu-Muslim" Encounter*. Princeton, NJ: Princeton University Press, 2009.

Foucault, Michel. *Discipline and Punish: The Birth of the Prison*. New York: Pantheon Books, 1977.

Frame, Mary. "Late Nasca Tassels." In *Andean Art at Dumbarton Oaks*, edited by Elizabeth Hill Boone, 365–73. Washington, DC: Dumbarton Oaks Research Library and Collection, 1996.

Franquemont, Christine. *The Ethnobotany of Chinchero: An Andean Community in Southern Peru*. Fieldiana Botany. Chicago: Field Museum of Natural History, 1990.

Fraser, Valerie. "Architecture and Imperialism in Sixteenth-Century Spanish America." *Art History* 9, no. 3 (1986): 325–35.

———. *The Architecture of Conquest: Building in the Viceroyalty of Peru 1535-1635*. Cambridge: Cambridge University Press, 1990.

Gakenheimer, Ralph. "The Peruvian City of the Sixteenth Cen-

tury." In *The Urban Explosion in Latin America: A Continent in Process of Modernization*, edited by Glenn H. Beyer, 33–56. Ithaca, NY: Cornell University Press, 1967.

Garcia, Pablo. "Blessing or Curse? The Chinchero Airport." *Cultural Survival* (2014). Published electronically 11 February 2014. https://http://www.culturalsurvival.org/news/blessing-or-curse-chinchero-airport.

Garcilaso de la Vega, Inca. *Comentarios reales de los Incas*. 2nd ed. 2 vols. Mexico City, Mexico: Fondo de Cultura Económica, 1995.

———. *Royal Commentaries of the Incas and General History of Peru*. Translated by Harold V. Livermore. 2 vols. Austin: University of Texas Press, 1966.

Gasparini, Graziano, and Luise Margolies. *Arquitectura Inka*. Caracas, Venezuela: Centro de Investigaciones Históricas y Estéticas, Facultad de Arquitectura y Urbanismo, Universidad Central de Venezuela, 1977.

———. *Inca Architecture*. Translated by Patricia J. Lyon. Bloomington: Indiana University Press, 1980.

Gibaja de Valencia, Arminda. "Secuencia cultural de Ollantaytambo." In *Current Archaeological Projects in the Central Andes: Some Approaches and Results*, edited by Ann Kendall. BAR International Series, 225–43. Oxford, UK: BAR, 1984.

Gonzalez Holguin, Diego. *Vocabvlario de la lengua general de todo el Perv llamada lengua qquichua o del Inca [1608]*. Prologue by Raúl Porras Barrenechea. Edición facsimilar de la versión de 1952 ed. Lima, Peru: Universidad Nacional Mayor de San Marcos, Editorial de la Universidad, 1989.

———. [Gonçalez Holguin, Diego.] *Vocabvlario de la lengua general de todo el Perv llamada lengua qquichua, o del Inca*. Ciudad de los Reyes, Peru: Francisco del Canto, 1608.

———. [Gonçález Holguín, Diego.] *Vocabulario de la lengua general de todo el Perú llamada lengua qquichua o del Inca*. Lima, Peru: Universidad Nacional Mayor de San Marcos, 1952.

Gose, Peter. *Deathly Waters and Hungry Mountains: Agrarian Ritual and Class Formation in an Andean Town*. Anthropological Horizons. Toronto: University of Toronto Press, 1994.

———. "House Rethatching in an Andean Annual Cycle: Practice, Meaning, and Contradiction." *American Ethnologist* 18, no. 1 (1991): 39–66.

Guaman Poma de Ayala, Felipe. *Nueva corónica y buen gobierno*. Edited and prologue by Franklin Pease. Vol. 1. Lima, Peru: Fondo de Cultura Económica, 1993.

———. *Nueva corónica y buen gobierno*. Vocabulary and translation by Jan Szeminski. Vol. 3. Lima, Peru: Fondo de Cultura Económica, 1993.

———. *El primer nueva coronica y buen gobierno (1615)*. Coleccion America Nuestra, America Antigua, edited by John V. Murra and Rolena Adorno. Mexico City, Mexico: Siglo Veintiuno Editores, 1980.

Harrison, Regina. *Signs, Songs, and Memory in the Andes: Translating Quechua Language and Culture*. Austin: University of Texas Press, 1989.

Heidegger, Martin. *The Basic Problems of Phenomenology*. Studies in Phenomenology and Existential Philosophy. Bloomington: Indiana University Press, 1982.

———. *Poetry, Language, Thought*. New York: Perennial Classics, 2001.

Hemming, John. *The Conquest of the Incas*. San Diego: Harvest/HBJ, 1970.

Houston, Stephen D., and Thomas Cummins. "Body, Presence, and Space in Andean and Mesoamerican Rulership." In *Palaces of the Ancient New World*, edited by Susan Toby Evans and Joanne Pillsbury, 359–98. Washington, DC: Dumbarton Oaks Research Library and Collection, 2008.

Husserl, Edmund. *Ideas: General Introduction to Pure Phenomenology*. Routledge Classics. London; New York: Routledge, 2012.

Husserl, Edmund, and Ludwig Landgrebe. *Experience and Judgment: Investigations in a Genealogy of Logic*. Northwestern University Studies in Phenomenology & Existential Philosophy. Evanston, IL: Northwestern University Press, 1973.

Husserl, Edmund, and Dermot Moran. *Logical Investigations*. 2 vols. London; New York: Routledge, 2001.

Hyslop, John. *The Inca Road System*. New York: Academic Press, 1984.

———. *Inka Settlement Planning*. Austin: University of Texas Press, 1990.

Isbell, William H. *Mummies and Mortuary Monuments: A Postprocessual Prehistory of Central Andean Social Organization*. Austin: University of Texas Press, 1997.

Isbell, William H., and Gordon F. McEwan, eds. *Huari Administrative Structure: Prehistoric Monumental Architecture and State Goverment*. Washington, DC: Dumbarton Oaks Research Library and Collection, 1991.

Julien, Catherine. "La metafora de la montaña." *Humboldt* 31, no. 100 (1990): 84–89.

———. "On Passing through the Portals of Machu Picchu." In *32nd Annual Meeting of the Institute of Andean Studies*. Berkeley, CA. January 10–11, 1992.

———. *Reading Inca History*. Iowa City: University of Iowa Press, 2000.

Jung, Hwa Yol. *Transversal Rationality and Intercultural Texts: Essays in Phenomenology and Comparative Philosophy*. Series in Continental Thought. Athens: Ohio University Press, 2011.

Kagan, Richard L. *Urban Images of the Hispanic World: 1493–1793*. New Haven, CT: Yale University Press, 2000.

———. "A World without Walls: City and Town in Colonial Spanish America." In *City Walls: The Urban Enceinte in Global Perspective*, edited by James D. Tracy, 117–52. Cambridge: Cambridge University Press, 2000.

Kendall, Ann. *Aspects of Inca Architecture: Description, Function, and Chronology*. BAR International Series. 2 vols. Oxford: BAR, 1984, 1985.

Klein, Cecelia F. "Teocuitlatl, 'Divine Excrement': The Significance of 'Holy Shit' in Aztec Mexico." *Art Journal* 52, no. 3 (1993): 20–27.

Kosiba, Steve, and Andrew M. Bauer. "Mapping the Political Landscape: Toward a GIS Analysis of Environmental and Social Difference." *Journal of Archaeological Method and Theory* 20, no. 1 (2013): 61–101.

Kostof, Spiro, ed. *The Architect: Chapters in the History of the Profession.* Oxford: Oxford University Press, 1997.

Lee, Vincent R. *The Lost Half of Inca Architecture.* Wilson, WY: Sixpac Manco Publications, 1988.

———. "Reconstructing the Great Hall at Inkallacta." In *32nd Annual Meeting of the Institute of Andean Studies.* Berkeley, CA. January 10–11, 1992.

Lefebvre, Henri. *The Production of Space.* Malden, MA: Blackwell Publishing, 1991.

LeVine, Terry. *Inka Storage Systems.* Norman: University of Oklahoma Press, 1992.

MacCormack, Sabine. "From the Sun of the Incas to the Virgin of Copacabana." *Representations* 8 (1984): 30–60.

———. "Pachacuti: Miracles, Punishments and Last Judgement: Visonary Past and Prophetic Future in Early Colonial Peru." *American Historical Review* 93, no. 4 (October 1988): 960–1006.

———. "Religion and Society in Inca and Spanish Peru." In *The Colonial Andes: Tapestries and Silverwork, 1530–1830,* edited by Elena Phipps, Johanna Hecht, Cristina Esteras Martín, Luisa Elena Alcalá, and Metropolitan Museum of Art (New York, NY), 101–13. New York: Metropolitan Museum of Art; New Haven, CT: Yale University Press, 2004.

———. *Religion in the Andes: Vision and Imagination in Early Colonial Peru.* Princeton, NJ: Princeton University Press, 1991.

McEwan, Gordon Francis. *The Incas: New Perspectives.* Understanding Ancient Civilizations. Santa Barbara, CA: ABC-CLIO, 2006.

———. *The Middle Horizon in the Valley of Cuzco, Peru: The Impact of the Wari Occupation of the Lucre Basin.* BAR International Series 372. Oxford, UK: BAR, 1987.

Mendoza, Sebastian, Matheo Pumaccahua Inca, Mattias Ponce de Leon, and P. Villca Nina Toccay. "Repartimiento septimo del pueblo de Chinchero, doctrina de estte nombre, dista de la capital seys leguas. ___ que contras de los libros parroquiales de este pueblo caueza de doctrina, segun la certificacion puesta de la reconocimiento desde el año de 722, es lo siguiente." In *Libros de matriculo, industria, indígenas y eclesiásticas: Provincia de Calca (1722–1887).* Cuzco, Peru: Archivo Arzobispal del Cuzco, 1772.

Mendoza, Zoila S. *Creating Our Own: Folklore, Performance, and Identity in Cuzco, Peru.* English ed. Durham, NC: Duke University Press, 2008.

———. "Exploring the Andean Sensory Model: Knowledge, Memory, and the Experience of Pilgrimage." In *Approaches to Ritual: Cognition, Performance, and the Senses,* edited by Michael Bull and Jonathan Mitchell. New York: Bloomsbury Publishing, 2014.

———. *Shaping Society through Dance: Mestizo Ritual Performance in the Peruvian Andes.* Chicago Studies in Ethnomusicology. Chicago: University of Chicago Press, 2000.

Merleau-Ponty, Maurice. *Phenomenology of Perception.* Translation of *Phénoménologie de la perception.* London: Routledge Classics, 2002.

Merleau-Ponty, Maurice, and John O'Neill. *Phenomenology, Language and Sociology: Selected Essays of Maurice Merleau-Ponty.* London: Heinemann Educational, 1974.

Metcalf, Thomas R. *An Imperial Vision: Indian Architecture and Britain's Raj.* Berkeley: University of California Press, 1989.

Moore, Jerry D. *Architecture and Power in the Ancient Andes: The Archaeology of Public Buildings.* New Studies in Archaeology, edited by Clive Gamble, Colin Renfrew, and Jeremy Sabloff. New York: Cambridge University Press, 1996.

———. *Cultural Landscapes in the Ancient Andes: Archaeologies of Place.* Gainesville: University Press of Florida, 2005.

Mörner, Magnus. "Continuidad y cambio en una provincia del Cuzco: Calca y Lares desde los años 1680 hasta los 1790." *Historia y cultura: Revista del Museo Nacional de Historia* 9 (1975): 8–113.

Morris, Craig. "Enclosures of Power: The Multiple Spaces of Inca Administrative Palaces." In *Palaces of the Ancient New World,* edited by Susan Toby Evans and Joanne Pillsbury, 299–322. Washington, DC: Dumbarton Oaks Research Library and Collection, 2004.

———. "Storage in Tawantinsuyu." Thesis, University of Chicago, 1967.

Morris, Craig, and Donald E. Thompson. *Huánuco Pampa, an Inca City and Its Hinterland.* New Aspects of Antiquity. London: Thames and Hudson, 1985.

Morse, Richard M. "Some Characteristics of Latin American Urban History." *American Historical Review* 67, no. 2 (January 1962): 317–38.

Mumford, Jeremy Ravi. *Vertical Empire: The General Resettlement of Indians in the Colonial Andes.* Durham, NC: Duke University Press, 2012.

Murra, John V. "Cloth and Its Functions in the Inca State." *American Anthropologist* 64, no. 4 (August 1962): 710–28.

———. "El 'control vertical' de un máximo de pisos ecológicos en la economía de las sociedades andinas." In *Visita de la provincia de León de Huánuco en 1562,* edited by J. Murra. Documentos para la Historia y Etnología de Huanuco y la Selva Central, 429–76. Huanuco, Peru: Universidad Nacional Hermilio Valdizan, 1972.

———. *The "Vertical Control" of a Maximum of Ecological Tiers in the Economies of Andean Societies.* Lima, Peru: Institutos de Estudios Peruanos, 1975.

Murúa, Martin de. *Historia del origen y genealogía real de los incas,* edited by Constantino Bayle. Madrid, Spain: Consejo Superior de Investigaciones Cientificas, Instituto Santo Toribio de Mogrovejo, 1946.

———. "Historia general del Perú." *Historia* 16 (1987).

Nair, Stella. "Localizing Sacredness, Difference, and *Yachacuscamcani* in a Colonial Andean Painting." *Art Bulletin* 89, no. 2 (2007): 211–38.

———. "Of Remembrance and Forgetting: The Architecture of Chinchero, Peru from Thupa 'Inka to the Spanish Occupation." Doctoral dissertation, University of California at Berkeley, 2003.

———. "Stone against Stone: An Investigation into the Use of Stone Tools at Tiahuanaco." Master's in Architecture, University of California at Berkeley, 1997.

Nast, Heidi J., and Steve Pile. *Places through the Body*. London; New York: Routledge, 1998.

Niles, Susan. "La arquitectura incaica y el paisaje sagrado." In *La antigua América: El arte de los parajes sagrados*, edited by Richard F. Townsend, 346–57. Mexico City: Grupo Azabache, S.A., 1993.

———. "Inca Architecture and the Sacred Landscape." In *The Ancient Americas: Art from Sacred Landscapes*, edited by Richard F. Townsend, 346–57. Chicago: Art Institute of Chicago, 1992.

———. "Looking for 'Lost' Inca Palaces." *Expedition* 30, no. 3 (1988): 56–64.

———. "The Nature of Inca Royal Estates." In *Machu Picchu: Unveiling the Mystery of the Incas*, edited by Richard L. Burger and Lucy C. Salazar, 49–70. New Haven, CT: Yale University Press, 2004.

———. *The Shape of Inca History*. Iowa City: University of Iowa Press, 1999.

Núñez del Prado, Oscar. "Chinchero: Un pueblo andino del sur." *Revista Universitaria: Organo de la Universidad Nacional del Cuzco* 38, no. 97 (1949): 177–230.

Nuttall, Zelia. "Royal Ordinances Concerning the Laying Out of New Towns." *Hispanic American Historical Review* 5, no. 2 (1922): 249–54.

Ogburn, Dennis E. "Evidence for Long-Distance Transportation of Building Stones in the Inka Empire, from Cuzco, Peru to Saragura, Ecuador." *Latin American Antiquity* 15, no. 4 (2004): 419–39.

Ossio, Juan. "Murúa, Martín De (?–1620)." In *Guide to Documentary Sources for Andean Studies, 1530–1900*, edited by Joanne Pillsbury, 436–41. Norman: University of Oklahoma Press, 2008.

Pachacuti, Juan de Santa Cruz. *Relación de antigüedades de este reino del Perú*, edited, analytical text, and glossary by Carlos Araníbar. Mexico City, Mexico: Fondo de Cultura Económica, 1995.

Pillsbury, Joanne. *Guide to Documentary Sources for Andean Studies, 1530–1900*. Center for Advanced Study in the Visual Arts (U.S.), 3 vols. Norman: University of Oklahoma Press, 2008.

Pizarro, Pedro. *Relación del descubrimiento y conquista del Perú [1570]*. Lima, Peru: Pontificia Universidad Católica del Perú, 1978.

———. *Relation of the Discovery and Conquest of the Kingdoms of Peru*. Translated by Philip Ainsworth Means. 2 vols. Boston, MA: Longwood Press, 1977.

———. *Relation of the Discovery and Conquest of the Kingdoms of Peru*. Translated by Philip Ainsworth Means. 2 vols. New York: Cortes Society, 1921.

Protzen, Jean-Pierre. "Inca Architecture." In *The Inca World: The Development of Pre-Columbian Peru, A.D. 1000–1534*, edited by Cecilia Bákula, Laura Laurencich Minelli, and Mireille Vautier, 193–217. Norman: University of Oklahoma Press, 2000.

———. *Inca Architecture and Construction at Ollantaytambo*. New York: Oxford University Press, 1993.

———. "Inca Quarrying and Stonecutting." *Journal of the Society of Architectural Historians* 44, no. 2 (1985): 161–82.

Protzen, Jean-Pierre, and Stella Nair. *The Stones of Tiahuanaco: A Study of Architecture and Construction*. Los Angeles: Cotsen Institute of Archaeology Press, 2013.

———. "Who Taught the Inca Stonemasons Their Skill? A Comparison of Tiahuanaco and Inca Cut-Stone Masonary." *Journal of the Society of Architectural Historians* 56, no. 2 (1997): 146–67.

Quiroz, Juan de, and Ana Guaco Ocllo. "Sepan quanto esta carta de donacion vieren. Como yo Doña Angelina Guaco Ocllo." Cuzco, Peru: Archivo Departamental del Cusco, 1579.

Rabinow, Paul. "Interview: Space, Knowledge, and Power." In *The Foucault Reader*, edited by Paul Rabinow, 239–56. New York: Pantheon Books, 1984.

Real Academia Española. *Diccionario de la lengua Castellana, en que se explica el verdadero sentido de las voces, su naturaleza y calidad, con las phrases o modos de hablar, los proverbios o refranes, y otras cosas convenientes al uso de la lengua*. 6 vols. Madrid, Spain: Imprenta de Francisco del Hierro, 1990.

Reinhard, Johan. *The Ice Maiden: Inca Mummies, Mountain Gods, and Sacred Sites in the Andes*. Washington, DC: National Geographic Society, 2005.

———. *Machu Picchu: Exploring an Ancient Sacred Center*. 4th rev. ed. World Heritage and Monument Series. Los Angeles: Cotsen Institute of Archaeology, University of California, 2007.

———. *Machu Picchu: The Sacred Center*. Lima, Peru: Nuevas Imágenes S.A., 1991.

Relph, E. C. *Place and Placelessness*. Research in Planning and Design. London: Pion, 1976.

Rostworowski de Diez Canseco, María. "Los Ayarmaca." *Revista del Museo Nacional* 36 (1970): 58–101.

———. *History of the Inca Realm*. Translated by Harry B. Iceland. Cambridge: Cambridge University Press, 1999.

Rowe, John H. "La constitución inca del Cuzco." *Historica* 9, no. 1 (July 1985): 35–73.

———. "Probanza de los Incas nietos de conquistadores." *Historica* 9, no. 2 (1985): 193–245.

Salazar, Lucy C. "Machu Picchu: Mysterious Royal Estate in the Cloud Forest." In *Machu Picchu: Unveiling the Mystery of the Incas*, edited by Richard L. Burger and Lucy C. Salazar, viii, 230. New Haven, CT: Yale University Press, 2004.

Sallnow, Michael J. *Pilgrims of the Andes: Regional Cults in Cusco*. Washington, DC: Smithsonian Institution Press, 1987.

Salomon, Frank. "The Beautiful Grandparents: Andean Ancestor Shrines and Mortuary Ritual as Seen through Colonial Records." In *Tombs for the Living: Andean Mortuary Practices*, edited by Tom D. Dillehay, 315–53. Washington, DC: Dumbarton Oaks Research Library and Collection, 1995.

———. *The Huarochirí Manuscript: A Testament of Ancient and Colo-*

nial Andean Religion. Translated from the Quechua by Frank Salomon and George L. Urioste. Transcription by George L. Urioste. Austin: University of Texas Press, 1991.

Sanchez, Antonio. "Estos domingo." Unpublished archive material. Cuzco, Peru: Archivo Arzobispal del Cuzco, 1583–1584.

Sancho, Pedro. An Account of the Conquest of Peru. Boston: Milford House, 1972.

Santo Tomás, Domingo de. Lexicón o vocabulario de la lengua general del Perú [1560]. Facsimile ed. Lima, Peru: Universidad Nacional Mayor de San Marcos, 1951.

Sarmiento de Gamboa, Pedro. Historia de los Incas. Biblioteca de Viajeros Hispánicos. Madrid, Spain: Miraguano Ediciones, Ediciones Polifemo, 1988.

———. History of the Incas. Translated by Clements R. Markham. Mineola, NY: Dover Publications, 1999.

———. The History of the Incas. Translated by Brian S. Bauer and Vania Smith. Joe R. and Teresa Lozano Long Series in Latin American and Latino Art and Culture. Austin: University of Texas Press, 2007.

Scott, Heidi V. Contested Territory: Mapping Peru in the Sixteenth and Seventeenth Centuries. History, Languages, and Cultures of the Spanish and Portuguese Worlds. Notre Dame, IN: University of Notre Dame Press, 2009.

Seamon, David. "Body-Subject, Time-Space Routines and Place-Ballets." In The Human Experience of Space and Place, edited by Anne Buttimer and David Seamon, 148–65. New York: St. Martin's Press, 1980.

———. A Geography of the Lifeworld: Movement, Rest, and Encounter. New York: St. Martin's Press, 1979.

Seamon, David, and Robert Mugerauer. Dwelling, Place, and Environment: Towards a Phenomenology of Person and World. Dordrecht, Netherlands; Boston, MA: Kluwer Academic Publishers, 1985.

Sillar, Bill. "The Social Life of the Andean Dead." Archaeological Review from Cambridge 11, no. 1 (1992): 107–23.

Silverblatt, Irene. Moon, Sun, and Witches: Gender Ideologies and Class in Inca and Colonial Peru. Princeton, NJ: Princeton University Press, 1987.

Silverman, Helaine. "The Historic District of Cusco as an Open-Air Site Museum." In Archaeological Sites Museums in Latin America, edited by Helaine Silverman, 159–83. Gainesville: University Press of Florida, 2006.

———. "Mayor Daniel Estrada and the Plaza de Armas of Cuzco, Peru." Heritage Management 1, no. 2 (2008): 181–218.

———. "The Space of Heroism in the Historic Center of Cuzco." In On Locations: Heritage Cities and Sites, edited by D. Fairchild Ruggles, 89–113. New York: Springer, 2012.

Simmel, George. "Bridge and Door." In Rethinking Architecture: A Reader in Cultural Theory, edited by Neil Leach, 66–69. New York: Routledge, 1997.

Spalding, Karen. "Kurakas and Commerce: A Chapter in the Evolution of Andean Society." Hispanic American Historical Review 53, no. 4 (November 1973): 581–99.

Squier, E. George. Peru: Incidents of Travel and Exploration in the Land of the Incas. Cambridge, MA: AMS Press for the Peabody Museum of Archaeology and Ethnology, Harvard University, 1973.

Stern, Steve J. Peru's Indian Peoples and the Challenge of Spanish Conquest: Huamanga to 1640. 2nd ed. Madison: University of Wisconsin Press, 1993.

Stone-Miller, Rebecca, ed. To Weave for the Sun: Ancient Andean Textiles in the Museum of Fine Arts, Boston. London: Thames and Hudson, 1992.

Taylor, Gerald. "Camay, comac et camasca dans le manuscrit Quechua de huarochiri." Journal de la Société des Américanistes 63 (1974): 231–43.

Toledo, Francisco de. Gobernantes del Perú. Cartas y papeles. Siglo XVI. Documentos del Archivo de Indias. Edited by Roberto Levillier. Vol. 7. Madrid, Spain: Imprenta de Juan Pueyo, 1924.

———. "Informaciones que mandó levantar el Virrey Toledo . . . (1572)." In Don Francisco Toledo, edited by Roberto Levillier. Buenos Aires, Argentina, 1935.

———. Tasa de la visita general de Francisco de Toledo. Introduction and transcription by Noble David Cook. Lima, Peru: Universidad Nacional Mayor de San Marcos, 1975.

Torres Rubio, Diego de. Arte de la lengua quichua [1619]. Lima, Peru: Por Francisco Lasso, 1619.

———. Arte, y vocabulario de la lengua quicua general de los indios de el Perú. Lima, Peru: Imprenta de la Plazuela de San Christoval, 1754.

Trachtenberg, Marvin, and Isabelle Hyman. Architecture from Prehistory to Post-modernism: The Western Tradition. New York: Abrams, 1986.

Tuan, Yi-Fu. Space and Place: The Perspective of Experience. Minneapolis: University of Minnesota Press, 1977.

———. Topophilia: A Study of Environmental Perception, Attitudes, and Values. Englewood Cliffs, NJ: Prentice-Hall, 1974.

Uhle, Max, Wolfgang W. Wurster, and Verena Liebscher. Pläne archäologischer stätten im andengebiet [in German and Spanish]. Materialien zur allgemeinen und Vergleichenden Archäologie. Mainz, Germany: P. von Zabern, 1999.

Upton, Dell. Architecture in the United States. Oxford: Oxford University Press, 1998.

Urton, Gary. "La arquitectura pública como texto social: La historia de un muro de adobe en Pacariqtambo, Perú (1915–1985)." Revista Andina 6, no. 1 (1988): 225–61.

Valencia Zegarra, Alfredo. "Recent Archaeological Investigations at Machu Picchu." In Machu Picchu: Unveiling the Mystery of the Incas, edited by Richard L. Burger and Lucy C. Salazar, 70–82. New Haven, CT: Yale University Press, 2004.

Van de Guchte, Maarten J. D. "'Carving the World': Inca Monumental Sculpture and Landscape." Dissertation. University of Illinois at Urbana-Champaign, 1990.

Vargas Ugarte, Rubén, ed. Concilios limenses (1551–1772). Vol. 1. Lima, Peru: Tipografía Peruana S.A., 1951.

Villanueva Urteaga, Horacio. Cusco 1689: Documentos, economía y

sociedad en el sur andino. Cuzco, Peru: Centro de Estudios Rurales Andinos "Bartolomé de las Casas," 1982.

———. "Documentos sobre Yucay en el Siglo XVI." *Revista del Archivo Histórico del Cuzco* 13 (1970): 1–148.

———, ed. *Historia de los incas y conquista del Perú*. Lima: Imprenta y Librería Sanmartí, 1924.

Villar Córdova, Sócrates. *La institución del yanacona en el incanato*. Nueva Corónica, V 1, Fasc 1. Lima, Peru: Universidad Nacional Mayor de San Marcos, Facultad de Letras y Ciencias Humanas, Departamento de Historia, 1966.

Violich, Francis. "Evolution of the Spanish City: Issues Basic to Planning Today." *Journal of the American Institute of Planners* 27, no. 3 (1962): 170–79.

Wagoner, Phillip B. "Sultan among Hindu Kings: Dress, Titles, and the Islamicization of Hindu Culture at Vijayanagara." *Journal of Asian Studies* 55, no. 4 (1996): 851–80.

Wernke, Steven A. *Negotiated Settlements: Andean Communities and Landscapes under Inka and Spanish Colonialism*. Gainesville: University Press of Florida, 2013. doi:40021962079.

———. "Negotiating Community and Landscape in the Peruvian Andes: A Transconquest View." *American Anthropologist* 109, no. 1 (2007): 130–52.

Wright, Kenneth R., Jonathan Kelly, and Alfredo Valencia Zegarra. "Machu Picchu: Ancient Hydraulic Engineering." *Journal of Hydraulic Engineering* (October 1997): 838–43.

Wright, Kenneth R., Gordon F. McEwan, and Ruth M. Wright. *Tipon: Water Engineering Masterpiece of the Inca Empire*. Reston, VA: American Society of Civil Engineers, 2006.

Wright, Kenneth R., Gary D. Witt, and Alfredo Valencia Zegarra. "Hydrogeology and Paleohydrology of Ancient Machu Picchu." *Groundwater* 35, no. 4 (1997): 660–66.

Wright, Kenneth R., Ruth M. Wright, M. E. Jensen, and Alfredi Valencia Zegarra. "Machu Picchu Ancient Agricultural Potential." *Applied Engineering in Agriculture* 123, no. 10 (October 1997): 39–47.

Zárate, Agustín de. *The Discovery and Conquest of Peru*. Translated by J. M. Cohen. Harmondsworth, UK: Penguin, 1968.

INDEX

Cañari people, 189, 244n81

cancha/kancha (physically bounded space, building cluster), 21f, 67–68; adapting to topography, 22f, 23; at Chinchero, 77–80 (77f–78f, 80f, 81f); in colonial era, 193, 193f; as corral, patio, 217n3; not defined by function, 68; at Ollantaytambo, 22f

Candia, Pedro de, 98f, 108

caninacukpirca (well-bonded wall), 7, 25, 27; "nibbling" bonded masonry, 25, 31, 209n76

capac (associated with royalty) and associated terms, 154, 231n2, 232n25, 232n25

Capac Ayllu (Topa Inca's *panaca*), 173–75, 177, 232n25, 239n10

Capac Huari/Qhapaq Wari (son of Topa Inca): banishment to Chinchero, 3, 9, 173–74; descendants of, 3, 178, 189; everyday life of, 82–83; sharing platform with Topa Inca, 87, 95–96, 116–17; significance of Chinchero to, 38, 87, 166, 168, 174; sleeping quarters of, 169; as son of Mama Chequi Ocllo, 2, 166, 168, 238–39n8; succession dispute with Huayna Capac, 2–3, 91, 152, 153, 172–74, 221n24, 239n18

capac marca uasi. See marca uasi

Capay ccapakpa huacin (royal, royal house), 221n21

Capilla de Señor de Huanca, 43f

Capillapampa. *See* Pampa at Chinchero

carpamazma (house with large eaves), 223n53

carpa uasi/carpahuaci (auditorium, house of three walls), 8, 97f–98f, 104–10 (107f), 226n80, 223nn42, 48; *carpa* (tent, *ramada*, covering), 104, 223nn48, 49, 224n68; three-walled structures, 108–9, 109f, 226n79

Cassana/Casana, 127, 228n22, 229n41, 230n42

caves: association with *mallqui*, 53, 79, 214n55; *charkimachay* (cave where meat is dried), 236n75; at Chinkana, 52–53 (52f), 79; as oracles, 31; as *pacarinas*/places of origin, 52, 214n54; at "Torreon," 214n54

ceque system, Cuzco, 39, 58, 203n4, 211n19, 212n24, 220n19, 221n26, 240n38, 243n75

Céspedes, Luis de, 188

Chama, Tomas, 190, 245n97

champi (royal standard of *sapa inca*), 85

Chanca, 75, 236n77

chapels at Chinchero, 180f, 185–88, 243n74; Ayllupongo (Uspapata), 148f, 186, 187; Cupir, 182f, 185, 186, 187; Huancapata (Capilla de Señor de Huanca), 39f, 42f, 43f, 187, 243n72; Inticapilla, 243n70; placement of, 185–88, 242n66; Yanacona, 150f, 185–87. *See also* Nuestra Señora de Montserrat, Church of

charkimachay (cave where meat is dried, street name in Chinchero), 236n75

chheccoscaa rumi (small ashlar blocks), 26, 27, 206n18

Chilche, Francisco, 189, 244n81

Chincana/Chinkana, 48–54 (49f–52f, 54f); cave at, 52–53 (52f), 79; derivation of name, 53, 214n56; different experience for arriving, departing visitors, 53, 79–80; as *pacarina*, 214n54

chincani, chincacuni (lost, diving into water), 214n56

Chinchero: arches, 183–85 (183f, 184f); burning and fragmentation of, 117f, 120–21, 175–76, 227n11, 239n26; *callanca uasi*

at, 26–27; Catholic priests avoiding, 189–90; choice of stone in, 29; church façade using original walls, 27, 27f; colonial-period homes in, 192–93 (193f); competing indigenous land claims in colonial era, 189; crops grown in, 244n87; current state of, 4–5; as *encomienda*, 188–89; formerly part of Ayarmaca lands, 37–38; gradual rebuilding of, 176; high-altitude climate of, 189–90; landscapes at, 37–38; location favoring Chequi Ocllo over Mama Ocllo, 34, 38; *mallqui* of Topa Inca at, 3; map of region, 37f; meaning of name, 2, 210n88; ownership disputes over, 3; reception area on road to Urubamba, 44, 44f; remaining relatively independent and indigenous, 188–89, 200, 245n96; renaming of, 200; site plan of surviving walls, 13f; sizes of surviving structures, 23; slated for international airport, 200–01; socially constructed spaces guiding access to, 5; southern portion of, 43, 245–46n107; Spanish imposition of street grids, 179–81 (180f); Spanish plaza replacing private *pata*, 181–83; as Topa Inca estate, 1–3, 14; written records on, 2–3. *See also* Nuestra Señora de Montserrat, Church of; Pampa at Chinchero; viewing platform at Chinchero

Chiripata *estancia*, 244n91

chiru (side of), 2, 33, 46, 210n88

Chivantito, Francisco, 195–97 (196f, 197f)

Choco, 2, 203n4

Christianity: *civitas Cristiana*, 179, 183, 188, 192, 196; entangled with Inca religious practices, 185–86 (186f); first colonial church at Chinchero, 176–77, 190, 239n31; importance of city concept to, 240–41n43; Inca conversions to, 176; priests avoiding Chinchero, 189–90; processions, 185. *See also* chapels at Chinchero; Nuestra Señora de Montserrat, Church of

Chukipampa. *See* Pampa at Chinchero

chuño (freeze-dried tuber), 190

churacona uasi/wasi (warehouses), 8, 156–58 (156f, 157f), 233n32; *churana/churaccuna* (storage box or locker), 233n34; *churcacuna huaci* (separated warehouses), 233n34

churches, 176–77, 190, 239n31. *See also* chapels at Chinchero; Nuestra Señora de Montserrat, Church of

churi (child of a male), 208n58

Chuso *estancia*, 190, 244n91

civitas Cristiana, 183, 188, 192, 196. See also *Law of the Indies*

Classen, Constance, 30–31, 209nn65–66, 77, 79

Cobo, Bernabé: on door frames, 222n31; on furnishings in highland houses, 227n8; on "*galpones*," 127, 228n20; on *guayyaya* dance, 85; on *huaca*, 79, 138, 213n51; on Inca veneration of snakes, 82; on Inca "wine room," 159; on respect for the dead, 239n24; on storage of ritual paraphernalia, 218–19n26

colca/collca (storage), 156 (156f), 158, 233n33

Collcampata, 127, 228n22

colonial-period homes in Chinchero, 192–93 (193f)

cona (denoting plural), 119, 156

concealed workmanship, 24–25

condor, 57–58, 57f, 79, 81, 214n66

Condorcaca, 54–59 (55f–57f), 77–80 (78f, 80f)

Contisuyu, 215n71

Coricancha/Qorikancha ("Golden Enclosure"), 2, 19, 20f, 27, 68, 185

corn beer. See *aka* (corn beer) and associated terms

Corominas, Joan, 128, 229nn27–29

Coya, Beatriz Clara, 189

coya/ccoya: sister wives, 219n44, 232nn18, 19; wife of *sapa inca*, 8, 162–69 (163f), 220n19, 237n87

CP0 building, 17f, 123f

CP1 building, 123f, 234n58

CP2 building, 123f, 234n58

CP3 building, 17f, 18f, 30f, 112f; building type of, 18; elite access to, 122–25 (123f), 139; forming façade with CP4 and CP5, 111; as "luxury boxes," 126; partly dismantled by local landowner, 228n16; possibly burned by Atahualpa, 175; sightlines to and from, 122–26 (124f, 125f); windows, 124, 125f

CP4 building, 17f, 18f, 112f; access to, 130, 131f; deep foundations suggesting tall roof, 135–36; double-jamb niches, 130–34 (131f, 133f, 134f); forming façade with CP3 and CP5, 111; height of walls, 137; I.N.C.-rebuilt terrace wall, 135f; possibly burned by Atahualpa, 175; restricted view into, 132; ritually sealed after burning, 138; as *suntur uasi*, 8, 136–38, 175; thresholds in, 229n36

CP5 building, 17f, 18, 18f, 112f; access point for elites, 139; ancillary room as baffled entrance, 114–15, 114f; building type of, 18; burn marks on, 117f, 120–21, 176; ceremonial burial offering under, 115; converted into church sanctuary, 176–77, 190, 239n31; floor of, 117; forming façade with CP3 and CP4, 111; hydraulic system underneath, 117; likely contents of, 120; north façade of, 113f; pathway from Pampa to, 114f; as possible *camachicona uasi*, 119; possibly burned by Atahualpa, 175; roof and ceiling, 120–21; situated between Pampa and platform, 112; view from inside, 113f; viewing platform procession visible from, 117, 117f, 120, 122; windows, 118, 118f

CP21 building, 66f, 70, 72f–74f, 80f, 112f, 116f

CP22 building, 66f, 72, 74f, 80f

Cresswell, Tim, 36, 211n15

crosses, 185–86 (186f), 243n70

cuipucamayoc. See camayoc and other specialists

cumbi (finely woven cloth), 154, 166

Cummins, Thomas, 151, 181, 208n63, 221n22, 241n54

çupan (shade of a person or animal), 243n67

çupay (the devil), 243n67

Cuper/Cupir: Cuper Alto, 189, 243n73; Cuper Bajo *ayllu*, 189, 211n22; Cuper Bajo shrine, 26, 37, 39–41 (40f, 41f); Cupir *ayllu*, 189, 199, 243n74; Cupir chapel, Chinchero, 182f, 185, 186, 187; Cupir *estancia*, 190, 244n91; maps of region, 37f, 39f; painted wall at, 41 (41f), 43, 212n28; territories associated with, 243n73

Curi Ocllo, 173, 220n19

current residents of Chinchero: architecture of buildings today, 154; avoiding Chinkana at night, 53; banned from farming by I.N.C., 46; collecting stones from Cuper Bajo, 41; on

Condorcaca stone *apu*, 55, 215n69; on cross from *Inticapilla*, 243n70; describing church built on Inca palace, 99; giving Capillapampa as name of "Pampa," 68; giving Pumawasi as name of CP22, 75; on landowner tearing down CP3's walls, 228n16; looting of a burial ground, 214n54; on *marca*, 154–55; on names of streets, 41, 181, 185, 246n110, 246n111; not using main staircase, 60; on Pampa de Anta, 217n7; participating in *Qoyllur Rit'i* pilgrimage, 243n72; rejecting name Chincheros, 200; on southern part of town, 245–46n107; still using Urubamba Valley roads, 44; threat from new airport, 200; on time before toiletry customs, 236n72

Cusichuri (Topa Inca's *huauque*), 29, 174, 177

Cusipata/Kusipata, 67, 181, 241n55

Cusi Yupanqui, 175

cuyusmanco (ruler's day room), 8, 144f, 145, 145f; above or level to *pata/pampa*, 222n34; architectural guards for, 102; Atahualpa attack on, 175; and building CP5, 115 (115f), 227n2; as building or entire site, 97; confusion with *carpa uasi*, 126–28; *cuyusmanco huaci*, 221n24; framing *sapa inca*, 96, 103, 110, 151; Guaman Poma on, 97–98 (97f, 98f), 103, 104, 107, 219–20n20, 222n29; introduced during Topa Inca's reign, 103, 138; Murúa description of, 220n19; none at Cajamarca, 151–53; none at Machu Picchu, 109; none found in Atahualpa's compound, 152, 231n17; possible meeting place with *orejones*, 150–51; possible *punona uasi* next to, 167; at Quispiguanca and Tambokancha-Tumibamba, 101; reuse of in colonial times, 98–99; Santa Cruz Pachacuti on, 221n24; status conveyed by, 153; as three-walled building, 99; use of in imperial times, 100–01; view of inside obscured, 103; visibility of, 102, 245n100; and wife of ruler, 220n19, 232n20. *See also* P4 (*cuyusmanco*) building; P5 (*cuyusmanco*) building

Cuzco: built-in pauses in road from, 43–44; churches built over sacred sites, 185; Coricancha/Qorikancha ("Golden Enclosure"), 2, 19, 20f, 68; "dual plazas" of, 67, 98, 181, 241n55; siege of, 179; Spanish sewage crisis in, 235n65; *suntar uasi* in, 136

dancing and singing: inside buildings, 127; no distinction made between, 69; *sapa inca* participating in, 90; types of dances, 69, 85–86. *See also* performance; processional movements

dead, housing and feeding of, 214nn54–55. *See also mallqui/mallki* (ancestor mummy)

Dean, Carolyn: on arches as Christian and secular, 243n76; architectural references to Cuzco, 205n4; on bonded masonry and "nibbling," 25, 209n76; on carved images on outcrops, 215n76; on caves as doorways, 214n54; on *huanca*, 29, 42; on *huauque*, 29; on landscape as memoryscape, 35; on meaning of unworked places, 213–14n52; on repetition in Inca architecture, 14, 205n4; on sacred natural stones, 54; on *saycusca*, 58; on steps on outcrops, 214n53

Devil, 186, 243n67

diseases from Europe, 3, 128, 174–75, 238n1

division between public and private spaces, 142, 151

doorways: building types defined by, 99–100, 104; in *carpa uasi*,

104, 106; in CP3, 122–23 (123f), 139, 228n16; in CP4, 130, 132f, 134–35 (134f), 138, 175; in CP5, 114–16 (114f, 115f); in *cuyusmanco* (P4, P5), 101–3, 107, 115–16 (115f), 146f, 150, 175; double/triple jambs in, 119, 130, 131f, 138; elevated doorway behind CP3, 122, 123f; frames for temporary covering, 99, 222n31; interior doorway within CP21, 71, 73f; matted reed frames as, 99, 222n31; in Ninomaru Palace, 222n40; preserved in new church, 191 (191f); *Puncu puncucamayoc* (door guard), 222n39; *puncu/punku* (doorways, openings), 17f, 89, 96, 110, 219n1; secret/hidden doorway in CP4, 134–35 (134f), 138, 175; and sightlines, 110, 113f, 116–17, 124; in *suntur uasi*, 137–38; use of multiple doorways, 27, 99, 126, 130, 139; as visual frames, 151

duho ("throne"), 129

eaves, 104, 106, 122, 223n53, 225n75, 229–30nn40, 41, 230n51
Edo, Japan, comparison to, 34, 222n40
encomiendas, 188–89
English country houses, building of, 34
epidemics, 3, 128, 174–75, 238n1
estancias around Chinchero, 190
estates. *See* royal estates, Inca
Europe/Europeans: admiration for Inca fitted stonework, 25; few living in Chinchero, 188–89; and high-altitude climate, 189; pathogens from, 3, 128, 174–75, 238n1; towns as central to civilized society, 178
exits from Pampa, 76f; Exit One, 77–80 (77f, 78f); Exit Two, 80–82 (81f); Exit Three, 82–83 (81f, 83f); Exit Four, 83–86 (83f, 84f)
exuviae (bodily sheddings), 29, 163, 164, 237n81

facture, 19, 24–28, 33, 58, 121–22
Farrington, Ian, 142, 207n45, 222nn28, 34, 224n66, 235n65
fertilizer, manure as, 161–62. *See also aca* (excrement) and associated terms
fieldstone masonry, 28
fingernails. *See* exuviae
form: form-following-function paradigm, 11–13, 18, 19, 142, 227n9; Inca meaning in, 21–24
fountains: at Chinchero, 60 (60f), 186, 193, 246n111; at Chinkana, 49, 51; at Cuper Bajo, 39, 40f; at Curi Ocllo's house, 220n19; at Cuzco, 240n38; at Machu Picchu, 235n68; *paqcha* (fountain), 186; at Peccacachu, 45, 46f; *pucyu/Pukyu* (fountain, water spring, crown of head), 246n111. *See also* water
Frame, Mary, 25
Franquemont, Christine, 213n41
Fraser, Valerie, 245n102, 246n109
free-standing, single-space structures, 14, 21–23 (21f, 22f)
function(s): of buildings CP4, CP5, 101–2, 112–14, 120, 176; *cancha, pata, pampa* not defined by, 68; of *carpa uasi*, 106–7; of *cuyusmanco*, 97–98; Dean on, 205n4; form-following-function paradigm, 11–13, 18, 19, 142, 227n9; Inca building forms not defined by, 110, 111; of *kallanka*, 18–19, 205n10; of *masma*, 225n75; of Pumawasi, 75; of *punona uasi*, 167; of royal building types,

96–104; Spanish changes to, 178, 187, 225n69, 242n58; of storehouses, 158, 159; of tents, 223–24n49; of terraces still the same, 199; of *tiana*, 225n77; of *usnu*, 225n71; of viewing platform, 90

gables: gabled roofs, 14, 104, 121, 158, 223n51; gable ends, 108–9, 190–91, 193–94, 218n23, 223n51, 230n52, 233n35; gable windows, 119, 120, 193–94, 222n29; and trapezoidal layout, 106; view approaching ends, 104
galpónes (galpol/kalpol), 8, 126–30, 228n20, 229n27
García de Loyola, Martín, 189, 244nn82, 83
Garcilaso de la Vega, Inca: on confusion of *aca* and *aka*, 160, 234–35n59; on human manure as fertilizer, 161–62; on Inca roofs, 105, 224n56; on Quispiguanca building, 137; seeing little distinction between buildings, 127–28; on structures turned into shops, 225n69
Gasparini, Graziano: and "architecture of power," 14, 205n3; on basic Andean architectural form, 21; on *kallanka*, 205nn9–10; on *masma*-type structure, 225n75; on standard aspects of Inca architecture, 205n2; on tiered platforms, 219n3; on *usnu*, 206n25, 225n71. *See also* Margolies, Louise
Gibaja de Valencia, Arminda, 206n22
gifting, 53, 90, 120, 153, 158–59, 162. *See also ayni* (reciprocity)
Goldstein, Paul, 223–24n56
Gonzalez Holguin, Diego, 160; on *aca* and associated terms, 160, 161, 235nn60, 62; on *aka* and associated terms, 234n47, 234n55, 235n60; on *anta* and associated terms, 245n101; on *ayllu*, 243n71; on *çacra*, 242n67; on *callanca* and associated terms, 228–29n26; on *Camachic* and associated terms, 227n7; on *cancha*, 217n3; on *Capay ccapakpa huacin*, 221n21; on *carpa*, 223n48; on *carpamazma*, 223n53; on *carpa uasi*, 104, 108, 126, 223n42; on *ccoya*, 237n87; on *chincana* and associated terms, 214n56; on *Chuqqui*, 217–18n110; on *churacona uasi*, 156, 157; on *churana/churaccuna*, 233n34; on *churcacuna huaci*, 233n34; on *çupan*, 243n67; on *çupay*, 243n67; on *cuyusmanco* and associated terms, 97–100, 126, 221n24; on *hanan* and associated terms, 222n32; on *hatun* and associated terms, 222n38, 231n2; on *huaccha* and associated terms, 237–38n99; on *huaci*, 226–27n1; on *huasca*, 246n110; on *Huchhuylla huaci*, 231n2; on *kapac* and associated terms, 232n25; on *llacta*, 247n118; on *maçana*, 236n75; on *marca*, 232n26; on *mazma*, 225n75; on *nina pachacuti*, 238n3; on *ñusta incap koyap vssusin huahuan*, 228n23; on *pacha cuti pach tiera*, 238n3; on *pacu*, 231n13; on *Panpa*, 217n6; on *pata* and associated terms, 217n4; on *pircani*, 205n1; on *Ppaccha*, 246n111; on *Pukyu*, 246n111; on *puma* and associated terms, 216n89; on *puncu*, 219n1; on *puñuna* and associated terms, 237n85; on *sañu* and associated terms, 246n110; on "separated warehouses," 156, 157; on *suntu* and associated terms, 136, 230n42; on *tampu*, 211n12; on terminology for royal things, 231n2; on *titi*, 216n88; on *usnu*, 225n71; on *vinirumi*, 207n33; on wall types, 207n41; on *Ysppay*, 236n71
Gregory (Pope), 242n63
Guacchaconcha. *See uaccha uasi*

Law of the Indies, 178–79, 181, 183, 240n44, 241n51

Lee, Vincent, 105, 223n49, 227n11

limestone, 29; behavior under high temperature, 120–21; bonded masonry, 45; gathered at site, 208n59; part of sacred outcrop, 92–93; polygonal terrace walls, 46, 55f, 65, 77f, 85, 89; Titicaca stairway of, 60 (60f)

lintels. *See* openings/apertures

llacta (community, town), 171, 198, 247n118

Loayza y García, Alonso de, 188

local population: controlling movement of, 36, 179; forced work by, 188–89; indigenous town councils, 98; redistribution of goods among, 154. *See also* current residents of Chinchero; processional movements

maçana. See uasi/wasi

machu (old, big), 157

Machu Colca, 26, 37f, 157–58 (157f), 233–34n39

Machu Picchu: bosses at, 63; handling of grey water, 235n67; interior rooms carved out of mountain face, 214n54; Intihuatana stone, 108; landscape views at, 243n69; manipulation of sightlines at, 29; modern construction, 4; no *cuyusmanco* or *carpa uasi* at, 103, 109; open-faced buildings at, 108–9, 109f, 226n79; Pachacuti estate at, 2, 4; purported toilet at, 235–36n68; road to, 207n42, 212n35; "Sun Temple" at, 27; visible from trail, 102

maize production, 161, 234n45

mallqui/mallki (ancestor mummy), 3; association with caves, 53, 79, 214n55; continuing to reside at royal estate, 172; food offerings to, 79; *panaca* caring for, 172–73; Topa Inca's killed by Atahualpa, 175; traveling with attendants and family, 79–80, 172; veneration of, 79–80; weighing in on successor, 175

Mama Chequi Ocllo (secondary wife of Topa Inca), 2, 239n10; accused of witchcraft, 173; Chinchero built for, 34, 38, 60–61, 166; executed by Huayna Capac, 2–3, 9, 173; favored over primary wife Ocllo, 38, 152, 237n92; life at Chinchero, 82–83, 125, 162–63, 167; lineage of, 152, 238–39n8; mother of Capac Huari, 2, 238–39n8

mamacona (secluded women), 165, 175

Mama Ocllo (principal wife of Topa Inca): accusing Chequi Ocllo of witchcraft, 173; description of, 152; Guaman Poma drawing of, 152f; lineage of, 232n18; marriage to Topa Inca, 2; mother of Huayna Capac, 2; owning lands near Urcos, 2, 38; possible half-sibling to Topa Inca, 152, 166, 219n44, 232n19; victory over Chequi Ocllo, 173

manca (round vase), 221n24

Manco Capac, 239n26

manure. *See aca*

Maras (salt mines, town), 37f, 38, 190

marca uasi/marca wasi/capac marca uasi/huasi (house of the royal treasury), 8, 142, 154–58, 232n28; *marca* (lawyer, loft built into storage building), 154–55 (155f), 193, 232nn26, 29; *sobrado* (Sp. attic or loft storage), 155, 232–33n29

Margolies, Luise, 14, 21, 205nn3, 10, 206n25; and "architecture of power," 14, 205n3; on basic Andean architectural form, 21; on *kallanka*, 205nn10–11; on *masma*-type structure, 225n75; on standard aspects of Inca architecture, 205n2; on tiered platforms, 219n3; on *usnu*, 206n25, 225n71. *See also* Gasparini, Graziano

marriage, sex before or outside of, 237–38n89

masana uasi. See uasi/wasi

mascaypacha (royal fringe), 153, 165, 175

masma/mazma, 225n73

masonry. *See* ashlar masonry; *caninacukpirca*; polygonal masonry

masons, 24–29, 93, 176, 208n46, 239–40n34

McEwan, Gordon, 211n14

measles, 175, 238n1

Mendoza, Zoila, 110, 204n13

Mercedarian order, 190, 241n55

miniature multicolored wall, 40f, 41, 41f, 43–44, 45

mita/mit'a, labor service, 3

Morris, Craig, 142, 157, 228n26, 237n92

mortared masonry, 25; at Chinchero and Ollantaytambo, 26; fieldstone walls, 207n44; used to denote relative status, 26, 28, 207n42

multicolored miniature wall, 40f, 41, 41f, 43–44

Mumford, Jeremy, 188

murals on church ceiling, 195, 196f

Murra, John, 153, 211n10

Murúa, Martin de, 231n6; on *capac marca huasi*, 154, 156; on *coya's* palace, 166, 220n19; on *cuyusmanca* as palace, 97–98; on guarded roads and spaces, 60, 71, 82, 154, 162; on *orejones*, 150–51; on royal estates' public/private division, 142–43, 150; on valets for *sapa inca*, 162–63

musical instruments, 69

ñaupa huasipi. See uasi/wasi

niche(s): adapted into Spanish arches, 246n113; added in colonial period, 146f, 184f, 192–95 (193f, 195f); adding privacy to CP4, 132, 133f; along canal behind CP4, 134, 135f, 229n39; alongside arches in indigenous homes, 246n109; of building CP5, 113f, 117, 118f; at Chinkana outcrop, 52 (52f); double jamb, 40f, 131f, 229nn35, 36; experimentation with shape of, 194, 195f; hiding secret doorway in CP4, 130, 131f, 134–35 (134f), 138, 175; incorporated into later building, 148f; opposite windows, 118f, 119; P13 wall with multiple, 145, 147f–48f, 167, 192; Paqcha, 186; trapezoidal, 26f; in *Virgin of Montserrat* painting, 197 (197f)

Niles, Susan: on distribution of royal estates, 156; on dual pattern in Inca architecture, 142; on importance of building to *sapa inca*, 33; on Inca commemoration of history, 86, 139, 172; on instability of three-walled buildings, 106; on large-scale buildings, 219n42; on patron driving site design, 44; on reputation of living tied to *mallqui*, 79–80; on royal estates as "strings of fields," 203n5; on storehouses as symbol of power, 233n38

nina pachacuti/pachacuti, see pachacuti.

Ninomaru Palace, Japan, 103, 222n40

Nuestra Señora de Montserrat, Church of, 18f, 133f, 147f; built in 1607, 190; built upon ruins of P4, 101f, 146f, 190–92 (191f), 208n59; ceiling murals, 195, 196f; dedication of, 190; first colonial church at Chinchero, 176–77, 190, 239n31; plan of, 99 (99f); as "templo" in colonial documents, 242n66. *See also* chapels at Chinchero

ñusta (princess), 127, 166, 168, 189, 228–29n23

Ollantaytambo: adjoining *cancha* at, 22f; bosses at, 26f, 63; *cuyusmanco* not found at, 103; estate of Pachacuti at, 44, 63; evidence of *marca uasi*, 232n28; mortared masonry at, 26; Protzen on, 216n94, 222n37, 234n41; reversible double jambs at, 130, 229nn33, 34; storage buildings at, 157; terraces and retaining walls of fieldstone masonry, 207n29

open-faced buildings at Machu Picchu, 108–9, 109f, 226n79

openings/apertures: of *carpa uasi* versus *cuyusmanco*, 100–01, 107–8; conveying hierarchy, 119; *cuyusmanco* framing *sapa inca*, 96, 103, 110, 151; differing views from P4, P5, 100–01; Exit Three, experience of, 82; experimentation with, 194–95 (195f); lintels, 146, 195f, 229n26, 243n61, 245n102; modifications to standard building form, 15f; niches, windows in opposition, 117; power of, 192–95 (193f, 194f); regulating access, 122, 126; reversible double-jamb doorways, 130, 229n32; seeing and being seen, 110, 118; spacing of, 132; Spanish changes to, 190–95; supporting illusions of scale, 85–86; windows, placement of, 117–19 (118f), 137, 194

open spaces, 67–68

oracles, 31, 69, 135, 209n63

orejones. See *pacuyoc* (ear)

"orphan" children of *sapa inca*. See *uaccha*

outcrops: adopting of from earlier peoples, 211n19; in Chinchero private sector, 147f; geometric carvings/"seats" on, 49–51 (50f), 54–57 (55f, 56f); given architectural setting, 31, 31f, 36; importance of in Andean topography, 36; pools carved into, 49. *See also* stones

P1 building, 144f, 182

P4 (*cuyusmanco*) building, 147f, 150; burning of, 175; doorways preserved, 27f, 191; original pathway to, 101–2 (102f); original plan of, 99 (99f); sight lines for, 100 (100f), 145, 150; on site plan, 66f, 112f, 144f. See also *cuyusmanco* (ruler's day room); Nuestra Señora de Montserrat, Church of

P5 (*cuyusmanco*) building, 175; burning of, 175; closed and filled by Spanish, 146f, 182; colonial-period niches in, 146f, 184f, 192; and course of processions, 242n61; excavation of, 242n61; interior of, 145f; original opening of, 146f; sight lines for, 100 (100f), 145, 150; on site plan, 112f, 144f. See also *cuyusmanco* (ruler's day room)

P6, P7, P8 buildings, 145, 167, 182

P10, P11 buildings, 182

P12 building, 123f

P13 wall with niches, 145, 147f, 148f, 167, 192

P14, P18, P22 buildings, 145

pacarina (place of origin/origin cave), 211n19, 214n54

pacha (place and time), 35, 63–64, 210n1, 246n111

Pachacuti, Juan (Joan) de Santa Cruz, 221n24

Pachacuti Inca Yupanqui (father of Topa Inca): beginning of Inca Empire, 205n8; calling up stones as warriors, 29; as "changer of the world," 33, 36; children of, 2, 168; Machu Picchu estate of, 4, 63; Mama Ocllo's relation to, 232n18; march in honor of, 75; Ollantaytambo estate of, 44, 63, 130; *panaca* of, 126, 152; redesigning/rebuilding Cuzco capital, 33, 98, 213n43; remaking ceque system, 203n4; sleeping in Cora Cora complex, 221n26; successful succession after, 2, 166, 173; victory over Chancas, 75; on viewing platform with Topa Inca, 220n10

pachacuti/nina pachacuti (moment of upheaval, end of world), 171, 188, 238n3

Pachacuti Yamqui, 220n10

Pachamama ("earth mother"), 28, 60, 158

Pachapujio, 193–94 (194f)

Pacheco offering pots, 224n56

pacuyoc: pacu (ear ornaments), 231n13; *pacuyoc inca* (elite man with ear ornaments, Sp. *orejones*), 142, 150–51, 231n13

painting on Inca stone, 212n28

palla (noble women), 69

pampa ("field," open space), 67–69, 217–18n6; Capillapampa ("fields of the church"), 68, 217n10, 228n16, 241n56; Chukipampa ("fields of the Inca lance"), 68; Huayllapampa ("savannah field"), 67; *pampa pampa* (flat areas), 217n6; *Panpa* (plaza, flat or common ground . . .), 217n6; Rimacpampa, Cuzco, 67–68

Pampa at Chinchero, 14, 17f; Exit One, 77–80 (77f, 78f); Exit Two, 80–82 (81f); Exit Three, 82–83 (81f, 83f); Exit Four, 83–86 (83f, 84f); activities at, 69–70; after Spanish Conquest, 176; current residents' names for, 68, 241n56; exiting and reentering, 76f, 76–77; forecourt (arrival area), 70, 71f; as open-air stage, 70–75 (71f–74f), 86–87; reason for designation as "pampa," 65–68 (66f). See also CP3 building; CP4 building; CP5 building; Pampa stairways at Chinchero

Pampa de Anta, 217n7; communities of, 189; Inca using architecture to naturalize, 38; pre-Inca history of, 37–38; road from Cuzco to Chinchero on, 39; site of Tambokancha-Tumibamba, 101; Topa Inca's use of, 36; Topa Inca transforming of, 36; Urquillos residence near, 2; west of Chinchero, 67

Pampa stairways at Chinchero: central staircase exit (Exit Four), 83–86 (83f, 84f), 101 (101f); to Chinkana/Condorcaca (Exit One), 77 (77f); to CP4, 134; to and from CP5, 114 (114f), 116–17, 120, 143; main staircase entrance, 66f, 70; modern construction, 113f, 114f, 146f, 191; to *pata*, 143–45 (143f, 144f); security monitoring of, 70–71, 143; underground staircase to CP21, 70, 73f

panaca (royal family group): caring for *mallqui*, 172–74; oral history preserved in song, 33; of Topa Inca, 3, 126

Pantheon (Rome), 5

pata: at Chinchero, 122, 123f, 141, 165; Collcampata, 127, 228n22; "dual plazas" Cusipata/Kusipata, Haucaypata/Hawkaypata,

67, 98, 181, 241n55; *Hanan pata* (high point of a hill), 100; Haucaypata/Hawkaypata, Cuzco, 67, 98, 136, 181; Huancapata, 37f, 39f, 41–44 (42f, 43f), 67, 187; Hurincaypata/Hurinkaypata, 68, 79; not defined by function, 68; *pata pata* ("many steps," stairway), 67, 217n4; as step, elevated platform, terrace, 8, 42, 67–68, 217nn4, 5, 231n1; *uspapata* (ash terrace), 243n68

Patallacta, 21f

pavilion roofs, 136, 223n51

performance: in Chinchero's Pampa, 70, 79, 103, 245n100; in Cuzco, 68, 70, 75; Huayna Capac's, 90; by noblemen, 68, 69, 75; of state, 8, 9, 85, 86; use of public space for, 218n22; victory *cantar*, 75. *See also* song and dance

Philip II, 179

Phuyupatamarca, 207n42

pilgrimages: in honor of deceased ruler, 172; with the *mallqui*, 79

Pipil Nawat language, 128–29

pirca (wall), 8, 26; materiality in, 28–29; original and current meanings, 26; *rumi pirca* (stone wall), 26; *tica pirca* (adobe wall), 26

pirca camayoc. See camayoc and other specialists

pircani (to make in order to build), 205n1

Pisac estate of Pachacuti, 2, 103, 245n95

Pitusiray *apu*, 28, 45, 55, 208n51, 215n71

Pizarro, Francisco, 98, 128, 171, 174, 221–22n27

Pizarro, Gonzalo, 188

Pizarro, Hernando, 107

Pizarro, Pedro: on burning of things touched by Atahualpa, 164; description of *cuyusmanco*-like building, 107; on *galpones*, 127; on Inca tactic of burning *suntar uasi*, 229–30n41; living in Pachacuti's palace, 98; on sapa inca *punona uasi*, 167

"plaza": allowed dimensions of, 181, 241nn50, 51; "dual plazas" Cusipata/Kusipata, Haucaypata/Hawkaypata, 67, 98, 181, 241n55; Huancapata, 37f, 39f, 41–44 (42f, 43f), 67, 187; Hurincaypata/Hurinkaypata, 68, 79; meaning of, 216–17n1, 65; ordinances on, 242nn57, 59; versus *pampa*, 65; Pampa and *pata* layout, 143; Spanish remaking of in Chinchero, 181–82

-*pol* (suffix meaning old or dilapidated), 128

policía, 178, 188. *See also Law of the Indies*

polygonal masonry, 14, 17f, 20f, 28; *caninacukpirca* (well-bonded wall), 7, 25, 27; "liminal" state of, 25

potatoes/tubers, 157–58, 189–90

priests: *ayatapuc* (priest who talks to dead), 209n72; Catholic, 189–90; *guacarimachic* (priest who talks to *huaca*), 209n72; hereditary *huaca* priests, 31; Mejia (name of a priest assigned to Chinchero church), 190

primogeniture, absence of, 2, 6, 173

processional movements, 139, 199; to and from CP5, 120, 122, 175, 177; in current times, 199–200; depicted in *Virgin of Montserrat* painting, 196–97 (196f, 197f); description of victory *cantar*, 75; giving meaning to place, 95–96; and illusions of scale, 85; and "kinesthetic mapping of space," 63; *mallqui* traveling with attendants and family, 79–80, 172; Proces-

sion of the Royal Ancestors, 77–80 (76f); routes of, 77–80 (77f, 78f, 80f); route to and from viewing platform, 112–17 (113f, 115f, 117f), 120; Spanish use of arches for, 185, 187, 242n61; of Topa Inca *mallqui*, 172, 174. *See also* performance; song and dance

process of making (facture), 19, 24–28, 33, 58, 121–22

Protzen, Jean-Pierre: on building types, 225n76; on *cancha* units as elements, 23; on effect of recent reconstruction, 204n8; on Guaman Poma's *suntur uasi* drawing, 230n52; on Inca preserving topsoil, 213n43; on Ollantaytambo (Pachacuti estate), 157–58, 207n29, 216n94, 222n37, 229n33, 234n41; on process of carving stone, 25, 28; on Quechua construction specialists, 208n46; on rectangular form in Inca design, 21; on reversible double-jamb doorways, 229–30nn32, 33; on road to Machu Picchu, 212n35; on scale in Inca design, 206n22, 216n94; on terrace construction, 213n43; on unfinished surfaces on Chinchero wall, 245n103; on variability in Inca architecture, 205n2

puma, 57–58 (57f); "game of the Indians," 216n89; versus jaguars, 215n73, 220n11; pelts given after manhood ritual, 215n75; Pumawasi (*puma uasi*) ("Puma's House," building CP22), 72, 75; sculptures on Pumacaca stone, 94–95 (95f); on Condorcaca, 58–59

Pumacaca ("crag of the puma"), 32f, 49f, 91–96 (91f–95f). *See also* viewing platforms

Pumapunku facture, 24, 24f

Puncu puncucamayoc. See camayoc and other specialists

puncu/punku (doorways, openings), 17f, 89, 96, 110, 219–20n1

Puno, 155

punona uasi/punona wasi (house of sleep and sex), 8, 164–68

puñuna (bed) and associated terms, 237n85

purucaya (canonization ceremony for dead ruler), 172, 238n4

pururauca (special stones), 29, 208n53

Qoyllur Rit'i pilgrimage, 243n72

queru/qero (vessel), 120, 158–59

quipu (accounts on threaded cords), 156

quipucamayoc. See camayoc and other specialists

quiro camayoc. See camayoc and other specialists

ramps, 218–19n40

receptions, 43, 44, 87, 151

reducción (Sp. "reduced town"), 178–79, 239n41

Reinhard, Johan, 243n69

Relph, Edward, 218n36

repartimiento (Sp. forced labor system), 189–90, 244n83

reqsiy/riksiy (to know a place or a people), 1, 5, 203n1, 204n13

rikuy (direct experience of space and place), 5, 8, 9, 93, 110, 204n13, 205n20

Rimacpampa, Cuzco, 67–68

ritualized feasts, 18–19

roads, Inca: built-in pauses in, 43–44; from Cuzco, 38–44 (39f–43f); filled in by Spanish, 179f; importance of, 36; regulation

uasi/wasi (building), 8, 19, 111–12, 138–39; *huacicamayoc/uasica-mayoc* (house guard), 222n39; *Huchhuylla huaci* (little house), 231n2; *Incap/Inkap uasi*, 220–21nn20, 21; *maçana* (place where clothes are spread to dry), 236n75; *masana uasi/masana wasi* (building for drying clothes), 8, 162, 165, 236n75; *ñaupa hua-sipi* ("at the old house"), 229n30; single-room rectangular structures, 14, 15f. See also *aca uasi*; *aka uasi*; *callanca*; *cama-chicona*; *camayoc and other specialists*; *carpa uasi*; *churacona uasi*; *cuyusmanco*; *marca uasi*; *punona uasi*; *suntur uasi*; *uaccha uasi*

uncu (tunic), 120, 153

Upton, Dell, 228n25

Urcos/Urquillos/Urcosbamba: chapel on road to, 243n70; map of region, 37f; near Mama Ocllo's land, 2, 44; residential center, 37, 212–13n37; roads from, 44–46, 44f, 46f, 47f, 48f; road to Chinchero bypassing, 38; storage in Chinchero for, 234n39

urine, 160, 161, 236–37n71

Urton, Gary, 244n76

Urubamba/Yucay Valley, 2; Chinchero storage facilities for, 234n39; Huayna Capac's estate in, 206n22; Machu Colca overlooking, 157; Mama Ocllo owning lands adjacent to, 2, 38; Pachacuti's *panaca* living in, 126, 151–52; pollution encroaching on, 199; warehouses on hills above, 233n38

usnu (viewing platform), 98f; chronological study on, 225n74; definition of, 225n71; Huayna Capac on, 90; special features for rituals, 108; varying in shape and form, 206n25. See also viewing platform(s)

uspapata (ash terrace), 243n68. See also *pata*

Uspapata street, Chinchero, 186. See also streets

Valcárcel, Luis, 225n75

viewing platform at Chinchero, 91–96 (91f–95f); processional route to and from, 112, 115f, 116–17 (117f), 120; sanctuary built over processional route, 177; small chambers below, 239–40n34. See also CP5 building

viewing platform(s), 177; description of Huayna Capac on, 90; description of Pachacuti and sons on, 220n10; functions of, 89–90; at Huánuco Pampa, 19, 27, 219n2; lack of study of, 225n73; at Machu Picchu, 108; ubiquity of, 90, 225n74; used by *sapa inca* and heir, 94–95; used by *sapa incas' mallqui*, 172, 174; use of space and sight lines in, 110, 116; *usnu* as, 90, 98f, 108,

206n75, 225nn73–74; at Vilcashuaman, 19, 27, 219n2. See also viewing platform at Chinchero

Vilcashuaman, 19, 27, 219n2

vinirumi (hammerstone), 207n33

Viracocha, 98, 221n26

Virgin of Montserrat (Chivantito), 195–97 (196f, 197f). See also Nuestra Señora de Montserrat, Church of

Virgin of Montserrat, arches and murals dedicated to, 147f, 183f, 186f, 195, 196f

walls. See buildings, Inca

Wari/Huari, 207n34, 211n14, 224n56

water: "biotic systems," 60; channeling of, 49–52 (51f), 60–61 (60f), 66f, 117; cleaning of canals, 227–28n13; drainage canals, 135f, 108, 125f; filtration system, 161; gray water, handling of, 161, 235n67; meaning of to Inca, 51, 60–61; modern canalizing of river, 243n70; *paccha* (fountain, waterspout . . .), 243n70; *ppaccha* (fountain, water spout, canal, spring), 246n111. See also fountains

wayronas/huaironas, 225n75

way stations. See *tambo*

Wernke, Steve, 188

windows. See openings/apertures

women: house of forced sex for captives, 165; making and serving *aka*, 158–59; during meals, 234n50; political marriages, 165; with power, 173; and *punona uasi* (house of sleep and sex), 8, 164–68; role of mother in status of child, 169; separate estates for *coya*, 152, 165–66. See also *coya/ccoya*; *ñusta*; *palla*

yachay (knowledge of sacred practices), 5, 204n13

yacolla (cloak), 153

Yahuar Huacac, 211n19

Yanacona: arch, 183f; *ayllu*, 199, 243n74; chapel, 186, 187; *yana-cona* (Inca servants), 9, 162, 189, 236n77, 237n80

yhuayu (hammerstone), 207n33

Yucay, 189

Yunca people, 226n81

Zárate, Agustín de: on Atahualpa royal reception, 151, 153; on Atahualpa's private compound, 151, 166–67; on Cajamarca day room, 237n95